New Worlds from Old

NEW WORLDS FROM OLD

19th Century Australian & American Landscapes

Elizabeth Johns
Andrew Sayers
Elizabeth Mankin Kornhauser
with
Amy Ellis

National Gallery of Australia, Canberra
and Wadsworth Atheneum, Hartford, Connecticut

Edited, designed and produced by the Publications Department
of the National Gallery of Australia, Canberra.
Designed by Kirsty Morrison.
Edited by Pauline Green.
Colour separations by Pep Colour.
Printed in Australia by Inprint Pty Ltd.

Distributed by
Thames and Hudson (Australia) Pty Ltd,
11 Central Boulevarde, Portside Business Park,
Port Melbourne, Victoria 3207, Australia

Thames and Hudson Ltd,
30–34 Bloomsbury Street,
London WC1B 3QP, UK

Thames and Hudson Inc.,
500 Fifth Avenue,
New York, NY 10110, USA

Cataloguing-publication-data

Johns, Elizabeth, 1937–
New worlds from old; 19th century Australian and American
landscapes.

ISBN 0 642 13076 0. (sc)
ISBN 0 642 13094 9. (hc)

1. Landscape painting, American – Exhibitions. 2. Landscape painting,
Australian–Exhibitions. 3. Landscape painting – 19th century –
United States – Exhibitions. I. Kornhauser, Elizabeth Mankin, 1950–.
II. Sayers, Andrew. III. National Gallery of Australia. IV. National
Gallery of Victoria. V. Wadsworth Atheneum. VI. Corcoran Gallery
of Art. VII. Title

758.1074

ISBN in USA 0 500 97469 1
Library of Congress Catalog Card Number: 97-62528

Catalogue: Full captions are beneath each work; the dimensions
of works are given in centimetres as well as in inches, height before
width. In the texts accompanying the illustrations in the catalogue
section, where there are linear measurements, these are imperial in
texts from the United States of America and metric in the texts
accompanying Australian works.

This catalogue accompanies the exhibition
New Worlds from Old: 19th Century Australian & American Landscapes
organised by the National Gallery of Australia, Canberra,
and the Wadsworth Atheneum, Hartford, Connecticut.

Australia:

National Gallery of Australia, Canberra
7 March – 17 May 1998

National Gallery of Victoria, Melbourne
3 June – 10 August 1998

United States of America:

Wadsworth Atheneum, Hartford, Connecticut
12 September 1998 – 4 January 1999

The Corcoran Gallery of Art, Washington, DC
26 January – 18 April 1999

Front cover:
Eugene von Guérard *Mount William from Mount Dryden, Victoria* 1857 (detail)

Back cover:
John F Kensett *Coast Scene with Figures (Beverly Shore)* 1869

Contents

Sponsors' Forewords 6

Directors' Foreword 8

Introduction and Acknowledgements 10

Likeness and Unlikeness: The American – Australian Experience 15
 Patrick McCaughey

Landscape Painting in America and Australia in an Urban Century 23
 Elizabeth Johns

The Shaping of Australian Landscape Painting 53
 Andrew Sayers

'all Nature here is new to Art': Painting the American Landscape, 1800–1900 71
 Elizabeth Mankin Kornhauser

The Catalogue

Meeting the Land 92

Claiming the Land 121

In Awe of the Land 153

A Landscape of Contemplation 177

The Figure defines the Landscape 201

Artists in Australia — Biographies 225

Artists in America — Biographies 235

Contributors 250

Appendices

Index of Works in the Exhibition 251

Cultural, Social and Historical Events 1770–1901 253

Maps: Australia; United States of America 270

Sponsor's Foreword

Australia and the United States were the last two of the great land masses of our world to be explored, settled and understood. Our collective ancestors — British, European, Native American, African–American, Aboriginal, Asian — shared the terrors and rewards of advancing frontiers on scales not seen before nor since.

Fortunately indeed, the encounter between man and frontier inspired artists of exceptional ability in both nations: from Thomas Cole to Winslow Homer in America and from John Glover to Tom Roberts in Australia. The beauty and wildness of the land, and its terrors and promises, are captured strikingly and romantically for us more than a century later.

New Worlds from Old is the first time these two landscape epics have been seen side by side. United Technologies is proud to support this sharing of new worlds, captured as only great artists can.

George David
Chairman and Chief Executive Officer
United Technologies Corporation

Sponsor's Foreword

Esso in the Gallery

Esso has great pleasure in presenting another landmark in Australia's cultural life with the exhibition *New Worlds from Old: 19th Century Australian & American Landscapes.*

Esso has had a long and rewarding relationship with both the National Gallery of Australia and the National Gallery of Victoria. In 1977 Esso's first major art sponsorship was with the National Gallery of Victoria which featured *The Heritage of American Art.* Esso's link with the National Gallery of Australia was established in 1985 with an Arthur Boyd exhibition, *Arthur Boyd: Seven Persistent Images,* and then in 1990 through our support for *Civilization: Ancient Treasures from the British Museum.* In 1992, we were the principal sponsor of the very successful exhibition *Esso presents Rubens and the Italian Renaissance* in both Canberra and Melbourne.

While Esso's main contribution to Australia is as a major producer of oil and natural gas, the company also believes it is important to contribute to the quality and character of life in our community. We are pleased to consolidate our commitment to promoting fine art for the enjoyment and benefit of all Australians with the presentation of *New Worlds from Old* — firstly at the National Gallery of Australia, Canberra, and continuing at the National Gallery of Victoria in Melbourne.

New Worlds from Old brings together for the first time more than 100 of the best landscape paintings produced in Australia and America to show both the similarities and differences across these two great nineteenth-century traditions. Many of the works have never been shown before in Australia. The thousands of people who will see the exhibition in Australia and then in America will be captivated by the beauty of the paintings and the inspiration of the artists.

Esso wishes to congratulate the Council, Board of Trustees and staff of the National Gallery of Australia, National Gallery of Victoria, the Wadsworth Atheneum and The Corcoran Gallery of Art for their collaborative effort in mounting *New Worlds from Old*, and joins with them in thanking the Australian Government for indemnifying the exhibition during its Australian tour.

Robert C. Olsen
Chairman and Managing Director
Esso Australia Ltd.

Directors' Foreword

This unprecedented exhibition conjoins the distinguished landscape traditions of two great and emergent nations. In the nineteenth century, the promise of our planet seemed boundless, horizons limitless, and destinies manifest. For explorers, settlers, indeed even convicts from Europe, the continents of North America and Australia presented lands of majesty, abundance, and seemingly endless promise. The new lands in turn inspired imagery that vindicated the newcomers' hopes, ambitions and sense of possession, as well as love of nature. Indeed, landscapes painted by American and Australian artists seem to verify their respective nation's self image.

This is the first exhibition to compare these images and the development and achievement of Australian and American landscape paintings generally. It explores their thematic and stylistic parallels, their shared expressive concerns as well as their divergent social and political origins. Tracing the two traditions from earlier European roots, the exhibition explores the ways in which the artists of both countries responded to European and English landscape traditions, only recently codified, and to received artistic concepts such as the picturesque and the sublime, creating imagery alternatively of great intimacy and of grandeur.

The exhibition also explores how the alien landscape was not so much commanded and conquered visually as gradually made familiar and championed as the emblem and symbol of their respective countries. Australian and American landscapists championed the indigenous *genius loci* through images of sentiment and settlement, awe and obeisance, contemplation and absorption, and the projection and enlargement of the figure, which began as a small presence — mere *staffage* — and grew to dominate its surroundings.

Exhibitions of this historical importance and ambitious scale are not possible without the energies of many individuals and the generous support of our sponsors. We are deeply grateful to Robert Olsen and Esso Australia Ltd, the principal sponsor in Australia, and to George David and United Technologies Corporation for sponsoring this exhibition in the United States. Qantas, once again, gave practical assistance by carrying our precious cargo, not merely once but thrice across the Pacific. For indemnifying this exhibition in Australia, we thank the Australian government, through the Department of Communications and the Arts; and in the United States of America this exhibition is supported by an indemnity from the Federal Council on the Arts and the Humanities, an agency of the United States government.

In addition, we would like to thank the Paul Mellon Foundation for its support of an educational symposium to be held at the Wadsworth Atheneum, and a special debt of gratitude is owed to Nancy B. Krieble for her generous personal support of the costs of conservation treatment for works in the exhibition. We thank Elizabeth Mankin Kornhauser, Chief Curator of the Wadsworth Atheneum and Krieble Curator of American Painting and Sculpture, Elizabeth Johns, Silfen Term Professor of the History of Art, University of Pennsylvania, and Andrew Sayers, Assistant Director, Collections, National Gallery of Australia, for their energy and vision in curating the exhibition, and for their significant contribution as the primary authors of the exhibition catalogue. We would also like to thank Amy Ellis, Assistant Curator, Department of American Paintings and Sculpture, Wadsworth Atheneum, and Lyn Conybeare, Exhibition Project Officer, National Gallery of Australia, for their support in coordinating and contributing to the exhibition and catalogue.

There are many revelations in the juxtapositions of this show, which systematically examines how two cultures convert nature to landscape and, while coming to terms with received traditions of their European heritage, creatively recast those conventions for their own purposes. Visitors in both countries will meet old favourites: for example,

the representative sampling of the famous painters of the Hudson River School of the United States and the Heidelberg School in Australia. The thematic organisation of the exhibition, however, is designed to reveal fresh perspectives on the familiar progression of art history. There will be unfamiliar names too, and revelations of the talents of underestimated or little known artists. In comparing and contrasting the two cultures, the exhibition is not so much a bifurcated view of regional responses to the European landscape tradition as a true testament to shared efforts to create new worlds from old. Australians and Americans have long been friends and allies with a common language and heritage but also with independent points of view. There is thankfully still much to be learned from one another, to our mutual enrichment.

Peter C. Sutton
Director, Wadsworth Atheneum

Brian Kennedy
Director, National Gallery of Australia

Introduction and Acknowledgements

Landscape painting reached its zenith in Australia and the United States in the nineteenth century. *New Worlds from Old: 19th Century Australian & American Landscapes* examines the tradition in both countries as it developed over the course of a century, finding similarities and differences in the art of two nations with ancient indigenous populations that were later settled by British colonists. Some fifty major paintings from each country reveal the transformation of old world European conventions to produce landscapes of 'new worlds', and at the same time reveal how nineteenth-century Australians and Americans saw themselves in relation to nature. Here art is seen in a larger context — as a meeting ground between two parallel traditions; and the paintings of both traditions offer cues for the rethinking of their counterparts.

Over the past few decades, and particularly recently, there has been an outpouring of scholarship on the landscape painting of both the United States and Australia. The result of this has been an enhanced market value for these paintings as well as an increased general awareness of the complexities of the respective landscape traditions. Although individually some of these paintings are familiar to the rest of the world, rarely has an exhibition examined the breadth of American landscape painting throughout the entire nineteenth century, and never before has such a large gathering of important American paintings travelled outside the United States. The Australian tradition is unfamiliar to Americans and to the wider world. Until this exhibition such a collection of Australia's most important historical landscape paintings has not travelled outside Australia.

Quality was a significant factor in choosing the paintings that were ultimately included in the show. Not only was an attempt made to find the best examples of an artist's work, but we naturally had to consider condition and whether or not the work could safely travel so great a distance. Works that had made an impact in their own day were at the top of the list for inclusion. Other works whose reception was not as well known were chosen on the basis of the circumstances of the commission or sale as well as technique and composition.

In keeping with the thesis of the show, the works included in the exhibition conform to European-derived landscape traditions. Therefore, works by Native American artists and Aboriginal artists of Australia do not appear in this gathering. An exhibition considering these traditions would be an exciting and illuminating project, but it would be a very different exploration than the one at hand. In order to maintain a coherent study, the group of American items was limited to those created in and picturing the contiguous United States, and not extending to Canada, Mexico, Central or South America. When the terms America or American are used, they refer to the United States only. Similarly, only paintings of and from continental Australia, with the addition of Tasmania, are included. Images of New Zealand, which were an important part of the world of nineteenth-century painting in Australia, are not included in this exhibition.

The historiography of American landscape painting has developed rapidly in the last few years, and the curators of *New Worlds from Old* have drawn on the recent scholarship and methodologies employed in the field. Early work in the history of American art sought to define what was distinctly American in that art. In addition, the focus was on artists from the north-east. Evaluations of the early scholarship in the field can be found in Wanda M. Corn, 'Coming of Age: Historical Scholarship in American Art', in *Art Bulletin* 10 (June 1988), pp.188–297, and Elizabeth Johns, 'Histories of American Art: The Changing Quest', in *Art Journal* 44 (winter 1984), pp.338–344. *New Worlds from Old*, in keeping with more recent scholarship, moves beyond traditional concerns of defining American qualities in American landscape art, searching for unified responses to American landscape, and identifying a homogeneous national school of painters who engaged in communal nationalist agendas. This exhibition asks new questions. In an effort to remedy the long-standing bias toward the north-east, this group of American landscapes reveals many regional differences. Intersecting questions of regional, sectional, and national identity have become the subject of study and are considered here. The most comprehensive treatment of this topic is found in Angela Miller's *The Empire of the Eye: Landscape Representation and American Cultural Politics, 1825–1875* (Ithaca and London: Cornell University Press, 1993). (Other sources are cited in the endnotes for the essays and catalogue entries contained herein.) Recent scholarship in American art history employs methodologies hitherto applied in other academic disciplines (as well as other areas of art history), allowing for the political and psychological interpretation of art. Examples are William H. Truettner and Alan Wallach's *Thomas Cole: Landscape into History* (New Haven and London: Yale University Press for the National Museum of American Art, Washington, DC, 1994)

and Bryan Jay Wolf's *Romantic Re-vision: Culture and Consciousness in Nineteenth-Century American Painting and Literature* (Chicago and London: University of Chicago Press, 1982). The work of cultural geographers who have explored the cultural meanings of landscape in new and important ways is reflected here. Michael P. Conzen, Alain Corbin and Stephen Daniels are a few of the scholars whose work we drew on. Finally, recent studies of the powerful role played by tourism in America's invention of its own culture have influenced the direction of this exhibition. Scholars who have contributed to the literature on tourism are Donald D. Keyes, Elizabeth McKinsey, Kenneth Myers and John Sears, among others.

Australian landscape painting of the nineteenth century has been undergoing increasing scrutiny over the last two decades and *New Worlds from Old* is indebted to much of the new research which has been undertaken in recent years. All of this research builds on the pioneering work of Bernard Smith, in particular his *European Vision and the South Pacific 1768–1850: A Study in the History of Art and Ideas* (1st edn, Oxford: Clarendon Press, 1960) which remains among the most persuasive of all books on the effect of the 'new world' on 'old world' art traditions. Daniel Thomas, as curator of the Art Gallery of New South Wales, then at the National Gallery of Australia, and finally the Art Gallery of South Australia, as Director (between 1984 and 1990), oversaw the building of a formidable collection of colonial art in a very short period. The results of this process of collection-building and research culminated in the Australian bicentennial touring exhibition catalogue *Creating Australia: 200 Years of Art 1788–1988* (Sydney: International Cultural Corporation of Australia, 1988) which sought to bring equal recognition and scholarship to the first century of European colonisation in Australia; and in the publication *Australian Colonial Art: 1800–1900* (Adelaide: Art Gallery of South Australia, 1995) written by Ron Radford and Jane Hylton.

Daniel Thomas encouraged the organisation of a touring exhibition of the work of Eugene von Guérard which he jointly curated with Candice Bruce, author of *Eugene von Guérard 1811–1901: A German Romantic in the Antipodes* (Martinborough, New Zealand: Alister Taylor, 1982). He also encouraged Tim Bonyhady's catalogue *Australian Colonial Paintings in the Australian National Gallery* (Canberra: Australian National Gallery, 1986). Bonyhady used much of this research in his seminal book *Images in Opposition: Australian Landscape Painting 1801–1890* (Melbourne: Oxford University Press, 1985). While the structure of *New Worlds from Old* differs from that in *Images in Opposition*, many of Bonyhady's insights about the broad shapes of colonial visual culture have informed the conception of this exhibition.

Joan Kerr's *The Dictionary of Australian Artists: Painters, Sketchers, Photographers and Engravers to 1870* (Melbourne: Oxford University Press, 1992) has provided an enormous wealth of material from which to understand the richness and complexity of the story of Australian colonial art. Kerr also provided the introduction for the only large-scale study of the patronage of colonial art, *The Artist and the Patron: Aspects of Colonial Art in New South Wales*, mounted as an exhibition for the bicentenary in 1988 (Patricia R. McDonald and Barry Pearce, *The Artist and the Patron: Aspects of Colonial Art in New South Wales*, Sydney: Art Gallery of New South Wales, 1988).

The increased scholarship of Australian nineteenth-century art of which we have had the benefit are three-fold. Firstly, monographic exhibitions and their catalogues (most of which are acknowledged in endnotes to the entries in this catalogue) have broadened our understanding of the range of work made by artists such as John Glover, John Skinner Prout, Eugene von Guérard, Tom Roberts, Frederick McCubbin, Arthur Streeton and W.C. Piguenit. Secondly, there is now an awareness that Australian art was not born with the Heidelberg School painters of the 1880s and 1890s, but that earlier artists were able to see, grasp and express a landscape which is, in many instances, as characteristically Australian as the work of Streeton and Roberts. And thirdly, recent scholarship has tended increasingly to look at art within a wider cultural framework. In this, the work of such cultural historians as Paul Carter in his *The Road to Botany Bay* (London: Faber, 1987) and Robert Dixon in his *The Course of Empire* (Melbourne: Oxford University Press, 1986) have provided important cultural underpinnings to this exhibition.

The title *New Worlds from Old* puts forward one of the major issues explored in the exhibition. In speaking of 'old worlds', we refer not only to Europe (and to England in particular), but to the ancient native worlds and cultures — Native American in the United States and Aboriginal in Australia — that existed long before Europeans landed on either shore. 'New worlds', in the title of the exhibition, refers to the worlds created

by European immigrants. The United States was settled first by religious dissidents; Australia as a penal colony. The concept of new world has a long history. The appellation was first applied to the United States to distinguish it from Asia. The existence of Australia, on the other hand, was mythologised as the great Southern Continent, called *Terra Australis nondum cognita* (the Southern Continent not yet discovered). In other ways, the landscapes of America and Australia were new because they — particularly Australia — had flora and fauna that were unfamiliar to Europeans. In addition, despite the populations that were already living there, these landscapes appeared to be wilderness, which was in great contrast to the heavily settled European countries.

A comparison of American and Australian art proposes to do many things: to compare and contrast the art of two young traditions with earlier art and with each other. Juxtaposition of the two landscape traditions serves to defamiliarise the art of one's respective study, thus causing us to look at our landscape afresh. And finally, the landscapes of both traditions trace the ever-changing complexities of bringing what is known to the experience of the unknown, illuminating the most profound material relationship that we have — that with the land on which we live.

This exhibition and catalogue, co-organised by the National Gallery of Australia and the Wadsworth Atheneum, are the result of considerable efforts of a great many people over the course of many years. Patrick McCaughey, who served as the director of both the National Gallery of Victoria, Melbourne, and the Wadsworth Atheneum, Hartford, before assuming the directorship of the Yale Center for British Art, New Haven, provided the necessary inspiration and bridge between two nations that allowed this exhibition to take shape. Jane Clark, previously curator at the National Gallery of Victoria and now Director of Paintings at Sotheby's, Australia, was also involved in the early planning phases of the exhibition. Ron Radford, Director, Art Gallery of South Australia, was also involved in the development of the exhibition concept. The show has also benefited from the inspired leadership of Betty Churcher, Director of the National Gallery of Australia, Canberra, and her recent successor, Brian Kennedy, and the Atheneum's current Director, Peter Sutton.

The early and generous support of United Technologies Chairman, George David, and his staff including Tom Fay and Larry Gavrich, has allowed this exhibition to move forward with assurity. In addition, we are most grateful to Nancy B. Krieble for providing crucial support for the conservation of key American works in the exhibition, and to the Paul Mellon Foundation headed by Brian Allen for the funding for a major international symposium in conjunction with the exhibition at the Wadsworth Atheneum.

In Australia, we extend our gratitude to Robert Olsen and his staff members, Ron Webb and Lisa Trood, of Esso Australia Ltd, for supporting the project at every point of planning with enthusiasm and generosity. We extend to James Strong and his colleagues at Qantas our particular thanks for applying substantial resources once again to another National Gallery exhibition.

To every member of staff at the Wadsworth Atheneum and the National Gallery of Australia who has been involved in the planning, coordination and promotion of the exhibition, we owe our warmest thanks. We would particularly like to express our appreciation for the enthusiastic support and tireless energy of the following staff members. At the Wadsworth Atheneum: Stephen H. Kornhauser, chief conservator; Lenora Paglia, painting conservator; Lois Wurzel; Zenon Gansziniec, assistant conservator; Martha Small, head registrar; Mary Schroeder, associate registrar; Cecil Adams, head of exhibition design; Eric Ben-Kiki, exhibition designer; Nicole Wholean, exhibition coordinator; Cindy Cormier, education; John Teahan, librarian; Charlie Owen, head of marketing. At the National Gallery of Australia: Geoffrey Major, head conservator; Bronwyn Ormsby and Jane Douglas, painting conservators; Erica Persak, head registrar, and Sarah Rennie; Ren Pryor, head of exhibitions, and Jos Jensen, exhibition designer; Jan Meek, senior advisor, public affairs, Helen Power and Liana Coombes; Ron Ramsey, head of education, Jenny Manning and David Sequiera; Bruce Moore, head of photographic services; Suzie Campbell, head of marketing and publications, Pauline Green, Susan Hall and Kirsty Morrison; Margaret Shaw, chief librarian, and Helen Hyland; Margaret Stack, executive; Elizabeth Malone, development officer; and Vivienne Dorsey, travel officer.

The catalogue has proven to be an enlightening project for its authors. We have had a great deal of help along the way. Amy Ellis, Assistant Curator of American Paintings and Sculpture at the Wadsworth Atheneum, has made a major contribution in writing catalogue entries and assembling transparencies of the American works. Marcia Hinkley and Elizabeth Kohn compiled the timeline of events in the United States. In Australia, Lyn Conybeare coordinated the contributions and illustrations, and Charlotte Galloway, Terence Lane and Magda Keaney greatly assisted Andrew Sayers with researching and writing catalogue entries for the Australian material. Owen Larkin of the Australian National University, Canberra, compiled the Australian timeline. We benefited from

the inspired reading and comments on the manuscript by Carol Troyen, Associate Curator of American Paintings, Museum of Fine Arts, Boston, and Tim Bonyhady, Australian National University, Canberra, Sue Ann Prince, John McCoubrey and Janet Headley. Our special thanks go to Kirsty Morrison for designing the catalogue, and to Pauline Green for editing the abundant material.

Both the National Gallery of Victoria, Melbourne, and The Corcoran Gallery of Art, Washington, DC, have served as colleagues and partners in presenting this exhibition. At the Corcoran Gallery, we thank in particular, David C. Levy, Director, Jack Cowart, Chief Curator, and Linda Crocker Simmons, Associate Curator of Collections; and at the National Gallery of Victoria, Timothy Potts, Director, and Terence Lane, Senior Curator, Australian Art to 1900.

The exhibition would not have been possible without the generosity of our lenders. We thank the following United States lenders: Rick Stewart, Amon Carter Museum, Fort Worth, Texas; Judith A. Barter, The Art Institute of Chicago, Illinois; Suzanne Foley, Bayly Art Museum at the University of Virginia, Charlottesville; Katharine J. Watson, Bowdoin College Museum of Art, Brunswick, Maine; Peter J. Bahra, Cincinnati Historical Society, Ohio; David Kahn, Rich Malley and Steven Rice, Connecticut Historical Society, Hartford; Jack Cowart and Linda Crocker Simmons, The Corcoran Gallery of Art, Washington, DC; Timothy Anglin Burgard, Jane Glover and Steven A. Nash, Fine Arts Museums of San Francisco, California; Ann Morand and Lisa C. Kahn, Gilcrease Museum, Tulsa, Oklahoma; Robert M. Hicklin, Jr, Spartanburg, South Carolina; Jennifer Saville, Honolulu Academy of Arts, Hawaii; Lidia Fouto and Laura Vookle, The Hudson River Museum of Westchester, Yonkers, New York; Stephanie Barron and Ilene Susan Fort, Los Angeles County Museum of Art, California; Kevin Avery, John K. Howat, and Barbara Weinberg, The Metropolitan Museum of Art, New York; Ellen S. Harris, Montclair Museum of Art, Montclair, New Jersey; Erica Hirshler, Theodore Stebbins and Carol Troyen, Museum of Fine Arts, Boston; Peter C. Marzio and Emily Baliew Neff, Museum of Fine Arts, Houston; Nancy Anderson, Nicolai Cikovsky and Franklin Kelly, National Gallery of Art, Washington, DC; Elizabeth Broun and William Truettner, National Museum of American Art, Washington, DC; Laurene Buckley, Mel Ellis and Renee Williams, New Britain Museum of American Art, New Britain, Connecticut; Harvey Jones and Arthur Monroe, The Oakland Museum, California; Trudy Kramer, Alicia Longwell and Kimberly Rhodes, Parrish Art Museum, Southampton, New York; Sylvia Yount, The Pennsylvania Academy of the Fine Arts, Philadelphia; Lily Downing Burke and Gerald P. Peters, Gerald Peters Gallery, New York and Santa Fe, New Mexico; Darrel Sewell, Philadelphia Museum of Art, Pennsylvania; Ellen Kutcher, Reynolda House Museum of American Art, Winston-Salem, North Carolina; J.B. Sands, The Rosewood Corporation, Dallas, Texas; Sidney M. Goldstein, The Saint Louis Art Museum; Suzannah Fabing and Linda Muehlig, Smith College Art Museum, Northampton, Massachusetts; Bruce C. Bergmann and Ira Spanierman, Spanierman Gallery, New York, New York; Michael Conforti, Sterling and Francine Clark Art Institute, Williamstown, Massachusetts; and Helen Cooper, Yale University Art Gallery, New Haven, Connecticut.

Our equal thanks go to the Australian lenders: Edmund Capon and Hendrik Kolenberg, the Art Gallery of New South Wales, Sydney; Ron Radford and Jane Hylton, the Art Gallery of South Australia, Adelaide; Alan Dodge, the Art Gallery of Western Australia, Perth; Margaret Rich, Ballarat Fine Art Gallery, Victoria; Timothy Potts, Gordon Morrison, Terence Lane, Fiona Bennie and Anne Roland, National Gallery of Victoria, Melbourne; Warren Horton, Barbara Perry, Chesley Engram and Kate Eccles-Smith, National Library of Australia, Canberra; Chris Tassell and Diane Dunbar, Queen Victoria Museum and Art Gallery, Launceston; Dagmar Schmidmaier, Alan Ventress and Elizabeth Ellis, State Library of New South Wales, Sydney; Dianne Reilly and Gerard Hayes, State Library of Victoria, Melbourne; Patricia Sabine and David Hansen, Tasmanian Museum and Art Gallery, Hobart; and Murray Bowes and Kirri Evans, Warrnambool Art Gallery, Victoria.

We extend our great appreciation to lenders outside the United States and Australia: Pierre Rosenberg, Jean-Pierre Cuzin and Olivier Meslay, Musée du Louvre, Paris, France; and Richard Ormond and Nicholas Booth, National Maritime Museum, Greenwich, London, United Kingdom.

Finally, we offer heartfelt thanks to our families who have supported our efforts and endured our travels allowing this project to reach completion.

Elizabeth Mankin Kornhauser, Elizabeth Johns, Andrew Sayers

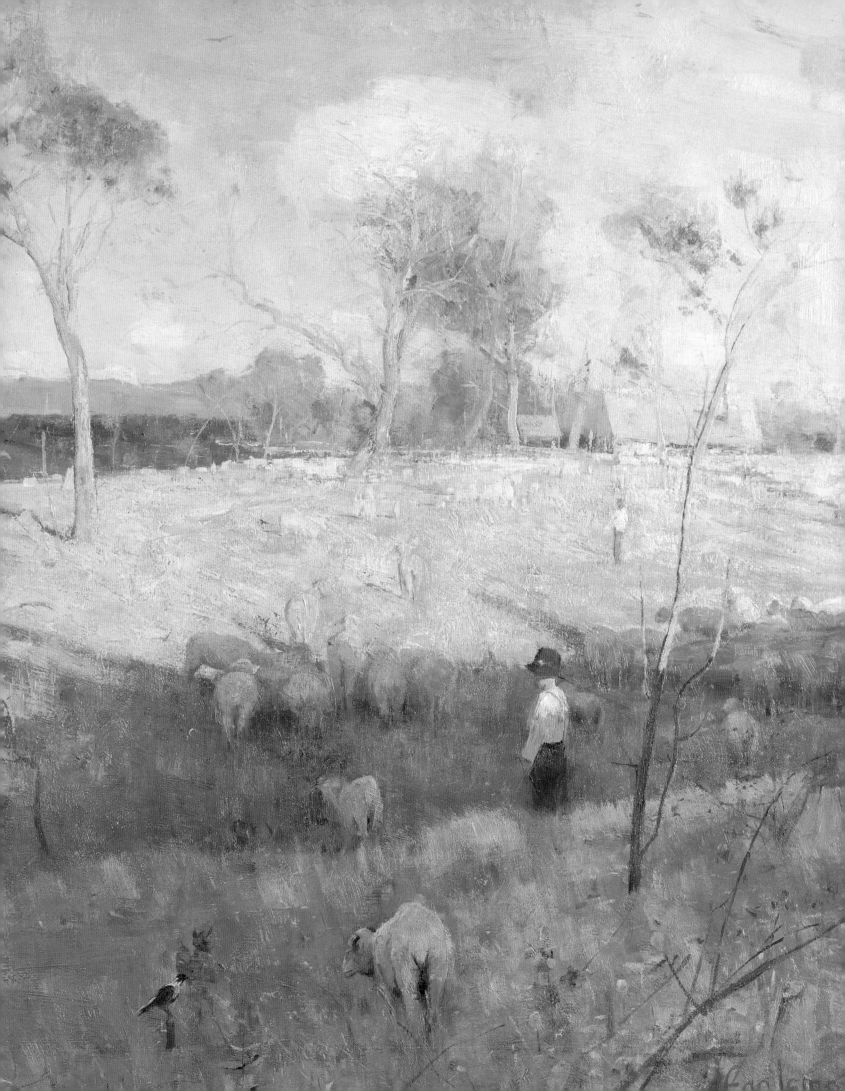

Likeness and Unlikeness:
The American–Australian Experience

The sophisticated American traveller to Australia expects to be excited and delighted by the pleasures and spectacles of nature — the Barrier Reef, Uluru, inland vastness and even perhaps Sydney Harbour — and correspondingly imagines that Australian cities will resemble American ones. Australian nature, even the accessible landscape of bush and plain, densely wooded hills and gleaming beaches, rarely disappoints. Australian landscape is, however, strikingly different for most Americans. The ubiquitous gum tree, which keeps its leaves all year round, sheds its bark, hangs its leaves down in the heat and offers little shade, alters the expectation most Americans have of landscape, namely that of seasonal change.

What is uncanny for the alert American is the rapidly diminishing human presence in the landscape. Within 80 or 90 kilometres (50–60 miles) of the centre of Melbourne or Sydney — and much less if you transfer the scene to Adelaide or Perth — the traveller can find himself in relatively sparsely populated farming land. Homesteads are placed away from the main road, back into the landscape, a retreat from the dust of an earlier era, whereas most American farmhouses and yards tend to cling to main roads to assist easy access of livestock and machinery in snowbound conditions. In Australia this furthers the effect of a landscape with less human presence than the general American experience. What makes the Australian experience so vivid is that it happens within easy reach of large and sophisticated cities like Melbourne and Sydney. An hour's drive from Boston or New York or Philadelphia would not win the same sense of isolation for the traveller.

The good guide book or tourist introduction to Australia may have told the American traveller that the population of Australia is just eighteen million, spread over a land mass the same as the United States (minus Alaska). Or, more exotically, that the population of Australia is roughly the same as the Netherlands, but you could put the whole of the Netherlands into half of Tasmania, the smallest Australian state. These statistics may reinforce experience, but it is unquestionably out there in the landscape that the American traveller begins to sense a crucial difference in scale between the human and the natural.

The cities turn out to surprise the perspicacious American. They are much larger than Americans assume, and accentuate the relative 'emptiness' of the landscape. Even in states with smaller populations such as Queensland, South Australia or Western Australia, the capital cities of Brisbane, Adelaide and Perth are larger, more attractive and frequently more culturally sophisticated than their United States equivalents. Sydney is one of the most dramatic urban experiences in the world, and the ensemble of Harbour Bridge, Circular Quay and Opera House make it one of the few man-made attractions for the American traveller in Australia. Away from the dazzle of Sydney Harbour, the experience of a quieter, less dramatic Australian city like Melbourne is no less a discovery. The downtown area is surprisingly large and apparently commercially thriving. The streets are safe and clean. The combination of well-maintained urban parkland provides a more garden-like experience than most American cities. Perhaps most surprisingly of all, the older, inner-city residential areas have been almost universally gentrified, and so preserve large tracts of nineteenth-century housing

Arthur Streeton *Golden Summer, Eaglemont* 1889 (detail) (cat.107)

and street design. They represent for an American a mode of urban living that is reserved for the wealthier classes. In Australia affluent cities look far more democratic. The impoverished and dangerous ghetto is uncommon. So that part of Australia which was supposed to be like America turns out to be as pleasingly unlike it as the landscape. Moreover, the cities cling to the littoral. In Melbourne and Sydney particularly the traveller is constantly aware of the sea, of the great oceans which lap Australia's shores. Perhaps with a little coaching the American traveller might now begin to see how the Australian imagination is formed by existing between a vast and underpopulated hinterland and an ocean which serves as a perpetual reminder of isolation. It gives to the Australian imagination a deeply romantic cast, a stubborn belief that somehow out there in the landscape lies 'the real Australia'.

Then the curious American traveller makes the most surprising discovery: the art of Australia reflects back and amplifies their own emerging experience of place. Both Aboriginal art and the art of white settlement from the early nineteenth century right through to the late twentieth century take up in different and changing ways the theme of the relation of the human to the natural world in the antipodes. In Aboriginal art there is the profound accommodation of human existence to the land from the dawn of time, the 'Dreaming', to the present day.

In white Australian art there is the perpetually challenging theme: What did the land do to the men and women who came to it in ships, and what did they do to the land — to paraphrase Manning Clark. What makes the discovery of Australian art such a revelation is that it is unknown to the American traveller as the place itself.

The experience of Australia *and* the art which attempts to place that experience, to give it value and to derive significance from it, are discovered at the same moment. Ironically it is here — in the art museum or the private collection — that the American begins to draw parallels between the Australian and the American experience. An art driven in the nineteenth century by exploration, the desire to find and describe the new, to conquer the unfamiliar and the untouched, are familiar themes to the cultivated American. So American travellers find themselves in a curiously ironical and paradoxical situation: the physical experience of Australia is excitingly and pleasurably different; the discovery of Australian art reveals a tantalising familiarity.

How does the curious Australian traveller to the United States fare? No doubt there are antipodean admirers of the Grand Canyon, Yellowstone National Park and Niagara Falls, but for the most part the Australian traveller comes to the United States to visit the cities in search of cultural artefacts and works of art. American cities are the destination points. To visit the United States is to go to Los Angeles or Chicago or New York or Boston or Washington. The focus of the visit more often than not is the art museum, the art district, a great university or the architectural legacy of a particular city. Although Australian cities from Perth to Brisbane sport large and seemingly ever-expanding art museums, the riches and resources of their American equivalents overwhelm even the most culturally patriotic Australian. What is least abundant in Australia — collections of old master paintings, modern masters from Manet to the present — abound in American collections. Even if the intrepid Australian traveller strays off the beaten track of familiar cities, to Minneapolis or Cleveland, Buffalo or Hartford, they still find art museums of high quality and substance at the civic heart. Indeed, often the main reason for visiting such cities is to see the art museum.

It would be fanciful to suggest that the Australian visitor turns avidly to the collections of American art. If my experience is anything to go on, Italian Renaissance paintings, of which barely a score of quality exist throughout Australian collections, plus the extraordinary collections of modern art, are the immediate claimants on Australian eyes.

If, however, the Australian visitor — by now sated with old masters, French impressionist painting and the galaxy of twentieth-century art found in American art museums — persists into the rooms of nineteenth- or early twentieth-century American art, there must come a quickening of the aesthetic pulse. The description of the wilderness and the sublimity of nature, the struggle for settlement, the discovery of natural beauty in the new world and the *dénouement* of the nineteenth century in direct *plein-air* painting should resonate deeply with the reasonably educated Australian. There is a kind of Eugene von Guérard which seems to rhyme with a certain kind of Albert Bierstadt. The fantastic light of Frederic Church can gleam in Nicholas Chevalier at Mount Arapiles. William Merritt Chase assaying the summery dunes of Shinnecock on Long Island recalls Charles Conder or Arthur Streeton at Heidelberg or by Port Phillip Bay. However glib or adventitious these likenesses may be, the Australian taste becomes rightfully transfixed by the analogy between the American experience of landscape and their own. What connects the Australian to the American experience is a kind of inner imaginative awakening. It happens inside the museum before the work of art, rather than out there in the American landscape. The American landscape of nineteenth-century pictorial experience has been so drastically changed through human settlement and economic development that the Australian's present day experience of the American landscape can be dismayingly different.

Where a thoughtful American visitor to Australia found his or her experience reinforced by their experience of Australian art, the Australian visitor discovers an America within the world of art which strikes a deeply resonant chord. The Australian realises that their emergent national school in the nineteenth century bears full comparison with the American drama. The Australian finds with pleasure and aesthetic pride that their voices, so seldom heard beyond Australian shores, retain a ring and timbre of their own. The Australian no longer feels an isolate in their fundamental experience of a place which nourishes them physically and imaginatively.

The constituents of this 'inner imaginative awakening' form the enterprise of this exhibition. So much is profoundly held in common between the two national experiences. First, it is impossible to imagine either Australia or America in the nineteenth century without recourse to the changing image of the landscape — from Thomas Cole to Winslow Homer or from John Glover to Tom Roberts. Painters and paintings have become indelible figures and shapes in the mind of America and Australia. Secondly, the role that experience plays in both national schools cannot be underestimated nor subsumed by the role of schools, academies, influences both literary and visual and all the elements which make up the schema of a painter's mind, to borrow E.H. Gombrich's term.

The openness of these nineteenth-century immigrants to the Australian experience makes John Glover or Eugene von Guérard into artists of substance. Frankly, how relatively dull or conventional both look in their pre-Australian work; the experience of Australia and its capacity to modify the schemas they inherited cannot be dismissed. The case is even more vividly made in the United States with Thomas Cole. There is no European or British prelude to Thomas Cole's career as there is with Glover and von Guérard. The landscapes Cole exhibited in New York in 1825 announced one of the most original starts in nineteenth-century painting. Certainly the role of ideas — the sublime, the role of association, picturesque theory — played a part, but the pictures themselves are remarkable for their vision, the sense of difference in the American landscape, the brilliance of fall colours, or the dreary wasteland of wilderness.

17

Allen Tate once wittily observed of Herbert Read that he sensed analogies and blurred distinctions. Anyone writing on Australian–American pictorial relationships would be wise to pay heed. The conditions under which Australian artists made their work in the nineteenth century differed from their American counterparts. Of all those conditions — differences of patronage, of the association of artists, of institutions — none differentiates the American and Australian experience more sharply than the American artist's relation and proximity to Europe. There is hardly an American landscape painter of significance in the nineteenth century who does not produce a significant body of work outside of the United States, whether it be Thomas Cole in Italy or Winslow Homer at Cullercoats or Frederic Church in the tropics and in Latin America. That option was more difficult for every Australian painter of substance in the nineteenth century. Very often, once you arrived in Australia, that was it; you were dependent on Australian realities as the subject of your art. Certainly outside influences tempered those realities. Barbizon influences made their way to Australia via Louis Buvelot, and *plein airism* through a variety of literary and artistic sources, but it was a relatively strangulated and attenuated flow of outside influences that came into Australia in the nineteenth century compared with the access an American artist enjoyed.

The effects of this are not easy to describe or characterise. There is a greater sense in American landscape painting of the mid-nineteenth century of the highly developed and the well-made painting, of the mighty Salon machine. The sheer size of the big pictures by Church and Bierstadt have few counterparts in Australian painting. The big machine would come into Australian art in the opening decades of the twentieth century in emulation of Royal Academy or Salon models, once Australians began to travel to Europe as a matter of course and necessity.

Thrown back on their own resources and the limited cultural and institutional nourishment of their cities, Australian nineteenth-century landscape painting has a more idiosyncratic quality. Eugene von Guérard is the prime example of the virtues of isolation. There is little development over the forty-odd years of his painting career in Australia. His style looked hopelessly old fashioned and *retardataire* to the young Turks of the Heidelberg School of the 1880s. Today von Guérard's very lack of change gives his paintings a primitive strength and vividness. It rings true as perhaps the more rhetorical grand manners of American nineteenth-century landscape painting do not. Where American painters sought to elevate American landscape painting to the presumed heights of European precedence, the Australian painter had to follow a humbler but more satisfying path. The latter could never outstrip or outrun the experience of his audience. Painter and viewer inhabited the same world and shared the same experience.

The advantage of this condition to Australian painters in the eyes of later judgement is most soundly demonstrated in the quality and originality of the Australian impressionists — still, if inaccurately, known as the Heidelberg School. Every Australian student knows that the extraordinary decade from Tom Roberts's return to Melbourne in 1885 to Arthur Streeton's departure in 1897 derives its strength from the steady application of a gifted generation of artists to Australian realities. It is a story born out of experience, from the artists' camps of Box Hill and Eaglemont where they lived and painted amongst their motif on a new level of intimacy, to the heroic epics of Australian life, and the revitalisation of the school in Streeton's Sydney paintings of the 1890s. The very comprehensiveness of their account of Australia, and human activity within it, attests to the steadiness of their application and the aesthetic nourishment they derived from it. The landscape of labour and leisure, the city and the golden plain, the blaze at noon and the glimmering of moonrise, the wintry landscape and the heat-filled beach, individual loss and pathos and collective strengths

— all and more of these extraordinary, rich and potent themes were theirs and have justly become part of the national consciousness.

They accomplished all this with little firsthand knowledge or experience of the impressionist masters, although they were by no means blind to hints and guesses of recent overseas practice in painting, frequently more British than French in origin. They knew that truthfulness for the modern painter lay outside the studio, out there in the landscape or the city in the midst of modern experience.

Equally well known is the sadder part of the story: the diaspora of the Heidelberg School starting with Charles Conder's departure in 1890 to Roberts's in 1903 which brought an end to the school, and the drastic loss of inspiration for all of them save Frederick McCubbin — he spent less than a year of his life out of Australia and maintained the inspiration drawn from the steady application of the Australian artist to Australian realities.

The decade of the Heidelberg School stands as one of the most profound and moving episodes of a local school far from the centre in the last quarter of the nineteenth century. The Australian movement is so sharply focused. American impressionism, by contrast, is a loose baggy monster. Numerous centres, a complex relationship between America and France, luminous expatriates and plodding provincial schools, brilliant brief candles such as Dennis Bunker and John Twachtman, and regrettably long careers like that of Childe Hassam, all form the complex universe of American impressionism. Nowhere does the proximity to Europe more sharply differentiate the American experience from the Australian one. To Australian eyes the pre-impressionist paintings of such artists as Childe Hassam (those marvellous wet Boston street scenes) and Theodore Robinson have a spark and originality to them. At that moment they resemble the Heidelberg School painters, thrown back on their own resources and their own local and distinctive motifs. The impact of Europe, especially Claude Monet, seems near fatal to their art. Although by no means the most embarrassingly obsequious at the shrine of Giverny, the struggle in both their arts is to find a way back to their American experience through the near suffocating, if brilliant haze of Monet's superior example. Hassam on the Isle of Shoals or in the Flag series, and occasionally in Connecticut on Long Island Sound, allows idea or experience to take hold of his paintings again. His provincialism is nowhere more apparent than in the moments when he surrenders his Americanness and looks like a turpentine-thinned Monet.

Besides the glittering expatriates — James McNeill Whistler, Mary Cassat and John Singer Sargent — the two American impressionist painters, who equal and in some respects surpass the achievements of the Heidelberg School, represent episodes where, ironically, the American experience seems both closest to the Australian and more remote.

The closeness occurs with William Merritt Chase's Shinnecock landscapes; the opposite is John Twachtman's snowbound Connecticut landscapes, or the series of his hemlock pool gripped by ice or transformed by thaw. As mentioned earlier, the passing resemblance of Chase's Shinnecock with Conder or Streeton at the beach, is an immediately fetching one. They deserve closer scrutiny, for the advent of women and children at leisure in the landscape, exclusive of any male interpolation, suggests certain places such as the beach where the feminine both dominates and is secure. A measure of independence is so given to the image of women able to enjoy their leisure and frequently — certainly in Chase — shown in intimate and confiding moments, woman-to-woman. What particularly recommends the connection between Chase and certain passages and moments in the Heidelberg School is the distinctiveness of the locality. Shinnecock, like Beaumaris or Sandringham or Mentone on the shores of Port Phillip Bay, represents the fashionable resort within easy reach of the city. It is the familiar, attainable refuge, known by painter and audience alike.

The clear, distilled light Chase achieves at Shinnecock and the explicitness of the motif with the figure resonating the summer landscape move the picture away from the atmosphere of French impressionism. The glare of the Australian summer sun in Conder and Streeton, often emphatically laid in with a square brush, wipe out the nuanced touch and interlace of impressionist facture. The strength of the Heidelberg School and Chase at Shinnecock is that the viewer is reminded of the particular nature of the locality and the place. You are at Long Island; you are by the Bay.

John Twachtman — by his thawing pool in Connecticut or looking across his house and fields buried in snow, or overwhelmed by the luxuriance of the New England summer — is equally the American impressionist who recalls the French example more distantly, allowing experience to shape his art. The originality of Twachtman stems primarily from his engagement with a distinctively American experience of the landscape: the extremes of seasonal change and the excessiveness of nature under snow, or the green redundancy of spring and summer foliage. These could not form part of an Australian impressionist's lexicon of experience. When artists of the Heidelberg School painted the 9 x 5 inch paintings for their one exhibition in 1889, they did so largely over winter — the exhibition opened in August — and the purple lights and rainy streets of Melbourne and its environs were as much colonial evocations of northern and British city life as accounts of winter in the antipodes.

Australian art remains a puzzle for those who either grew up with it or developed an enthusiasm for it in later life: Why should such a distinctive and distinguished national school have won such little recognition beyond its shores? The puzzle applies equally to nineteenth- and to twentieth-century Australian art. The reasons are complex and manifold and this is not quite the occasion to go into them all.

Overwhelmingly, the discovery of Australian art is made at the same moment as the discovery of Australia itself. If you are born there, your coming to consciousness of the nature of Australia readily coincides with your awareness of Australian art. If you visit, you experience the place and the art simultaneously. Do you have to 'be there' in order to get Australian art in a way that you don't have to 'be there' to understand Italian, French, Spanish or British art? This exhibition tests the doctrine of 'being there' as the all important factor in the recognition and appreciation of Australian art.

Aligning Australian art with another nineteenth-century national school, demonstrating that the Australian experience is part of and adds to universal history, makes a start in answering the puzzle of non-recognition. Certainly it would be difficult both imaginatively and organisationally to interest a major American art museum in an exhibition solely of nineteenth- or twentieth-century Australian art. In order for the antipodean voice to be heard, it has to come out of isolation and be ranged with other voices. It has to be brought to the bar of aesthetic judgement with like objects, derived from a related experience. Far from detracting from its interest or intrinsic quality, Australian nineteenth-century art comes of age by being placed beside the art of another expanding and developing society.

Two caveats must be sounded. First, both the United States and Australia may claim remarkable pictorial achievements in the nineteenth century; these achievements enjoy the highest esteem within their own cultures; but both remain objects of curiosity to European taste. The achievements of contemporary American art from World War II to the present are objects of intense interest to European taste and form part of the canon of recent art. Some contemporary figures and movements may be overrated; just as some may suffer from an anti-American bias, but there is no doubting the impact and influence of contemporary American art over other national schools during

the past four or five decades. Nineteenth-century or even early twentieth-century American art enjoys no such critical approval. Even such titans of the story as Winslow Homer and Thomas Eakins are virtually unrepresented in collections outside the United States. The new worlds may mean something to each other, but their past presses lightly on the imagination of the old.

Second, there is and perhaps always will be an imbalance in the intellectual and cultural relationship between Australia and the United States. Australians know about American art and read American literature, past and present, with an avidity, comprehensiveness and sophistication that still surprises Americans. Only a tiny minority of Americans know about Australia, let alone its art and literature. Australian artists and writers, more confident of their quality and identity than ever before, pay particular attention to new directions in American art and literature. They also long to succeed, to be recognised in America. Such an ambition is neither obsequious nor cringing. But Australians are perpetually disappointed and surprised that even well-disposed American individuals and institutions know so little and pay such scant heed to Australian cultural achievements. Perhaps the opening of the American mind to those possibilities will have its start in this exhibition.

Patrick McCaughey
New Haven, 1998

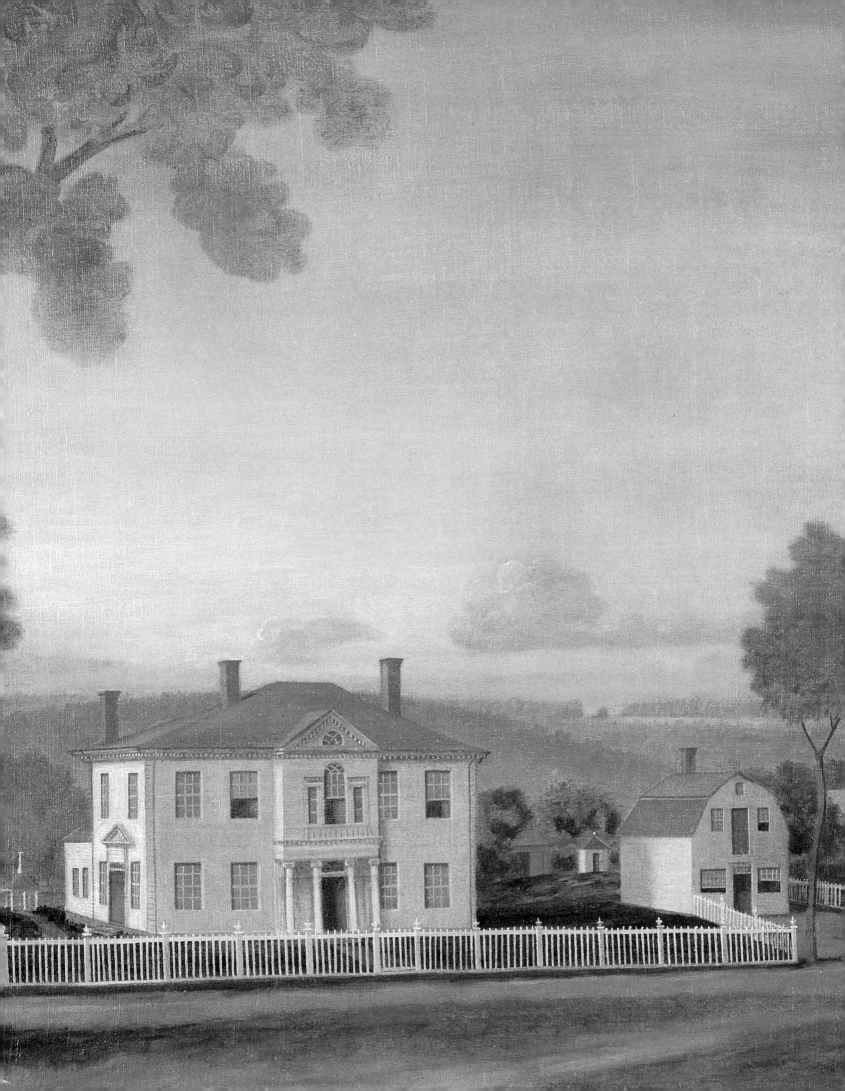

Landscape Painting in America and Australia in an Urban Century

'Landscape' is made in the mind. Whether paintings or poetry, formal gardens or prose, European landscape over the centuries has expressed humanity's longings for deep moorings in nature and all its associations — the changing seasons, cultivation, storms and droughts, divinity, home, and towns nestled near rivers and harbours. Artists in antiquity intensified the mental life of city dwellers with wall paintings of landscaped gardens; medieval manuscript illuminators delighted in the planted cloister of the Virgin Mary; in sixteenth-century paintings of the forest in Germany, artists showed nature at her most mysterious; others depicted nature at her most ordinary, as in seventeenth-century Dutch landscapes of fertile fields and prospering towns; and still others produced reveries with scenes of a mythical Golden Age.[1]

In the late eighteenth century, landscape gripped artists and poets and travellers with an urgency that was to preoccupy generations for more than a hundred years. In an irreversible historical process, towns — indeed, cities — became so integral to European and Euro-colonial development that the work of landscape painting moved into new territory. The city developed from being the headquarters for life lived on and from the land to being the productive centre itself. In cities were the engines of trade and the accumulations of market-produced wealth, the armatures of emerging industrialisation, growing institutions of learning and study, the organs of publication for the mass distribution of information, as well as merchants and patrons making and spending the new wealth. Nature in all its previous meanings seemed to become ancillary rather than fundamental to human enterprise. A print culture and the extension of markets around the globe meant that merchants and politicians and professionals lived life increasingly in the mind; their association with reality became mental rather than physical. The rich life of the senses seemed to be constricted to the visual and the imagined, which, although it allowed a sense of control, provided no bodily participation in nature. Puzzled and thoughtful urban citizens turned to landscape — visual, verbal, and imagined — to compensate for this loss of sensory connection, to reconceptualise the meaning of nature, and to draw on it for substitute engagement with the physical world. Because England was the earliest country to enter this stage of modernisation in all its phases, from about 1780 until the mid-nineteenth century, writing about landscape and making images of it were more important there than anywhere else.[2]

The shift from nature to city, from being in or on the land to being simply an observer of it, played a major role in the art that interpreted the colonial peopling of America and Australia. Histories of landscape imagery on the two continents have focused on the relationship between the image and the local political community in which it developed, following the general convention that art historians looking at imagery produced after about 1750 typically confine their work within national boundaries. However, this essay proposes that a more incisive understanding of landscape painting in America and Australia emerges through a study of its relationship to the larger stream of social history and visual culture.[3]

From the seventeenth century in America and the late eighteenth in Australia, landscape images in the new worlds first of all conveyed the urban frames that the settlers had brought with them; then gradually, across the nineteenth century, the landscape was seen through the lenses that they and their descendants developed in their local experience as part of this larger culture. Artists probed the implications of city-driven life on their particular land, portraying the settling communities' shifting relation to all that had been associated with nature — scenery, cultivation, the physical creation, living in communities, traditional work, and rest.[4]

Ralph Earl *Houses and Shop of Elijah Boardman (Houses Fronting New Milford Green)* 1795–96 (detail) (cat.49)

There were, of course, major differences in the settling process and in the continents themselves. The European emigration to North America began almost two hundred years earlier than that to Australia, and the two streams of population shifts were motivated by distinct circumstances. The first English arrivals in America in the early seventeenth century came for religious and economic freedom (differences that make generalisations about *the* immigrants difficult), whereas the English first settled Australia as a penal colony. Before the first boat load of convicts landed in Botany Bay in 1788, immigrant Americans, in 1776, had forged political separateness as the United States of America. It was not until 1901 that Australians united in federation, and even then they maintained their identity as part of the British Commonwealth. The continental land masses, although similar in size, contributed other differences: America has towering mountain ranges, the relief line of Australia is relatively low; America is swept by extensive river systems, Australia by only a few. Over the nineteenth century, the portion of North America that had become the United States revealed itself to be astonishingly fertile, but a major portion of Australia proved to be near desert and inhospitable to agriculture. And the populations were quite different in size, that of America consistently about eighteen times greater than that of Australia.

Overwhelmingly however, commonalities shaped landscape painting. The penetration and settling of Australia was primarily from Britain, and although the Spanish and French made substantial early settlement in what became the United States, British verbal and visual ideas dominated landscape painting in the larger American community until the middle of the nineteenth century. In many respects, regardless of the specific stage of urbanisation and industrialisation in different European countries and their colonies, and despite differences in geography and politics, the social dilemmas of 'Western civilisation' presented themselves almost synchronously around the globe wherever Europeans had a footing. Landscape painting played a major part in nineteenth-century art and culture because it grappled with the conundrums caused by the intensification of the mental world of city life — the economic and the social, the personal and the communal, the sensory and the emotional.

Meeting the Land: the landscape of assessment, the tour

In few material practices was compensation for separation from nature clearer than in touring, whether actual or imaginary. Informing the expectations of settlers and immigrant artists in America and Australia was this urban-based ritual that had swept Europe and especially England in the late eighteenth century. The tour combined aesthetic appreciation of nature's appearance with practical calculations of its utility. With an Enlightenment-shaped confidence that cataloguing everything one saw made life profitable in all respects, tourists assessed what they saw with urban-forged knowledge and ambition.

Eager for experience of the 'land itself', in England and on the Continent, newly affluent travellers took in local geography, went down the Rhine and across the Alps, and visited Italy to ponder antiquity. English tourists with less wealth and time (as well as even the affluent during the Napoleonic wars, when travel on the Continent was restricted) took British tours — up and down the Thames, through Wales, to the Lake District, or to the Scottish Highlands. Some were looking for sublime scenery and medieval ruins, others for well-tended countryside, still others for evidence of 'improvement', all for scenes that would make complete their own existence in cities.

Artists were a part of this stream, their small landscapes, many in watercolour, registering and encouraging the interest in travelling. Touring the countryside and recording observations became a way to test metaphors about the relation between a simple past and an industrialising present, and between the rural countryside and urban society. Images of well-landscaped country estates promised a virtue that the moneyed classes could act out in the country. River traffic demonstrated prosperity. Waterfalls, like the popular Falls of Clyde (fig.1), gave tourists the opportunity to test

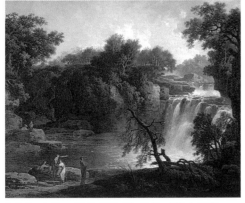

fig.1 Jacob More 1740–1793 *The Falls of Clyde* 1771
oil on canvas 85.0 x 100.0 cm (33-1/2 x 39-1/4 in)
National Gallery of Scotland, Edinburgh

their responsiveness to nature's beauty, as defined by William Gilpin and Edmund Burke.[5] Scenes of agriculture spoke to the knowledgeable about rural dislocation.[6] And throughout the entire period, images of prospering cities nestled in the landscape testified to the careful use of wealth for civic advancement.

Many artists published portfolios of their tours, collections of images, like *Boydell's History of the River Thames* (1794–96), that inventoried the 'progress of civilisation'. These collections became part of the preparation for those planning a tour, souvenir books for tourists who had already travelled, or substitutes for travel for those unable to make the journey. Becoming material reality through a critical mass of eager travellers, of places agreed upon as important to see, and of an apparatus of roads, paths, conveyances, inns, maps, and travel guides, tours served as collections of activities, each part as well as the whole to be savoured. The very format of the tour itself, as well as the tour picture — the 'picturesque' composition, with carefully framing trees and an ordered recession into space — spoke to knowledgeable urban dwellers who rearranged what they saw or hoped to see, or who simply wanted to know about what was 'there', in order to enlarge their universe.

The idea of the tour prepared travellers for citizenship in the world, and it prepared artists and viewers to 'see' America and Australia.

Towns — or at least ambitious concentrations of activity — had sprung up quickly on both continents upon the establishment of garrisons and trading centres. Towns were typically the landing place for immigrants, and the point from which trade and communications started their journey back to the old worlds. In the early years, 'wilderness' had no meaning or only negative meaning, but towns signified present and future commerce, social opportunity, and the sophistication that informed assessments of the countryside. And thus, by depicting the towns, artists established the reality of the new worlds.

In America, where small cities dotted the eastern seaboard, artists and printmakers drew on the established imagery of topographical landscape prints to celebrate the bustling seaports of New York, Boston, Philadelphia, Baltimore, Charleston, and Savannah. Through ships in the harbour, prominent buildings, and little or no evidence of the nearby forest, these landscape views boasted to experienced tourists in England, and to new world residents overlooking their own community, that the concentrated energy necessary for settlement was readily available: commerce was flourishing, the institutions of church and government were in place and guaranteeing order, and wilderness both literal and metaphorical was at bay.[7] (fig.2)

In contrast to the almost bewildering burst of commercial centres along the eastern coast of America, in Australia the point of reference was primarily Sydney. Almost in defiance of the socially conflicted purpose of settlement (the penal colonies were long seen by many 'back home' as depraved), artists drew Sydney as a sign to viewers both in England and in the colonies that sufficient elements of an outpost of the Empire were there: ships, orderly streets, and prominent government buildings vouched for the community's potential, and functioned as propaganda designed to encourage settlement. (fig.3)

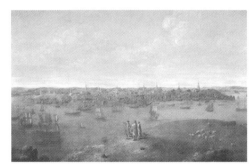

fig.2 John Smibert 1688–1751
A View of Boston c.1738–41
oil on canvas 76.2 x 127.0 cm (30 x 50 in)
Childs Gallery, Boston, Massachusetts

fig.3 Robert Havell after James Taylor 1785–1829
Panorama of Sydney. The Entrance of Port Jackson and Part of the Town of Sydney, New South Wales, August 1823
hand-coloured aquatint
3 plates, each 39.4 x 57.3 cm (15-1/2 x 22-1/2 in)
Ballarat Fine Art Gallery, Victoria
Caltex Victorian Government Art Fund 1977

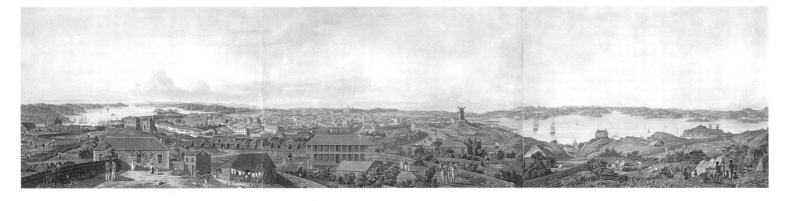

With towns providing a jumping off point from which to chart and assess unknown territory, explorers and artists on both continents moved along the coasts and inland. In emulation of English practice, early travellers along these opening routes recorded journeys and sights that attracted visitors, artists, and settlers. Local patronage of these images developed first in America.[8] The standard of assessment was always English, but the objectives on each continent were different. Touring in America — already a separate nation — premised the resemblance *and* the difference of American nature and civil society from that of England. Touring in Australia, on the other hand, provided a warranty that this new world was — or could be — very much like the old.[9] Americans needed to underscore their distinctiveness, Australians their connectedness.

The earliest images of a sequential tour in America — an inventory of important sites — were produced by Governor Pownal, who in 1761 along with officers of the British army and navy produced drawings of the continent 'taken on the spot' and published in London as *Scenographia Americana: or, A Collection of Views in North America and the West Indies*. In the 1760s 'America' meant the entire northern continent, and the twenty-eight views featured major cities (including Quebec, Montreal, New York, Boston, Charlestown and Havana), harbours and waterfalls. By 1820 citizens of the United States had taken over the designation 'American' for themselves, and Joshua Shaw's *Picturesque Views of American Scenery* (1820–21) played on that fervour.[10] Taking his cue from the claims his British colleagues had made for the superiority of Welsh or Scottish Highlands or Lake District scenery, and assuming the patriotism of his American audience, the immigrant artist proclaimed to readers on both sides of the Atlantic the excellence of new world nature, finding it superior to the 'tame level of the English landscape':

> [America's] lofty mountains and almost boundless prairies, our broad and magnificent rivers, the unexampled magnitude of our cataracts, the wild grandeur of our western forests, and the rich and variegated tints of our autumnal landscapes, are unsurpassed by any of the boasted scenery of other countries.[11]

Although Shaw began his collection with the 'Sepulchre of Washington' and included several views associated with the American victory over the British in the Revolution and in the War of 1812, he gave full play to waterfalls and the dense American forest.[12] The same year, William Guy Wall, also an English-trained immigrant, surveyed the Hudson (just as his colleagues in England were judging the Thames) for its signs of progress in a 320-kilometre (200-mile) journey from Luzerne to Governor's Island, from which he selected twenty-four views for his *Hudson River Portfolio* (c.1821–25).[13] Wall encompassed the entire range of tourist experiences and judgements — the more sublime aspects of nature such as waterfalls, evidence of human cultivation in rolling and carefully divided countryside, landscaped country houses overlooking the river, commerce of all kinds, towns, and, climactically, the city of New York.[14]

At almost precisely the same moment in Australia, Joseph Lycett performed a similar inventory. Judging that he could appeal to two audiences — the successful local citizenry of New South Wales and Van Diemen's Land (later called Tasmania), including the colonial-born and the free (those who had not come under legal duress), and potential investors and emigrants in England — he carefully laid out the twenty-four images in his *Views in Australia* (1824–25) in the form of two tours: one began in Sydney and surveyed New South Wales; and one began in Hobart and proceeded through the interior of Van Diemen's Land. Lycett included a map at the start of each tour so that viewers could plot their imaginary journey and note the qualities of the land available for settlement.

These journeys, like those of William Guy Wall on the American continent, took the mental tourist through a sequence of fertile plains, orderly towns, impressive country estates with outlying gardens, rivers that supported commerce, and mountains and cataracts that invited reactions of awe. Lycett's text accompanying the image of 'The Residence of John McArthur, Esqr., near Parramatta, New South Wales' (fig.4) is quite typical. Houses in 'remote' Australia, viewers were assured, 'challenge comparison with some of the Country Residences of the Gentry of England', are fashionably landscaped, with the land around them 'mown in the hay-season, as in England', and with gardens in which grow 'the choicest fruits and productions

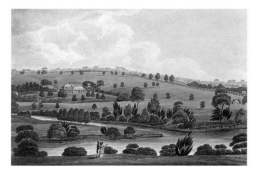

fig.4 Joseph Lycett c.1775–1828
The Residence of John McArthur, Esqr., near Parramatta, New South Wales from *Views in Australia or New South Wales, & Van Diemen's Land Delineated* 1824–25
aquatint, etching, hand-coloured
23.3 x 32.4 cm (9-1/4 x 12-3/4 in)
National Gallery of Australia, Canberra

of Europe and of tropical climates; among which may be enumerated the Orange, Lemon, Lime, Citron, Cocoa, Olive, Grape, Fig, Peach, Apricot, Nectarine, Mulberry, and Almond…' Whereas Shaw had proclaimed America's distinctiveness in scenery and politics, Lycett extended to Australia a specifically English setting. Yet he drew on rhetoric about the progress of empire that Americans also used:

> If we turn from the wild scenery of Australia in her pristine state, to view the benign changes which the arts and sciences of Britain, aided by the liberal policy of her government, and the enterprising spirit of her merchants, manufacturers, and traders, have produced upon this new theatre of Nature, we shall have before us one of the most pleasing studies which can engage the mind of the philosopher or the philanthropist. We behold the gloomy grandeur of solitary woods and forests exchanged for the noise and bustle of thronged marts of commerce; while the dens of savage animals, and the hiding places of yet more savage men, have become transformed into peaceful villages or cheerful towns.[15]

In the more narrowly aesthetic realm of the tour, the most popular single sight on the circuits in the new worlds was the waterfall, just as it had been in the old.[16] Waterfalls called forth every nuance of reaction and knowledge, and artists flocked to them as familiar entities in the midst of strange surroundings, subjects sure to attract visitors and patrons. Their selling points were many: the tourist had to make a long journey and undertake a difficult climb to reach the best viewing point; the chasm into which the water fell provided the thrill of danger; the aesthetic experience of sublimity combined awe at what was terrifying in nature with comfort that one was safe from its hazards; and the tourist who had made the effort to see the cataract could celebrate the feat with others who had done so, and boast of it to those who had not. In the United States, the Passaic, Kaaterskill, Trenton, Genessee, Potomac and, most prominently, Niagara Falls served as magnets for travellers. In Australia, the Wentworth Falls in the Blue Mountains (variously called Bougainville Falls and Weatherboard Falls) attracted visitors from early on (including Charles Darwin in 1836). Later the Fitzroy, Apsley (fig.5) and Wannon Falls served a similar function.

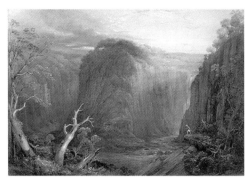

fig.5 Conrad Martens 1801–1878
One of the Falls on the Apsley, New South Wales 1873
watercolour 46.3 x 67.3 cm
National Gallery of Victoria, Melbourne

Because the point of the touring picture was the tourist who believed that nature could be absorbed into one's mental world through such exposure, on both continents artists' early images of waterfalls were typically mediated by figures. As in England, the foreground figures in American and Australian images of waterfalls expressed emotions that in turn guided the viewer of the picture. In his *Niagara Falls* 1823 (cat.28), the American artist Alvan Fisher provided a well-dressed couple in the central foreground, who take in the scene with dignity; a group of three on the edge of the foreground ledge convey the excitement associated with dangerous sublimity (one man is being pulled up by a companion and a third has dropped to his knees to help, or perhaps simply to gape); on the very right, a man registers awe with outstretched arms; while a small boatload of tourists test their courage on the swirling waters below. In later pictures of Niagara, Fisher included a Native American among his tourists, signalling the association of the falls with wilderness; but the presence of the Native as a guide to the mysteries of wilderness also signals the ultimate replacement of 'primitive' humanity with civilisation.

In Australia the British painter Augustus Earle used similar conventions in his *Wentworth Falls* c.1830 (cat.6).[17] Two Aboriginal men, one of whom is being sketched by an artist, convey the associations of cataracts with wilderness and the transformation of the wilderness already under way through settlement. Other visitors in Earle's picture carry out a repertory of reactions to cataracts: two men on the edge of the promontory on the right stare at the falls with amazement; a third man pulls another up to the rock from which he seems to have fallen. Earle's horizon is quite high, the outcroppings of rock and the deep chasm emphasising the mystery of the unknown continent.[18] By contrast, Fisher's scene is balanced, almost serene.

If waterfalls assured urban tourists of the resemblance of the new worlds to the old, forests were reminders of their profound differences. Settlers were unclear about the kind of literal and figurative shelter that these lands would provide. Forests offered vegetation that was uncultivated and exotic — thus only speculatively

compatible with civilisation. Joshua Shaw evoked the strangeness of American southern forests in 'View by Moonlight, near Fayetteville, N. Carolina' in his *Picturesque Views of American Scenery* (1820–21), a scene of a gloomy forest interior under a full moon, with figures by a campfire and a nearby horse-drawn wagon. His text reveals both fascination and doubt:

> On the road from Raleigh to Fayetteville, the traveller passes through long tracts of close forest, which even in the day time are sufficiently dark and gloomy. At night the dreariness of the scene is occasionally relieved by the cheerful blaze of fires lighted by the farmer on his way to market, and around which he reposes with his family. Pine trees intermingled with the ash, the swamp white oak, and various other trees, among which are cedars of giant size, are seen for fifty miles together, covered with an immense quantity of green moss, which hanging as it does, pendant from the highest tops, gives the country, otherwise flat and uninteresting, a wild and singular appearance.

Augustus Earle, in his *A Bivouac of Travellers in Australia in a Cabbage Tree Forest, Daybreak* c.1838 (cat.8), also surveyed the incongruity between the old world and the new. Employing devices of the tourist memento — exotic vegetation, travellers themselves (nightcaps and yawns emphasising the time of day, as well as providing a touch of humour), and Aborigines — and evoking the temporary establishment of 'home' that a fire conveys, he located his scene in a landscape of daybreak. The literal dawn in an Australian forest suggests the famous dictum of Bishop Berkeley in the eighteenth century that civilisation was on a dependable world march from east to west. Thus the painting reassured those 'back home' in London, where Earle exhibited it, that the British Empire prevailed around the globe.[19]

Claiming the Land: the landscape of improvement

Although the inventory of the tour persisted for some time, it was accompanied by landscapes of improvement and eventually gave way completely to this motif. Landscapes of improvement defined the land not from the point of view of the tourist but by the immigrants' habitation of it. The shift from tour to settlement — from outsiders' judgements to insiders' hopeful investments — was ambitious. In America the land was bewilderingly fecund; in Australia, for most of the arrivals, the land was bewilderingly strange.

Thomas Cole wrote of the primitiveness of the American forest that contrasted so dramatically to European cultivation. Although he and others were dismayed that American scenery provided no associations of human antiquity — a staple of European landscape — he saw as compensation that America had an exclusive corner on nature's primeval stage, 'the primitive features of European scenery long since [having] been destroyed or modified'. Praising American distinctiveness, he wrote:

> In the American forest we find trees in every stage of vegetable life and decay — the slender sapling rises in the shadow of the lofty tree, and the giant in his prime stands by the hoary patriarch of the wood — on the ground lie prostrate decaying ranks that once waved their verdant heads in the sun and wind. These are circumstances productive of great variety and picturesqueness — green umbrageous masses — lofty and scathed trunks — contorted branches thrust athwart the sky — the mouldering dead below, shrouded in moss of every hue and texture, form richer combinations than can be found in the trimmed and planted grove.[20]

However, Cole's naturalist counterpart, Barron Field, a Supreme Court Judge in New South Wales with a lifelong devotion to the study of nature, had nothing but despair about Australia's differences from Europe. Field was quite certain that landscape painting could not be done in Australia:

> New South Wales is a perpetual flower-garden, but there is not a single scene in it of which a painter could make a landscape, without greatly disguising the true character of the trees. They have no lateral boughs, and cast no masses of shade …

[Their] leaves of eucalyptus and acacia … are vertical [and evergreen] … no tree, to my taste, can be beautiful that is not deciduous. What can a painter do with one cold olive-green?

Field went on to make it clear that the very foundation of European landscape painting was the metaphor of the changing seasons:

There is a dry harshness about the perennial leafe, that does not savour of humanity in my eyes. There is no flesh and blood in it: it is not of us, and is nothing to us …
All the dearest allegories of human life are bound up in the infant and slender green of spring, the dark redundance of summer, and the sere and yellow leaf of autumn. [21]

As these passages suggest, the transition from assessment to investment, from the landscape of the tour to the image of settlement, assumed a distinct pace within each continent. Differences in geography, the size of the population, the rate of settlement, and the political community meant that, relatively, Americans began to see their landscape as a setting for social unity considerably sooner than Australians did theirs. In America, where beginning artists (many of them, by 1830, native-born) found patronage in cities from Boston to Charleston and in the interior as well, the major market for landscapes was in New York City. There commerce was booming after the opening of the Erie Canal, and self-made merchants began commissioning landscapes that would celebrate this success, much of it obviously to their credit. American patrons were members of a political community (to be sure, one that was marked by ongoing economic and social rivalry among regions and classes) that had been forming for half a century.

Settlement in Australia was still restricted to the south-eastern rim, including Tasmania, and the ties to Britain were unquestioned. However, by the 1830s, the growing size of the colonial-born (and free) population led to the beginnings of a community not quite 'at home' in Australia but able to claim that settlement in the colony was respectable. Most artists in this period were immigrants, and still primarily from England; they appealed for their major patronage to entrepreneurs in Sydney and Hobart.

The motif of 'improvement' that guided image-making on each continent was undergirded by a faith in progress.[22] It called for evidence that economic, social, and political order was being established in the new world. Just as the images of towns anchored the touring landscape, whether literally or by implication, through the presence of the tourist, so the early images that anchored settlement and improvement were of proper (that is, old world) homes.

In America the well-landscaped country house, and by implication the well-managed estate property, was the evidence of urban sophistication that evoked British values. Although a number of these images were made in New England in the 1790s, American artists typically found commissions for them slightly later in the middle-Atlantic and southern regions, where emulation of British gentry was strongest. In Philadelphia, for instance, a city of considerable size, English-trained William Russell Birch and his son Thomas painted landscapes of prominently located country seats above the Schuylkill River in what became Fairmount Park. William Birch's *Sweetbriar* c. 1808 (The Corcoran Gallery of Art, Washington, DC) flatters the owner's proper siting of his house on a rise, its rolling grounds providing pleasure for family members relaxing on the left, and another impressive house in the distance implying the sociability of an entire class.[23] In Maryland, Thomas Doughty, one of the first native-born American landscapists, chose a vantage point that associated the country house of his merchant patron with the important port of Baltimore in his *View of Baltimore from Beech Hill, The Seat of Robert Gilmor, Jr.* 1821 (Baltimore Museum of Art). Other artists, such as Charles Fraser, were active as far south as Charleston, South Carolina; and north, up the Hudson River, Thomas Cole painted country estates into the 1830s.[24] The genre moved westward: in 1877 George Caleb Bingham painted *'Forest Hill': The Nelson Homestead, Boonville, Missouri* (private collection), celebrating the prominent citizen's classical porticoed two-storey Georgian house sheltered by graceful trees, with the Missouri River in the background and, on the grounds near the house, his patron's family, cattle, and horses.[25] The same decade in California,

Joseph Lee painted the *Residence of Captain Thomas W. Badger, Brooklyn [California], from the Northwest* 1871 (cat.61), that sets forth fashionable house, picket fence, water tower, ships, and railroad, all evidence of Captain Badger's success.

In Australia the landscape of the impressive home — specifically, the country estate — prevailed for almost as long as Australians thought of themselves as Britons. Importing English vegetation in order to 'acclimatise' their environment, Australian gentry paid close attention to 'home' fashions in landscape gardening. Lycett had included several estate pictures in his *Views in Australia*,[26] but the landscapist who swept the field in commissions was the English-born Conrad Martens, who continued the turn-of-the-century English landscape tradition by working extensively in watercolour. Having been on the *Beagle* with Charles Darwin, Martens arrived in New South Wales in 1835 when squatters (settlers who developed land — not originally a term of opprobrium as in the United States) and newly affluent merchants were building impressive estates. He typically placed Australian plants, ferns and gum trees in his foregrounds to set off the English-looking house and garden: his watercolour *Elizabeth Bay and Elizabeth Bay House* 1839 (fig.6) shows a handsome Regency town house in the distance, in front of which is a carefully designed landscape garden stretching down to the shores of the bay. The garden apparently met even the most rigorous British standards. Sir Joseph Hooker, later to become director of the Royal Botanic Gardens, Kew, visited the estate and wrote in 1841: 'My surprise was unbounded at the natural beauty of this spot, the inimitable taste with which the grounds were laid out, and the number and rarity of the plants which were collected together.'[27] Martens's *View from Rose Bank* 1840 (cat.43) is similarly flattering, showing a garden piazza looking over the newly established villas on Woolloomooloo Bay.

Yet another prominent image is George Edwards Peacock's *Craig End, Sydney New South Wales* c.1850 (National Library of Australia, Canberra), which presents an immaculately ordered garden in front of a large porticoed and verandahed house; a man at work in the foreground performs the literal turning of the wilderness into a garden. Just as in America, artists in Australia met the desires of status-hungry settlers across the century. For example, Henry Gritten's *The Lodge, New Town Park, Hobart* c.1857 (Queen Victoria Museum and Art Gallery, Launceston) is a picture of a modestly-sized Gothic stone house, and William Tibbits's *Residence of Mr. W. Anderson, Smeaton* c.1871–73 (City of Ballarat Fine Art Gallery), like the American painting by Joseph Lee, is virtually an inventory of every popularly fashionable improvement.[28]

Perhaps because John Glover had spent a long career as a landscapist in England — where he would have known the work of John Constable and other artists who celebrated harvests and rural gardens (fig.7) — his is the most autobiographical and memorable Australian picture of a country estate. Just before emigrating, Glover wrote to his English patron Sir Thomas Phillipps that he expected to find 'a beautiful new world — new landscapes, new trees, new flowers, new animals, birds &c. &c.'[29] Once settled in the new world, he named his Tasmanian home 'Patterdale' in emulation of an area in the Lake District that he had sketched many times. In *My Harvest Home* 1835 (cat.36), together with a companion picture *A View of the Artist's House and Garden, in Mills Plains, Van Diemen's Land* 1835 (fig.8), Glover pronounced his deep fulfilment in the new land. *My Harvest Home* is dominated by a fully loaded hay wagon; overhead the dazzling late afternoon sun irradiates the sky and casts deep shadows. Prominent in the foreground of *A View of the Artist's House and Garden* is a detailed inventory of the flower garden in which Glover mixed British and native Australian plants. In the left distance is the artist's home and next to it his studio, to which is attached a greenhouse.

Glover's homage to his own success has no counterpart in American picture-making in the first half of the century, perhaps in part because no American painters were settled agriculturalists, but no doubt as well because Americans defined improvement not so much in terms of individual settlement as in terms of community — to which the many American town pictures of the 1790s into the 1830s testify.

Hence the later estate paintings in Australia of sheep stations (the American term for 'station' would be 'ranch', or 'spread') also have no counterpart in America,

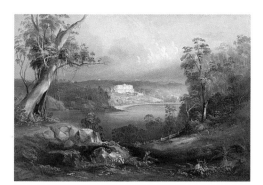

fig.6 Conrad Martens 1801–1878
Elizabeth Bay and Elizabeth Bay House 1839
watercolour 46.1 x 66.3 cm (18-1/4 x 26 in)
National Gallery of Victoria, Melbourne
Felton Bequest 1950

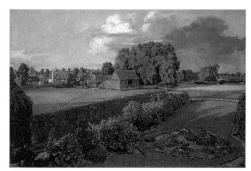

fig.7 John Constable 1776–1837
Golding Constable's Flower Garden 1815
oil on canvas 33.0 x 50.8 cm (13 x 20 in)
Ipswich Borough Council Museums and Galleries,
United Kingdom

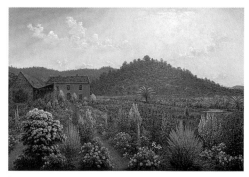

fig.8 John Glover 1767–1849
A View of the Artist's House and Garden, in Mills Plains, Van Diemen's Land 1835
oil on canvas 76.4 x 114.4 cm (30 x 45 in)
Art Gallery of South Australia, Adelaide
Morgan Thomas Bequest Fund 1951

although by the 1860s, when station painting flourished in Australia, there were certainly large single-owned ranches in America. As in the earlier round of estate portraits, only a few artists dominated the field. The Austrian-born, German-trained immigrant Eugene von Guérard — after his attempt at gold prospecting proved unsuccessful (gold discoveries in America and Australia were within a year of each other) — found a ready market for such images in the Western District of Victoria, which by the late 1850s was dotted with grand estates. These paintings extend the claims made by Lycett's earlier views — that is, they represent the dream of country aristocracy and were made to satisfy the pride of the settlers. Such works as von Guérard's *Bushy Park* 1861 (cat.47), *Woodlands* 1869 (National Gallery of Australia, Canberra) and *Yalla-y-Poora* homestead 1864 (Joseph Brown collection) reveal the ambition at work here, a pride that structured station landscapes as English parks. These landscapes celebrated an improvement distinctive to Australian opportunities, hailed in 1868 by a commentator in the *Guide for Excursionists from Melbourne*:

> [W]here once the blackfellows in hundreds camped and held corroboree, we have lordly houses such as Woodlands and Longerenong with all their beautiful surroundings and the refinements of an advanced civilisation.[30]

Hovering over the process of 'improvement' were questions about the very meaning of land that had been unimproved. Because these new worlds were inhabited by indigenous peoples, such questions begged consideration. They had been anticipated by eighteenth-century philosophy: What effect on humankind does the environment have? Is humanity 'naturally' good outside of cities?[31] In America, a burning question came to be: 'What is the consequence of transplanting a citizen into the wilderness?'; and in Australia cultural commentators debated not only the dismal effect of the penal colony on the larger society but the effect of the inhospitable environment. On both continents the Aboriginal presence focused these questions: Did land that was being lived on, or had been lived on by an Aboriginal population have any meaning at all? Many asserted that as the indigenous peoples did not farm the land they had no right to it (to 'improve' land established ownership). American and Australian settlers pondered the received idea of the noble savage, wavering between assessments of the Aboriginal people as venerable or as base — some felt that their groups were like peasant populations; others compared them to the primitive peoples of an imaginary golden age.

One of the earliest landscapists to treat the Native American was Thomas Cole. He identified the 'race' with wilderness, saw Indians as both savage and noble, and painted landscapes that merged their disappearance with that of the forest. In *The Clove, Catskills* c.1826 (cat.30), as in many other of his early landscapes, Cole placed a single Indian figure against a wilderness landscape, distinguishing the land as now ready to receive a new people. At some point he attempted to paint this figure out, perhaps in uncertainty about the ultimate meaning of the Native presence. In *Scene from 'The Last of the Mohicans', Cora kneeling at the Feet of Tamenund* 1827 (cat.52), Cole considered the meaning of the passing of the Indian from the American landscape.

Over the next three decades, after the government's Indian Removal Act of 1830 had sent all Native Americans westward, other artists, including European travellers, made ethnographic landscapes. Images such as Philadelphian George Catlin's *Buffalo Chase in Winter* 1830–39 (National Museum of American Art, Smithsonian Institution, Washington, DC) showed the Indians in dramatic activities that emphasised their 'savage' capabilities in the wilderness, so different a set of skills and values from those of settlers bent on improvement. Still another group of landscapes presented a vision of the land before European arrivals. Henry Cheever Pratt painted a veritable Eden in *Indians Bathing: A Scene of New England* 1843 (fig.9), in which fair-skinned Native American women and two small children bathe nude in a calm pool, their neat tepees in the middle distance on a larger body of water; all of this surrounded by peaceful trees and protected from the rest of the world by mountains. Some twelve years later in the region recently added to the country through the Mexican War (1848), Pratt registered the drive to possess territory that had fuelled the war. His *View from Maricopa Mountain near the Rio Gila* 1855 (cat.33) depicts land not protected

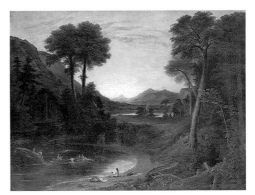

fig.9 Henry Cheever Pratt 1803–1880
Indians Bathing: A Scene of New England 1843
oil on canvas 69.9 x 95.3 cm (27-1/2 x 37-1/2 in)
Courtesy of the Cooley Gallery, Inc., Old Lyme, Conecticut

from civilisation but thoroughly available — ready to be crossed and assimilated by settlers rushing into the new territory. In the foreground are large native plants and, almost invisible on the left, two Native Americans on the hillside — as though these elements were negligible 'local colour' in the larger scheme of continental development.

Australian landscapists also pondered the character of the relationship between Aboriginal people and land. Glover's *A Corrobery of Natives in Mills Plains* c.1832 (cat.7) was one of several in which he depicted the land of his property as though it were in earlier times, with Aborigines celebrating a corroboree, or ceremonial gathering of community story-telling, singing, dancing, and relaxing, beneath typical eucalyptus trees, all of this under the powerful metaphor of a sunset sky. In actuality, by 1833, after the government's concerted drive to remove the Aboriginal people to Flinders Island, there were few of them left in Tasmania, and certainly none dwelled on or regularly crossed through Glover's property. As Pratt was to do in America, Glover created an explicitly early-world landscape in his *The Bath of Diana, Van Diemen's Land* 1837 (cat.40), in which he depicts Aborigines as classical figures set amidst Australian eucalypts, their paradise before European arrival analogous to the ancient Arcadian world. Yet, given the unusual role that Glover played in painting his own property, it is almost impossible to generalise that 'artists and patrons' of Australia in the process of claiming the land as their own felt a particular way about Aboriginal people. We can state only that Glover might have visualised the questions that many pondered or discussed.

Eugene von Guérard synthesised several assessments of the Australian Aboriginal people in his *Stony Rises, Lake Corangamite* 1857 (cat.46). He chose the volcanic outcropping of rock as background, and potentially as commentary on an Aboriginal community who had made their home there in bark shelters amidst the scrub. As the Aboriginals come together with the products of hunting and gathering, the time of day is twilight, a metaphor for the passing of their dominance of the continent, their very home a dramatic contrast to the typical settler's estate for which von Guérard was receiving commissions.

Whatever character the land was deemed to have, artists (and presumably settlers) saw indigenous peoples as essential to the early definition of improvement. Their presence in the foreground of town pictures in America, and estate and town pictures in Australia, was a device used to specify that the immigrants were bringing progress to the new worlds. In America as early as 1738 in his *A View of Boston* (fig.2), John Smibert had depicted Native American figures in the foreground looking out over the community that had replaced their own. The motif became important again when Americans began to envision their move across the continent as fulfilling a Manifest Destiny. In *Oregon City on the Willamette River* 1850–52 (cat.58), for instance, John Mix Stanley celebrated the destination of the family migration on the Oregon Trail with straight, tidy streets and such prominent buildings as a church carrying out the 'improvement' motif; in the distance are the falls, and the broad river forecasts the fertility of the land that will keep the city booming as a centre of agricultural production. In the left foreground two Native Americans look toward the viewer, disenfranchised from the valley and separated from the promising future.

The fullest development of this idea was Asher B. Durand's *Progress* 1853 (fig.10). He placed Native Americans on a promontory in the left foreground, observing the unfolding of American civilisation — from the small pioneer clearing in the right, to the development of towns in the middle ground, to centres of industrialisation in the morning-light-filled distance, all made possible by developments in transportation (a train on the viaduct) and communication (telegraph poles in the foreground). What is left of wilderness in the near left (a waterfall and a thick forest) is doomed to the same extinction as the observing Indians and the prominent blasted trees.

On the southern continent artists depicted indigenous people in landscapes of settlement and progress much more widely than was the practice in America. This may have registered the ongoing presence of Aboriginal people near city areas, and/or it may have continued the landscapists' desire to specify that it was Australia being depicted (early American landscapists also made their scenes geographically

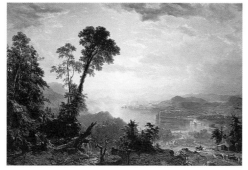

fig.10 Asher B. Durand 1796–1886
Progress 1853
oil on canvas 121.9 x 182.8 cm (48 x 71-15/16 in)
Warner Collection of Gulf States Paper Corporation,
Tuscaloosa, Alabama

specific with Native Americans).[32] The *Panorama of Sydney* 1823 (fig.3) shows Aborigines in the foreground, with urban buildings, respectable homes and gardens, and the busy harbour in the distance. The males carry spears, symbol of their warlikeness, and in another grouping families gather near a tent. The artist and his viewers may have seen these 'primitive simplicities' as didactic contrasts to the ambition and depravity in the British outpost, or perhaps they saw them as simple stages of humanity in contrast to the sophistication required for commerce and civic improvement.

One wonders if there were such didactic impulses in later images, or if the presence of Aboriginal people near towns or near estates signified peaceful coexistence, or perhaps even if it evoked the immigrants' lingering sense of their heroism in settling a 'savage' continent. Because estate pictures were commissioned, the presence of Aborigines in the foreground had perhaps been requested by the owners, many of whom used Aboriginal workers on their land. Martens, for instance, included Aborigines in many of his estate portraits, such as his watercolour *View from Sandy Bay* 1836 (cat.39), which combines a picturesque view of Sydney in the distance, the proper estate, Henrietta Villa, on Point Piper across the bay, and two groups of Aborigines in the foreground, one pair with a fire on the beach, the other fishing off a point with a spear. This image distinguishes between past and present, for the Aborigines are on the undeveloped north shore of the harbour looking across to the developed township.

Although early images of improvement of the landscape included indigenous peoples to bolster the argument, increasingly it was literally life in the city that told the story of settlement — implying city dwellers' energies, their savvy entrepreneurial sense, their organisations, and the progress that they effected with economic, political, and social improvements. These were the forces that now informed the meaning of landscape and, from the 1830s into the middle of the century in America and Australia, an outpouring of city images testified to developing industry, social amenities in such institutions as government buildings, hospitals, prisons, and churches, and even a special moral or social character.[33]

Joining a similar current in England and in Europe, and meeting the patronage of new urban wealth, these images catered to city leaders who craved self-congratulation and encouragement (often the images were lithographed for broad distribution) and who, in a spirit of boosterism, differentiated their cities from others.

In America Thomas Birch fed the civic pride of Philadelphians with *Fairmount Waterworks* 1821 (cat.50), a celebration of the first public water system in the country, healthy river traffic, both commercial and leisurely (on the river are touring steamboats), and Fairmount's social implications with its picturesquely landscaped and classically ornamented public garden. Frederic Church's *West Rock, New Haven* 1849 (cat.57), in which well-cultivated fields provide a splendid harvest, associated the growing Connecticut town with the moral fibre and resistance to tyranny of its anti-royalist ancestors who, after the restoration of the British monarchy in 1666, gave sanctuary to political refugees by hiding them in the caves of West Rock. Robert S. Duncanson's *View of Cincinnati, Ohio from Covington, Kentucky* c.1851 (cat.60), painted for the abolitionist patron Nicholas Longworth, placed the city in the sunlight, framing it with trees, and inviting the viewer into the space with an imagined dialogue among two children and an African–American male in the foreground. This called attention to Cincinnati, not only as a major springboard for ongoing westward migration but as a major post on the underground railroad, the escape route for slaves over the Ohio River from the slave-owning South. George Inness celebrated the progress of Scranton, Pennsylvania in his *Lackawanna Valley* 1855 (National Gallery of Art, Washington, DC), in which a city rises in comfortable compatibility with technology (the prominent train and roundhouse) and its natural setting (represented by the distant mountains). Tree stumps in the foreground remind viewers of the progressive removal of the wilderness that cities accomplished.

Early celebrations of cities in Australia focused on Sydney, Hobart, and Melbourne. During the middle third of the century, Sydney grew enormously from the wool industry, shipping, and trade. Ship owners, merchants, and government leaders commissioned

views of Sydney and its harbour as the source and evidence of their success. Whereas in America images of towns suggested their independence from old world standards, those in Australia boasted that British social and economic practices were thriving in the new world. Thus in Jacob Janssen's *Panorama of Sydney Harbour with Government House and Fort Macquarie, from Mrs. Macquarie's Chair* c.1845 (Art Gallery of South Australia, Adelaide), foreground figures promenade in fashionable clothing on the domain in front of the new Government House. The domain (or space for public relaxation) was in the antipodes, but the social world was British.

Called on frequently for pictures of economic success were Frederick Garling, who painted *Fort Macquarie from Pinchgut* c.1850 (State Library of New South Wales, Sydney), and Conrad Martens, whose *View of the Heads, Port Jackson* 1853 (Art Gallery of New South Wales, Sydney) and *St Mark's Church Darling Point* 1855 (The National Trust of Australia, Sydney) certify civic responsibility in a new world most promisingly in place.[34]

Hobart had attracted artists as early as 1824, when Lycett painted there; and after Van Diemen's Land became separately governed in 1850 (having been established as a penal colony in 1804) it was celebrated as a model British town. Glover lived there temporarily before he moved to Mills Plains; later he affectionately painted *Hobart Town, taken from the Garden where I lived* 1832 (cat.35). The immigrant Knut Bull, in *View of Hobart Town* 1855 (cat.44), acquaints the viewer first with the pastoral life, with sheep grazing on the outskirts of the small metropolis, all rendered in fine detail.

After 1850 in Melbourne, when the gold rush led to a three-fold increase in the population, artists celebrated the commercial and institutional growth of that city. Henry Gritten, a popular cityscapist, carefully delineated *Old Prince's Bridge* 1856 (National Gallery of Victoria, Melbourne), a watercolour in which one can see the first bridge over the Yarra, built in 1850, St Paul's cathedral, the Melbourne town hall, commercial and business buildings, fashionable pedestrians, and cart transportation over the bridge.

To improve the land meant to establish on it not only all the urban evidence of the progress of civilisation, but rural evidence as well — landscapes, that is, of rural communities. Many American landscapes at mid-century pictured regions that had just been settled. This was seldom the case in Australia, where, except for the station landscapes, urban settlement was the continuing pattern.[35] Americans had settled much of their new world by moving out from port cities into the country to cut trees, plough the earth and farm; the areas they developed became known through the work of journalists and artists. Among paintings of regions are scenes of fertile valleys under cultivation, some with railroads, others with river traffic, such as Asher B. Durand's *Dover Plains, Dutchess County, New York* 1848 (cat.56), which evoked the fertility and promise of this region near the city of New York, and Frederic Church's *West Rock, New Haven* 1849 (cat.57).

With affection for the land and the mood of the American South, which attracted few landscapists, Addison Richards travelled through Georgia and Mississippi between 1845 and 1855, painting scenes of southern fields and trees.[36] George Inness's *Delaware Water Gap* 1857 (James Maroney) looks out over the place where the Delaware River cuts through the Appalachians between Pennsylvania and New Jersey, showing settlement with a rich harvest on the left, a raft taking goods down-river, and a train crossing the bridge, all in the light tones of a benign landscape. Jasper Cropsey's *The Valley of Wyoming* 1865 (The Metropolitan Museum of Art, New York), a popular tourist site earlier known as a 'perfect Indian paradise', was praised by one reviewer as evoking 'the courage with which a vast sweep of country [had been] laid bare'[37] — that is, cut clean for 'improvement'.

Thomas Rossiter evoked the fertility of the land in his *Minnesota Prairie* c.1858–59 (fig.11). In 1874, riding a long wave of affection for such landscapes, Cropsey's *Sidney Plains with the Union of the Susquehanna and Unadilla Rivers* 1874 (cat.80), recapitulated settlement with tree rows, plentiful water reflecting the sky, autumn colours, puff of steam in the distance, fences, sheep and cattle, orchards, and telegraph poles.

fig.11 Thomas Pritchard Rossiter 1818–1871
Minnesota Prairie c.1858–59
oil on canvas 39.8 x 64.8 cm (15-5/8 x 25-1/2 in)
Frederick R. Weisman Art Museum at the University of Minnesota, Minnesota Gift of Daniel S. Feidt

A major concern for Americans about their citizenry involved the environmental circumstances within which settlers might live responsibly — a question very much like those asked on both continents regarding indigenous peoples. What character, cultural leaders fretted, would the ordinary pioneer develop in the remote wilderness? To be on the frontier in America was to have a primitive cabin in a clearing, quite a different experience from that envisioned in mid-century of the 'frontier' in Australia, which more often meant to have a sheep station that one developed (or at least commissioned an artist to paint) to resemble as closely as possible an English country estate.

Thomas Jefferson had exhorted that the yeoman, not the city person, was the economic and moral backbone of the country; and into the middle of the nineteenth century harvest scenes in American landscapes testified to this cherished belief. However, in contrast to the optimism of Durand's *Harvest in the Wilderness* 1853 (Brooklyn Museum of Art, New York), which glowed with certainty that success would follow cultivation, and William Hahn's *Harvest Time* 1875 (The Fine Arts Museums of San Francisco), which celebrated the mechanisation of Californian agriculture, a more cautious and even pessimistic note was expressed by many. In Thomas Cole's *In the Woods* 1844 (Reynolda House, Winston-Salem), the hunter and his family in their tiny clearing suggest the unknown effects of the wilderness. A disorderliness marks the house and garden, an uncertainty about nature's influence that was explicit in frontier tales and east-coast urban journalism. In *A View of the Mountain Pass called the Notch of the White Mountains (Crawford Notch)* 1839 (cat.53), Cole presented rural settlement as a bare toe-hold, and American nature as actively hostile. Crawford Notch, already on the tourists' route through the White Mountains, was the site of a tragedy in 1826 when the Willey family was crushed to death in an avalanche. Cole's landscape is dominated by the colours of the American fall and by a passing storm, metaphors that the artist used consistently to remind viewers of nature's dominance and treachery.

In other landscapes about the wilderness the inference is even more direct that American city-dwellers were anxious about the consequences of living in the forest and its effect upon the moral capacities of remote settlers. The very term 'backwoods' came to be an epithet that derided the wilderness dweller as being without discipline and vaguely immoral, especially with the rise to power of Westerners in national political life, and the increased antipathy, economic and political, between city and country. Some of these paintings of wilderness settlers, such as Cropsey's *Backwoods* (Detroit Institute of Arts), very strongly imply character degeneration; and in George Caleb Bingham's *The Squatters* 1850 (fig.12), the condemnation is unequivocal. These settlers have failed to improve their land; they are merely temporary residents on this particular spot, dreamily (and irresponsibly) lured on by the land to the west. In urban-based stereotype, the backwoodsman of America was not far removed from the Aboriginal of both continents, except that the backwoodsman was never perceived as an Arcadian.

fig.12 George Caleb Bingham 1811–1879
The Squatters 1850
oil on canvas 58.8 x 71.8 cm (23-1/8 x 28-1/4 in)
Museum of Fine Arts, Boston, Massachusetts
Bequest of Henry Lee Shattuck in Memory of
the late Ralph W. Gray

In Awe of the Land: the landscape of expedition and study

During the late 1850s, artists and patrons in the new worlds turned from their preoccupation with land as defined by human settlement to land as defined by the character of natural, not human, processes. They were attuned to the important intellectual developments of new theories about the history of the earth and the participation of human beings in the ongoing workings of nature. For a brief time certain landscapists subordinated human presence to a powerful, incompletely understood and even autonomous nature. Farms, fields and developing towns were depicted less often than mountains and other natural wonders. These were subjects that appealed to a community of urban amateur scientists and their patrons who could read about, discuss and underwrite scientific exploration. Just as earlier pictures had appealed to tourists for enlargement and for validation of their mental experience, these images appealed to viewers' desires for confirmation of their growing repertories of knowledge.

And scientific knowledge now had new implications. In 1847 the prominent critic John Ruskin in his *Modern Painters* had advocated familiarity with geology, botany, and meteorology — sciences that had been developing at an increasingly rapid pace — and proclaimed that to be true to what one saw was also to be true to a divinely created universe. But within a decade the universe was no longer deemed to be static. Led by the work of the German scientist Alexander von Humboldt, who proposed and gathered evidence to show that nature was constantly in flux, scientists theorised that the continents had been built up primarily by volcanic action and then were subject to ongoing erosion by rain, torrential flows of water and winds. Suddenly the new worlds of north and south America as well as Australia became primary evidence of the theories of uniformitarianism — the conviction that earth had been modelled over the millennia by the same forces discernible in the present. Westward movement of the populations in both America and Australia revealed mountains that were evidence of the momentous forces of uplift — among them, in America the Rocky Mountains, and in Australia the mountains and other formations of the ranges in the Western District of Victoria.[38]

Travel to these and other areas was undertaken for science, not personal enrichment. Artists, many of them German immigrants familiar with von Humboldt's vision and trained in the tight Düsseldorf style that would communicate it, made images of scientific evidence (formerly natural 'wonders') such as rock formations, lakes, waterfalls and high mountains, all of which revealed the ongoing formation of the earth.

Back in the cities that had become major centres of artistic and other intellectual activity, audiences flocked to natural history museums, special exhibitions and fairs, to marvel at the physical evidence of (and pictures about) the antiquity and physical power of the earth.

Although individual and newly successful patrons continued to acquire town and homestead images until late in the century, by mid-century major artists and influential viewers had begun to see landscape painting as exalting the earth's physical system. Alexander von Humboldt's thesis took hold: the earth functioned as an intricate totality; humanity was part of the large totality; and just as earth evolved, so did humanity.

A new generation of artists accompanied expeditions and took on the aura of explorers–scientists themselves. Meeting the new standards of meticulous observation, artists made explorers–scientists out of their viewers, whether these audiences saw the works in the context of the 'great picture' exhibition or bought portfolios of engravings or lithographs to study at home. The artists' hunger for subject matter occasioned admiration as well as some amusement. One American critic surveyed their entrepreneurship thus:

> Our artists are quite generally 'out of town' — which means gone to the antipodes, or anywhere else that a good sketch can be had. The hope of that great picture, of which every artist dreams, sends him into every imaginable locality in quest of the sketch. They straddle mountains, ford rivers, explore plains, dive into caves, gaze inquisitively into the clouds (not always, we are sorry to say, into Heaven), sail seas, run into icebergs, scald themselves in Amazonian valleys — always returning safely home in the golden October, with a lean pocket and plethoric portfolio, ready for commissions and praise.[39]

Perhaps no earth form on either continent attracted so much dramatic attention as its mountains. On the tourist circuits mountains had long been popular destinations. By allying them with the Alps of Europe, mountains made the new worlds more familiar to those who still had their eye on the old. In the United States viewers never tired of boasting that the Rocky Mountains were the American Alps; and in Australia the Snowy Mountains range was designated the 'Australian Alps'. In Ruskin's formulation, mountains were powerful symbols of force and wonder, providing awe-inspiring sights; for von Humboldt and his followers they became the strongest evidence of the earth's continuous process, challenging a new generation of map makers to determine their accurate height, their role in the earth's magnetic field, and their antiquity in geological formation. These factors shaped the careers and images of Albert Bierstadt and Eugene von Guérard, German-trained painters who emigrated to America and Australia, respectively.

In his *Mount Corcoran* c.1875–77 (cat.81), Bierstadt presented a towering mountain, boulders, fast-moving stream and billowing, turbulent clouds — evidence of a nature constantly reshaping itself. His *View of Donner Lake, California* 1871–72 (cat.78) even more directly invoked nature in formation. The landscape shows a precipitous drop from a summit (on which the viewer is placed), jagged cliffs to which trees cling, a train shed on the right (a subtle admission that this nature has been violated) and a view of Donner Lake in the distance with the Sierra range in the background. Bierstadt's picture seems to be about the history of the world, as distinct from those of Durand and Cropsey that tell the history of human settlement.[40]

In Australia, Eugene von Guérard was the artist most prominently associated with mountains, and perhaps already familiar with the Humboldtian scientific philosophy when he arrived. His magnificent *North-east View from the Northern Top of Mount Kosciusko* 1863 (cat.65) was the outcome of his participation in a scientific expedition in Victoria led by the German Humboldtian scientist Georg von Neumayer to survey the magnetic properties of the earth.[41] Mount Kosciuszko, near the border separating Victoria and New South Wales, is the highest mountain in Australia, and von Guérard enhanced that reputation by adding rocks on the left to suggest endless heights yet to be achieved. Perhaps even more important, these rocks are evidence of ongoing geological de-formation. Brilliant light illuminates the snow-covered mountains nearby and the ranges in the distance; in the sky, clouds move in from the left. In this painting, as in early images of waterfalls, humanity appears in several relationships to the awesome scene. Two figures look out as though in wonder; two attend to their scientific measurements; and a fifth climbs. Like Bierstadt in America, von Guérard in Australia developed a larger audience for his mountain scenes through engravings and lithographs.

Other artists were especially attentive to rock formations. J.D. Hutton painted *Citadel Rock, Upper Missouri River* for a United States Government topographical expedition of the 1850s (Beinecke Rare Book and Manuscript Library, Yale University),[42] and Thomas Moran devoted much of his career to the rocks of the great American West and their accompanying geological phenomena, as can be seen in his *Hot Springs of Gardiners River, Yellowstone National Park* 1872 (cat.79).

In Australia artists were intrigued by formations in western Victoria and Tasmania. Typically, however, they did not depict the rocks as separate from human existence but as coexisting with it. Nicholas Chevalier, in his *Mount Arapiles and the Mitre Rock* 1863 (cat.66), presented the mysterious rocks as survivors of extensive erosion, remnants of the past on lands grazed by cattle, a scene that combined the antiquity of the continent with signs of its pastoral improvement. He was even more explicit about this symbiosis in his *Buffalo Ranges* 1864 (National Gallery of Victoria, Melbourne), a comfortable scene in which humble human agricultural activity is carried out in the proximity of spectacular volcanic formations.

In Tasmania, W.C. Piguenit, who had been employed as a draughtsman for the Lands Department until 1873, drew on his vast experience in travelling through remote regions of Tasmania to make wilderness scenes that were popular until the end of the century. Although most of his pictures do not integrate human life with the wilderness, they do assess rocks, clouds and water as part of earth's intricate totality. In *A Mountain Top, Tasmania* c.1886 (cat.70), for instance, volcanic formations co-exist with soft-painted mists and clouds.

In addition to mountains, artists developed repertoires of water at work in its many forms. While waterfalls had earlier provided the highlight of tours seeking the exhilarating experience of sublimity, by mid-century they had assumed a considerably more complex meaning: they were primary evidence of water's shaping of the earth through its constant abrading action. Mid-century pictures of waterfalls often contain no tourists. In Frederic Church's well-known painting of *Niagara Falls* 1856 (cat.72), the water swirls and plunges right at the viewer's feet — with no foreground element, the viewer is placed in the immediate presence of a mysterious and powerful force. Conrad Martens achieved a similar expressive effect by reducing the scale

of the figures in his Australian waterfall scenes such as *One of the Falls on the Apsley, New South Wales* 1873 (fig.5), in which tiny human figures look on in awe.[43]

Another impressive site for the erosive action of water was the coast, where the land was always under siege and the rocks themselves were the evidence of the battle. Artists chose coastal areas that were well known and, as in their depictions of waterfalls at mid-century, they diminished or banished altogether the human presence. Church picked the popular American tourist destination of Mount Desert for his searching *Coast Scene, Mount Desert* 1863 (cat.75) that shows the ocean's ongoing wearing down of the rocks. It is a startling scene, as Henry Tuckerman wrote:

> Here is magnificent force in the sea; we give ourselves up to enthusiasm for it, regarded as pure power … we feel ourselves in an audacious actual presence, whose passion moves us almost like a living fact of surf.[44]

The Düsseldorf-trained artist William Stanley Haseltine made the assault of sea upon shore a major focus of his career, depicting it not in crashing waves, as had Church, but as a drama that had already occurred, demonstrated by rocks strewn everywhere. For his subjects Haseltine was drawn to Nahant, north of Boston, the site of naturalist Louis Agassiz's laboratory for the study of sea life and minerals. Over and again, in such pictures as *Rocks at Nahant* 1864 (fig.13) and others of the area, Haseltine demonstrated his sympathy with Agassiz's glacial theories of land formation.[45] Tuckerman mused that Haseltine's rock pictures 'speak to the eye of science, of a volcanic birth and the antiquity of man'.[46] In Australia the coast was not only the site of ongoing erosion, but a boundary between the continent and the rest of the world. The very persistence of the continent at this remote outpost was a marvel. Von Guérard's *Castle Rock, Cape Schanck* 1865 (cat.67) called attention to the often peculiar results of 'weathering' or erosion. These rocks (given metaphorical names as on other shores on the globe) are insistently attacked and reshaped by the ocean force.

Occasionally the force of water was inland. One of the most dramatic Australian pictures of the power of water is W.C. Piguenit's *The Flood in the Darling 1890* 1895 (cat.89). This picture presents the total devastation wrought in March and April of 1890 by the flood of the River Darling in western New South Wales. The spreading water reached 67.5 kilometres (40 miles) in width, completely obliterating all traces of humanity. In Piguenit's painting of the stunning aftermath of this violence, water can be seen as the source of total destruction as well as that of all life. In its awesome stillness, the picture provides no answers.

On their damper continent, Americans knew water in its various manifestations more intimately than did Australians. As scientific understanding of meteorology became more intense, artists developed the softer styles that could suggest the moistness of the air, and they became weather experts, skilled in the vocabulary of meteorology. Some developed a moving, almost breathing atmosphere as their hallmark. George Inness's *Clearing Up* 1860 (George Walter Vincent Smith Art Museum, Springfield, Massachusetts), for instance, was praised for presenting 'moisture-laden air, rain effects, clouds clearing after rain, rainbows, mists, vapours, fogs, smokes, hazes — all phases of the atmosphere'.[47] Sanford Gifford was another landscapist enthralled by water vapour. His *A passing Storm in the Adirondacks* 1866 (cat.76) depicts Keene Valley at about three on a summer afternoon. As Gifford wrote to his patron Elizabeth Colt, the distant sky reveals 'a thin, illuminated, veil of rain, which gradually thickens to the extreme right into a dense shower'.[48] Samuel Colman's *Storm King on the Hudson* 1866 (cat.77), a scene near West Point, shows water in motion in its many forms — slight ripples in the surface of the river, especially in the foreground, steam and smoke coming out of the boats' smokestacks, and tremendous rolling, billowing clouds.

With these scientifically informed works, artists addressed a larger range of viewer interests than ever before. In America in 1864, the periodical *The New Path* — the organ of artists who banded together as the Association for the Advancement of Truth in Art — delighted in the fact that recent landscape painting was such 'that the poet, the naturalist and the geologist might have taken large pleasure from it'.[49]

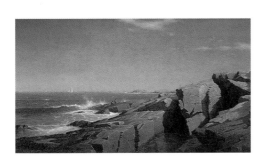

fig.13 William Stanley Haseltine 1835–1900
Rocks at Nahant 1864
oil on canvas 56.2 x 102.0 cm (22-1/8 x 40-1/8 in)
Brooklyn Museum of Art, New York
Dick S. Ramsay Fund and A. Augustus Healy Fund

In Australia, Eugene von Guérard advertised lithographs of his landscapes with the promise that 'Besides the natural beauty of the scenery, the artist, the geologist, and the tourist in search of the picturesque' would all be satisfied. On both continents such pictures attracted viewers who paid admission for the spectacle of the single-picture exhibition, they were sought by entrepreneurs whose railroad or mining investments contained the mountains or waterfalls, and were available as well to purchasers of lithographs who could 'possess' the landscape on their parlour tables. Although Australians had the British and European audience in mind, like Americans, they were also addressing audiences in their own coastal cities.

The single body of work that best illustrates the heterogeneous audience for these pictures is *Eugene von Guérard's Australian Landscapes* (1866–68) (cat.68), a book of twenty-four coloured lithographs and letterpress based on his paintings. In his sequencing of the lithographs, von Guérard appealed to several groups, some with desires to settle as pastoralists, others to make money in mining, some to appreciate rare geological formations, and others to have ecstatic 'tourist' experiences. Thus he arranged the lithographs so that, regardless of their specific desires toward or in Australia, viewers would be 'hooked' within the first few images. Beginning with the fertile Western District of Victoria, which was attracting new pastoralists, he moved on to 'The Valley of the Ovens River', with mountains described as 'rich in Mineral Treasures; as, besides Gold and Tin, Diamonds, Sapphires, Rubies and Topazes, and other Precious Stones have been discovered in the creeks by which it is intersected'. Accompanying his lithograph of Mount Kosciuszko was his claim that he, the artist, and the scientist Georg von Neumeyer, along with their guides and servant, were probably the first Europeans there. He celebrated Castle Rock at Cape Schanck as 'one of the most picturesque "bits" of scenery on the Victorian coast', and Hobart Town as 'superior to Genoa, Naples and Rio de Janeiro'. In other scenes he enticed the reader with promises of abundant game and fishing; and, writing about Ben Lomond in Tasmania and the landscape that the mountain dominated, he rhapsodised:

> [Ben Lomond] looks down upon a scene of fertility and repose, such as reminds the traveller, fresh from the mother country, of some of the landscapes in the midland counties of England. The forest in the middle distance borrows its name from an old English chase — that of Epping; and the seats of some of the wealthy settlers in the neighborhood will vie, both in the hospitality they offer, and the elegant comforts they command, with the country houses 'at home'.[50]

At this point, the issue of home began to organise the interpretation of landscape permanently. American critics had claimed a national meaning for landscapes of harvest and settlement as early as the 1840s. Despite the fact that Australia was not yet a 'nation', the connection between land and community began to be made there by the 1860s. Viewers tended to see mountains in particular as topography that redounded to the credit of the settlers. In America one critic wrote in response to Bierstadt's *The Domes of the Yosemite* 1867 (St Johnsbury Athenaeum, St Johnsbury, Vermont): 'We recommend our readers to go at once and see the work. They will feel that the world is progressing and the Americans are a great people.'[51] And in Australia a chauvinistic reviewer delighted that von Guérard's *Mount Kosciusko* 'alone is a complete rebuttal of the theory, if such a theory be now held by anyone, that Australian scenery possesses no elements of the sublime'.[52]

Eugene von Guérard elevated the mountains to symbols for all of Australia. In 1870, thirty-one years before Australian federation, he offered *Mount Kosciusko seen from the Victorian Border (Mount Hope Ranges)* 1866 (fig.35) to the National Gallery of Victoria: 'It was my long Cherished wish that this Painting should become national property', associating the mountain of the painting and the gallery in which the image would hang with a national community.[53]

A Landscape of Contemplation: the excursion

Artists who painted tributes to the complexity of nature as an organic system were envisioning it as newly strange. And fuelling artists' attentiveness was the recognition that human beings were part of this nature in a not yet completely understood way: nature was emerging as a powerful 'other', and human beings were being reconceptualised as part of this otherness. A potent indication of this was the responsiveness of the sensitive individual to nature's emotional effects. Just beyond nature's quiet scenes, many believed, was a God who could not be fathomed solely in terms of a Creator.

These ideas took hold in the early 1860s about the same time as the rise of the day excursion. Members of the middle and upper classes in America and Australia, as elsewhere, began to make excursions and summer retreats to areas of cultivated nature that were accessible and comforting.[54] Unlike touring early in the century, which had been undertaken to obtain intellectual worldliness, excursioning provided emotional respite. Excursionists did not see land as an economic resource, or the setting for estate building, or as evidence of progress, but in many instances almost the reverse — as an escape from the responsibilities, the clamour, and the materialism of urban life. Summer retreats and Sunday excursions provided a temporary alternative to city life, completing rather than replacing it. Country experience was given its meaning by visitors' urban rootedness, for they discovered that temporary re-immersion in nature could give them sensuous experience for which they were starved.

Thus during the same years that some artists were making headlines in the press with finely detailed interpretations of remote mountains and rocky coasts, others turned to the known countryside. Rather than recording the land as a series of tourist experiences, or as sites of production or commerce, or as scientifically intriguing evidence of the earth's antiquity and process, these artists interpreted land as a place of retreat, both literal and psychological. In both America and Australia, and in Europe as well, landscapists cherished the countryside, painting it with a soft, loose style that preserved the quiet and transitional moments of nature.

Although an appetite for remote wilderness scenes continued until almost the end of the century, especially in Australia, most artists repudiated the themes of scientific study and improvement and presented a nature to be attended to and felt in silence. God's place in this nature was no longer as the mysterious Creator, but as the ever-present Spirit.

Landscape became local. In France such painting was sparked by revulsion at the artificiality of city life and Salon painting, and artists fled to the forests of Barbizon where their landscapes of the local woodlands, countryside and peasantry inspired similar movements elsewhere, and across the rest of the century. From Brittany to Concarneau, Newlyn in Cornwall, Whitby, and Cockburspath on the east coast of Scotland, artists sought out the humble. In the local, we might say in hindsight, human beings settled down into their condition as creatures in nature.

In America and Australia, artists satisfied different inclinations. American artists were struggling to adapt to the new taste of cosmopolitan and wealthy patrons after the Civil War. These were socially self-conscious buyers attracted to European styles and subjects because of their dislike for the bombast of the recent 'great pictures' of the American West. They associated a less detailed style with their capacity to appreciate 'poetic' subtlety. Australians, on the other hand, wanted to import into their painting what they perceived as an English comfort but they, too, wanted to keep up with European styles. A growing patron class, a readership for the developing field of art criticism, and cultural leaders who established the art galleries of the individual states encouraged regional pride in art collecting and eventually in art making. Land Selection Acts of the 1800s, which opened up land to settlement for agriculture, stirred thoughts of the cherished British yeoman ideal. All in all, such images represent a major turn on both continents toward establishing a patronage group who were comfortable 'at home' and yet who were also well travelled, urban and increasingly insistent that pictures replace description and study with poetry.

In America the earlier artists in this movement transformed familiar summering sites for their affluent patrons — many of them industrialists. In such popular recreational destinations as Lake George and coastal areas in New England, artists ignored the hustle and bustle, much as they had earlier idealised the wilderness, to convey the effect of nature itself on the emotions of the sensitive visitor. Coastal and lake scenes dominated artists' choices, but in contrast to the scenes of dramatic confrontation and erosion in the works of Church and Haseltine, the lakes and coastal areas in these images lay in hushed silence. In Australia the more popular pictures were inspired by the day excursion. Typically, the country destinations outside Melbourne and Sydney — the Yarra Valley, Mount Macedon and the Hawkesbury River region — were imaged as farmed and dotted with orchards and cattle, fences, homes and outbuildings.

For city dwellers on both continents, the peaceful rural scene, whether an isolated beach or a country orchard, was attractive not because it reminded excursionists of days past (after all, most of them had never lived in the country, nor had their immediate ancestors) but because it offered a remote area or a rural village, especially reminiscent of English life, as the model for reflection and community unavailable in the cities.

Many American landscapes appealed to an audience who with urban sophistication could convert quickly to the contemplative mode. This mode in turn often inspired awe at nature's poignant and even disturbing unknowableness. In his *Lake George* 1860 (cat.92), John Casilear depicted a completely calm water surface under a light sky, with benign clouds tipped with sunlight. A critic delighted that Casilear's 'work is marked by a peculiar silvery tone and a delicacy of expression which is in pleasant accord with Nature in repose, and of his own poetically-inclined feelings'.[55] Other images, almost preternatural in their stillness, conveyed an unsettling melancholy. Fitz Hugh Lane, who had been painting for discerning patrons since the early 1850s, took up his brush near areas of Maine and Massachusetts that had long been popular with tourists and summer residents from Philadelphia, New York, Boston, and Portland. In his *Brace's Rock, Brace's Cove* 1864 (fig.57), he provided everything in nature needed by the contemplative viewer — water lapping the shore, a rocky promontory, tiny and colourful foreground vegetation, a quietly radiant sky, and an empty boat, discreet, even melancholic, evidence of human presence.

At Newport, which in the 1860s and 1870s became the summer retreat of prominent New York and Boston families, John Frederick Kensett painted such reveries as *Beach at Newport* c.1869–72 (fig.14), in which figures on the beach, tiny sailboats in the distance, carefully articulated rocks and promontory set a scene for meditation and wonder. Kensett also took his easel to the popular north-eastern Massachusetts coastal area near Beverly. In his *Coast Scene with Figures (Beverly Shore)* 1869 (cat.95), one of the most vivid of such meditations, we see the evidence of excursionists — a man and woman looking out to sea. Under a palpable atmospheric sky, a crisply painted long wave is about to break, the foam from the previous one washing outward along the beach. In scale and tone the scene insists on the mystery of the sheer being of nature and humanity.[56]

In many of these images humankind's participation in the natural world seems to be conveyed by a quietly radiant combination of air and light. Referring to this aspect of his own work, Sanford Robinson Gifford called it 'air painting ... achieving on canvas the illusion of warm pervasive sunlight and moist atmosphere'. The critic G.W. Sheldon, in 1877, saw atmospheric conditions as directly related to human emotions:

> The condition — that is, the colour — of the air is the one essential thing ...
> in landscape painting ... Different conditions of the air produce different impressions
> upon the mind, making us feel sad, or glad, or awed.[57]

Sanford Gifford's *Kauterskill Clove* 1862 (cat.93), a striking combination of light and air, transforms into a breathtaking vista a tourist area that had once been completely deforested. Here the forest has regenerated; the tiny detail in the foreground of hunters and their dog scrambling up to the ledge, presumably to view the scene, emphasises the smallness of humanity within nature's vastness. In his landscapes

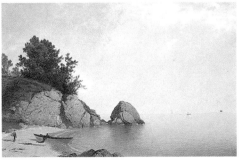

fig.14 John F. Kensett 1816–1872
Beach at Newport c.1869–72
oil on canvas 55.9 x 86.4 cm (22 x 34-1/16 in)
National Gallery of Art, Washington, DC
Gift of Frederick Sturges, Jr

Martin Johnson Heade conveys his remarkable fascination with coastal marshes, combined in hushed reports of the atmospheric changes that hover over the marshes through which water relentlessly ebbs and flows. With such works as *View of Marshfield* 1865–70 (cat.94) and *Lynn Meadows* 1863 (Yale University Art Gallery, New Haven) — two of more than one hundred scenes he painted of the well-travelled Massachusetts coast — Heade appealed to his patrons' interest in the relation between atmospheric change and emotion. In these images, too, natural phenomena were no longer recording Humboltian process but had become vehicles of sentiment.

In the South, Joseph Meeker found strong patronage for swamp scenes, such as his *The Land of Evangeline* 1874 (cat.96), a regional feature that he elevated to mysterious beauty. In the next decade John Twachtman celebrated the cold, moist whiteness of New England in images such as *Winter Harmony* c.1890–1900 (cat.100) that depict his own property.

Fewer American than Australian artists specialised in the 'civilised' or village landscape (possibly because American politics were predicated on the 'empty' continent), but George Inness in particular found many buyers for such scenes. As he declared in 1878, such a landscape was 'more worthy of reproduction than that which is savage and untamed. It is more significant. Every act of man, every thing of labor, effort, suffering, want, anxiety, necessity, love, marks itself wherever it has been.'[58] Living out his affection for village life, Inness settled in Medfield, Massachusetts, in the 1860s, where he celebrated the rich fertility of the land under cultivation. Over the years he moved more and more toward poetic evocation of the countryside, organising such pictures as *Winter Morning, Montclair* 1882 (cat.97) on a delicately suggested composition and broad sweeps of colour that rewarded the viewer's quiet attention.

The movement toward affectionate localism took hold dramatically in Australia with the arrival of Louis Buvelot in Melbourne in 1865. Buvelot had the training, the disposition toward cities, and the entrepreneurial alertness to look to Australian excursionists as his patrons. He had been taught the Barbizon style in Switzerland, and on setting up practice in Melbourne gravitated immediately to areas in the Yarra Valley outside the city, earning critical approval not only because he painted 'all sorts of previously unnoticed beauties in our indigenous timber and foliage, and ... caused us to look upon our sylvan scenery with something like a new sense of vision',[59] but because he provided an example of 'practice [that] conforms to some of the best landscape painters of Europe'.[60]

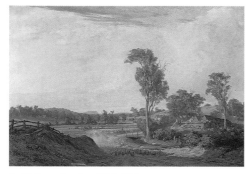

fig.15 Louis Buvelot 1814–1888
Summer Afternoon, Templestowe 1866
oil on canvas 76.6 x 118.9 cm (30 x 47 in)
National Gallery of Victoria, Melbourne

Thus at the same time that von Guérard was painting his spectacular images of Australian mountains, Buvelot announced his very different landscape endeavour with *Winter Morning near Heidelberg* (cat.82) and *Summer Afternoon, Templestowe* (fig.15), both of 1866, two Yarra Valley pictures of popular country destinations for Melbourne excursionists. *Winter Morning*, a tranquil, settled scene, shows peppermint gum and yellow box, the two most common eucalypts in the area. The uprooted trees are evidence of the flooding common to the Yarra River, and hollow trunks speak of earlier bushfires, also quite common. Yet the figures gathering wood suggest that nature and humanity are now at peace. As a commentator noted the next year:

> [Buvelot's pictures] are so sunny, so pleasant, in a word, so nice. Mr. Buvelot's pencil ... seldom strays many miles from Melbourne ... No mountains, no gum forests, no wildernesses, but snug little nooks, eminently suggestive of noontide meditations, lovemakings and picnics.[61]

Buvelot's *Near Fernshaw* 1873 (cat.85), focusing on a spot north-east of Melbourne increasingly popular as a cool summering place somewhat like Tasmania, capitalised on the British affection for tree ferns.[62]

> While there is no sacrifice of truth [in his paintings] there is produced as the general result a picture as charming as an English green lane or woodland dell.[63]

Indeed, Buvelot had so successfully made Australia 'as charming as an English green lane' that the newly established National Gallery of Victoria purchased in 1869, among its first Australian accessions, his *Winter Morning near Heidelberg* and *Summer Afternoon, Templestowe*.

Slightly later, artists began to celebrate the Hawkesbury River region north of Sydney, many painting out of doors in watercolour. For example, Julian Ashton's *The Afterglow, Foul Weather Reach, Hawkesbury River, New South Wales* 1884 (National Gallery of Victoria, Melbourne), which invites viewers into a landscape of flowers, grasses, and comfortable human activity, was praised by the *Sydney Morning Herald* as 'a real poem in colour'.[64] Ashton's *Mosman Ferry* 1888 (National Gallery of Victoria, Melbourne), records Sydney day trippers' excursions, and his *The Corner of the Paddock* 1888 (fig.16) depicts the type of comforting rural scene treasured by excursionists — an old farm with a milkmaid by the fence holding a pail, and her elders talking in the background. Arthur Streeton, who had painted outlying Melbourne scenes but moved on to Sydney in 1890, wrote to a friend in great joy about his experience painting the watercolour *Mittagong* 1892 (fig.17):

> You can see for about 80 miles — tremendous horizon — ... even the atmosphere seems thin and scarce. Oh you would enjoy it — the waves of Ranges rolling away to the north. Oh its glorious, its wealthy — Truly Australia.[65]

fig.16 Julian Ashton 1851–1942
The Corner of the Paddock 1888
watercolour 40.5 x 58.8 cm (16 x 23 in)
National Gallery of Victoria, Melbourne

The view from the Hawkesbury River toward the Blue Mountains that is perhaps the best-loved evocation of the sensuous Australian light and atmosphere, Streeton's *The Purple Noon's Transparent Might* 1896 (cat.91), presents a comfortable, settled (but not too closely) rural landscape. In the middleground, near the lazy winding river, is a windmill; there are fences here and there; cattle, homes and smoke rising convey a pleasant at-home-ness. The light blues, yellow-greens, ivories, browns, and sandy tones, all laid with obvious brushwork one on top of another or side by side, contribute the crucial element in the picture — the physical presence of light and atmosphere. Tellingly, the title, from a poem by Shelley, links the scene and the emotion to England and to the romantic experience of resteeping oneself in the sensuous gifts of nature.

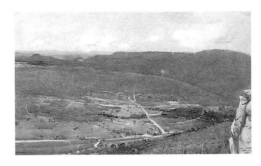

fig.17 Arthur Streeton 1867–1943
Mittagong 1892
watercolour over pencil 55.9 x 97.2 cm (22 x 38-1/4 in)
National Gallery of Victoria, Melbourne
G.W. Booth Bequest 1961

In these still revered, emotion inducing Australian landscapes, quiet bodies of water were often the centre of the picture — with a special resonance in Australia where water was so scarce. From early in the century, on both continents in fact, bodies of water had a particular emotional and spiritual attraction — as in the Lake District in England. An early Australian image to register this emotional depth was Buvelot's *Waterpool near Coleraine (Sunset)* 1869 (cat.83). Coleraine, in the Western District of Victoria, was newly developed after the gold rush and, many felt, the most English of all the known landscape of Australia. There selectors, or the new yeoman farmers, had established an admirable, 'natural' way of life, with 'Farm houses built after English fashion, well-cared for crops, and ever-widening lines of fencing, [giving] the appearance of a race of independent yeomen, eager to found new homes in the liberal and fertile land of their adoption'.[66] The waterpool in Buvelot's picture is a reflection and centre of all these treasured associations.

In South Australia, Henry James Johnstone specialised in scenes of tranquil waters, rivers and eucalypts in early morning and evening. The swamp stage was characteristic of the effects of sporadic and heavy Australian rainfall in parts of the interior. Johnstone's enormously popular *Evening Shadows, Backwater of the Murray, South Australia* 1880 (cat.86) so deeply touched patrons' desire for specificity that he was able to sell more than one version[67] — and this particular painting was the first of an Australian subject acquired by the Art Gallery of South Australia.

Many of the American and Australian landscapes during these decades showed not only a nearby and cultivated nature but one in transition. The transition was delicate. Sometimes it was obvious — as in rain clouds, or a sunset — but often artists made the element of change explicit in the title. Winter, summer, morning, evening, moonrise, sunset — all these moments pointed to nature as ongoing process and implicated the viewer in a process of growth and decay on the same terms as nature. In these paintings human life is lived *within* nature rather than *against* it. Twilight inspired such pictures in America as Church's *Twilight in the Wilderness* 1860 (Cleveland Museum of Art, Ohio), Worthington Whittredge's *Twilight on Shawangunk Mountain* 1865 (private collection),[68] Sanford Gifford's *Twilight in the Adirondacks* 1864 (Adirondack Museum, New York) and *Hunter Mountain, Twilight* 1866 (fig.18). In Australia times of day inspired Buvelot's

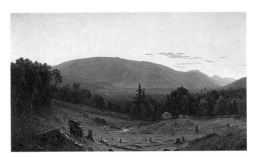

fig.18 Sanford Robinson Gifford 1823–1880
Hunter Mountain, Twilight 1866
oil on canvas 77.7 x 137.5 cm (30-5/8 x 54-1/8 in)
© Daniel J. Terra Collection, 5.1983;
photograph courtesy of Terra Museum of American Art, Chicago, Illinois

Waterpool near Coleraine (Sunset), Streeton's *The Purple Noon's Transparent Might* and David Davies's *Moonrise* 1894 (cat.88). Seasons, also times of transition, were the subjects of such pictures in America as William Sonntag's *Autumn in the Alleghenies* c.1860–66 (Mellon Bank, Pittsburgh, Pennsylvania)[69] and Jasper Cropsey's *Autumn on the Hudson River* 1860 (National Gallery of Art, Washington, DC), and in Australia, Walter Withers's *Tranquil Winter* 1895 (cat.90).[70]

In yet other variations on the theme, artists noted imminent meteorological changes, especially in pictures of approaching storms. Although recent art historians have linked the storm pictures in America to the social tensions of the Civil War, these images seem actually to have been inspired by attentiveness to nature as process. In Heade's *Thunderstorm over Narragansett Bay* 1868 (Amon Carter Museum, Fort Worth, Texas) and *Approaching Storm: Beach near Newport* 1860s (fig.19), the sky occupies most of the canvas, and the tremendous gathering forces of lightning, wind and moving water are the subjects.

With increasing frequency, critics identified landscape paintings as statements about national community. In America from about 1840 the vegetation, natural wonders and abundant harvests had set off the landscape, like the American body politic, as distinct from Europe. And because most paintings of landscapes were made in the economically and politically powerful regions of New York and New England, critics claimed that these landscapes represented the 'character' of the entire nation. In Australia, where landscape could not be posited as standing for a community until members of the social body had begun to see themselves as 'not-British', that is, as 'Australian', the rise of attention to local geography, botany, and geology, assisted such a conceptualisation. As one critic put it:

> [Artists should] teach us that even gum trees are not alike, but that each has its own peculiar habit in trunk, and branch, and leaf, and in the thick masses of scanty sprays of its foliage. They have to show us the beauty of the sapling and of the giant of the ranges, of the wattle bending to the breeze and shedding on the river the glory of its bloom … We look to them to learn by heart and tell us what few adequately know, the characteristic traits of our Australian seasons.[71]

Another critic pointed to the sense of history that Buvelot's landscapes made imaginable: 'M. Buvelot is still the only artist who has caught the spirit of Australian scenery … all the weird romance and strange old-time mystery which seems to live in our Australian forests.'[72] In 1889, the critic Frederick Broomfield could claim in art-conscious Victoria:

> The predominant element was this year distinctly local. The majority of canvases were covered with scenes from the Australian bush, incidents of Australian life, and glimpses of the Australian coast. A few years ago there would have been, perhaps, half-a-dozen pictures in the entire collection which would have owed their origin to the inspiration of the country in which they were painted … Today the visitor is agreeably assured that the sentiment of this new Southern World is beginning to find expression, and that the penumbra of a genuinely Australian School of Art is veritably visible.[73]

The Figure defines the Landscape: the landscape of immersion

Landscapes began the century with the confidence of the tourist and optimistic settler that nature would be subject to their understanding and improvement, and they concluded the century with the bravado of urban dwellers who thirsted for a real acquaintance with nature on secular and, one might even say, therapeutic grounds. From these perspectives the landscapes of the 1860s and 1870s (and some even later) seem to have been byways. In them a reverence for nature in the awe-inspiring wilderness, and the homage to a mysterious God in the quieter landscapes, are the last concerns with divinity that artists and critics acknowledged.[74]

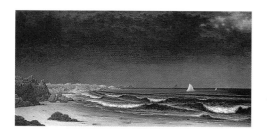

fig.19 Martin Johnson Heade 1819–1904
Approaching Storm: Beach near Newport 1860s
oil on canvas 71.1. x 148.3 cm (28 x 58-3/8 in)
Museum of Fine Arts, Boston, Massachusetts
Gift of Mrs. Maxim Karolik for the M. and M. Karolik
Collection of American Paintings, 1815–1865

By the 1880s, with urbanisation and industrialisation so riddled with consequences that major doubts had arisen about the future of city life and about the character that urban dwellers could develop there, landscapes tended to focus on snatches of nature that might restore individual and social health. Artists continued to rely on palettes and brushwork that conveyed atmosphere, light and the colour of an experienced earth. In the hands of many, landscape became explicitly sensuous. Pigment and brushstroke replaced non-tactile conventions as communicators of meaning, as though to assure viewers that nature was indeed physical. However, with few exceptions, nature as an autonomous power receded in these landscapes. Artists depicted figures actively at work, so prominent in the picture that they make nature the accessory, even just the backdrop, to their self-definition. In these scenes of activity, landscape is stripped of its capacity to inspire reflection. City figures act in the landscape with social roles of gender and class that had been defined in the city. And rural figures in the landscape live with a simplicity and closeness to nature that provided an alternative imaginative life for urban visitors for whom life was bewilderingly complex — for these viewers the rural farmgirls and fisherfolk modelled courage and fidelity. In short, the landscape itself became a stage upon which artists and patrons constructed an ideal social self, and the figures in these landscapes acted out their designated roles.

No artist saw this transition so clearly as Tom Roberts, who wrote in 1893 that the time had passed when artists had looked 'into the deep quiet face of Nature; lingering where the winding, almost silent river bathes the feathery wattle branches … finding beauty in odd corners of some country shanty, or by some lagoon which palely reflects the banks all bathed in a great shimmer of trembling, brilliant sunshine'.[75]

Among the earliest paintings to suggest nature as a theatre for human definition of self were images of the shore. Although painters such as John Frederick Kensett in America and Eugene von Guérard in Australia had placed figures in coastal landscapes in the 1860s, typically these figures were so small that they conveyed human reaction to the awe-inspiring mystery of the ocean. The figures in late-century shore scenes are not contemplating nature. They are not inspired by the ocean but by themselves — their bright costume, their attractiveness, their status as 'interesting'. These are scenes of urban leisure; the ocean and the shore are not quiet calls for meditation but liberating backdrops for city dwellers' drama in the social world. Artists probed the shore as the sites of holidays, where well-dressed young women, male *flâneurs*, older helpful gentlemen, and the modest mother or nurse with children promenaded. Nature provided the rhythm of the tides, the sun radiated warmth, the sea breeze provided refreshment — all a conversational backdrop to the interaction of people who were essentially strangers. In this natural environment one lived completely artificially, choosing activities that would best construct an attractive persona. In Winslow Homer's *Long Branch, New Jersey* 1869 (cat.115), a scene splashed with brilliant light, nature is the stage on which fashionably dressed young women look out into the sea and pose to attract the interest of proper suitors. Long Branch was associated with a wide social spectrum of promenaders. And in this early period of public leisure, with the shore a questionable environment for young women making their debut into social activity, Homer's presentation is an inquiring one: What is the meaning of this space, of young women in it, of the sun and the sand and the sea turned into entertainment? A decade later, in the fashionable Newport area, Worthington Whittredge in his *Second Beach, Newport* 1865 (fig.20), had nothing but certainty about the shore as an arena of display: the scene is populated with confident women in bright dresses engaged in lively conversation.

Shore holidays and beach paintings became popular in Australia after the construction of tramways from the city to the beach in the 1880s. Charles Conder's *A Holiday at Mentone* 1888 (Art Gallery of South Australia, Adelaide) celebrates youth, or youthful dress and gestures, and hopefulness and *savoir faire*. Painted at a resort near financially booming Melbourne, just when Conder had arrived from Sydney, and in the year of Australia's centenary celebration, the composition is like a stage set. Figures are the height of self-consciousness, acted out most prominently by the foreground woman

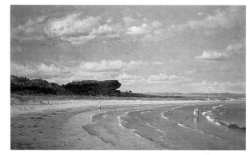

fig.20 Worthington Whittredge 1820–1910
Second Beach, Newport 1865
oil on canvas 45.7 x 76.2 (18 x 30 in)
Collection of Peter G. Terian
Courtesy of D. Nisinson Fine Art

who pretends to read her newspaper while the man in the middle ground poses with his back to her. On and beyond the jetty are conversational groupings orchestrated with touches of splendid red and mauve under a brilliant light blue sky.

As Americans had done slightly earlier in the century, Australians took the picnic as a landscape motif from the 1860s, when day trips out from Melbourne promoted the picnic as a rural activity, and rocks and sheltering trees became the stage setting for conversation and refreshment. Just how thirsty urban citizens were for moments in nature is revealed by a critic's account of William Ford's *At the Hanging Rock* 1875 (cat.103) as a scene 'resorted to by visitors in search of natural beauties and by picnic parties innumerable at holiday times. About Christmas and New Year the grass is trodden to the bare earth in all directions. People clamber up the hill in thousands and explore the labyrinths formed by the complications of rocks ...'[76] In virtually all dimensions, scenes of urban figures in nature at leisure (holiday landscapes, we might call them, as distinct from landscapes of reflection) subordinated the location, the flora, the ground or sands, and the natural process of tides to the self-shaping presence of urban citizens acting out against a natural backdrop social roles that had been conceived in the context of city life.

Landscapes of the city itself presented it as a place of excitement and yet order. Bustling streets, parks with promenading figures and bright colours in pictures with tilted up space and high horizons thoroughly pull viewers into the urban experience. In contrast to earlier city landscapes in which urban life was a prospect certified by rising institutions, such images in America as Chase's *A City Park* c.1887 (cat.118) and *Prospect Park, Brooklyn* c.1887 (cat.119), and in Australia as Tom Roberts's *Allegro con brio; Bourke Street West* c.1886 (cat.105), immerse the viewer in a vast organism, a city that runs on its own processes within which human beings find their identity.

And yet all was not well in the city. Cultural critics decried the artificiality of city work and worried that urban life prevented the proper character development of manhood and womanhood. And thus many landscapes during this late period focused on rural workers, or 'ordinary' people, and often children, comfortably at one with nature. The earth in these landscapes reached up to high horizons, absorbing into healthy connectedness with nature workers who carried out regional activities such as ranching or farming or sheep herding. These idealised rural types — hardy, dedicated, honest and, most important, independent — were salutary examples to city classes. In America the movement of the population westward with all that it implied in courage, skills in woodcraft, and independence, had long been seen (with a few worries here and there) as productive of a national character. In Australia, where the population had always been strongly urban, it was not until working-class activism developed late in the century that labour itself came to be seen as attractive. There, even more than in America, artists and writers turned to the rural community as an example of living in concord with the universe, and to the worker in the countryside as a therapeutic model.

On both continents non-urban work by dual models exemplified the best national character — women who encouraged nature to flower in gardens, orchards, and farms, and men who dominated nature as outdoor guides, fishermen, and cowboys. In America this relationship between ideal female and male types played out the social stresses of art patrons: wives and daughters practised the conspicuous leisure earned by the newly wealthy male entrepreneurs, and the men themselves yearned for a command of the outdoors that would give 'manliness' to their urban and bureaucratic pursuits.

The ideal American females, if not inside their homes, were in gardens and domestic landscapes, and they were of the leisure class. Childe Hassam's *In the Garden (Celia Thaxter in her Garden)* 1892 (cat.121) and Chase's *Untitled (Shinnecock Landscape)* c.1892 (cat.120) create the woman who is at one with nature's serenity. In Hassam's painting, art patroness Celia Thaxter tends her famous garden on the favourite holiday destination of the Shoals, off Portsmouth, New Hampshire; in the Chase landscape, one of many that Chase and others painted in Long Island's

fig.21 Frederic Remington 1861–1909
The Bronco Buster modelled 1909, cast 1912
bronze height: 82.6 cm (32-1/2 in)
The Metropolitan Museum of Art, New York
Rogers Fund, 1907

Shinnecock Hills, women and children sit demurely in the popular excursion spot, dressed for the afternoon. Critics reviewed these pictures with language redolent of British allusions and comfort:

> Our own warm hills and orchards ... our own clear, cold, seas and repeating purple hills ... New England ... scenes that to-day rank our artists among the greatest landscape painters of the world.[77]

Male models for Americans were the hardy workers of the New England mountains, the Atlantic shore in the fishing communities, and the cattle and sheep ranches of the far west. In Winslow Homer's *Two Guides* c.1875 (cat.116), for example, set in the Adirondacks of upper New York State, two guides assess the forest. As craftsmen who know nature, and as guides to the many urban 'sports' who came to the Adirondacks for rejuvenation through camping and hunting, they represent two distinct generations of manliness, the older by implication passing on his woodcraft to the younger. With their heads below the rising line of the mountain in the distance, they are fully part of this natural world.[78] In *Mending the Nets* 1881 (cat.117), a scene on the New Jersey shore, Thomas Eakins provided a thoughtful consideration of the fishermen who in a humble setting work together to prepare for the next round of fishing. In his green and blue palette, even figures on the horizon line silhouetted against the sky are at one with the environment. In the 1880s, from his home on the coast of Maine, Homer painted dramas of mariners and fishermen who represented what critics called the old 'Yankee' virtues of hardihood and courage. And in the American West, the cowboy characterised for Frederic Remington and his eastern buyers the ideal fearlessness, capabilities and freedom of the male who worked close to nature: *The Bronco Buster* modelled 1909 (fig.21) and *Fight for the Water Hole* c.1903 (cat.123). All of these figures, particularly those of Homer, Eakins, and Remington, were 'on their own hook' (in Australia, the expression was 'on the wallaby track') — that is, they were free agents economically, working only for themselves, an ideal virtually unattainable to the city person enmeshed in bureaucracy but translatable into moral integrity.

Because of the diversity of regions in America, and therefore activities, there were several types of rural character to hold up as models. In Australia the ideal female was more often than not the rural farm wife, associated with old English village comfort; for men, the major rural character was the 'bushman'.

In the idealisation of women's roles, scenes in this later period emphasised women's work being carried on in a comfortable, earthy, long-domesticated nature. In Australia, Clara Southern's *An Old Bee Farm* c.1900 (cat.114), for example, focuses on the woman who is at one with the land of the 'old' and settled farm. Charles Conder's *The Farm, Richmond, New South Wales* 1888 (fig.22) also presents humble yet comfortable ways of living, with detail of orchards, grasses, geese, pigs, figures beyond a fence, a hay rick and an out building, all of which take the imaginative viewer into a sensuous and peaceful place. Julian Ashton's *The Selector's Home* 1895 (fig.23) presents humanity deeply integrated with landscape: a young country girl carries a bucket up a hill toward home, amidst beautiful light reflected off the bare tree branches. Orchards served as a major motif in late-century rural landscapes, the combination of nature and human productivity, of the beauty in flowering, and of the associations with England re-establishing the city excursionist and dreamer in relationship with a fecund and homey nature.

Yet artists also alluded to the at-home-ness in the landscape of the leisure class. Like Chase's scenes in America of elegantly dressed women in the Shinnecock hills, Tom Roberts places a scene of domestic interchange in the Australian bush in his *A Summer Morning Tiff* 1886 (cat.104), where the contrast of the female figure's fine clothing to the tall grasses of the bush suggests a persistent upper-class stylishness with which many Australians lived in their environment.

As in America, however, it was the ideal male type that evoked 'real' national character, and this type was the 'bushman' (the European immigrant who felt at home in the 'bush' — the American equivalent was the wilderness). As the critic Broomfield explained in associating the bushman with proper 'Australian' painting:

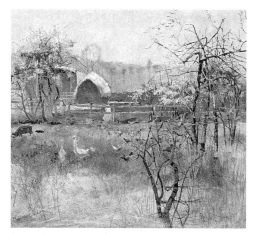

fig.22 Charles Conder 1868–1909
The Farm, Richmond, New South Wales 1888
oil on canvas 45.6 x 51.3 cm (18 x 20-1/4 in)
National Gallery of Victoria, Melbourne

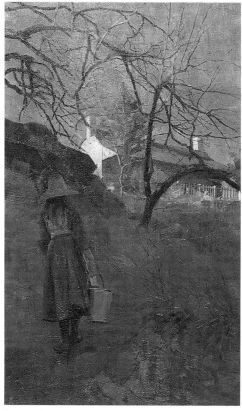

fig.23 Julian Ashton 1851–1942
The Selector's Home 1895
oil on wood panel 42.5 x 26.2 cm (16-3/4 x 10-1/4 in)
Art Gallery of Western Australia, Perth

The townsman's life is merely a replica of the townsman's life wherever the English language is spoken — it is not distinctive enough to be representative. In the bush, conventionalism is absent and if the bushman is painted from the standpoint of the bushman, unconventionally amid his surroundings, clothed in his proper atmosphere, the painting will be an example and a triumph of the Australian school.[79]

In romanticising the bushman, Australians collated the uncertainties of prospecting for gold and other minerals with the often tragic outcome of explorers who ventured across the interior. They made the terrors of the bush even more dramatic, thus complimenting themselves even as urbanites on their persistence on what Marcus Clarke called the 'melancholy continent'.[80] Frederick McCubbin's *Down on his Luck* 1889 (cat.108) suggests all of these qualities. The despondent gold prospector sits at his small campfire, his swag nearby and his empty billy on its side. He is so much at home in nature that his clothes are virtually the same colours as the grasses, saplings and tree bark. With a relatively high horizon, more than half of the picture is earth; the rest of the composition consists of trees through which sky can only be glimpsed.[81] Critics hailed the picture as exemplary:

> The face tells of hardships, keen and blighting in their influence, but there is a nonchalant and slightly cynical expression, which proclaims the absence of all self-pity … and the misty atmosphere around which is so dreamily subduing the leaves and branches of the trees into a general neutrality of color seems to leave the lonely figure of the wanderer untouched as he sits brooding over what might have been. Mr. McCubbin's picture is thoroughly Australian in spirit, and yet so poetic, that it is a veritable bush idyll … [82]

Another figure of admiration toward the end of the century was the hard-working selector, an independent person who in the distribution of lands after the 1860s had replaced the earlier privileged squatter. Arthur Streeton's *The Selector's Hut: Whelan on the Log* 1890 (cat.110) pays tribute to this new type.[83] Whelan, rather like the idealised American pioneer, sits on a log with axe at hand and pipe in his mouth, surveying his property. The horizon in this brilliantly lit picture is fairly low, with the selector's chest and head rising above it as though to suggest his command of the scene. He is not yet possessed by the land, or at one with it; the picture is virtually a recapitulation of the settlement process.

The most dramatic reading of Australian male national character was Tom Roberts's *A Break Away!* 1891 (cat.111). In this picture, now virtually a national icon, a brave horseriding stockman races to control the rush of his sheep to a waterhole at the lower right. The land is arid and desolate, wracked by drought. The very conception of such heroism brought to Australia the ideas of Frederic Remington, circulated in the 1880s in periodicals. Just as Remington had exaggerated the ordeals of the American cowboy, so Roberts heightened the difficulties of the Australian environment. As the century waned, these pictures remind us that even the outdoor, natural life had become less authentic.

Two last landscapes point to different moments on the two continents in their citizens' relationship with the land. In his celebrated *Northeaster* 1895 (fig.24), Winslow Homer looked out to the sea from the shore at Prout's Neck, Maine, where ocean and land engage in dramatic confrontation. This was one of the last of his landscapes, as his critics referred to them, or marines, as we might call them, in which he included a figure. He changed his mind after exhibiting the work and painted out the figure. The painting so strongly caught the sensibility of viewers that it first won a prize with the figure, and later won a prize without it. For Homer and for his viewers, it would seem, American humanity was ever more inescapably part of a nature that remained unknowable and uncontrollable. In Australia, by contrast, Arthur Streeton in his *Fire's On!* 1891 (fig.38) heroicised the first blasting through the coastal mountains (the Blue Mountains, near Sydney) for a tunnel to facilitate transportation westward. Although the project assumed that for some purposes nature could be manipulated, Streeton chose to depict the moment in which an accident has just occurred, suggesting that even such confidence in human engineering would be met with resistance.

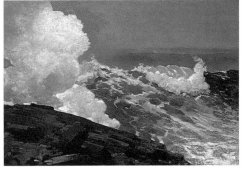

fig.24 Winslow Homer 1836–1910
Northeaster 1895
oil on canvas 87.6 x 127.0 cm (34-1/2 x 50 in)
The Metropolitan Museum of Art, New York
Gift of George A. Hearn, 1910

Resistance was precisely what nature offered to the end-of-the-century urban citizen in America and Australia. Just as the scrutiny of tourism at the beginning of the century had provided worldliness but not intimacy, and scientific probing in the middle of the century offered knowledge but not control, so urbanites' immersion in 'nature' at the end of the century revealed just how far nature remained from their grasp.

Elizabeth Johns

I would like to thank Elizabeth Kornhauser, Amy Ellis, Andrew Sayers, Carol Troyen, Sue Ann Prince, John McCoubrey and Tim Bonyhady for their critical comments on drafts of this essay.

1 Of the many scholars who have influenced my thinking about landscape, those of the greatest importance have been such cultural geographers as Michael P. Conzen and other contributors to Conzen, *The Making of the American Landscape,* London: HarperCollins, 1990, in the tradition of landscape study initiated in England by William G. Hoskins. My list continues with D.W. Meinig, *The Shaping of America: A Geographical Perspective on 500 Years of History,* vols 1 and 2, New Haven and London: Yale University Press, 1986 and 1993; Denis Cosgrove and Stephen Daniels, *The Iconography of Landscape,* Cambridge: Cambridge University Press, 1988; Neil Evernden, *The Social Creation of Nature,* Baltimore: Johns Hopkins University Press, 1992; Stephen Daniels, *Fields of Vision: Landscape Imagery and National Identity in England and the United States,* Princeton: Princeton University Press, 1993; W.J.T. Mitchell, *Landscape and Power,* Chicago: University of Chicago Press, 1994; Raymond Williams, *The Country and the City,* London: Chatto and Windus, 1973; Paul Carter, *The Road to Botany Bay: An Exploration of Landscape and History,* New York: Knopf, 1988; Jay Appleton, *The Symbolism of Habitat: An Interpretation of Landscape in the Arts,* Seattle: University of Washington Press, 1990; and Simon Schama, *Landscape and Memory,* New York: Knopf, 1996.

2 On landscape imagery and urbanism in England, see Andrew Hemingway, *Landscape Imagery and Urban Culture in Early Nineteenth-Century Britain,* Cambridge: Cambridge University Press, 1992; and Ann Bermingham, *Landscape and Ideology: The English Rustic Tradition, 1740–1860,* Berkeley: University of California Press, 1986. For general histories of landscape painting in Britain, see Michael Rosenthal, *British Landscape Painting,* Ithaca: Cornell University Press, 1982; and Katherine Baetjer, *Glorious Nature: British Landscape Painting 1750–1850,* New York: Hudson Hills Press, in association with the Denver Art Museum, 1993. For recent essays pointing to the reassessment of European art in the nineteenth century, including landscape, see Stephen F. Eisenman, *Nineteenth Century Art: A Critical History,* London: Thames and Hudson, 1994. An excellent specific study is Nicholas Green, *The Spectacle of Nature: Landscape and Bourgeois Culture in Nineteenth-century France,* Manchester and New York: Manchester University Press, 1990.

3 Style has also been an organising factor in these art histories. In contrast, my essay is a social and intellectual history that encompasses rather than favours attention to style.

4 My study of the history of Australian landscape painting would not have been possible without the extensive scholarship of Tim Bonyhady, particularly his *Images in Opposition: Australian Landscape Painting 1801–1890,* Melbourne: Oxford University Press, 1985; I have also drawn on his *Australian Colonial Paintings in the Australian National Gallery,* Canberra: Australian national Gallery, 1986, and his *The Colonial Image: Australian Painting 1800–1880,* Chippendale: Ellsyd Press, 1987. I have profited a great deal from Andrew Sayers, *Drawing in Australia: Drawings, Water-Colours, Pastels and Collages from the 1770s to the 1980s,* Melbourne: Oxford University Press for the Australian National Gallery, 1989; Ron Radford, *19th-Century Australian Art: M J.M. Carter Collection,* Art Gallery of South Australia, Adelaide: Art Gallery of South Australia, 1993; Ron Radford and Jane Hylton, *Australian Colonial Art 1800–1900,* Adelaide: Art Gallery of South Australia, 1995; and a number of publications associated with the Australian Bicentenary of 1988, which I cite below. Of course an obligatory starting point for the study of Australian painting is the work of Bernard Smith, particularly his *Place, Taste and Tradition,* Sydney: Oxford University Press, 1945, his *European Vision and the South Pacific,* 2nd edn, New Haven and London: Yale University Press, 1985; and Bernard Smith and Terry Smith, *Australian Painting 1788–1990,* Melbourne: Oxford University Press, 1991. I have also been grateful for several social, economic, and political histories of Australia, notably *Manning Clark's History of Australia,* abridged by Michael Cathcart, Carlton: Melbourne University Press, 1993; and Gordon Greenwood, *Australia: A Social and Political History,* Sydney and London: Angus and Robertson (1955), reprint 1966. For the seminal studies of American landscape painting, see the historiography in the Introduction and Acknowledgements, this catalogue, pp.9–13.

5 William Gilpin, *Observations on the River Wye, and Several Parts of South Wales, etc. Relative Chiefly to Picturesque Beauty; Made in the Summer of the Year 1770,* (1783), 2nd edn, London: R. Blamire, 1789. For an early evaluation of the broader meanings of tourism, see Dean MacCannell, *The Tourist: A New Theory of the Leisure Class,* New York: Schocken Books, 1976. For studies of English tourism, see Malcolm Andrews, *The Search for the Picturesque,* Stanford: Stanford University Press, 1989; Matha Tedeschi, *Wonders Never Ceasing! Viewmaking and the Rise of British Tourism,* Chicago: Art Institute of Chicago, 1991; and Timothy J. Standring, 'Watercolor Landscape Sketching During the Popular Picturesque Era in Britain', in Katherine Baetjer, *Glorious Nature: British Landscape Painting 1750–1850,* New York: Hudson Hills press, 1993.

6 See Christiana Payne, *Toil and Plenty: Images of the Agricultural Landscape in England, 1780–1890,* New Haven: Yale Center for British Art and Yale University Press, 1993; and John Barrell, *The Dark Side of the Landscape: The Rural Poor in English Painting, 1730–1840,* Cambridge: Cambridge University Press, 1980.

7 See, for example, town views of Charlestown, Baltimore, and New Orleans, illustrated in Jessie Poesch, *The Art of the Old South,* New York: Knopf, 1983, pp.81,178 and 180 respectively; and of Washington, illustrated in Edward J. Nygren, with Bruce Robertson et al., *Views and Visions: American Landscape before 1830,* exhibition catalogue, Washington, DC: The Corcoran Gallery of Art, 1986, p.23.

8 See a detailed discussion in ibid., pp.21–41.

9 That the Australian continent itself proved in many respects to be very much *unlike* nature of the old world baffled and disappointed immigrants, as will be discussed below.

10 Joshua Shaw, *Picturesque Views of American Scenery,* Philadelphia: M. Carey and Sons, 1820–21.

11 Quoted in Nygren, Robertson et al., *Views and Visions* (1986), p.46.

12 His base in Philadelphia and his pitch to the interests of Philadelphia patrons is apparent in the many scenes in the portfolio of Philadelphia environs and areas in the South, an emphasis that imagery by artists headquartered in New York yielded to New York and New England.

13 William Guy Wall, *Hudson River Portfolio,* New York: Mengarey, 1823–24

14 See Donald A. Shelley, 'William Guy Wall and His Watercolors for the Historic *Hudson River Portfolio,*' *New-York Historical Society Quarterly,* New York, January 1947, vol. 31, pp.25–45.

15 Joseph Lycett, *Views in Australia or New South Wales, & Van Diemen's Land Delineated*, London: J. Souter, 1824–25, p.1, facsimile reprint, West Melbourne: Nelson, 1971. For an analysis of this phenomenon, see Robert Dixon, *The Course of Empire: Neoclassical Culture in New South Wales, 1788–1850*, Melbourne and New York: Oxford University Press, 1986.

16 In America, the only challenge to the popularity of Niagara Falls was the Natural Bridge of Virginia, brought to public notice by Thomas Jefferson's *Notes on the State of Virginia; written in the year 1761, somewhat corrected and enlarged in the winter of 1782 ...*, Paris: Printed 1784–85. Some time later, Mammoth Cave in Kentucky joined Niagara as a favourite tourist site, as Joachim Richardt registered in his *Echo River, Mammoth Cave* 1857 (cat.34).

17 Earle himself was the quintessential tourist; when in Rio de Janeiro with ambitions to travel to India, in 1825 he was diverted by chance to Tasmania. He later wrote that his three years in Australia had left him 'with an increased and more insatiable desire to visit climes which he had read of, but never seen', and subsequently signed up for a voyage on the survey ship HMS *Beagle*. Quoted in Bonyhady, *Images in Opposition* (1985), p.5.

18 Conrad Martens's *One of the Falls on the Apsley, New South Wales* 1873 (fig.5) also conveys the wildness of the Australian continent.

19 Earle apparently painted this picture when he returned to England and exhibited it at the Royal Academy in 1838. See Bonyhady, *Images in Opposition* (1985), p.71.

20 'Essay on American Scenery', 1836, as quoted in Harold Spencer, *American Art: Readings from the Colonial Era to the Present*, New York: Charles Scribner's Sons, 1980, pp.85–87.

21 *Geographical Memoirs on New South Wales*, 1825, quoted in Bernard Smith ed., *Documents on Art and Taste in Australia 1770–1941*, Melbourne: Oxford University Press, 1975, p.36.

22 For a study of this phenomenon in Australia, see Robert Dixon, *The Course of Empire: Neo-Classical Culture in New South Wales, 1788–1860*, Melbourne: Oxford University Press, 1986.

23 For an illustration of the Birch painting as well as other estate pictures, see Nygren, Robertson et al., *Views and Visions* (1986), p.24 passim.

24 For instance, Charles Fraser, *Richmond, Home of Colonel John Harleston, built Second Half of Eighteenth Century*, 1803, watercolour, Carolina Art Association/Gibbes Art Gallery, Charleston. Illustrated in Poesch, *The Art of the Old South* (1983), p.57. For Cole, see William H. Truettner and Alan Wallach, *Thomas Cole: Landscape into History*, New Haven and London: Yale University Press for the National Museum of American Art, 1994.

25 For an illustration of the Bingham painting, see William H. Truettner et al., *The West as America: Reinterpreting Images of the Frontier, 1820–1920*, Washington, DC: National Museum of American Art/Smithsonian Press, 1991, p.206.

26 See, for instance, Lycett's *The Residence of Edward Riley Esqr., Wooloomooloo near Sydney, New South Wales* c.1822, watercolour painted for his *Views in Australia* (1824–25), illustrated in Caroline Clemente, *Australian Watercolours 1802–1926 in the Collection of the National Gallery of Victoria*, Melbourne: National Gallery of Victoria, 1991, p.21.

27 Rachael Roxburgh, *Early Colonial Houses of New South Wales*, Sydney: Ure Smith, 1974, p.9. Quoted in Clemente, *Australian Watercolours 1802–1926* (1991), p.50.

28 Both works are illustrated in David Hansen, *The Face of Australia: The Land and the People, the Past and the Present*, Sydney: Child and Associates/Australian Bicentennial Authority, 1988, p.15. See also Tibbetts's *Wando Dale Homestead* 1876 (City of Hamilton Art Gallery, Victoria), illustrated in ibid., p.17.

29 John Glover to Sir Thomas Phillipps, 15 January 1830, quoted in Bonyhady, *Images in Opposition* (1985), p.6.

30 Quoted in Bonyhady, *Australian Colonial Paintings* (1986), p. 201.

31 The most prominent voice in this discussion was, of course, that of Jean-Jacques Rousseau.

32 See Bonyhady, *Images in Opposition* (1985), ch.2.

33 In France at this time, Charles Baudelaire called for images of city life.

34 An excellent study of the relationships between urban growth and patronage is Patricia R. McDonald and Barry Pearce, *The Artist and the Patron: Aspects of Colonial Art in New South Wales*, Sydney: Art Gallery of New South Wales, 1988, in which these and other such pictures are illustrated.

35 However, artists in Australia did make images of slab huts of squatters in the bush, or the outback, such as Harden S. Melville's *The Squatter's Hut: News from Home* 1850–51 (National Gallery of Australia, Canberra). Significantly though, as in this work, the images typically connected the bushmen with England.

36 Poesch, *The Art of the old South* (1983).

37 Quoted in John K. Howat et al., *American Paradise: The World of the Hudson River School*, New York: The Metropolitan Museum of Art, 1987, p.209, on which page the picture is reproduced.

38 Ruskin and von Humboldt were important not only in America and Australia, but also, as might be expected, in Germany. See Timothy F. Mitchell, *Art and Science in German Landscape Painting 1770–1840*, Oxford: Clarendon Press, 1993. Katherine Emma Manthorne, *Tropical Renaissance: North American Artists Exploring Latin America, 1839–1879*, Washington and London: Smithsonian Institution Press, 1989, discusses Americans' interests in Latin American geography.

39 Art Gossip, *Cosmopolitan Art Journal*, 4, no.3, September 1860, p.126.

40 Many of Bierstadt's purchasers were English capitalists, perhaps because there was no such scenery in England. See Nancy Anderson and Linda Ferber *Albert Bierstadt: Art and Enterprise*, New York: The Brooklyn Museum in Association with Hudson Hills Press, 1990, p.26. See also *Discovered Lands, Invented Pasts: Transforming Visions of the American West*, New Haven: Yale University Press for Yale University Art Gallery, 1992.

41 For a detailed treatment of this image, see Bonyhady, *Australian Colonial Paintings* (1986), pp.188–198. Von Guérard also painted several scenes of the Grampians mountain range in western Victoria, such as *Mount William from Mount Dryden, Victoria* 1857 (cat.63). In 1997 an Australian federal government decision officially restored the correct spelling of Mount Kosciuszko.

42 This work is illustrated in Jules Prown et al., *Discovered Lands, Invented Pasts*, New Haven: Yale University Press, 1992, p.49.

43 Thomas Clark made several images of the Wannon Falls, discussed in Bonyhady, *Australian Colonial Paintings* (1986), p.46 ff. J.H. Carse's *Wentworth Falls, Blue Mountains, NSW* 1873 (Warrnambool Art Gallery, Victoria) is illustrated in Hansen, *The Face of Australia* (1988), p.10.

44 Henry C. Tuckerman, *Book of the Artists*, New York: G.P. Putnam and son, 1867, p.372.

45 See Marc Simpson et al. *Expressions of Place: The Art of William Stanley Haseltine*, San Francisco: The Fine Arts Museums of San Francisco, 1992, in which are illustrated among others *Castle Rock, Nahant* 1864 (Corcoran Gallery of Art, Washington, DC), p.24; and *Rocks at Nahant, Massachusetts* 1864 (Brooklyn Museum, New York), p.101.

46 Tuckerman, *Book of the Artists* (1867), p. 557, quoted in Linda S. Ferber and William H. Gerdts, *The New Path: Ruskin and the American Pre-Raphaelites*, New York: Schocken Books Inc. for the Brooklyn Museum, 1985, p.265. Among other American artists, John Frederick Kensett, Martin Johnson Heade and Fitz Hugh Lane consistently showed an interest in coastal rocks.

47 John C. Van Dyke, 'George Inness as a Painter', *Outlook*, 73, 7 March 1903, p.539, quoted in Howat et al., *American Paradise* (1987), p.237, which also cites John Ireland's earlier study of Inness (in 1965) claiming 70 titles by Inness with stormy weather themes.

48 Elizabeth Kornhauser, *American Paintings before 1945 in the Wadsworth Atheneum*, New Haven: Yale University Press, 1996, 2 vols, vol.2, p.404.

49 *The New Path*, 1, no.12, April 1864, p.162, quoted in Ferber and Gerdts, *The New Path* (1985), p.13.
50 Marjorie Tipping, *Eugene von Guérard's Australian Landscapes*, Melbourne: Lansdowne Press, 1975, p.62, a reprint of the 1867 edition with commentary. Of course there is a strong irony in Austrian-born and German-trained von Guérard comparing Australia to 'home', by which he meant England.
51 Anderson and Ferber, *Albert Bierstadt* (1990), p.25.
52 Quoted in Bonyhady, *Australian Colonial Paintings* (1986), p.194.
53 Ibid., p.198, n.49.
54 The most notable place where this occurred was France, but my argument is that this was a widely dispersed European phenomenon. See Robert L. Herbert, *Impressionism: Art, Leisure, & Parisian Society*, New Haven and London: Yale University Press, 1988.
55 'American Paintings — John Casilear', *Art Journal*, 2, 1876, pp.16–17, quoted in Kornhauser, *American Paintings before 1945 in the Wadsworth Atheneum* (1996), vol.1, p.175.
56 I subsume the twentieth-century interpretive category of 'luminism' (for which see Barbara Novak, *Nature and Culture: American Landscape Painting 1825–1875*, New York: Oxford University Press, 1980; and John Wilmerding ed., *American Light: The Luminist Movement 1850–1875*, Washington, DC: National Gallery of Art, 1980) into a larger explanation.
57 Howat et al., *American Paradise* (1987), p.77.
58 Ibid., p.79, quoting Inness in 1878.
59 *Argus*, Melbourne, 11 September 1879, p.5.
60 *Argus*, Melbourne, 25 October 1866, p.7, quoted in Clemente, *Australian Watercolours 1802–1926* (1991), p. 26. The passage criticised the work of Henry Gritten for 'delineating the foliage of the gum and peppermint trees, leaf by leaf, with Pre-Raphaellitish painstaking and perspecuity'.
61 Ibid., p.56, quoting Jocelyn Gray, 'A New Vision: Louis Buvelot's Press in 1870s', in Anne Galbally and Margaret Plant eds, *Studies in Australian Art*, Melbourne: Department of Fine Arts, University of Melbourne, 1978, p.20.
62 *The Illustrated Australian News*, 16 April 1872, p.18: 'If some accident were to direct the attention of the luxurious class of our population to this charming spot as a summer retreat, it would prove a very paradise for invalids, and afford a shelter and escape from the heat and dust of summer that would vie with whatever advantages Tasmania may possess — and within an eight-hours' coach journey of Melbourne.'
63 *Argus*, Melbourne, 27 March 1871, p.5, quoted in Daniel Thomas ed., *Creating Australia: 200 Years of Art 1788–1988*, Sydney: International Cultural Corporation of Australia, 1988, p.49.
64 Clemente, *Australian Watercolours 1802–1926* (1991), p.70, quoting the *Sydney Morning Herald*, 27 October 1884, p.11.
65 Quoted in ibid., p.98. This work was painted specifically for a competition for watercolours of New South Wales by artists who lived there.
66 Bonyhady, *Images In Opposition* (1985), p.116.
67 Ron Radford and Jane Hylton, *Australian Colonial Art 1800–1900* (1995), p.134.
68 This painting is illustrated in Howat et al., *American Paradise* (1987), p.183.
69 This painting is illustrated in ibid., p.199.
70 Bonyhady, *Images in Opposition* (1985), p.148.
71 'Some of Browning's Thoughts About Painting: An Address Delivered to the Victorian Artists', *Centennial Magazine*, vol.2, no.1, August 1889, p.37, quoted in Helen Topliss, *The Artists' Camps: 'Plein Air' Painting in Australia*, Melbourne: Hedley Australia Publications, 1992, p.54.
72 *Argus*, Melbourne, 24 March 1873, p.6; and 25 March, 1873, p.7.
73 F.J. Broomfield, 'Art and Artists in Victoria', *Centennial Magazine*, vol.1, 1889, pp.883–889, quoted in Topliss, *The Artists' Camps* (1992), p.53.
74 I would suggest that late nineteenth- and early twentieth-century mystics such as the Symbolists in France and John Marin and Marsden Hartley in the United States were attempting to express their perception of divinity in the landscape, but on different terms than their predecessors.
75 Quoted in Bonhady, *Images in Opposition* (1985), p.154.
76 Ibid., p.105, citing *The Illustrated Australian News*, 30 December 1874, p.219, col.3. Illustrated in McDonald and Pearce, *The Artist and the Patron* (1988), p.117, as artist unknown, *Picnic at Mrs. Macquarie's Chair* c.1856, that shows a fashionable gathering on the government Domain.
77 Susan Danly, *Light, Air, and Color: American Impressionist Paintings from the Collection of the Pennsylvania Academy of the Fine Arts*, Philadelphia: Pennsylvania Academy of the Fine Arts, 1990, p.12, citing a critic in 1906.
78 J. Alden Weir's *Midday Rest in New England* 1897 (Pennsylvania Academy of the Fine Arts), illustration p.87 in Danly, *Light, Air, and Color* (1990), points to a similar continuity of character in New England, holding up for admiration older ways of clearing the forest, work in sympathy with the rhythms of nature, and an ideal continuity between generations, where a younger man is accompanied, and presumably guided, by his elder.
79 Broomfield, 'Art and Artists in Victoria', *Centennial Magazine*, vol.1, 1889, p.887.
80 Marcus Clarke, 'The Weird Melancholy of the Australian Bush', 1874, quoted in Smith, *Documents on Art and Taste* (1975), pp.133–136.
81 Such heroism as symbolised by identification with the bush was accessible to urban viewers: this spot at Box Hill was actually near a suburban railway station. See Topliss, *The Artists' Camps* (1992); and Leigh Astbury, *City Bushmen: The Heidelberg School and the Rural Mythology*, Melbourne: Oxford University Press, 1985.
82 *Table Talk*, Melbourne, 26 April 1889, p.5, quoted in Thomas ed., *Creating Australia* (1988), p.119.
83 This picture was also painted quite near the city of Melbourne, at Heidelberg.

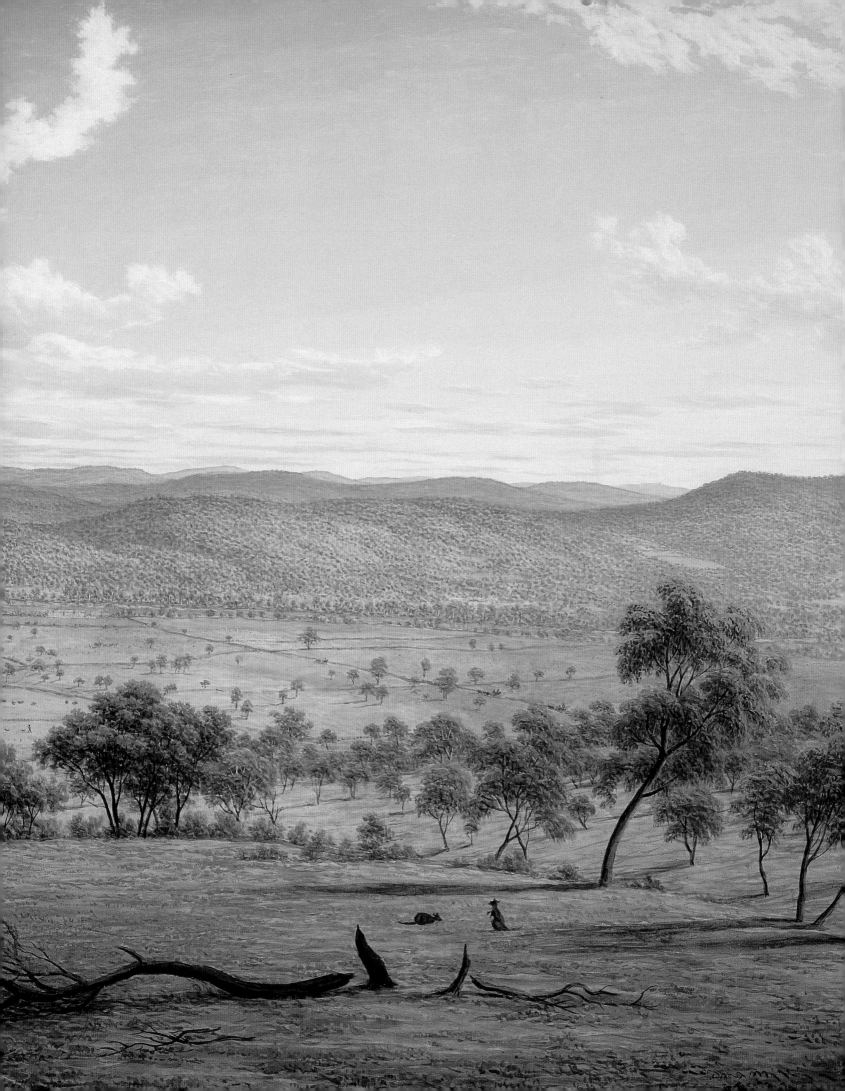

The Shaping of Australian Landscape Painting

The exhibition of Works of Art Ornamental and Decorative Art mounted in the Melbourne Public Library and Museum in 1869 constituted something of a colonial 'blockbuster'. During its three-month season it attracted a huge audience of over 70,000 people (out of a metropolitan population of around 200,000). Like most art exhibitions held in the middle years of the nineteenth century, the 1869 show was vast and all-embracing. But unlike most nineteenth-century exhibitions held in Australia, whose fatiguing accumulations of work the art historian of today can only conjure up from catalogue lists and press description, this particular exhibition was recorded in a series of detailed photographic plates (figs 25, 26). The sixteen photographs, taken by Charles Nettleton, afford the opportunity to experience one of the high points of the public display of art in colonial Australia at a time of significant transition in the history of Australian art.

The 1869 exhibition was very different from the modern art display. Few exhibitions today include 700 paintings, not to mention several hundred works in other classes of the fine and decorative arts. The density of the display (which, in spite of the exquisite taste and refined talents of its designer Edward La Trobe Bateman, looks as though it had been pieced together as a jigsaw puzzle) is not the only feature likely to strike an observer from the late twentieth century. The extremely heterogeneous nature of the work included in the exhibition is also remarkable. We are accustomed to thinking of the nineteenth century as a period dominated (in Australian art at least) by landscape painting. However, in the 1869 exhibition, landscape paintings were outnumbered and outscaled by historical, genre, religious and narrative paintings. Original Australian works were swamped by copies after European painters and by works purporting to be from the hands of an embarrassing number of old masters. It is not surprising that Sir Redmond Barry, the Supreme Court judge and founder of the Melbourne Public Library and Museum, when speaking at the opening of the exhibition, congratulated the organisers on their having flushed out such 'a large number of pictures of undoubted worth ... the existence of which in this country has hitherto been known to few, except the immediate possessors'.[1]

fig.25 Charles Nettleton 1825[?]–1902
View of Public Library and Museum exhibition, Melbourne 1869
photograph
State Library of Victoria, Melbourne

We can learn much about the visual culture of mid-century colonial Australia from the 1869 exhibition. It is a reminder that the landscape paintings which now constitute an orderly and simplified progression on the walls of Australian art museums were, in their own day, part of a different whole; they were seen in the context of a culture that was comfortably, and comfortingly European. When studying Nettleton's installation shots, the art historian will find interest and pleasure in recognising important and familiar works by colonial Australian landscape artists such as John Glover, Louis Buvelot and Eugene von Guérard; but it is likely that the same art historian will overlook the portraits of British royals, the Scottish and English landscapes, the copies after Guido Reni and Teniers, and the coy animal pieces. For the audience of 1869, however, such works possessed great appeal and would have evoked associations and affections beyond our 1990s imaginings.

fig.26 Charles Nettleton 1825[?]–1902
View of Public Library and Museum exhibition, Melbourne 1869 Interior showing John Glover's
The Bath of Diana, Van Diemen's Land 1837 (cat.40)
photograph
State Library of Victoria, Melbourne

The late 1860s was a significant time for the development of the visual arts in Australia, and Melbourne was at the centre of that development. In that decade a truly critical culture emerged; such a culture was essential to the development of a visual art tradition. Whilst we now understand that, in the colonial period, visual art in Australia was extremely various and fascinatingly complex, it is doubtful that it was reckoned by contemporary thinkers to constitute a tradition. Indeed, for the audience of the 1869 exhibition, the idea that there existed an Australian art tradition would probably have seemed presumptuous, almost a contradiction in terms. For the European-trained artists

John Glover *Cawood on the Ouse River* 1835 (detail) (cat.37)

whose works were included, art traditions rested on more profound foundations than existed in Australia. One of the most accomplished of them, the Austrian-born and German-trained painter Eugene von Guérard, wrote in 1870 that his was the worst age for great art. In von Guérard's view, the demand for accuracy and topographical precision among the clientele for a certain type of landscape painting in Australia was not conducive to the emergence of great art:

> It is not the want of a proper genius in the artist to create but in our time it is principally the wish for the works of art copied or taken from nature, nearly in all branches of art and especially in landscape painting.[2]

By the time von Guérard penned his unnecessarily pessimistic view, taste in Australia was already shifting away from a desire for the precise and accurate portrayal of nature's details upon which he had based his own career. In fact his statement is taken from a long defence, written in response to the criticism of Melbourne-based journalist James Smith, that his work was too much concerned with precision and too little concerned with feeling. Von Guérard was then in his first year as head of the newly established National Gallery of Victoria and the National Gallery School in Melbourne. By all accounts he was an uninspiring teacher, and he had little direct influence on the ideas of the subsequent generation.[3] However it was the National Gallery School, more than any other institution, that contributed to the development of a group of artists (principally Arthur Streeton, Tom Roberts and Frederick McCubbin) who came to see themselves as pioneers of an authentic Australian painting, and who were seen by subsequent generations as the founders of the Australian visual art tradition. Towards the close of the nineteenth century, when this group of painters began to discern the possibility of an 'Australian School', the claim was firmly, and perhaps inevitably, on the basis of its approach to the landscape: they believed that unique Australian subjects (landscape and light) would create a distinctive Australian art. It is a view which has remained remarkably persistent in Australia's culture until the present day, but it is a view which had its origins in the very earliest years of the nineteenth century.

If we are to introduce the idea of tradition to the study of Australian colonial culture, it is important to acknowledge that, for much of the nineteenth century, the Australians who possessed a set of sustained transmissible cultural values which could be described as embodying an indigenous Australian tradition were certain groups of Aboriginal people. The European colonists, by contrast, were acutely aware of the fragmented and displaced culture in which they now lived; the majority were apt to view themselves more as Britons in exile than as 'Australians'. An Australian visual arts tradition in the settler culture would not develop until this view shifted and the audience for art achieved some confidence in the embrace of their surroundings. Other preconditions were important. A reflective critical culture was one; it followed the establishment of independent exhibiting and teaching institutions. In the case of artists themselves, the identification and reiteration of important subject matter and the recognition of forerunners, peers and teachers were significant indicators to the emergence of the idea of a tradition. All of these conditions developed slowly over the colonial period, reaching maturity only in the 1880s.

Landscape of Novelty

At the outset of the European settlement of the Australian continent, when the traditions of Europe provided frameworks for understanding the world, for mastering it and for validating an imposed social, political and judicial structure, the most conspicuous feature of the colonial situation was that it was new, that fundamentally it was without tradition. Compared with European societies (whose traditions the colonists recognised as exclusively embodying civilised values), the European foothold on Australia could only be seen in terms of its lack of age and its limited experience. In 1823 when the colonial judge Barron Field published the second edition of the first book of Australian poetry under the title *First Fruits of Australian Poetry*, he gave one of the poems in the new collection this epigraph: 'Anticipation is to a young country what antiquity is

to an old.'[4] A truism perhaps, but one which the colonists of Australia must have taken as an apt description of their cultural position.

Throughout the nineteenth century, but most insistently in the first eighty years after European settlement, the novelty of the Australian scene, its 'new world' status, was a constant theme in the visual arts and literature. Initially this was an element of the European exploration of what was (at least for cartographers and geographers) a new continent. A great many of the earliest pictorial records made by European visitors were not considered by their makers to be high art. However, the landscape painter William Westall, who accompanied the naval map maker Matthew Flinders on his 1801–03 circumnavigation of the continent of Australia, had higher aspirations. Westall was searching for scenery from which he could make interesting and aesthetically acceptable oil paintings to be displayed in London, after the fashion of his colleague William Daniell, who had successfully shown views of India at the Royal Academy. But Westall was to be disappointed in Australia. For him the coastline would not yield such exotic subjects and he considered Australia to be pictorially unpromising. Shortly after leaving Australian shores, Westall summed up his years on the Flinders voyage as a barren experience. He was pessimistic about the drawings he had made, about which he wrote: 'when executed [they] can neither afford pleasure from exhibiting the face of a beautiful country nor curiosity from their singularity'.[5]

Westall was just one of a number of early artists and writers who shared the view that the Australian landscape lacked beauty: the convict draughtsman Thomas Watling famously decried his inability to find or mould the picturesque from the landscape of the penal colony; and Barron Field looked fondly upon the ship that would carry him from 'this prose-dull land'. However, there could be no underestimating the appeal of its novelty. When Westall accepted a commission in 1809 for a series of oil paintings of Australian landscape views and exhibited them in London, there was considerable interest in these depictions of places which had not before been visited by Europeans. Indeed, Westall's landscape paintings depict remote parts of Australia which, since he painted them, have rarely been painted by European artists. Two views of the Arnhem Land coast, of an island in the Sir Edward Pellew's group, and of Pobassoo's Island in the English Company's group, are remarkable in their depiction of atmosphere and their resistance to the view-making conventions which characterise much of Westall's work. In *View of Sir Edward Pellew's Group, Northern Territory, December 1802* 1811 (cat.2), interest is centred upon a painted ceremonial object in the foreground, the mute and mysterious evidence of the Aboriginal material culture. The work has a fresh, high key; the bright palette, more consistent with a much later period in Australian art, has led Bernard Smith to describe it as a 'remarkable painting for its time'.[6] By contrast, *View of Malay Road from Pobassoo's Island, February 1803* 1811 (cat.3) is endowed with a sense of apocalyptic doom with the onset of dense monsoonal rains. The figure in the foreground is not an Australian Aboriginal, but a Macassarese, a reference to the fishing fleet encountered by the Flinders party in 1803 which Westall has shown at anchor in the bay. In the bright red of the figure's cloak, caught in the wind before the storm, Westall adds life to a landscape subject which, undoubtedly, he would have found unpromising. In a much larger painting, *View of Port Bowen, Queensland, August 1802* 1811 (cat.1), Westall depicts the triumvirate of Australian novelty — flora, fauna and Aboriginal people. The jungle setting of the painting is at odds with Westall's description of the Australian coast as 'barren', and it is clearly not in keeping with his description of the general appearance of Australia as 'differing little from the northern parts of England'.[7]

The idea of Australia as a new world, which both stood in comparison and invited contrast with the known landscapes of the northern hemisphere, continued to be exploited by artists working in the first Australian colonies to be established, New South Wales and Van Diemen's Land (which was officially called Tasmania after 1855). Their imagined audiences were not the colonial inhabitants but the various audiences of Europe. The tone of curiosity which the artists hoped to capture was typified in the work of the convict artist Joseph Lycett. During the period of his enforced exile in Australia, between 1814 and 1822, Lycett drew its strange landscapes, its plants and the Aboriginal people. He was the first of many nineteenth-century artists to paint

a corroboree; these ceremonial meetings and dances of the Aboriginal people were the most exotic of spectacles to European eyes. In his *Corroboree at Newcastle* c.1820s (cat.4) the dancers and their gloomy forest setting seem to be as one — they are characteristically depicted as an emanation of wilderness Australia. In the distance, the distinctive topography of the prison settlement at Newcastle has been carefully delineated to add the veracity of a precise location. The artist seems to be saying, in effect: 'I was there.'

Lycett's *Views in Australia*, published in London between 1824 and 1825, was one of the earliest compilations of scenes of the Australian landscape (figs 27, 28). Such compilations were produced throughout the nineteenth century and tell us a great deal about changing attitudes to the landscape. The plates in *Views in Australia* were based on drawings Lycett had made during his time in Australia. The publisher's advertisement stated (with the over-hyped optimism characteristic of much early colonial writing):

> [I]t is, indeed, impossible to contemplate the scenes of natural grandeur, beauty, richness and variety, with which the Colonies of NEW SOUTH WALES and VAN DIEMEN'S LAND abound, without impressions of mingled delight and wonder at such magnificent specimens of the stupendous power of nature, as they burst upon our view in all the freshness of a new Creation.[8]

Despite the promise of a series of views of the natural phenomena of the Australian landscape, *Views in Australia,* like a great many early prints and drawings which depict New South Wales and Van Diemen's Land, tends to emphasise the impact of settlement. On occasion, however, the accompanying text highlights the impact on the observer of a view of a river, gorge or waterfall. Describing the Apsley Falls, the text runs:

> The genius of a SALVATOR ROSA could scarcely render justice to such Scenery as this; in attempting to copy or describe which, the utmost stretch of human art can merely produce a faint and feeble outline of that superlatively magnificent and awfully sublime Landscape, which the hand of Nature has produced in this wild solitude of AUSTRALIA.[9]

All of the cues by which the reading public of early nineteenth-century Britain would understand and recognise landscape were compressed into the adjective-rich text alongside Lycett's images. The references to the Italian seventeenth-century painter Salvator Rosa and the use of such phrases as 'awfully sublime' and 'wild solitude' were attempts to convey the thrill of the wilderness to the reader, or prospective visitor.

The highly original artist, Augustus Earle arrived in Sydney in 1825 with the expressed intention of adding new subjects to his portfolio. His grand plan of publishing the many drawings he made as he travelled the world seeking new subjects did not eventuate,[10] however his collected watercolours give an indication of the range of Earle's interests. These include records of the artist at the extremities of the visitable areas of New South Wales. In 1826 he crossed the rugged Blue Mountains and travelled inland as far as the settlements of Bathurst and the Wellington Valley. In the Wellington Valley he visited the limestone caves which were later to become a popular tourist destination. In 1827 he travelled south from Sydney to the densely forested escarpment of the Illawarra district.

In two of Earle's oil paintings, made after his return to England in 1828, he presented to the English audience novel aspects of Australian scenery. The first of these, *A Bivouac of Travellers in Australia in a Cabbage Tree Forest, Daybreak* c.1838 (cat.8), is set within a uniquely Australian forest of native cedars and cabbage palms. At the time of Earle's visit this rainforest area to the south of Sydney was remote and difficult to traverse; in fact the artist broke his leg on the journey. It is not surprising that Earle is able to evoke a genuine feeling of frontier life.

Earle's view of *Wentworth Falls* c.1830 (cat.6) was the first significant painting of this waterfall in the Blue Mountains which would be painted many times in the nineteenth century. He emphasises the difficulty of the journey to the falls by including a group of figures clambering up the rockface in the foreground of the composition. The wilderness nature of the location is symbolised by the presence of an Aboriginal man silhouetted against the torrent of water. We know from his watercolours that Earle met this man much further to the west of the mountains, at the rural settlement

fig.27 Joseph Lycett c.1775–1825
The Homestead at Raby belonging to Alexander Riley Esqr.
from *Views in Australia or New South Wales,*
& Van Diemen's Land delineated 1824–25
book of engravings, hand-coloured
National Gallery of Australia, Canberra

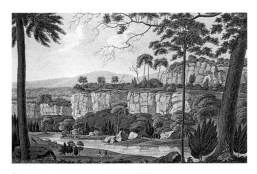

fig.28 Joseph Lycett c.1775–1825
View of the Wingeecarrabee River from *Views in Australia or New South Wales, & Van Diemen's Land delineated* 1824–25
book of engravings, hand-coloured
National Gallery of Australia, Canberra

in the Wellington Valley. By including an Aboriginal figure as part of a wilderness image, (and as Westall had done in his *View of Port Bowen*) Earle has brought together, in one image, three elements of Antipodean visual novelty: the landscape, Aboriginal people and Australian flora, seen particularly in the rainforest vegetation at the bottom of the valley.

Earle's art prefigures tourism, yet it cannot be described as tourist art. Tourism implies that the viewer comes along after others who have experienced remarkable sites. Earle's imagery always implies that he was the first artist to depict a particular place, as indeed he was in many cases. Nonetheless, several of the areas in which he painted rapidly assumed the status of tourist destinations. Earle's robust painting of Wentworth Falls can be compared to J.H. Carse's view of the same subject — but with its alternative name, Weatherboard Falls — painted in 1873 (cat.69). By this time the falls had become popular and relatively easy to visit. In Carse's painting the ease with which the falls could be approached is all too obvious and the landscape has been sufficiently tamed to allow well-dressed visitors to admire the view. Whereas Earle drew attention to the terror of the scene through the torrent of the cataract, the ruggedness of the rocks and the reactions of his companions, Carse emphasises the sweep of the valley (echoed in the gesture of the guide) and endows the work with a soft mistiness.

While the novelty of Australian landscape with its flora and fauna was a significant subject for art from the late eighteenth century and into the early nineteenth century, such interest was not confined to those decades. There were new subjects to be found and painted until well into the late 1870s. Furthermore, many artists who painted what were, by mid-century, tourist destinations, often imbued them with the trappings of wilderness. In 1862, when Eugene von Guérard placed an Aborigine in the foreground of his painting of Weatherboard Falls, he exaggerated the wilderness setting. The Melbourne *Argus* critic felt that this addition (clearly recognised as symbolic rather than descriptive) was not needed to reassure viewers of the Australian identity of the scene:

> There are virgin forests which have never echoed with the crash of the woodman's axe or the ring of the sportsman's rifle; the hills gathering in a solemn circle round the lucid horizon, and the cataract tossing its wealth of waters wastefully into the invisible abyss, diminishing from a roaring torrent in the winter to a silver thread in the summer. Similar combinations of mountain, wood and water, rock and valley, exist, of course, in other parts of the world ... but the foliage, the sky, the atmosphere of Australia, have no counterpart in other portions of the world.[11]

When von Guérard came to make a lithograph of the Weatherboard Falls, however, he substituted a group of tourists for the Aborigine in the foreground of the painting, thus emphasising the accessibility of the site to the urban tourist (fig.29).

Tourists had created a familiarity with many subjects in coastal south-eastern Australia by the 1850s, but it would be wrong to suggest that the urge to present the novelty of the Australian landscape was dead. (Indeed, the interior of Australia remained largely unknown to most of its settler populations until the twentieth century; the now familiar tourist icon of central Australia, Uluru, was not encountered by European explorers until 1873.) During the 1850s two of the most dedicated searchers for novel Australian phenomena and landscapes were the German-born and trained artist–naturalists, William Blandowski and Ludwig Becker. Blandowski arrived in Australia in 1849 and spent much of the decade of the 1850s searching for material which he eventually hoped to publish in a large series of prints under the title 'Australia Terra Cognita'. The proposed title (which harks back to 'terra incognita', the appellation of the continent as it was marked on maps before its colonisation by the British) implies that the scientific investigation and description of Australian zoology, botany, ethnology and geology was a continuous process of discovery. Blandowski's interest was not narrowly scientific however; engravings after his drawings demonstrate a sense of awe before the remarkable rock formations he encountered as he travelled through Victoria, and they enhance the drama of his subjects with the addition of theatrical light effects.

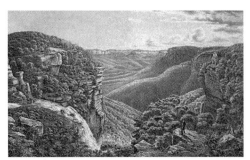

fig.29 Eugene von Guérard 1811–1901
Weatherboard Falls
from *Eugene von Guérard's Australian Landscapes*
1866–1868 book of lithographs, printed in colour
National Gallery of Australia, Canberra

The watercolours of Ludwig Becker, who arrived in Australia in 1851, two years after Blandowski, show a similar obsession with unusual atmospheric effects and remarkable geological phenomena. Becker's *Blow-hole, Tasman's Peninsula, Van Diemen's Land 1852* (cat.11) not only celebrates a geological curiosity, but also records his own visit to the place — while the artist sits on a rock making a drawing, portfolio by his side, his companions are drenched by a wave. Becker's humorous approach suggests that a visit to the blow-hole was by a well-travelled tourist route. However, when he was appointed as the official artist for the Victorian Exploring Expedition of 1860–61 (the Burke and Wills expedition), he knew that the journey, which sought to make the first south–north crossing of the Australian continent, would take him into completely new terrain. Becker's series of watercolours made on the expedition (cats 14–19) show a passion for new information about birds, landscapes, meteorology, astronomy and the traditions of Aboriginal people. Yet, like Blandowski and von Guérard, Becker was not content that novelty alone should inspire his approach to landscape. In his last letter, written shortly before his death on the expedition in 1861, Becker describes the Darling River at sunset as 'a bit of nature so rich and poetical that I saw no necessity for asking my fancy or imagination to lend me a hand while painting [it]'.[12]

A Landscape of Claim

The earliest artists who sought to make an impression with views of New South Wales and Van Diemen's Land did so not only by stressing the 'new creation' which nature set before them, but also by celebrating the impact of settlement. An important function of Lycett's *Views in Australia* was to promote the progress of colonisation, and the work was clearly intended to encourage emigration to further that end. For such purposes the exoticism of wilderness views had to be tempered with reassurance. For example, the text accompanying Lycett's view of *The Homestead at Raby belonging to Alexander Riley Esqr.* (fig.27) describes it as 'one of those striking contrasts which agreeably surprise the traveller in the forests of this country, on suddenly coming in view of the vast openings cleared by the industry of man'.

Before the ageing English painter John Glover left London to emigrate to Van Diemen's Land in 1830, novelty had been uppermost in his mind. He expected to discover new plants and animals; however his emigration, and subsequent establishment on agricultural land farmed by his sons, gave Glover a deep engagement with the landscape which went beyond the opportunistic approach of the visitor or the official proponent of immigration policy. He was involved with the landscape in a very profound way, and this gave great force to his art. After he had been in Australia for some four years Glover was keen to put his adopted land before an English audience, and in 1835 an exhibition of his Australian paintings opened in London at a private gallery in Bond Street. It was described as being 'Descriptive of the Scenery & Customs' of Tasmania. Glover's notes in the exhibition catalogue (in which he drew attention to details of Australian trees, pastures and Aboriginal life) were a mixture of comparison and contrast with the experience of his audience. Thus, while he drew attention to 'the remarkable peculiarity in the trees in this Country', he added that English gardens could be brought to perfection in Tasmania, and that on his farming property 'it is possible to drive a Carriage as easily as in a Gentleman's Park in England'.[13]

Glover's work was noted in one of the earliest thoughtful attempts to describe the shape of Australian art, made in 1839 by the naturalist John Lhotsky in the English periodical *The Art Union*.[14] Lhotsky spent six years in New South Wales and Van Diemen's Land, between 1832 and 1838, and in general was unimpressed by the quality of the art he encountered. He selected only four artists for special mention; the 'eminent' painter John Glover was the only landscapist among them. However Lhotsky was the first of a succession of critics to judge Glover's Australian work unfavourably for a perceived lack of fidelity to foliage and light conditions. Lhotsky clearly had doubts about the abilities of other Australian artists, damning them in his oft-quoted conclusion: 'Australian sky and nature, awaits, and merits real artists to portray it.'

Lhotsky imagined the possibilities with which these 'real artists' would work. He was rhapsodic about the variety and novelty of the elements which made up Australian scenery; he wrote that in Australia 'there is a whole system of landscape painting of the most striking character' in which 'our mind shall never lack objects worthy of its attention and exertion'. He believed that this landscape would give rise to a succession of distinctive painters who would perhaps go on to greater heights than European landscapists then in favour, such as the fashionable Salvator Rosa. In short, Lhotsky's was the earliest statement of the *idée fixe* of Australian visual culture — that an Australian tradition would emerge from an engagement with the distinct qualities of the Australian bush.

Glover's 1835 London exhibition echoed to some extent the optimistic tone which Lycett's *Views in Australia* projected. Lycett clearly proclaimed a sort of official line on the potential benefits of emigration (although his action of returning to England after serving his sentence may suggest a personal scepticism), whereas Glover's attitude was more the result of his own experience, firstly as a town dweller, seen in his *Hobart Town, taken from the Garden where I lived* 1832 (cat.35), then as a landowner and farmer in northern Tasmania.

City views were a significant genre in the nineteenth century. The city symbolised progress in the simplest way: the growth and health of the colonies were measured in the size and activity of the cities and the number of imposing buildings. Highly trained professional artists such as Glover in Tasmania and Conrad Martens in New South Wales (artists who sought to portray complex ideas through landscape painting) imbued their images of the city with evidence of cultural as well as commercial aspiration. Whereas many city views in the first half of the century were straightforwardly topographical, the works of these two artists suggest breadth and plenitude. Glover's attitude to the city was unique. He painted a view of Launceston (a distant aspect seen from the surrounding bush), two views of Hobart (one a distant view, the other concentrating on the success of his own garden) and, most unusual of all, a view of the orphan asylum at New Town on the slopes of Hobart's Mount Wellington, in which the asylum building is isolated in a sea of trees, but apparently blessed by an overarching rainbow (fig.30).

fig.30 John Glover 1767–1849
Mount Wellington with Orphan Asylum, Van Diemen's Land c.1837
oil on canvas 74.4 x 112.4 cm (29-1/4 x 44-1/4 in)
National Gallery of Victoria, Melbourne
Purchased through The Art Foundation of Victoria with the assistance of the Joe White Bequest, Governor, 1981

Conrad Martens specialised in city views. On his arrival in Sydney in 1835 he discovered that he could make a respectable living from depictions (mostly in watercolour, but occasionally in oils) of the harbour and surrounding buildings. His *View from Rose Bank* 1840 (cat.43), painted for the commodities merchant Robert Campbell, is characteristic of the optimistic view of colonial progress which he exploited. The artist has skilfully rendered the houses of the wealthy colonists as though they were Italian villas (which is how they were often described in contemporary literature), but he gives no hint that these houses lacked antiquity — not one of the houses seen from the terrace at Rose Bank in 1840 was more than ten years old. Martens was successful because he was able to bring a feeling of amplitude to his works;'breadth' was a commonly used epithet to describe his landscapes. He was able to combine the demands of topography with a feeling for atmospheric drama and impeccably formulaic picture making.

Although he painted several city views, John Glover's temperament was undoubtedly pastoral. *My Harvest Home* 1835 (cat.36) is entirely bucolic; it projects an unalloyed beatific feeling (one verging on amazement) at the bounty of Glover's adopted home and its natural beauty. And the feeling of comfort which pervades many of Glover's paintings of his own property, Patterdale, was not confined to those subjects: *Cawood on the Ouse River* 1835 (cat.37), painted for his fellow Tasmanian landholder T.F. Marzetti, also has a sense of peace and anticipated beneficence.

Unlike a number of earlier painters and writers on the quality of the Australian landscape, Glover did not find it dull or untidy or monotonous. His depiction of Cawood embodies some of the lightness which he found in the Tasmanian landscape. Its balanced composition rests above a foreground of cleared land surrounded by a semi-circle of trees with park-like pastureland and a wooded range beyond. In a note on one of his paintings of Patterdale, Glover mused:

> There is a trilling and graceful play in the landscape of this country which is more difficult to do justice to than to the landscape of England.[15] (fig.31)

fig.31 John Glover 1767–1849
View of Mills Plains, Van Diemen's Land 1833
oil on canvas 76.2 x 114.6 cm (30 x 45 in)
Art Gallery of South Australia, Adelaide
Morgan Thomas Bequest Fund 1951

A Landscape of Dispossession

Perhaps it was John Glover's deep engagement with the landscape which led to his profound interest in the fate of the Aboriginal people. He painted Aboriginal subjects throughout his Australian years and they became a major theme in his late works. Much has been written about these paintings and their interpretation, and there has been a deal of speculation about Glover's experience of traditional Aboriginal life (a flame which had been almost completely extinguished in Tasmania by the time of his arrival in 1831).[16] He certainly met small groups of Aboriginal people, some of them Tasmanian, some from other parts of Australia, but it is unlikely, indeed impossible given the circumstances of an aggressively colonising settler society, that he had any extensive experience of them. It is important to remember that Glover was a painter steeped in the tradition of Claude Lorrain (he wanted to be known as the English Claude), Gaspar Poussin and Salvator Rosa. He was an artist, therefore, who needed only a slender visual suggestion (and this appears to be all that he had to rely upon) with which to build an imagined picture of Aboriginal life in Tasmania.

Glover painted numerous paintings suggesting, as he described it, 'the gay, happy life' of the Aboriginal people before the arrival of Europeans in Tasmania. Like a number of artists before and after him, Glover was fascinated by the nocturnal spectacle of the corroboree. *A Corrobery of Natives in Mills Plains*, c.1832 (cat.7), painted early in his Australian years, has the modest understatement of an observed motif. By contrast, *A Corrobery of Natives in Van Diemen's Land* (cat.41), that he painted to be sent as a gift to the French king in 1840, has all of the wild extravagance of Lycett's earlier moonlight dance; and, like most of Glover's Aboriginal subjects, it falls into the category of the historical landscape (as opposed to pastoral landscapes such as his view of Cawood). The Aboriginal subjects appear to refer to an earlier phase or cycle of history (just as figures in Claude's landscapes often referred to a classical past). Sometimes Glover's titles tell us this: his *The Last Muster of the Aborigines at Risdon* 1836 (cat.38) is quite specifically intended to be a representation of an historical moment, one of the last occasions on which a large group of the indigenous inhabitants of Tasmania came together before the inception of the determined destruction of their society by the European colonisers.

Towards the end of Glover's life, the Bristol watercolourist John Skinner Prout arrived in Tasmania. Prout used Aboriginal people in his paintings more as conventional staffage than as people engaged with the landscape. His view of *Maria Island from Little Swanport, Van Diemen's Land* 1846 (cat.9) includes a single Aboriginal figure. Dressed in a blanket, the figure does not appear to have a symbolic value unless it is, as Jane Hylton has suggested: 'to serve as a reminder to the viewer of both Maori and Aborigines who had been denied their freedom and banished to hostile islands across the water'; and to make a comparison between Flinders Island (where Tasmanian Aborigines were relocated after being taken from their traditional lands) and Maria Island, a prison island, 'a place of anger and sadness'.[17]

By contrast with Prout's somewhat detached observation and ultimately unconvincing inclusion of an Aboriginal figure in his work, Glover's treatment of Aboriginal subjects was laden with deliberately symbolic messages. *The Bath of Diana, Van Diemen's Land* 1837 (cat.40) appears to be an intentionally allegorical work. In this painting Glover casts in an Aboriginal setting the moment in Greek myth immediately before the hunter Actæon is discovered looking at Diana bathing, and is tranformed into a stag and set upon by his own hounds. Tim Bonyhady has suggested that Glover's choice of this moment is significant as an allegory of the moment of European impact, with its devastating and destructive consequences.[18] In many paintings Glover's insistent use of evening light, most notably seen in his *Ben Lomond Setting Sun. From near the Bottom of Mr Boney's Farm* 1840 (cat.42), may also be symbolic and an indication of the artist's sense of the passing of one phase of history associated with the Aboriginal habitation of the landscape of Tasmania.

A similar sunset light pervades Eugene von Guérard's *Stony Rises, Lake Corangamite* 1857 (cat.46), which has also been interpreted as symbolic of the end of traditional Aboriginal life in Victoria.[19] Whilst it would be possible to question the validity of such an intention (von Guérard did paint several sunset views without apparently symbolic intent), there can be little doubt that *Evening Shadows, Backwater of the Murray, South Australia* (cat.86), painted by the photographer–painter H.J. Johnstone in 1880, makes a direct link between the group of Aborigines included in the work and the gloomy passing of day. Whereas the tone of *Stony Rises* is gothic, Johnstone's painting is, in the fashion of his day, quietly melancholic.[20]

Aside from Glover's meditations on the lives and fate of the Tasmanian Aborigines, the most significant painting to embody the theme of the Aboriginal relationship with the land is von Guérard's panorama *Bushy Park* 1861 (cat.47). Again, some commentators have discerned a symbolic element in the dark and light bulls locking horns in the centre of the left hand panel.[21] If this element is indeed symbolic, it is symbolic of the struggle for land. The presence of a family of Aboriginal people in the right hand panel suggests that the struggle is at a moment of balance; there is a possibility of coexistence. Ostensibly this is a painting of the property of the Gippsland landholder Angus McMillan, yet the homestead is almost invisible in the background. It is as though such pioneers as McMillan have barely made an impression on the land, let alone claiming it exclusively. In *Bushy Park* Aboriginal people still inhabit their land, they move through the landscape, but the framework of possession of the land is no longer theirs.

The Physiognomy of Nature

John Skinner Prout in the 1840s was the first important artist to work in Australia whose sketching itinerary encompassed New South Wales, Tasmania and the relatively new settlements at Port Phillip and Geelong in Victoria. During the eight years he spent in Australia he produced three series of prints: *Sydney Illustrated*, *Tasmania Illustrated* (fig.32) and *Views of Melbourne and Geelong*. Other artists intent on creating portfolios of Australian views (George French Angas and S.T. Gill) followed similar itineraries but there was an element of opportunism in the landscapes they chose to focus upon, especially after the discovery of gold in New South Wales and Victoria in the early 1850s. These events created a demand for views of otherwise unremarkable landscapes which prospectors and diggers hoped would become remarkable as the source of wealth and good fortune.

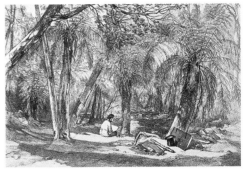

fig.32 John Skinner Prout 1805–1876
Fern Tree Valley, Mount Wellington
from *Tasmania Illustrated* 1844
colour lithograph 29.6 x 41.6 cm (11-3/4 x 16-1/2 in)
National Gallery of Australia, Canberra

By the middle of the nineteenth century the European culture of Australia was developing strongly and the discovery of gold added considerably to the booming economy. Undoubtedly, Eugene von Guérard was the most significant artist to come to Australia at this time. He arrived in 1852 and, after unsuccessfully digging for gold, returned to a career as a landscape painter. Von Guérard's artistic fortunes in the 1850s and 1860s very much parallel the rising importance of Melbourne as a centre of visual arts activity. He first exhibited there in 1854, in one of Victoria's earliest art exhibitions, and very rapidly came to be recognised as the leading landscape painter in the colony. By 1858 *The Illustrated Journal of Australasia*, published in Melbourne, could describe von Guérard as 'decidedly the landscape painter of Australia'.[22]

Between the mid-1850s and the early 1860s von Guérard painted the properties of pastoralists in the Western District of Victoria and in Gippsland. At the same time he painted wilderness subjects which resulted from his travels with scientist–explorers such as A.W. Howitt and Georg von Neumayer. It is not easy or wise, however, to make a distinct categorisation of von Guérard's work. *Bushy Park*, for example, is both a painting of the McMillan property and a celebration of the mountains of northern Victoria which the artist (setting out from Bushy Park) explored with Howitt in 1860. Similarly, the painting by von Guérard's contemporary Nicholas Chevalier,

Mount Arapiles and the Mitre Rock 1863 (cat.66), celebrates a spectacular geological formation which was a part of the property of the western Victorian landholder Alexander Wilson, the host of the artist's visit in May 1862 (along with the scientist von Neumayer).[23]

Having drawn attention to the blurring of the distinction between paintings of property and paintings of wilderness, it would be a distortion to think that von Guérard and Chevalier were not interested in the grand subjects of mountains, waterfalls and lakes as subjects in their own right. The fact that both artists travelled extensively in the company of scientists is indicative of a phenomenon of mid-nineteenth-century art in Australia which is attributable, at least in part, to the shared enthusiasm of artists and scientists for the work of the German naturalist Alexander von Humboldt (1769–1859). So pervasive were Humboldtian attitudes in nineteenth-century Australia that, in its 1858 appraisal of painting in Victoria, *The Illustrated Journal of Australasia* chose to describe von Guérard's art by quoting from Humboldt:

> The art of landscape painting ... requires a great number and variety of actual and sensible observations, which the mind must contrive and fertilise by its own power, and then restore to the senses as a new work of art. The grand style in landscapes is the product of a deep comprehension of nature, and their internal mental processes ... There is a certain physiognomy of nature which belongs exclusively to each latitude of the physiognomy.[24]

It is not surprising that the journal quoted Humboldt at length; the quotation is particularly apposite in pointing to the two most highly original features of von Guérard's work. Firstly, his landscape painting sought to blend or, more precisely, to balance scientific accuracy and emotional response. Secondly, it was multi-dimensional painting, needing to be as various as physiognomy in its cataloguing of a range of types.

In order to depict fully the physiognomy of the Australian landscape, von Guérard (like Lycett, Earle, Glover and Prout) produced multiple images. In 1858 the Melbourne businessman, John Bakewell commissioned the artist to create a set of pen and ink drawings which he took with him to England. Soon after, the Governor of Victoria, Sir Henry Barkly commissioned a similar set.[25] Such sets of drawings were described at the time as proof to offer sceptics that:

> Victoria comprises within its limits mountain ranges as wildly romantic as the European Pyrenees, lakes as picturesque as those of Killarney, and waterfalls that may vie with those of Westmoreland.[26]

Whereas these drawings, for the most part, were views of Victoria, the publication of the collection of lithographs, *Eugene von Guérard's Australian Landscapes* (1866-68) (cat.68), allowed for coverage of a much broader geographic scope in its twenty-four plates. The title page promised the prints to be 'illustrative of the most striking and picturesque features of the landscape Scenery of Victoria, New South Wales, South Australia and Tasmania'. The spread of Australian landscape types and their variety were features of his *Australian Landscapes* commented upon by contemporaries. The *Argus* critic was conscious of the comparative nature of the decision to compile plates showing the widest variety of landscapes:

> Taken as a whole ... these pictures will do much to dissipate many prevalent errors with respect to the uninteresting character of Australian scenery, and to show European artists who have pretty well used up the themes and motifs presented by the old world, what a splendid variety of subjects for the pencil await the landscape painter among the mountain ranges, in the fern-tree gullies and by the sea shores of these colonies.[27]

The idea that Australia represented a new field of endeavour for jaded European eyes was restated.

The contemporary response to von Guérard's drawings and his *Australian Landscapes* demonstrates that, while the collections included several images depicting scenery of an intimate or pleasantly domesticated type, it was the wildly romantic mountains, spectacular waterfalls and forests which attracted the admiration of the artist's contemporaries. Of course von Guérard was not the only artist to exploit this taste

for grandeur and romantic subject matter. Chevalier's *Mount Arapiles and the Mitre Rock* celebrates, indeed exaggerates the extraordinary wall of rock rising abruptly from the surrounding plain in the far west of Victoria. The forest gullies of the Dandenong Range, celebrated in von Guérard's view of that popular tourist destination near Melbourne, became the stock subject of the Melbourne painter and picture-framer Isaac Whitehead who specialised in views which were described at the time as showing 'the grandeur of some of our mountain forests'.[28] Whitehead presents a high viewpoint in his *A Sassafras Gully, Gippsland c.*1870 (cat.84); the viewer is not able to enter the landscape space of the composition, thus the artist has emphasised the enormity of the forest trees.

In his *Australian Landscapes* von Guérard attempted to produce a range of subjects which, 'taken as a whole', would represent the novelty and the comparability of Australian landscape. It is unlikely that he would have considered any single landscape in his repertoire to be generally representative of the colonies. Only once did he attempt to create a landscape that could be described as general rather than specific to a locality. In a somewhat incongruous work entitled *Sunset in New South Wales* 1865 (fig.33), the artist took drawings of different regions of New South Wales (the Illawarra and the Blue Mountains) and attempted to forge them into a unified, and presumably generic, landscape image. The painting remains an exception in his *oeuvre*: the locations of the vast majority of von Guérard's landscapes are quite specifically identified — to the extent that, despite his occasional compositional manipulations, it is possible even today to locate the exact spots from which his drawings were made.

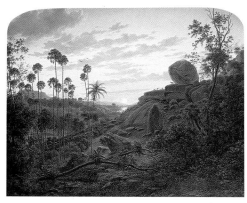

fig.33 Eugene von Guérard 1811–1901
Sunset in New South Wales 1865
oil on canvas 69.5 x 88.9 cm (27-5/8 x 35 in)
Mitchell Library. State Library of New South Wales, Sydney

A Poetic Landscape

John Skinner Prout had predicted in 1848 that a general improvement in colonial visual culture in Australia would come about only with the development of art exhibitions[29] — these were sporadic events until the late 1840s. In the 1850s regular exhibitions became a feature of Australian cultural life, not only in the major cities of Sydney and Melbourne, but also in Hobart (whose leading role in the visual arts rapidly diminished after the 1840s) and Launceston in Tasmania, and in the new boom towns of Geelong and Ballarat in Victoria. Exhibitions heralded a much greater activity in art writing and appreciation. Generally such writing was descriptive; however in Melbourne, particularly with the arrival of James Smith (the dominant critical voice in Australia in the late nineteenth century), a focus on the defining characteristics of Australian painting gradually emerged.

There was often an overly relativistic quality to art criticism in Australia during the decades of the 1850s to the 1870s. Writing in 1869 James Smith noted: 'The art world here is small, and it as much divided as all art worlds are.'[30] When criticism looked beyond such parochial comparisons, something of 'a new sense of vision'[31] was discerned in Australian landscape art — a quality which critics found particularly strongly in the art of Louis Buvelot.

Buvelot arrived in Australia in 1865 and established a reputation as Victoria's foremost landscape painter as rapidly as von Guérard had done a decade earlier. *Winter Morning near Heidelberg* 1866 (cat.82) is a characteristic early work and demonstrates the poetic, intimate view of the landscape which Buvelot brought to Australia. In 1872 the Melbourne *Herald* expressed the view that:

> the names of Messrs Buvelot and von Guérard stand almost side by side, and in spite of others that have attained to a certain position and passed away, they will remain the founders of our school of Australian landscape painters.[32]

Of the two artists, the critic believed that Buvelot had achieved a more complete mastery of the characteristics of the Australian bush and therefore deserved to be assigned 'the first position amongst our pioneer artists'.

The comment made by the *Herald* critic is significant because it appears to be the first attempt to assign a place to Buvelot as the founder of an 'Australian school'.

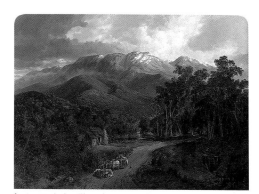

fig.34 Nicholas Chevalier 1828–1902
The Buffalo Ranges 1864
oil on canvas 132.8 x 183.7 cm (52-1/4 x 72-1/4 in)
National Gallery of Victoria, Melbourne

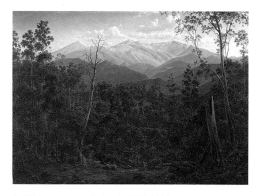

fig.35 Eugene von Guérard 1811–1901
*Mount Kosciusko seen from the Victorian Border
(Mount Hope Ranges)* 1866
oil on canvas 107.0 x 153.0 cm (42 x 60-1/4 in)
National Gallery of Victoria, Melbourne

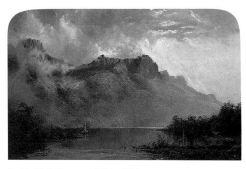

fig.36 W.C. Piguenit 1836–1914
*Mount Olympus, Lake St Clair, Tasmania,
The Source of the Derwent* 1875
oil on canvas 69.0 x 107.0 cm (27 x 42 in)
Art Gallery of New South Wales, Sydney
Gift of fifty subscribers 1875

This notion of Buvelot's position gained increasing strength in the 1870s and by the time of his death in 1888 a younger generation of Australian landscape painters was prepared at last to acknowledge a precursor. Buvelot's place as a father figure was maintained with such determination after his death that much of the art before his time was eclipsed. The idea was strengthened by comments made by the major innovative painters of the 1880s and 1890s. Tom Roberts, for example, described Buvelot as the painter 'who began the real painting of Australia'; Arthur Streeton assessed the veteran artist as 'the first noteworthy painter of Australian landscape'; and Frederick McCubbin, consigning almost a century of art activity to oblivion, wrote: 'There was no one before him to point out the way; he possessed therefore in himself the genius to catch and understand the salient living features of this country'.[33]

In recognising that Buvelot's comfortable vision prefigured their own, the generation of his admirers defined a tradition for the visual arts in European Australia.[34] Buvelot's arrival coincided with the moment at which the balance of native born and immigrants was statistically tending toward a majority of native born people in the population at large — and among artists; it coincided with the establishment of art schools, and a generation of artists who looked upon their teachers as either mentors or anti-mentors; and it coincided with the impending centenary of the European presence in Australia, a consciousness of which led to a broader historical perspective.[35] However, these factors alone are insufficient to explain the persistence of Buvelot's status as the father of Australian painting for nearly a century from the1870s.

By the 1870s it was possible to see that Buvelot's work was symptomatic of a change in the direction of Australian art in which the general overtook the specific — in which the spirit, so to speak, was more important than the letter of the landscape. The transition, which took place around the end of the decade of the 1860s, is dramatically highlighted by a comparison of von Guérard's *Ferntree Gully in the Dandenong Ranges* 1857 (cat.64) — a work which depicts Australian flora (and fauna) with painstaking fidelity to the accurate rendering of detail — and Buvelot's *Near Fernshaw* 1873 (cat.85), which one contemporary described as having 'caught the spirit of Australian scenery'.[36] *The Illustrated Australian News* commented in 1874 that Buvelot's subjects were 'ordinary material such as is to the right or the left of every observer in Australia'.[37] Yet, in the same year as Buvelot's work was recognised as being cut from ordinary material, the author, Marcus Clarke used this artist's painting, *Waterpool near Coleraine (Sunset)* 1869 (cat.83) as a pretext for musings on the weird melancholy of the Australian bush. This late-sounding echo of an idea, which had great currency earlier in the century when Australia was conceived as a strange inverted antipodes of the natural (European) order, was to become one of the most widely quoted of all writings on Australian art. Leaving aside Clarke's ideas about the meaning of the work, one important aspect of his essay was that he found the painting poetic:

> With true artistic instinct [Buvelot] has selected a subject which at once touches that sense of the poetic which dwells in awakened memories and suggested contrasts of past with present.[38]

The subject of the painting was simple, but its significance was, for Clarke, the power of its evocation.

Waterpool near Coleraine (Sunset) was purchased by the National Gallery of Victoria in 1871. It joined Chevalier's *The Buffalo Ranges* 1864 (fig.34) and von Guérard's *Mount Kosciusko seen from the Victorian Border (Mount Hope Ranges)* 1866 (fig.35) as significant early acquisitions of colonial art in the national art museum in Victoria. The first Australian work to enter the public art collection in New South Wales (in 1875) was another landscape — a mountain subject, *Mount Olympus, Lake St Clair, Tasmania, The Source of the Derwent,* painted by the Tasmanian artist W.C. Piguenit (fig.36).

Piguenit has long been regarded as a late colonial painter who lived into the twentieth century still painting mountains and gorges when all around him were painting *pastorales*. However his position as 'the last colonial artist' has distorted the ways in which Piguenit's work fits into the artistic milieu of the 1880s and 1890s. He was a very successful and popular artist in his day and there are elements of his work

which are far from the topographical precision which characterised the work of the romantic scenery painters of the 1860s such as von Guérard and Chevalier. Australian art history has tended to maximise the distance between a work such as Piguenit's *The Flood in the Darling, 1890* (cat.89), painted in 1895, and examples such as the closely contemporary *Moonrise 1894* (cat.88) painted by the Victorian artist David Davies, or Arthur Streeton's *The Purple Noon's Transparent Might* 1896 (cat.91). Yet these three works are linked by their intensely poetic approach — and the tendency to dissolve. *The Purple Noon's Transparent Might* was first exhibited as 'Hawkesbury Landscape', but Streeton soon gave it the more poetic title (a quotation from Shelley). Piguenit, too, in the 1890s tended to make his paintings more timeless and placeless; in spite of a certain grandiosity of subject, he gave them broadly generic and poetic titles such as *A Mountain Top, Tasmania c.*1886 (cat.70), *A Tasmanian Waterfall* (Art Gallery of Western Australia, Perth) or *An Australian Fjord* (Art Gallery of South Australia, Adelaide). Increasingly in Piguenit's work, the certainties of landscape dissolve into the atmosphere, or are erased by fingers of cloud resting on the mountain tops.

Piguenit's paintings, and those of Streeton and Davies, could be described as landscapes of contemplation — the viewer's way is not strewn with rugged rocks or blocked by trees, but the eye is led into the compositions through pathways or rivers. Even when Piguenit painted mountains there were significant differences between his approach and that of the earlier nineteenth-century practitioners of the mountain view. A comparison of the Kosciuszko paintings of von Guérard and Piguenit's 1903 painting of the same mountain (fig.37) highlights these differences. Unlike the precisely delineated outline of the mountain described in von Guérard's work, Piguenit's painting makes no pretence of topographical descriptiveness — the painting is less about a place than concerned with illustrating an idea of drama. It is no surprise to learn that his Kosciuszko painting (one of Piguenit's least convincing works) was commissioned in 1902 to celebrate a political and nationalist event — the federation of the Australian states in 1901. It is a painting which embodies a contradiction between the artist's desire to dissolve his subject and the requirement to make an unequivocally grand statement.

'A simple motif becomes impressive' if the artist is able to 'see the great side of small things' was the conclusion of a critic when discussing David Davies's nocturnal landscapes which were painted over the period 1893 to 1897. In many ways his *Moonrise* is the ultimate expression of the idea of poetry in the familiar landscape. Ron Radford has observed of the painting, that it describes 'an apparently ordinary Australian rural scene and yet its features are only hinted at and barely perceptible. One's imagination is invited to enter and complete this timeless, placeless painting.'[39] *Moonrise* was exhibited in Melbourne in 1894 and acquired by the National Gallery of Victoria in the following year. Its immediate recognition as a major painting demonstrates that by the 1890s a trend in landscape painting which was first recognised in the 1870s was complete — the trend towards the evocation of shared experience.

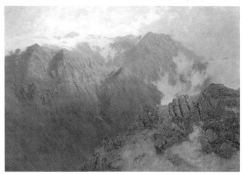

fig.37 W.C. Piguenit 1836–1914
Kosciusko 1903
oil on canvas 179.2 x 261.6 cm (70-1/2 x 103 in)
Art Gallery of New South Wales, Sydney
Commissioned by the Trustees 1902

Figures in the Landscape

In the first acquisitions of Australian art by the two most significant art collecting institutions of the late colonial period (the Art Gallery of New South Wales and the National Gallery of Victoria), it is not possible to detect any clearly stated ideological agenda. By the 1890s, however, both institutions participated in the nationalist sentiment surrounding the discussions which were to lead to a defining moment in Australia's sense of nationhood — the federation of the Australian colonies under a Commonwealth government. In 1891 the trustees of the Art Gallery of New South Wales offered a substantial sum to be spent annually on the acquisition of the best New South Wales landscape in watercolour. The aim of the competition was to build up, over time, a collection of works which would illustrate the range and diversity of the landscapes of the colony. The guidelines for the competition spelled out the possible subjects:

fig.38 Arthur Streeton 1867–1943
Fire's On 1891
oil on canvas 183.8 x 122.5 cm (72-1/2 x 48-1/4 in)
Art Gallery of New South Wales, Sydney

fig.39 *View of 1892 Victorian Artists' Society Exhibition*
Arthur Streeton's *Fire's On* (right)
(Foster and Martin, photographer)
albumen silver photograph
Australian Manuscript Collection. State Library of Victoria, Melbourne

coasts and harbours; tidal rivers, lakes, lagoons; inland rivers and lakes; mountains, gorges, glens, valleys; and inland plains and scenes introducing pastoral and agricultural occupations.

Many artists were interested in the competition, which was widely advertised in Australia,[40] and a number of Melbourne artists, most notably Arthur Streeton and Tom Roberts, entered works. Streeton moved to Sydney in mid-1890 and he tried out a number of locations. In the ensuing exhibition he was represented by the watercolour version of his monumental work *Fire's On* 1891 (fig.38), and by a view, not west towards the Blue Mountains but east from the first rise in the range, in the settled plains surrounded by forest-covered hills — a view in which he saw 'a great rich drama going on in front of me'.[41] After the initial exhibition, the scheme of the Art Gallery of New South Wales, to build up a representative collection of typical subjects, faltered.

By the 1890s landscape painting was deeply linked to cultural nationalism in Australia, and the work of those artists who engaged with these broader cultural ideas increasingly came to be seen as the 'national school'. Whilst this may have been a phenomenon which was most pronounced in the 1890s, the work of Tom Roberts, Arthur Streeton, Charles Conder and Frederick McCubbin was already showing a tendency to generalise an Australian visual typology in the 1880s. It was a typology which came essentially from urban roots, from the experience of city dwellers, be it the immediate experience of the bush near at hand, or the historical experience of the earlier generation which persisted in the memory or in stories. This group of artists was the core of the generation that came to be described in the twentieth century as the 'Heidelberg School', whose paintings constitute the pervading image of Australia. As Ian Burn has written: 'Perhaps no other local imagery is so much a part of an Australian consciousness and ideological make-up.'[42]

The subject of the city was one of the major themes of the Heidelberg School painters. Among the most successful of the paintings which sought to express the soul of the Australian city was Tom Roberts's *Allegro con brio; Bourke Street West* c.1886 (cat.105). This work was painted in the year following the artist's return to Australia after four years' study in England and travel in Europe — a year which, for several significant twentieth-century writers on Australian art, marked the beginning of the Australian painting tradition.[43] *Allegro con brio* demonstrates the radically different viewpoint which the Heidelberg School brought to the painting of landscape in Australia: the painting is high-toned and the composition flattened; and all incident is rendered impressionistically. Roberts's dusty and hot Melbourne street scene is in contrast to the more watery views of Sydney which occupied both Roberts and Streeton in the 1890s. Streeton's *From McMahon's Point — Fare One Penny* 1890 (cat.109) is a languid celebration of the beauties of Sydney Harbour — not apparently a city of work, but more a place of relaxation.

Recreational subjects — beaches, picnic parties and strolls down bush pathways, all within or close to Melbourne and Sydney — were another of the major preoccupations of the painters of the 1880s. Roberts's *A Summer Morning Tiff* 1886 (cat.104) is one of the most unforced of these compositions. Although the title draws our attention to the subject as a narrative, the incident is pushed into insignificance. The success of the painting relies upon its graceful rendition of the Australian bush. Virginia Spate has observed that while this painting is less radical than *Allegro con brio*, it is an experiment with a new way of suggesting space. According to Spate, this explains a feature found in many of Roberts's paintings — the presence of (often discontinuous) space indicators and framing devices, such as trees, tufts of grass and gum leaves. In 1887 Roberts painted *Slumbering Sea, Mentone* (cat.106), a fresh and light-filled work depicting the popular beach holiday location 22 kilometres (13-1/2 miles) from Melbourne. It is, as Virginia Spate has suggested, the painting in which Australian impressionism comes closest to French impressionism.

The subject of the bush worker was a major theme for the Heidelberg School artists. But, as has been repeatedly pointed out in studies of these artists, the bush labour they presented in the paintings of the 1890s was, in actuality, a labour in transition. The gap between the reality of rural labour and the historical

typology attached to it is nowhere better characterised than in Streeton's *The Selector's Hut: Whelan on the Log* 1890 (cat.110). The title leads to the conclusion that it is a celebration of pioneering endeavour; however the subject of the painting, Whelan, was not a selector in the historical sense of the word but a caretaker on rural land near Melbourne which had been subdivided for housing. Streeton's effective mythologising was not confined to his identification of the subject with a wider, more heroic history; in 1896 he exhibited the work under the simple but loaded title *Australia*.

The Selector's Hut: Whelan on the Log presents a view of Australian pioneering endeavour which highlights the individual, rather than the collective effort of settling and working. Charles Conder painted Whelan on the same day as Streeton; his painting presents a view built around the same split log and gum tree, but includes a child and the prosaic detail of washing hanging on a line to dry. Ian Burn has described the significance of these differences in constructing meaning:

> Conder's picture informs us that the selector is not alone but has his family and child with him, while the background landscape [with tent and washing line] suggests that the locale is not nearly as lonely and isolated as Streeton would have us believe.[44]

The purposefulness of the activity in Streeton's painting is diffused in Conder's work, and the 1890s tendency to generalise the subject is present too in the title, *Under a Southern Sun* (fig.40).

Clara Southern's *An Old Bee Farm* c.1900 (cat.114), the latest Australian painting included in this exhibition, similarly looks back to an earlier age of rural labour. As Jane Clark has written, the title points to its being 'a nostalgic evocation of Australia's past and nation-building self-sufficiency'.[45] Although the painting celebrates self-sufficiency on the suburban fringe of Melbourne (probably at Kew), it projects a very different view from the paintings of Whelan by Streeton and Conder. Firstly, the title suggests a comfortable, antique relationship with the land, rather than stressing the rawness of newly felled trees and freshly split slabs. And secondly, the painting continues the mood of nostalgic reverie which, in the late nineteenth century, was consistently associated with the evening hour, and which in the hands of Southern, David Davies and Walter Withers contrasts strongly with the high noon brightness that characterised many of the bush paintings of Streeton, Conder and Roberts.

The most powerful and heroic statements of the theme of work in the bush were the large sheep station paintings of Tom Roberts, such as *A Break Away!* 1891 (cat.111), and Arthur Streeton's brilliant and equally large *Fire's On*. Streeton's subject, the blasting of a railway tunnel through the lower Blue Mountains, was discovered by the artist on a summer painting trip. He was captivated by the drama of this transformation of the landscape — intensified by the death of a worker which Streeton witnessed while sketching the subject. When exhibited in the Victorian Artists' Society exhibition in Melbourne in 1892 (fig.39), the *Age* devoted considerable length to a discussion of *Fire's On*, described as having so many 'new world associations' clinging to it. The critic raised again the most deeply felt questions which underlay all of the nineteenth century's visual culture in Australia:

> Why should the artist of a new country which has started with the accumulated inventions and discoveries of the old world be expected to feel and express subjects which belong to conditions foreign to all his own experiences and associations? Such a subject as the blasting of a tunnel will strike many people as unpicturesque and inartistic, but it is only because they will not realise that in reflecting the contemporaneous life and activity of a new continent and a new race Australian art will most surely find its keynote ... Australian art has all its traditions to make ... [46]

Andrew Sayers

fig.40 Charles Conder 1868–1909
Under a Southern Sun 1890
oil on canvas 71.5 x 35.5 cm (28-1/4 x 14 in)
National Gallery of Australia, Canberra
Bequest of Mary Meyer in memory of her late husband, Dr Felix Meyer, 1975

Tim Bonyhady's critical reading of this essay is gratefully acknowledged.

1 Preface to *Catalogue of the Works of Art Ornamental and Decorative Art, Exhibited by the Trustees of the Melbourne Public Library and Museum, in March, April and May, 1869,* final edn, Melbourne: Mason, Firth and Co., 1869, p.5.

2 Eugene von Guérard [Reply to the critic of von Guérard's painting of the North Grampians] in Bernard Smith ed., *Documents on Art and Taste in Australia 1770–1914*, Melbourne: Oxford University Press, 1975, p.169.

3 See Candice Bruce, Edward Comstock and Frank McDonald, *Eugene von Guérard, 1811–1901: A German Romantic in the Antipodes*, Martinborough, New Zealand: Alister Taylor, 1982, pp.47–48.

4 'On reading the controversy between Lord Byron and Mr Bowles', in Barron Field, *First Fruits of Australian Poetry*, 2nd edn, Sydney: Printed for private distribution, 1823, p.14.

5 William Westall to Sir Joseph Banks, 13 January 1804, Banks Papers, IV, Mitchell Library, State Library of New South Wales, Sydney, f.149, p.4.

6 Bernard Smith, *European Vision and the South Pacific*, 2nd edn, New Haven: Yale University Press, 1985, p.196.

7 Westall to Banks, 13 January 1804, Banks Papers, IV.

8 Lycett's *Views in Australia* was originally published by J. Souter in 13 parts between August 1824 and June 1825.

9 Ibid., text accompanying the plate 'Bathurst Cataract on the River Apsley, New South Wales'.

10 'It is likely that Earle painted the watercolours in the Rex Nan Kivell Collection [National Library of Australia, Canberra] with the intention of publishing them either as a volume of aquatints, as several volumes illustrating his travels, or possibly as companion illustrations to his unpublished *Voyage Round the World*, mentioned in the original manuscript list of numbers and titles which accompanied the paintings': Jocelyn Hackforth-Jones *Augustus Earle, Travel Artist*, Canberra: National Library of Australia, 1980, p.45.

11 *Argus*, Melbourne, 29 December 1862, p.5.

12 Reprinted in Marjorie Tipping, *Ludwig Becker: Artist and Naturalist with the Burke and Wills Expedition*, Melbourne: Melbourne University Press, 1979, pp.191–192.

13 *A Catalogue of Sixtyeight Pictures, Descriptive of the Scenery and Customs of the Inhabitants of Van Dieman's* [sic] *Land ... painted by John Glover, Esq.*, London: Printed by A. Snell, 1835. This catalogue also exists in a reprinted version, published by Sir Thomas Phillipps in 1868 and printed by J.Rogers, The Middle Hill Press.

14 John Lhotsky, 'The State of Arts in New South Wales and Van Diemen's Land', reprinted in Bernard Smith ed., *Documents on Art and Taste in Australia* (1975), pp.71–76.

15 Glover's handwritten note, originally with the painting *View of Mills Plains, Van Diemen's Land* (Art Gallery of South Australia, Adelaide), undated catalogue of the collection of Sir Thomas Phillipps, Thirlestaine House, Cheltenham (not dated, but after 1866).

16 See Tim Bonyhady, *Images in Opposition: Australian Landscape Painting 1801–1890*, Melbourne: Oxford University Press, 1985, pp.27–34.

17 Jane Hylton, 'John Skinner Prout: Maria Island from Little Swanport VDL', in Ron Radford and Jane Hylton, *Australian Colonial Art: 1800–1900*, Adelaide: Art Gallery of Australia, 1995, pp.79–80.

18 Sotheby's Australia Pty Ltd, *John Glover: 'The Bath of Diana, Van Diemen's Land', 1837*, individual catalogue, 17 April 1989, unpaginated [unattributed text by Tim Bonyhady].

19 Ron Radford, 'Eugene von Guérard: Stony Rises, Lake Corangamite, 1857', in Radford and Hylton, *Australian Colonial Art 1800–1900* (1995), pp.98–100.

20 Jane Hylton, 'H.J. Johnstone: Evening Shadows, backwater of the Murray, South Australia, 1880', in ibid., pp.133-135.

21 Daniel Thomas, Introduction to Candice Bruce, *Eugene von Guérard*, Canberra: Australian National Gallery/AGDC, 1980, p.13

22 'Art in Victoria', *The Illustrated Journal of Australasia*, 4 January 1858, p.35.

23 Tim Bonyhady, *Australian Colonial Paintings in the Australian National Gallery,* Canberra: Australian National Gallery, 1986, pp.41–42.

24 'Art In Victoria', *The Illustrated Journal of Australasia*, 4 January 1858.

25 Bruce, Comstock and McDonald, *Eugene von Guérard* (1982), pp.175–176.

26 *Argus*, Melbourne, 5 August 1858, p.5, quoted in ibid., pp.175–176.

27 *Argus*, Melbourne, 10 April 1867, p.5, quoted in ibid., p.177.

28 *Melbourne International Exhibition, 1880: The Argus Supplement*, no.10, 3 December 1880 (1st page of supplement, unnumbered), quoted in Joan Kerr ed., *The Dictionary of Australian Artists : Painters, Sketchers, Photographers and Engravers to 1870*, Melbourne: Oxford University Press, 1992, p.857.

29 John Skinner Prout, 'The Fine Arts in Australia', *The Art Union*, London, 1 November 1848, p.332.

30 *Herald*, Melbourne, 10 January 1867, p.3.

31 *Argus*, Melbourne, 11 September 1879, p.5.

32 *Herald*, Melbourne, 19 March 1872, p.2.

33 Both Roberts and Streeton are quoted in R.H. Croll, *Tom Roberts: Father of Australian Landscape Paintings*, Melbourne: Robertson and Mullins, 1935, pp.5,15 respectively; the quote from McCubbin is from his [Some Remarks on the History of Australian Art] in Bernard Smith ed., *Documents on Art and Taste in Australia* (1975), p.271.

34 In his 1934 *The Story of Australian Art*, Sydney: Angus and Robertson, 1934 (still the longest book on Australian art), William Moore describes Buvelot's position as a bridge between the 'first artists' (ch.1), not Aboriginal artists, but explorer and settler artists working in the eighteenth and nineteenth centuries, and an 'Australian School' of painting (ch.3). Moore's position was more just and inclusive than that of Clive Turnbull whose *Art Here*, Melbourne: Hawthorn, 1947, was subtitled 'Buvelot to Nolan', a progression which earns the author more credit for its perspicacious end point than for its conventional starting point. Turnbull described Australian art before Buvelot as a 'slow-growing, a brown, uninteresting, commonplace organism'(p.10). He deemed colonial art 'valueless' (p.10) and found that Buvelot had gone part of the way to creating the 'Springtime' (p.10) of Australian art properly speaking. Bernard Smith's in many ways definitive *Australian Painting*, Melbourne: Oxford University Press, 1962, p.16, declared that whereas the European artists who worked in Australia before Buvelot worked in isolation and even those among them who had pupils 'did not make any permanent contributions to the growth of a local tradition', Buvelot was influential in the lives and art of a number of artists who Smith considered to be the foundation figures of Australian art

35 Jocelyn Gray, 'A New Vision', *Studies in Australian Art*, 1978, p.19.
36 *Argus*, Melbourne, 24 March 1873, quoted in Tim Bonyhady, *Australian Colonial Paintings in the Australian National Gallery* (1986), p.26.
37 *The Illustrated Australian News*, Melbourne, 7 October 1874, p.170.
38 Marcus Clarke ed., *Photographs of the Pictures in the National Gallery, Melbourne, photographed by Thomas F. Chuck under the Direction of Eugene von Guérard, Master of the School of Painting*, Melbourne: Ballière, 1873–74, no.8 (1874), p.2.
39 Ron Radford, 'The Enchanted Moonrise', in Daniel Thomas ed., *Creating Australia: 200 Years of Art 1788–1988*, Adelaide: Art Gallery of South Australia, 1988, pp.108–109, p.109.
40 See *Bohemia*, Melbourne, 29 October 1891, p.5.
41 Arthur Streeton to Tom Roberts, December 1891, in Ann Galbally and Anne Gray eds, *Letters from Smike*, Melbourne: Oxford Universtiy Press, 1989, p.38. Both works, *The Valley of the Nepean* (National Gallery of Australia, Canberra) and *Mittagong* (National Gallery of Victoria, Melbourne), are illustrated in Caroline Clemente, *Australian Watercolours 1802–1926 in the Collection of the National Gallery of Victoria*, Melbourne: National Gallery of Victoria, 1991 p.99.
42 Ian Burn, 'Beating about the Bush: The Landscapes of the Heidelberg School', in Anthony Bradley and Terry Smith eds, *Australian Art and Architecture: Essays presented to Bernard Smith*, Melbourne: Oxford University Press, 1980, pp.83–98
43 Notably William Moore, in his *The Story of Australian Art* (1934); and Bernard Smith in his *Australian Painting* (1962), of which ch.4 is entitled 'Genesis 1885–1914'.
44 Ian Burn,'Beating about the Bush', in Bradley and Smith eds, *Australian Art and Architecture* (1980), p.93.
45 Jane Clark, in Joan Kerr ed., *Heritage; The National Women's Art book*, Sydney: Craftsman House, 1995. p.116.
46 *Age*, Melbourne, 27 May 1892, p.6.

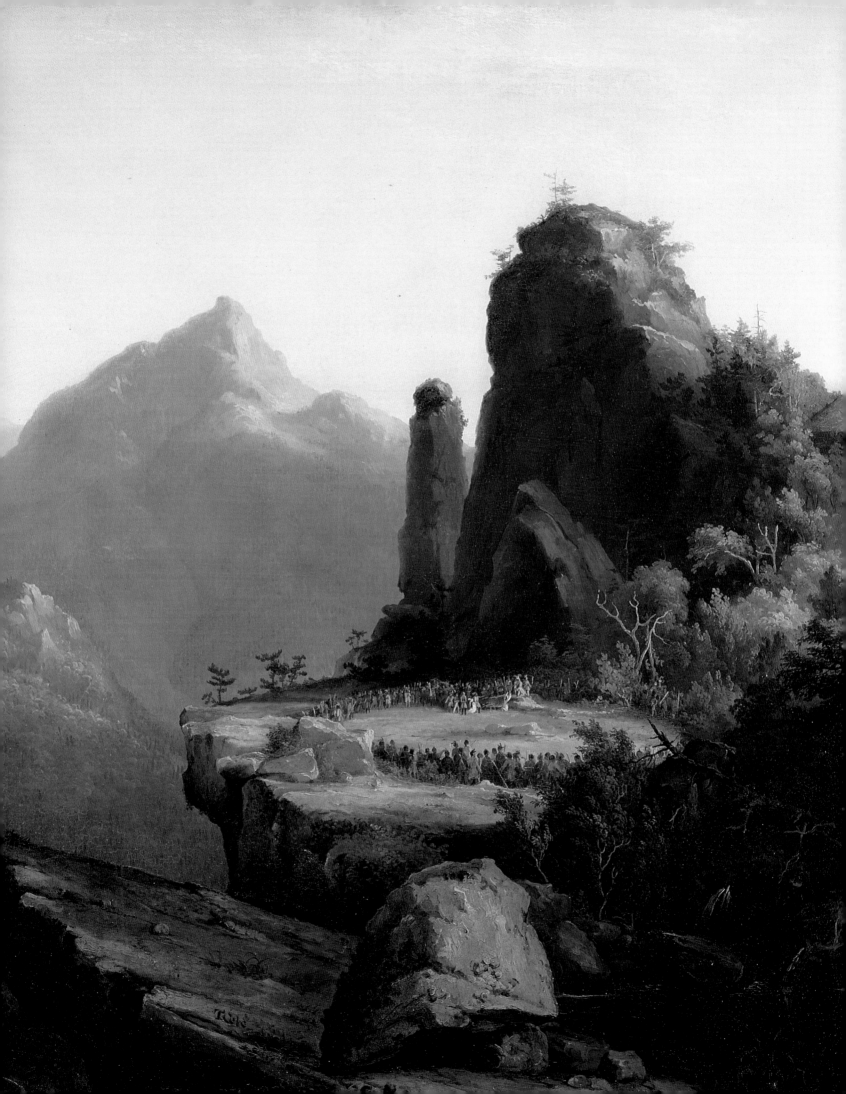

'all Nature here is new to Art':
Painting the American Landscape, 1800–1900

Landscape served as the foremost subject of aesthetic inquiry in nineteenth-century America. Native-born, immigrant, and visiting European artists focused their attention on the terrain of this new world, often combining literalism and lyricism to convey the transformation of the land from its early wilderness beginnings to an industrialised, urban-based society by the century's end. Their art reveals the changing relationship of humans to nature, from that of dominance by nature's forces to the gradual integration of landscape into human existence. This essay explores landscape in the United States from 1800 to 1900 within the thematic categories set out for this exhibition, revising the received tradition of earlier scholarship in a number of ways, especially in the consideration of landscape clear across the century.

Meeting the Land

During the first half of the nineteenth century, travellers and artists explored the American landscape in search of an understanding of both the physical and the spiritual aspects of nature. At the beginning of the century, feeling a sense of their own insignificance in the face of such a vast wilderness, these explorers relied on a set of established artistic conventions and ways of looking at nature in order to frame the landscape — applying the traditions of the old world to the geography of the new. As settlement took hold, many landscape painters adapted these traditions and gradually abandoned them as, by mid-century, deeper understandings of nature and the American landscape were reached.

Emergence of Landscape Culture in America

As in England and elsewhere around the globe, a growing fascination with native scenery fuelled the development of landscape art and landscape culture in the United States, in the form of prints, paintings, travel guides, travel literature, treatises on aesthetics, and tourism. By the end of the eighteenth century, prospective travellers in the 'new world' could educate themselves about landscape culture by reading the works of prominent English writers whose books on landscape aesthetics were by this time widely available in America. The 'taste' for landscape was largely restricted to the north-eastern elite. They naturally turned to England as a cultural model, and were necessarily educated in the contemporary theories of English landscape aesthetics. The writings of William Gilpin, Uvedale Price and Richard Payne Knight informed their ideas on the basic categories of the beautiful, the sublime, and the picturesque.[1]

The most influential British writer of the period, William Gilpin explained to the reader the 'various purposes' for travel, adding 'a new object of pursuit', picturesque travel, which he defined as:

> that of not barely examining the face of the country; but of examining it *by the rules of picturesque beauty*: that of not merely describing; but of adapting the descriptions of natural scenery to the principles of artificial landscape; and of opening the source of those pleasures; which are derived from comparison.[2]

Such pursuits as seeking wilderness scenery for its aesthetic properties were the preserve of an aristocratic few both in England and, more so, in America. Writing in 1791, Gilpin noted the prevalent preference for domesticated landscape:

> the idea of a wild country, in a natural state, however picturesque, is to the generality of people but an unpleasing one ... There are few who do not prefer the busy scenes of cultivation to the grandest of nature's rough productions.[3]

Thomas Cole Scene from 'The Last of the Mohicans', Cora kneeling at the Feet of Tamenund *1827 (detail) (cat.52)*

By the 1820s, with settlement well under way, American writers, including Timothy Dwight, Benjamin Silliman and Theodore Dwight, were publishing their travels through their own native landscape, celebrating wilderness and encouraging the rise of tourism among a wider class of people.[4]

The collaboration of the painter John Trumbull, the picturesque traveller and patron Daniel Wadsworth, and the Yale College geologist and travel writer Benjamin Silliman (all well versed in the aesthetics of the picturesque — and friends, related through marriage) — provides an apt example of the earliest developments of landscape culture in the United States. As arbiters of taste, these men drew attention to the virtues of the American landscape. Trumbull's *View on the West Mountain near Hartford* c.1791 (cat.20), based on his sketches of the site, captured the picturesque possibilities of the land that Wadsworth later turned into his country estate. In 1805, working in partnership with Trumbull, Wadsworth began transforming the wilderness tract of land on the summit of Talcott Mountain west of Hartford, into a carefully cultivated summer retreat with a neo-Gothic house, surrounding gardens, a boathouse, and a working farm. He named the estate Monte Video, completing it by about 1810 with the construction of its most distinctive feature, a 17-metre (55-foot) viewing tower which commanded a spectacular sweep of the surrounding scenery.

In 1819 Wadsworth and Silliman made a tour from Hartford to Quebec, which resulted in a book written by Silliman, with illustrations after Wadsworth's drawings: *Remarks made, on a Short Tour, between Hartford and Quebec in the Autumn of 1819* (New Haven, 1824) (cat.23). In the introduction, Silliman expressed the beliefs he shared with Wadsworth and others regarding the value of landscape for Americans, that:

> national character often receives its peculiar cast from natural scenery …
> Thus natural scenery is intimately connected with taste, moral feeling, utility and instruction.[5]

A detailed description of Monte Video was included, with illustrations based on Wadsworth's drawings of the house and tower: for example, *Monte Video* c.1810–19 (cat.21). He later commissioned the artist Thomas Cole to paint *View of Monte Video, the Seat of Daniel Wadsworth, Esq.* 1828 (fig.41), a panoramic view from the base of the tower. While Trumbull's earlier painting of the site reveals his reliance on the compositional conventions of the old world, Cole dispenses with these traditions in an effort to convey the visual mastery that this mountain-top locale afforded the viewer in the grand panoramic sweep of the scenery.[6] To elevate the taste of American citizens, Wadsworth opened the property to the public, encouraging visitors to enjoy his wilderness estate. In 1844 he established a public art museum in Hartford, the Wadsworth Atheneum, filled with contemporary American landscapes by the country's leading painters, and featuring works by Cole.

The taste for landscape demanded that the individual not only admire images of landscape and read treatises on landscape aesthetics, but also experience landscape at first hand. While the thrill of sublime scenery, which allowed one's mind to be affected by a sense of overwhelming grandeur or irresistible power, was most sought after, picturesque views attracted travellers as well. Comparisons were frequently made between old world landscape and that of the new: the panoramic expanses of the Connecticut and Hudson River valleys, for example, lent themselves to favourable comparison with England and Europe. Of the Hudson, Cole wrote: 'Its shores are not besprinkled with venerated ruins, or the palaces of princes; but there are flourishing towns, and neat villas, and the hand of taste has already been at work.'[7] The taste for picturesque scenery was spurred on in the early decades of the nineteenth century by a proliferation of landscape engravings of American scenery.[8] The exalted views presented by the English-born artist William Guy Wall, in his *Hudson River Portfolio* c.1821–25 (cats 24–27), for example, helped to popularise the Hudson River as a tourist attraction.

fig.41 Thomas Cole 1801–1848
View of Monte Video, the Seat of Daniel Wadsworth, Esq.
1828
oil on wood 50.2 x 66.2 cm (19-3/4 x 26-1/16 in)
Wadsworth Atheneum, Hartford, Connecticut
Bequest of Daniel Wadsworth

Encountering the Wilderness: Great Natural Wonders

As a new nation attempting to define its identity, America celebrated in its art the novelties of its landscape — its scale, freshness, and variety. The wilderness, which had been feared and loathed in the eighteenth century, was now viewed as America's most distinctive feature — a symbol of the nation's potential as well as the country's history. In the absence of cultural history so celebrated in European art, educated tourists sought spiritual renewal in the ruins of nature and monuments of their own sublime wilderness scenery. They delighted in the mysterious and uncontrollable aspects of nature, and in the sudden fear they experienced upon confronting its power. To seek these sublime thrills they travelled, in increasing comfort, to view America's unparalleled natural wonders — the waterfalls, mountains and forests of the north-east and, later, the West.

Geology reigned as the most important field of scientific inquiry at this time. Theories of the creation of the world suggested that the earth was far more ancient than previously thought, and that it had been dramatically transformed by geological forces: the influential German geographer and scientist Alexander von Humboldt gained an international audience with his series of books about the physical history of the earth; and their fascination with geological time led travellers to seek natural phenomena both above and below the earth's surface.

Along with the most exceptional features of the wilderness landscape, Native Americans served as an important symbol of the new world. In landscape art they are so fully integrated into the wilderness scenery as to seem one and the same. In an effort to justify their claim to this vast landscape, artists and the American public romanticised the indigenous presence, while eliminating all signs of the Native Americans' actual relationship with the land. They appear in north-eastern scenery as symbols of the original purity of God's wilderness; and later, as they are encountered in the western territories, they are documented with a sense of urgency that forecasts their threatened extinction.

For its obvious associative qualities of scale, power and sublimity, Niagara Falls achieved aesthetic pre-eminence during the first half of the nineteenth century, becoming the most frequently painted natural wonder in the United States. With the opening of the Erie Canal in 1825, Niagara became a tourist destination for thousands each year. Its importance lay in the fact that it had no equal in the old world, allowing Americans to claim cultural prominence. Anticipating an emotional and religious experience, visitors to the Falls saw themselves as pilgrims on a religious journey to a sacred site.[9]

Nearly every landscape painter of the period accepted the challenge of capturing Niagara on canvas. Alvan Fisher was one of a number of native-born painters to specialise in the production of paintings of the Falls. Most were versions of two paintings based on sketches he made on his first trip to Niagara in 1820: *The Great Horseshoe Fall, Niagara* and *A General View of the Falls of Niagara* (figs 42, 43).[10] By the time of that visit, a number of comfortable hotels existed on both the American and Canadian shores.[11] Early landscape painters such as Trumbull and Fisher adopted conventional compositional structures for their landscapes as one way of taming the wilderness. In Fisher's paintings of Niagara, including *Niagara Falls* 1823 (cat.28), the artist's carefully composed views are taken from the Canadian side. He depicts visitors to the sites as separate from their surroundings, placed in the foreground in a stage-like setting that removes them from imminent peril. In *The Great Horseshoe Fall, Niagara*, he includes the figure of an Indian, who provides his wisdom to the visitor — a necessary intermediary between the white tourists and the wilderness. The Iroquois had dominated the region until the end of the eighteenth century, and held the belief that the Falls was a dark spirit with 'a voice of thunder'.[12] As the century progressed, a trip to the Falls was considered a part of every American's duty as a citizen of the United States.

Most leading artists at this time were based in New York City, the nation's cultural centre. Thomas Cole's arrival there in 1825 has traditionally marked the beginning of the Hudson River School, which reigned as a national school of landscape art until about 1870.[13] Cole, the acknowledged founder of the school, was the premier landscape

fig.42 Alvan Fisher 1792–1863
The Great Horseshoe Fall, Niagara 1820
oil on canvas 87.2 x 122.0 cm (34-3/8 x 48-1/8 in)
National Museum of American Art,
Smithsonian Institution, Washington DC

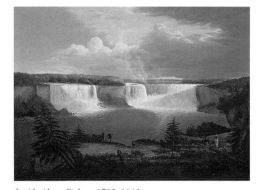

fig.43 Alvan Fisher 1792–1863
A General View of the Falls of Niagara 1820
oil on canvas 87.2 x 122.3 cm (34-3/8 x 48-1/4 in)
National Museum of American Art,
Smithsonian Institution, Washington DC

painter of the second quarter of the nineteenth century. He proved to be a far more cerebral landscape painter than those who had come before him, such as Fisher. Cole drew on his childhood experiences in industrial England, using landscape art as a means of upholding traditional beliefs as he warned Americans of the dangers of material progress, unlimited democracy, and expansionism which he believed to be rampant in the Jacksonian era.[14]

In a break from the European convention of landscape painting, which was dominated by pastoral views, wild nature became a prime subject of Cole's early landscapes. As the first artist to depict the Catskill Mountain region in New York State, Cole painted its most spectacular sites, including *The Clove, Catskills* c.1826 (cat.30) and *Kaaterskill Falls* 1826 (fig.44) in which he eliminates all signs of tourism, and instead presents images of the pristine wilderness of the past. These works epitomise the romantic sublime — storms sweep across the sky and natural forms of rocks and gnarled branches of dead trees assume anthropomorphic forms. In each painting Cole places the figure of an Indian as sole witness to the purity of American wilderness. Indians had long since been removed from the north-east, as white settlement and tourism claimed this region. Cole may have intended that the viewer comprehend the Catskill wilderness through the eyes of Native Americans, to see it as he thought they had seen it, unchanged since creation.

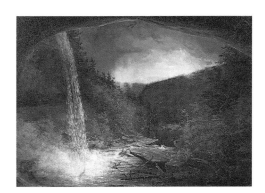

fig.44 Thomas Cole 1801–1848
Kaaterskill Falls 1826
oil on canvas 64.1 x 92.2 cm (25-1/4 x 36-5/16 in)
Wadsworth Atheneum, Hartford, Connecticut
Bequest of Daniel Wadsworth

Years later, after returning from a trip to the Catskill region, Cole reflected on the role of the American landscape painter:

The painter of American scenery has indeed privileges superior to any other; all nature here is new to Art. No Tivoli's[,] Mont Blanc's, Plinlimmons, hackneyed & worn by the daily pencils of hundreds, but virgin forests, lakes & waterfalls feast his eye with new delights, fill his portfolio with their features of beauty and magnificence and hallowed to his soul because they had been preserved untouched from the time of creation for his heaven-favored pencil.[15]

As Alan Wallach has noted, Cole exaggerated the 'untouched' quality of the Catskill region's wilderness lands, by this time a tourist destination, but he did articulate 'the central problem confronting early American landscapists — the problem of portraying a hitherto unrepresented nature'.[16]

Not all those who followed Cole into the Catskills employed his innovative approach to depicting the wilderness scenery. Perhaps encouraged by Cole's success, William Guy Wall was drawn to the region. His *Cauterskill Falls on the Catskill Mountains taken from under the Cavern* 1826–27 (cat.29) is clearly inspired by the composition of Cole's *Kaaterskill Falls* in which Cole drew on his knowledge of picturesque theory. Wall also uses the cavern walls as a framing device to heighten the visual effects for the viewer, but rather than depicting America's untouched past he emphasises the present, seen in his celebration of tourism. The visitor's experience was completely programmed by this time. Scampering across the rocks, one tourist appears to be signalling to the top of the falls, where a deluge would be released upon request to recreate the effect of spring flood waters; and an observation platform with a refreshment stand allowed tourists to view the falls from a safe distance.[17]

The majority of landscape painters during the first half of the century practised their art in the north-east. Southern-born artists, such as Louis Rémy Mignot, were themselves drawn to New York in search of training and patronage.[18] Landscape publications, including William Bartlett's *American Scenery* (1840) reinforced this north-eastern bias. As Angela Miller has noted, the limited number of landscapes of southern scenery tended to be of sites carrying associations with the American Revolution and the early federal period.[19] For example, Thomas Jefferson had made the Natural Bridge in Virginia famous in his *Notes on the State of Virginia* (1784–85). The Bridge, 61 metres (200 feet) in height, was first worshipped by the Monacan Indians, who called it the 'Bridge of God'.[20] Jefferson, who had owned the site and the surrounding land since 1774 through the grant of King George III, declared the Bridge to be 'the most sublime of nature's work', and he urged artists to paint it.[21] Like Niagara, the Bridge was considered unparalleled as a geological phenomenon. Part of its fascination was the seeming

mystery of its creation. Most early travellers turned to theories of catastrophe to explain geological wonders like the Natural Bridge; and Jefferson had written that it seemed to have been 'cloven through its length by some great convulsion'.[22] By mid-century however, scientific knowledge revealed that over eons of time the eroding effects of Cedar Creek on the soft limestone had caused the Natural Bridge to form.

Scientific observation and the experience of the sublime were not incompatible for educated travellers, making the Natural Bridge an attraction for the artist–explorer Frederic Church and his patron Cyrus Field, an amateur geologist and merchant, who travelled to Virginia in the summer of 1851. Aware of contemporary theories of geology, Church was directly influenced by the writings of Alexander von Humboldt who challenged his readers to focus on 'the true image of the varied forms of nature', and in such works as *Natural Bridge, Virginia* 1852 (cat.32) he attempted to answer von Humboldt's call.[23] Field asked Church to make a sketch of the Bridge during their visit and, out of concern for accuracy, he collected rock samples. Duly pleased when he compared them to Church's painting, Field acquired *Natural Bridge* upon its completion.[24] Based on careful observation of nature, and exhibiting a Ruskinian correctness of detail in the precisely rendered rocks, *Natural Bridge, Virginia* was the first work that Church sent to London, where it was shown at the Royal Academy in 1852. Reflecting their shared interest in geology, Field went on to acquire a number of landscapes by Church featuring rock formations, including *West Rock, New Haven* 1849 (cat.57) and *Cotopaxi* 1855 (fig.45).

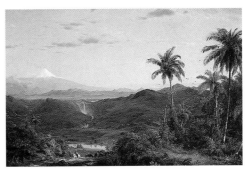

fig.45 Frederic Edwin Church 1826–1900
Cotopaxi 1855
oil on canvas 76.2 x 118.0 (30 x 46-7/16 in)
The Museum of Fine Arts, Houston, Texas
Museum purchase with funds provided
by the Hogg Brothers Collection, gift of Miss Ima Hogg

Prominent in the centre foreground of Church's *Natural Bridge* landscape is the figure of an African–American guide (possibly the slave of the current owner of the Bridge); he holds the attention of a woman seated at his feet as he gestures toward the Bridge.[25] In place of the more familiar Native American who served as a guide or intermediary in depictions of north-eastern wilderness scenery, the inclusion of a black guide by Church provides a visual reference to viewers that this site was in a southern slave state. Additionally, taking a view that looks from the east toward the west, Church includes the detail of the wooden railing along the famous Wilderness Road that ran across the top of the Bridge and served as a gateway to western expansion.[26]

Also located in the South, the underground geological phenomenon, Mammoth Cave in Kentucky — believed to be the longest cave system in the world — was the least accessible of the natural wonders for visitors and artists due to its remote location. The site did not gain national recognition until 1817 when Nahum Ward, a traveller from Massachusetts, published a report of his visit, including his discovery there of a mummified Indian.[27]

Like the other natural wonders, Mammoth Cave embodied both the sacred and the profane. The cave's features and the way these were interpreted by guides suggested images of 'Hades, Heaven, and the creation of the world'.[28] As with the Natural Bridge, the guides, who became renowned for their knowledge of the Mammoth Cave site, were African–American slaves, the property of the cave's owners. Mammoth Cave was perhaps the most horrific of the romantic sublime experiences for the traveller, who was transported on a raft through a seemingly endless 'underworld' of dark, damp cavernous spaces, along rivers named Styx, Echo, and Lethe. Most visitors subscribed to the catastrophist theories which held that the cave had been formed by a sudden violent event, such as a deluge. Benjamin Silliman, however, reflected the modern and correct theory of the gradualist school, writing in 1851 that the force that formed the cave was 'decidedly *water* and no other cause'.[29]

Despite its great drama, few images of Mammoth Cave were produced. Most northern painters did not paint extensively in the South, perhaps in part because of the distaste northerners held for southern scenery, which they perceived as the landscape of slavery.[30] The Danish-born artist Ferdinand Richardt, who may not have been bound by such constraints, visited the site in 1857 and painted a number of views including *Echo River, Mammoth Cave* 1857 (cat.34), which captures the sublime experience of the tourists travelling underground along the Echo River in a skiff manned by African–American slave guides.[31]

Encountering the American West

When the French and English first settled Quebec, Plymouth Rock, and the James River estuary in the early 1600s, North America was not a virgin land, but an 'old world' that had been inhabited by Native American tribes for millennia. As the European settlers cut their way through eastern forests and pushed the Indians westward off their lands, an image of a new European landscape emerged. From the start the French and English considered Indians as outsiders, without a legitimate claim to the land on which they lived. On the other hand, Spaniards, who had arrived in the 1500s and explored the south-west, acknowledged the presence of an indigenous culture, and eventually assimilated Pueblo Indians into their own world in part through intermarriage.[32]

In the early nineteenth century artists painted romantic images of the noble Indian living on lands that were still beyond the frontier of advancing white settlement. Many artists such as Titian Ramsey Peale (1799–1885) followed government sponsored expeditions into the prairies, documenting the land and its inhabitants, while others used private funding for their trips. Inspired by the scientific spirit of the age and holding a romantic vision of his quest, George Catlin (fig.46) set out on his own to document the western landscape and the Indian tribes that inhabited the land along with the buffalo herds that sustained them, before all disappeared. Seeing himself as an ethnographer, Catlin described his mission:

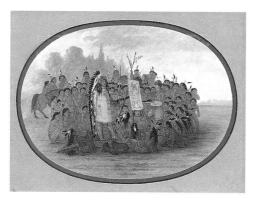

fig.46 George Catlin 1796–1872
Catlin painting the Portrait of Mah-to-toh-pa — Mandan
1861–1869
oil on paperboard mounted on heavier paperboard
47.0 x 61.0 cm (18-1/2 x 24 in)
National Gallery of Art, Washington, DC
Paul Mellon Collection

> I have for many years past, contemplated the noble races of red men who have now spread over these trackless forests and boundless prairies, melting away at the approach of civilization ... I have flown to their rescue — not of their lives or of their race (for they are '*doomed*' and must perish), but to the rescue of their looks and their modes, at which the acquisitive world may hurl their poison and every besom of destruction, and trample them down and crush them to death; yet phoenix-like, they may rise from the stain of a painter's palette, and live again upon canvass, and stand forth for centuries yet to come, the living monuments of a noble race.[33]

In the course of his travels Catlin realised that with the loss of indigenous cultures would follow the loss of the wilderness lands, in this case the Great Plains. As one of the last sections of the United States to be settled during the final decades of the century, this vast region of prairie grassland once extended over one-third of the American continent, presenting challenges for settlement as well as for the artists who attempted to depict the region for their eastern audience.[34] To European settlers in the east, accustomed to forested landscape, the treeless, windswept hills and seemingly unbroken horizons of the prairielands appeared hostile and uncontrollable. The Sioux, the Comanche, the Arapaho, the Cheyenne, and other tribes who adeptly moved across the Plains following herds of buffalo also posed a major threat to settlement.

There were as many as twenty million bison on the Great Plains in the early nineteenth century. As their hides became prized by white hunters and Native Americans in their employ, the herds dwindled over the course of the century, their carcasses littering the landscape. By 1890 only about a thousand buffalo survived.[35] In such works as *Buffaloes in the Salt Meadows, Upper Missouri* c.1851–52 (cat.31), Catlin predicted the loss of the buffalo, depicting the congregation of herds at the meadows where salt from the springs had dried. Abandoning traditional framing devices, his panoramic sweep and unrelieved horizon line convey the relentlessness of the Plains landscape. A year later Catlin proposed an alternative for the inevitable extinction of the Indian and the buffalo, suggesting the designation of 'A *nation's Park*, containing man and beast, in all the wild and freshness of their nature's beauty!'[36]

While the Plains presented seemingly insurmountable problems to the settlers facing treeless prairielands dominated by hostile Indian tribes, the south-west was viewed by artist–explorers as potentially inhabitable. Following the War with Mexico, the boundary between the United States and Mexico, long a contested region, was surveyed and marked in the years from 1849 to 1856. In the process Mexico was dispossessed of half of its national domain, while the United States expanded its lands by almost a third.[37]

The Boston artist Henry Cheever Pratt was appointed official draughtsman of the U.S.–Mexico Boundary Survey, to take sketches of important scenery along the border. What he found and depicted for the official reports was a frontier region of ancient Indian cultures and ruined cities, replete with a legendary Spanish colonial past. Rather than the hostile Indians who roamed the Plains on horseback, Pratt encountered peaceful Pueblo tribes who farmed the lands around their villages and had been converted to European ways, having been partially absorbed by the invading Spanish culture. Pratt's *View from Maricopa Mountain near the Rio Gila* 1855 (cat.33) celebrates the potential of the fertile Gila River valley, land of the Maricopa Indians. The region (the site of the present day city of Phoenix) was seen as a potential route for a transcontinental railroad, and the valley's abundant water held the promise of agricultural settlement. To amaze his eastern audience (Pratt exhibited this and his other south-western paintings in Boston in 1855), he placed in the foreground the exotic giant saguaro cactus, which could reach a height of 15.25 metres (50 feet). Based on the artist's sketches, the full cycle of the cactus's flowering is represented. He includes two Pima-Maricopa Indians who have pierced the cactus with their arrows, and have gathered the fruit of the plants. An Indian settlement with irrigated fields lies in the valley below and, beyond, the Gila River is lined with cottonwood trees. The entire scene invites white settlement.

Claiming the Land

Most landscape imagery of the first half of the nineteenth century celebrated human progress in transforming the landscape, of claiming and settling America's wilderness. In 1831 Alexis de Tocqueville, observed this phenomenon:

> In Europe people talk a great deal of the wilds of America, but the Americans themselves never think about them; they are insensible to the wonders of inanimate nature and they may be said not to perceive the mighty forests that surround them till they fall beneath the hatchet. Their eyes are fixed upon another sight: the American people views its own march across these wilds, draining swamps, turning the course of rivers, peopling solitudes, and subduing nature.[38]

The great majority of Americans were too busy pursuing progress to admire their vast wilderness landscape until they had subdued it. The rapid expansion of the young nation was fuelled by the conviction held by Americans that they were meant to establish a great empire. By the 1840s these beliefs led to the quasi-religious doctrine of Manifest Destiny — that the United States was destined to expand westward across the continent. The discovery of gold in the American River, California, in 1848 provided the impetus to develop land in the West. Believed to be sanctioned by God, Manifest Destiny to some suggested expansion across the entire continent to the Pacific; to others it included the entire North American continent; while to many the entire hemisphere was considered fair game.[39]

Settling the Wilderness

In the early decades of the young Republic, laying claim to the land signified land ownership to many American citizens. As the economy of the United States stabilised, newly built houses and cultivated landscape settings were frequently the subject of landscape art. Once again England served as a cultural model — the tradition of English country house painting was applied to the more modest American counterpart. The American artist Ralph Earl was particularly well-suited to depict images of the rising middle-class gentry of New England, having received artistic training in England during the Revolutionary War. His *Houses and Shop of Elijah Boardman* (*Houses fronting New Milford Green*) (cat.49), painted in about 1795, features the newly built Palladian style 'mansion' of Elijah Boardman, a merchant in this small rural Connecticut town. Rather than in an expansive rural setting in the manner of an English country house, Boardman's house is in the middle of town and displays

the architectural features that were fashionable in the new world, including an imposing front entrance. Next to the main house, a wide drive leads to the merchant's newly built drygoods store, his source of income unabashedly placed in the centre of the composition.[40] Accurate signs of landscape cultivation, emulating English designs, are seen in the side yard, including a summer house built on a cultivated lawn that leads down to the Housatonic River.[41] The pink hues of the sky imbue the scene with an overall sense of well-being, suggesting the promise of the growing nation.

In addition to the emergence of a few native-born landscape artists in the early years of the Republic, an influx of British artists came to the United States in search of new artistic opportunities, often portraying imagery that would compare favourably with familiar scenes at home. They painted domesticated landscapes that also highlighted the progress of America. William Birch, for example, with his son Thomas, settled in Philadelphia, where, following English models, they produced and published a series of landscapes entitled *The Country Seats of the United States of North America* (1808). The Philadelphia estate, Lemon Hill, which was famous for its gardens, appears in *Country Seats* as well as in Thomas Birch's painting *Fairmount Waterworks* 1821 (cat.50). Lemon Hill had an immense greenhouse filled with citrus trees, and the grounds were decorated with bowers, rustic retreats, fountains, fishponds, and an artificial cascade.[42] Technology is placed in harmony with nature in *Fairmount Waterworks*, which features the nation's first municipal waterworks, a celebration of American ingenuity. Fairmount Park, which opened to the public in 1815, boasted a beautiful public garden that surrounded the technological wonder of the waterworks itself.

The concept of claiming the land extended to both coastlines, and is revealed in the topographical paintings of Fitz Hugh Lane and Joseph Lee. In about 1850, the Gloucester, Massachusetts artist Fitz Hugh Lane painted *Fresh Water Cove from Dolliver's Neck, Gloucester* (cat.59), which claims the coastline as private property. The viewer gazes across a bucolic coastal creek to the shoreline dotted with neatly placed summer houses separated by fences. Brookhaven, owned by the artist's prominent patron Samuel E. Sawyer, is the largest house seen on the shore. Lane's landscape forecasts the region's development into a popular summer resort by century's end.

With expansion reaching the west coast by the third quarter of the nineteenth century, New England ideals were carried out as far as California, as seen in Joseph Lee's estate painting *Residence of Captain Thomas W. Badger, Brooklyn [California], from the Northwest* 1871 (cat.61). The painting celebrates this family's success in settling on the Pacific coast and establishing a fashionable Victorian homestead, including a windmill, watertower, large barn, and picket fencing around the property. Beyond the homestead, commerce is symbolised by the various forms of transportation including Badger's source of income in maritime trade, implied by the large sailing boat visible through the trees.

The continuing transformation of wilderness to pastoral land as settlers pressed westward inspired a number of landscapes depicting newly established river towns along the arteries of the nation's mid- and western territories. After learning of the discoveries made by the expedition of Lewis and Clark up the Missouri river in 1804, Thomas Jefferson realised with disappointment that the United States lacked a 'great western river' to connect the Missouri with the Pacific Ocean.[43] American landscape painters made do with views of the wild beauty and commercial development of the Hudson, Ohio, and Mississippi rivers, which provided the nation with lines of circulation. While Hudson River scenery became the sustained subject of a national school of painters, landscape artists in more recently settled regions of the United States depicted new communities along the Ohio and Mississippi rivers and beyond. In their depictions of thriving town and city centres, artists conveyed the message of the opportunities these settlements offered to white settlers, while at the same time revealing that they excluded African–Americans and Native Americans.

The African–American artist Robert Duncanson painted *View of Cincinnati, Ohio from Covington, Kentucky* c.1851 (cat.60) during a time of great unrest caused by the Compromise of 1850 between the northern and southern states. To his accurate

rendition based on a daguerreotype of this booming mid-western city, Duncanson has added a number of narrative elements. In the foreground he includes a white couple seated on the Kentucky bank of the Ohio River (at this period a turbulent slave crossing) looking across to the prospering city of Cincinnati. Also in the foreground, a black man holding a scythe addresses two white children, while a black woman hangs laundry near a ramshackle cabin. The composition sharply contrasts the poverty of the slave state of Kentucky with the thriving industrial economy of the free state of Ohio.

In *Oregon City on the Willamette River* 1850–52 (cat.58), John Mix Stanley portrays a flourishing frontier river town, celebrating the transformation of wilderness to settled, pastoral landscape. The falls of the Willamette River provides a focal point for the composition, a symbol of the region's potential for industrial growth. To the far left, the artist indicates the fast disappearing forest, and at the lower left he includes two Native Americans who turn away from the scene, having lost their lands to the lumber and fishing industries.

Landscapes of Association

Many middle-class Americans, admiring European landscapes for their associations with the past, felt a sense of inferiority when they attempted to compare their recent history and culture with that of Europe. At the same time they proclaimed their exceptional status as citizens of a new world destined to prosper. In the early decades of the nineteenth century, American landscape painters in partnership with travel writers, novelists, and poets, sought to provide local associations for the American landscape. The question arose, however, as to the nature of the associations — should they refer to America's past, present, or future? Thomas Cole reveals this sense of ambivalence in his 'Essay on American Scenery' (1835), proclaiming that:

> American scenes are not destitute of historical and legendary associations — the great struggle for freedom has sanctified many a spot, and many a mountain, stream, and rock has its legend, worthy of poet's pen or the painter's pencil ...

while declaring, in the same essay:

> American associations are not so much of the past as of the present and the future ... Where the wolf roams, the plow shall glisten; on the gray crag shall rise temple and tower — mighty deeds shall be done in the now pathless wilderness; and poets yet unborn shall sanctify the soil.[44]

Reflecting Cole's ambivalence, American landscape painters incorporated a variety of associations in allegorical landscapes, often evoking a sequential narrative that charted a progressive transformation from wilderness to pastoral and settled land.[45] Their responses to this challenge ranged from the pessimism of Thomas Cole's series *The Course of Empire* c. 1836 (figs 47–51), which rejected America's nationalist pride by predicting its inevitable decline, to the optimism portrayed in the series of great national images painted by Cole's pupil, Frederic Church, (see cats 54, 73), which reinforced America's imperial ambitions of expansionism.

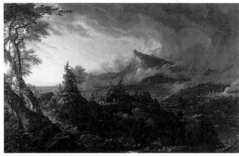
fig.47 Thomas Cole 1801–1848
The Course of Empire: The Savage State 1836
oil on canvas 99.7 x 160.7 cm (39-1/4 x 63-1/4 in)
© Collection of The New-York Historical Society

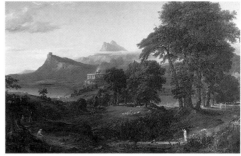
fig.48 Thomas Cole 1801–1848
The Course of Empire: The Arcadian or Pastoral State c.1836
oil on canvas 99.7 x 160.7 cm (39-1/4 x 63-1/4 in)
© Collection of the New-York Historical Society

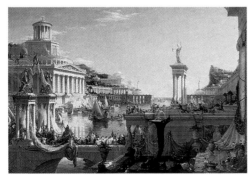
fig.49 Thomas Cole 1801–1848
The Course of Empire: Consummation c.1835–36
oil on canvas 130.2 x 193 cm (51-1/4 x 76 in)
© Collection of the New-York Historical Society

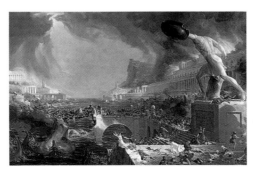
fig.50 Thomas Cole 1801–1848
The Course of Empire: Destruction 1836
oil on canvas 99.7 x 161.3 cm (39-1/4 x 63-1/2in)
© Collection of the New-York Historical Society

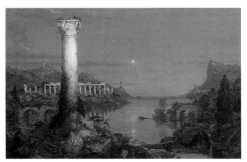
fig.51 Thomas Cole 1801–1848
The Course of Empire: Desolation 1836
oil on canvas 99.7 x 160.7 cm (39-1/4 x 63-1/4 in)
© Collection of the New-York Historical Society

American society, rooted in the Protestant faith, adhered to a self-proclaimed belief that its historical destiny to claim and settle the new world was sanctioned by God. With the founding of the Republic came the belief that America would realise the biblical prophecy of a thousand-year reign of peace.[46] The Quaker artist and minister Edward Hicks employed landscape imagery to convey America's millennial promise. In *Peaceable Kingdom of the Branch* c.1826–30 (cat.51), taken from an illustration of the Book of Isaiah, he portrays a child amidst domestic and wild animals, who lie together in a peaceful grouping. At the left he includes the Natural Bridge in Virginia, with an historic scene of William Penn's treaty with the Indians. He thus merges symbols of the nation's past represented by Penn's purchase of lands from the Indians, with its present promise symbolised by the youth, and millennial future by the Natural Bridge connoting divine power in nature.[47]

While Hicks, a provincial painter, drew on biblical sources for his paintings, Thomas Cole and other members of the urban-based Hudson River School used contemporary literature as well as the Bible for their pictorial themes. They worked in concert with such leading writers of the day as Washington Irving, William Cullen Bryant and James Fenimore Cooper using landscape as a vehicle to develop American historical themes and narratives.

Cole's *Scene from 'The Last of the Mohicans', Cora Kneeling at the Feet of Tamenund* 1827 (cat.52) uses landscape to convey psychological meaning. The artist's representation of a scene drawn from recent American literature (Cooper's popular novel of the same title) reflects American settlers' attitudes toward Native Americans as savages. The scene (Cole had carefully inscribed the exact passage from the novel on the back of the canvas) took place in the vicinity of Lake George, in upstate New York. In the composition, real and idealised imagery are combined. Cole includes both a faithful rendering of New Hampshire's White Mountain scenery (which he considered the finest he had ever beheld) at upper left, and idealised geological features enhancing the minute narrative scene in the foreground.[48] The sexual tension in Cooper's novel is evoked by a rocking stone atop a huge phallic pinnacle, and a dark cave, which provides a backdrop for the narrative scene of the young girl pleading for her sister's and her own life in front of the Indian Chief.[49]

In laying claim to the American wilderness, artists associated landscape sites with actual events, as opposed to biblical or fictional ones. Cole's *A View of the Mountain Pass called the Notch of the White Mountains (Crawford Notch)* 1839 (cat.53), for example, depicts the site in the White Mountains of New Hampshire where in August 1826 a massive landslide destroyed the Willey family, pioneer settlers of Crawford Notch. This lurid tale quickly entered the realm of popular legend, adding a sense of history and drama to the American landscape, and led to the site's attraction for tourists. The associations that the site conjured up ranged from New England's providential beliefs, warning that God spoke through nature and that this tragedy was a symbol of His sublime power, to evoking a sense of America's own past. The avalanches supplied a substitute for ancient ruins.[50] On a trip to the site in 1828, Cole recorded his thoughts:

A dreadful mytery [sic] hangs over the events of that night — We walked among the rocks and felt as though we were but as worms insignificant and feeble … we looked up at the pinnacles above and measured ourselves and found ourselves nothing.[51]

In this masterful landscape the artist personifies the sense of human frailty in the face of wild nature by showing a youth on horseback confronting twisted, writhing trees in the foreground, the notch riven through the mountain, and the stormy sky above.

Frederic Church's earliest works followed Cole's precept to paint a 'higher style of landscape'. In his first ambitious composition, *Hooker and Company journeying through the Wilderness from Plymouth to Hartford in 1636* 1846 (cat.54), Church chose to paint a heroic event drawn from colonial history — the migration of a band of religious dissidents led by the Puritan preacher Thomas Hooker to found Hartford, Connecticut. This was a natural subject for Church, a sixth-generation Connecticut Yankee whose ancestor had been a member of Hooker's party. Like Cole, Church used human and spiritual drama to define the landscape; the figures evoke the Holy Family.

The brilliant light that illumines their passage through the wilderness completes the allegory of divine providence at work in the Connecticut valley. Diverging from his teacher's pessimism, Church embraces the theme of Manifest Destiny in this work which is one of the earliest representations of westward expansion. Landscape features such as the historic Charter Oak Tree, seen at the left, and the anthropomorphic forms of the gnarled trees and rocks in the foreground, along with the stylised rays of sunlight symbolic of divine light, enhance the meaning of the painting. This historical landscape became the first of a thematic trio in which the artist explored the roots of American democracy as revealed in the landscape and history of Connecticut. The second work, *The Charter Oak* 1847 (Olana State Historic Site, Hudson, New York),[52] and the third, *West Rock, New Haven* 1849 (cat.57) represent contemporary views of historic sites.

In *West Rock* Church provides a record of the current productive use of the land in a bucolic harvest scene that includes a church steeple. By including the recognisable geological feature of West Rock, he communicates as well the level of historical association. For the nineteenth-century audience, this natural monument, like the Natural Bridge and Mammoth Cave, had significance beyond its geological characteristics. Many of Church's viewers would have known that two British regicides, Edward Whalley and William Goffe, had been hidden by the colonists from royal agents in a cave on West Rock, an episode that foreshadowed the struggle for independence from Britain a century later. Like Hicks's *Peaceable Kingdom of the Branch*, Church provides the viewer with the message that the rewards for heroic struggles of the past resided in the peaceable 'harvests' of the present.

By mid-century, at a period of social and political upheaval caused by American sectional conflicts over the issue of slavery, the pastoral ideal expressed in such works as *West Rock* was appropriated by national art organisations, particularly the American Art-Union in New York. During its twelve years of existence (from 1839 to 1851), the American Art-Union came to rival the National Academy of Design as 'the leading forum for contemporary American art' and its exhibitions and lotteries reached tens of thousands.[53] Asher Durand's *Dover Plains, Dutchess County, New York* 1848 (cat.56) was selected to be engraved by the Art-Union because it seemed truthful to nature while providing an edifying message, and promoted patriotic sentiment:

> [I]t is not only nature that we want in our works of art, but it is our own nature, something that will awaken our sympathies and strengthen the bond that binds us to our homes.[54]

Durand's pastoral, panoramic view displays the Edenic qualities of American scenery — berry pickers at left, and grazing cattle on gentle plains provide a justification of the white settlers' claims to the land.

While New York-based artists painted pastoral views of the north-east, George Catlin continued to document the indigenous culture he encountered in the western territories. His ethnographic depictions reinforced the Europeans' belief that the way of life of the Native Americans was timeless and unchanging and that they had no impact on the land. As William Cronin has noted, we now know this was not the case: 'Indians profoundly altered the environments of North America, most notably through their use of fire', burning the land to allow it to regenerate.[55] However, to justify the unbridled expansion of white settlement, artists generally depicted Indians as nomadic roaming tribes, with no seeming relation to the natural world around them. Most painted images are of male Plains Indians on horseback as the 'noble hunter–savage' (fig.52). One rare exception, which only hints at the Indians' relationship to the earth, Catlin's *The Pipestone Quarry* 1848 (cat.55) continues to reinforce the idea of nomadic life but goes so far as to acknowledge the Indians' claim to the resources of the land at a communal site for spiritual purposes.[56]

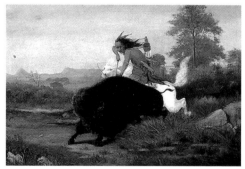

fig.52 Charles Wimar 1828–1862
Buffalo Hunt 1861
oil on canvas 55.9 x 83.8 cm (22 X 33 in)
The Thomas Gilcrease Institute of History and Art, Tulsa, Oklahoma

In Awe of the Land

fig.53 Frederic Edwin Church 1826–1900
Heart of the Andes 1859
oil on canvas 168.0 x 302.9 cm (66-1/8 x 119-1/4 in)
The Metropolitan Museum of Art, New York
Bequest of Mrs David Dows, 1909

By mid-century New York had become the base for the promotion of a national artistic culture, and most leading landscape painters were associated with the Hudson River School. The artistic community flourished through the National Academy of Design, the journal *The Crayon*, the American Art-Union, the opening of the Tenth Street Studio Building, the Artists' Fund Society, and the Century Club. Artists sought to come to terms with their nation's landscape, by this time transcending pictorial tradition to capture the essence of nature, including new scientific understandings regarding nature's processes and new ideas of the sublime. Challenged by the competitive climate for patronage in New York, artists strove to develop new, more painterly techniques to convey romantic landscape images, focusing on such subjects as water, forest interiors and mountains, that evoked the deeper meanings of nature. They employed bigger canvases to capture their expanding notions of landscape; the entrepreneurial spirit among leading painters resulted in 'the great picture'. Exhibitions of single works on a grand scale, such as Church's *Heart of the Andes* 1859 (fig.53), were presented to the public for a fee. Artists honed their marketing skills, seeking patronage amongst America's railroad magnates and robber barons, as well as looking to London and Europe in search of an international audience.

Frederic Church reigned at mid-century as the new world's most talented landscape painter. In 1850, upon reading Alexander von Humboldt's *Cosmos*, he was inspired by the descriptions of the world, particularly the tropics, which the scientist drew to the artist's attention as an ideal natural world. Church retraced von Humboldt's early travels through South America, making two trips in the 1850s. In search of creation's origins, and fascinated by the processes of nature, he painted a series of major South American landscapes.[57]

In 1856, between his trips to South America, Church read John Ruskin's *Modern Painters* volumes 3 and 4, and was so impressed that he reread the earlier volumes. Ruskin's discussion of water as 'to all human minds the best emblem of unwearied, unconquerable power', likely led Church to make water the central subject of two of his most important landscapes, *Niagara Falls* 1857 (cat.73) and *Coast Scene, Mount Desert* 1863 (cat.75).[58] Church broke new ground with these two paintings, employing innovative techniques for his daring compositions.

It was shortly after reading Ruskin that Church travelled to Niagara Falls for the first time, embracing its aesthetic challenge. And following von Humboldt's advice, he produced colour oil sketches for use in his studio — oil sketches being a relatively new approach to landscape painting. Church produced over seventy sketches including *Niagara Falls* 1856 (cat.72) in preparation for his final canvas.

The final conception for his grand-scale painting encompasses a view on the very brink of the western edge of Horseshoe Fall. By eliminating the foreground altogether, Church has created the psychological sensation that the viewer is suspended over the torrent itself. *Niagara Falls*, his first 'great picture', gained for him an international audience. The technical brilliance of this work and its extraordinary illusionism made him the most famous painter in America, and succeeded in impressing his British audience as well, including J.M.W. Turner and Ruskin.[59] As a North American landscape with nationalist overtones, Church presents the Falls as a symbol of the power and energy of the new world. Water as subject in conjunction with ideas concerning the erosion of the earth continued to attract Church, as seen in such technically brilliant works as his seascape *Coast Scene, Mount Desert*. Once again eliminating the foreground, Church places the viewer in direct confrontation with the sea and its sublime power.

While his readings of *Modern Painters* provided one of many influences on Church's art, a small band of New York-based artists, calling themselves The Association for the Advancement of Truth in Art, became strict disciples of Ruskin and the Pre-Raphaelite movement. A member, William Trost Richards demonstrates a mastery of the Pre-Raphaelite manner in his *In the Woods* 1860 (cat.74), with its adherence to Ruskin's call for 'truth to nature', seen in the brilliance of local colour and profuse

botanical detail in the foreground. This landscape commands a response completely different to that of the more conventional grand panoramas of the Hudson River School. *In the Woods* inspires the kind of reverential response toward the forest interior as a natural sanctuary, or primeval cathedral, found in such paintings as one of the same title by Asher B. Durand, *In the Woods* 1855 (fig.54), and expressed in such poems as William Cullen Bryant's 'A Forest Hymn'.

In addition to the influence of the English sublime found in Ruskin's writings, many American landscape painters sought training at mid-century in Düsseldorf where their exposure to German Romantic idealism was later demonstrated in romantic sublime paintings of the American landscape. Mountains of the north-east as well as the newly discovered mountains and valleys in the West persisted as favourite subjects of these artists (who were members of the Hudson River School) until the later part of the century.

Sanford Gifford's *A passing Storm in the Adirondacks* 1866 (cat.76) was painted for the private picture gallery of Elizabeth Colt, widow of the arms manufacturing magnate Samuel Colt, at a considerable price that demonstrates the artist's entrepreneurial talents.[60] Gifford has depicted a scene in the Adirondack mountains that includes two themes of central interest to him during the Civil War era — storm imagery and the pioneer in the wilderness. Between 1859 and 1868, Gifford employed storm imagery, perhaps as a symbol of civil discord, painting a series of 'coming', 'approaching' and 'passing' storm scenes that may have related to the effects of the Civil War.[61] *A passing Storm in the Adirondacks* was painted in the war's aftermath, ironically commissioned by Elizabeth Colt who oversaw the management of Colts Arms Manufactory, which had supplied both the North and South with guns during the conflict.[62] The thinly veiled atmosphere of the storm passes over a pastoral scene that conveys the theme of the pioneer in the wilderness, which was still a pervasive subject in landscape art after mid-century.

While some early nineteenth-century painters had expressed their fears regarding unbridled progress and the impending loss of wilderness, most notably seen in the cut tree trunks placed as warnings in the foreground of Cole's landscapes, by mid-century many American landscapes showed a harmonious balance between nature and technology.[63] Samuel Colman's *Storm King on the Hudson* 1866 (cat.77), for example, combines the region's scenic grandeur with its commercial power. All manner of river traffic is depicted on the calm river waters, including eight steam transport barges, two sailing boats and two row-boats. Storm King Mountain, just north of West Point, was said to have been named for the meteorological phenomenon of storm clouds that gather at its peak. Colman merges the mountain's dark clouds with smoke from the steamers, weaving a tapestry of the natural and the man-made.

In May 1869 a golden spike was driven into the ground at Promontory Point, Utah, in celebration of the joining of the Union Pacific and Central Pacific lines, marking the first transcontinental railroad. Rising from the ashes of the Civil War, railroad companies expanded westward in the post-war years, laying 150,000 kilometres (93,000 miles) of track by the 1890s. Jasper Cropsey painted his grand-scale panorama *Sidney Plains with the Union of the Susquehanna and Unadilla Rivers* 1874 (cat.80) — an inventory of a landscape that had been transformed from wilderness to one replete with signs of modern technology. This work is thought to have been painted for the railroad magnate John Taylor Johnston.[64] The composition juxtaposes numerous pastoral and mechanical references. A railroad trench at the lower left, lined with telegraph poles, runs parallel to a gully filled with grazing sheep. Cows graze in the plains along the river, while on the other side a train cuts across the same horizontal path. Brilliant rays of sun provide a divine presence in this landscape, while human presence seems dwarfed in this large, flat valley.

As the railroads opened the West, America's landscape painters rode out with them. Albert Bierstadt's *View of Donner Lake, California* 1871–72 (cat.78), commissioned by Colis P. Huntington, director of the Central Pacific railroad, was painted in preparation for a large-scale version, *Donner Lake from the Summit* c.1873 (fig.55), which was intended as a promotional tool for the company. The site became notorious in 1846

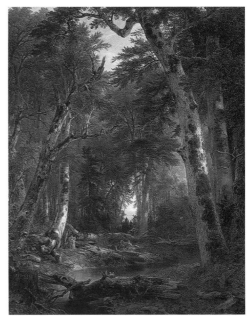

fig.54 Asher B. Durand 1796–1886
In the Woods 1855
oil on canvas 153.5 x 124.5 cm (60-1/2 x 49 in)
The Metropolitan Museum of Art, New York
Gift in memory of Jonathan Sturges by his children, 1895

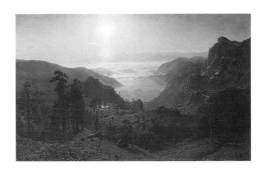

fig.55 Albert Bierstadt 1830–1902
Donner Lake from the Summit c.1873
oil on canvas 182.9 x 304.8 cm (72 x 120 in)
© Collection of the New-York Historical Society

when the Donner party of settlers, trapped by a snowstorm in the mountain pass at the summit of the Sierra Mountains, resorted to cannibalism to survive. The Central Pacific constructed snowsheds, clearly seen in *View of Donner Lake*, as a solution to the problem of passing through this mountain range, which had been one of the last remaining barriers to immigrants moving west. Bierstadt's depiction, which alludes to the Donner party tragedy in the large cross at the left centre of the landscape, attempts to show that western wilderness retains its beauty despite the triumph of technology.

As the leading painter of the American West, with an entrepreneurial spirit that rivalled that of Frederic Church, Bierstadt not only aligned himself with the railroads, but in order to gain national recognition he also went so far as to rename the mountains in his western paintings for leading patrons. He went to such lengths in order to place a major work in the Corcoran Art Gallery, a cultural institution that opened in the nation's capital in 1874: the painting Bierstadt had exhibited at the National Academy of Design in 1877 — typical of his epic western landscapes and titled simply *Mountain Lake* — was renamed *Mount Corcoran* in order to attract the patronage of William Corcoran who placed it in the museum he founded.

Thomas Moran was the most prominent of the landscape artists to follow Bierstadt's lead by focusing on the distinctive landscape of the Far West in the 1870s. He became part of the survey team led by Ferdinand Hayden that explored the Yellowstone region in the Wyoming Territory, and he produced watercolour field sketches including *Hot Springs of Gardiners River, Yellowstone National Park* 1872 (cat.79) and such finished oils as his massive and spectacular *The Grand Canyon of the Yellowstone* 1872 (fig.56, version of 1893–1901), which helped to influence Congress in its decision in 1874 to declare the Yellowstone area America's first national park.

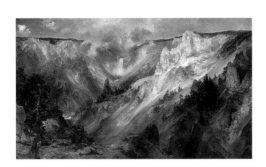

fig.56 Thomas Moran 1836–1926
The Grand Canyon of the Yellowstone 1893–1901
oil on canvas 245.1 x 427.8 cm (96-1/2 x 168-3/8 in)
National Museum of American Art, Smithsonian
Institution, Washington, DC Gift of George D. Pratt

A Landscape of Contemplation

American landscape painters who established their careers after mid-century continued to explore familiar scenery in the north-east, but their landscapes demonstrated new aesthetic concerns. In the 1860s and 1870s Americans, who travelled in greater numbers to Europe, became more cosmopolitan in their tastes. Artists sought training and inspiration in Europe at the same time as American patrons supported the large-scale importation of European art. Several new trends rooted in European art began to have an impact on art in America including French Barbizon landscape painting, the Munich School, and the British-inspired Aesthetic movement. It was in the late 1870s that the term Hudson River School was first introduced, and used at the time in a disparaging way to describe the panoramic vision and precise detail of such artists as Asher B. Durand, Frederic Church, and Albert Bierstadt, among many others whose works began to appear conservative in the face of new stylistic concerns.[65] Additionally, advancements in photography threatened the landscape painters' hegemony over this newer, more 'truthful' medium.[66] These changes signalled a transitional phase in landscape art that was resolved by the end of the century when the figure loomed prominently in the landscape, often replacing nature as the essential subject.

Beginning in the 1860s, some Hudson River School painters, most notably Sanford Gifford and John Kensett, painted light-infused atmospheric landscapes that demonstrate their shift in artistic priorities. Paintings such as Gifford's *Kauterskill Clove* 1862 (cat.93) and Kensett's *Coast Scene with Figures (Beverly Shore)* 1869 (cat.95), in which detail and spatial effects have been starkly reduced, have come to be termed 'luminist' paintings in this century.[67] New understandings of the scientific theories of natural law including Charles Darwin's *On the Origin of Species* (1859) which described the evolution of nature as a process of natural selection marked by random variations, and Charles Lyell's uniformitarian theories of geology which held that changes in the earth's surface occurred slowly over extremely long periods of time, added to the changes in landscape art. Widespread in his writing, John Ruskin expressed the new response to nature:

It is not in the broad and fierce manifestations of the elemental energies, not in the clash and hail, nor the drift of the whirlwind, that the highest characters of the sublime are developed. God is not in the earthquake, nor in the fire, but in the still small voice.[68]

Sanford Gifford's masterful *Kauterskill Clove* marks a shift away from the rugged, masculine associations of the romantic sublime — seen in such works as Cole's *A View of the Mountain Pass called the Notch of the White Mountains* 1839 (cat.53) or Bierstadt's *Mount Corcoran* c.1875–77 (cat.81) — toward a contemplative sublime, realised in the painting's emphasis on atmospheric space, described by Gifford as 'air painting'.[69] Here he revisits a familiar site, first made famous by Cole's *The Clove, Catskills* c.1826 (cat.30) — a view toward the east with the Berkshire Mountains visible in the distance. Gifford abandons the romantic sublime emphasis on the fearsome aspects of wild nature that Cole depicted in his psychologically charged mountain image, enhanced by passing storm clouds, blasted tree trunks, brilliant autumnal colour and the inclusion of a Native American. Instead Gifford chooses a vantage point looking west toward Haines Falls, thus focusing the composition on a great cavity of light-filled atmosphere rather than the traditional massive mountain forms. Human presence is diminished — a hunter and his dog ascending the rock ledge at the lower left are barely visible. The viewer confronts an expanse of hushed stillness that is intended as a subject of meditation.[70]

While Gifford favoured atmospheric spaces over massive mountains, Fitz Hugh Lane and John Kensett depicted local shoreline scenery, evoking a similar, contemplative sublime emotion where the coastline is seen as quietly mysterious. Lane's *Brace's Rock, Brace's Cove* 1864 (fig.57) depicts a relatively inaccessible stretch of the Cape Ann, Massachusetts shoreline. The pervasive stillness is emphasised by the simplification and abstraction of forms in a carefully balanced, calmly ordered composition, with radiant effects of light.[71] Kensett's *Coast Scene with Figures (Beverly Shore)* is a mature work and one of his largest canvases. The tightly controlled brushwork, subtle palette and emphasis on delicate atmospheric effects, combined with a reductive composition made up of two large masses of land and water, harmoniously balanced against the larger mass of the sky, are distinctive characteristics of his later work. Humans on the shoreline contemplate a benign setting, disturbed only by the giant breakers about to crash on the shore.

More typical of the intimate scale favoured by artists at this time is Martin Johnson Heade's *View of Marshfield* 1865-70 (cat.94). Heade produced more than one hundred landscapes investigating the haystacks seen along the coastal marshes of the north-east. In these works, he explored the evanescent effects of light and weather. Salt marshes were interesting as subjects because, neither wild nor domesticated, they are beyond human control; the grass grows without cultivation, and although harvesting takes place little change is made to the marshes.[72]

In his landscapes of the South, the St Louis-based artist Joseph Meeker examined the mysteries of the mists that emanated from the swamps along the Mississippi.[73] Meeker's paintings retain the earlier associative elements absent from the landscapes of Gifford, Kensett, and Heade, but include mysterious, mournful aspects of nature, seen in rising mists and the drapery of moss-covered trees. Painted in the aftermath of the Civil War, Meeker's *The Land of Evangeline* 1874 (cat.96) refers to Henry Wadsworth Longfellow's poem 'Evangeline', a tale of lost love. Set in the seventeenth century, it deals with the arrival of French Canadians or Acadians in southern Louisiana.

During the 1870s and 1880s, artists favoured tamed landscapes rather than the wilderness of Cole and Church. The evocative, romantic style of tonalism emerged in 1880s landscape art, strongly influenced by the lyrical nocturnes of James McNeill Whistler (fig.58) and, like Whistler, inspired in part by Asian art, particularly Japanese prints. Landscape painters used a limited range of colours, often a single tone, to create softly lit scenes in which detail is obscured.

George Inness proved to be one of the most dynamic American landscape painters of the third quarter of the century. Inspired by Barbizon painting, which emphasised

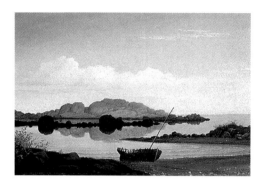

fig.57 Fitz Hugh Lane 1804–1865
Brace's Rock, Brace's Cove 1864
oil on canvas 26.0 x 38.7 cm (10-1/4 x 15-1/4 in)
Daniel J. Terra Collection, Terra Museum of American Art, Chicago, Illinois

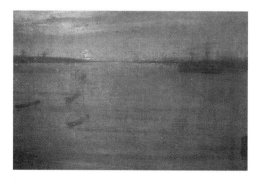

fig.58 James Abbott McNeill Whistler 1834–1903
Nocturne: Blue and Gold — Southampton Water 1872
oil on canvas 50.5 x 76.0 cm (19-7/8 x 29-15/16 in)
The Art Institute of Chicago, Illinois
The Stickney Fund, 1900.52

mood and expression over topography, he sought the local, more civilised landscape that he felt was 'more worthy of reproduction than that which is savage and untamed'.[74] Inness worked from memory and imagination, distancing himself from the immediate experience of nature and often painting over earlier canvases. In his mature landscapes, such as *Winter Morning, Montclair* 1882 (cat.97), he produced a breadth of effect, focusing on the formal qualities of the winter landscape. Painting his favoured, local New Jersey landscape, he strove 'to awaken an emotion' with the composition's fragile beauty and restrained harmonies of colour.[75] Like Inness, Dwight Tryon presents his favourite subject in *First Leaves* 1889 (cat. 98) — simple, local scenery. According to the artist, the work was inspired by a 'walk among the trees in early May' in the meadows of Dartmouth, Massachusetts.[76] This was the first in a series of landscapes in which Tryon depicted a graceful line of tall white birch trees, marked by a stone wall. The trees serve as a screen between the viewer and the landscape beyond, a device also employed by Inness. Both artists used screens made up of thinly painted trees, the branches of which sit at the surface of the canvas, tantalising the viewer to peer into the deep space beyond.

The individual artist's personal response to nature is also found in the landscapes of John Twachtman, whose *Winter Harmony* c.1890–1900 (cat.100) excels as an example of the evanescent winter scenes he painted of Horseneck Brook on his property in Greenwich, Connecticut. Twachtman developed an individual impressionist style that captured the subtleties of changing conditions of season and weather. Kathleen Pyne has noted that for Twachtman, who trained in the cosmopolitan centres of New York and Paris, the rural countryside of Connecticut existed 'as a psychological and spiritual antidote — a place where individual identity and selfhood, depleted by the demands of the modern urban arena, could be reinstated'.[77] Hailed for his depictions of the emotive beauties of the winter season, Twachtman's personal approach to nature, his preference for the indistinct light of the dawn and dusk, moonlight and mists, was shared with artists at the end of the century, including Inness, Tryon, and Thomas Wilmer Dewing (1851–1938) (fig.59). In *Winter Harmony*, Twachtman transferred his masterful technique in pastel to oil painting, overlaying cool and warm tones of white and violet that produce a dry, opalescent colour effect, evoking a mood of contemplation.

In his brief career, Dennis Miller Bunker painted some of the earliest and most beautiful American impressionist landscapes. *Wild Asters* 1889 (cat.99) represents the culmination of Bunker's assimilation of the impressionist aesthetic, as seen in the light filled, freely brushed and richly coloured close-up view of the meadow and stream in Medfield, Massachusetts. As Bunker explained:

> The highest phase of art is to be perfectly lovely, gorgeous, or beautiful, through some quality, of light, or life, or solemnity, or richness, or loving elaboration of delicate forms, anything so that it be a gracious and beautiful canvas to look at.[78]

The American impressionist Theodore Robinson sought solace in his nostalgic views of the Delaware and Hudson Canal in Napanoch in the Shawungunk Mountains (a site favoured by Hudson River School artists earlier in the century). By the time Robinson painted the canal, in 1893, it was only a reminder of the commercial ambitions of the past, long since lost to the railroads.[79] One of the series, *White Bridge on the Canal (White Bridge near Napanoch)* 1893 (cat.101), celebrates the beauty of the ordinary. Robinson focuses attention on the structure of a white bridge, reducing the various components of the composition to geometric planes, using a modern compositional structure to provide a tranquil glimpse of a rural American past.

The Figure defines the Landscape

By the end of the century the American frontier was declared 'closed' by the young historian Frederick Jackson Turner. In 1893, four years after the Oklahoma Territory, the last tract of western Indian land, was opened to non-Indian settlement, Turner delivered his lecture entitled 'The Significance of the Frontier in American History'. He declared

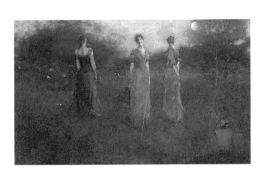

fig.59 Thomas W. Dewing 1851–1938
In the Garden c.1889
oil on canvas 52.3 x 88.9 cm (20-5/8 x 35 in)
National Museum of American Art,
Smithsonian Institution, Washington, DC
Gift of John Gellatly

frontier is gone and with its going has closed the first period of American history'. As one recent historian has noted, however, Turner's frontier thesis rested on a single point of view: 'it required that the observer stand in the East and look to the West', interpreting the western frontier as a process rather than a place that continues to have a history.[80] American artists returning home from European sojourns in the 1870s and 1880s found that the earlier agrarian society had rapidly shifted by the final decades of the century to an industrialised and increasingly urban culture. Artists such as Winslow Homer and William Merritt Chase turned their attention to depictions of modern life, capturing fleeting moments, as well as to subjects that reflected the need to retreat from the fast pace of humans in the changing American landscape. Placing the figure prominently in nature, American landscape artists drew on the academic training they had gained in Europe. When compared to early landscapes that featured tourists admiring nature from a distance, the shift in balance was complete by century's end — humans were fully integrated into a landscape that they cared for and often controlled. Shorelines and wilderness mountains, urban parks and gardens, became the sites for leisure activities and spiritual renewal — an escape from modern urban living.

Beach scenes, a modern phenomenon, also became the subject of landscape art. Americans now enjoyed open access to nature that prior to the Civil War had been the preserve of the privileged classes. The proximity of New York City to the newly popular summer resort of Long Branch, New Jersey, allowed a broader cross-section of people, a democratic mix, to enjoy the seaside. With the eye of a sociologist, Winslow Homer acknowledges the social aspect of the landscape in his light-filled painting of this subject *Long Branch, New Jersey* 1869 (cat.115). He focuses the viewer's gaze on two women, clearly overdressed for the beach, engaged in another popular preoccupation, as noted at the time: 'Many a Heart has been lost in the surf here … The surf and flirtation make the main business of life at the Branch, with a slight advantage in favor of the latter.'[81] Homer also turned his attention to wilderness sites as appropriate places for renewal and, in the process, as Sarah Burns has written, Homer revitalised the 'painted-out' northern landscape. For men, wilderness served a twofold purpose, important by century's end — 'individual hardening through rough living, and reinforcement of the male bonding', crucial to a world of corporate bureaucracy amongst members of an elite class threatened by an increasingly heterogeneous society.[82] Homer's masterful painting *Two Guides* c.1875 (cat.116) depicts Orson 'Old Mountain' Phelps, one of the most famous Adirondack guides, and the younger Monroe Holt, standing on a clear-cut slope, with Beaver Mountain in the background.[83] The two woodsmen carry axes, and are linked to the wilderness through their attire, with complementary touches of red and green found in the natural surroundings. Phelps carries an Adirondack pack basket which he made himself, inspired by the tradition of north-east Native Americans. He imparts his knowledge of the wilderness to the younger guide who follows his pointing gesture. The figures of the guides, rather than serving as narrative vignettes in a larger landscape (see cats 30, 32) have, by the late nineteenth century, become the central subject of wilderness landscape, symbolic of the values of rugged independence and self-sufficiency admired by an increasingly urban society.

In sharp contrast, William Merritt Chase pursued *plein-air* painting techniques in his intimate renditions of Manhattan and Brooklyn parks, responding to the influence of contemporary French painting. Thought to be a depiction of Tompkins Park in Brooklyn, *A City Park* c.1887 (cat.118) displays this influence in the dramatic spatial effects, high-keyed palette, fluid brushwork and small scale.[84] Chase celebrates the democratic nature of the city parks and carefully balances both their natural and constructed elements. In his quiet, uncrowded scenes of women and children, New Yorkers escape the surrounding bustle, and here contemplate nature's beauty while engaging in games such as lawn tennis.[85] In 1891 Chase took up residence in Shinnecock, by this time a beach resort on eastern Long Island where he taught the art of *plein-air* painting to students at his summer art school. The gently rolling dunes, shimmering blue water, and cloud-filled sky become the subject of more private landscapes, peopled with figures representing members of his own family. These paintings

complemented the more public New York park scenes as settings of genteel leisure. In *Untitled (Shinnecock Landscape)* c.1892 (cat.120), Chase creates a bucolic balance of domesticity and nature; his children are shown at play in the dunes in front of the family house, all in perfect accord with the natural setting around them.

Women and men loom large in the landscapes of the period, often as the creators of their surroundings. Thomas Eakin's *Mending the Nets* 1881 (cat.117) was based on a series of photographs as well as oil studies the artist made of shad fishermen in Gloucester, New Jersey. Eakins succeeds in assembling a seamless composition of men integrated into their surroundings, quietly preoccupied with their work, which creates a 'sense of the timeless poetry of the everyday'.[86]

In contrast to the workaday world of the New Jersey fishermen, Childe Hassam portrays the poet Celia Laighton Thaxter in her island garden on Appledore, a creative retreat for artists, writers, and musicians off the coast of New Hampshire. *In the Garden (Celia Thaxter in her Garden)* 1892 (cat.121) depicts Thaxter lost in reverie as she stands firmly in the midst of her creation as the garden's designer. The carefully selected and planted flowers are as described by Thaxter, 'a sea of exquisite color swaying in the light', in contrast to the wilder aspects of the island viewed just beyond the fence.[87] As in earlier works (cats 49, 61), the fence provides a demarcation between cultivated and wilderness landscape.

In Homer's series of Prout's Neck seascapes of the 1890s, a direct confrontation takes place between the viewer and the beauty and power of nature's eternal drama, the stormy sea crashing against the rocky coast. In the early works in this series, Homer often included the mediating figures of men and women on the coast, watchful or, more often, in danger. In his late works, he reduces his compositions, moving closer to the rocks, and often eliminating figures altogether. In *Northeaster* 1895 (see fig.24), Homer originally included in the lower left two men in foul-weather gear on the rocks, confronting the fury of an autumn storm, but he chose to paint out the two figures at some point before 1900. In *Maine Coast* (cat.122), painted in 1896, Homer reduces the natural world to its fundamental elements, eliminating virtually all the landscape elements with the exception of a few rocks, allowing the viewer to confront directly the rough coastal waters.

While landscape art continued to emanate from the cultural centres of the northeast, the western landscape as subject grew over the course of the nineteenth century, taking hold as portrayal of a powerful myth for Americans at the turn of the century. Like Homer's heroic guides to the wilderness, American cowboys, independent and reliant, became a source of legend and rose to national prominence in the late nineteenth century at the very moment their role as cow herders became obsolete.[88] Cowboys became the subject of western landscape paintings. The popular New York illustrator and painter Frederic Remington created romantic images of the Old West where cowboys and Indians continued their conflict for dominance over the land. In one of his most famous paintings, *Fight for the Water Hole* c.1903 (cat.123), five cowboys bravely defend a waterhole against attacking Indians. Remington's seemingly 'natural' settings, seen here in the spent cartridges of the cowboys' rifles and the harsh south-western desert, and his recurring theme of the 'Last Stand', have lived on in the myths and movies of twentieth-century America.[89]

Over the course of the nineteenth century, landscape painters in the United States investigated the transformation of the wilderness forests to cultivated fields as European settlement took hold from the eastern to the western edges of the North American continent. In their aesthetic inquiries these artists explored the the nation's geography including its picturesque river valleys and sublime natural wonders; wilderness mountains and forests; swamps and vast deserts. As Americans laid claim to the land, inscribing it with property lines, artists painted the newly built houses, recently settled towns, and flourishing cities. At the same time, artists imbued their landscapes with uniquely American historic associations. Moving westward, artists documented the imminent extinction of Native Americans as they were forced off their lands. Scientific and religious knowledge provided deeper meanings for landscape and nature at mid-century, expressed by painters in ever larger canvases. As the century progressed, landscape and landscape painting served as a vehicle for therapeutic retreat from an increasingly industrial, urban-based society. By the end of the century, the transformation process was seemingly complete. Humans' changed relationship to nature — from subject to master — was revealed in landscape art and, by century's end, figure painting effectively replaced landscape as the leading artistic genre.[90]

Elizabeth Mankin Kornhauser

This essay has greatly benefited from the reading of Carol Troyen, Associate Curator, Museum of Fine Arts, Boston.

1 For much of the eighteenth century Edmund Burke's definitions of the beautiful, meaning the harmonious, sensual, feminine aspects of nature, and the sublime, which he associated with the harsh, masculine, horrific aspects of nature, were widely accepted. See Edmund Burke, *A Philosophical Inquiry into the Origins of Our Ideas of the Sublime and Beautiful* (1757–1759), James T. Boulton ed., Notre Dame and London: University of Notre Dame, 1968. With the growing interest in landscape painting and tourism by century's end, the category of the picturesque resulted, and was defined in the writings of Gilpin, Price and Knight. For a discussion of their writings, and the changing definitions of the picturesque, see Malcolm Andrews, *The Search for the Picturesque,* Stanford: Stanford University Press, 1989.

2 Gilpin, quoted in Michael Rosenthal, 'Landscape as High Art', in *Glorious Nature: British Landscape Painting 1750–1850,* exhibition catalogue, Denver: Denver Art Museum, 1993, pp.13–30, p.14.

3 Gilpin, quoted in Edward J. Nygren, with Bruce Robertson et al., *Views and Visions: American Landscape before 1830,* exhibition catalogue, Washington, DC: The Corcoran Gallery of Art, 1986, p.18.

4 Timothy Dwight, *Travels in New England and New York 1769–1815,* 3 vols (1822), reprint, Barbara Miller Solomon ed., Cambridge, Massachusetts: Harvard University Press, 1969; Benjamin Silliman, *Remarks made, on a Short Tour, between Hartford and Quebec, in the Autumn of 1819* (1820), reprint, New Haven: Converse, 1824; Theodore Dwight, *Northern Traveler,* New York: Wilder and Campbell, 1826, Theodore Dwight, *Sketches of Scenery and Manners in the United States,* New York: Goodrich, 1829, and Theodore Dwight, *Things as They Are; Notes of a Traveler through Some of the Middle and Northern States,* New York: Harper, 1834.

5 Silliman, *Remarks made, on a Short Tour, between Hartford and Quebec* (1820), p.18.

6 As Alan Wallach notes, Cole's painting hints at the experience of what he calls the 'panoptic sublime' that was afforded by the view from the tower, providing both panoramic or visual mastery of the scene with telescopic vision resulting in 'a sudden loss of boundaries'. See Alan Wallach, 'Wadsworth's Tower: An Episode in the History of American Landscape Vision', *American Art,*10, no.3, Fall 1996, pp.8–27, p.22.

7 Thomas Cole, 'Essay on American Scenery', 1835, in John W. McCoubrey, *American Art 1700–1960,* Englewood Cliffs: Prentice-Hall, Inc., 1965, pp.98–109, p.106.

8 Nygren, with Robertson et al., *Views and Visions* (1986), pp.42–57.

9 John F. Sears, *Sacred Places: American Tourist Attractions in the Nineteenth Century,* New York: Oxford University Press, 1989, p.13.

10 Fred Barry Adelson, *Alvan Fisher (1792–1863): Pioneer in American Landscape Painting* (Ph.D. diss., Columbia University, 1982), Ann Arbor, Michigan: University Microfilms International, 1985, vol.1, pp.167–188.

11 Jeremy Elwell Adamson et al., *Niagara: Two Centuries of Changing Attitudes, 1697–1901,* exhibition catalogue, Washington, DC: The Corcoran Gallery of Art, 1985, p.35, n.90.

12 Sears, *Sacred Places* (1989), p.120.

13 'Hudson River School' was originally intended as a derogatory label, first used in the late 1870s, that called attention to the provinciality of the painters; see Kevin J. Avery, 'A Historiography of the Hudson River School', in John K. Howat, *American Paradise: The World of the Hudson River School,* exhibition catalogue, New York: The Metropolitan Museum of Art, 1988, pp.3–20; also see Angela Miller, *The Empire of the Eye: Landscape Representation and American Cultural Politics, 1825–1875,* Ithaca and London: Cornell University Press, 1993, pp.21–65.

14 See Christine Stansell and Sean Wilentz, 'Cole's America', in William H. Truettner and Alan Wallach eds, *Thomas Cole: Landscape into History,* exhibition catalogue, New Haven and London: Yale University Press, for the National Museum of American Art, 1994, pp.3–23.

15 Marshall Tymn ed., *Thomas Cole: The Collected Essays and Prose Sketches,* St Paul, Minnesota: John Colet Press, 1980, p.131.

16 Truettner and Wallach eds, *Thomas Cole: Landscape into History* (1994), p.51.

17 John K. Howat, 'A Picturesque Site in the Catskills: The Kaaterskill Falls as Painted by William Guy Wall',
 in *Honolulu Academy of Arts Journal,* 1, 1974, pp.20–21.
18 Katherine E. Manthorne with John W. Coffey, *The Landscapes of Louis Rémy Mignot: A Southern Painter Abroad,*
 exhibition catalogue, Washington and London, Smithsonian Institution Press, 1996; Ella-Prince Knox et al.,
 Painting in the South: 1564–1980, exhibition catalogue, Richmond: Virginia Museum, 1983.
19 Miller, *The Empire of the Eye* (1993), pp.233–234.
20 Henry Wiencek, *Smithsonian Guide to Historic America: Virginia and the Capital Region,* New York:
 Stewart, Tabori and Chang, 1989, p.236.
21 Thomas Jefferson, *Notes on the State of Virginia: written in the year 1781, somewhat corrected and enlarged
 in the winter of 1782 ...*, Paris: Printed 1784–85, p.21.
22 Ibid., quoted in Charles C. Eldredge et al., *American Originals: Selections from Reynolda House,
 Museum of American Art*, New York: Abbeville Press, 1990, p.58.
23 Church owned editions of Alexander von Humboldt's *Cosmos; Personal Narratives;* and *Aspects of Nature*.
24 Isabella P. Judson, *Cyrus W. Field, His Life and Work*, New York, 1896, p.39.
25 Thomas Jefferson owned a slave named Patrick Henry who guided visitors through the Natural Bridge site.
 The current owner of the Bridge was William M. Lackland; see J. Lee Davis, *Bits of History and Legends Around
 and About the Natural Bridge of Virginia*, Lynchburg, Virginia: Brown-Morrison Co., c.1949., pp.44–45.
26 Robert Kincaid, *The Wilderness Road*, New York: Bobbs-Merrill Co., 1947.
27 Sears, *Sacred Places* (1989), p.32.
28 Ibid., p.38; the cave's owners allowed small groups to travel through the cave, but only in company with a guide,
 Stephen Bishop, who was also their slave. Becoming renowned in his own right Bishop was described by Nathaniel
 Willis as 'a slave, and part mulatto and part Indian, but with more of the physiognomy of a Spaniard ... he is famous for the
 dexterity and bodily strength which are necessary to his vocation'. quoted in ibid., p.33; in Nathaniel Parker Willis,
 Health Trip to the Tropics, New York: Scribner, 1854, p.149.
29 Quoted in Sears, *Sacred Places* (1989), p.43
30 Miller, *The Empire of the Eye,* (1993), p.238.
31 My thanks to Robert M. Hinklin Jr and Melinda Young Stuart for providing information on this painting.
32 Karl W. Butzer, 'The Indian Legacy in the American Landscape', in Michael P. Conzen ed., *The Making of the
 American Landscape* (1990), reprint, New York and London: Routledge, 1994, p.27.
33 George Catlin, *Letters and Notes on the Manners, Customs, and Condition of the North American Indians,*
 2 vols (London, 1841), reprint, New York: Dover, 1973, vol.1, p.16.
34 For a discussion of landscapes of the plains, see Joni L. Kinsey, *Plain Pictures: Images of the American Prairie,*
 Washington and London: Smithsonian Institution Press for the University of Iowa, 1996.
35 David B. Danbom, *Born in the Country: A History of Rural America*, Baltimore and London: John Hopkins
 University Press, 1995, pp.135–139.
36 Catlin, *Letters and Notes* (1841), vol.1, pp.261–262.
37 J. Gray Sweeney, *Drawing the Borderline: Artist-Explorers of the U.S.–Mexico Boundary Survey*, exhibition
 catalogue, Albuquerque, New Mexico: The Albuquerque Museum, 1996, p.13.
38 Alexis de Tocqueville, *Democracy in America* (1835, 1840), reprint, New York: Vintage Books, 1954, p.2.
39 In 1844 the growing popular sentiment for expansionism, including the annexation of Texas, led to the election
 of James K. Polk as President of the United States. The phrase that captured this expansionist spirit became
 'Manifest Destiny', first used in 1845 in a speech by the New York Democratic journalist John L.O.Sullivan,
 who wrote of the 'our manifest destiny to overspread and to possess the whole of the continent which Providence has
 given us for the development of the great experiment of liberty and federative self-government entrusted to us'.
 See Frederick Merk, *Manifest Destiny and Mission in American History* (1963), reprint, Cambridge, Massachusetts:
 Harvard University Press, 1995, p.32. The term was widely embraced at mid-century to justify western expansion.
40 Boardman related his entrepreneurial preoccupations in a letter to his brother-in-law, writing: 'I confess my busy mind
 is anxiously employed in pursuit of wealth.' Elijah Boardman to Samuel Whiting, March 1790, quoted in Elizabeth
 Mankin Kornhauser, '"By Your Inimitable Hand": Elijah Boardman's Patronage of Ralph Earl', *The American Art
 Journal,* 23, no.1,1991, p.8.
41 By the end of the eighteenth century, English ideas about landscape gardening began to influence Americans. The first
 comprehensive book on gardening for the American climate and soil appeared at about this time: Bernard McMahon's,
 American Gardener's Calendar, Philadelphia: Printed by B.Graves for the author, 1906. See Ann Leighton, *American
 Gardens in the Eighteenth Century: For Use or for Delight*, Boston: Houghton, Mifflin, 1976; and Ann Leighton,
 American Gardens of the Nineteenth Century: 'For Comfort and Affluence', Amherst: University of Massachusetts
 Press, 1987.
42 Nygren, Robertson et al., *Views and Visions* (1986), p.144.
43 Simon Schama, *Landscape of Memory*, New York: Alfred A. Knopf, 1995, p.664.
44 Quoted in Truettner and Wallach eds, *Thomas Cole: Landscape into History* (1994), pp.53–54; Thomas Cole,
 'Essay on American Scenery', in Tymn ed., *Thomas Cole: The Collected Essays* (1980), pp.16–17.
45 Miller, *The Empire of the Eye* (1993), p.83.
46 Ibid., p.108.
47 Nygren, Robertson et al., *Views and Visions* (1986), p.58.
48 Thomas Cole to Daniel Wadsworth, 4 August 1827, in J. Bard McNulty ed.,*The Correspondence of Thomas Cole
 and Daniel Wadsworth*, Hartford: Connecticut Historical Society, 1983, p.12.
49 Richard Slotkin, introduction to James Fenimore Cooper, *Last of the Mohicans*, New York: Penguin, 1988, pp.ix–xxviii.
50 Sears, *Sacred Places* (1989), pp.72–86.
51 Thomas Cole, 'Sketch of My Tour to the White Mountains with Mr. Pratt', *Bulletin of the Detroit Institute of Arts,*
 66, no.1,1990, p.28.
52 There is a second version of the painting, *The Charter Oak, at Hartford* (Hartford Steam Boiler Inspection and
 Insurance Company, Hartford, Connecticut).
53 Carol Troyen, 'Retreat to Arcadia: American Landscape and the American Art-Union', *The American Art Journal,*
 23, no. 1,1991, p.21.
54 *Bulletin of the American Art Union*, 1848, quoted in ibid., p.31.
55 William Cronin, 'Telling Tales on Canvas: Landscapes of Frontier Change', in Jules David Prown ed., *Discovered
 Lands, Invented Pasts: Transforming Visions of the American West*, New Haven and London: Yale University Press,
 1992, pp.37–87, p.51.
56 Ibid.
57 Katherine Emma Manthorne, *Tropical Renaissance: North American Artists Exploring Latin America, 1839–1879,*
 Washington and London: Smithsonian Institution Press, 1989.
58 Ruskin, quoted in David C. Huntington, *The Landscapes of Frederic Edwin Church: Vision of an American Era*,
 New York: Braziller, 1966, pp.65–66.
59 Adamson et al., *Niagara* (1985), pp.15–17.

60 Elizabeth Mankin Kornhauser et al., *American Paintings before 1945
 in the Wadsworth Atheneum*, New Haven and London: Yale University Press, 1996, vol.2, p.26.

61 A convincing argument concerning Gifford's response to the Civil War is presented in Ila Weiss, *Poetic Landscape:
 The Art and Experience of Sanford R. Gifford*, American Art Series, Newark: University of Delaware Press, 1988,
 p.260.

62 Kornhauser et al., *American Paintings before 1945 in the Wadsworth Atheneum* (1996), vol.1, pp.22–30; vol.2,
 pp.404–407.

63 The concept of the technological sublime is explored in David E. Nye, *American Technological Sublime*, Cambridge,
 Massachusetts and London: MIT Press, 1994.

64 Ilene Susan Fort and Michael Quick, *American Art: A Catalogue of the Los Angeles County Museum of Art*,
 Los Angeles County Museum, 1991, p.161.

65 Doreen Bolger Burke and Catherine Hoover Voorsanger, 'The Hudson River School in Eclipse', in Howat et al.,
 American Paradise (1988), pp.71–98, pp.71–73.

66 Ibid., pp.74–75.

67 While scholars have tended to define this mode as a unified approach to landscape art, carried out by a second
 generation of Hudson River School painters whose quiet, simplified style emerged after the Civil War (and perhaps
 in response to that conflict), the term Luminist as well as the concept remains controversial. The major works
 on Luminism include: John I.H. Baur, 'Early Studies in Light and Air by American Landscape Painters',
 Bulletin of the Brooklyn Museum, 9, Winter 1948, pp.1–9; John I.H. Baur, 'American Luminism: A Neglected Aspect
 of the Realist Movement in Nineteenth-Century American Painting', *Perspectives USA*, 9, Autumn 1954, pp.90–98;
 Barbara Novak, *American Painting of the Nineteenth Century: Realism, Idealism, and the American Experience*
 (1969), rev. edn, New York: Harper and Row, 1979; and John Wilmerding ed., *American Light: The Luminist
 Movement, 1850–1875*, exhibition catalogue, Washington, DC: National Gallery of Art, 1980. In more recent years,
 scholars have offered new, more contextually- and psychologically-based interpretations for this mode, exploring new
 definitions of the sublime in nature, as seen in artists focusing on nature's 'feminine' characteristics — voids displace
 mass, and silent process displaces noisy manifestations of natural force. See Miller, *The Empire of the Eye* (1993),
 pp.243–289.

68 Quoted in ibid., p.251.

69 George William Sheldon, *American Painters,* enl. edn, New York: B. Appleton, 1881, p.284.

70 As Angela Miller suggests, '*Kauterskill Clove*, a womblike gorge filled with life-giving light, is the landscape equivalent
 of the feminine principle, nurturing through self-negation rather than summoning spiritual aspiration through sublime
 example', see Miller, *The Empire of the Eye* (1993), p.284.

71 The stranded boat, seen in Lane's landscape, became a common image during the Civil War era, and has been
 suggested by some scholars as conveying meaning as a motif for the state of democracy in the aftermath of the
 Civil War. See David Miller, 'The Iconology of Wrecked or Stranded Boats in Mid to Late Nineteenth-Century American
 Culture', in David C. Miller ed., *American Iconology,* New Haven and London: Yale University Press, 1993, pp.186–208.

72 Diana J. Stazdes, entry, Martin Johnson Heade, *Newburyport Meadows*, c.1872–1878, in Howat et al., *American
 Paradise* (1988), pp.177–178.

73 See David Miller, *Dark Eden: The Swamp in Nineteenth-Century American Culture,* Cambridge: Cambridge
 University Press, 1989, pp.68–70.

74 Quoted in Howat et al., *American Paradise*, 1988, p.79.

75 [George Inness] 'A Painter on Painting', *Harper's New Monthly Magazine,* 56, February 1878, p.458.

76 Quoted in Linda Merrill, *An Ideal Country: Paintings by Dwight William Tryon in the Freer Gallery of Art,*
 Washington, DC: Freer Gallery of Art; distributed by University Press of New England, Hanover, Massachusetts
 and London, 1991, p.50.

77 Kathleen Pyne, *Art and the Higher Life: Painting and Evolutionary Thought in Late Nineteenth-Century America,*
 Austin: University of Texas, 1996, pp.278–279.

78 Quoted in H. Barbara Weinberg, Doreen Bolger and David Park Curry, *American Impressionism and Realism:
 The Painting of Modern Life, 1885–1915,* exhibition catalogue, New York: The Metropolitan Museum of Art, 1994,
 pp.77–79.

79 Ibid., p.69.

80 Patricia Nelson Limerick, *The Legacy of Conquest: The Unbroken Past of the West*, New York and London:
 W.W. Norton, 1987, pp.25–26.

81 *Round Table*, 6, no.8, 6 July 1867, quoted in Nicolai Cikovsky Jr and Franklin Kelly, *Winslow Homer*, exhibition
 catalogue, Washington, DC: National Gallery of Art and New Haven and London: Yale University Press, 1995, p.80.
 For a discussion of this work, also see Nicolai Cikovsky Jr, 'Winslow Homer's National Style', in Thomas W. Gaehtgens
 and Heinz Ickstadt, *American Icons: Transatlantic Perspectives on Eighteenth- and Nineteenth-Century American
 Art*, The Getty Center for the History of Art and the Humanities with University of Chicago Press, 1992, pp.250–253.

82 Sarah Burns, 'Revitalizing the "Painted-Out" North: Winslow Homer, Manly Health, and New England Regionalism
 in Turn-of-the-Century America', *American Art*, 9, no.2, Summer 1995, pp.20–37, p.30.

83 David Tatham, *Winslow Homer in the Adirondack,* Syracuse: Syracuse University Press, 1996, pp.68-69.

84 Barbara Dayer Gallati, *William Merritt Chase*, New York: Harry Abrams, Inc., with The National Museum
 of American Art, 1995, p.71.

85 For a discussion of Chase's paintings of parks, and a discussion of New York's park movement, see Weinberg, Bolger,
 and Curry, *American Impressionism and Realism* (1994), pp.138–152.

86 Kathleen A. Foster, 'Realism or Impressionism? The Landscapes of Thomas Eakins', in *American Art around 1900,
 Studies in the History of Art*, 37, Washington DC: National Gallery of Art, 1990, pp.68–91, p.82.

87 Quoted in Weinberg, Bolger, and Curry, *American Impressionism and Realism* (1994), p.89.

88 The invention of barbed-wire fencing and the arrival of the railroads eliminated the need for long cattle drives.
 See Lonn Taylor and Ingrid Maar, *The American Cowboy*, exhibition catalogue, Washington DC:
 American Folklife Center, Library of Congress, 1983.

89 Alexander Nemerov, *Frederic Remington and Turn-of-the-century America*, New Haven and London:
 Yale University Press, 1995.

90 Winslow Homer's series of Prout's Neck, Maine seascapes serves as an exception to this sense of mastery.
 In the later works, Homer treats the sea rather than the land, as in *Maine Coast* 1896 (cat.123),
 and here nature retains its power.

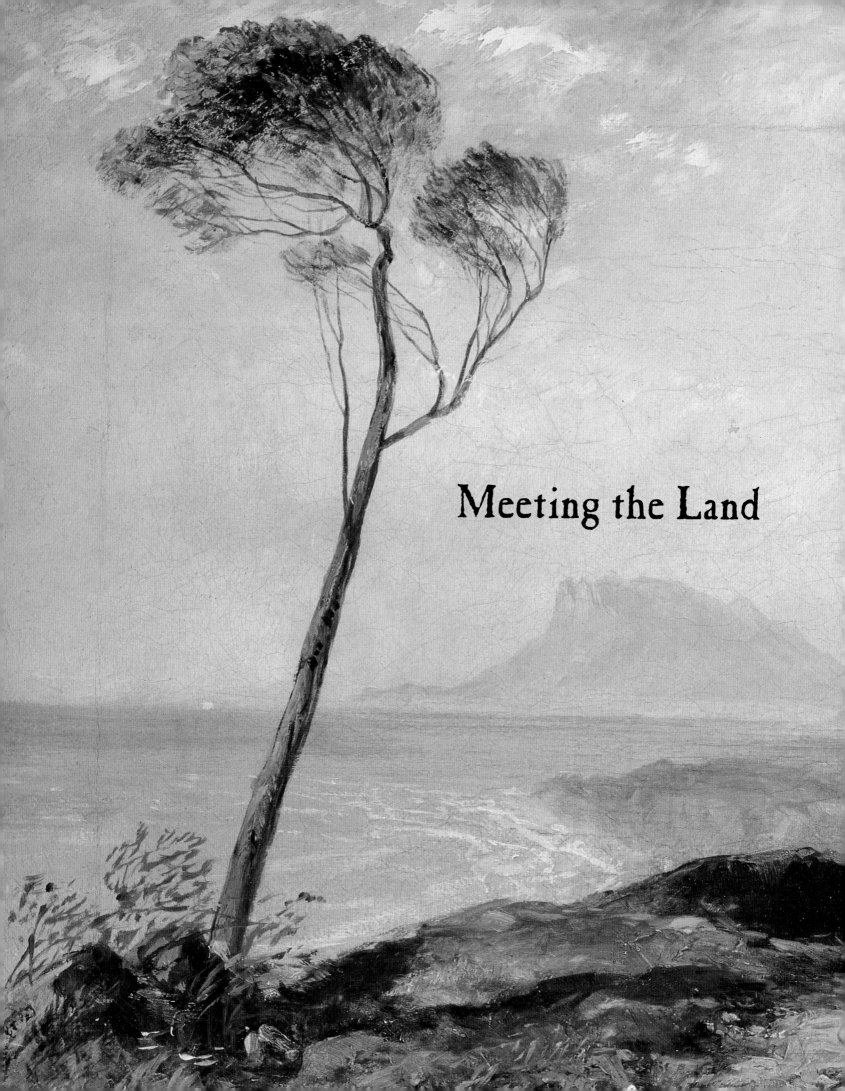

Meeting the Land

William Westall 1781–1850

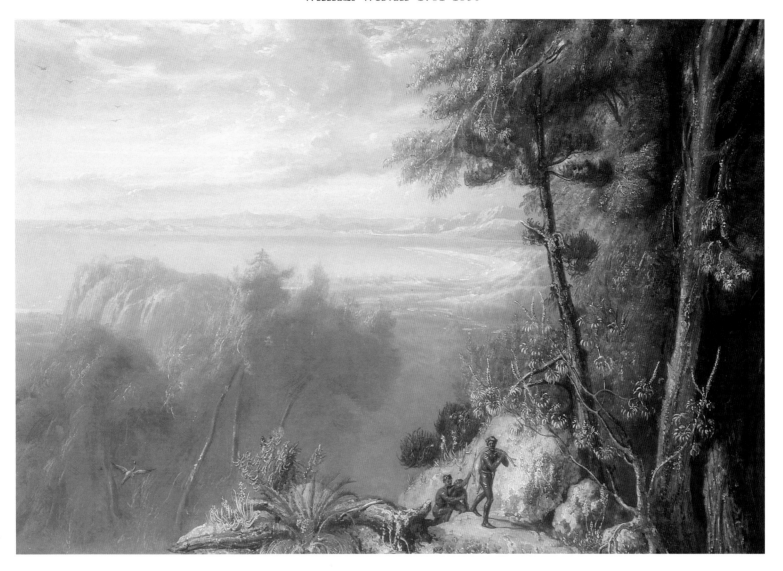

1. *View of Port Bowen, Queensland, August 1802* 1811
oil on canvas 87.0 x 127.5 cm (34-1/4 x 50-1/4 in) National Maritime Museum, Greenwich

When William Westall took up the position of topographical painter with the expedition of Matthew Flinders aboard the *Investigator* in 1801, it was with the expectation that he would be travelling to the Pacific, not just to Australia, which was of little interest to him. Writing later to the explorer and botanist, Joseph Banks, Westall indicated that, had he been fully informed of the nature of the expedition, he 'most certainly would not have engaged in a hazardous voyage where I could have little opportunity of employing my pencil with any advantage to myself or my employers'.[1]

Fortunately Westall overcame his lack of enthusiasm sufficiently to produce an extremely accurate coastal survey of Australia, and in doing so he engaged his creditable landscape painting skills. The result was an extensive series of watercolours, as much landscapes as factual representations of the coastline.

In 1811, Flinders, in consultation with Banks, Westall and the Admiralty, chose nine of the artist's drawings to be recreated as oil paintings and later engraved as illustrations for Flinders's book, *A Voyage to Terra Australis*, published in 1814. The three oil paintings in the exhibition were amongst the nine subjects chosen.

The *Investigator*'s first sighting of land, after rounding the Cape of Good Hope, was Cape Leeuwin on Australia's far south-west coast on 6 December 1801. From that point Flinders proceeded to circumnavigate Australia in an anti-clockwise direction. He followed the southern coastline, passing through Bass Strait on his way to the settlement of Port Jackson (later named Sydney). After a refit, the *Investigator* sailed northwards. On 21 August 1802 a large bay was sighted which Flinders named Port Bowen after Captain James Bowen, RN.[2]

John Skinner Prout *Maria Island from Little Swanport, Van Diemen's Land* 1846 (detail) (cat.9)

William Westall 1781–1850

2. *View of Sir Edward Pellew's Group, Northern Territory,*
December 1802 1811
oil on canvas 61.0 x 86.5 cm (24 x 34 in) National Maritime Museum, Greenwich

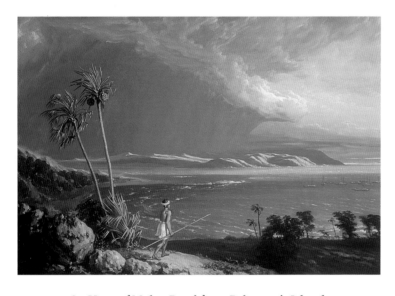

3. *View of Malay Road from Pobassoo's Island,*
February 1803 1811
oil on canvas 61.0 x 86.5 cm (24 x 34 in) National Maritime Museum, Greenwich

Westall's *View of Port Bowen, Queensland, August 1802* looks south-west across the bay. Seen from the top of the watering gully (so named as it provided a source of fresh water) Westall's treatment of the distant landscape captures the 'romantic appearance' of the hills around Port Bowen remarked upon by Flinders in his log. The softness of the distant outlines and gentle colours contrast markedly with the clear, detailed treatment given to the foreground. The pine trees which the navigator was pleased to have discovered growing on this part of the coast are precisely painted. The figures of the Aborigines receive a similar treatment; painted with precision and without exaggeration, their presence serving to emphasise the size of the vegetation. Interestingly, Flinders's log of the voyage states that no Aborigines were seen during their stay at Port Bowen, though evidence of recent fires abounded.[3]

After rounding Cape York, the northern-most point of Australia, the *Investigator* turned south into the Gulf of Carpentaria. In December 1802, the party reached a group of islands which had originally been charted by the Dutch, but Flinders decided that 'the great alteration produced in the geography of these parts by our survey, gives authority to apply a name which, without prejudice to the original one, should mark the nation by which the survey was made; and in compliment to a distinguished officer of the British navy ... I have called this cluster of islands Sir Edward Pellew's Group'.[4]

Westall's *View of Sir Edward Pellew's Group, Northern Territory, December 1802*, based on a drawing made on North Island looking across to Vanderlin Island, clearly shows the sparseness of the vegetation and the sandy soil, and again includes items of ethnographic, botanic and natural interest. The small enclosure housing two cylindrical stones, which is the central focus of the painting, was clearly described by Flinders in his log: he noted that white feathers had been stuck to the stones and that a substance resembling charcoal had been applied to them in regular oval shapes. The purpose of the monument remained a mystery to the explorers.

On 19 February 1803, Flinders and his party were sailing through a group of islands off the north-western coast of the Gulf of Carpentaria when they encountered a fishing fleet anchored in the lee of an island. The leader of the fleet, Pobassoo, told Flinders that this was his sixth or seventh voyage to the area. They were Macassarese, from the south-west of Celebes, and sailed regularly to Australia to harvest trepang (sea slugs or sea cucumbers).

View of Malay Road from Pobassoo's Island, February 1803 includes nearly all of the physical elements noted by Flinders in his log: Malay Road, the sea passage between Pobassoo's Island (named after the leader of the fleet) and Cotton Island, which was the place where the *Investigator* anchored. A Macassarese is placed prominently on Pobassoo's Island and the prow fleet can be seen to the right. The approaching monsoonal storm completes the composition which also includes detailed botanical elements.

CG

Joseph Lycett c.1775–1828

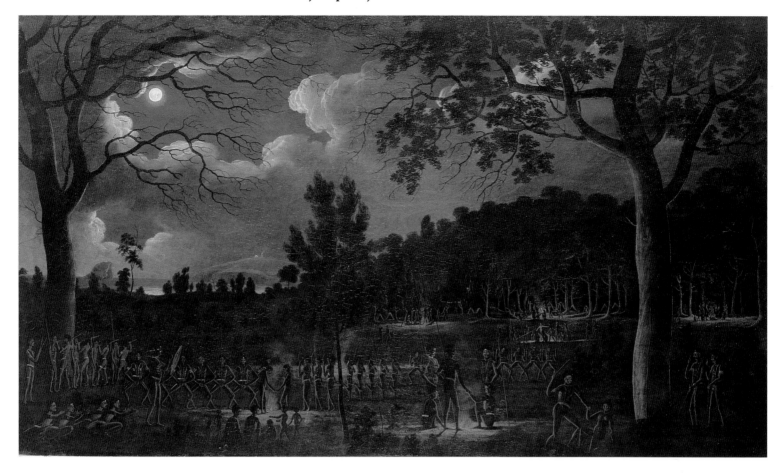

4. *Corroboree at Newcastle* c.1820s
oil on panel 71.0 x 122.0 cm (28 x 48 in) Dixson Galleries. State Library of New South Wales, Sydney

Bernard Smith describes *Corroboree at Newcastle* as 'the earliest painting of an Australian subject in which the romantic attitude to nature is clearly and unambiguously expressed'.[1] The painting is also something of an enigma. It has variously been attributed to Joseph Lycett and to Captain James Wallis, commandant of the penal settlement at Newcastle in New South Wales.[2] The difficulty in attributing this unsigned work arises from the fact that both Lycett and Wallis were artists, and that the convict Lycett made drawings and paintings *for* Wallis. Certainly the composition resembles an engraving accompanying Wallis's *An Historical Account of the Colony of New South Wales*, published in 1821, but, as the two men were so closely linked in their practice, this in itself does not assist in attributing the work conclusively to Wallis.[3]

The location of this moonlit dance scene is clearly identifiable. In the background, sitting on the ocean horizon, is the distinctive shape of Newcastle's Nobby's Head (or Coal Island) at the mouth of the Hunter River. Wallis's account describes this scene of 'savage festivity' precisely:

The preparation for their dance is striking and curious. They assemble in groups, and commence marking their arms, legs and bodies, in various directions with pipe-clay and a kind of red ochre; some of them displaying great taste at their toilet as in the representation. Their musician who is generally an elderly man, sings a monotonous tune, in which they all join, striking in regular time his shield with a club or waddy. Each dancer carries a green bough in his hand. The beauty of the scenery, the pleasing reflection of light from the fire round which they dance, the grotesque and singular appearance of the savages, and their wild notes of festivity, all form a strange and interesting contrast to any thing ever witnessed in civilised society. The women never dance; and, where several tribes meet together, each tribe dances separately.[4]

The moonlit corroboree was fascinating to European writers and artists alike.[5] The spectacle incorporated all of the thrilling elements of theatricality which characterised romantic taste: moonlight, firelight, the outdoors, 'the grotesque', and the wild.

AS

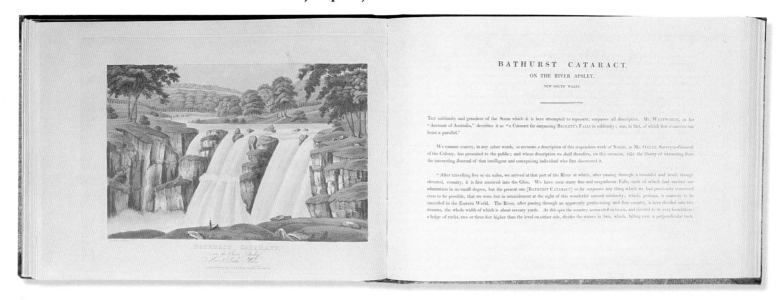

5. *Views in Australia or New South Wales, & Van Diemen's Land delineated* 1824–25
book of engravings, hand-coloured National Gallery of Australia, Canberra

Joseph Lycett's *Views in Australia* were published in thirteen parts by the London publisher John Souter between August 1824 and June 1825.[1] In an introduction to the plates, the publisher set out his plan for the work: it was 'designed to be at the same time a HISTORY of the Discovery, Settlement, and Progress, of these Colonies, and a GRAPHIC DELINEATION of the principal Scenery, and of every object of interest in that part of the New World'.[2] A second volume was to follow, describing and illustrating Australian natural history. This volume never appeared, however an album of watercolours in the National Library of Australia — a collection depicting Aboriginal life in the Newcastle area — may have been the basis for the proposed publication.

Lycett's compilation of Australian views was calculated to present the most optimistic picture of the young colonies to an English audience. Not only do the fifty plates present an idealised view of the Australian landscape, the accompanying text is comprised almost exclusively of hyperbole. The work, in one sense, is a shameless attempt to solicit emigration to Australia at a time when labour was needed to consolidate the gains made after the settlement by Europeans. This also explains why the map of New South Wales which prefaces the *Views* is annotated with information about the availability of land in the localities described.

The sequence of plates takes an orderly tour, first through the settled parts of New South Wales and then further afield into outlying regions, and through Tasmania, starting in Hobart and proceeding in a northerly direction. Lycett presents an overall picture of rapid settlement and expansion — interestingly, the introductory text ends with extensive reflections on 'the origin and decay of nations'. The tenor of these reflections is typical in that they anticipate a future for settled Australia in which the new world will eclipse the old. In this context Lycett's views of settler Australia being literally carved out of the wilderness are imagined to be valuable visual records giving 'more correct ideas of [Australia's] ABORIGINAL state than it is in the power of the most eloquent historian to impact'.[3]

AS

Augustus Earle 1793–1838

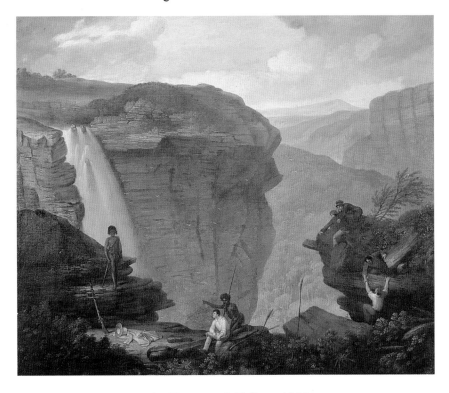

6. *Wentworth Falls* c.1830
oil on canvas 71.0 x 83.2 cm (28 x 32-3/4 in) Rex Nan Kivell Collection, National Library of Australia and National Gallery of Australia, Canberra

Augustus Earle visited Wentworth Falls during his journey through the Blue Mountains in 1826; however this painting was probably not completed until after he had returned to England in 1829. Unlike many artists of the colonial period, Earle's exploration of New South Wales was not associated with documentation of official expeditions or scientific surveys. His excursions to remote areas of the Blue Mountains, Bathurst and the Wellington Valley in 1826, and Port Stephens, Port Macquarie and the Illawarra district in 1827, reflect his determination to fill his sketchbooks with exotic peoples and landscapes of 'places hitherto unvisited by any artist'.

Earle's interest in the Wentworth Falls may have been due to the threat of a French artist, E.B. de la Touanne, producing a series of lithographic views of the Blue Mountains — thereby (as the press of the day remarked) 'depriving our Colonial artists of the credit of a first publication'.[1] La Touanne had visited and sketched the Wentworth Falls in 1825 with the scientific expedition led by Commodore Hyacinthe de Bougainville, however his lithograph of the area was not produced until 1837, many years after Earle completed this painting.

Until recently Earle's painting held the title 'Bougainville Falls, Prince Regent's Glen, Blue Mountains'. Governor Brisbane (governor, 1821–25) named the cascading falls Bougainville Falls, in honour of the French expedition. 'Prince Regent's Glen' refers to the overlapping valley seen in the middle distance of the painting, named by Governor Macquarie (governor, 1810–21) after the Prince of Wales who was appointed Regent in 1811. Macquarie had named the area 'Campbell's Cataract' after his

secretary John T. Campbell. It was also known as 'The Fall of the Weatherboard' or 'Weatherboard Falls' because of a small hut located nearby.

William Charles Wentworth, William Lawson and Gregory Blaxland were the first Europeans to find a path through the Blue Mountains. Wentworth's name was given to the falls in 1869 and the site remains known as Wentworth Falls today.

In his painting, Earle has emphasised the scale of landscape features such as the imposing cliff face which dominates the canvas and increases the drama of the view looking past the falls to the steep descent of the valley below and the receding mountains in the distance. While much attention has been given to the details of rock forms and plant life in the foreground, the overall topographical impression is not as detailed as in later depictions of the same scene by artists such as Eugene von Guérard, John Skinner Prout, or even la Touanne.

Earle has included himself in the picture, with his back to the view drawing one of his Aboriginal guides. The figure of the guide, standing closest to the falls and looking out of the canvas, was probably based on a series of watercolours of Aborigines of Wellington Valley that Earle completed in 1826–27. In *Native of N.S Wales Wellington Valley*, *Native of Wellington Valley* and *Wellington Valley, N.S. Wales* (all in the Rex Nan Kivell Collection, National Library of Australia, Canberra), the figure is almost identical in appearance and stance to the Aboriginal included in Earle's painting of Wentworth Falls.

MK

John Glover 1767–1849

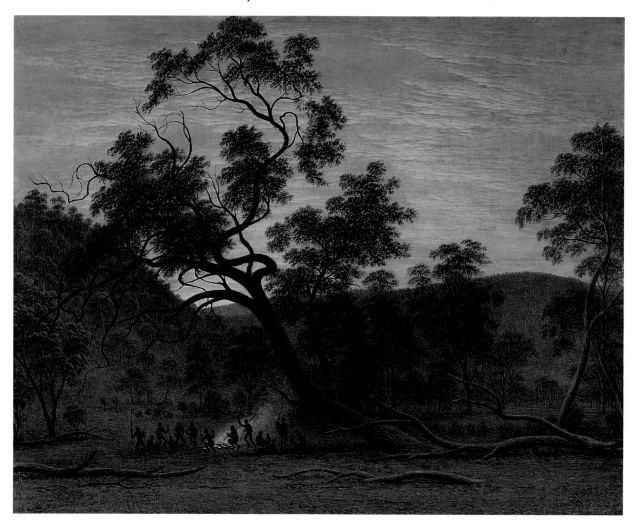

7. *A Corrobery of Natives in Mills Plains* 1832
oil on canvas on board 56.5 x 71.4 cm (22-1/4 x 28-1/8 in) Art Gallery of South Australia, Adelaide Morgan Thomas Bequest Fund 1951

Ron Radford has surmised that this small painting was among the earliest works painted by John Glover when he settled at Mills Plains in northern Tasmania.[1] Recent research supports this view, confirming this as a painting of 1832,[2] and therefore among the earliest of the artist's responses to the landscape and inhabitants of Tasmania. Whereas Glover's later paintings of Tasmanian Aboriginal subjects — such as *The Bath of Diana* 1837 (cat. 40) or the two Aboriginal subjects now in the Louvre (cats 41, 42) — were meditations on a previous history, this 1832 painting was probably based on Glover's actual observation of Aboriginal people. It was included in the exhibition of sixty-eight works which Glover sent to London in 1835; the accompanying inscription suggests that the artist's obervation was at first hand: 'in the Evening they [the Aborigines] usually amuse themselves by dancing around their fires'.[3] Furthermore, the composition is based on some of Glover's earliest Australian drawings in a sketchbook of 1832. The tree which dominates the composition, with its snaky limbs and branches, is also recorded in the sketchbook drawings.[4]

After its exhibition in London in 1835, this painting was purchased by Glover's most devoted patron, Sir Thomas Phillipps; it was in his collection by 1840. Phillipps expanded his collection of Australian paintings by Glover throughout the 1860s, adding them to his collection of the artist's pre-Australian work. Eventually Phillipps had sufficient Glover paintings (twenty-nine in 1866) to set aside an entire room of his Thirlestaine House in Cheltenham for his Glover Gallery. Interestingly, Phillipps's other collecting passion (besides being one of the greatest book collectors of the century) was the work of the American artist George Catlin, and he also created a Catlin Gallery in his house.[5] Phillipps's association with Catlin was as long standing as his relationship with Glover and may have disposed him towards collecting pictures such as *Corrobery*, a painting with sufficient ethnographic interest for Phillipps to have retained Glover's description (unfortunately, now lost).[6]

AS

Augustus Earle 1793–1838

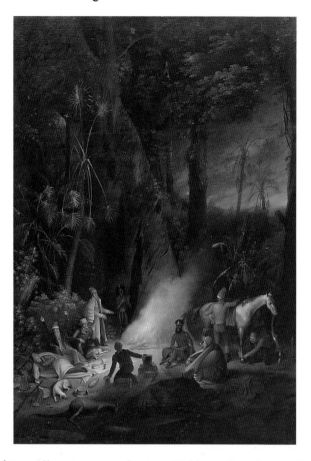

8. *A Bivouac of Travellers in Australia in a Cabbage Tree Forest, Daybreak* c.1838
oil on canvas 118.0 x 82.0 cm (46-1/2 x 32-1/4 in) Rex Nan Kivell Collection, National Library of Australia and National Gallery of Australia, Canberra

When Augustus Earle travelled to the Illawarra region of New South Wales in May 1827 he encountered an entirely different type of landscape to that seen in his painting of Wentworth Falls in the Blue Mountains (cat.6). *A Bivouac of Travellers in Australia in a Cabbage Tree Forest, Daybreak* shows jungle-like vegetation with dense forest, palms and towering trees. Like the painting of Wentworth Falls, this work was completed after the artist's return to England and was based on watercolours he had made while touring through New South Wales.

The term 'bivouacking' was widely used in the nineteenth century to describe setting up camp and sleeping out in the wilderness. It became a common practice in Australia, as journeys between settlements often could not be completed in one day. The cabbage tree palm (*Livistona Australis*), so called because of the cabbage like growth at the head of the trunk, can be seen in several places throughout the composition. The tree is native to Victoria, New South Wales and Queensland. The large specimen on the left of the canvas is based, almost exactly, on Earle's watercolour study *The Cabbage Tree, New South Wales* 1827 (Rex Nan Kivell Collection, National Library of Australia, Canberra). In his painting Earle has incorporated many romanticised aspects of colonial life that had wide popular appeal and mystique: weary travellers resting around an open fire,

Aboriginal guides, hunting, and the experience of direct contact with an exotic untamed landscape.

The painting was exhibited at the Royal Academy in London in 1838, the year it was completed — eleven years after Earle's visit to the Illawarra. As it was hung in the miniatures and small paintings room, there has been some speculation about the existence of another, smaller version.[1] There has been interest also in an Aboriginal figure which Earle painted out of the finished picture — covered by the billowing smoke of the camp fire. This was probably a late decision to improve the composition and balance of the group around the fire. In the transition to the final painting, Earle made several other changes to his original watercolour studies. A naked Aboriginal figure standing by the fire has been replaced by the seated figure with the cone-shaped head piece — this figure had originally appeared in an unrelated watercolour study of a Newcastle Aborigine made in 1826. The image of the sleeping dog in the foreground has been taken from Earle's earlier watercolour *Governor Glass and His Companions* (Rex Nan Kivell Collection, National Library of Australia, Canberra), which he completed on the island of Tristan da Cunha in 1824, and shows his dog Jemmy resting by an open fire.

MK

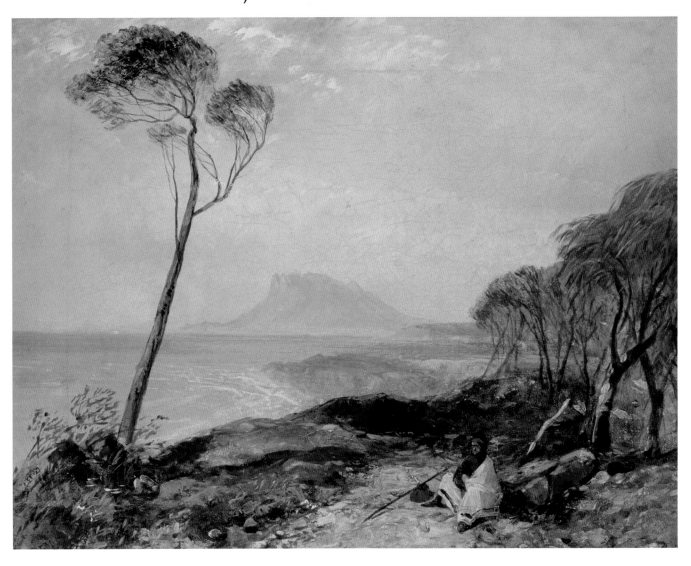

9. *Maria Island from Little Swanport, Van Diemen's Land* 1846
oil on canvas 29.0 x 35.5 cm (11-1/2 x 14 in) Art Gallery of South Australia, Adelaide M.J.M. Carter Collection

John Skinner Prout was primarily a watercolourist. Most of the works painted during his stay in Australia (1840–48) were watercolours; the few oils he painted, with the exception of this work, do not show him to have been particularly comfortable with the richer medium. As a watercolourist Prout preferred the rapid sketch to the highly finished work, and some of this liking comes through in this small, fresh and atmospheric work.

Maria Island lies off the eastern coast of Tasmania. Prout has taken a most dramatic angle, emphasising the steep cliffs which run along the north-east of the island. There is nothing in the work which suggests that the rocky eminence was inhabited, although when Prout saw it Maria Island was effectively a prison. It had been the site of a penal settlement between 1825 and 1832 and in 1842 the settlement was resumed as a probation station. When Prout looked out from the coast towards Maria Island the probation station was about to undergo an extensive expansion. However the expansion was short lived.

In 1850 the station closed and, after the cessation of convict transportation to Tasmania in 1853, the island was no longer used as a convict settlement.

Prout lived in Hobart between 1844 and mid-1848, and on several occasions took sketching trips to other parts of Tasmania. The watercolour on which this painting is based was made during a trip up the eastern coast of Tasmania as far as the Freycinet Peninsula between December 1845 and January 1846. Prout was in the company of fellow watercolourist Francis Simpkinson: the title of this painting comes from Simpkinson's annotation on his own sketch, which is an almost identical view.[1]

This work was later used by Prout as the basis of a steel engraving included in Edwin Carton Booth's *Australia Illustrated,* published in 1873.

AS

Conrad Martens 1801–1878

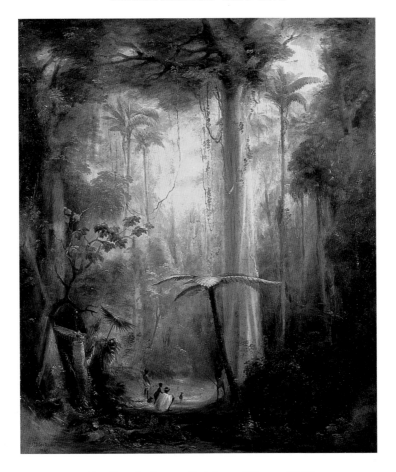

10. *Brush Scene, Brisbane Water* 1848
oil on canvas 75.0 x 63.0 cm (29-1/2 x 24-4/5 in) Dixson Galleries. State Library of New South Wales, Sydney

In September 1835 Conrad Martens visited Frederick Augustus Hely's property Wyoming, at Brisbane Water — a broad inlet 90 kilometres to the north of Sydney. Over a period of five days he made drawings which formed the basis of the brush scene which he painted some thirteen years later.[1]

The area around Brisbane Water, like the landscape of the Illawarra district which Martens had visited in the month after his arrival in Sydney, was abundant in rainforest. Rainforest subjects fascinated Martens and he was to paint them frequently throughout his Australian career — the drawings he made in 1835 were still furnishing him with subjects for large watercolours as late as 1859. The appeal of rainforest was threefold. Firstly, it was true wilderness landscape — by contrast with the landscape of settlement which was the standard fare of Martens's commissions. Secondly, it provided the artist with an opportunity to depict unique Australian flora, particularly the elegant cabbage tree. And thirdly, rainforest represented a type of landscape — tropical landscape — which had so interested the German naturalist Alexander von Humboldt and his favourite artist Johann Moritz Rugendas (1802–1858). En route to Australia Martens had met and stayed with Rugendas in Valparaiso. Elizabeth Ellis believes that his stay with Rugendas had a profound effect on Martens's art, causing an adjustment

to its tonality and sense of breadth.[2] At the time he came under the influence of the German artist, Martens's awareness of geography and the importance of botany — in short, the acuteness of his faculties for grasping the variety of landscape types — would have been heightened by his recent experience as an artist among observant scientists with Charles Darwin aboard the *Beagle*.

Brush Scene, Brisbane Water was exhibited in one of the earliest art exhibitions in Australia, the second exhibition of the Society for the Promotion of the Fine Arts in Australia mounted in Sydney in 1849. Martens was a major exhibitor in the exhibition, with twenty-two works — and several, including *Brush Scene, Brisbane Water,* were views of wild and picturesque landscapes. The 1849 exhibition included Martens's series of oil paintings of the interior of the Burrangalong Cavern (now known as the Abercrombie Caves). With this group of paintings he may have been attempting to exploit a growing taste for wild subjects. This may also have been the artist's motivation for including rainforest subjects in his set of lithographs, *Sketches in the Environs of Sydney* (1850–51), including one entitled 'Scene near Brisbane Water'.

AS

Ludwig Becker 1808–1861

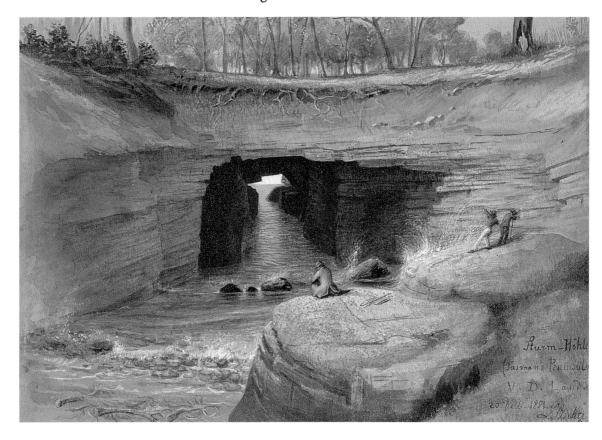

11. *Blow-hole, Tasman's Peninsula, Van Diemen's Land* 1852
watercolour 17.0 x 24.2 cm (6-3/4 x 9-1/2 in) National Gallery of Australia, Canberra

Ludwig Becker's watercolour of the blow-hole on the Tasman Peninsula dates from the artist's twenty-month stay in Van Diemen's Land between March 1851 and November 1852 — Van Diemen's Land was named Tasmania in 1855. During this period Becker travelled widely in the colony, collecting specimens, making drawings and 'paying his way by taking likeness-miniatures which he does very nicely'.[1]

Becker probably visited the blow-hole in the latter part of 1851. This geological phenomenon is one of a series of features found within a short distance (the blow-hole, the Devil's Kitchen — another blow-hole — and Tasman's Arch, all painted by Becker), which have long been popular tourist sites on the Tasman Peninsula, 75 kilometres from Hobart. In 1854 the Governor of Tasmania, Sir William Denison wrote:

> The blowhole *par excellence* is really a fine sight; a curious hole in the rocks, through which the waves come roaring with a noise like distant guns firing and burst into daylight at the end with a force that seems to shake the rocks around

... At the inland entrance of the hole you can ... stand on the rocks above, and watch the waves come roaring and bounding through.[2]

Becker was fascinated by the blow-hole as a curiosity and as a geological phenomenon. His drawing, characteristically small and fastidiously detailed, is both a precise representation of this feature and a response to the wondrous aspects of the place. The shape of the tunnel, perfectly bisected by the horizon beyond, is the focus of the composition. But Becker's wonder in the face of romantic nature is tempered by his humanity and good humour, shown in the wave drenching the two onlookers. Becker has placed himself in the composition, sitting on a rock making a drawing, his portfolio and umbrella resting alongside.

Interestingly, it is not possible to see the horizon from the place where this view is taken; Becker has dramatised the impact of the blow-hole by allowing us to see the expanse of sea beyond.

AS

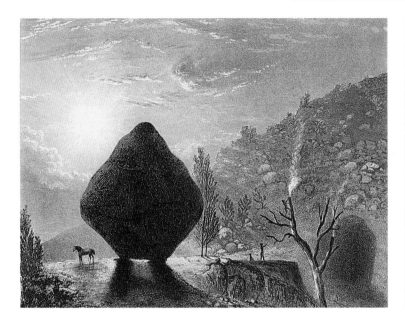

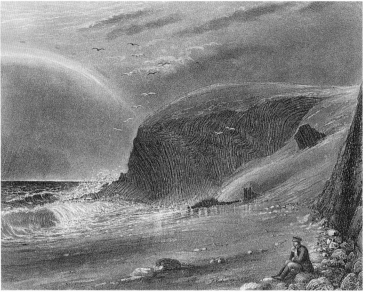

12. *Pattowatto. Granite boulders (Perrys Haystack)
looking NW, 47 miles N by W of Melbourne*
from 'Australia Terra Cognita' portfolio 1855–59 James Redaway & Sons, engraver
etching, engraving, aquatint, painted in black from one copper plate
21.2 x 27.8 cm (8-3/8 x 10-7/8 in)
National Gallery of Australia, Canberra
Gift of Major General T.F. Cape in loving memory of his wife Elizabeth Rabett 1996

13. *Compressed strata west of section 512
near Morphet Valley, 16 miles S from Adelaide*
from 'Australia Terra Cognita' portfolio 1855–59 James Redaway & Sons, engraver
etching, engraving, aquatint, painted in black from one copper plate
21.2 x 27.8 cm (8-1/3 x 10-7/8 in)
National Gallery of Australia, Canberra
Gift of Major General T.F. Cape in loving memory of his wife Elizabeth Rabett 1996

The granite boulder at Pattowatto sits timeless, its bulk silhouetted against the glare of the late afternoon sky. Its ancient grandeur is contrasted with the ephemeral — wisps of high cloud catch the last rays of the setting sun, the Aborigines continue their hunting, smoking a possum from a tree, seemingly oblivious of this wonder of nature. Even the horse has turned its back .

A similar pattern of forces is portrayed in the engraving of the rock strata near Morphet Valley. The parallel layers of compressed rock that have been twisted over eons are revealed at the sea's edge where waves pound the shore. The storm has gone to sea, the rain has ceased, a rainbow has formed and gulls glide on the air currents searching for food. A lone man sits on the rocks at the water's edge, perhaps contemplating his role in the vastness of time.

Although the sentiments may be lofty, these modest engravings were produced to illustrate a scientific text —'Australia Terra Cognita'. Its author, the Prussian-born William Blandowski, mining engineer, naturalist, photographer and natural history artist, intended the book to be a compilation of his scientific inquiries in Australia. Arriving in Adelaide in 1849 he explored widely, travelling overland to Victoria where he made money goldmining before being appointed government zoologist.

After conducting three successful expeditions he fell out with his colleagues and, in 1859, he left the colony and returned to Germany. His book was never completed, only twenty-nine of the projected 200 illustrations being engraved.

Blandowski was aware of his limitations as an artist. In Melbourne he employed the engravers James Redaway & Sons to translate his work into prints, and later in Germany Gustav Mutzel worked up Blandowski's sketches and photographs into paintings.

The role of James Redaway in the prints under discussion cannot be underestimated. Blandowski allowed the engraver extraordinary latitude in the interpretation of his landscape subjects — particularly those depicting geological formations. Redaway claimed the central role in the final look of the printed works by the unusual engraved inscription: 'Effect & Engraving by ...'

The similarity of these works with the engravings in J.M.W. Turner's *Liber Studiorum* (1807–19) is obvious and it is not surprising to find that Redaway engraved one print after Turner before he migrated to Australia in 1852.

RB

Ludwig Becker 1808–1861

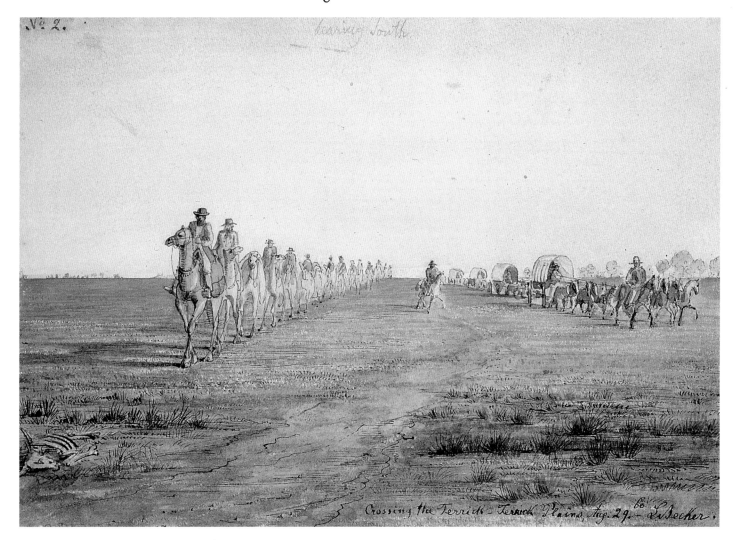

14. *Crossing the Terrick-Terrick Plains, August 29 1860* 1860
watercolour, pen and ink on grey paper 12.5 x 17.7 cm (5 x 7 in) La Trobe Australian Manuscripts Collection State Library of Victoria, Melbourne

In 1859 Ludwig Becker succeeded in his quest to be appointed artist, ethnographer and naturalist (zoology and geology) with the Victorian Exploring Expedition to the Gulf of Carpenteria, approved by Premier John O'Shanassy, and led by Robert O'Hara Burke. Ostensibly the expedition sought a route north from Victoria and New South Wales, through Cooper's Creek, to the northern coast of Australia, in order to establish a port to service the shipping route from England through the Suez Canel and across the Indian Ocean. More recent research suggests that the underlying purpose of the expedition was to acquire land for the colony of Victoria in what is now Western Queensland.[1]

Recording the tenth day of the expedition travelling north-east of Bendigo near Piccaninny Creek between Elmore to the north and Mitiamo to the south, *Crossing the Terrick-Terrick Plains, August 29, 1860* shows an orderly progression of the camel line to the left, the covered horse-drawn wagons to the right, linked by Burke commanding centre stage. (The area is in the traditional land of the Jaara: Terrick-Terrick means 'a pool where emus drink'.) The late afternoon sunlight effects a translucent quality to the camels' flanks, and the dry creek bed leads from Burke's white steed to the skeleton of a bullock, 'said to have been killed by lightning, a common occurrence in these plains'.[2]

Becker claims dissatisfaction with this sketch in his report, in which he describes the scene:

> The effect on one who sees extensive plaines for the first time is somewhat very peculiar: the plain looks like a calm ocean with green water; the horizon appears to be much higher than the point the spectator stands on, the whole plain looks concave ... The plains are free from any stone, and consist of a feruginous loam and sometimes of clay, intermixed with small bits of calcarious or limestone(?) concrete. During the dry season these plaines are bare of grass and hard like bricks, after a fall of rain they become muddy and soon after are covered with a fine verdure.[3]

Ludwig Becker 1808–1861

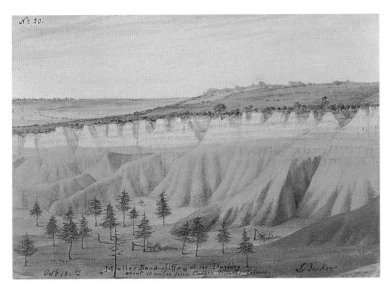

15. *Mallee Sand-cliffs at the Darling,*
about 10 Miles from Cuthro towards Tolano 1860
watercolour and pencil on buff paper 12.2 x 17.0 cm (4-7/8 x 6-3/4 in)
La Trobe Australian Manuscripts Collection State Library of Victoria, Melbourne

Situated between Harcourt and Pooncarie in western New South Wales, the ancient *Mallee Sand-cliffs at the Darling, about 10 Miles from Cuthro towards Tolano* impressed Becker as a grand theatre set carved by natural forces — infrequent but harsh floods pouring through the Darling and downwards from across the plains above. He has painted the cliffs with their long, clawed feet in a tonal range of ochres, from brownish-red sand on the dry river bed through yellow to almost white at the top of the cliffs.

Typical of the Darling River topography, *Junction: The Bamamoro Creek with the Darling, 7 Miles from Minindie, up the Darling* reflects shadows of the steep tidal banks and saplings in the still water on the river bend, described by Becker as 'milky coffee' in colour. Eucalyptus leaves show the artist's mastery of fine detail. The evening light imbues the trunks of the mature river red gums (*Eucalyptus camaldulensis*) with a peaceful afterglow. Scars on the right-hand tree are the result of the removal of bark by Aborigines for use as canoes or for building huts. A centrepiece of the work shows a fire at the base of the dead tree on the left which may have been set alight by the Aboriginal woman bearing a child on her back and carrying a stick, possibly a fire stick, in her left hand.

After unloading the stores at this river bend, the men and camels returned to Menindie. The last note in Becker's fifth and final report suggests satisfaction at being alone to attend to his research and sketching: 'I remained behind and after storing safely the goods brought up, I put myself under shelter by pitching my tent on a spot high & dry & near a cluster of beautiful Gum-trees.'[4] Today the area has disappeared beneath the waters of the Menindie Lakes.

Meteor seen by me on October 11 at 10h 35m pm at the River Darling, 25 Miles N. of Macpherson's Station, in Lat: 33, S 1860. It made its appearance in a bright part of the milky way near the tail of Scorpio, to the right of it, but, to the left of the Ecliptic; it commenced small but grew in the time of 1-1/2 second to 7 inches, the moon taken to 12. Green color; after disappearance red sparks. The delicate white flecks tipping the camels' heads and humps accent the light from the meteorite. They lend an ethereal aura to the wide, silent indigo sky, gently illuminated by starlight in the desert night. While searching desperately for the forward camp after enduring a day without food or water, and pulling three camels over 32 kilometres, Becker's initial sense of shock turning to wonderment at the sight of the abnormally large meteorite with crimson pearl-drop tail can be imagined.

Sharp triangular peaks slanting at awkward angles — such as the one in the far middle distance of *Mutwanji Ranges from the Track to Nanthwinngee Creek* — are characteristic of the Mootwingee Ranges (meaning a place of green grass and waterholes) situated 150 kilometres north-east of Broken Hill in New South Wales. Expedition members remarked on an abundance of emus, pigeons, water hen and parrots in these grassy, pine-clad valleys and sandhills — apparently unaware of the ancient rock paintings and carvings in the red ochre cliffs, the site of many great corroborees.

Mootwingee National Park, the first of five planned transfers of ownership of national parks identified for their Aboriginal cultural significance, will be returned to the Aboriginal people from the Wilyakali, Bandjikali, Malankapa and Wanyuearlku groups who, since 1989, 'have been involved in the committee of management for the park and working as interpretive guides'. When the park is handed back in 1998, the Mootwingee National Land Council plans to hold a corroboree 'the like of which has not been seen in this lifetime'.[5]

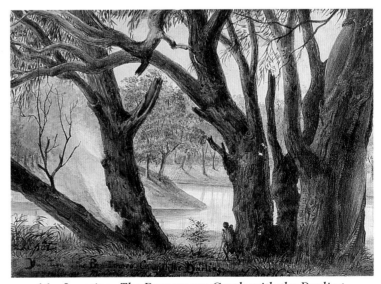

16. *Junction: The Bamamoro Creek with the Darling,*
7 Miles from Minindie, up the Darling 1860
watercolour, brush and ink on buff paper 12.6 x 17.8 cm (5 x 7 in)
La Trobe Australian Manuscripts Collection State Library of Victoria, Melbourne

Ludwig Becker 1808–1861

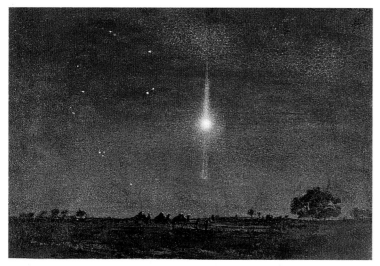

17. *Meteor seen by me on October 11 at 10h 35m pm at the River Darling, 25 Miles N. of Macpherson's Station, in Lat: 33, S 1860*
watercolour on cream paper 12.3 x 17.2 cm (4-7/8 x 6-3/4 in)
La Trobe Australian Manuscripts Collection State Library of Victoria, Melbourne

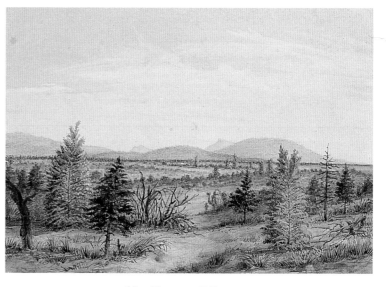

18. *Mutwanji Ranges from the Track to Nanthwinngee Creek 1861*
watercolour, brush and ink on buff paper 12.3 x 17.2 cm (4-7/8 x 6-3/4 in)
La Trobe Australian Manuscripts Collection State Library of Victoria, Melbourne

Camp on the Edge of the Earthy or Mud Plains 40 Miles from Duroadoo depicts a location east of the Sturt National Park in the north-western corner of New South Wales. A low, rocky outcrop and saltbush vegetation in the foreground gives way to the chalky mud flats under gently crazing patterns of cirrus cloud. Near the horizon appears the glimmer of a distant mirage.

Becker chose not to represent the lean-to shelter he shared with Purcell, the expedition's cook, a man of 'ill temper'. Virtually abandoned at Rat Point for fifteen days — two of them without drinkable water — attacked by flies throughout the stifling heat of daylight hours and rats by night, he suffered indescribably from scurvy, berri-berri and dysentery. The artist executed this work just several weeks before his death on 29 April 1861 at Bulloo, north of the Queensland border. In minute detail, this most sensitive German immigrant captured perhaps the most precious and realistic image of any colonial artist–explorer. The scene endures unchanged to this day.

LC

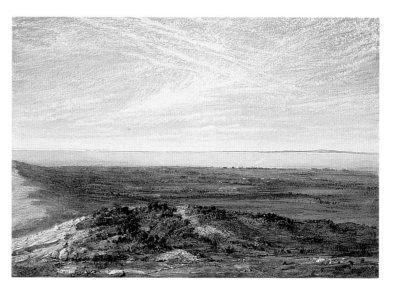

19. *Camp on the Edge of the Earthy or Mud Plains 40 Miles from Duroadoo 1861*
watercolour on cream paper 17.5 x 25.5 cm (6-7/8 x 10 in)
La Trobe Australian Manuscripts Collection State Library of Victoria, Melbourne

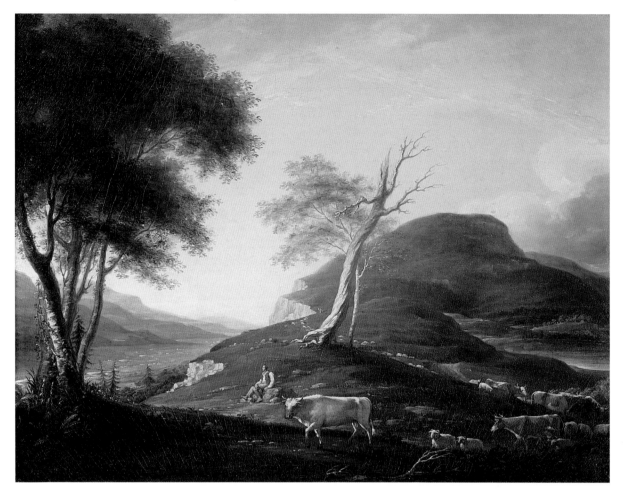

20. *View on the West Mountain near Hartford* c.1791

oil on canvas, mounted on wood 48.3 x 63.2 cm (19 x 24-7/8 in) Yale University Art Gallery, New Haven, Connecticut Bequest of Miss Marian Cruger Coffin in memory of Mrs Julian Coffin (Alice Church)

In one of his earliest landscapes of a specific topographical American site, John Trumbull painted the land which later became part of the estate called Monte Video owned by the artist's nephew-in-law Daniel Wadsworth (see cats 21, 22). In *View on the West Mountain near Hartford*, Trumbull captured the picturesque possibilities of the land outside of Hartford, Connecticut, on which Wadsworth later built his neo-Gothic country house. Trumbull was familiar with the English writers who defined contemporary picturesque theory — his ease with these conventions is apparent in this carefully formulated composition that incorporates irregularity and variety — and undoubtedly imparted this knowledge to Wadsworth. He based the landscape painting on a sketch, inscribed 'View on the West Mountain / near Hartford / May 1791' (Yale University Art Gallery, New Haven), in which he roughly sketched the major forms indicating trees, mountains, sky and the suggestion of shadows and foliage. In the finished painting of this wilderness site, Trumbull added a seated herdsman who gazes over the Farmington Valley while a herd of cattle and sheep slowly amble up the hill, completing this Arcadian view.

Trumbull had more than a purely aesthetic interest in this site. In a letter written from London to Daniel Wadsworth's father Jeremiah (Trumbull had returned to London in 1794), he indicated that he planned to act as an agent for the sale of the land on West Mountain to William Beckford, the English man of letters and a renowned landscape gardener, owner of the neo-Gothic estate Fonthill Abbey:

> West Mountain ... [is] a place more calculated to make a delightful and magnificent country residence, like what He has here than any thing I have ever met with either in America or Europe. He was struck with the description and desired to know how much it might cost an Acre and whether it could be bought.[1]

While nothing came of this offer, Trumbull himself began to acquire land at Talcott Mountain, in Avon, Connecticut, and in a letter of October 1805 offered to share it with Daniel Wadsworth, or to turn the property over to him.[2] Wadsworth acquired Trumbull's holdings and continued to add lands to the mountain estate throughout his life.

EMK

Daniel Wadsworth 1771–1848

21. *Monte Video* c.1810–19
watercolour on paper 7.7 x 11.4 cm (3 x 4-1/2 in) The Connecticut Historical Society, Hartford, Connecticut

Daniel Wadsworth was among an elite group of travellers at the end of the eighteenth century who, educated in the contemporary aesthetic theories of the picturesque, sketched and wrote about the American landscape during their travels. Wadsworth became part of an exclusive community of affluent New Englanders, including the artist John Trumbull, the scientist Benjamin Silliman (both relations of Wadsworth through marriage), and the travel writer Theodore Dwight, who were familiar with British eighteenth-century writings on landscape aesthetics.

Wadsworth's travels are chronicled by his approximately ninety surviving pencil drawings and watercolour sketches including depictions of his trips to the nation's great natural wonders — Niagara Falls and the Natural Bridge, Virginia, to the Connecticut, Susquehanna, and Hudson River Valleys, and to the Adirondack, Catskill, and White Mountain regions.

In the first decade of the nineteenth century, Wadsworth began buying land on top of Talcott Mountain, in Avon, Connecticut. Between 1805 and 1809, in conjunction with his uncle-in-law John Trumbull, he designed and built his country estate, Monte Video, on the site — at the time of his death the estate comprised 250 acres. The Gothic features of the house and outbuildings made Monte Video among the earliest and most elaborate Gothic Revival country estates in America.[1] The focal point of the property was a 55-foot hexagonal wooden tower completed by Wadsworth in 1810. Visitors to the tower experienced sublimity and a sense of power as they gazed out at the spectacular panoramic view below them.[2]

Wadsworth produced a number of sketches of his estate, including *Monte Video* which shows a view of the house looking south, with the viewing tower in the distance, and *Monte Video overlooking the Farmington Valley* looking north to the valley below. With Wadsworth's encouragement, the lands of the estate and the viewing tower became a tourist attraction during his lifetime.

EMK

22. *Monte Video overlooking the Farmington Valley* c.1810
pencil and ink on paper 7.8 x 11.7 cm (3-1/16 x 4-9/16 in)
Wadsworth Atheneum, Hartford, Connecticut William A. Healy Fund

23. *Remarks made, on a Short Tour, between Hartford and Quebec in the Autumn of 1819*
with illustrations after sketches by Daniel Wadsworth (New Haven, 1824) Private collection

In September 1819, Daniel Wadsworth set off with Benjamin Silliman, a professor of chemistry and natural history at Yale College, on a five-week tour to Canada. On the trip Silliman kept a notebook of his observations on geology and mineralogy, while Wadsworth sketched the various sites along the way. The trip resulted in the publication of *Remarks made, on a Short Tour, between Hartford and Quebec in the Autumn of 1819* which was illustrated with engravings after nine of Wadsworth's sketches. The travelogue begins with a lengthy description of Monte Video, illustrated with engravings after Wadsworth's drawings. Silliman carefully described the mountaintop estate and surrounding grounds, pond and viewing tower. In a description of the view from the house, he commented on the site's harmonious contrast of wilderness and cultivated lands:

> Everything in this view is calculated to make an impression of the most entire seclusion; for beyond the water and the open ground, rocks and forests alone meet the eye, and appear to separate you from all the rest of the world. But at the same moment that you are contemplating this picture of the deepest solitude, you may without leaving your place, merely by changing your position, see through one of the long Gothic windows of the same room, which reach to a level with the turf, the glowing western valley, one vast sheet of cultivation, filled with inhabitants, and so near, that with the aid of only a common spy glass you distinguish the motions of every individual who is abroad in the neighboring village.[1]

As a leading patron of American artists, Wadsworth filled his house with paintings by Alvan Fisher, Thomas Cole, and others. He had a life-long friendship with Cole, who visited Wadsworth in Hartford and at his mountaintop retreat on a number of occasions. Among the many landscapes Cole painted for Wadsworth, and which he hung in his house, *View of Monte Video, the Seat of Daniel Wadsworth, Esq.* (fig.41) captured the harmony between wilderness and cultivated lands and the site's impressive elevation in a sweeping panorama taken from the tower.[2]

EMK

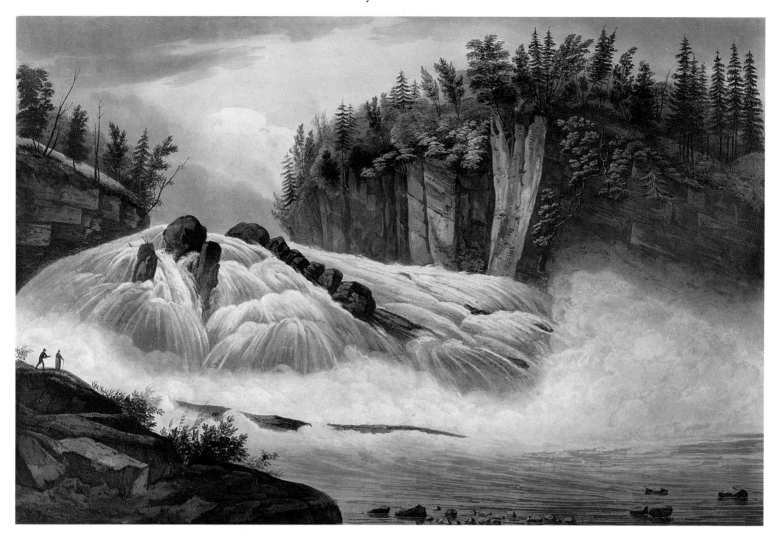

24. *Hadley's Falls* (John Rubens Smith and John Hill after Wall)
aquatint 35.6 x 56.7 cm (14 x 22-3/8 in) from the *Hudson River Portfolio* c.1821–25 Collection of the Hudson River Museum of Westchester, Yonkers, New York Gift of Miss Susan D. Bliss

William Guy Wall toured the Hudson River Valley in 1820. Twenty of the watercolours that he produced after this trip were engraved and published in the *Hudson River Portfolio* from 1821 to 1825, with written descriptions by John Agg to accompany each image. Several editions of this highly popular series were published up to 1828.[1]

William Dunlap, writing in 1834, remarked that Wall painted his views of the Hudson River 'on the spot', but, as Edward Nygren has pointed out, Wall's usual working method — and that of most artists at the time — was to compose later, in the studio, from notes and sketches made at the sites. The large size of the original watercolours (each about 14 x 21 inches), as well as their high degree of finish, make it unlikely that Wall was painting them directly from nature.[2]

Most of the aquatints that appeared in the completed *Hudson River Portfolio* are of the upper part of the Hudson River.

Although this stretch was only thinly settled, Wall includes evidence of non-Native settlement in every image — sometimes a mill, a figure or two, or boats. This is particularly interesting given the contemporary popularity of depictions of untamed American wilderness. Ironically, John Agg, author of the captions to the aquatints, laughed at the farmer and shepherd who were not sophisticated enough to understand wilderness in terms of landscape theory, even as he wrote about the 'uncouth rudenesses of nature' and expressed his own inability to appreciate wilderness.[3]

John F. Sears has suggested, however, that Americans were drawn to the cultivation of the Hudson River Valley rather than the wilderness, since they sought to compare the civilisation of their country with that of rural England. For this reason, the Hudson River (along with the Connecticut River) was one of the earliest regions in the United States to be visited by tourists.[4]

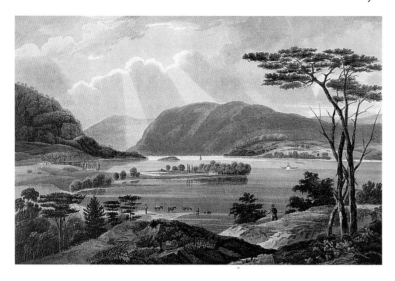

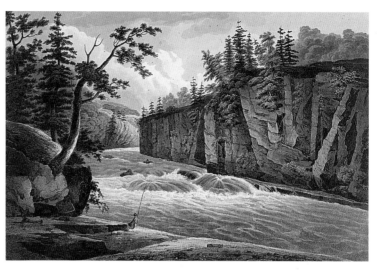

25. *View from Fishkill looking to West Point*
(John Hill after Wall)
aquatint 35.6 x 53.6 cm (13-15/16 x 21-1/8 in) from the *Hudson River Portfolio* c.1821–25
Collection of the Hudson River Museum of Westchester, Yonkers, New York
Gift of Miss Susan D. Bliss

26. *Rapids above Hadley*
(John Hill after Wall)
aquatint 36.2 x 54.0 cm (14-1/4 x 21-1/4 in) from the *Hudson River Portfolio* c.1821–25
Collection of the Hudson River Museum of Westchester, Yonkers, New York
Gift of Miss Susan D. Bliss

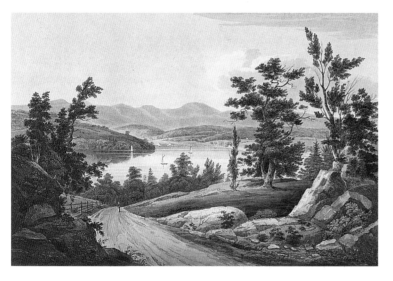

27. *View near Hudson*
(John Hill after Wall)
aquatint 36.0 x 53.3 cm (14-3/16 x 21 in) from the *Hudson River Portfolio* c.1821–25
Collection of the Hudson River Museum of Westchester, Yonkers, New York
Gift of Miss Susan D. Bliss

John Hill (1770–1850) was born in London and moved to Philadelphia in 1816. Engraving the plates for Joshua Shaw's *Picturesque Views of American Scenery* (1820–21) was his first important work. He moved to New York City in 1822, where he soon secured the commission for aquatint engravings after Wall's watercolours for the *Hudson River Portfolio*, finishing four plates started by John Rubens Smith and engraving the other sixteen himself.[5] John Rubens Smith (1775–1849) was born in London, the son of John Raphael Smith, a mezzotint engraver, with whom he studied. (His grandfather was Thomas Smith of Derby, a landscape painter.) John Rubens Smith was a portrait, miniature, and topographical painter as well as an engraver and lithographer. He emigrated to Boston by 1809 and, sometime around 1814, moved to Brooklyn, New York, where he taught drawing. He claimed to have taught William Guy Wall the technique of watercolour.[6]

AE

Alvan Fisher 1792–1863

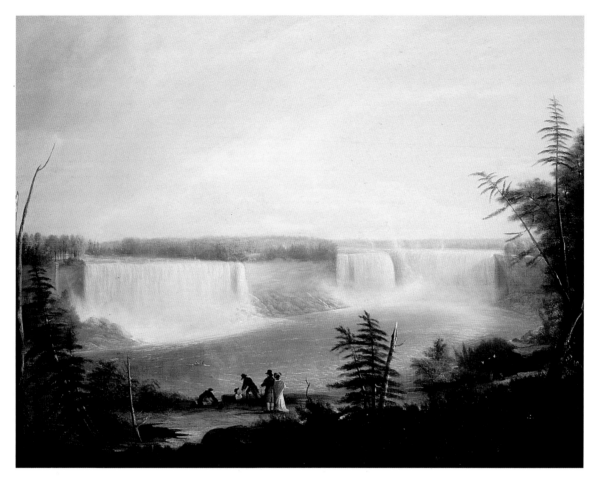

28. *Niagara Falls* 1823
oil on canvas 58.7 x 75.9 cm (23-1/8 x 29-7/8 in) Wadsworth Atheneum, Hartford, Connecticut Bequest of Clara Hinton Gould

In 1822 Mr. Fisher established himself in Hartford. His work was chiefly pastoral, that class of paintings being almost a novelty in the State. Among his more important works was one of Niagara Falls, which was engraved by Asaph Willard. He painted in Hartford for three years, and, as the first pastoral painter of importance to visit the State, produced an impression and influence visible afterward.[1]

As one of the earliest American artists to concentrate on landscape, Alvan Fisher visited Niagara Falls in 1820, making a number of sketches from which he composed a pair of paintings of Niagara (see figs 42, 43) commissioned by Daniel Appleton White of Boston.[2] Most of Fisher's Niagara paintings — there were at least ten of them — were based on this original pair.[3]

In *Niagara Falls*, Fisher draws on the picturesque tradition, framing the foreground with trees on either side and introducing anecdotal interest with figures in the centre foreground, against the sublime backdrop of the falls themselves.[4] Elizabeth McKinsey has suggested that these figures are not merely for narrative interest, but that they reveal the human relationship to the landscape, which is that of the spectator. One figure exclaims over the grandeur of the falls; one is climbing up a ladder and has reached the brink. Although the suggestion of danger is ever present, the figures experience the sublimity of the falls in safety.[5] While the picturesque implies a landscape that can be controlled, the sublime is impervious to human intervention — the irony was that while the sublime wild nature of Niagara claimed many human lives, its water power would be harnessed for human use in industry.[6]

Niagara, particularly by the middle of the nineteenth century, had become a national icon — despite the opinion of some visitors that the American falls were much less impressive than the Horseshoe Fall of Canada. It was first, however, a sacred site for Native Americans. According to François Gendron, a seventeenth-century doctor, Indians claimed that a 'petrified spray' could be found at the base of the falls, which could magically cure 'sores, fistules, and malign ulcers'.[7] One 1783 engraving depicts a Native American seeming to introduce the falls to European visitors, and thus suggesting that the history of Niagara Falls as a wonder of the 'new world' began long before Europeans arrived. But by 1820, Niagara was a tourist attraction, and Native Americans had been supplanted by European visitors.

AE

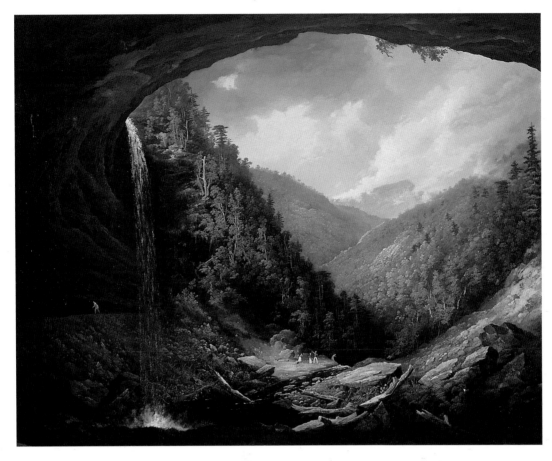

29. *Cauterskill Falls on the Catskill Mountains taken from under the Cavern* 1826–27
oil on canvas 68.8 x 94.0 cm (27 x 37 in) Honolulu Academy of Arts, Hawaii Gift of the Mared Foundation, 1969

Beginning in 1825, Kaaterskill Falls, as they are more commonly known, was a key site on a picturesque tour of the Catskill Mountain region. The falls are on Kaaterskill Creek, in Greene County, New York, about 12 miles west of the Hudson River. The two-tiered falls — the highest in the state — cascade over 260 feet.[1]

Thomas Cole was the first and arguably the foremost artist to depict Kaaterskill Falls.[2] In 1825 he painted *Caatterskill Upper Fall, Catskill Mountains*, which was purchased by John Trumbull. He made a replica of the work, now known as *Kaaterskill Falls*, dated 1826 (fig.44), which was bought by Daniel Wadsworth of Hartford, Connecticut. This painting, unusual in its vantage point from the cavern under the upper tier, was the inspiration for William Guy Wall's *Cauterskill Falls*.[3]

One of the ways in which Wall's depiction differs from Thomas Cole's is his inclusion of a group of tourists in place of a Native American — Cole's romantic symbol of a vanished wilderness.[4] In *Cauterskill Falls*, Wall emphasised the site's picturesque qualities.[5] Indeed, while Cole's solitary figure looks away from the viewer, over an abyss and toward the mountains, Wall's tourists gesture and call attention to the surrounding terrain. By the time both Cole and Wall were sketching in the Catskills, the tourist industry had taken over, and most

of the Native American population had left.[6] In 1824 William L. Stone wrote a series of articles on the Catskills called 'Ten Days in the Country'. Commenting that the creek leading to the falls had been dammed for a sawmill, Stone wrote: 'This saw-mill, we shrewdly suspect, had been erected for a purpose different from that of cutting boards. The owner has dammed up the water so as to nearly destroy the beauty of the cascade at pleasure, and when visitors come, he lets off the waters as a matter of favor, and before they leave the spot, duns everyone to pay for it.' Stone did appreciate the spectacle, however, exclaiming that the falls were 'one of nature's mightiest efforts ... Nothing can equal the sparkling brilliancy of the scene [viewed from the amphitheatre behind the falls], as the torrent rains down its exhaustless store of diamonds.'[7]

When Wall's painting was exhibited at the National Academy of Design in New York City in 1827, it met with glowing reviews, one critic remarking on Wall's depiction of fall foliage, as 'a richness unknown to European eyes, and a splendour amounting almost to gaudiness, which would scarcely be appreciated but by those who have visited our shores'.[8]

AE

Thomas Cole 1801–1848

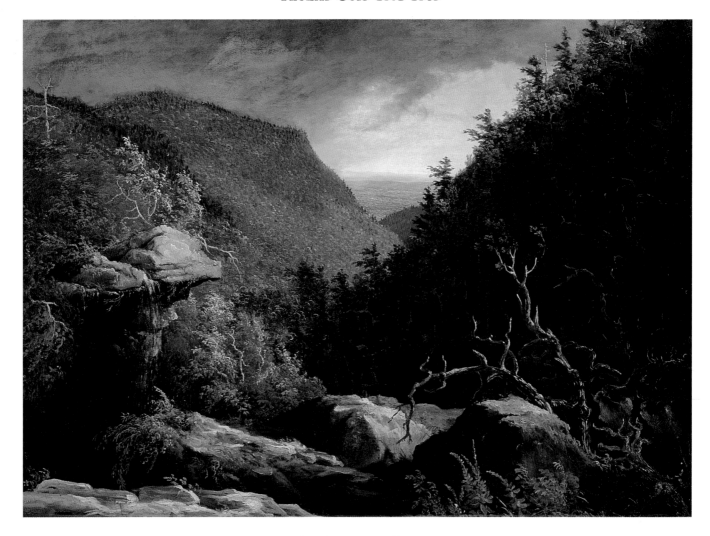

30. *The Clove, Catskills* c.1826

oil on canvas 64.8 x 89.0 cm (25-1/2 x 35 in) New Britain Museum of American Art, Conecticut Charles F. Smith Fund

Thomas Cole visited the Catskill area in New York State to sketch in 1826, spending the summer and early fall there.[1] He reported to his friend and patron Daniel Wadsworth that he was 'enjoying & I hope improving myself amidst the beautiful scenery of Lake George & the wild magnificence of the Catskill mountains — I have made many sketches'.[2] Cole captured that 'wild magnificence' in *The Clove, Catskills*, including the iconography of the sublime in the bare branches at the lower right and the stormy clouds overhead. These elements, traditionally associated with the passage of time and the power of nature over human civilisation, became stock features of Cole's romantic depictions of the American landscape and were drawn from the European tradition of the sublime.[3]

By the time Cole arrived in the Catskills, Kaaterskill Clove was developing into an international centre for the leather trade; a number of tanneries were already in operation. Tourists began arriving in large numbers, partly as a result of a developing taste for landscape, and partly as a result of improved transportation and accommodation. Because the local Native American population had been decimated by disease and warfare, Cole's view of the Clove — a depiction of wilderness reinforced by the inclusion of a Native American — is probably idealised. An image of an American wilderness where that condition no longer existed, this painting thus qualifies, in Alan Wallach's estimation, as a history painting and is the first stage of Cole's allegorical history of the United States.[4]

The work is undated. It may be that Cole painted it prior to 1827, when it was most likely first exhibited. As there is no hard evidence that Cole returned to the Catskills in the summer of 1827, it may be assumed that he took his composition for *The Clove* from the group of sketches he made in the area the previous summer. In 1826 Cole made a list of pictures painted in New York from 1825 to 1826: number 24 is 'View down the Clove'. No owner is mentioned, nor is a price given.[5] It may be that this title refers to the New Britain museum's painting.

AE

George Catlin 1796–1872

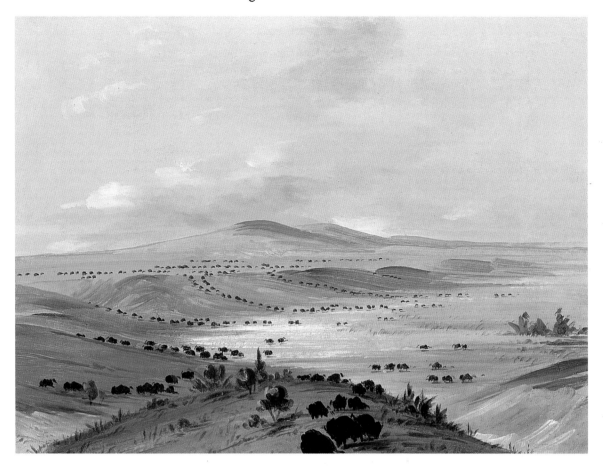

31. *Buffaloes in the Salt Meadows, Upper Missouri* c.1851–52
oil on canvas 28.2 x 37.0 cm (11-1/8 x 14-3/4 in) Gilcrease Museum, Tulsa, Oklahoma

In the 1830s George Catlin travelled up the Missouri River into the region that is now South Dakota and there he first encountered the salt meadows. He wrote:

> [W]e came in contact with an immense saline, or 'salt meadow', as they are termed in this country, which turned us out of our path, and compelled us to travel several miles out of our way, to get by it; we came suddenly upon a great depression of the prairie, which extended for several miles, and as we stood upon its green banks, which were gracefully sloping down, we could overlook some hundreds of acres of the prairie which were covered with an incrustation of salt, that appeared the same as if the ground was everywhere covered with snow.[1]

Buffaloes in the Salt Meadows is a good example of the artist's prairie paintings, which emphasise the natural horizontality of the plains.[2] The Gilcrease painting is a later version of one from 1832–33 known as 'Salt Meadows on the Upper Missouri, and Great Herds of Buffalo'. Catlin probably sketched the scene in 1832.[3]

Buffalo were prevalent in the first half of the nineteenth century, numbering close to twenty million on the Great Plains. By 1800, the Plains Indians relied on the buffalo for their livelihood, killing the slow-moving animals with lances and bow-and-arrow.

Soon, harvesting bison was a commercial enterprise: hides were sold for leather for coats and robes; buffalo tongue was pickled and considered a delicacy by some eastern Americans.[4] In the 1830s, when Catlin first travelled to the Salt Meadow area, the American Fur Company hired Indians to hunt buffalo in return for goods, including alcohol. The hide trade, while supporting the Indians for a time, eventually wiped out the buffalo and the Plains Indians along with them. Catlin himself commented on the practice:

> Oh insatiable man, is thy avarice such! wouldst thou tear the skin from the back of the last animal of this noble race, and rob thy fellow-man of his meat, and for it give him poison![5]

Even at the beginning of the Civil War, the plains were still only sparsely settled by whites. The inhospitable plains seemed ill-suited for cultivation and white civilisation but were beautiful in their own right. Catlin wrote:

> [The buffaloes] were lying in countless numbers, on the level prairie above, and stretching down by hundreds, to lick at the salt, forming in distance, large masses of black, most pleasingly to contrast with the snow white, and the vivid green ...[6]

AE

Frederic Edwin Church 1826–1900

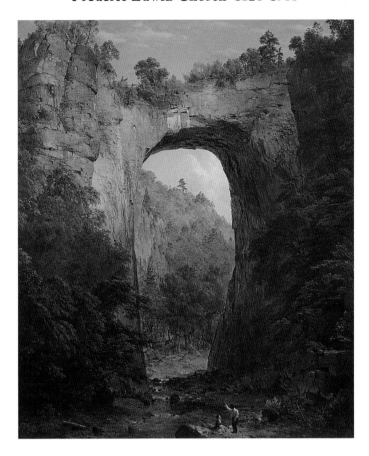

32. *Natural Bridge, Virginia* 1852
oil on canvas 71.1 x 58.4 cm (28 x 23 in) Bayly Art Museum of the University of Virginia, Charlottesville

Thomas Jefferson bought the Natural Bridge from George III of Great Britain in 1774. He described it in his *Notes on the State of Virginia* (1785) as:

> the most sublime of nature's works ... so elevated, so light, and springing as it were up to heaven! the rapture of the spectator is really indescribable![1]

Before Jefferson, George Washington had surveyed the Bridge and laid claim to the natural wonder by carving his initials into it. The spiritual or religious quality that both presidents found in the Bridge was anticipated by Native Americans who called it the 'Bridge of God'.[2]

Jefferson described the formation of the Bridge as a cataclysmic event. By the time Church painted it, the theory that it was formed through erosion was gaining acceptance. This, however, did not lessen the awe it inspired — the time that elapsed during the process of its creation was a cause for interest and wonder.[3]

The limestone Bridge arches over Cedar Creek in the Shenandoah Valley, West Virginia. Its colour was Church's challenge in painting *Natural Bridge*. Cyrus Field, Church's friend, a wholesale paper dealer, and a future promoter of the first transatlantic cable, was an amateur geologist. Field bet Church that he would not be able to capture the colour accurately in paint.[4] Concerned with the truthfulness of Church's depiction, he counselled the artist to collect limestone samples.

Though Church refused, Field took samples himself. When he checked the finished painting against reality, he was so pleased that he purchased it.

With *Natural Bridge*, Church depicted a historic site, much like his painting of *West Rock, New Haven* (cat.57) which Field already owned. The path (now a highway) that crosses the arch was part of an Indian warpath that led through the Great Valley of Virginia, over the Bridge, and to the Cumberland Gap and Kentucky. Daniel Boone was one of the frontiersmen and settlers who took the path over the Bridge. By then known as the Wilderness Road, the trail was a primary route for westward expansion from 1775 to 1800.[5]

Of further interest is the inclusion of the African–American figure — unique in Church's *oeuvre*. This figure is undoubtedly a guide to the site and a slave. Patrick Henry, who was one of Jefferson's slaves, guided visitors at the Bridge when Jefferson was unavailable. By 1803, it was a tourist attraction.[6]

In 1852 *Natural Bridge* was shown at the Royal Academy in London. Franklin Kelly has suggested that Field may have proposed this to Church with the idea that its Ruskinian detail would be of particular interest to the English.[7]

AE

Henry Cheever Pratt 1803–1880

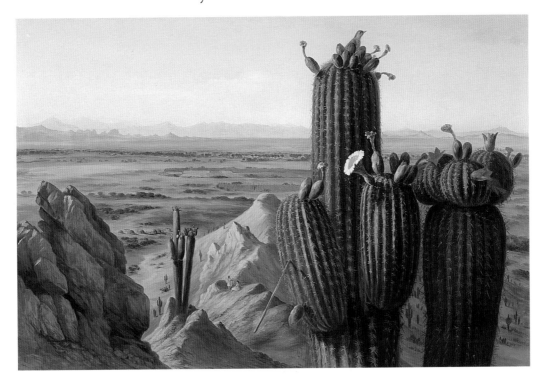

33. *View from Maricopa Mountain near the Rio Gila* 1855
oil on canvas 83.8 x 121.9 cm (33 x 48 in) The Rosewood Corporation, Dallas, Texas

When Henry Cheever Pratt exhibited *View from Maricopa Mountain near the Rio Gila* in 1855, with other paintings of the border region between the United States and Mexico, a writer remarked on the novelty of the landscape:

> Some of the natural productions, introduced into these paintings are so strange, so colossal, that nothing less than the testimony of an honorable man would entitle the assertion of their real existence to any credit.[1]

The Mexican War ended with an American victory in 1848, and a new border between the two nations had to be drawn. John Russell Bartlett, a bookseller, antiquarian and amateur scholar, born in Providence, Rhode Island, and with political connections, received the appointment of border commissioner in 1850. He was excited by the opportunity to study at first hand the flora and fauna of the region, but factionalism and sectional tensions among the Americans on the surveying team led to problems and his subsequent dismissal.[2] In 1854 Bartlett published his illustrated *Personal Narrative of the Explorations and Incidents in Texas, New Mexico, California, Sonora, and Chihuahua* in two volumes.[3]

Pratt had joined the government-sponsored expedition in 1851 and acted as Bartlett's collaborator, recording the topography of the area of the proposed boundary. Although originally Pratt intended his paintings for Bartlett's *Narrative*, Bartlett used his own drawings — he commented that he was unable to use Pratt's because 'it would detract too much from their merits to reduce them to the size of an octavo page'.[4] When Bartlett was forced to resign from the boundary survey, William Emery took over,

but he, too, declined to use Pratt's work, possibly because of Pratt's and Bartlett's relationship.[5]

View from Maricopa Mountain near the Rio Gila features a panoramic view of the landscape of what is now the state of Arizona. At the right and in the middleground are large saguaro cacti, the blossoms of which are now the Arizona state flower. Cacti usually bloom only in the spring and sometimes for a short time.[6] Pratt has shown an arrow stuck in the cactus in the foreground: Bartlett described Native Americans shooting at cactus and illustrated the sport as an anthropological anecdote in his *Narrative*. The surveyors were very interested in the saguaro, and in *View from Maricopa Mountain*, Pratt has depicted different stages of the cycle of growth, from flower to seed pod. In the middleground, two Native Americans are visible on the bare mountain terrain; near the base of the mountain are their huts. The Natives of this region were from the Pima-Maricopa groups.[7] While Pratt includes the Native American presence in his painting, he relegates it to the middleground and distance as almost a footnote, preferring instead to feature the unusual landscape, the real subject of the painting.

Pratt exhibited the picture again in 1858 at the National Academy of Design with the title *Cactus Cereus, Gigomtus*. It had not sold by 1872, when it was once again exhibited with the following description: 'On the plains below, are seen grainfields and the dwellings of the Maricopa Indians. The new Southern Pacific Railroad will pass by the foot of this mountain.'[8]

AE

Joachim Ferdinand Richardt 1819–1895

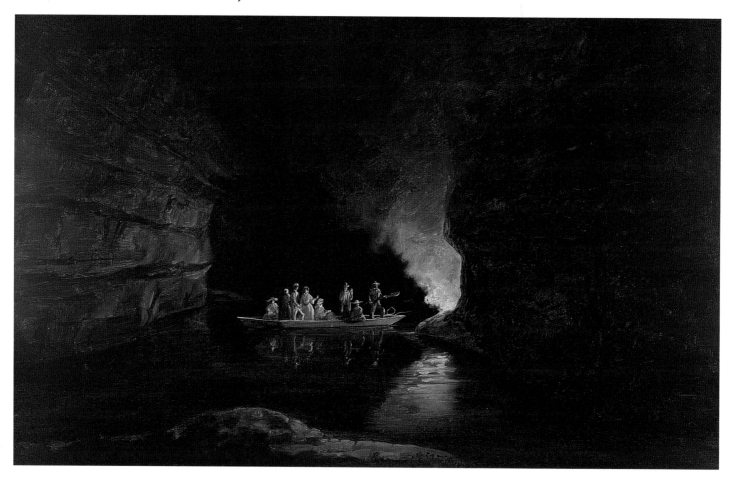

34. *Echo River, Mammoth Cave* 1857
oil on canvas 38.7 x 62.2 cm (15-1/4 x 24-1/2 in) Robert M. Hicklin, Jr., Inc., Spartanburg, South Carolina

Mammoth Cave, part of a national park in southern Kentucky since 1936, is one of the largest of the world's known caves. The full extent of its chambers and passages has not yet been explored, but some 300 miles have been charted. Echo River, which Joachim Ferdinand Richardt depicts, flows through the lowest of five levels of the limestone cave — around 360 feet below ground level — and drains into the Green River. Although known to Native Americans, the cave was not discovered by white Kentucky pioneers until around 1800. During the War of 1812, the cave was a source of saltpetre, which was used for gunpowder.[1]

In 1816 Nahum Ward from Massachusetts published an article about the cave and the mummified corpse he discovered there. The article appeared in newspapers throughout the United States and was published in England in 1817. After Ward, a number of travel writers visited Mammoth Cave, including Nathaniel P. Willis and Bayard Taylor who wrote: 'It is the greatest natural curiosity I have ever visited, Niagara not excepted.'[2]

Franklin Gorin, recognising the potential of Mammoth Cave as a tourist site, bought it in 1838 and brought his young black slave, Stephen Bishop (1821–1857), to serve as a tour guide. (Bishop and the cave were purchased by Dr John Croghan in 1839.) Bishop passed on his considerable knowledge to Mat and Nick Bransford, also slaves, who took over as guides upon Bishop's death in 1857, only weeks before Richardt visited.[3] It was Bishop who was most respected as a guide and most often requested by visitors. In fact he became almost legendary and was compared to Benjamin Silliman in his ability to lecture on the cave formations. Because it was relatively inaccessible, fewer people toured the cave than visited such sites as Niagara Falls, and, by the same token, the site was not depicted by artists as often as Niagara.[4]

The two to three thousand who visited each year could tour the cave only in small groups accompanied by a guide. They donned special clothing and climbed over rocks, squeezed through narrow passages and, carrying lamps, travelled down Echo River in a boat.

Richardt's *Echo River, Mammoth Cave* is an image of tourists exploring the cave in a boat on Echo River. At the bow is an African–American guide — whether it is Stephen Bishop, who would have been familiar to Richardt through guidebooks, is not known.[5]

AE

Notes

Cats 1–3 William Westall *View of Port Bowen, Queensland, August 1802; View of Sir Edward Pellew's Group, Northern Territory, December 1802; View of Malay Road from Pobassoo's Island, February 1803*

1 Westall to Banks, 31 January 1804, Banks Correspondence vol.4, Mitchell Library, Sydney, quoted in Bernard Smith, *European Vision and the South Pacific*, Sydney: Harper Row, 1984, p.193.
2 Matthew Flinders, *A Voyage to Terra Australis* (1814), facsimile edition, Adelaide: Libraries Board of South Australia, 1966, vol.2, p.36. Port Bowen was renamed Port Clinton in 1892 to avoid confusion with the nearby town of Bowen
3 Ibid., vol.2, p.39.
4 Ibid., vol.2, p.170.

Cat.4 Joseph Lycett *Corroboree at Newcastle*

1 Bernard Smith, *European Vision and the South Pacific, 1768–1850*, 2nd edn, Melbourne: Oxford University Press, 1989, p.236.
2 For a detailed argument for attribution to Joseph Lycett see Richard Neville 'Don't We have More Important Fish to Fry?', *Art Monthly Australia*, no.105, November 1997, pp.21–24.
3 Interestingly, while all of the other plates in Wallis's account attribute the original drawings from which Walter Preston made his engravings to Captain Wallis, 46th Regiment, the corroboree image, plate no.6, is inscribed simply 'W. Preston. Sculp.'.
4 James Wallis, *An Historical Account of the Colony of New South Wales*, London: Ackermann, 1821, p.40.
5 For a discussion of the subject see Candice Bruce and Anita Callaway, 'Wild Nights and Savage Festivities; White Views of Corroborees', *Art and Australia*, vol.27, no.2, 1989, pp.269–275.

Cat.5 Joseph Lycett *Views in Australia or New South Wales, & Van Diemen's Land delineated*

1 See entry for Joseph Lycett in Joan Kerr ed., *The Dictionary of Australian Artists: Painters, Sketchers, Photographers and Engravers to 1870*, Melbourne: Oxford University Press, 1992, pp.482–484.
2 *Views in Australia or New South Wales, & Van Diemen's Land delineated*, London: J. Souter, 1824–25, introduction, p.ii.
3 Ibid., p.15.

Cat.6 Augustus Earle *Wentworth Falls*

1 *Sydney Gazette and New South Wales Advertiser*, 27 September 1826, quoted in Tim Bonyhady, *Images in Opposition: Australian Landscape Painting 1801–1890*, Melbourne: Oxford University Press, 1985, p.71.

Cat.7 John Glover *A Corrobery of Natives in Mills Plains*

1 Ron Radford, 'A Corrobery of Natives in Mills Plains', in Ron Radford and Jane Hylton, *Australian Colonial Art 1800–1900*, Adelaide: Art Gallery of South Australia, 1995, pp.68–70.
2 Undated catalogue (after 1866) of collection of Sir Thomas Phillipps, Thirlestaine House, Cheltenham, records the date of the work as 1832.
3 Catalogue of Glover's 1835 exhibition (reprinted for Sir Thomas Phillipps in 1868).
4 The sketchbook is in the Tasmanian Museum and Art Gallery, Hobart.
5 See N.L. Munby, 'The Formation of the Phillipps Library from 1841 to 1872', in *Phillipps Studies No.IV*, Cambridge University Press, 1956. Also Appendix B of the same publication by A.E. Popham, 'Sir Thomas Phillipps as a Patron of Artists and a Collector of Pictures & Drawings', pp.212–227.
6 A note in the Phillipps Papers, vol. 215, f.44, Bodleian Library, Oxford.

Cat.8 Augustus Earle *A Bivouac of Travellers in a Cabbage Tree Forest, Daybreak*

1 Tim Bonyhady points out two reasons why a smaller version probably does not exist 'Firstly, the painting in the National Library [Rex Nan Kivell Collection, on loan to the National Gallery of Australia] is quite small relative to paintings shown at the Academy in the 1830s. Secondly, Earle died in 1838. Given the importance of the Academy he is unlikely to have exhibited there a small version of a painting he had already executed.' From Tim Bonyhady, *Images in Opposition: Australian Landscape Painting 1801–1890*, Melbourne: Oxford University Press, 1985, p.164, n.74.

Cat.9 John Skinner Prout *Maria Island from Little Swanport, Van Diemen's Land*

1 Simpkinson's watercolour is in the collection of the Royal Society of Tasmania, Tasmanian Museum and Art Gallery, Hobart. See Max Angus, *Simpkinson de Wesselow Landscape Painting in Van Diemen's Land and the Port Phillip District 1844–48*, Hobart: Blubber Head Press, 1984.

Cat.10 Conrad Martens *Brush Scene, Brisbane Water*

1 These drawings are now in the State Library of New South Wales, see Elizabeth Ellis, *Conrad Martens: Life and Art*, Sydney: State Library of New South Wales, 1994.
2 Ibid., p.11.

Cat.11 Ludwig Becker *Blow-hole, Tasman's Peninsula, Van Diemen's Land*

1 William Denison, *Varieties of Vice-Regal Life*, vol.1, London: Longmans, 1870.
2 Ibid.

Cats 14–19 Ludwig Becker *Crossing the Terrick-Terrick Plains; Mallee Sand-cliffs at the Darling; Junction: The Bamamoro Creek with the Darling; Meteor seen by me on October 11; Mutawanji Ranges; Camp on the Edge of Earthy or Mud Plains*

1 T.J. Bergin, 'Courage and Corruption: An Analysis of the Burke & Wills Expedition and of the Subsequent Royal Commission of Enquiry', unpublished MA(Hons) thesis, Faculty of History, University of New England, 1982.
2 Ludwig Becker's First Report, Friday 31 August 1860, in Marjorie Tipping, *Ludwig Becker: Artist and Naturalist with the Burke and Wills Expedition*, Carlton: Melbourne University Press, 1979, p.195.
3 Ibid.
4 Ludwig Becker's Fifth Report, Monday 22 October 1860, in Tipping, *Ludwig Becker* (1979), p.205.
5 *Sydney Morning Herald*, 13 October 1997, p.5.

Cat.20 John Trumbull *View on the West Mountain near Hartford*

1 Reproduced in Helen A. Cooper ed., *John Trumbull: The Hand and Spirit of a Painter*, exhibition catalogue, New Haven: Yale University Art Gallery, 1982, p.220.
2 Trumbull to Wadsworth, 15 October 1805, John Trumbull Papers, Yale University, New Haven, Connecticut.

Cats 21–22 Daniel Wadsworth *Monte Video; Monte Video overlooking the Farmington Valley*

1 Richard Saunders, with Helen Raye, *Daniel Wadsworth: Patron of the Arts*, Hartford Connecticut: Wadsworth Atheneum, 1981.
2 Alan Wallach, 'Wadsworth's Tower: An Episode in the History of American Landscape Vision', in *American Art*, 10, no.3, Fall 1996, pp.8–28.

Cat 23 Benjamin Silliman, Sr *Remarks made, on a Short Tour, between Hartford and Quebec*

1 Benjamin Silliman, *Remarks made, on a Short Tour, between Hartford and Quebec in the Autumn of 1819*, New Haven, 1824, p.14.
2 For a discussion of this painting see Elizabeth Mankin Kornhauser's entry for this painting in Kornhauser, with contributions by Elizabeth R. McClintock and Amy Ellis, *American Paintings before 1945 in the Wadsworth Atheneum*, vol.1, New Haven: Yale University Press, 1996, pp.230–233.

Cats 24–27 William Guy Wall *Hadley's Falls; View from Fishkill looking to West Point; Rapids Above Hadley; View near Hudson*

1 Edward J. Nygren, with Bruce Robertson et al., *Views and Visions: American Landscape before 1830*, exhibition catalogue, Washington, DC: The Corcoran Gallery of Art, 1986, p.301.
2 Ibid., p.301. See William Dunlap, *A History of the Rise and Progress of the Arts of Design in the United States* (1834), reprint, New York: Benjamin Blom, 1965, vol.3, pp.103–104.
3 Kenneth Myers, with contributions by Margaret Favretti, *The Catskills: Painters, Writers and Tourists in the Mountains, 1820–1895*, exhibition catalogue, Yonkers, New York: The Hudson River Musuem of Westchester, 1987, pp.188–189.
4 John F. Sears, *Sacred Places: American Tourist Attractions in the Nineteenth Century*, New York and Oxford: Oxford University Press, 1989, pp.49–50.
5 George C. Groce and David H. Wallace, *The New-York Historical Society's Dictionary of Artists in America, 1564–1860*, New Haven: Yale University Press, 1957, pp.315–316. Nygren, Robertson et al., *Views and Visions* (1986), pp.301–302.
6 Groce and Wallace, *The New-York Historical Society's Dictionary of Artists* (1957), p.589. Nygren, Robertson et al., *Views and Visions* (1986), p.300.

Cat.28 Alvan Fisher *Niagara Falls*

1 H.W. French, *Art and Artists in Connecticut*, Boston: Lee and Shepard, Publishers; New York: Charles T. Dillingham, 1879, p.54.
2 See Fred B. Adelson, 'Alvan Fisher (1792–1863): Pioneer in American Landscape Painting', Ph.D.diss., Columbia University, 1982, Ann Arbor, Michigan: University Microfilms International, 1984, p.172. It may be that the 1820 visit was Fisher's first, although Robert Vose has suggested that the artist may have sketched at Niagara as early as 1818. See Robert C. Vose, Jr, 'Alvan Fisher, 1792–1863, American Pioneer in Landscape and Genre', in *Connecticut Historical Society Bulletin*, 27, October 1962, pp.97–130. The paintings that White commissioned are the pair now in the collection of the National Museum of American Art in Washington, DC.
3 Jeremy Elwell Adamson, 'Nature's Grandest Scene in Art', in Adamson et al., *Niagara: Two Centuries of Changing Attitudes, 1697–1901*, exhibition catalogue, Washington, DC: The Corcoran Gallery of Art, 1985, p.37.
4 See Elizabeth McKinsey, *Niagara Falls: Icon of the American Sublime*, New York: Cambridge University Press, 1985, p.118.
5 See ibid., p.119.
6 Ibid., pp.120, 128–131. On the association of death with Niagara Falls, see Patrick McGreevy, 'Reading the Texts of Niagara Falls: The Metaphor of Death', in Trevor J. Barnes and James S. Duncan, *Writing Worlds: Discourse, Text and Metaphor in the Representation of Landscape*, London and New York: Routledge, 1992, pp.50–72.
7 As quoted in Elizabeth McKinsey, 'An American Icon', in Adamson et al., *Niagara* (1985), p.83.

Cat.29 William Guy Wall *Cauterskill Falls on the Catskill Mountains taken from under the Cavern*

1 The first tier falls 175 feet, and the second tier, 85 feet. Kaaterskill was the most common name for the falls in the Catskill Mountains, but they were variously known as Cauterskill, Cattskill, Causkill, and Kautskill. The origin of the name is thought to be either Indian or Dutch.
See John K. Howat, 'A Picturesque Site in the Catskills: The Kaaterskill Falls as Painted by William Guy Wall', *Honolulu Academy of Arts Journal*, vol.1, 1974, pp.17–19.
2 On Thomas Cole in the Catskills, see Kenneth Myers, with contributions by Margaret Favretti, *The Catskills: Painters, Writers, and Tourists in the Mountains, 1820–1895*, exhibition catalogue, Yonkers, New York: The Hudson River Museum of Westchester, 1987, pp.40–46.
3 Ibid., p.47.
4 Edward J. Nygren, 'From View to Vision', in Nygren with Bruce Robertson et al., *Views and Visions: American Landscape before 1830*, exhibition catalogue, Washington, DC: The Corcoran Gallery of Art, 1986, p.63.
5 Ibid.
6 Myers, *The Catskills* (1987), pp.22–23.
7 William L. Stone, 'Ten Days in the Country', in *New-York Commercial Advertiser*, no.5, vol.27, 7 September 1824, as quoted in Howat, in *Honolulu Academy Arts Journal*, 1974, pp.20–21.
8 D. Fanshaw, 'Review — The Exhibition of the National Academy of Design, 1827: The Second', in *United States Review and Literary Gazette*, vol.2, no.4, 4 July 1827, p.255, as quoted in Howat, in *Honolulu Academy Arts Journal* (1974), p.27.

Cat.30 Thomas Cole *The Clove, Catskills*

1 He may have returned the following summer. Kenneth Myers with contributions by Margaret Favretti, *The Catskills: Painters, Writers, and Tourists in the Mountains, 1820–1895*, exhibition catalogue, Yonkers, New York: The Hudson River Museum of Westchester, 1987, pp.40, 117.
2 Thomas Cole to Daniel Wadsworth, Catskill, 6 July 1826, in J. Bard McNulty ed., *The Correspondence of Thomas Cole and Daniel Wadsworth: Letters in the Watkinson Library, Trinity College, Hartford, and in the New York State Library, Albany, New York*, Hartford: The Connecticut State Historical Society, p.1.
3 For a recent exploration of the sublime in Cole's work, see Bryan Jay Wolf, *Romantic Re-Vision: Culture and Consciousness in Nineteenth-Century American Painting and Literature*, Chicago and London: The University of Chicago Press, 1982, ch.5.
4 See Alan Wallach, 'Thomas Cole: Landscape and the Course of American Empire', in William H. Truettner and Alan Wallach eds, *Thomas Cole: Landscape into History*, exhibition catalogue, New Haven: Yale University Press in association with the National Museum of American Art, 1994, esp.pp.64–66.
5 This list is in the collection of the Detroit Institute of Arts, 39.680.1 and 39.680.2. It is reproduced in Ellwood C. Parry III, *The Art of Thomas Cole: Ambition and Imagination*, Newark: University of Delaware Press, 1988, p.22.

Cat. 31 George Catlin *Buffaloes in the Salt Meadows, Upper Missouri*

1 George Catlin, *North American Indians: Being Letters and Notes on Their Manners, Customs and Conditions, Written during Eight Years' Travel Amongst the Wildest Tribes of Indians in North America, 1832–1839*, Edinburgh: John Grant, 1926, vol.1, p.247.
2 Joan Carpenter Troccoli, *First Artist of the West: George Catlin's Paintings and Watercolors from the Collection of Gilcrease Museum*, exhibition catalogue, Tulsa, Oklahoma:Gilcrease Museum, 1993, p.26.
3 William H. Truettner, *The Natural Man Observed: A Study of Catlin's Indian Gallery*, exhibition catalogue, Washington, DC: Smithsonian Institution Press, in association with the Amon Carter Museum of Western Art, Fort Worth, and the National Collection of Fine Arts, Smithsonian Institution, 1979, cat.no.342.
4 David B. Danbom, *Born in the Country: A History of Rural America*, Baltimore and London: The Johns Hopkins University Press, 1995, pp.138–139.
5 George Catlin, *Letters and Notes on the Manners, Customs, and Conditions of North American Indians*(1844), reprint, New York: Dover, 1973, vol.1, pp.259–261, quoted in Patricia Nelson Limerick, *The Legacy of Conquest: The Unbroken Past of the American West*, New York and London: W.W. Norton and Company, 1987, p.182.
6 Catlin, *Letters and Notes* (1844), vol.1, pp.220–221.

Cat.32 Frederic Edwin Church *Natural Bridge, Virginia*

1 Thomas Jefferson, *Notes on the State of Virginia* (1785), reprint, ed. by William Peden, New York: W.W. Norton and Co., Inc., 1954, as quoted in William Howard Adams, ed., *The Eye of Thomas Jefferson*, exhibition catalogue, Washington, DC: National Gallery of Art, 1976, p.338.
2 The Monocan tribe was the group that referred to the Bridge as such.
3 DuPont Gallery, *So Beautiful an Arch: Images of the Natural Bridge, 1787–1890*, exhibition catalogue, Lexington, Virginia: duPont Gallery, Washington and Lee University, 1982, introduction, n.p.
4 For biographical information on Cyrus Field, see Allen Johnson and Dumas Malone eds, *Dictionary of American Biography*, New York: Charles Scribner's Sons, 1931, vol.6, pp.357–359.
5 See the foreword and introduction to Robert Kincaid, *The Wilderness Road*, New York: Bobbs-Merrill Co., 1947.
6 See J. Lee Davis, *Bits of History and Legends Around and About the Natural Bridge of Virginia*, pp.44–45, cited in Dana Cline,'Frederick Edwin Church's *Natural Bridge*', Virginia: Virginia Commonwealth University,1996, p.4.
7 Franklin Kelly et al., *Frederic Edwin Church*, exhibition catalogue, Washington, DC: National Gallery of Art, 1989, p.46.

Cat.33 Henry Cheever Pratt *View from Maricopa Mountain near the Rio Gila*

1 Sigma, 'Works of Art', in *Boston Evening Transcript*, 5 December 1855, p.1, as quoted in Gray Sweeney, 'Drawing Borders: Art and the Cultural Politics of the U.S.–Mexico Boundary Survey 1850-1853', in *Drawing the Borderline: Artist–Explorers of the U.S.–Mexico Boundary Survey*, exhibition catalogue, Albuquerque, New Mexico: The Albuquerque Museum, 1996, p.67.
2 For information on the problems Bartlett encountered in fulfilling his task, see Patricia Nelson Limerick, *The Legacy of Conquest: The Unbroken Past of the American West*, New York and London: W.W. Norton and Company, 1987, pp.233–234, as well as John Mack Faragher, 'North, South, & West: Sectional Controversies and the U.S.–Mexico Boundary Survey', in Albuquerque Museum, *Drawing the Borderline* (1996), pp.1–2. Biographical information on Bartlett can be found in Allen Johnson ed., *Dictionary of American Biography*, vol.2, New York: Charles Scribner's Sons, 1929, pp.7–8.
3 Sweeney, in *Drawing the Borderline* (1996), p.23. Sweeney cites Robert V. Hine, *Bartlett's West: Drawing the Mexican Boundary*, New Haven: Yale University Press, 1968, for information about Bartlett's survey.
4 Bartlett, quoted in James K. Ballinger and Andrea D. Rubinstein, *Visitors to Arizona 1846–1980*, exhibition catalogue, Phoenix, Arizona: Phoenix Art Museum, 1980, p.80.
5 Ibid., p.81.
6 See William H. Harris and Judith S. Levey, *The New Columbia Encyclopedia*, New York and London: Columbia University Press, 1975, entry for cactus, p.414.
7 Sweeney, in *Drawing the Borderline* (1996) pp.67–68.
8 'A Peculiar Cactus', in *Boston Evening Transcript*, 22 May 1872, quoted in Sweeney, in *Drawing the Borderline* (1996), p.68.

Cat.34 Joachim Ferdinand Richardt *Echo River, Mammoth Cave*

1 William H. Harris and Judith S. Levey eds, *The New Columbia Encyclopedia*, New York and London: Columbia University Press, 1975, p.1676. See also Patricia L. Hudson and Sandra L. Ballard, *The Smithsonian Guide to Historic America: The Carolinas and the Appalachian States*, New York: Stewart, Tabori and Chang, 1989, pp.415–418.
2 This information and quote is from John F. Sears, *Sacred Places: American Tourist Attractions in the Nineteenth Century*, New York and Oxford: Oxford University Press, 1989, p.32. See also Bayard Taylor, *At Home and Abroad*, New York: G.P. Putnam, 1860, p.224.
3 Hudson and Ballard, *The Smithsonian Guide* (1989), p.418. See Sears, *Sacred Places* (1989), pp.32–33. Melinda Young Frye has done much of the available research on Richardt.
4 Sears, *Sacred Places* (1989), pp.32–33.
5 See Melinda Young Frye's description of the painting for Robert M. Hicklin Jr, Inc., Spartanburg, South Carolina.

Fitz Hugh Lane *Fresh Water Cove from Dolliver's Neck, Gloucester* early 1850s (detail) (cat.59)

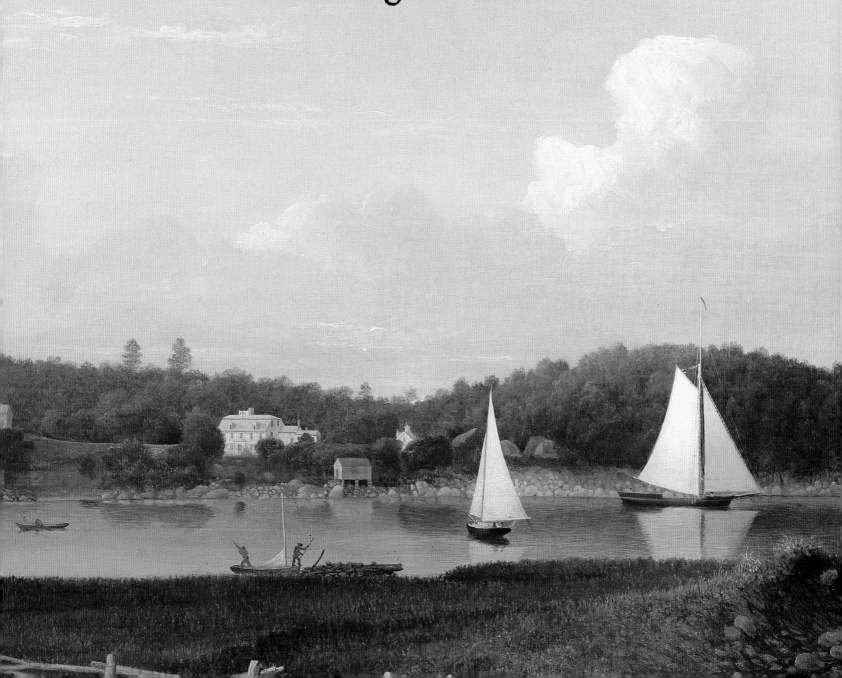

Claiming the Land

John Glover 1767–1849

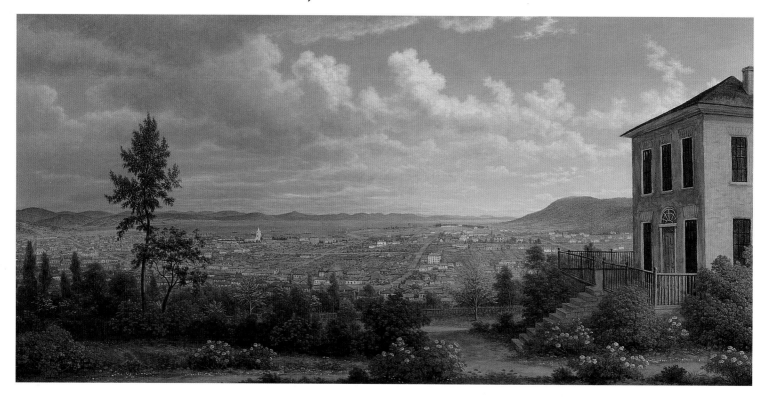

35. *Hobart Town, taken from the Garden where I lived* 1832
oil on canvas 76.0 x 152.0 cm (30 x 59-7/8 in) Dixson Galleries. State Library of New South Wales, Sydney

When John Glover arrived in Tasmania he was immediately struck by its natural beauty. Indeed, his prolific output during his Australian period — which represents the end of his artistic life — shows an artist who has found fresh inspiration and new challenges. This is reflected in works which demonstrate a decisive and almost immediate change in his approach to landscape painting.

Glover arrived in Hobart Town on 1 April 1831 and moved into Stanwell Hall a week later. Situated on a hill overlooking the town, with views extending to the Derwent River and the hills beyond, the two-storey stone house had been built in 1828 in Georgian style, featuring the plain and symmetrical facade found in many domestic dwellings in England at the time.

This view of Hobart Town is a panorama of a prosperous and thriving settlement: in 1832 the population of Hobart was 10,101 — second only to Sydney. While originally a penal settlement, by the time of Glover's arrival many free settlers were emigrating to take advantage of the generous government land grants. The land proved to be very good for grazing and crops, and a wool industry was already well established.

Hobart Town taken from the Garden where I lived is one of Glover's first works to be completed in his new homeland. On the reverse is the inscription:

The Geraniums, Roses, etc., will give some idea how magnificent the garden may be had here. Government House is to the left of the church, the Barracks on the eminence to the right.

The foreground is dominated by the flowers mentioned in the inscription, painted in meticulous detail — a feature of Glover's work which can be traced back to his early drawing skills and extensive watercolour experience. However, Glover has already managed to make concessions to a vastly different environment. The rich greens associated with the English countryside have been toned down and the trees are shown as distinct entities, representative of the Australian forest, rather than the dense foliage of a European equivalent. The large areas of greenery present in Hobart Town constitute a marked departure from the closely packed villages and towns of rural England.

Glover remained in Hobart Town until March 1832 when he took up his land grant at Mills Plains at the base of Ben Lomond in the northern part of the island.

Stanwell Hall still exists at its site in Melville Street, Hobart, though the building has been considerably altered. The church spire seen to the left of centre is now the site of St David's cathedral. The sailing vessels beyond are anchored in Sullivan's Cove; the military barracks to the right is now the Anglesea Barracks, close to Sandy Bay.

CG

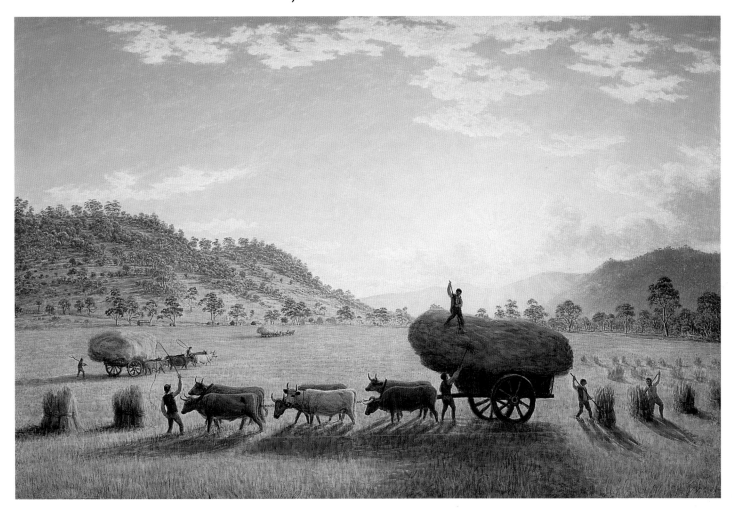

36. *My Harvest Home* 1835
oil on canvas 76.2 x 113.9 cm (30 x 44-7/8 in) Tasmanian Museum and Art Gallery, Hobart Gift of Mrs C. Allport 1935

My Harvest Home is an autobiographical statement about John Glover's life in Australia — a quality the work shares with *Hobart Town taken from the Garden where I lived* (cat.35) and *The Artist's House and Garden, Mills Plains* 1835 (fig.8). The use of the possessive pronoun in the title endows the work with a sense of personal good fortune and veracity. This is further strengthened by the artist's inscription on the stretcher bar of the canvas: 'My Harvest Home Van Diemen's Land/the Picture began March 19th 1835 the day the harvest was all got in.'[1]

On a personal level, Glover was very much at home on a working farm. He was the son of a farmer, and many of his early drawings depict countryside and farm animals around Lichfield near Birmingham where he lived from 1794. When, late in life, Glover decided to emigrate to Australia he looked forward to planting an extensive vineyard.[2] While this plan did not eventuate, he certainly planted a garden (celebrated in his painting of 1835 referred to above).

Glover emigrated to Tasmania in 1830 with his wife and eldest son. His three younger sons had already established productive farms in the colony. Once there, Glover successfully applied for a grant of land, and in 1832 with his wife and eldest son he travelled from Hobart to his grant at Mills Plains, to the property he named Patterdale. By the end of 1832, Henry Glover had joined his brother and father on the property, crops had been planted and homestead buildings constructed. What we know of the Glover family's life at Patterdale is almost entirely due to descriptions in the letters of John Richardson Glover (John Glover Jnr), written to his married sister Mary Bowles in the 1830s. In September 1833 he wrote that a third crop of corn had been planted in the 'corn paddock' on Mills Plains.[3] By 1839 he was able to report that the cycle of planting and harvest had become routine and that 'our crops, thank Goodness, turn out equal to most, our wheat in particular often surpasses most of our neighbours'. He commented that in the late 1830s the price of wheat had risen dramatically.[4] While the Glovers grew enough wheat for their own use, besides other grain for disposal, wool was their principal commercial farm production.

AS

John Glover 1767–1849

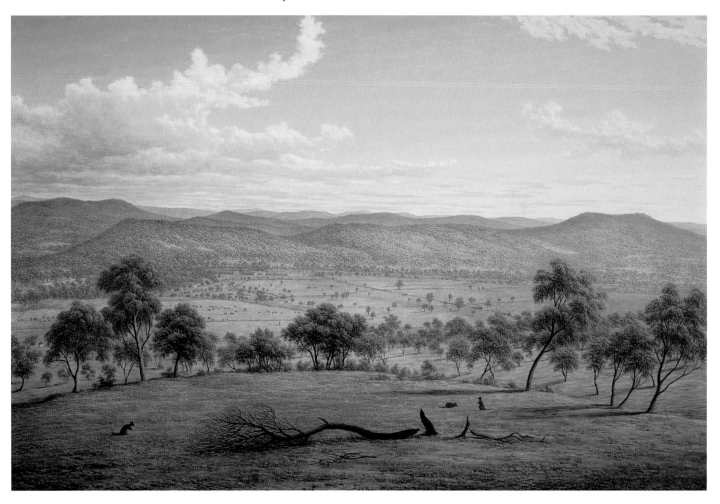

37. *Cawood on the Ouse River* 1835
oil on canvas 76.0 x 114.4 cm (30 x 45 in) Tasmanian Museum and Art Gallery, Hobart Gift of Mrs G.C. Nicholas 1936

In John Glover's sketchbook begun on 19 December 1834 there are four drawings of the Ouse River at Cawood.[1] The Ouse (which was also known as the Big River) runs from the glacial lakes in the central mountainous region in the western part of Tasmania and joins the Derwent River close to the town of Ouse. The property, Cawood, is on what was (originally) a 1,000-acre grant made to T.F. Mazetti who arrived in Tasmania in 1824, and who was responsible for building the significant stone house and outbuildings visible in Glover's painting. Mazetti owned the property when Glover visited, presumably in 1835, but sold it in 1844 to the Nicholas family who, by the end of the nineteenth century had expanded it into one of the most extensive sheep farms in Tasmania.[2]

Glover's drawing shows all the natural advantages of Cawood, so admired in the nineteenth century. Situated on the sinuous Ouse River and set on well irrigated river flats, the property was described at its sale in 1844 as comprising 'excellent pasture and arable land, the whole substantially fenced in and subdivided into convenient sized paddocks' with several hundred acres under crop. The homestead was 'of a description not generally seen in the colony, comprising large family mansion, with extensive outbuildings, the whole substantially built of stone ...'[3] In Glover's painting the half dozen extensive paddocks stretching before the house are planted with grain crops. In the near foreground are paddocks with grazing cattle and sheep.

Comparing the sketchbook drawing with the finished painting reveals the way in which Glover endowed his painting with a sense of breadth and scale. In the drawing the buildings are much closer than they appear in the painting. Glover has reduced them in size and created a more extensive landscape setting — a technique he used on more than one occasion, such as in his painting of the Hobart Town Orphan Asylum dwarfed by the massive bulk of Mount Wellington, in *Mount Wellington with the Orphan Asylum, Van Diemen's Land*, c. 1837 (fig.30). Furthermore, Glover's parabolic foreground (in the drawing) has been converted to a gently convex amphitheatre in the painting, a feature which emphasises the park-like landscape of the estate — a serene stage from which the viewer can enjoy a scene of endless bounty.

AS

John Glover 1767-1849

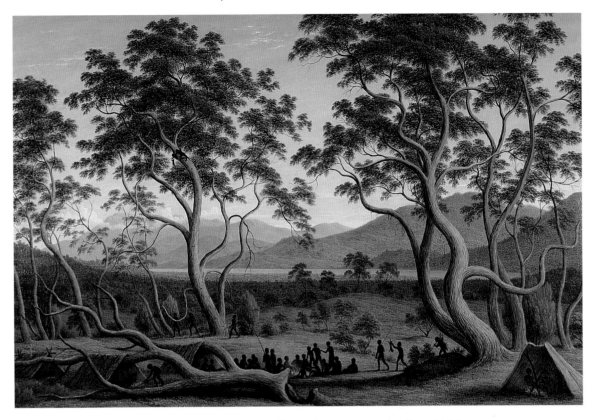

38. *The Last Muster of the Aborigines at Risdon* 1836
oil on canvas 121.8 x 182.6 cm (48 x 71-7/8 in) Queen Victoria Museum and Art Gallery, Launceston Gift of Mrs T. Baker

This painting is the largest of John Glover's Australian works, and its scale befits its status as a history painting. With apparently more historical precision than his allegorical *The Bath of Diana, Van Diemen's Land* (cat.40) or the symbolic *Ben Lomond Setting Sun. From near the Bottom of Mr Boney's Farm* (cat.42), it records the events surrounding the dispossession of the Tasmanian Aboriginal people. While not explicit in its title, this painting — like *Aborigines Dancing at Brighton, Tasmania,* 1835 (Mitchell Library, State Library of New South Wales, Sydney) painted by Glover in the previous year — is linked to his understanding of the work of George Augustus Robinson, known as the 'conciliator' of the Aborigines. Between 1830 and 1834 Robinson was responsible for advocating and carrying through a plan to make contact with the Aboriginal people who remained in the bush in Tasmania, convincing them to join him, and finally shipping them to a settlement offshore, on Flinders Island in Bass Strait.

Glover's painting of Aborigines dancing at Brighton was presented to Robinson, whom the artist admired greatly. The painting, replete with ethnographic detail, reflected Robinson's genuine interest in (though not respect for) Aboriginal traditional life and language. Robinson's interest was documented in his diaries, which became a major source of knowledge about the organisation of Tasmanian Aboriginal society. *The Last Muster of the Aborigines at Risdon* depicts a group of Aboriginal people before their transfer to Flinders Island. It, too, is full of

ethnographic interest, showing a man climbing a tree and catching a possum.

The scene in Glover's painting, Risdon Cove, is on the eastern side of the Derwent River estuary; it was the site of the first settlement in 1803 of Europeans on Van Diemen's Land (named Tasmania in 1855). The settlement which later became Hobart was moved to Sullivan's Cove on the opposite side of the estuary. It is perhaps ironic that the scene of the first European settlement in Tasmania should have become, in Glover's painting, the setting of the last mainland gathering of the island's remaining indigenous people.

The most striking feature of *The Last Muster of the Aborigines at Risdon* is the exaggerated sinuosity of the trees — a treatment invariably associated with Glover's Aboriginal subjects (and found in all of his Aboriginal paintings included in this exhibition) — which is not characteristic of his paintings of settler subjects, such as those of his own property. Ian Maclean has suggested that the sinuous trees give a clue to Glover's attitude toward the Aboriginal landscape — an attitude conditioned to accept it as strangely Gothic and exotic — and contrasts this with the graceful quality Glover sought to express in his paintings of property.[1] A painting such as *The Last Muster of the Aborigines at Risdon* therefore seems to owe more to Salvator Rosa than to Glover's artist hero Claude Lorraine.

AS

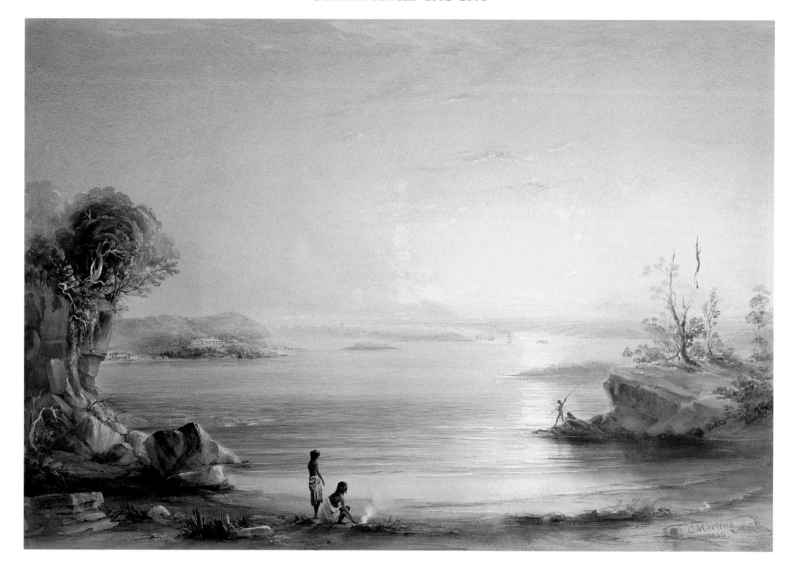

39. *View from Sandy Bay* 1836
pencil and watercolour 46.1 x 66.4 cm (18-1/8 x 26-1/8 in) National Gallery of Victoria, Melbourne Felton Bequest 1950

This watercolour dates from the year after the arrival of Conrad Martens in Sydney. It sounds a new note in the depiction of Sydney as a subject of topographical interest. Martens dissolves the buildings making up the town in a distant blaze of sunlight. His focus is upon the natural beauty of the harbour and atmospheric effect, and this contrasts with the interest of earlier topographical artists whose concern was to delineate, with exaggerated care, the government buildings, flagstaffs, windmills and fortifications of the town.

Today there is no Sandy Bay on Sydney Harbour, but the spot from which the view is taken is clearly identifiable as either at Rose Bay or close to it.[1] While Martens's treatment may have departed from that of earlier artists, his viewpoint was not original. Throughout the 1820s artists such as Joseph Lycett had produced watercolour views taken from the same vantage point and included groups of Aboriginal people hunting and fishing.[2] A feature of these depictions was invariably Captain Piper's Henrietta Villa which can be seen on the prominence on the left hand side of the composition. This grand Regency villa was greatly admired, as much for its idyllic harbour-side position and setting in landscaped gardens as for its architectural ostentation.

This view — which embodies a sense of optimistic promise (despite the fact that it is a setting rather than a rising sun) and which evokes memories of Claude Lorrain and J.M.W. Turner, must have been very successful for Martens — as Caroline Clemente has pointed out, there are at least six versions of it entered into the artist's account book.[3]

AS

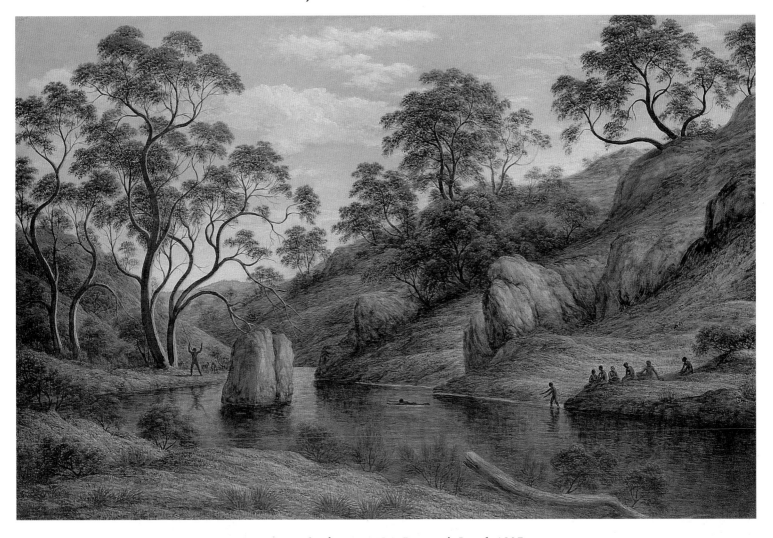

40. *The Bath of Diana, Van Diemen's Land* 1837
oil on canvas 76.0 x 114.0 cm (30 x 44-7/8 in) National Gallery of Australia, Canberra

By the time of John Glover's arrival in Tasmania in 1831, it was too late (it is thought) to see Aboriginal people living so freely in groups in the bush such as he depicts in *The Bath of Diana, Van Diemen's Land*. However, from the moment of his settling in the colony, Glover was acutely interested in the indigenous people. In his first year he made a small drawing in his sketchbook which he inscribed with the title 'Diana and Actæon'[1]— a composition which, six years later, he turned into this oil painting. It is not known whether the subject was inspired by a particular locality — the work certainly suggests direct observation of a corner of the Tasmanian bush. In terms of the people depicted, however, it presents an imagined scene of their idyllic and untroubled life before the European invasion — what Glover called 'the gay, happy life the natives led before the White people came here'.[2]

There is evidence in his comments on several of his other paintings that Glover saw the life of Aborigines in Tasmania before the arrival of Europeans as rather like the existence in Eden before the fall. In one small drawing he explicitly compares the Aborigines to Adam and Eve, with the serpent coiling around a tree, as yet unseen.[3]

The Bath of Diana, Van Diemen's Land is a further expression of this view. As Tim Bonyhady has pointed out in his discussion of this painting, the moment in the story of Diana and Actæon which Glover depicts in the painting is 'the last moment of order and tranquillity before invasion is apprehended and violence and mayhem break out'.[4] In the Greek myth, the hunter Actæon comes upon Diana and her attendants bathing. When she discovers his presence, the outraged Diana turns Actæon into a stag and he is set upon by his own hounds who tear him to pieces. In Glover's painting the Actæon figure is obscured from Diana's view behind a large rock.

In its explicit use of mythology to comment on contemporary events, Glover's painting is unique in Australian colonial art, and remained extremely rare in the entire history of art in Australia in the nineteenth century.

AS

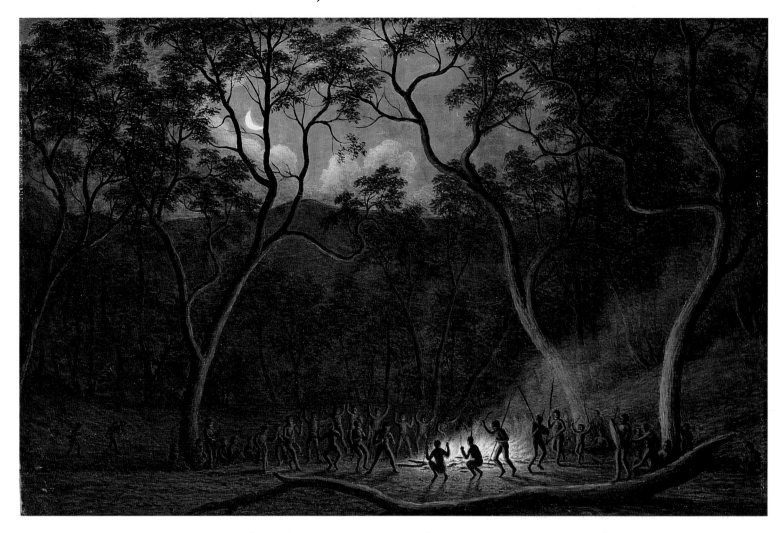

41. *Danse d'indigènes de la Terre Van Diemen* [*A Corrobery of Natives in Van Diemen's Land*] 1840
oil on canvas 77.0 x 114.5 cm (30-1/3 x 45 in) Musée du Louvre, Paris

John Glover sent six paintings to King Louis-Philippe of France in the early 1840s — among them, *Danse d'indigènes de la Terre Van Diemen* and *Soleil couchant à Ben Lomond*. In 1814, both Louis-Philippe (then Duc d'Orleans) and Louis XVIII had been impressed by Glover's work which was shown in the Paris Salon that year, and the king subsequently awarded Glover a gold medal for a painting of the Bay of Naples. It is not known whether Glover had any continuing association with Louis-Philippe, but he was obviously impressed by the latter's strong interest in world exploration and discovery hence his decision to send to France paintings of Van Diemen's Land , where the artist lived from 1831 (Van Diemen's Land was named Tasmania in 1855).

Both paintings, which depict the landscape and the indigenous inhabitants, are contrived scenes, as by 1840 there were virtually no groups of Aborigines still living in the vicinity of Glover's property. His paintings of the Aboriginal people were based on sketches he made during his first years in the colony —

even then, the process of eradicating the Aboriginal population was under way.

One of Glover's favourite Aboriginal subjects was the corroboree, celebrated in his very first Aboriginal subject painted in Tasmania in 1832 (cat.7). *Danse d'indigènes de la Terre Van Diemen* bears an inscription on the reverse which reads: 'I have seen more enjoyment and Mirth in such occasion than I ever saw in a Ballroom in England.' By 1840 Glover was well aware of the miserable plight of the Aboriginal people, but continued to append a description he had first used to describe a (possibly) first-hand observation. When compared to his earlier works depicting Aborigines, however, there are now symbolic references which can be interpreted as the artist's recognition of their demise.

The first impression when viewing *Soleil couchant à Ben Lomond* is of a Claudian landscape, with the atmospheric sky and serene landscape evoking the romantic feeling of the age.

John Glover 1767–1849

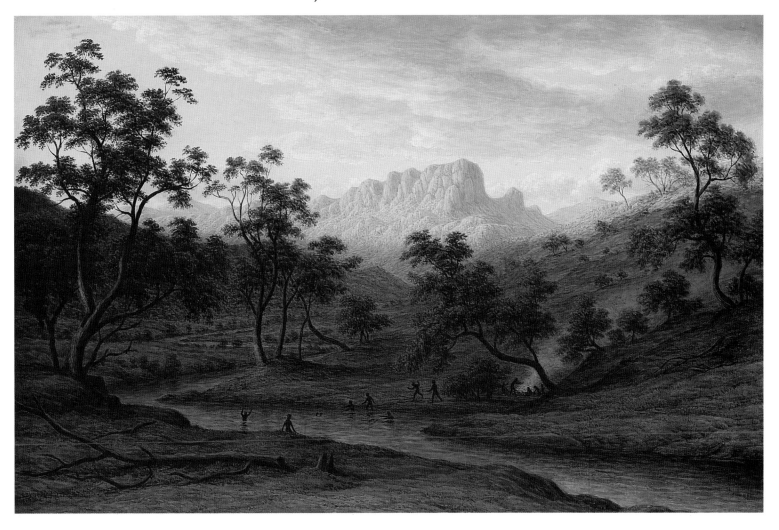

42. *Soleil couchant à Ben Lomond* [*Ben Lomond Setting Sun. From near the Bottom of Mr Boney's Farm*] 1840
oil on canvas 77.0 x 114.0 cm (30-1/3 x 44-7/8 in) Musée du Louvre, Paris

Glover has focused on the mountainous structure of Ben Lomond, which bears a resemblance to its Scottish namesake, while leaving the rest of the composition in shadow. On closer inspection, one sees a group of Aborigines in the foreground engaged in a variety of activities. Some are bathing while others are attending to the campfire. The firelight draws the viewer to the human forms which occupy a small but intense area of the canvas; and against the sunset the large gum trees assume a ghostly and almost overpowering permanence.

Ben Lomond had special significance for Glover. He and his neighbouring landholder, John Batman, were the first Europeans to ascend the peak, a feat they achieved on horseback.[1] The mountain was a dominant feature in the landscape surrounding Glover's property, Patterdale; he included it in many of his landscape paintings and its dramatic solidity always acts as a visual anchor.

Apart from Glover's obvious concern for the plight of Aborigines, it should be remembered that these paintings were sent along with four others to King Louis-Philippe of France for possible purchase. He was appealing to the king's interest in exotic far-flung localities; and both works combine pictorial subject matter with ethnography. When the pair of paintings chosen by the king were viewed by M. Le Berle, in charge of acquisitions for the royal collection, he wrote that they would not be classified as works of art but would be catalogued as works of curiosity.[2]

The paintings were first housed at the Chateau d'Eu, owned by King Louis-Philippe, before being transferred to the Louvre in 1848–49. In 1933 they were sent to the Museum of the Colonies which had opened in 1931, but were returned to the Louvre in 1968. They were exhibited for the first time in 1994 as part of the exhibition, *D'outre-Manche*, which highlighted British works in the Louvre collection.[3]

CG

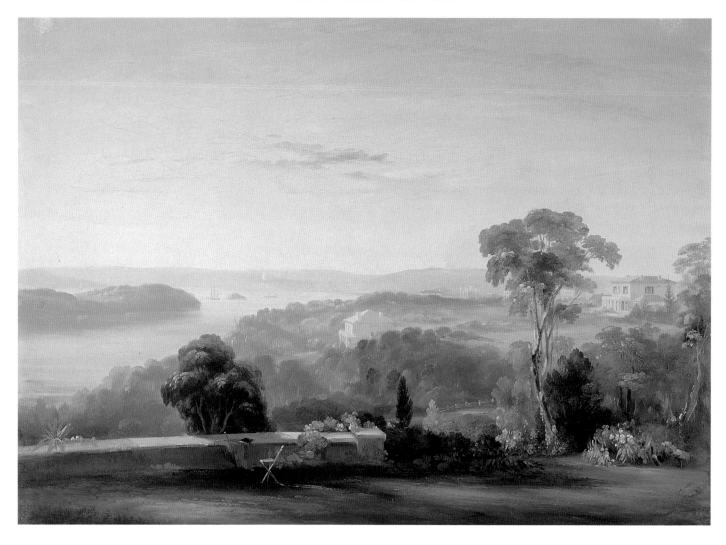

43. *View from Rose Bank* 1840
oil on canvas 47.0 x 66.0 cm (18-1/2 x 26 in) National Gallery of Autsralia, Canberra

Rose Bank was built, probably in 1831, for the Deputy Commissary General James Laidley, who lived in the residence until 1835. The house (which cannot be seen in this painting) was at the top end and south side of William Street in Darlinghurst, Sydney; it was a two-storey structure with three windows across the top floor, a verandah below, and two single-storey side wings.[1] It was sold to Robert Campbell Tertius in 1836; he owned it until 1844. Campbell purchased this painting from Conrad Martens together with the watercolour *View of Rose Bank* (now in the collection of the Mitchell Library, State Library of New South Wales, Sydney) which shows the house set back among trees and shrubs. (A pencil drawing for *View from Rose Bank,* dated 7 July 1840, can also be found in the Mitchell Library.)

Martens completed many watercolours and paintings for the wealthy owners of Sydney houses. In his account book entries for 15 and 23 July 1840, the sale of the two Rose Bank works were noted (15 guineas for the oil and 10 guineas for the watercolour), but it is not known if Robert Campbell Tertius commissioned the pieces.

Until recently some uncertainty has surrounded the identification of the houses that can be seen in *View from Rose Bank*. However, the recent discovery that the house in the centre of the composition is Telford Place, has enabled us to accurately name the other houses seen in Martens's view.[2] Clockwise from Telford Place, the first house is Tarmons, probably designed by John Verge, the leading Sydney domestic architect of the time. On the right of Tarmons is the Gothic style Grantham(ville), which was begun for Caleb Wilson and completed for the merchant, Frederick Parbury. A tree obscures most of the next three houses — all were probably designed by Verge. The last house along, and the most prominent in the painting, is Brougham Lodge which was built for Mr Justice James Dowling who lived there until he died in 1844.[3]

MK

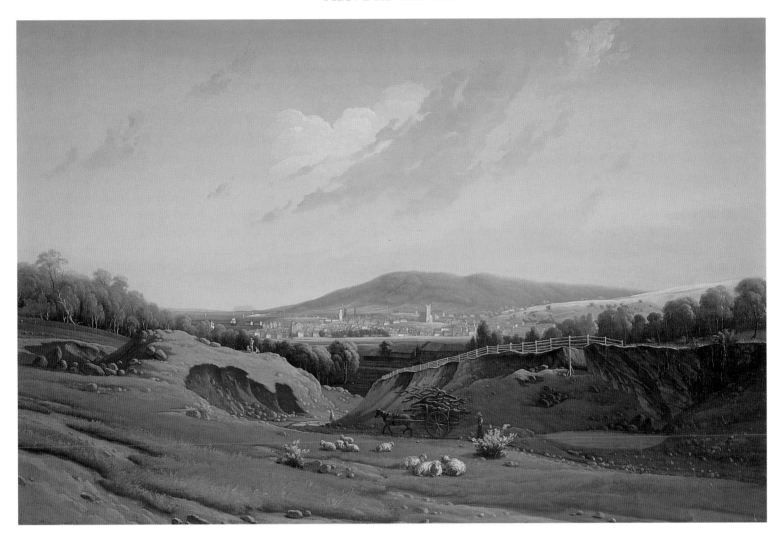

44. *View of Hobart Town* 1855

oil on canvas 86.0 x 132.0 cm (33-7/8 x 52 in) Tasmanian Museum and Art Gallery, Hobart Gift of Miss Ada Wilson 1907

By 1855 Hobart was a well-established town and much of the surrounding area had been opened up for farming. However, with the expansion of the mainland towns of Adelaide and Melbourne, Hobart was losing its significance as Australia's second major settlement (after Sydney).

Knut Bull's landscape views of Tasmania are known for their atmospheric effects and sense of melancholy. *View of Hobart Town* depicts a serene landscape, the only harshness being the sharp contours of the exposed orange-red ground. The farmer with his horse and cart, the sheep, and the distant church tower which dominates the skyline, reflect the very European nature of this early settlement. There is little indication that the scene is of a 'new world'.

A comparison of Bull's view of Hobart Town with that of John Glover, some twenty years earlier (cat.35), provides a record of the town's growth in that time .

CG

Knut Bull 1811–1889

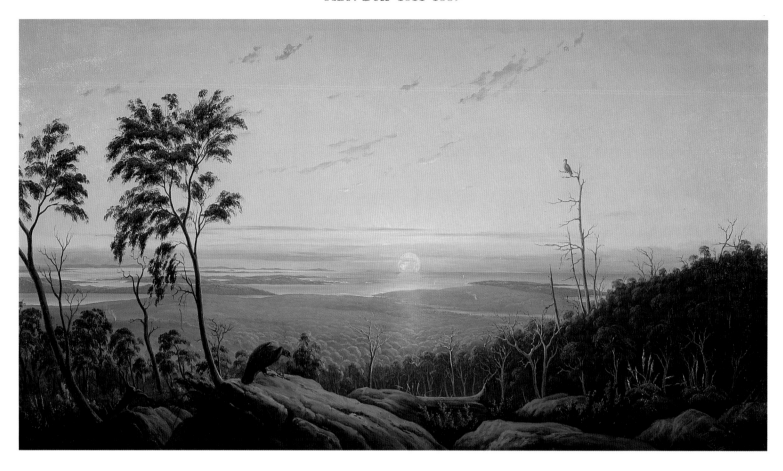

45. *Entrance to the River Derwent from the Springs, Mount Wellington* 1856
oil on canvas 75.5 x 132.0 cm (29-3/4 x 52 in) Tasmanian Museum and Art Gallery, Hobart Gift of Miss Ada Wilson 1907

In *Entrance to the River Derwent from the Springs, Mount Wellington*, Knut Bull captures the pale, luminescent colours of the rising sun, with the reflections on the water highlighting the vastness of the region. He has interpreted the landscape in a manner removed from his European background, adapting his colour palette to the bright Australian light. His depiction of the low, dense vegetation clearly shows its daunting, impenetrable nature. The only signs of habitation are insignificant man-made signals — small wisps of smoke rising in the distance to the left and right of the canvas.

The inclusion of the birds of prey as the only animal life is intriguing. The menacing figure of the bird in the foreground, and the authoritative stance of its companion atop the dead tree branches, contrast with the superb sunrise — a reference to the beauty and threat to be found in the natural world. This allusion to the balance of nature may have reflected Bull's own internal conflict, as the talent which enabled him to paint such works also led to his transportation to Australia for forgery.

View of Hobart Town and *Entrance to the River Derwent from the Springs, Mount Wellington* were among the last of Bull's Tasmanian paintings. He moved to Sydney in 1856–57 where he continued to paint in oils and watercolours.

CG

Eugene von Guérard 1811–1901

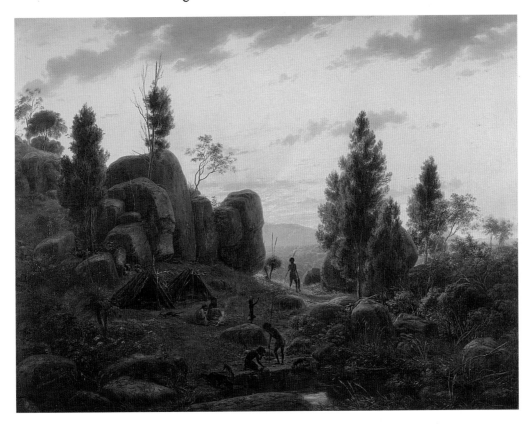

46. *Stony Rises, Lake Corangamite* 1857
oil on canvas 71.0 x 86.4 cm (28 x 34 in) Art Gallery of South Australia, Adelaide
Purchased with assistance of the Utah Foundation through the Art Gallery of South Australia Foundation 1981

The educationalist, writer and historian James Bonwick described the Stony Rises in Victoria's Western District in his *Narrative of an Educational Tour in 1857*:

The Rises are a remarkable geological feature. The basalt, instead of being spread out, as on the plains, or massive, as in mountains, is here reared up as waves petrified in their rise. Huge Barriers meet the eye on all sides, of heights from ten to sixty feet, and the traveller has to thread his way between them or over them as best he can. Dieffenbach rightly describes a similar place in New Zealand as a 'sea of rocks'. When I saw them I thought of Ross's account of the storm among the icebergs. Emory speaks of the *Devil's Turnpike* in New Mexico, whose ascents and descents were paved with sharp angular fragments of basaltic trap. They are like the *Via Mala* of the Alps, a 'tortuous, black jagged chasm, in perpendicular, angular, and convoluted zigzag rifts'. The old lava of Hecla is said to be in high glazed cliffs, or immense, rugged vitrified walls. Darwin compares a similar scene he beheld, to a sea petrified in a storm; but he adds, 'no sea could present such irregular undulations or could be traversed by such deep chasms'. Once in the Rises it is no easy matter to get out again from this Victorian Labyrinth. In some parts the chasms are deep and the bold fronts of the Barriers in the dim evening twilight have a most unearthly appearance; especially when frowning upon some yawning cavern, from whose dismal recesses one hears the mysterious flitting of bats, and the repulsive growls of wild cats. Fancy placed the armed but terrified Christian before me, to realise the terrors of Bunyan's Valley.[1]

In many ways Eugene von Guérard's painting of the Stony Rises echoes the romantic sensibility which gave rise to Bonwick's admittedly over-enthusiastic description. The painting resulted from the artist's trip through the Western District of Victoria in April 1857 — the same year as Bonwick's journey. And Bonwick's description gives us the key to the way the artist's contemporaries would have read this painting. Although the road through the Western District was well travelled by the 1850s, the Stony Rises was considered a wild place. Everything in von Guérard's painting is calculated to reinforce this view — the gathering shadows, the massive rocks everywhere pushing up through the ground, the tangled undergrowth. In this context, the Aboriginal family lately returned from hunting seems to be an emanation of nature. Furthermore, they are an imaginative reconstruction of pre-European Australia. When von Guérard visited the Stony Rises, the local Aboriginal population (the Colac tribe) had been reduced to sixteen people, none of whom lived in the bush, but rather worked on nearby sheep and cattle stations.[2]

AS

Eugene von Guérard 1811–1901

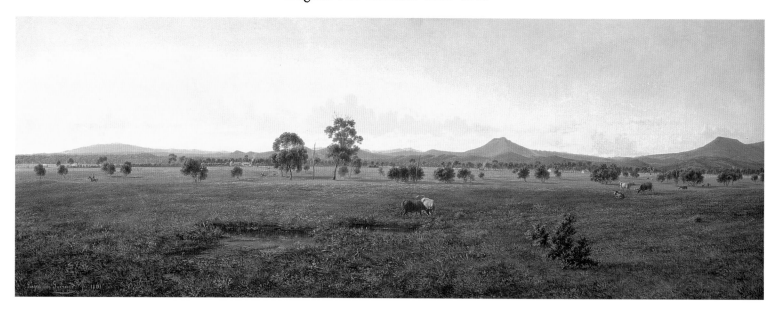

47. *Bushy Park* 1861
oil on a pair of canvases each 36.1 x 94.2 cm (14-1/4 x 37 in) Rex Nan Kivell Collection, National Library of Australia and National Gallery of Australia, Canberra

Bushy Park was the name of the property selected and owned by Angus McMillan near Stratford in the Gippsland district of Victoria. McMillan's generation attributed the discovery of Gippsland to him; certainly he was among the first Europeans to journey into this region from the Monaro in New South Wales. McMillan settled on Bushy Park in 1840 and over the subsequent two decades expanded his property and stock holdings considerably.[1]

The year of Eugene von Guérard's painting, 1861, was a disastrous one for McMillan. Early in the year the effects of the depression of the late 1850s and the drop in beef prices saw his financial situation collapse. The expansion of Bushy Park had relied upon heavy borrowings and when McMillan was unable to pay his debts to the stock and station agents, Kay and Butchardt, they foreclosed on Bushy Park and auctioned the land and stock in November 1861.[2] Therefore the date of the work, 1861, is significant; it represents a moment in the history of the property

when all was in flux. Whether von Guérard's painting was made for McMillan is not known since its early provenance is untraced.

Bushy Park had a wider significance for von Guérard than other pastoral properties he painted in the late 1850s and early 1860s. There are two unique features of the Bushy Park diptych in von Guérard's *oeuvre*. First, the homestead itself (with its attendant outbuildings, more like a village than a farm, according to contemporaries) is pushed into the background; it is so small as to be almost invisible. Secondly, and more tellingly, von Guérard has departed from the standard pattern of his paintings of properties and created a continuous panorama, rather than the view towards and the view from the homestead which was the standard paired description. This points to one of the artist's real interests in the subject — the mountains beyond the property. It was into these ranges than von Guérard accompanied A.W. Howitt on his 1860 prospecting expedition through the Victorian Alps. These mountains obsessed

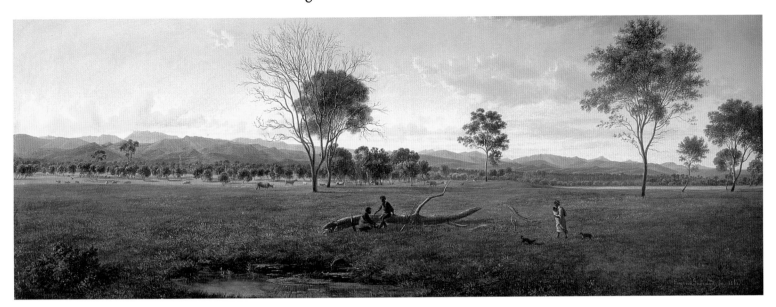

McMillan too; he led an expedition through them in 1864 which led to the discovery of payable gold.

The Aborigines of Bushy Park were also of interest to von Guérard. The figures in the foreground of the right-hand panel probably allude to events at Bushy Park which were still fresh in the memory of people there. A.W. Howitt described Bushy Park as the site of 'the last great battle of the Gippsland class' — a feud among two Aboriginal groups, the Kamilaroi and the Kurnai, which culminated in a large armed fight on the property in 1857.[3] The Aboriginal group in the painting presents a picture of harmony — weapons are laid aside and the two men and the woman are dressed in European clothes. Clearly the artist points us to an aspect of the contemporary life of the Kurnai in 1861, but he probably included the figures as a deferential tribute to McMillan's reputation as a friend of Aboriginal people. McMillan was the officially designated Protector of the Aborigines for the locality (having responsibility for the distribution of stores and blankets) and was widely known to have successfully intervened to the defence of the Kurnai man, William Login, who was tried for the murder of Richard Dothwaite in 1858.[4]

Interestingly, while the early 1860s was a defining moment in the career of Angus McMillan, this was a defining moment also for the Kurnai people. In 1862 after a protracted discussion which involved McMillan and other Gippsland landowners, the Victorian government established an Aboriginal reserve (Ramahyuck) at the mouth of the Avon River under the direction of the Moravian missionary, Reverend Hagenauer. Whilst in McMillan's time Aboriginal people lived on Bushy Park, by the mid–1870s the majority of the remaining Kurnai had left the property and were living at the Ramahyuck mission.[5]

AS

Conrad Martens 1801–1878

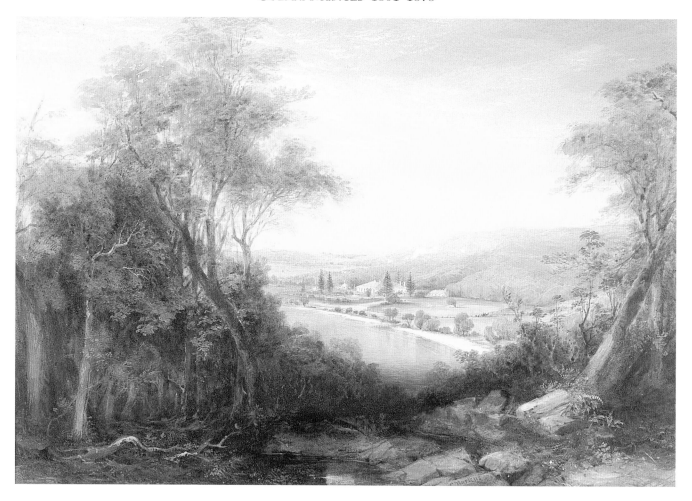

48. *The Cottage, Rose Bay* c.1857
watercolour, gouache, pencil, gum arabic on paper 46.1 x 66.0 cm (18-1/8 x 26 in) National Gallery of Australia, Canberra

The Cottage was designed by the architect John Verge and built in 1835 for James Holt, business partner of the merchant and aspiring politician Daniel Cooper, who lived in the house from 1843 and commissioned Conrad Martens to paint this highly finished watercolour view. The Cottage still stands and has recently undergone extensive restoration to remove the excrescences of decades and return it to its original Vergeian proportions and detailing.

In many ways this work is typical of the house views in which Martens specialised throughout the late 1830s, 1840s and 1850s. It shows not only the house, but suggests an idyllic setting and brings into its compass Cooper's large tract of land, which included part of Rose Bay on Sydney Harbour and most of the land which now comprises the suburb of Woollahra.[1]

Martens has framed his view of the Cottage within large forest trees. Although this was a characteristic compositional device used by the nineteenth-century landscapist, there is a particular significance in the place from which the view is taken. In 1857 Sir Daniel Cooper (he was knighted in that year) was engaged in building a new and, he hoped, spectacular house on the very spot Martens chose as the vantage point to look towards the earlier

and more modest house. Construction on the new house, Woollahra House, was begun in 1856 but it was never completed in the grandiose style Cooper had intended.

Martens was able to give to his subjects that most desired of qualities in the mid-nineteenth century — breadth. This skill accounts for his popularity as a painter of property. He was also a more suave watercolourist than any other artist living in Sydney during the century. *The Cottage, Rose Bay* displays the full range of techniques which were available to him: the use of gum arabic varnish to give depth to the foreground; the judicious use of body colour to give density to the rocks; successive washes of transparent colour to impart lightness and interest to the sky and water; the tell-tale touch of red in the left foreground to enliven the shadows. All of these techniques were characteristic of an art which became richer throughout the 1850s as a response to a more opulent taste, and as a result of Martens's study of the work of J.M.W. Turner.[2]

AS

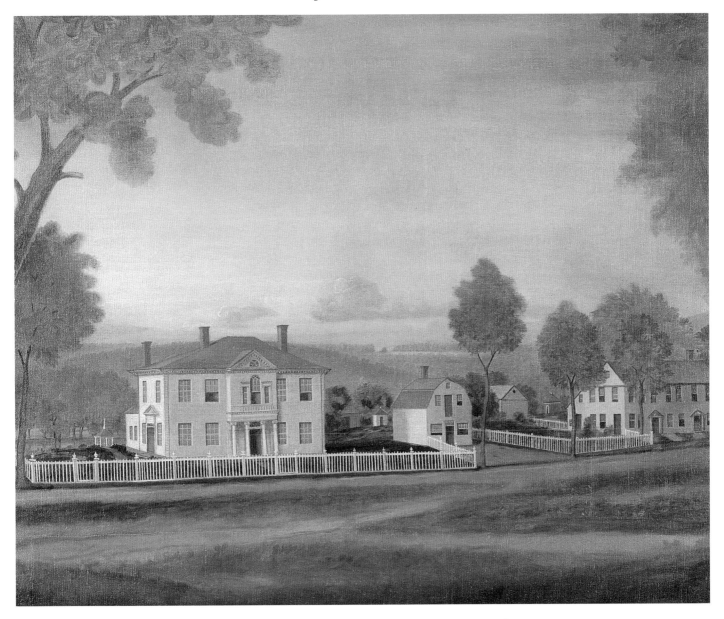

49. *Houses and Shop of Elijah Boardman (Houses Fronting New Milford Green)* 1795–96

oil on canvas 121.9 x 137.8 cm (48 x 54-1/8 in) Wadsworth Atheneum, Hartford, Connecticut The Dorothy Clark Archibald and Thomas L. Archibald Fund, The Ella Gallup Sumner and Mary Catlin Sumner Collection Fund, The Krieble Family Fund for American Art, The Gift of James Junius Goodwin, and The Douglas Tracy Smith and Dorothy Potter Smith Fund

Landscape paintings of regional American scenery were extremely rare in the United States before the nineteenth century. *Houses and Shop of Elijah Boardman* was commissioned by Ralph Earl's patron Elijah Boardman (1760–1823), a shopkeeper in the small town of New Milford, Connecticut, who had also commissioned Earl to paint portraits of himself and his family.[1] This landscape portrays Boardman's Palladian-style house and shop, recently built by the local architect William Sprats, and at the right, the Bostwick house, also owned by Boardman and which had served as the previous site of his drygoods store. The landscape accurately documents the stylish architecture of the house and includes details of the elaborate white fence that surrounds the house, protecting it from the road in the foreground.

Next to the main house, a large driveway leads to Boardman's new mercantile store, the source of his income. The neatly tended grounds, with a British-style summer house on the side lawn, run down to the picturesque Housatonic River behind the house.

Unlike the tradition of English country house painting, in which the mansion house is set within an expansive rural landscape, Earl's depiction of Boardman's property reflects its location on the main road of a thriving town centre. Directly in front of the house and surrounding fence, newly planted saplings line the road. Earl employs pink and blue hues in the sky, creating a sense of well-being in his depiction of this 'new world' landscape.

EMK

Thomas Birch 1779–1851

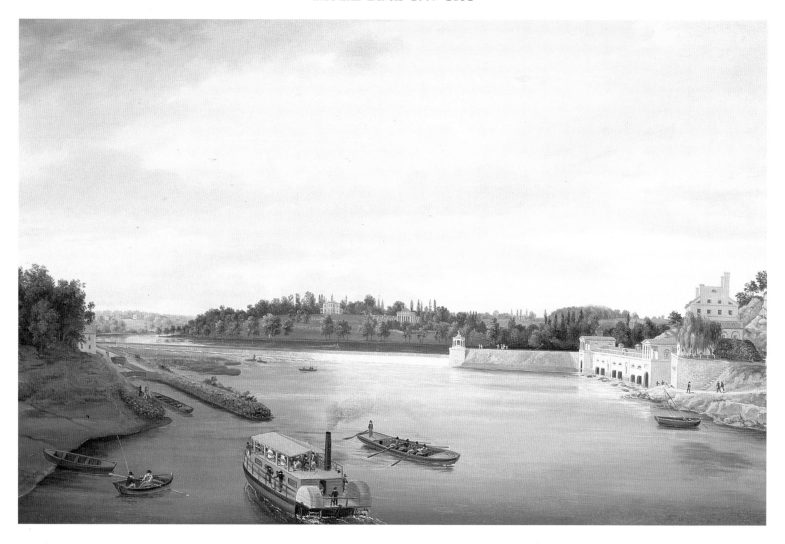

50. *Fairmount Waterworks* 1821
oil on canvas 51.3 x 76.4 cm (20-1/8 x 30-1/16 in) The Museum of American Art of the Pennsylvania Academy of the Fine Arts, Philadelphia Bequest of Charles Graff

Thomas Birch painted a number of views of the Fairmount Waterworks, which were designed by Frederick Graff (1774–1847) and built on the Schuylkill River in Philadelphia between 1812 and 1822.[1] Considered an engineering feat, the waterworks were set on five acres that were landscaped according to the precepts of picturesque theory. They opened in 1815 as an early example of the public garden, which was to be the democratic answer to the great estate gardens of England and Europe. The combined celebration of both landscape and technology implicit in Fairmount Park, as the site came to be called, typified Americans' changing attitudes toward the landscape. Technology could now be used to harness the vast natural resources of the United States in order to create a democratic society of order and prosperity.[2]

Lemon Hill, the country estate of Henry Pratt, is visible in the distance. Pratt was a successful Philadelphia merchant who also had a keen interest in horticulture. He built the house in 1799–1800: in plan, it resembles the Castlecoole, Enniskillen, County Fermanagh, Ireland (1791–98), and may have been based on illustrations in the widely available *Picturesque and Descriptive View of the City of Dublin* by James Malton (London, 1792–95).[3] The garden became famous for its horticultural wonders, and Lemon Hill was known as 'Pratt's Garden'. The complex design of the garden includes both formal and naturalistic elements, including grottoes, fishponds, bowers and summer houses. In the style of William Kent and Alexander Pope, Lemon Hill borrows its shell-encrusted grotto, among other elements, from Pope's garden at Twickenham, England.[4]

AE

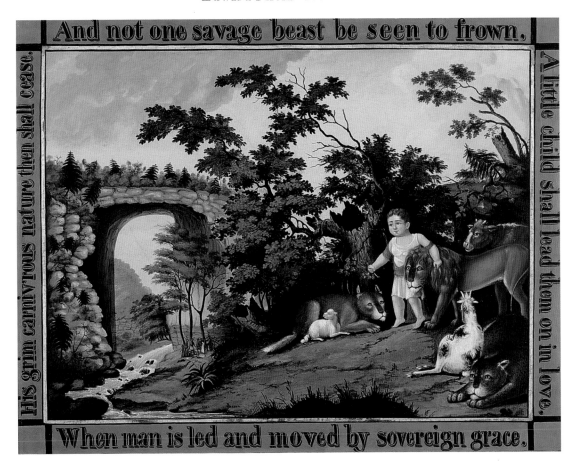

51. *Peaceable Kingdom of the Branch* c.1826–30
oil on canvas 59.7 x 78.1 cm (23-1/2 x 30-3/4 in) Reynolda House, Museum of American Art, Winston-Salem, North Carolina

Edward Hicks painted some sixty works based on the theme of the Peaceable Kingdom, which he drew from the Old Testament book of Isaiah. One passage in particular contains the prophecy of a better time to come, when 'the wolf shall live with the lamb' (Isaiah 11:6), and the holy city (Jerusalem) will be marked by peace and justice (11:6–9). That Hicks was making a connection between the holy city and the United States is suggested by his inclusion of the treaty scene, probably taken from a print by John Hall after Benjamin West's *William Penn's Treaty with the Indians* (Pennsylvania Academy of the Fine Arts, Philadelphia).[1] The scene in West's painting is of the Quaker founder of Pennsylvania, William Penn (1644–1718), making a peace treaty with the Lenape Indians in 1682, not long after Penn arrived in the United States. The event is supposed to have occurred under the Great Elm at Shackamaxon (now a part of Philadelphia) on the Delaware River.

Hicks's intentions might be summarised by the last few lines of his poem 'Peaceable Kingdom':

> The illustrious Penn this heavenly kingdom felt / Then with Columbia's native sons he dealt, / Without an oath a lasting treaty made / In Christian faith beneath the elm tree's shade.[2]

The title, *Peaceable Kingdom of the Branch*, refers to the grapevine held in the right hand of the child and symbolising redemption and the Holy Communion. This is an odd choice for Hicks, a Quaker minister, to have made, since the Quaker faith did not advocate the practice of such sacraments, but believed in the 'inner light'.

Penn's signing of the peace treaty was said to have occurred in Pennsylvania and not Virginia. Although Hicks was undoubtedly aware of this, he included the Natural Bridge of Virginia, considered one of the great natural wonders of America in the late eighteenth and early nineteenth centuries. The Bridge was described by one writer in 1858 as 'the famous curiosity — so simple, yet so grand as to assure you that it is the work of God alone …'[3] Thus, the Bridge most likely seemed to Hicks an appropriate element to include in his Peaceable Kingdoms, suggesting a relation between the natural wonder and divine providence.[4]

Hicks paraphrased Isaiah's prophecy in his poem 'The Peaceable Kingdom' and incorporated a variation of this into the border of the Reynolda House *Peaceable Kingdom of the Branch*:

> His grim carniv'rous nature then shall cease / And not one savage beast be seen to frown / A little child shall lead them on in love / When man is led and moved by sovereign grace.[5]

AE

Thomas Cole 1801–1848

52. *Scene from 'The Last of the Mohicans', Cora kneeling at the Feet of Tamenund* 1827
oil on canvas 64.5 x 89.1 cm (25-3/8 x 35-1/16 in) Wadsworth Atheneum, Hartford, Connecticut, Bequest of Alfred Smith

Thomas Cole took the subject of his painting from James Fenimore Cooper's novel *The Last of the Mohicans*, published in early 1826 — the second in what would become Cooper's Leatherstocking series.[1] It was Robert Gilmor, Jr, a collector from Baltimore and one of Cole's early patrons, who first suggested a subject from Cooper's novels to the artist. Gilmor's choice was the boat race in *The Last of the Mohicans*, but he went on to say that he would also like some other 'known subject from Cooper's novels to enliven the landscape', and continued, 'Your own good taste will suggest the fittest for the purpose'.[2]

Cole selected a dramatic moment: the scene of Cora's pleading to the Delaware chief for her half-sister Alice's life. His choice of subject is a significant one, both historically and thematically. As Richard Slotkin observed in his introduction to the novel, Cooper's subtitle sets the scene during the French and Indian War, in 1757; while the epigraph, from *The Merchant of Venice*, points to the sub-theme of race: 'Mislike me not for my complexion, / The shadowed livery of the burnished sun.' Racial conflict is captured in a triangle of savage Indians, represented by Tamenund; civilised whites, represented by Alice; and the mediator, Cora. Because Cora's mother was a West Indian Creole and her father was white, Cora straddles the races and so is the one who can appeal to Tamenund for Alice's life.[3]

The French and Indian War (1756–63) was the decisive conflict in the struggle between the French and the English for control of the North American continent. The two sides realised that forging both military and trade alliances with the Native Americans would be crucial to gaining the advantage in the war. In 1760, after the fall of Montreal, the French capitulated and, with the signing of the Treaty of Paris in 1763, turned over Canada and the land east of the Mississippi River to Great Britain.[4]

Although Cooper set his scene at Lake George (the site of a battle in 1755), Cole chose White Mountain scenery, and Mount Chocorua in particular, as a backdrop for his depiction. The mountain — the subject of a rich folklore — was named for the Sokosis chief Chocorua, who lived in the early eighteenth century and died tragically on that peak. Several versions of the legend tell of Chocorua's son's dying after eating poison left for foxes by white frontierspeople. Chocorua, with whom the whites had maintained good relations up to this point, sought revenge for his son's death and killed the wife and children of one white settler. In retaliation, the settlers banded together against Chocorua, chasing him to the top of the mountain, where they shot him. His last words left a curse on his assailants, which, according to the legend, caused large numbers of cattle to die in the region. Another version suggests that Chocorua was blamed for an Indian massacre and was chased to the top of the mountain, where he leapt to his death.[5] Cole's reference to this legend foretells the inevitable doom of Native Americans and their claim to the wilderness as white settlers take over.

AE

53. *A View of the Mountain Pass called the Notch of the White Mountains (Crawford Notch)* 1839
oil on canvas 101.6 x 156.0 cm (40 x 60-1/2 in) National Gallery of Art, Washington, DC Andrew W. Mellon Fund

In the year he executed this painting, Thomas Cole travelled to the White Mountains with Asher B. Durand, and visited again Crawford Notch, which both artists sketched.[1] The painting was commissioned by Rufus Lord, a wealthy, retired drygoods merchant from New York, to complement his other Cole, *Landscape Composition, Italian Scenery* 1832 (Memorial Art Gallery, University of Rochester, New York), suggesting that either Lord or Cole thought that the Notch might serve as an appropriate counterpart to the European ruins pictured in *Landscape Composition*. Landscape artists and others sought a United States historical past not in the ruins of human civilisation, as in Europe, but in nature and wilderness itself.[2] In his *Essay on American Scenery* (1835), Cole suggests as much, criticising those who looked only to Europe for associations, and remarking on the potential for such in the American landscape, where 'the great struggle for freedom has sanctified many a spot, and many a mountain, stream, and rock, has its legend, worthy of poet's pen or the painter's pencil'.[3]

Crawford Notch, originally called simply the Notch of the White Mountains, gained its fame and status as a major tourist attraction beginning in 1826, when the Willey family was killed in an avalanche. The fascination with this story derived from the perverse twist in the tale. After a landslide several days before the avalanche, Mr Willey took the precautionary measure of erecting a shelter to which the family could escape. When they again heard a rumbling in the mountains, the Willeys ran from their home, in the path of the falling rocks, toward the shelter. The avalanche, however, split into two halves before reaching the house and reunited after passing it, leaving it intact. The Willeys were buried as they attempted to flee to safety.[4]

The Willey Disaster, as it came to be known, was reported widely in the New England Press in 1826. While few tourists had visited the site prior to the incident, their numbers increased dramatically in the months following.[5] Daniel Wadsworth, one of Cole's early and important patrons, promptly took a trip to the Notch. It was he who counselled Cole to visit.

Ethan Allen Crawford, for whom the Notch was named by the 1850s, was the owner of the Notch House pictured in Cole's painting and was known as the 'Keeper of the White Mountains'. Abel Crawford and his sons Ethan and Thomas Jefferson were early pioneers in the White Mountains. Their choice of the cold and remote Notch was a savvy one as it was a direct trade route between Portland, Maine, and northern New Hampshire and Vermont. The Crawfords capitalised on the 1803 turnpike authorisation by the state of New Hampshire, taking over the building and maintenance of the road, and building three inns along the route. In the 1820s, as tourism grew, the Crawfords became guides to the area, with Ethan taking a particular interest in promoting and advertising the area to potential visitors. Crawford saw the potential of the Willey Disaster when it occurred, marking the site for tourists, and inviting visitors to see the Willey home. By 1837, however, Ethan Crawford had left the Notch, plagued by illness and debt, and forced out by the competition.[6]

AE

Frederic Edwin Church 1826–1900

54. *Hooker and Company journeying through the Wilderness from Plymouth to Hartford in 1636* 1846
oil on canvas 102.2 x 152.9 cm (40-1/4 x 60-3/16 in) Wadsworth Atheneum, Hartford, Connecticut

Frederic Church painted *Hooker and Company*, his first major landscape, just after finishing two years of study with Thomas Cole. The migration to Hartford of the Reverend Thomas Hooker and his congregation had been considered by Cole as a possible subject for painting: 'The migration of the settlers from Massachusetts to Connecticut — through the wilderness — see Trumbull's history of Connecticut.' Undoubtedly it was he who suggested the subject to Church.[1]

The theme of the painting — settlement of the wilderness with Divine sanction — is a metaphor for the expansion taking place in the United States at mid-century. A contemporary of Church's wrote:

> What was this band, now composed, that thus ventured through the wilderness to found a Town, and aid to found a state? One of the exiles from their fatherland for faith and liberty — a band of serious, hardy, enterprising hopeful settlers, ready to carve out, for themselves and their posterity, new and happy homes in a wilderness — there to sink the foundations for a chosen Israel — there to till, create, replenish, extend trade, spread the gospel, spread civilization, spread liberty — there to live, act, die and dig quiet sepulchres, in a hope and happiness that were destined

to spring, phoenix-like, from the ashes of one generation to illumine and beautify the generation which was to succeed.[2]

During the 1840s, American interest in territorial expansion was revived. The romanticising of the West, the desire for trade with the Orient, and a fear of European intervention along American borders, spurred by British activity in California, Oregon, and Texas, contributed to this revival. The phrase 'Manifest Destiny' originated in the words of a New York editor who wrote that it was America's 'manifest destiny to overspread and to possess the whole of the continent which Providence has given us for the development of the great experiment of liberty and federated self-government entrusted to us'. Manifest Destiny became a justification for the Anglo-Saxon conquest of Native Americans, the continuing subjugation of African–Americans and, later, Latin Americans, and claiming the land they lived on.[3]

Church sold *Hooker and Company* to the Wadsworth Atheneum in 1846 — his first work to enter a museum collection and his first documented sale. An engraving after the painting later appeared as the frontispiece for *Hartford in the Olden Times* (1853).[4]

AE

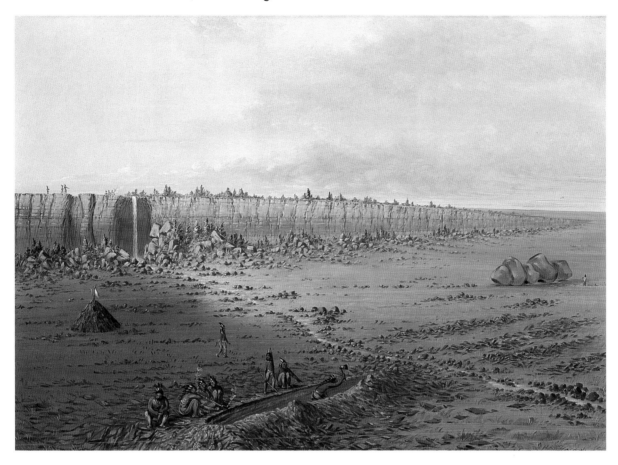

55. *The Pipestone Quarry* 1848
oil on canvas 47.9 x 66.7 cm (19 x 26-1/4 in) Gilcrease Museum, Tulsa, Oklahoma

The pipestone quarry, located in the prairies of contemporary Minnesota, provided red clay (or pipestone) for calumets, the carved pipes used in Native American ceremonies and transactions. Native Americans had been mining the clay for centuries before the town of Pipestone was settled by white homesteaders in 1873.[1]

George Catlin first visited the pipestone quarry in 1836, claiming to be the first white ever to do so. Natives arrested Catlin and his English travelling companion 150 miles from the site, allegedly explaining: 'You see that this pipe is part of our flesh. The red men are a part of the red stone. If the white men take away a piece of the red pipe stone, it is a hole made in our flesh, and the blood will always run. We cannot stop the blood from running.' Catlin was determined to visit the quarry, however, and collect mineral samples.[2] His subsequent analysis of pipestone as a 'new variety of steatite', was published in Benjamin Silliman's *American Journal of Sciences and Arts* in 1839 and christened catlinite in his honour.[3]

Catlin's detailed painting of the quarry refers to the Indian legends associated with the site.[4] At the right are the Three Maidens, a series of boulders under which Native women hid and thus saved the race from extinction.[5] A waterfall issued from beneath the feet of the Great Spirit, but whether or not this

is the waterfall pictured in *The Pipestone Quarry* is uncertain. (Catlin's own description suggests that it is not, but he often changed the location of detail to suit his dramatic purpose.[6]) The Great Spirit made the first calumet and, with it, signalled to all Native Americans to gather in peace at what would become the pipestone quarry. It was to be a sacred spot, neutral ground where all tribes would come to get stone for peace pipes.[7]

The Pipestone Quarry is unusual because it depicts Native Americans actively altering the landscape through mining. However, Catlin's primary interest seems to be in the geological characteristics of the site, suggesting that the Indians are nomadic, with only a minor role in shaping their surroundings.[8]

The Indian Removal Act was passed in 1830, and President Andrew Jackson pushed Native Americans off lands between the Great Lakes and the Gulf of Mexico and west of the Mississippi. The pipestone quarry was just on the other side of this demarcation, but, with the succession of treaties that ensued, the Indians there were also in danger of removal. The justification for the Act rested on the belief that Natives had no culture worth preserving. Presumed white hegemony demanded Indian surrender of their lands.[9]

AE

Asher B. Durand 1796–1886

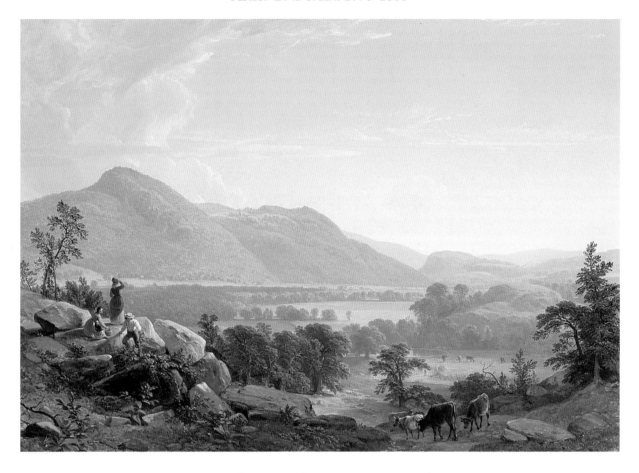

56. *Dover Plains, Dutchess County, New York* 1848

oil on canvas 107.9 x 153.7 cm (42-1/2 x 60-1/2 in)) National Museum of American Art, Smithsonian Institution, Washington, DC
Gift of Thomas M. Evans and museum purchase through the Smithsonian Collections Acquisitions Program

When *Dover Plains* was exhibited at the National Academy of Design in 1848, a critic remarked:

> The Scene in Dutchess County is, we think, one of the best pictures [Durand] has ever exhibited. It is full of truth as well as beauty, and so invested with the characteristics of the natural scenery of certain portions of our land, that almost every visitor who looks upon it could localize the scene.[1]

In the same year, the painting was exhibited at the American Art-Union in New York City. James Smillie engraved *Dover Plains* for distribution by the American Art-Union to its subscribers, ensuring a large audience for the image.[2]

The American Art-Union's decision to purchase *Dover Plains* is significant. According to a monthly bulletin published by the Art-Union, its aim 'shall ever be to promote the permanent and progressive advance of American Art',[3] and to create a so-called national school of art through discouraging reliance on European precedent and encouraging the choice of native subjects. At a meeting of the Art-Union in 1851, the keynote speaker, Reverend Osgood, declared 'Art the interpreter of Nature, Nature the interpreter of God'. The organisation did not usually choose to purchase landscape paintings, and more frequently bought American history paintings or genre scenes of American life.[4] This purchase suggests all the more that Durand's *Dover Plains* fulfilled the requisite conditions of Art-Union paintings — that they 'promote patriotic sentiment'.[5]

The Mexican War ended in 1848 with the Treaty of Guadalupe Hidalgo, which ceded to the United States part of what is now California, Arizona, and New Mexico. That same year, Zachary Taylor, the Whig candidate, won the presidential election on the basis of his war record. In 1851, one year after Smillie engraved Durand's painting for the Art-Union, Alfred Jones engraved Richard Caton Woodville's *Mexican News,* and Joseph I. Pease engraved Woodville's *Old '76 and Young '48* — both paintings were direct references to the Mexican War.

Asher B. Durand's *Dover Plains*, by contrast, avoids any obvious allusion to the war, instead providing an image of a peaceful, pastoral landscape, peopled by berry-pickers and dotted with cows. The optimistic vista suggests a citizenry in command of a calm future for the United States and a world far removed from the turmoil of the war.[6]

AE

Frederic Edwin Church 1826–1900

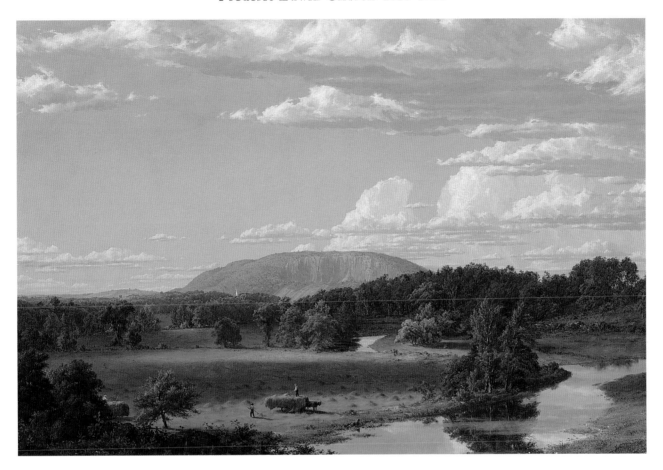

57. *West Rock, New Haven* 1849
oil on canvas 67.3 x 101.6 cm (26-1/2 x 40 in) New Britain Museum of American Art, Connecticut, Talcott Art Fund

For years, Frederic Church's painting was thought to be of East Rock:[1] East Rock was painted more often than West Rock (both near New Haven on the eastern Connecticut shore) in part because it offered the more picturesque view. In the words of a writer in *Picturesque America*, West Rock 'has the counterbalance' to these advantages of a positive historic charm in the shape of the Regicides' or Judges' Cave'.[2]

It was this association with a historic event that undoubtedly interested Church in painting a view of West Rock.

The Regicides' Cave, and West Rock by extension, played an important role in the cultural history of New Haven. William Goffe (died c.1679) and his father-in-law Edward Whalley (died 1675?) served in the English Civil War and were adherents of Oliver Cromwell. Both signed the death warrant of Charles I. With the restoration of the monarchy in 1660, and subsequent executions of the signers, Goffe and Whalley fled to New England where they hid in a cave in West Rock. They were hunted but never found by English agents.[3] The theme of resisting an oppressive regime had particular resonance for New Englanders in terms of the colonies' revolt against British rule, and for Church, whose Connecticut ancestry dated back to the 1600s.[4]

Church's relation with his friend and patron, the New York businessman Cyrus Field, also the patron for *Natural Bridge* (cat.32),

is integral to an understanding of *West Rock*.[5] Field's family, like Church's, had long roots in Connecticut, and so the choice of subject was one that Field would appreciate. In addition, the harvest field in the foreground and the steeple in the background refer to the patron (Field) and the artist (Church) respectively. These elements were added to Church's original sketch for the painting.[6] Of course, the harvest field and the church have other associations as well: the harvest theme, of which this is an early example in American painting, symbolises the fertility and bounty of the new world, with God's blessing represented by the church steeple. Here, those who work hard are rewarded.[7] Field's and Church's shared interest in geology may also have been a factor in the choice of West Rock. Both East and West Rocks drew geologists in addition to artists and writers.

When *West Rock, New Haven*, was exhibited at the National Academy of Design in 1849, it met with critical acclaim. It was seen as a 'faithful, natural picture',[8] and one writer praised Church for meeting John Ruskin's standards for truth to nature. Church had a copy of Ruskin's *Modern Painters* in his studio in 1848, the year before *West Rock* was finished.[9]

AE

John Mix Stanley 1814–1872

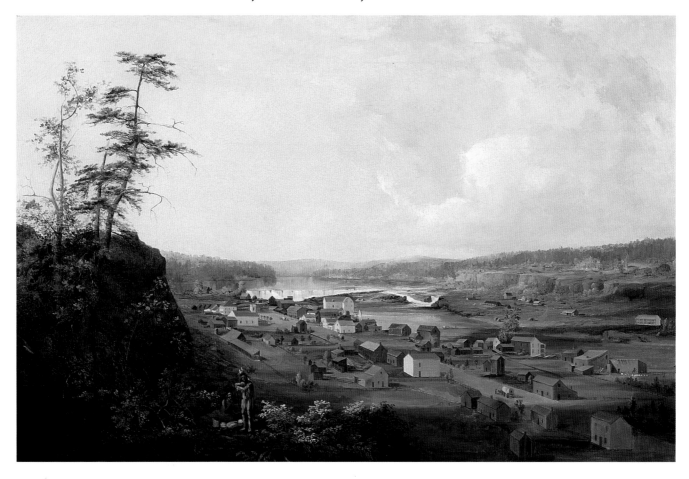

58. *Oregon City on the Willamette River* 1850–52
oil on canvas 67.3 x 101.6 cm (26-1/2 x 40 in) Amon Carter Museum, Fort Worth, Texas

John Mix Stanley travelled to the Oregon Territory from San Francisco in 1847, following the Columbia River into the interior. The Columbia meets the Willamette River near the start of the Oregon Trail. It was on this trip in February and March 1848 that Stanley stopped at Oregon City, which is located below the Willamette Falls, south of Fort Vancouver, Washington.[1]

Oregon City lies within the American half of the then-disputed Oregon Territory, which extended from the border of Mexico in the south to the border of Russia in the north. Both the United States and Britain claimed the area, and the 1818 British–American convention stated that citizens of both nations could settle in the Oregon Territory.[2] Willamette Falls was a stop on the Oregon Trail, which led 2,000 miles from Independence, Missouri, to the Pacific Northwest.

In the winter of 1828–29, John McLoughlin of the Hudson's Bay Company, based at Fort Vancouver, had three log cabins built next to the falls; these were burned down by the Indians. In 1832, McLoughlin constructed a sawmill and a flour mill at the falls. Over the next ten years or so, Americans began settling the area, and a group of Methodist missionaries established a milling company in competition with McLoughlin's. By 1842, despite McLoughlin's naming the town and sending a group of settlers over, the Americans voted to set up a provisional government, and Oregon City was made its seat. By 1846 Americans had secured the title to Oregon in a treaty with Britain.[3]

By the time Stanley arrived in Oregon City in 1848, it had a population of about 300 and was a prospering lumber town. In the previous year, the *Oregon Spectator*, based in Oregon City, noted with pleasure that Stanley was coming to the city for the 'purpose of transcribing to canvas some portions of the beauty and sublime scenery with which our city abounds'.[4] Stanley's painting shows the city at the foot of the Willamette Falls. The two Native Americans pictured in the foreground, turning away from the settlement, are most likely Willamette Indians, whose livelihood was destroyed in order for white Oregon City to prosper.[5]

Stanley includes signs of the progress and potential of the site (orderly streets with covered wagons, workshops, a sawmill, stores, and a church) at the same time as he includes symbols of the past — the Native Americans. Prior to white settlement, missionaries had been active in the area, but the site of Oregon City was still forest and it was the home of Indians.[6]

AE

Fitz Hugh Lane 1804–1865

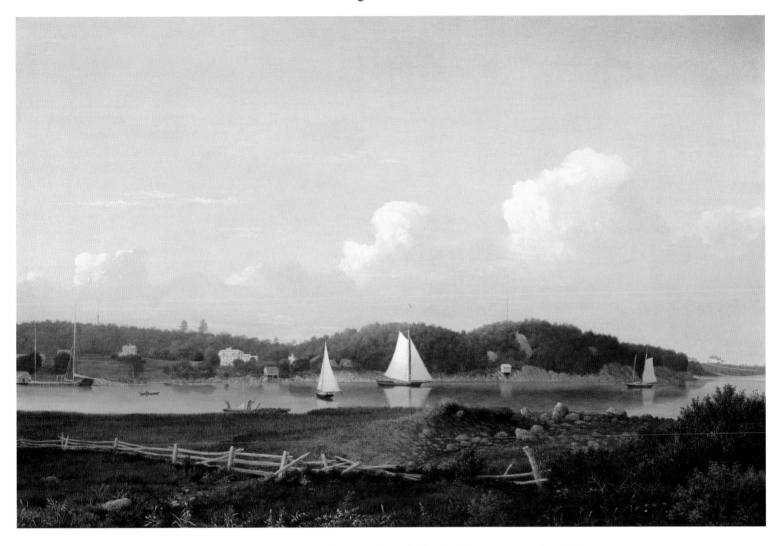

59. *Fresh Water Cove from Dolliver's Neck, Gloucester* early 1850s
oil on canvas 61.3 x 91.7 cm (24-1/8 x 36-1/8 in) Museum of Fine Arts, Boston, Massachusetts
Bequest of Martha C. Karolik for the M. and M. Karolik Collection of American Paintings, 1815–1865

The oldest fishing port in Massachusetts, Gloucester was founded in 1623.[1] In 1846, the Eastern Railroad was extended to Gloucester and the port was commercially revitalised, now able to take advantage of new technologies in fishing and gain access to markets west of the town. New capital flowed into Gloucester, and in 1846 the *Gloucester Telegraph* was able to report a 'slight advance ... in the value of real estate'. This was the start of a twenty-year upward trend in land values. By the end of the 1840s, Cape Ann, where Gloucester is located, was a summer resort.[2]

Fitz Hugh Lane moved permanently to Gloucester — the hometown of his forefathers — in 1849, a few years before painting *Fresh Water Cove from Dolliver's Neck*. As Elizabeth Garrity Ellis has observed, Lane's images of Gloucester and the surrounding area from this period helped stimulate even as they reflected the vital economy of the port. The painting is a depiction of property. The foreground is fenced off and Lane has included the line of large houses along Western Avenue, featuring the largest, Brookbank, to the left of centre — the summer residence of Samuel E. Sawyer, an important patron of the artist's work.[3] As Ellis has written, Lane himself may have profited from the healthy real estate market — his own property on Duncan's Point in Gloucester more than doubled in value by the end of the 1850s.[4]

Fresh Water Cove was named in 1607, when the French explorer Samuel de Champlain (1567–1635) landed there in quest of drinking water.[5]

AE

Robert S. Duncanson 1821–1872

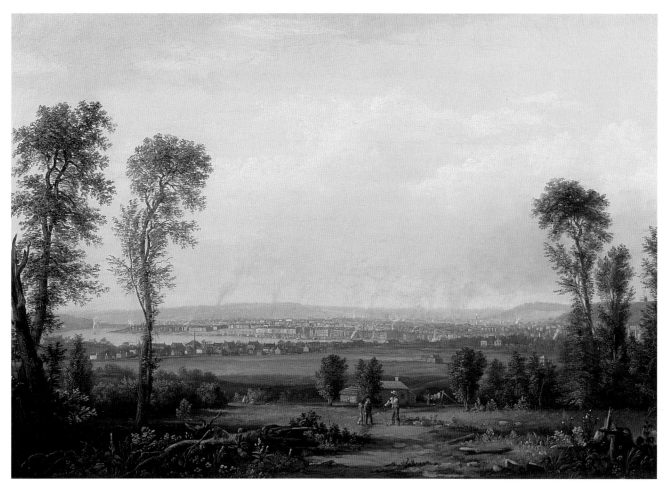

60. *View of Cincinnati, Ohio from Covington, Kentucky* c.1851
oil on canvas 63.5 x 91.4 cm (25 x 36 in) Cincinnati Museum Center, Ohio

Cincinnati, called the Queen City after a famous riverboat, was the chief port on the Ohio River, and a ship-building centre beginning in the early nineteenth century. In 1829, with the opening of the Miami and Erie Canal to Dayton and then to Toledo, Cincinnati became an important trade centre.[1] The Ohio River is central to Robert Duncanson's *View of Cincinnati*, marking the crucial line between north and south, the free northern state of Ohio and the southern slave-holding state of Kentucky.[2]

Robert S. Duncanson based *View of Cincinnati* on a daguerreotype, *View of Cincinnati, Ohio*, and the significance of the painting lies in its differences from the latter. While the topographical detail is nearly identical, Duncanson altered one of the figures in the foreground, changing a white man who leans on a rifle in the daguerreotype to the black man leaning on a scythe. (In both cases, the figure is talking to two white children.) In addition, he changed from white to black the woman hanging laundry in the background. This, in conjunction, with the white couple sitting in the left middleground has led Joseph Ketner to suggest that in this painting Duncanson is contrasting the lives of the free whites of the South and the lives of the enslaved blacks. Across the river, of course, lies prosperous Cincinnati and freedom.[3]

The Compromise of 1850, enacted in Congress in September of that year, was composed of six separate laws. One of these, the Fugitive Slave Act, was an attempt to appease the South through the return of escaped slaves to their owners — no longer would the so-called free states be safe havens for these African–Americans.[4] The Fugitive Slave Act inspired Harriet Beecher Stowe's anti-slavery novel, *Uncle Tom's Cabin, or, Life among the Lowly*, serialised in the Washington *National Era* from 1851 to 1852. In 1852 it was published in book form and became the best-selling novel of the nineteenth century. It is likely that Duncanson knew Stowe, who in 1832 moved to Cincinnati, where her father, Lyman, became the first president of Lane Seminary. Later, in 1853, Duncanson was commissioned by the Rev. James Francis Conover, an abolitionist, to paint a scene from Stowe's novel.[5]

If Duncanson painted *View of Cincinnati* after the Compromise of 1850, as Ketner's dating suggests, then Cincinnati could represent a freedom and prosperity, at that time, available only to the white population of the United States.[6]

AE

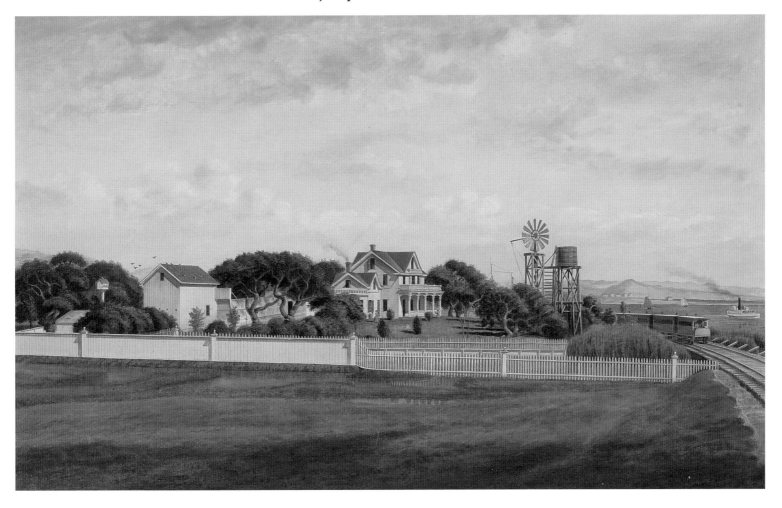

61. *Residence of Captain Thomas W. Badger, Brooklyn [California], from the Northwest* 1871
oil on canvas 66.7 x 106.7 cm (26-1/4 x 42 in) Oakland Museum of California Gift of Lester M. Hale

Captain Thomas W. Badger's property was located in Oakland, near what is today known as Lake Merritt, in Alameda County, California.[1] Brooklyn (Oakland), along with Berkeley and other smaller towns, was part of the Peralta Land Grant of 1820 — granted by the Spanish government to Don Luis Peralta, a Spanish soldier.[2] Upper California, of which Brooklyn is a part, became Mexican territory in 1822 when Spanish rule ended. After the Mexican War (1846–48), California was ceded to the United States from Mexico and admitted as a free state in 1850.[3]

By 1869 the Central Pacific Railroad was connected with Union Pacific Railroad in California. Fortunes were being made in rail transportation and in land speculation. Because the men making these fortunes wanted permanent records of their success, they commissioned established artists to make oil paintings of their estates and property.[4] Captain Badger, a prominent citizen in Brooklyn, made his own fortune in shipping via trade routes from California to Australia, the Orient, and along the western coast of the United States.[5]

Joseph Lee's painting of Badger's estate reflects the new prosperity of the region. Badger's neo-Gothic house, although a little old-fashioned for East Coast taste, was a symbol of middle-class respectability. In the painting, Lee included the railroad as it passes just to the right of the house; a windmill; a water tower; and a ship in the Oakland Harbour (an allusion to Badger's profession). An outbuilding, a birdhouse and the picket fence add to the scene of domestic tranquillity and well being — the fence, a boundary around Badger's property, asserts the Captain's ownership of the land.[6]

Badger planted formal gardens of exotic and native trees and flowers on his property and, despite the implications of the fence, opened it to the public, who visited by ferry and train. In 1872 he gave his land as a public park he named Badger's Grand Central Park, adding a large pavilion for skating and dancing, ballrooms, bars, dining halls, bowling alleys, and a menagerie. (The park was closed in 1876 or 1877 by the Temperance Society and local vote.)[7]

AE

Notes

Cat.36 John Glover *My Harvest Home*

1 Hendrik and Juliana Kolenberg, *Tasmanian Vision: The Art of Nineteenth-century Tasmania*, Hobart: Tasmanian Museum and Art Gallery, 1988, p.66.
2 John Glover to Sir Thomas Phillipps, 15 January1830, correspondence, Bodleian Library, Oxford, (copy in National Gallery of Australia Research Library).
3 John Richardson Glover to Mary Bowles (née Glover), 22 September 1833, Mitchell Library, State Library of New South Wales, Sydney.
4 John Richardson Glover to Mary Bowles, 12 July 1839, Mitchell Library, State Library of New South Wales, Sydney.

Cat.37 John Glover *Cawood on the Ouse River*

1 The sketchbook is in the National Library of Australia, Canberra, NK644/1.
2 K.R. von Stieglitz, *A History of Hamilton, Ouse and Gretna*, Launceston: s.n., printed by Telegraph printery, 1963, pp.61–62.
3 *Hobart Town Courier*, 5 January 1844, p.3.

Cat.38 John Glover *The Last Muster of the Aborigines at Risdon*

1 Ian Maclean, 'Under Saturn; Melancholy and the Colonial Imagination', in Nicholas Thomas and Diane Losche eds, *Double Vision: Art Histories and Colonial Histories*, Cambridge University Press (forthcoming).

Cat.39 Conrad Martens *View from Sandy Bay*

1 Caroline Clemente, *Australian Watercolours 1802–1926 in the Collection of the National Gallery of Victoria*, Melbourne: National Gallery of Victoria, 1991, p.48.
2 Joseph Lycett painted watercolours of this view, from a slightly higher vantage point called Bell mount — present-day Vaucluse (National Library of Australia); as did G.W. Evans (State Library of New South Wales); and Stephen Taylor (Kerry Stokes collection).
3 Clemente, *Australian Watercolours* (1991), p.48.

Cat.40 John Glover *The Bath of Diana, Van Diemen's Land*

1 The sketchbook is in the Dixson Galleries, State Library of New South Wales, Sydney.
2 John Glover to George Augustus Robinson, Robinson Papers, vol.37, p.430, Mitchell Library, State Library of New South Wales, Sydney.
3 The 'Adam and Eve' drawing is in the Glover sketchbook, National Library of Australia, Canberra, NK644/1.
4 *John Glover: 'The Bath of Diana, Van Diemen's Land'*, Sotheby's catalogue, Sotheby's Australia Pty Ltd, individual catalogue, 17 April 1989, unpaginated.

Cats 41–42 John Glover *A Corrobery of Natives in Van Diemen's Land; Ben Lomond Setting Sun*

1 Ben Lomond rises 1,500 metres. Henry Button, *Flotsam and Jetsam*, Launceston: A.W. Burchall, 1909, p.21.
2 Extract from a letter written by M. Le Berle, in the official records of the Louvre, 1845, p.6.
3 Olivier Meslay, *D'outre-Manche: l'art britannique dans les collections publiques françaises*, Paris: Bibliotheque Nationale de France, c.1994, pp.52–53.

Cat.43 Conrad Martens *View from Rose Bank*

1 See James Broadbent, *The Australian Colonial House; Architecture and Society in New South Wales 1788–1842*, Sydney: Hordern House, 1997.
2 With many thanks to Sydney architect, Mr Clive Lucas, who undertook research which led to the identification of Telford Place.
3 The houses mostly obscured are Adelaide Cottage (of which we can only see a hint of the roof), Rockwall (which can be seen on the left side of the gum tree) and Tusculum (on the right of the gum tree). The roof and chimney just discernible between Tusculum and Brougham Lodge are almost certainly the out offices for an unseen house, Orwell, also designed by John Verge. Margaret Vine, Department of Australian Art, National Gallery of Australia, researched all information regarding identification of the houses in the painting.

Cat.46 Eugene von Guérard *Stony Rises, Lake Corangamite*

1 James Bonwick, *Western Victoria: Its Geography, Geology, and Social Condition: The Narrative of an Educational Tour in 1857*, Geelong: T. Brown, 1858, republished Melbourne: W. Heinemann Aust. Pty Ltd., 1970.
2 See Ron Radford, 'Stony Rises, Lake Corangamite 1857', in Radford and Jane Hylton, *Australian Colonial Art 1800–1900*, Adelaide: Art Gallery of South Australia, 1995, pp.98–100.

Cat.47 Eugene von Guérard *Bushy Park*

1 Theo Webster, 'Angus McMillan', *Australian Dictionary of Biography*, vol.2, Melbourne: Melbourne University Press, 1967, pp.183–184.
2 P.D. Gardner, *Our Founding Murdering Father: Angus McMillan and the Kurnai Tribe of Gippsland*, Ensay, Victoria: Ngarak Press, 1990, p.83.
3 L. Fison and A.W. Howitt, *Kamilaroi and Kurnai*, Melbourne: George Robertson, 1880, p.217.
4 See Bain Attwood, 'Tara Bobby, a Brataualung Man', *Aboriginal History*, vol.11, 1987, pp.41–57.
5 See Aldo Massola, *Aboriginal Mission Stations in Victoria*, Melbourne: Hawthorn Press, 1970, pp.63–87.

Cat.49 Ralph Earl *Houses and Shop of Elijah Boardman*

1 Elizabeth Mankin Kornhauser, '"By Your Inimmitable Hand": Elijah Boardman's Patronage of Ralph Earl', in *The American Art Journal*, 23, no.1, 1991, pp.4–20.

Cat.50 Thomas Birch *Fairmont Waterworks*

1 See Richard Webster, entry for 'Fairmount Waterworks' in Philadelphia Museum of Art, *Philadelphia: Three Centuries of American Art*, exhibition catalogue, Philadelphia: Philadelphia Museum of Art, 1976, pp.223–224.
2 See Therese O'Malley, 'Landscape Gardening in the Early National Period', in Edward J. Nygren with Bruce Robertson et al., *Views and Visions: American Landscape before 1830*, exhibition catalogue, Washington, DC: The Corcoran Gallery of Art, 1986, especially pp.145–150.
3 Philadelphia Museum of Art, *Philadelphia* (1976), pp.185–186, cat.151.
4 See Virginia Norton Naude, 'Lemon Hill', in *Antiques*, vol.82, no.5, November 1962, p.533; and O'Malley, in Nygren, Robertson et al., *Views and Visions* (1986), p.144.

Cat.51 Edward Hicks *Peaceable Kingdom of the Branch*

1 *American Folk Paintings: Paintings and Drawings other than Portraits from the Abby Aldrich Rockefeller Folk Art Center*, Boston: Little, Brown and Company, in association with the Colonial Williamsburg Foundation, 1988, p. 266.
2 As quoted in Deborah Chotner et al., *American Naive Paintings*, New York: Cambridge University Press, in association with the National Gallery of Art, Washington, 1993, p.189.
3 Edward Beyer, *Album of Virginia* (Virginia, 1858), p.5, signed 'an Old Virginian', as quoted in DuPont Gallery, *So Beautiful An Arch: Images of the Natural Bridge, 1787–1890*, exhibition catalogue, Lexington, Virginia: DuPont Gallery, Washington and Lee University, 1982, introduction.
4 Abby Aldrich Rockefeller Folk Art Center (1988), p. 266. See Edward J. Nygren with Bruce Robertson et al., *Views and Visions: American Landscape before 1830*, exhibition catalogue, Washington, DC: The Corcoran Gallery of Art, 1986, p.58.
5 Hicks had his paraphrase of Isaiah's prophecy printed on cards and distributed to the owners of his *Peaceable Kingdoms*. The text of one of these cards is quoted in Jean Lipman and Alice Winchester, *Primitive Painters in America, 1750–1950*, New York: Dodd Mead and Company, 1950, p.44. Because of the way the canvas is attached to the stretcher, Hicks's verses on the painting are not completely visible.

Cat.52 Thomas Cole *Scene from 'The Last of the Mohicans', Cora kneeling at the Feet of Tamenund*

1 For a comprehensive discussion of the Atheneum's painting, see Elizabeth Mankin Kornhauser, entry for '"Scene from the Last of the Mohicans", Cora Kneeling at the Feet of Tamenund', in Kornhauser, with contributions by Elizabeth R. McClintock and Amy Ellis, *American Paintings before 1945 in the Wadsworth Atheneum*, New Haven and London: Yale University Press in association with the Wadsworth Atheneum, 1996, pp.227–230.
2 See Gilmor to Cole, 1 August 1826, as quoted in *The Baltimore Museum of Art Annual II: Studies on Thomas Cole, an American Romanticist*, Baltimore: The Baltimore Museum of Art, 1967, p.44. See also Marilyn Sarterbrook, Department of Fine Art, University of Toronto, 'An Analysis of the Two Versions of "The Last of the Mohicans" by Thomas Cole', unpublished manuscript, copy in curatorial painting file, Wadsworth Atheneum, for a comparison of Gilmor's and Wadsworth's versions.
3 Richard Slotkin, introduction to the 1831 edition of James Fenimore Cooper, *The Last of the Mohicans*, New York: Penguin, 1986, pp.xiv–xvii.
4 On the French and Indian War, see, for example, John A. Garraty with Robert A. McCaughey, *The American Nation: A History of the United States*, 7th edn, New York: HarperCollins Publishers, 1991, pp.85–90, and John M. Blum et al., *The National Experience: A History of the United States*, 8th edn, Fort Worth, Texas: Harcourt Brace Jovanovich College Publishers, 1993, pp.87–93.
5 Robert and Mary Hixon, *The Place Names of the White Mountains: History and Origins*, Camden, Maine: Down East Books, 1980, pp.37–38.

Cat.53 Thomas Cole *A View of the Mountain Pass called the Notch of the White Mountains (Crawford Notch)*

1 A detailed drawing for the work is in the collection of the Princeton University Art Museum, New Jersey.
2 See Ellwood C. Parry III, *The Art of Thomas Cole: Ambition and Imagination*, Newark: University of Delaware Press, 1988, p.219; and Judith A. Ruskin, 'Thomas Cole and the White Mountains: The Picturesque, the Sublime, and the Magnificent', *Bulletin of the Detroit Institute of Arts*, vol.66, no.1, 1990, pp.24 and 25, n.16.
3 Thomas Cole, 'Essay on American Scenery' (1835), pp.108–109, in John W. McCoubrey, *American Art, 1700–1960: Sources and Documents*, Englewood Cliffs, New Jersey: Prentice-Hall, Inc., 1965. See also Barbara Novak, *American Paintings of the Nineteenth Century: Realism, Idealism, and the American Experience*, New York, Washington, and London: Praeger Publishers, 1969, ch.3, especially pp.61–62.
4 A number of early accounts of the slide exist. See, for example, Nathaniel P. Willis, *American Scenery, or Land, Lake, and River: Illustrations of Transatlantic Nature*, (1840), reprint, Barre, Massachusetts: Imprint Society, 1971, pp.110–113.
5 See John F. Sears, *Sacred Places: American Tourist Attractions in the Nineteenth Century*, New York and Oxford: Oxford University Press, 1989, pp.73–74.
6 Dona Brown gives a complete discussion and analysis of the Crawfords' role in developing the potential of the Notch for tourism in Brown, *Inventing New England: Regional Tourism in the Nineteenth Century*, Washington, DC, and London: Smithsonian Institution Press, 1995; see ch.2, 'The Uses of Scenery: Scenic Touring in the White Mountains, 1830-1860', especially pp.43–46.

Cat.54 Frederic Edwin Church *Hooker and Company journeying through the Wilderness from Plymouth to Hartford in 1636*

1 See Elizabeth Mankin Kornhauser, entry for Frederic E. Church, *Hooker and Company journeying through the Wilderness from Plymouth to Hartford, in 1636* 1846, in Kornhauser, with contributions by Elizabeth R. McClintock and Amy Ellis, *American Paintings before 1945 in the Wadsworth Atheneum*, New Haven and London: Yale University Press, 1996, vol.1, pp.195–198. See also Franklin Kelly, *Frederic Church and the National Landscape*, Washington, DC, and London: Smithsonian Institution Press, 1988, pp.6–9. See Benjamin Trumbull, *A Complete History of Connecticut, Civil and Ecclesiastical from the Emigration of Its First Planters from England in the Year 1630, to the Year 1764; and to the Close of the Indian Wars* (1818), reprint, New London, Connecticut: H.D. Utley, 1898, p.43, quoted in part in Kornhauser et al., *American Paintings before 1945 in the Wadsworth Atheneum* (1996), pp.195–196. For Cole's list of subjects, see 'Thomas Cole's List "Subjects for Pictures"', in *Studies on Thomas Cole, an American Romanticist*, Baltimore: Baltimore Museum of Art, 1967, p.90.
2 Scaeva [I.W. Stuart], *Hartford in Olden times* (1853), p.9, quoted in David C. Huntington, *The Landscapes of Frederic Edwin Church*, New York: George Braziller, 1966, p.28, and subsequently in Kelly, *Frederic Church* (1988), p.7.
3 As quoted in John M. Blum et al., *The National Experience: A History of the United States*, 8th edn, Fort Worth, Texas: Harcourt Brace Jovanovich College Publishers, 1993, p.284. See ibid., pp.283–284.
4 See Kornhauser, in Kornhauser et al., *American Paintings before 1945 in the Wadsworth Atheneum* (1996), p.196.

Cat.55 George Catlin *The Pipestone Quarry*

1 See Suzanne Winckler, *The Smithsonian Guide to Historic America: The Great Lakes States*, New York: Stewart, Tabori and Chang, 1989, pp.460–462.
2 George Catlin, *Letters and Notes on the Manners, Customs, and Conditions of the North American Indians*, London: Author, 1841, vol.2, pp.173–175, as quoted in Brian W. Dippie, *Catlin and His Contemporaries: The Politics of Patronage*, Lincoln and London: University of Nebraska Press, 1990, p.42.
3 Ibid. Catlin's letter to Dr Charles T. Jackson, printed in *The American Journal of Science and Arts*, vol.38, no.1, 1839, pp.138–146, is reprinted in John C. Ewers ed., *George Catlin's Portfolio in the British Museum*, Washington, DC: Smithsonian Institution Press and British Museum Publications Ltd., 1979, pp.69–77.
4 Joan Carpenter Troccoli, *First Artist of the West: George Catlin Paintings and Watercolors from the Collection of Gilcrease Museum*, exhibition catalogue, Tulsa, Oklahoma: Gilcrease Museum, 1993, entry for *The Pipestone Quarry*, p.156.
5 'Native/American Stories: Traditional Interpretations', *Couteau Heritage: Journal of the Pipestone County Historical Society*, vol.2, no.1, April 1989, p.28.
6 See William H. Truettner, *The Natural Man Observed: A Study of Catlin's Indian Gallery*, exhibition catalogue, Washington, DC: Smithsonian Institution Press, in association with the Amon Carter Museum of Western Art, Fort Worth, and the National Collection of Fine Arts, Smithsonian Institution, 1979, cat.337.
7 C.A. White, MD, 'A Trip to the Pipestone Quarry', *American Naturalist* (1890), reprinted in *Couteau Heritage*, April 1989, pp.20–22. Catlin recorded the various versions of this legend in *North American Indians*, Edinburgh: John Grant, 1926, vol.2, pp.186–194.
8 William Cronon, 'Telling Tales on Canvas: Landscapes of Frontier Change', in Jules David Prown et al., *Discovered Lands Invented Pasts: Transforming Visions of the American West*, exhibition catalogue, New Haven and London: Yale University Press, 1992, p.52. See also Truettner, *The Natural Man Observed* (1979), p.31.
9 See Julie Schimmel, 'Inventing "the Indian"', in William H. Truettner ed., *The West as America: Reinterpreting Images of the Frontier, 1820–1920*, exhibition catalogue, Washington and London: Smithsonian Institution Press for the National Museum of American Art, 1991, pp.149–189, especially pp.150–151, 159–162.

Cat.56 Asher B. Durand *Dover Plains, Dutchess County, New York*

1 *Literary World*, 3, no.15, 13 May 1848, p.287, as quoted in David B. Lawall, *A Documentary Catalogue of the Narrative and Landscape Paintings*, New York and London: Garland Publishing, Inc., 1978, pp.72–73.
2 The American Art-Union was in operation in New York from 1839 until 1851, when it was dissolved because it distributed the paintings it purchased for engraving by lottery, which was considered illegal. See Maybelle Mann, *The American Art-Union*, exhibition catalogue, Jupiter, Florida: ALM Associates, 1977, n.p.
3 Quoted in Carol Troyen, 'Arcadia in America: *New England Scenery* by Frederic Edwin Church, *American Harvesting* by Jasper Francis Cropsey, and *Mount Washington from the Valley of Conway* by John Frederick Kensett', exhibition brochure essay, Wellesley, Massachusetts: Wellesley College Museum, 1990.
4 See ibid.
5 See ibid. See also Charles E. Baker, 'The American Art-Union', in Mary Bartlett Cowdrey and Theodore Sizer, *American Academy of Fine Arts and American Art-Union*, New York: New-York Historical Society, 1953.
6 Albert Boime, *The Magisterial Gaze: Manifest Destiny and American Landscape Painting c.1830–1865*, Washington and London: Smithsonian Institution Press, 1991, pp.75–76.

Cat.57 Frederic Edwin Church *West Rock, New Haven*

1 See Christopher Kent Wilson,'The Landscape of Democracy: Frederic Church's *West Rock, New Haven*', *The American Art Journal*, vol.18, no.3, 1986, pp.30–32. Wilson cites the *Crayon*, vol.7 (1860), Henry T. Tuckerman, *Book of the Artists* (1867), the *Art Journal*, George Sheldon, *American Painters* (1881), and *American Art and American Collectors* (1889) as examples.
2 William Cullen Bryant ed., *Picturesque America* (1874), reprint Secaucus, New Jersey: Lyle Stuart, Inc., 1976, vol.2, p.444. For a complete analysis of the painting, see Franklin Kelly, entry for Frederic Edwin Church, *West Rock, New Haven*, 1849, in the forthcoming catalogue of the collection of the New Britain Museum of American Art.
3 William H. Harris and Judith S. Levey eds, *The New Columbia Encyclopedia*, New York and London: Columbia University Press, 1975, pp.1101, 2965. The story of Goffe and Whalley was well known in the nineteenth century as is evident from the frequent references in literature of the day: for example, Nathaniel Hawthorne's short story 'The Gray Champion' (1835) and a mention in Henry David Thoreau's *Walden* (1854). The story also appeared in a number of guidebooks and popular journals. See Wilson, 'The Landscape of Democracy' (1986), p.34.
4 Ibid., p.37.
5 Information on the relations between Field and Church can be found in Albert Boime, *The Magisterial Gaze: Manifest Destiny and American Landscape Painting c.1830–1865*, Washington and London: Smithsonian Institution Press, 1991, pp.62–75.
6 See Wilson, in *The American Art Journal* (18:3, 1986), pp.27–28. Wilson notes that it is not known whether Field commissioned the painting.
7 Franklin Kelly, *Frederic Edwin Church and the National Landscape*, Washington, DC and London: Smithsonian Institution Press, 1988, pp.22–23.
8 'National Academy of Design', *Knickerbocker*, 33, May 1849, pp.469–470, as quoted in Kelly's entry (forthcoming catalogue of the collection of the New Britain Museum of American Art).
9 'Fine-Art Gossip', *Bulletin of the American Art-Union*, 2, April 1849, p.20, as quoted in Kelly's entry (forthcoming catalogue of the collection of the New Britain Museum of American Art).

Cat.58 John Mix Stanley *Oregon City on the Willamette River*

1 Linda Ayres et al., *American Paintings: Selections from the Amon Carter Museum*, Birmingham, Alabama: Oxmoor House, Inc., 1986, entry for John Mix Stanley, *Oregon City on the Willamette River*, n.p.
2 See, for example, James A. Henretta et al., *America's History*, New York: Worth Publishers, 1993 vol.1, p.403.
3 See William Bryant Logan and Susan Ochshorn, *The Smithsonian Guide to Historic America: The Pacific States*, New York: Stewart, Tabori and Chang, 1989, pp.311–312.
4 *Oregon Spectator*, 8 July 1847, p.2, col.1, quoted in Peter Hassrick, *The Way West: Art of Frontier America*, New York: Harry N. Abrams, Inc., 1977, p.60; and Ayres et al., *American Paintings* (1986), n.p.
5 Ayres et al., *American Paintings* (1986), n.p.
6 William Cronon, 'Telling Tales on Canvas: Landscapes of Frontier Change', in Jules David Prown et al., *Discovered Lands, Invented Pasts: Transforming Visions of the American West*, exhibition catalogue, New Haven and London: Yale University Press for the Yale University Art Gallery, 1992, pp.68–70. See also Elizabeth Johns, 'Settlement and Development: Claiming the West', ch.4 in William H. Truettner ed., *The West as America: Reinterpreting Images of the Frontier, 1820–1920*, exhibition catalogue, Washington and London: Smithsonian Institution Press for the National Museum of American Art, 1991, pp.208–209.

Cat.59 Fitz Hugh Lane *Fresh Water Cove from Dolliver's Neck, Gloucester*

1 See Henry Wiencek, *The Smithsonian Guide to Historic America: Southern New England*, New York: Stewart, Tabori and Chang, 1989, p.210

2 See Elizabeth Garrity Ellis, 'Cape Ann Views', in John Wilmerding et al., *Paintings by Fitz Hugh Lane*, exhibition catalogue, New York: Harry N. Abrams, Inc., in association with the National Gallery of Art, Washington, DC, 1988, pp.23,28.

3 Sawyer was a Boston merchant as well as a benefactor of Gloucester. Lane painted Sawyer's estate, Brookbank, so called because of the brook that ran through it, on at least two other occasions. See entry for Lane's *Fresh Water Cove from Dolliver's Neck* in *M. and M. Karolik Collection of American Paintings, 1815 to 1865*, Cambridge, Massachusetts: Harvard University Press for the Museum of Fine Arts, Boston, 1949, p.400. The painting was owned by Leo Landry of Lynn, Massachusetts, and then by Harvey F. Additon of Boston, by 1946, prior to its entering the Karolik Collection. Nothing is known about either of these individuals.

4 Ellis, in Wilmerding et al., *Paintings by Fitz Hugh Lane* (1988), p.32.

5 Carol Troyen, entry for Lane's *Fresh Water Cove from Dolliver's Neck, Gloucester*, in Troyen, *The Boston Tradition: American Paintings from the Museum of Fine Arts, Boston*, exhibition catalogue, Boston: The Museum of Fine Arts, Boston, and New York: The American Federation of Arts, 1980, p.114. For information on Samuel de Champlain, see, for example, Thomas H. Johnson, in consultation with Harvey Wish, *The Oxford Companion to American History*, New York: Oxford University Press, 1966, pp.157–158.

Cat.60 Robert S. Duncanson *View of Cincinnati, Ohio from Covington, Kentucky*

1 Suzanne Winckler, *The Smithsonian Guide to Historic America: The Great Lakes States*, New York: Stewart, Tabori and Chang, 1989, pp.48–49.

2 See David M. Lubin, *Picturing a Nation: Art and Social Change in Nineteenth-Century America*, New Haven and London: Yale University Press, 1994, pp.117–120.

3 Joseph D. Ketner, *The Emergence of the African–American Artist: Robert S. Duncanson 1821–1872*, Columbia and London: University of Missouri Press, 1993, pp.40–41. Boime has suggested that the black figures are likely freed slaves. He dated the painting to 1858; by that time the population of Covington included fifty free blacks. He also suggests that the painting treats the evolution of emancipation, for African–Americans, the route from slavery to freedom. See Albert Boime, *The Magisterial Gaze: Manifest Destiny and American Landscape Painting c.1830–1865*, Washington and London: Smithsonian Institution Press, 1991, pp.121–123. Ketner does not agree with Boime's interpretation. See Ketner, *The Emergence of the African–American Artist* (1993), pp.211–212, n.16.

4 See, for example, James A. Henretta et al., *America's History to 1877*, 2nd edn, New York: Worth Publishers, Inc., 1993, vol.1, pp.422–425; and Thomas H. Johnson, in consultation with Harvey Wish, *The Oxford Companion to American History*, New York: Oxford University Press, 1966, p.318.

5 The painting is *Uncle Tom and Little Eva* (Detroit Institute of Arts). See Ketner, *The Emergence of the African–American Artist* (1993), pp.46–49. See also Ian Ousby ed., *The Cambridge Guide to Literature in English*, Cambridge, England, and New York: Cambridge University Press, 1988, pp.954, 1019.

6 See Elizabeth Mankin Kornhauser 'Painting the American Landscape 1800–1900', this catalogue, pp.71–91.

Cat.61 Joseph Lee *Residence of Captain Thomas W. Badger, Brooklyn [California], from the Northwest*

1 Alice Putnam Erskine, 'Joseph Lee. Painter', *Antiques*, vol.95, no.6, June 1969, p.809. The Oakland Museum's object sheet notes that the 10-acre piece of property was located on San Antonio Creek, between 7th and 8th Avenues and East 9th and East 10th Streets, Oakland. See curatorial painting file, Oakland Museum of California.

2 Stephen Vincent ed., *O California! Nineteenth and Early Twentieth Century California Landscapes and Observations*, San Francisco: Bedford Arts, Publishers, 1990, p.23.

3 Thomas H. Johnson, in consultation with Harvey Wish, *The Oxford Companion to American History*, New York: Oxford University Press, 1966, pp.130–131; see p. 527 on the Mexican War; see pp.198–199 on the Compromise of 1850 which provided for admission of California as a free (rather than slave) state.

4 See Arthur Woodward, *California Centennial Exhibition of Art*, exhibition catalogue, Los Angeles: Los Angeles County Museum, 1949, p.5. In 1871 Joseph Lee was listed in the San Francisco directory as an artist. A brief biography of Lee appears on p.39 of the catalogue.

5 Other biographical information on Badger can be found in notes made by L. Ferbrache in the painting file at the Oakland Museum of California.

6 Elizabeth Johns, 'Settlement and Development: Claiming the West', in William H. Truettner ed., *The West as America: Reinterpreting Images of the Frontier, 1820–1920*, exhibition catalogue, Washington and London: Smithsonian Institution Press for the National Museum of American Art, 1991, pp.205–206.

7 See Ferbrache notes, painting file, Oakland Museum of California.

Eugene von Guérard *Ferntree Gully in the Dandenong Ranges* 1857 (detail) (cat.64)

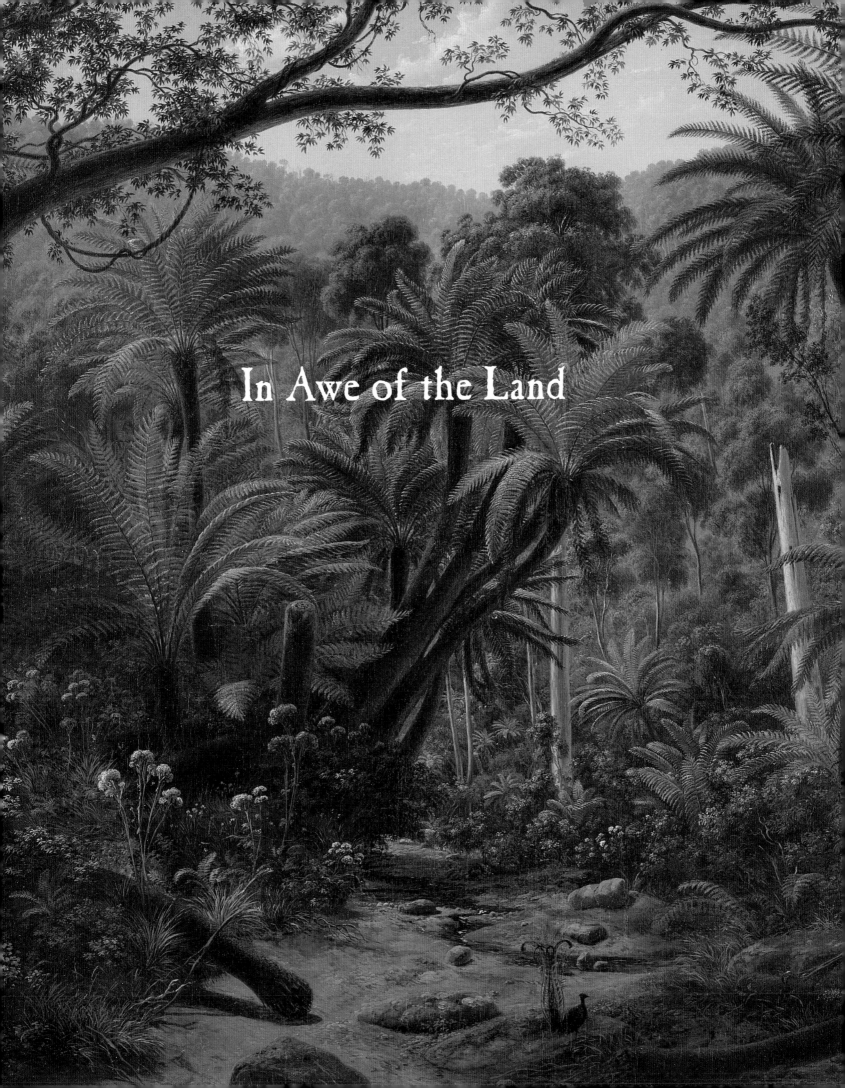

In Awe of the Land

Eugene von Guérard 1811–1901

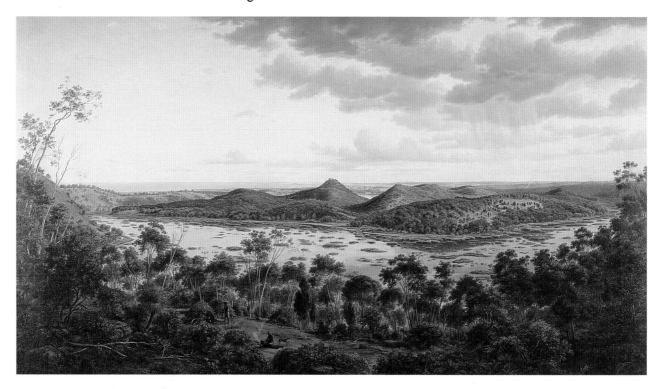

62. *Tower Hill* 1855
oil on canvas 68.0 x 122.0 cm (26-3/4 x 48 in) Department of Natural Resources and Environment, on loan to the Warrnambool Art Gallery

Tower Hill is a series of extinct volcanic cones within a larger cone. It lies between the coastal town of Warrnambool and the smaller town of Koroit in the Western District of Victoria. Eugene von Guérard visited the area in the winter of 1855 at the invitation of James Dawson whose property, Kangatong, lay adjacent to Tower Hill. Von Guérard's painting was commissioned by Dawson and was completed in Melbourne in 1855.

Two years after von Guérard's visit, the educationalist, writer and historian James Bonwick recorded his own observations of the site. By 1857 the first of a succession of changes to Tower Hill had already taken place, as the landowner whose property encompassed the crater had put in a dam wall to create a deeper lake. Bonwick commented: 'Had Mr Dawson's hundred guinea painting been executed since the birth of the lake, it would have been even more charming.'[1] As it is, von Guérard's painting depicts the shallow marsh which originally surrounded the central craters, part of a connected series of wetlands and a fertile breeding ground for birds and other wetland animals. Bonwick described Tower Hill as 'the most interesting locality' he had visited. He expressed astonishment that the remarkable landform was not better known in Melbourne and the regional city of Geelong.

Von Guérard was clearly fascinated by crater lakes such as Tower Hill, nearby Lake Eccles, and those at Mount Gambier in South Australia, each of which was the subject of several of his drawings and prints. At Tower Hill, the artist not only made the painting for Dawson, but also made a highly finished drawing of the subject, as well as a watercolour and a lithograph.

In the painting he has presented Tower Hill as a natural paradise. Aborigines inhabit the landscape, with barely a mark made by Europeans — distant ships are discernible, as is the cluster of buildings at Port Fairy. For von Guérard therefore, as for Bonwick, the geology of Tower Hill evoked an earlier time in the imagination. But the presence of Aborigines in the painting has further significance: James Dawson was a most unusual landowner in that he was very interested in Aboriginal culture. He was later to write an excellent and informative book about the Aborigines, for the most part drawn from his interviews with local people.[2]

Today the best known feature of this painting is the role it played in the revegetation of the Tower Hill area. While the late 1850s saw the formation of a lake from the original marsh, by the 1920s the area had been completely drained and all of the vegetation cleared from the hills and the surrounding crater rim. This was to make way for increased grazing. Furthermore, quarrying for scoria had taken place in a number of places around the rim.[3] From 1961 the area was declared a State Game Reserve and a restoration program was undertaken which involved the reforestation of the hill and the replanting of the fern gullies which were once a feature of the landscape. Von Guérard's painting was used as the blueprint for this landscape restoration program and today, from the 'von Guérard lookout' on the Koroit road, the visitor can see a view which, allowing for various twentieth-century depredations, looks remarkably like von Guérard's painting of 1855.

AS

Eugene von Guérard 1811–1901

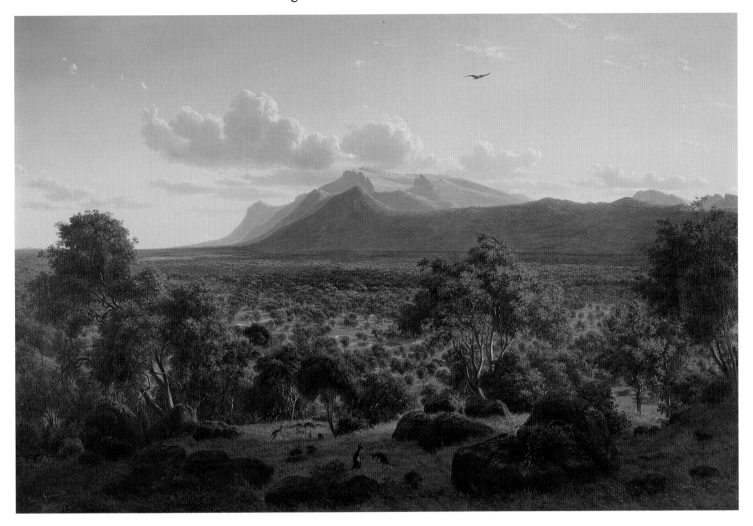

63. *Mount William from Mount Dryden, Victoria* 1857
oil on canvas 61.9 x 91.4 cm (24-1/3 x 36 in) Art Gallery of Western Australia, Perth

At 1371.5 metres above the surrounding plains, Mount William is the highest peak of the Grampian Ranges, a large group of jagged sandstone formations that extend over 1036 square kilometres through the Western District of Victoria. Major Thomas Mitchell, the first colonial explorer to reach its summit, named Mount William in 1836 after the reigning king of England.

Eugene von Guérard first visited the region in 1855 to undertake James Dawson's commission of the painting *Tower Hill* (cat.62). Von Guérard returned to the area in 1856, perhaps because of this positive response to his work, and spent a considerable time travelling through the Grampian Ranges.

Mount William from Mount Dryden is one of several large scale canvases developed from sketches made on von Guérard's second journey into the Grampians and surrounding districts and completed in the artist's Melbourne studio. When the painting was exhibited at the Victorian Society of Fine Arts exhibition in Melbourne in 1857 it was acclaimed as one of von Guérard's most successful landscape views. Several newspapers discussed the painting between December 1857 and January 1858,

commenting favourably on the beauty of the natural landscape and commending von Guérard for his composition and the chosen vantage point. The artist was praised for his empathy with the Australian landscape and described in terms of his national significance. The *Argus* remarked that he had displayed 'the feeling of a poet and the touch of a master',[1] and the *Illustrated Journal of Australasia* described him as 'decidedly the landscape painter of Australia'[2]. *Mount William from Mount Dryden* was reproduced in the *Illustrated Journal of Australasia* in 1858, and in the *Illustrated Melbourne Post* in 1862.

Mount William from Mount Dryden was originally purchased around 1865 by John Bakewell, the owner of a Melbourne wool sorting business. Bakewell took the painting to London, along with a substantial portfolio of von Guérard's highly finished landscape drawings. In 1972 it was acquired by the Art Gallery of Western Australia and remains one of that gallery's most significant colonial Australian paintings.

MK

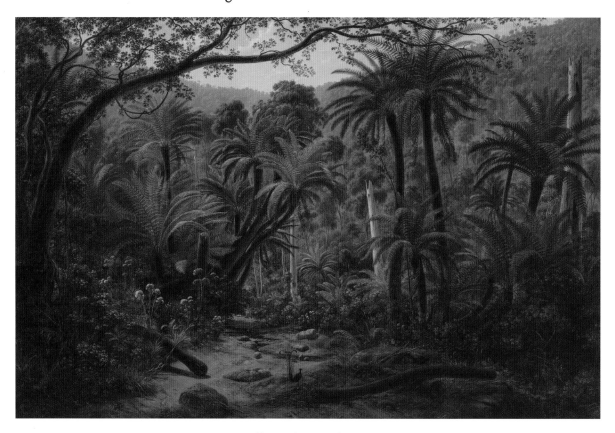

64. *Ferntree Gully in the Dandenong Ranges* 1857
oil on canvas 92.0 x 138.0 cm (36-1/4 x 54-3/8 in) National Gallery of Australia, Canberra Purchased with the assistance of Dr Joseph Brown AO OBE

M. de Guérard is at present engaged in elaborating his sketches lately taken in the magnificent scenery to be found among the Australian Alps and Grampians, and his depictions of the jungles of the ranges of Cape Otway and the Dandenong. Several of his pictures are to be devoted to the representation of the ferntree gullies of the latter range of mountains, and they promise to prove as valuable to the botanist as they will be gratifying to the lovers of art.[1]

A major work resulting from Eugene von Guérard's endeavours was *Ferntree Gully in the Dandenong Ranges*. When first shown at the Victorian Society of Fine Arts Exhibition in October 1857, the painting received high praise and the suggestion was made that it should be purchased by public subscription and presented to Queen Victoria. Although public support was substantial, it appears that the lottery which was to sponsor the sale did not bring in enough money for the proposal to go ahead.

At the time of von Guérard's visit to the Dandenong Ranges, approximately 33 kilometres east of Melbourne, the area was a dense, natural forest. As in his *North-east View from the Northern Top of Mount Kosciusko* 1863 (cat 65), with its high degree of geographical accuracy, this work is very precise in its botanical representation — species of tree ferns and other plants can be identified. Von Guérard's success with *Ferntree Gully in the Dandenong Ranges* inspired him to produce further works with this theme and popularised the subject for other artists and photographers. In 1866 a colour lithograph of Ferntree Gully

was included as part of von Guérard's *Australian Landscapes* series 1866–68 (cat.68). The accompanying text begins:

One of the most characteristic and beautiful features of the mountain scenery of Australia is what is known as a Fern Tree Gully. It combines the vivid verdure, the cool freshness, and the shadowy softness of an English woodland stream, with the luxuriant richness and graceful forms of tropical vegetation. A rill welling out from the summit or the shoulders of a lofty range hurries down its shaggy sides, wearing a channel for itself, trickling and sparkling over the mossy boulders which impede but scarcely divert its course: and, on either side, nature builds up a vista of rounded columns sometimes attaining a height of thirty feet, and from their summits spring out the exquisitely curved and brilliant green fronds of the fern tree, overarching the ice-cold brook below, and constituting one of the loveliest cloisters it is possible to imagine.

Whilst von Guérard's painting (and subsequent print) appear to present a natural wilderness., the area had become, by 1866, 'a favourite resort for summer tourists' and a hotel had been built nearby. The area was made a forest reserve in 1869, and in 1956 became a national park — there has been substantial degradation as a result of natural disasters and man-made intrusions.[2]

CG

Eugene von Guérard 1811–1901

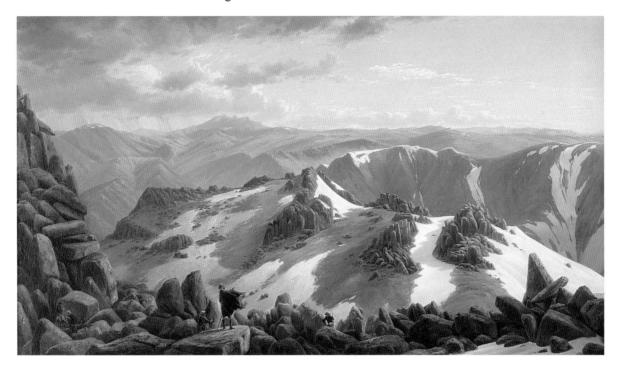

65. *North-east View from the Northern Top of Mount Kosciusko* 1863
oil on canvas 66.5 x 116.8 cm (26-1/8 x 46 in) National Gallery of Australia, Canberra

In 1862 Eugene von Guérard joined an expedition led by the German scientist Georg von Neumayer, who was conducting magnetic surveys throughout Victoria. Neumayer was a renowned geophysicist and his magnetic and meteorological measurements taken in Victoria were part of a world-wide scientific program to measure the earth's magnetic field. He was a follower of Alexander von Humbolt's theories of scientific investigation which rejected laboratory based methods in favour of direct measurements and experimentation in the field.[1]

Neumayer's party travelled from Melbourne to the north-east, crossing the border into New South Wales in November 1862 where, in a remote and relatively unexplored region of the Australian Alps, they were to climb Mount Kosciuszko, Australia's highest mountain, rising 2,228 metres.[2] From Tom Groggin, a landholding near the base of Mount Kosciuszko, their climb took two days due to the dense and difficult terrain and unseasonably high temperatures. During the ascent and at the summit von Guérard made a number of sketches, recording the views in all directions.

This painting was based on the sketches made during the expedition (now in the Mitchell and Dixson collections, State Library of New South Wales, Sydney). Although von Guérard painted *North-east View from the Northern top of Mount Kosciusko* in 1863, it is dated 19 November 1862, the day the group arrived at the summit. When compared to the original sketches, the rock formation on the left has been exaggerated to intensify the scale of the landscape in relation to the members of the expedition in the foreground.[3] Each member of the party is visible in the painting; von Guérard, Neumayer with his assistant Edward Brinkmann and the two guides Twynham and Weston.

Clouds and rain showers are shown on the left, while the right side of the painting is bathed in sunlight. This accurately portrays the fickle weather conditions found at high altitudes. Neumayer's account reveals that:

> the wind was so very strong and the granite boulders, of which the summit is so composed were so piled up, that I did not think it prudent to take the barometers to the top and accordingly mounted them some 40 ft lower down … M. de Guérard, meanwhile had seated himself on the summit, which affords a beautiful view of the mountainous country of New South Wales and Victoria, as well as the plains of the Murray River, and was taking a sketch of the scenery, when, just as I was completing my observations, he called out that it appeared to him a heavy storm was approaching form [sic] the New South Wales side.[4]

Indeed, the party was engulfed in a raging storm and one member was lost for eighteen days.

This landscape view remains virtually unchanged today. Now part of a national park, the area is popular with bush walkers and cross-country skiers. Tom Groggin is still a working property and an important local landmark. A walking track, mostly of metal grating, accommodates the day walkers who ascend Mt Kosciuszko from Thredbo Village on the south-eastern side of the range. However, the path taken by Neumayer and his party remains difficult terrain with much of the original bushland intact.

CG

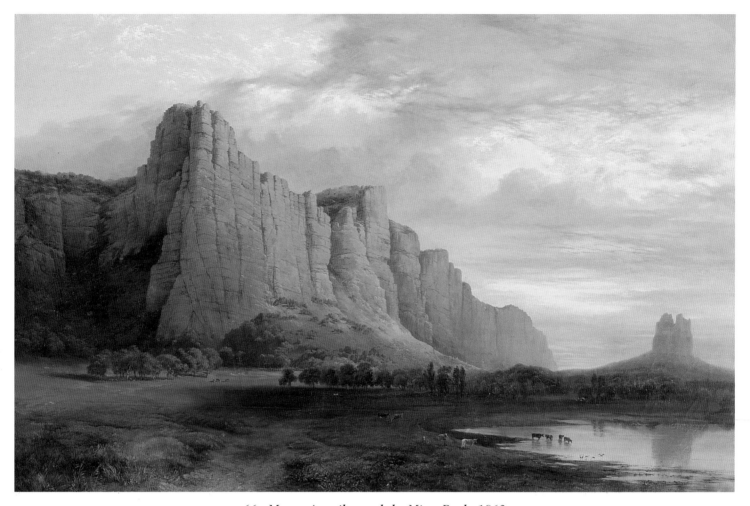

66. *Mount Arapiles and the Mitre Rock* 1863
oil on canvas 77.5 x 120.6 cm (30-1/2 x 47-1/2 in) National Gallery of Australia, Canberra

Mount Arapiles is approximately 30 kilometres from the town of Horsham in Victoria, and was named by the explorer Major Thomas Mitchell, who visited the region while travelling from Sydney to Portland Bay in 1836. The sandstone Mount Arapiles rises 369 metres, covers 25 square kilometres and rises abruptly from the flat plain which surrounds it for many hundreds of kilometres on each side. Mitre Rock is about one kilometre from Mount Arapiles — 61 metres high, it is one of Australia's most significant rock-climbing sites.

Mitchell had made sketches of the mountain which he published as an illustration in his book *Three Expeditions into the Interior of Australia* (1838). He wrote of the area:

This is certainly a remarkable portion of the earth's surface and might rather have belonged to that of the moon as seen through a telescope. [1]

Nicholas Chevalier and Eugene von Guérard visited Mount Arapiles on 4 May 1862 with the German scientist Georg von Neumayer, on his magnetic survey of Victoria. Both artists painted vast landscapes looking from the top of the mountain, and Chevalier also completed this view showing the approach to Mount Arapiles with the Mitre Rock to the right. His painting celebrates the grandeur of nature in both enduring and passing ways — the monumentality of Arapiles, shaped by elements over many million years, and the effects of light and colour in the sky at sunset on this particular day. Grazing cattle and a camp site in the foreground 'render[ed] the vast solitude and desolate grandeur of the scene more palatable' to critics of the time. [2]

In 1862 Chevalier exhibited an oil sketch for this painting in Melbourne, and probably completed the final work as a commission for Alexander Wilson, on whose property Mount Arapiles and the Mitre Rock were located. Chevalier produced a chromolithograph of the painting in 1864, changing the composition slightly, for publication in an album of twelve lithographs based on his Australian paintings — these were offered for sale in 1865 at three guineas per set. The painting was made more widely known through prints, including a wood engraving by Fredrick Grosse (*The Illustrated Australian News*); a steelengraving by S.Bradshaw (*Australia Illustrated*); and a wood engraving after S.Bradshaw which appeared in the *Australasian Sketcher*. [3]

MK

Eugene von Guérard 1811–1901

67. *Castle Rock, Cape Schanck* 1865
oil on canvas 61.0 x 91.3 cm (24 x 36 in) Art Gallery of South Autsralia, Adelaide M.J.M. Carter Collection through the Art Gallery of South Australia Foundation 1992

When *Castle Rock, Cape Schanck* was included as a plate in Eugene von Guérard's series of landscape lithographs (1866–68) (cat.68), it was accompanied by this description:

> The bold and romantic headland which bears this title forms one of the most picturesque 'bits' of scenery on the Victorian coast. The rocks have been worn into the most grotesque and fantastic shapes by the action of the waves, which rush in, with a majestic sweep, from the Southern Ocean, and the sides of the precipitous cliffs are perforated with caverns, of which the roof and walls appear to be covered with roughly sculptured images; and the illusion is heightened by the dim light which pervades these cool and moist recesses. Seen at sunset, or during the brief twilight of a summer morning or evening, the Castle Rock might easily be mistaken for a dismantled fortress, connected with the main land by a causeway, which some convulsion of nature had riven in twain. The lighthouse and telegraph station have been established on the summit of the promontory, and the greater part of the land at the Cape forms portion of the estate of Mr John Barker, one of the earliest settlers in this district.[1]

Cape Schanck is some 70 kilometres from Melbourne on the southern extremity of the Mornington Peninsula. Von Guérard's view, which looks towards the west, encompasses not only the Cape, but the coastline west of the heads of Port Philip Bay. A number of ships on the horizon indicate the narrow shipping channel between Port Philip Bay and the open sea. The significance of Cape Schanck to maritime traffic is attested by the lighthouse, built in 1859.

The name 'Castle Rock' with its associations of antiquity drew attention to the lack of ancient ruins in the Australian landscape. An ancient geology on the other hand clearly fascinated the artist. He visited the Cape in 1858 and again in April 1863 when he made the drawings on which this painting was based.[2] A companion painting, *Pulpit Rock, Cape Schanck* (private collection) was also painted in 1865 from sketches made in April 1863; it is identical in size but takes a more distant view of the Cape, focusing on the rugged bush around the cliff-tops.[3] The Cape Schanck paintings are two of a number of works depicting the extremities of the Australian land-mass in von Guérard's *oeuvre*. By 1870 he had visited all of the most spectacular coastal outcrops within a relatively close distance of Melbourne. In addition to his 1858 and 1863 trips to Cape Schanck, he visited Cape Otway in 1859 and again in 1862, and Cape Woolamai in 1869.

Whereas the Cape Schanck paintings emphasise the calm serenity of the ocean, von Guérard's Cape Woolamai painting (a small version of which is in the collection the National Gallery of Australia) is more dramatic.[4] Coming so late in his Australian career, the overblown Cape Woolamai painting was considered pretentious.[5] The Cape Schanck painting, by contrast, was admired for its fidelity to the geological facts of the scene and for the skill with which von Guérard handled the compositional challenge he had set himself — to balance a distant setting sun on one extreme of the work with the immensity of the rocky outcrop on the other.

AS

Eugene von Guérard 1811–1901

68. *Eugene von Guérard's Australian Landscapes* 1866–68
book of lithographs, printed in colour National Gallery of Australia, Canberra

During the nineteenth century there was a substantial market locally in Australia, and in Europe and America, for folios or albums containing prints of picturesque Australian landscape views, usually lithographs or wood engravings based on well-known paintings by the more important artists working in the colonies. *Eugene von Guérard's Australian Landscapes*, according to its publisher Hamel and Ferguson of Melbourne, would 'communicate to friends and relatives in Europe a vivid idea of the natural beauties of [the] land'.[1]

Von Guérard made six separate groups of lithographs, and these were published at intervals between 1866 and 1868. Each group comprised of four different prints divided into two sections, each containing two lithographs. From the end of 1868 the complete set of twenty-four prints could be purchased for £8 for a bound leather album or £7.10s for the works in a folio. The title page describes *Australian Landscapes* as 'A series of 24 tinted lithographs illustrative of the most striking and picturesque features of the landscape scenery of Victoria, New South Wales, South Australia and Tasmania' — these were lithographs after some of von Guérard's most popular paintings including *Ferntree Gully in the Dandenong Ranges* (cat.64) and *North-east View*

from the Northern Top of Mount Kosciusko (cat.65). Like the paintings, the lithographs present the range of geographical phenomena in the Australian landscape, and almost always include some kind of human endeavour or evidence of settlement. Each lithograph is prefaced by a short note describing the location, highlights, various features, and details of the topography, as well as providing travel notes for the prospective tourist. The landscape is often equated to famous European sites — Mount Kosciuszko, for example, being compared to 'Athos, Pindus, Olympus and the most celebrated mountains of Greece'.

In 1866 von Guérard exhibited works from his first group of prints at the Intercolonial Exhibition in Melbourne, and he received a medal in the section 'Processes of Multiple Production'. Despite this award and several favourable mentions in Melbourne newspapers, the album was not a commercial success and was remaindered in 1877.[2] Von Guérard himself was unhappy with the final result, particularly the limitation of using only three colours. Writing to his friend and fellow artist William Strutt in 1872 he stated: 'I am very sorry that you have seen that series of views ... because after all my trouble and time which I spent on that work, it was so totally spoiled in printing.'[3]

MK

J.H. Carse c.1820–1900

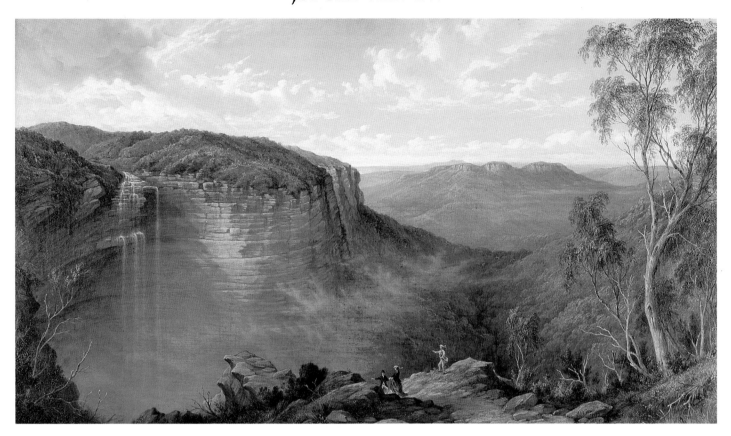

69. *Weatherboard Falls* 1873
oil on canvas 61.9 x 107.6 cm (24-3/8 x 42-3/8 in) Warrnambool Art Gallery

In 1867 a railway linking Sydney and the Weatherboard Falls in the Blue Mountains was completed and the region became very popular amongst Sydney's wealthier citizens, with many of them building country retreats in the area. The climate was deemed very beneficial to health, and from the 1880s a steady stream of invalids spent time recuperating in the Blue Mountains. Tourists were attracted to the area because of the wonderful landscape, and botanists and scientists revelled in its wealth of new material. During his 1867–68 tour of Australia, Prince Alfred, Duke of Edinburgh, was taken by train to the falls to view the spectacular scenery.

The aspect of the falls chosen by Augustus Earle in 1826, from one of many natural lookouts in the area (see cat.6), became the favoured view of artists.[1] Soon after J.H. Carse moved to Sydney in 1871 he travelled into the Blue Mountains in search of new subject matter. With the craggy mountains, deep gullies with wisps of cloud and mist, and a seemingly endless panorama, Weatherboard Falls scenery exemplified current notions of the grand landscape. In *Weatherboard Falls* Carse emphasises the grandeur of the scene by placing three small figures in the foreground. The tourists and their guide are dwarfed in the face of the escarpment; and the deep gully between them and the falls appears as a bottomless void with the water cascading into unknown terrain. The men point towards the far side of the valley, their gestures suggesting wonder at such a spectacular sight.

Carse painted this view on at least two occasions. In *The Weatherboard Falls, Blue Mountains* 1876 (The Joseph Brown Collection), the figures of Aborigines replace the Europeans of the earlier work. One figure stands confidently on the jutting rocky outcrop as he gazes at the view; this is in contrast to the attitudes of the Europeans in *Weatherboard Falls* who, perhaps, dare not venture so close to the edge. The inclusion of Aborigines in this landscape was, of course, symbolic — their presence suggests the evocation of the rugged and ancient scenery rather than something which could be encountered by the tourist of the 1870s.

Close to the Weatherboard Falls was the Weatherboard Inn, an overnight stop for travellers along the route from Bathurst, on the western side of the range, to Sydney, as well as for tourists who were able to then walk to the nearby falls. Both the railway station and Weatherboard Falls were renamed Wentworth Falls in 1879 in recognition of the explorer William Charles Wentworth's achievements in crossing the Blue Mountains with William Lawson and Gregory Blaxland in 1813. In the 1870s two other railway stations along the route which, by then, extended over the Blue Mountains were renamed in honour of Lawson and Blaxland, and the region was successfully promoted as a tourist attraction.[2] Today, the towns in the Blue Mountains are within daily commuting distance of Sydney.

CG

W.C. Piguenit 1836–1914

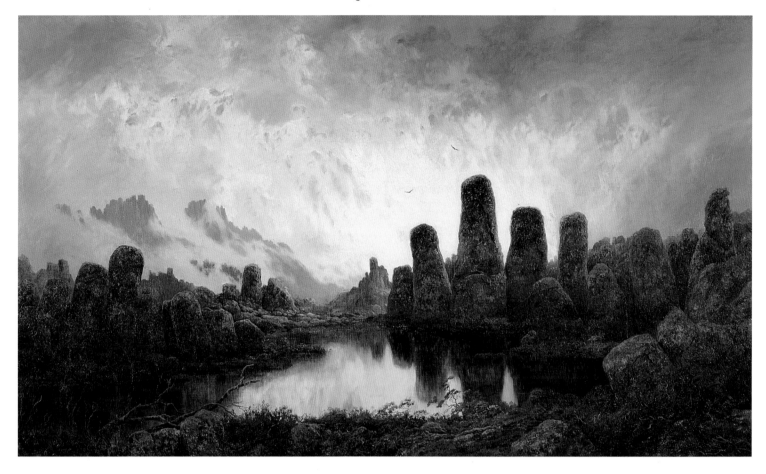

70. *A Mountain Top, Tasmania* c.1886

oil on canvas 76.0 x 127.5 cm (30 x 50-1/5 in) Tasmanian Museum and Art Gallery, Hobart Presented by the Tasmanian Government 1955

Paintings such as this have confirmed W.C. Piguenit in the art historical mind as a painter out of step with his contemporaries and have justified his status as the last true Romantic landscapist in the history of Australian painting. Whilst younger artists such as Tom Roberts were presenting Australia as an amiable sunshiny land, Piguenit was looking for the dramatic mood in the landscape. The subject here is not specified; the title, *A Mountain Top, Tasmania*, generalises the topography and could represent a number of Tasmanian mountain tops. Piguenit himself described the purpose of the work:

> to show the peculiar — one might almost say weird — character of the mountain solitudes where basalt on greenstone is their geological structure — such as Mt Wellington, Ben Lomond, Mt Olympus, the King William Range etc.[1]

Piguenit's knowledge of geology was informed by his friendship with R.M. Johnston, author of numerous scientific papers, and a major work of Tasmanian science, *A Systematic Account of the Geology of Tasmania* (1888), which included illustrations after Piguenit's paintings. Both Piguenit and Johnston were members of expeditions into wilderness Tasmania undertaken in 1874 and 1887. These expeditions traversed many kilometres of mountainous terrain. The second expedition was known as the 'West Coast Party', but the fifty-year old artist did not continue to the west coast; he turned back to Hobart at some point between Lake St Clair and the coast, preferring to spend time in the mountains rather than press on to look at the mines of the King River, the ultimate destination of the party.

A Mountain Top, Tasmania is unusual in Piguenit's *oeuvre* in its close viewpoint — most of the artist's mountain landscapes show peaks in the distance where the size of their massive bulk rising from the surrounding landscape could be appreciated. In 1892, however, Piguenit again showed a mysterious mountain top painting, *The Summit of the King William Range, Tasmania* (private collection). When Piguenit came to paint his best known (but least successful) painting of a mountain summit, *Mount Kosciusko* 1903 (Art Gallery of New South Wales, Sydney), he again used the technique of imparting mystery through the use of shrouds of mist clinging to the terrain. In *A Mountain Top, Tasmania* Piguenit used this technique to achieve a Gothic mood, the vertical greenstone outcrops suggesting a cluster of ancient ruins.

AS

W.C. Piguenit 1836–1914

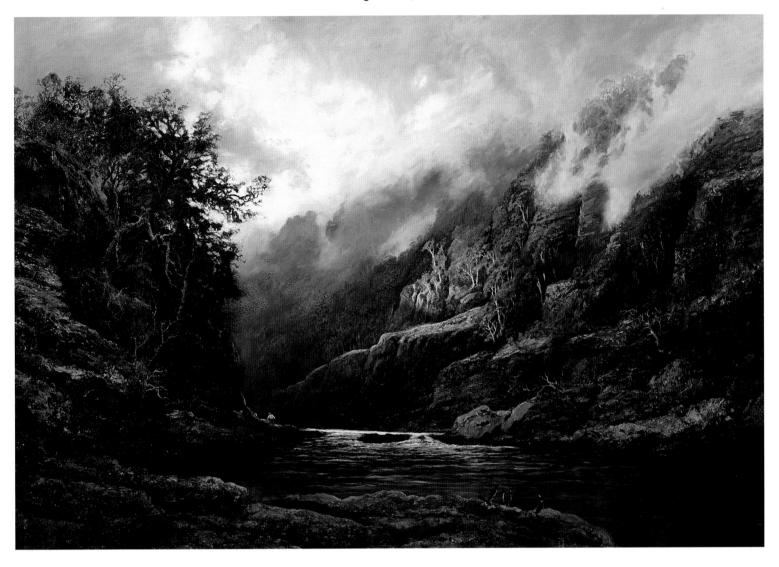

71. *The Upper Nepean, New South Wales* 1889
oil on canvas 91.0 x 129.9 cm (35-7/8 x 51-1/8 in) Art Gallery of New South Wales, Sydney

By 1889 W.C.Piguenit had been living in Sydney for almost a decade, yet he continued to prefer subjects which at first sight appear more redolent of the rugged wilderness of Tasmania than New South Wales scenery.

The Upper Nepean, New South Wales is Piguenit's most dramatic painting of the river that he painted on numerous occasions. The Nepean runs from the hilly areas to the south of Sydney, in a northerly direction on the eastern side of the Blue Mountains and into the Hawkesbury River. Shortly after he completed this work Piguenit described the upper reaches of the Nepean in a letter to his English cousin, Fanny:

> in places [the river] rushes through some very wild and rugged gorges — the cliffs often attaining a height of 700 to 800 feet, on each side. These, especially when partially hidden by mist, have a very imposing appearance, and it is under this aspect that I painted the picture.[1]

As with many of the watercourses around Sydney, the complexion of the Nepean River has now been significantly changed by dams.

When *The Upper Nepean, New South Wales* was exhibited in the Spring Exhibition of the Art Society of New South Wales in 1889, one critic found it oppressive in its relentless grey tonality.[2] However the Art Gallery of New South Wales was sufficiently convinced that the work was a major statement by the artist and bought the painting, adding it to the Piguenit oils they had bought in 1875 and 1885 and the watercolour purchased in 1882. The work was exhibited in Chicago in 1893 as a part of the New South Wales displays at the Columbian Worlds Fair.

AS

Frederic Edwin Church 1826–1900

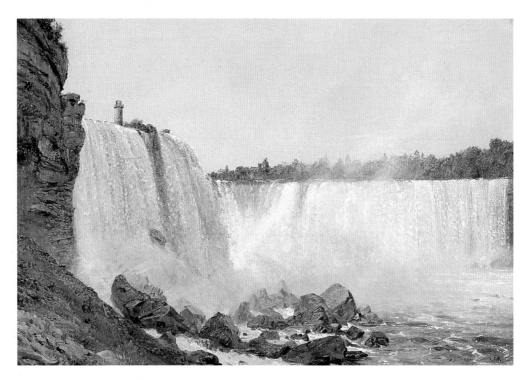

72. *Niagara Falls* 1856
pencil and oil on paper mounted on canvas 30.3 x 44.8 cm (11-15/16 x 17-5/8 in) Wadsworth Atheneum, Hartford, Connecticut Gift of Miss Barbara Cheney

In preparation for his 1857 depiction of Niagara Falls, Frederic Church made a number of oil studies (and pencil studies) of the site from different vantage points. Having recently read the third and fourth volumes of John Ruskin's *Modern Painters*, the artist was eager to make an accurate picture of the natural wonder. The Atheneum's oil study is one of these. Like the finished composition, it is of the Horseshoe Fall, but from the American side, rather than the Canadian. It is a traditional view, taken from below so as to emphasise the great height and force of the cataract.[1]

Church seems to have first sketched Niagara in March 1856. He made two more trips to the Falls that year, once in July and once again in the autumn. While Church made a number of *plein-air* oil studies throughout his career, the Atheneum's study, a finished work in itself, is based on a detailed pencil sketch on which he made colour notations. This method of working was characteristic of the Hudson River School artists.[2] By the 1820s, the *plein-air* oil sketch was flourishing in England, and artists such as John Constable made scientific studies of clouds and trees. Later, Church would adopt this method of working as well.[3]

The study remained with the family of the artist and his descendants until 1971 when Church's grandniece gave it to the Atheneum.[4]

AE

Frederic Edwin Church 1826–1900

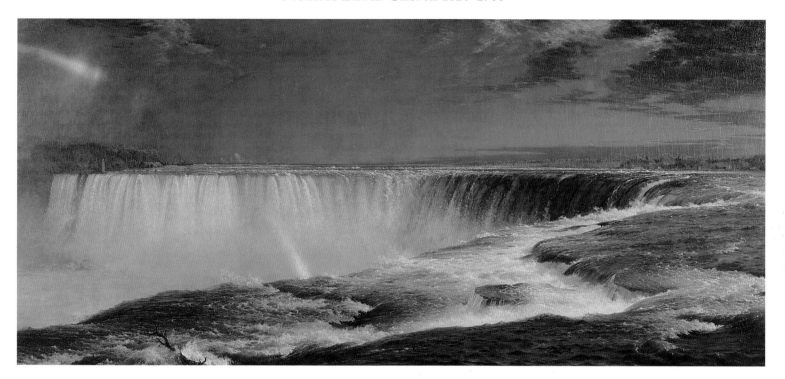

73. *Niagara Falls* 1857
oil on canvas 107.9 x 229.9 cm (42-1/4 x 90-1/2 in) The Corcoran Gallery of Art, Washington, DC

Nathaniel P. Willis described the Horseshoe Fall, the subject of *Niagara Falls*, as 'unquestionably the sublimest thing in nature'. He continued: 'To know that the angle of the cataract, from the British shore to the tower, is near half a mile in length; that it falls so many feet with so many tons of water a minute … conveys no idea to the reader of the impression produced on the spectator …'[1]

Niagara Falls was the most frequently depicted North-American natural wonder in the nineteenth century.[2] Just two years after Frederic Church completed this painting, Adam Badeau wrote:

[*Niagara* is] perhaps the finest picture yet done by an American; at least, that which is the fullest of feeling … If it is inspired by Niagara, it is grand and sublime; it is natural to the nation, since nature herself, has given the type; it is wild and ungovernable, mad at times, but all power is terrible at times. It is the effect of various causes; it is a true development of the American mind; the result of democracy, of individuality, of the expansion of each, of the liberty allowed to all; of ineradicable and lofty qualities in human nature …[3]

Although the Falls (as well as Church's painting of it) was an American icon representing the strength and potential of the New World and the United States in particular, Church chose a view from the Canadian shore of the Canadian side. This view, as the writer for *Picturesque America* pointed out, 'was the best point of view for the ordinary spectator … Immediately in front of them is the Horseshoe Fall, where, from the extreme depth of the channel, the water has a deep-emerald tinge of exquisite beauty'.[4]

In 1856 Church read volumes three and four of John Ruskin's *Modern Painters* and reviewed the first two. He was particularly drawn to Ruskin's remarks about water as a subject. Ruskin wrote: 'Of all inorganic substances acting in their own proper nature, water is the most wonderful … It is to all human minds the best emblem of unwearied, unconquerable power.'[5] Later, when *Niagara Falls* was exhibited in London before being chromolithographed by a British firm, Ruskin previewed the picture and was astonished by its scientific naturalism.[6]

During the nineteenth century, Niagara was seen as a sign from God that America was the Promised Land. Church included the Eternal Rainbow, symbolic of the covenant between God and humankind after the great Flood and a reference to the 'emblem of peace' seen by Noah. While the force and violence of the Falls were thought of as Divine wrath, the rainbow functioned as a symbol of Divine mercy. Thus, while viewing Niagara was a sublime experience, provoking a certain amount of excitement and terror in the spectator, it was also beautiful and had a calming and comforting, indeed a spiritual effect on those who saw it.[7]

Church's choice of a panoramic format for the painting, exaggerated in its proportions — its width is nearly twice its height — served to emphasise the breadth of the Falls. He eliminated a foreground, thus increasing the verisimilitude of the experience of viewing.[8] The size and grandeur of Niagara in comparison with European nature was a source of nationalistic pride for the United States and previously competitive sections were unified in rivalry with Europe.[9]

AE

William Trost Richards 1833–1905

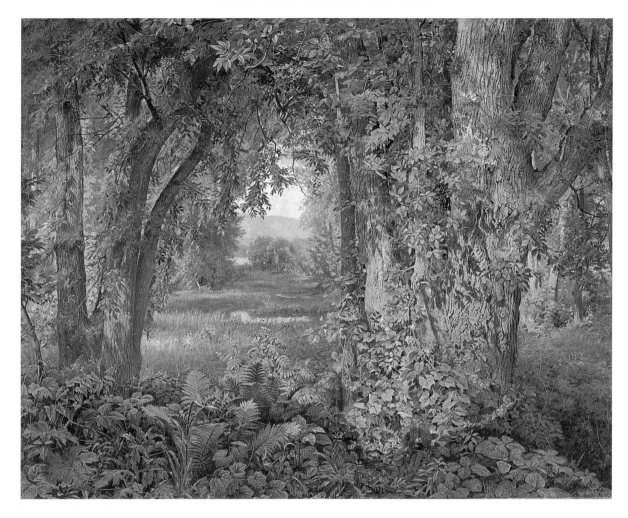

74. *In the Woods* 1860
oil on canvas 40.0 x 50.8 cm (15-3/4 x 20 in) Bowdoin College Museum of Art, Brunswick, Maine Gift of the Misses Mary T. and Jane Mason

William Trost Richards began making meticulously detailed and bontanically accurate drawings of plants in the late 1850s and the 1860s; these then served as studies for his highly naturalistic oils and watercolours, delineated with comparable detail. Linda Ferber credits Richards's technical control and skill to his early career as a commercial draughtsman. Other influences Ferber cites are his familiarity with the art of the Düsseldorf school (Richards visited Düsseldorf in 1856); the work of Frederic Church; and Asher B. Durand's 'Letters on Landscape Painting', published in the *Crayon* in 1855.[1]

By the late 1850s, Richards had probably read the English moralist and art critic John Ruskin's *Modern Painters*, which was published in the United States in 1855–60, and he began painting in the meticulously detailed style Ruskin advocated.[2] By 1860, when Richards painted *In the Woods*, the artist had mastered this style.[3]

The American Pre-Raphaelite movement, known as the Association for the Advancement of Truth in Art, which Richards joined in 1863, was dedicated to the accurate transcription of nature. Drawing their inspiration from the writings of Ruskin

— some of which were published in the *Crayon* — the American Pre-Raphaelites believed in what Ruskin called 'the innocence of the eye', that is, coming to the subject with a freshness available to 'a blind man … suddenly gifted with sight'.[4] Henry Tuckerman found fault with the Americans' extreme interpretation of Ruskin's words and, in his paragraph on Richards and his landscapes, commented:

> Marvellous in accurate imitation are the separate objects in the foreground of these pictures: the golden rod seems to wave, and the blackberry to glisten; but the relative finish of the foreground, centre, and background is not always harmonious; there is little perspective illusion; what is gained in accuracy of details seems lost in aerial gradation and distances.[5]

In the Woods suffers somewhat from this inability — prevalent among the Pre-Raphaelites — to reconcile foreground and background: there is almost no middleground in the composition.[6]

AE

Frederic Edwin Church 1826–1900

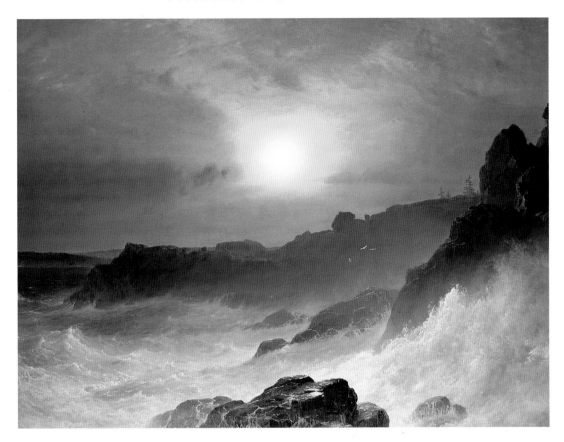

75. *Coast Scene, Mount Desert* 1863
oil on canvas 91.8 x 121.9 cm (36-1/8 x 48 in) Wadsworth Atheneum, Hartford, Connecticut Bequest of Clara Hinton Gould

Frederic Church first visited Mount Desert Island, Maine, in 1850. Mount Desert's particular topography of evergreen trees, pink granite, northern light, and, especially, the dramatic drop of rocky cliffs directly into the Atlantic Ocean, made this wilderness area a popular destination for those seeking refuge from urban living.[1]

While the interior of the island offered picturesque vistas, the rugged coastline where waves crash against precipitous rocks was sublime.[2] It is this sublimity that Church captured in *Coast Scene*. He described the water as follows:

> There is no such picture of wild, reckless, mad abandonment to its own impulses, as the fierce, frolicsome march of a gigantic wave. We tried painting them, and drawing and taking notes of them, but cannot suppress a doubt that we shall neither be able to give actual motion nor roar to any we may place upon canvas.[3]

Church made a preparatory *plein-air* oil sketch of Mount Desert in the mid-1850s called *Study for Storm at Mt. Desert (Surf pounding against the Rocky Maine Coast)*. The naturalistic *plein-air* oil sketch, to which Church was devoted, flourished in England in the hands of John Constable, among others.[4]

Other European artists, namely J.M.W. Turner and the Düsseldorf-trained Andreas Achenbach, also influenced Church's final composition. His attention to light and water in *Coast Scene* is indebted to Turner, and his treatment of the waves battering the rocks has been traced to Achenbach's *Clearing Up,* *Coast of Sicily* (Walters Art Gallery, Baltimore). (He had probably seen Achenbach's painting at the American Art-Union in New York City where it had been on view in 1849.) Henry Tuckerman's comment on *Coast Scene* — 'the peculiar yeasty waves and lurid glow [are] incident to a dry autumnal storm in northern latitudes' — echoes John Ruskin's discussion in *Modern Painters* of 'yesty [sic] waves'.[5]

At least one scholar has suggested that the date of *Coast Scene, Mount Desert* is significant. Painted in the middle of the Civil War, at a particularly violent point in the conflict, when the Northern cause seemed threatened, it features an image of nature's forces embroiled in a struggle with one another.[6] The painting also prefigures Winslow Homer's later paintings of the Maine coast. As such, the rugged coast of Maine was considered a vital symbol of New England character and those masculine qualities that urban Americans of Homer's generation sought to recapture.[7]

Marshall Owen Roberts purchased *Coast Scene* directly from Church in 1863. He had a significant art collection appraised at half a million dollars and held in his Fifth Avenue mansion in New York City. Roberts made his fortune in mail steamships in the 1840s and 1850s and in chartering and selling steamships during the Civil War. He was a staunch supporter of the Northern cause.[8]

AE

Sanford Robinson Gifford 1823–1880

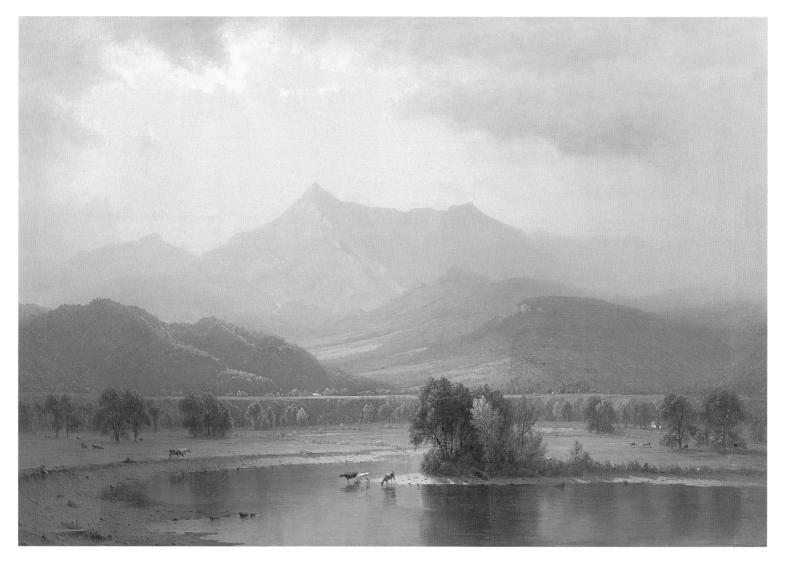

76. *A passing Storm in the Adirondacks* 1866
oil on canvas 94.6 x 137.8 cm (37-1/4 x 54-1/4in) Wadsworth Atheneum, Hartford, Connecticut Bequest of Elizabeth Hart Jarvis Colt

During the Civil War years (1861–65), Sanford Gifford developed the theme of the 'coming' or 'approaching' storm in his painting. Ila Weiss has interpreted these pictures in terms of the turmoil of the war and the nation's anxiety associated with the war. In the Atheneum's work, the break in the clouds and the theme of the passing storm — in contrast to the earlier approaching storm paintings — seems to reflect the date of the picture, which was completed after the end of the Civil War.[1] Gifford painted *A passing Storm in the Adirondacks* on commission for Elizabeth Hart Jarvis Colt (1826–1905), widow of the arms manufacturer Samuel Colt (1814–1862) of Hartford, Connecticut.[2] The Colt factory, under Samuel first and later Elizabeth, made a considerable profit on arms sales to the Union military during the Civil War. Although a fire in 1864 destroyed much of the factory, production soon resumed in those buildings that could be salvaged and, in the next three years, the remainder of the operation was restored.[3]

The scale of nature is overwhelming in relation to the few small houses in the middleground and the village at the base of the mountains. The suggestion of a pastoral settlement represented by the church steeple and cows grazing near the water is just that — a suggestion — in the face of the sublimity of nature.[4]

Gifford served in the Civil War and painted a few paintings that deal directly with Civil War themes, such as *Bivouac of the Seventh Regiment at Arlington Heights, Va.*, 1861 (Seventh Regiment Armory, New York).[5]

AE

Samuel Colman 1832–1920

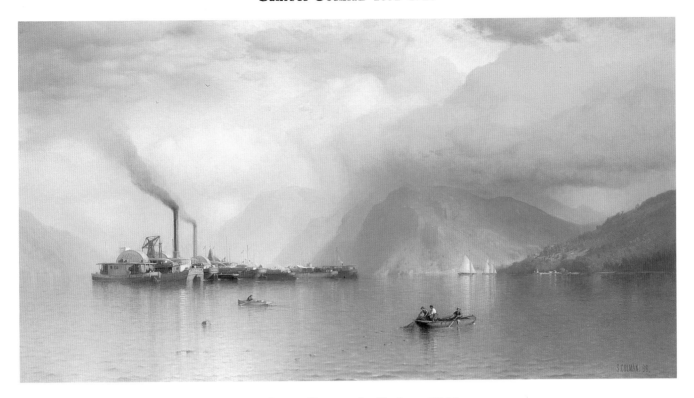

77. *Storm King on the Hudson* 1866
oil on canvas 81.6 x 152.0 cm (32-1/8 x 59-7/8 in) National Museum of American Art, Smithsonian Institution, Washington, DC Gift of John Gellatly

At the gates of the Hudson Highlands, just north of West Point on the Hudson River, stand two mountains, Storm King and the Cro'-Nest, the largest of the Highland range. In *Picturesque America*, the effects of weather on the mountains are described:

Under the frown of a low thunder-cloud they take on a grim majesty that makes their black masses strangely threatening and weird; one forgets to measure their height, and their massive, strongly-marked features, by any common standard of every-day measurement, and they seem to tower and overshadow all the scene around them, like the very rulers and controllers of the coming storm. And when the sunlight comes back again, they seem to have brought it, and to look down with a bright benignity, like giant protectors of the valley that lies below.[1]

Indeed, the effects of meteorological change on Storm King are one of the subjects of Samuel Colman's painting. The name 'Storm King' is credited to Nathaniel Parker Willis, who called it such because of 'the fact that for years [Storm King] ... served as a weather-signal to the inhabitants of the immediate district'.[2]

The other subject that Colman treats is the activity on the river at this spot on the Hudson. In 1853 Fredrika Bremer wrote:

The river was full of life. Wooden-roofed steam-boats, brilliant, as ours, with gold and white, passed up and down the river. Other steam-boats drew along with them flotillas of from twenty to thirty boats, laden with goods from the country to New York, while hundreds of smaller and larger craft were seen skimming along past the precipitous shores like white doves with red, fluttering neck-ribbons.[3]

Colman's depiction of river activity is in high relief against a backdrop of the spectacular mountain, but the boats appear frozen in space. The steam from the side-winders and the clouds in the sky mingle, and this juxtaposition of nature and technology offers not a menacing view of the development of the Hudson River Valley, but rather one of commercial prosperity intertwined with the beauty of natural world.[4]

The Hudson River played an important role in the early history of what would become the United States, and it was a bone of contention between the British and the Americans in the American Revolution. For example, it was West Point, just north of the scene depicted by Colman, that the treasonous Benedict Arnold tried to turn over to the British. The river became a major commercial route with the 1825 opening of the Erie Canal, which linked the Hudson with the Great Lakes in the north.[5]

Colman's loose and fluid brushwork in *Storm King* may be traced to his highly-praised work in watercolour. His interest and success in the depiction of the sky may be due to his acquaintance with the paintings of the English landscape painter J.M.W. Turner, whose work he knew through engravings if not through the originals. There is scant evidence that Colman ever travelled to England. We do know, however, that Colman read John Ruskin and, through Ruskin, would have developed an understanding of Turner.[6]

AE

Albert Bierstadt 1830–1902

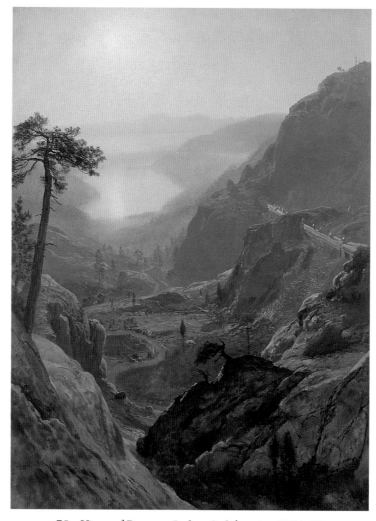

78. *View of Donner Lake, California* 1871–72
oil on paper mounted on canvas 73.6 x 54.0 cm (29 x 21-1/4 in) Fine Arts Museums of San Francisco, California Gift of Anna Bennett and Jessie Jonas in memory of August F. Jonas, Jr

View of Donner Lake is one of the most finished of the many oil sketches that Albert Bierstadt executed in preparation for *Donner Lake from the Summit* c.1873 (fig.55), a commission from Collis P. Huntington, one of the men who financed the building of the Central Pacific Railroad.[1] With the completion of the railroad through the granite Sierra Nevada mountains in 1869, travel between the East and West coasts of the United States became comfortable. Tourists flocked to California to see the natural wonders of Yosemite and the Mariposa redwoods, areas that were declared national parklands by President Abraham Lincoln in 1864.[2]

The site of Donner Lake was well-known to travellers. The lake was named after the Donner Party, a group of settlers, who, on their way to Sacramento, California, were trapped by an early snow storm there in 1846. Several people in the party died, and those who survived were driven to cannibalism. It was 1847 before the survivors were rescued.[3] Huntington apparently chose the site for the painting in celebration of the triumph of the railroad over the highest and most difficult section of the Sierra Nevada — a place where nature had previously triumphed over humans. A cross in the centre of the oil sketch seems to commemorate the Donner tragedy.[4] In 1873, writing about the finished painting, a critic for the *Overland Monthly* commented:

> The two associations of the spot are ... sharply and suggestively antithetical: so much slowness and hardship in the early days, so much rapidity and ease now; great physical obstacles overcome by a triumph of well-directed science and mechanics.[5]

Bierstadt's composition ultimately pays homage to both the natural and the technological sublime.

The Central Pacific Railroad followed the same route as the settlers, through Donner Pass, above Donner Lake. The tracks and the snowsheds, visible in the oil sketch at the right, were for the most part built by Chinese labourers.[6] Interestingly, these snowsheds, while protecting the trains and travellers, obstructed the view of the Sierra scenery, a drawback lamented in *Picturesque America*.[7]

AE

Thomas Moran 1837–1926

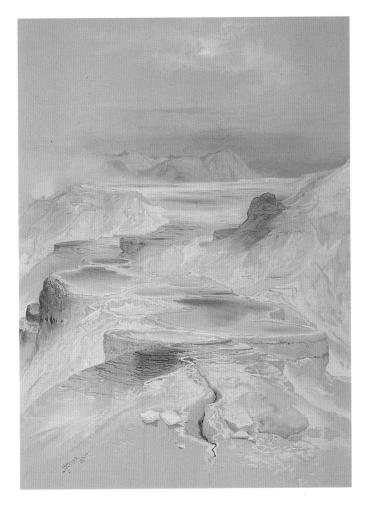

79. *Hot Springs of Gardiners River, Yellowstone National Park* 1872
watercolour on paper 33.0 x 23.7 cm (13 x 9-3/8 in) Gerald Peters Gallery, Santa Fe, New Mexico

In 1871 Thomas Moran joined Ferdinand Hayden's United States Geological Survey of the Territories in the West. It was the fifth year of the expedition, and they were heading to Yellowstone. Although Yellowstone was considered by many to be a new discovery at this time, the region was well known to Native Americans and, since 1805 or 1806, to trappers, traders, mountain men, and the military.[1] In order to finance his trip west, Moran secured funds from Roswell Smith of *Scribner's Monthly* and from Jay Cooke of the Northern Pacific Railroad. In exchange for Cooke's contribution, the artist pledged twelve of his watercolours of the Yellowstone area to the railroad financier. Moran was also to provide illustrations for an article on Yellowstone that was to appear in *Scribner's*.[2]

The Federal Government commissioned Hayden's survey in part to determine future commercial use of the land and its resources. The government required complete documentation of surveys, both verbal and pictorial, and so photographers and artists accompanied the topographers, cartographers, and scientists on these expeditions.[3]

Yellowstone was named as such for the sulphuric yellow deposits in the area. Located on a large plateau of once-molten lava in the Rocky Mountains, Yellowstone is approximately 8,000 feet above sea level and extends from Northern Wyoming into Montana and Idaho. Volcanic activity is indicated in part by the some 10,000 hot springs and 200 geysers. Mammoth Hot Springs, which Moran depicts in *Hot Springs of Gardiners River*, is composed of a series of terraces with steaming, mineral-rich reflecting pools.[4]

Moran's finished Yellowstone paintings were after watercolour sketches that served as the basis for his more ambitious watercolours and oils of the site. These final compositions served as selling props for western settlement and investment; they also had a role in convincing the United States Congress to designate Yellowstone a national park (fig.56).[5]

Congress set aside Yellowstone as a national park in 1872, making it the first national park anywhere. According to the Yellowstone Act of 1872, the park was a 'pleasuring-ground for the benefit and enjoyment of the people' and assured the 'preservation, from injury or spoilation, of all timber, mineral deposits, natural curiosities, or wonders within'.[6]

AE

Jasper F. Cropsey 1823–1900

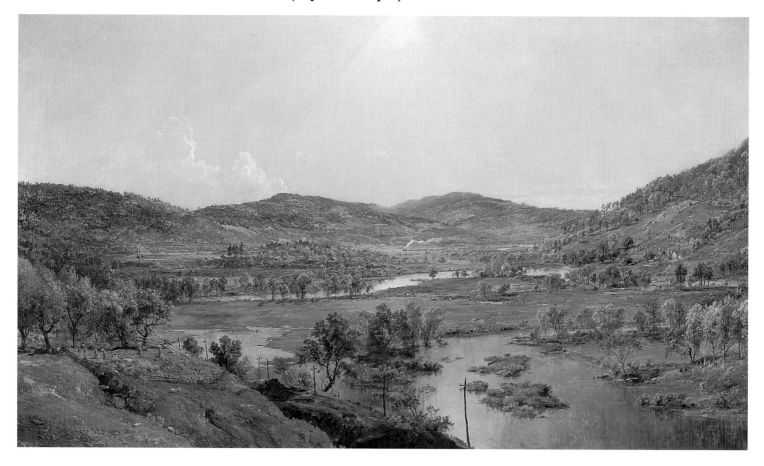

80. *Sidney Plains with the Union of the Susquehanna and Unadilla Rivers* 1874
oil on canvas 107.0 x 182.5 cm (42-1/8 x 71-7/8 in) Los Angeles County Museum of Art, California Jessie R. McMahan Memorial and Museum Acquisition Fund

Jasper Cropsey painted *Sidney Plains* one year after the Panic of 1873, in the thick of a five-year economic depression. The Panic was set off by over-speculation on the part of entrepreneurs. The phenomenal growth of the railroad after the Civil War transformed the north-eastern economy as coal mines and steel mills benefited from the railroad's demands for fuel and track.[1]

One of a number of large-scale landscapes Cropsey painted after his return from London in 1863, *Sidney Plains* is a topographical view of south-central New York State, between Binghamton and Oneonta, where the Susquehanna and Unadilla rivers meet. In Henry James's opinion, Cropsey's composition lacked impact:

> It may seem disrespectful ... to allude to ... Bierstadt's *California in Spring* and Mr. Cropsey's *Sidney Plains* as 'details', they take up so much space on the walls, but they have taken little (and even that we grudge them) in our recollections.[2]

Cropsey's turning away from the more romantic style of Thomas Cole toward the naturalistic detail of artists such as Asher B. Durand and Frederic Church is due to the direct influence of these American artists and also to his friendships with John Ruskin and the Pre-Raphaelite artists he met in England. Cropsey's intense autumn colours — he was known as the foremost painter of fall foliage — might also be the result of his contact with the Pre-Raphaelites.[3]

Sidney Plains is a vast panoramic depiction of a settled valley, where the pastoral ideal meets the technological: sheep graze on the hillside in the left foreground, and the Erie Railroad makes its way across the middle background at the foot of the hills. There is no obvious hint of the economic despair of 1874. *Sidney Plains* was painted the year that *Picturesque America* was published. The two volumes celebrate the natural wonders and tourist attractions of the United States. Both painting and books are imbued with nostalgia, created as they were for the Victorian elite who preferred rose-coloured views in a troubled time.[4]

According to contemporary sources, *Sidney Plains* was painted for a John N. Johnston or was in the collection of a John H. Johnston.[5] It is possible, however, that Cropsey painted the work for John Taylor Johnston, a railroad magnate, art collector, and the first president of the Metropolitan Museum of Art, New York. John T. Johnston owned the Lehigh & Susquehanna Railroad, which connected the coal fields of Pennsylvania to the seaboard.[6]

AE

Albert Bierstadt 1830–1902

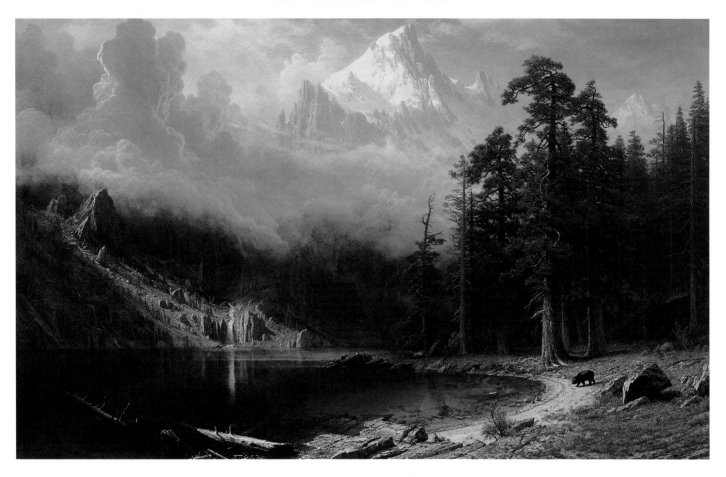

81. *Mount Corcoran c.1875–77*
oil on canvas 154.9 x 244.5 cm (61 x 96-1/4 in) The Corcoran Gallery of Art, Washington, DC

When Albert Bierstadt first exhibited *Mount Corcoran*, he called it *Mountain Lake*. It was shown at the National Academy of Design in New York City in April 1877. Not long after that, Bierstadt strategically renamed the painting in honour of William Wilson Corcoran (1798–1888). Corcoran was a Washington, DC banker and philanthropist, and founder of the Corcoran Gallery of Art, whose patronage the artist hoped to gain. Corcoran's collection included works by Thomas Cole, John F. Kensett, Jasper F. Cropsey, Frederic Edwin Church, and Emmanuel Leutze.[1]

Bierstadt may have felt most competitive with Church, whose *Niagara* the gallery had purchased in 1876. He applied to the gallery to purchase the painting, renamed *Mount Corcoran*, and, when unsuccessful, turned to Corcoran himself, who did in the end buy the work. Through some manoeuvring on Bierstadt's part, Corcoran donated the painting to the gallery.[2]

The critical response to the exhibition of *Mount Corcoran* at the National Academy of Design was at times harsh. One critic wrote: 'The whole picture is a mistake ... He possesses skill and talents and fancy; he is industrious and ambitious to excel: he understands the "popular taste" ... but, he has considerable climbing to do before he reaches the top of Pisgah or Parnassus.'[3]

Bierstadt took a strong interest in printmaking and photomechanical processes and used these media to promote himself. One of the last major prints after Bierstadt's work was a photogravure after *Mount Corcoran*, made in 1887, published in 1889 in the series *One Hundred Crowned Masterpieces: Photogravures from the greatest modern paintings of all nations selected from the public and private galleries of Europe and America* (Philadelphia: Gebbie & Husson Co. Ltd). All versions of the series included *Mount Corcoran*.[4]

A wood engraving of *Mount Corcoran* appeared in George Sheldon's *American Painters* in 1881, as 'Mount Corcoran, Sierra Nevada'. Quoting an unknown source, Sheldon wrote:

> The peak rises to a height of fourteen thousand eight hundred and eighty-seven feet, and is about five miles distant from the little lake led by the snows of the mountain-range. The picture is considered to be a happy combination of the best points in Mr. Bierstadt's style, and, while treated with a bold, broad effect, abounds in finished truthfulness of form and colour.[5]

Although identified — and praised — as a truthful depiction of a site in the Sierra Nevada mountain range, *Mount Corcoran*, like most of Bierstadt's paintings, was a composite of impressive sites in that range.

AE

Notes

Cat.62 Eugene von Guérard *Tower Hill*

1 James Bonwick, *Western Victoria: Its Geography, Geology and Social Condition*, (Geelong 1858), reprint (with introduction by C.E. Sayers), Melbourne: Lothian, 1970, p.72.
2 James Dawson's *The Australian Aborigines* was published in 1881.
3 David Hansen and Christina Davidson, *Tower Hill and its Artists,* exhibition catalogue, Warrnambool: Warrnambool Art Gallery, 1985.

Cat.63 Eugene von Guérard *Mount William from Mount Dryden, Victoria*

1 *Argus*, Melbourne, 4 December 1857, p.5.,
2 'Art in Victoria', *Illustrated Journal of Australasia*, January 1858, pp.34–38, p.35.

Cat.64 Eugene von Guérard *Ferntree Gully in the Dandenong Ranges*

1 *Age*, Melbourne, 22 May 1857, p.5.
2 Ibid., pp.171–172.

Cat.65 Eugene von Guérard *North-east View from the Northern Top of Mount Kosciusko*

1 While it took until the twentieth century to confirm George von Neumayer's belief that magnetic mapping would yield useful information regarding the location of valuable mineral deposits, his precise recordings were used by Victorian surveyors for many years. See R.W.Home, 'Georg von Neumayer and the Flagstaff Observatory, Melbourne', in *From Berlin to Burdekin. The German Contribution to the Development of Australian Science, Exploration and the Arts*, New South Wales University Press, 1991, pp.40–53.
2 Mount Kosciuszko was named in 1839 by the Polish explorer Paul Edmund de Strzelecki (1797–1873), who was the first the ascend the peak. He named it after the Polish political figure, Tadeusz Kosciuszko, though the spelling was later corrupted. In 1997 an Australian federal government decision officially restored the correct spelling.
3 A thorough examination of von Guérard's sketches and their relationship with this work can be found in Tim Bonyhady, *Australian Colonial Paintings at the Australian National Gallery*, Canberra: Australian National Gallery, 1986, pp.189–194.
4 Neumayer, *Magnetic Survey*, 7, quoted in ibid., p.190.

Cat.66 Nicholas Chevalier *Mount Arapiles and the Mitre Rock*

1 *The Australian Encyclopedia*, vol.1, 1977, p.150.
2 *The Illustrated Australian News*, Melbourne, 28 January 1967, quoted in Tim Bonyhady, *Images in Opposition: Australian Landscape Painting 1801–1890*, Melbourne: Oxford University Press, 1985, p.77.
3 Information about exhibition dates and prints after Chevalier's painting from Tim Bonyhady, *Australian Colonial Paintings in the Australian National Gallery*, Canberra: Australian National Gallery, 1986, pp.42–43.

Cat.67 Eugene von Guérard *Castle Rock, Cape Schanck*

1 Description accompanying plate 5 in *Eugene von Guérard's Australian Landscapes*, Melbourne: Hamel and Ferguson, 1866–67.
2 In the Dixson Library, State Library of New South Wales, Sydney.
3 See Candice Bruce, *Eugene von Guérard*, exhibition catalogue, Canberra; Australian National Gallery, 1980, pp.74, 106 (where the work is illustrated and included with *Ferntree Gully in the Dandenong Ranges* 1857, *Mount William from Mount Dryden* 1857 and other works) under the heading 'Sacred Landscapes'.
4 The serenity of *Castle Rock, Cape Schanck* is emphasised by Jane Hylton, 'Castle Rock, Cape Schanck, 1865', in Ron Radford and Jane Hylton, *Australian Colonial Art 1800–1900*, Adelaide: Art Gallery of South Australia, 1995, pp.101–104.
5 See Tim Bonyhady, *Australian Colonial Paintings in the Australian National Gallery*, Canberra: Australian National Gallery, 1986, p.205.

Cat.68 Eugene von Guérard *Eugene von Guérard's Australian Landscapes*

1 Hamel and Ferguson publishers, letter to potential subscribers, in Tim Bonyhady, 'Eugene von Guerard's South Australia', *Imprint*, 1/2, June 1987, pp.12–14.
2 Ibid.
3 Von Guérard to William Strutt, 13 August 1872, Strutt Papers, Mitchell Library, State Library of New South Wales, Sydney, quoted in Candice Bruce, 'Eugene von Guérard: A German Romantic in the Antipodes', Martinborough, New Zealand, Alister Taylor, 1982, p.178.

Cat.69 J.H. Carse *Weatherboard Falls*

1 Tim Bonyhady, *Images in Opposition: Australian Landscape Painting 1801–1890*, Melbourne: Oxford University Press, p.102.
2 P. Holt and P. Spearritt, 'Retreat to the Mountains: The Blue Mountains of New South Wales', in *Journeys into History*, Sydney: Weedon Russell Publishing, 1990, pp.47–59.

Cat.70 W.C. Piguenit *A Mountain Top, Tasmania*

1 Piguenit to N.J. Brown, 22 October 1891, quoted in Christa Johannes and Anthony Brown *W.C. Piguenit 1836–1914 Retrospective*, exhibition catalogue, Hobart: Tasmanian Museum and Art Gallery, 1992, p.101.

Cat.71 W.C. Piguenit *The Upper Nepean, New South Wales*

1 Piguenit to Francis Piguenit, 18 October 1889, quoted in Christa Johannes and Anthony Brown, *W.C. Piguenit 1836–1914 Retrospective*, exhibition catalogue, Hobart: Tasmanian Museum and Art Gallery, 1992, p.27.
2 Ibid.

Cat.72 Frederic Edwin Church *Niagara Falls*

1 See Elizabeth Mankin Kornhauser, entry for Frederic Edwin Church, *Niagara Falls*, 1856, in Kornhauser, with contributions by Elizabeth R. McClintock and Amy Ellis, *American Paintings before 1945 in the Wadsworth Atheneum*, New Haven and London: Yale University Press, in association with the Wadsworth Atheneum, 1996, vol.1, pp.201–204.
2 This sketch is in the Cooper-Hewitt, National Museum of Design, Smithsonian Institution, New York City. See Kornhauser, in Kornhauser et al., *American Paintings before 1945 in the Wadsworth Atheneum* (1996), pp.202–203. For more information on Church's oil studies, see Theodore E. Stebbins, Jr, *Close Observation: Selected Oil Sketches by Frederic E. Church from the Collections of the Cooper-Hewitt Museum, the Smithsonian Institution's National Museum of Design*, exhibition catalogue, Washington, DC: Smithsonian Institution Press, 1978.
3 See ibid., pp.9–10.
4 See Kornhauser et al., *American Paintings before 1945 in the Wadsworth Atheneum* (1996), p.202.

Cat.73 Frederic Edwin Church *Niagara Falls*

1 N.P. Willis, *American Scenery* (1840), reprint, Barre, Massachusetts: Imprint Society, 1971, pp.47–49.
2 Jeremy Elwell Adamson, 'Nature's Grandest Scene in Art', in Adamson et al., *Niagara: Two Centuries of Changing Attitudes, 1697–1901*, exhibition catalogue, Washington, DC: The Corcoran Gallery of Art, 1985, p.11.
3 Adam Badeau, *The Vagabond*, New York: Rudd and Carleton, 1859, as quoted in David Huntington, *The Landscapes of Frederic Edwin Church: Vision of an American Era*, New York: George Braziller, 1966, pp.67–68.
4 William Cullen Bryant ed., *Picturesque America* (1874), reprint, Secaucus, New Jersey: Lyle Stuart, Inc., 1974, vol.1, p.438.
5 John Ruskin, quoted in Huntington, *The Landscapes of Frederic Edwin Church* (1966), pp.65–66. See also Elizabeth Mankin Kornhauser, entry for Frederic Edwin Church, *Niagara Falls*, 1856, in Kornhauser, with contributions by Elizabeth R. McClintock and Amy Ellis, *American Paintings before 1945 in the Wadsworth Atheneum*, New Haven and London: Yale University Press, 1996, pp.114,115.
6 Franklin Kelly et al., *Frederic Edwin Church*, exhibition catalogue, Washington, DC: National Gallery of Art, 1989, p.52; and Adamson, in Adamson et al., *Niagara* (1985), pp.15–16.
7 Ibid., pp.64-67. In a recent article, Martin Christadler has suggested that, in the context of the work of Edgar Allen Poe and Herman Melville, *Niagara* suggests annihilation, and the rainbow, which is broken, seems to confirm this interpretation. In Christadler's view, science and religion are not seamlessly merged. See Martin Christadler, 'Romantic Landscape Painting in America: History as Nature, Nature as History', in Thomas W. Gaehtgens and Heinz Ickstadt eds, *American Icons: Transatlantic Perspectives on Eighteenth- and Nineteenth-Century American Art*, Santa Monica, California: The Getty Center for the History of Art and the Humanities, 1992, pp.99, 105, 108, 111. Two years after *Niagara*, in 1859, Darwin's *Origin of Species* was published, throwing the traditional alliance between God and Nature into question.
8 Kelly, *Frederic Edwin Church* (1989), p.51.
9 Angela Miller, *The Empire of the Eye: Landscape Representation and American Cultural Politics, 1825–1875*, Ithaca and London: Cornell University Press, 1993, p.218.

Cat.74 William Trost Richards *In the Woods*

1 Linda S. Ferber, *William Trost Richards: American Landscape and Marine Painter, 1833–1905*, exhibition catalogue, Brooklyn, New York: The Brooklyn Museum, 1973, p.24.
2 Linda S. Ferber and William H. Gerdts, *The New Path: Ruskin and the American Pre-Raphaelites*, exhibition catalogue, New York: Schocken Books, Inc., in association with the Brooklyn Museum, 1985, p.214.
3 Ferber, in ibid., p.224.
4 John Ruskin, *The Elements of Drawing* (1857), as quoted in Susan P. Casteras et al., *John Ruskin and the Victorian Eye*, exhibition catalogue, New York: Harry N. Abrams, Inc., in association with the Phoenix Art Museum, 1993, p.10. On Ruskin and the *Crayon*, see Marion Grzesiak, *The Crayon and the American Landscape*, exhibition catalogue, Montclair, New Jersey: The Montclair Museum of Art, 1993.
5 Henry T. Tuckerman, *Book of the Artists. American Artist Life*, New York: G.P. Putnam and Son, 1867, p.524.
6 Ferber, in Ferber and Gerdts, *The New Path* (1985), p.224.

Cat.75 Frederic Edwin Church *Coast Scene, Mount Desert*

1 John Wilmerding, 'The Allure of Mount Desert', in Wilmerding, *American Views: Essays on American Art*, Princeton, New Jersey: Princeton University Press, 1991, p.3.
2 Ibid., p.7.
3 *Bulletin of the American Art-Union*, November 1850, p.131, quoted in Franklin Kelly, *Frederic Edwin Church and the National Landscape*, Washington, DC and London: Smithsonian Institution Press, 1988, p.36, and John Wilmerding, *The Artist's Mount Desert: American Painters on the Maine Coast*, Princeton, New Jersey: Princeton University Press, 1994, p.72.
4 Theodore E. Stebbins, Jr, *Close Observation: Selected Oil Sketches by Frederic E. Church from the Collections of the Cooper-Hewitt Museum, the Smithsonian Institution's National Museum of Design*, exhibition catalogue, Washington, DC: Smithsonian Institution Press, 1978.
5 See Elizabeth Mankin Kornhauser, entry for Frederic Edwin Church, *Coast Scene, Mount Desert*, in Kornhauser, with contributions by Elizabeth R. McClintock and Amy Ellis, *American Paintings before 1945 in the Wadsworth Atheneum*, New Haven and London: Yale University Press, 1996, pp.204–206. Franklin Kelly et al., *Frederic Edwin Church*, exhibition catalogue, Washington, DC: National Gallery of Art, 1989, p.74, n.140, cites John Ruskin's *Modern Painters*, vol.1, New York: Wiley, 1882, ch.3, 'Of Water as painted by Turner', sec.5, 'Of Truth of Water', pp.402–403.
6 Wilmerding, *The Artist's Mount Desert* (1994), pp.102–103. Wilmerding has re-titled the Atheneum's painting 'Storm at Mount Desert', see p.101.
7 For a discussion of this theme, see Sarah Burns, 'Revitalizing the "Painted-Out" North: Winslow Homer, Manly Health, and New England Regionalism in Turn-of-the-Century America', *American Art*, vol. 9, no. 2, Summer 1995, pp.21–37.
8 Dumas Malone ed., *Dictionary of American Biography*, vol.16, New York: Charles Scribner's Sons, 1935, pp.11–12.

Cat.76 Sanford Robinson Gifford *A passing Storm in the Adirondacks*

1 Ila Weiss, *Poetic Landscape: The Art and Experience of Sanford R. Gifford*, Newark, Delaware: University of Delaware Press, 1987, p.237. See also Elizabeth Mankin Kornhauser, entry for Sanford Robinson Gifford, *A passing Storm in the Adirondacks*, 1866, in Kornhauser, with contributions by Elizabeth R. McClintock and Amy Ellis, *American Paintings before 1945 in the Wadsworth Atheneum*, vol.2, New Haven and London: Yale University Press in association with the Wadsworth Atheneum, 1996, pp.404–406. Recently, the storm as a simile for war in both literature and art of the era has been a topic of scholarly investigation. See, for example, Sarah Cash, with technical notes by Claire M. Barry, *Ominous Hush: The Thunderstorm Paintings of Martin Johnson Heade*, exhibition catalogue, Fort Worth, Texas: Amon Carter Museum, 1994.
2 For information on Elizabeth Hart Jarvis Colt, see Elizabeth Mankin Kornhauser, 'Elizabeth Hart Jarvis Colt's Picture Gallery', *Wadsworth Atheneum: Guide to the American Galleries*, Hartford, Connecticut: Wadsworth Atheneum, 1996, and Kornhauser et al., *American Paintings before 1945 in the Wadsworth Atheneum* (1996), pp.22–30.
3 See R.L. Wilson, *Colt: An American Legend*, New York: Abbeville Press, Publishers, 1985, pp.95–123.
4 See Kornhauser et al., *American Paintings before 1945 in the Wadsworth Atheneum* (1996), p.405.
5 Ila Weiss, 'Two Paintings by Sanford R. Gifford', in *Bulletin of the Wadsworth Atheneum*, Spring and Fall 1968, pp.49–50, 51, n.7. See also Natalie Spassky et al., *American Paintings in The Metropolitan Museum of Art*, Princeton, New Jersey: Princeton University Press, in association with The Metropolitan Museum of Art, 1985, vol.2, p.169.

Cat.77 Samuel Colman *Storm King on the Hudson*

1 See William Cullen Bryant ed., *Picturesque America*, New York: D. Appleton and Company, vol.2, (1874), reprint Secaucus, New Jersey: Lyle Stuart, Inc., 1976, p.7.
2 E.M. Ruttenber and L.H. Clark comps., *History of Orange County, New York*, Philadelphia, 1881, p.32, as quoted in Merrill-Anne Halkerston, entry for Samuel Colman, *Storm King on the Hudson*, in John K. Howat et al., *American Paradise: The World of the Hudson River School*, exhibition catalogue, New York: The Metropolitan Museum of Art, 1987, p.303.
3 Fredrika Bremer, *The Homes of the New World*, New York: Harper and Brothers, 1853, p.18, as quoted in Kenneth W. Maddox, *In Search of the Picturesque: Nineteenth Century Images of Industry along the Hudson River Valley*, exhibition catalogue, Annandale-on-Hudson, New York: Bard College, 1983, p.66.
4 Ibid. See also William Kloss, *Treasures from the National Museum of American Art*, exhibition catalogue, Washington and London: Smithsonian Institution Press, 1985, cat.25, n.p.
5 See, for example, Michael S. Durham, *The Smithsonian Guide to Historic America: The Mid-Atlantic States*, New York: Stewart, Tabori and Chang, 1989, pp.172–176, 184. See also Stephen Daniels, *Fields of Vision: Landscape Imagery and National Identity in England and the United States*, Princeton, New Jersey: Princeton University Press, 1993, pp.146–149.
6 These deductions are from Howat et al., *American Paradise* (1987), p. 304.

Cat.78 Albert Bierstadt *View of Donner Lake, California*

1 For biographical information on Huntington, see Dumas Malone ed., *Dictionary of American Biography*, New York: Charles Scribner's Sons, 1932, vol. 9, pp.408–412.
2 See Nancy K. Anderson, '"Wondrously Full of Invention": The Western Landscapes of Albert Bierstadt', in Anderson and Linda S. Ferber et al., *Albert Bierstadt: Art & Enterprise*, exhibition catalogue, New York: Hudson Hills Press, in association with the Brooklyn Museum, 1991, pp.94–95.
3 See, for example, William Bryant Logan and Susan Ochshorn, *The Smithsonian Guide to Historic America: The Pacific States*, New York: Stewart, Tabori and Chang, 1989, pp.148–150. Despite the fame of the story and its inclusion in numerous travel books of the period, the description of the area in *Picturesque America* makes no mention of the tragedy, preferring instead to dwell on the natural beauty of the area. See William Cullen Bryant ed., *Picturesque America*, vol.2, (1874), reprint, Secaucus, New Jersey: Lyle Stuart, Inc., 1976, pp.194–203.
4 Marc Simpson, catalogue entry for *View of Donner Lake, California*, in Simpson et al., *The American Canvas: Paintings from the Collection of The Fine Arts Museums of San Francisco*, New York: Hudson Hills Press, in association with The Fine Arts Museums of San Francisco, 1989, p.122. See also Anderson, Ferber at al., *Albert Bierstadt* (1991), pp.95–97.
5 *Overland Monthly* 10, March 1873, p. 287, as quoted in Anderson, Ferber et al., *Albert Bierstadt* (1991), p.97. See also Nancy K. Anderson, 'The Western Landscape as Symbol and Resource', in William H. Truettner ed., *The West as America: Reinterpreting Images of the Frontier, 1820–1920*, exhibition catalogue, Washington and London: Smithsonian Institution Press for the National Museum of American Art, 1991, pp.259–268.
6 Logan and Ochshorn, *The Smithsonian Guide to Historic America* (1989), pp.148, 150.
7 See Bryant ed., *Picturesque America* (1874), pp.201–203.

Cat.79 Thomas Moran *Hot Springs of Gardiners River*

1 Joni Louise Kinsey, *Thomas Moran and the Surveying of the American West*, Washington and London: Smithsonian Institution Press, 1992, p.45. The sight of the thermal pools and geysers caused the Indians to believe that the area was controlled by evil spirits and they would not touch the water. John Colter, the first white to bring back news of the natural wonder, was not believed by those back east, and later trappers and others spun tall tales explaining the origin of the phenomena. See Jerry Camarillo Dunn, Jr, *The Smithsonian Guide to Historic America: The Rocky Mountain States*, New York: Stewart, Tabori and Chang, 1989, pp.225–227.
2 William H. Truettner, '"Scenes of Majesty and Enduring Interest", Thomas Moran Goes West', *Art Bulletin*, vol.58, no.2, June 1976, p. 241. See also Patricia Trenton and Peter H. Hassrick, *The Rocky Mountains: A Vision for Artists in the Nineteenth Century*, exhibition catalogue, Norman: University of Oklahoma Press, in association with the Buffalo Bill Historical Center, Cody, Wyoming, 1983, p.178.
3 Kinsey, *Thomas Moran and the Surveying of the American West* (1992), pp.1–2.
4 William H. Harris and Judith S. Levey eds, *The New Columbia Encyclopedia*, New York and London: Columbia University Press, 1975, pp.3023–3024.
5 See Sue Welsh Reed, biography and entry for Thomas Moran, *Cliffs Green River, Wyoming*, 1872, in Reed and Carol Troyen et al., *Awash in Color: Homer, Sargent, and the Great American Watercolor*, exhibition catalogue, Boston, Toronto, and London: Bullfinch Press, Little, Brown and Company, in association with the Museum of Fine Arts, Boston, 1993, pp.64-65. See also Trenton and Hassrick, *The Rocky Mountains* (1983), p.181.
6 Dunn, *The Smithsonian Guide to Historic America* (1989), p.227.

Cat.80 Jasper F. Cropsey *Sidney Plains with the Union of the Susquehanna and Unadilla Rivers*

1 See, for example, Paul S. Boyer et al., *The Enduring Vision: A History of the American People*, 2nd edn, Lexington, Massachusetts: D.C. Heath and Company, 1993, p. 539.
2 William Silas Talbot, 'Jasper F. Cropsey, 1823–1900', vol.1, (Ph.D. dissertation, New York University, 1972), Ann Arbor, Michigan: University Microfilms International, 1992, p.194. Henry James, review of the 1875 National Academy of Design exhibition, *Galaxy* (New York), 20, July 1875, p.96, as quoted in Talbot, 'Jasper Cropsey' (1972), p.195. See also Ilene Susan Fort and Michael Quick, *American Art: A Catalogue of the Los Angeles County Museum of Art Collection*, Los Angeles, California: Los Angeles County Museum of Art, 1991, p.160.
3 See Talbot, 'Jasper Cropsey' (1972), pp.119–123.
4 Roger B. Stein, *Susquehanna: Images of the Settled Landscape*, exhibition catalogue, Binghamton, New York: Roberson Center for the Arts and Sciences, 1981, pp.63–64, 67. See William Cullen Bryant ed., *Picturesque America; or The Land We Live In*, New York: D. Appleton and Company (1874), reprint 1974, vol.2, pp.204–228. On *Picturesque America*, see Sue Rainey, *Creating Picturesque America: Monument to the Natural and Cultural Landscape*, Nashville and London: Vanderbilt University Press, 1994.
5 See Clara Erskine Clement and Laurence Hutton, *Artists of the Nineteenth Century and Their Works*, vol.1, reprint, St Louis: North Point, Inc., 1969, p.173, and Maria Naylor, comp. and ed., *The National Academy of Design Exhibition Record 1861–1900*, New York, New York: Kennedy Galleries, Inc., 1973, vol.1, p.203.
6 This is not the railroad pictured in *Sidney Plains*. Fort and Quick, *American Art* (1991), pp.160–161. For more information on John Taylor Johnston, see Dumas Malone ed., *Dictionary of American Biography*, New York: Charles Scribner's Sons, 1933, vol.10, pp.143–144.

Cat.81 Albert Bierstadt *Mount Corcoran*

1 Linda S. Ferber, 'Albert Bierstadt: The History of a Reputation', in Nancy K. Anderson and Linda S. Ferber et al., *Albert Bierstadt: Art & Enterprise,* exhibition catalogue, New York: Hudson Hills Press, in association with the Brooklyn Museum, 1991, pp.54–57. For a biography of William Wilson Corcoran, see Allen Johnson and Dumas Malone eds, *Dictionary of American Biography*, New York: Charles Scribner's Sons, 1930, pp.440–441.
2 Anderson, Ferber et al., *Albert Bierstadt* (1991), p.55. According to Gordon Hendricks, Bierstadt compared Corcoran to the mountain's 'lofty serenity and the firmness of its foundations'. See Gordon Hendricks, *Albert Bierstadt, Painter of the American West*, New York: Harry N. Abrams, 1988, as quoted in Albert Boime, *The Magisterial Gaze: Manifest Destiny and American Landscape Painting, c.1830–1865*, Washington and London: Smithsonian Institution Press, 1991, p.135.
3 *New York Post*, 10 April 1877, as quoted in Anderson, Ferber et al., *Albert Bierstadt* (1991), p.230.
4 See Helena E. Wright, 'Bierstadt and the Business of Printmaking', in ibid., pp.267–288.
5 G.W. Sheldon, *American Painters*, New York: D. Appleton and Company, 1881, p.146.

John F. Kensett *Coast Scene with Figures (Beverly Shore)* 1869 (detail) (cat.95)

A Landscape of
Contemplation

Louis Buvelot 1814–1888

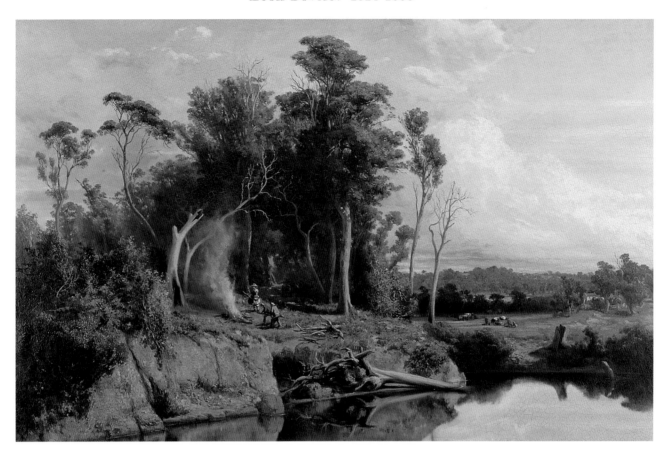

82. *Winter Morning near Heidelberg* 1866
oil on canvas 76.3 x 118.2 cm (30 x 46-1/2 in) National Gallery of Victoria, Melbourne

The Yarra valley, cultivated since the 1830s, was the closest Melbourne could offer Louis Buvelot to the *paysages intimes* of the Swiss followers of Corot, Daubigny and Rousseau with whom he had exhibited at Neuchâtel in the ten years before his departure for Australia. Within a year of settling in Melbourne he had painted views of the edge of the city, such as *The Yarra Valley, Melbourne* (National Gallery of Victoria, Melbourne), and upriver, such as *Winter Morning near Heidelberg* and *Summer Afternoon, Templestowe*. (The latter two paintings and *Waterpool near Coleraine (Sunset)* [cat.83] were among the first Australian works to enter the collection the Museum of Art at the Melbourne Public Library — soon to be come the National Gallery of Victoria.)

The landscapes at Heidelberg, some 14 kilometres from the city, were renowned for their beauty and had already attracted a number of artists, including John Skinner Prout and Edward La Trobe Bateman. Part of the appeal, apart from the hills and rolling terrain, was due to the Europeanisation of the area and its rapid evolution since the earliest days of white settlement: in the 1840s Heidelberg had been a 'distinctly aristocratic locality'[1] of gentlemen's estates; in the years immediately following the discovery of gold it had become 'the garden of the colony';[2] but with the economic downturn of the late 1850s and a succession of disastrous floods in the early 1860s, intensive agriculture on the fertile floodplains had been shown to be a precarious occupation and grazing tended to take over.

In *Winter Morning near Heidelberg* Buvelot shows a herd of cows on the partially cleared riverbank in the middleground, with a cottage on a knoll nearby. The glory of the picture, though, is the forested bank projecting from the left-hand side of the composition. The alluvial nature of the soil, so typical of the banks of the Yarra at Heidelberg, is clearly shown, as is its susceptibility to erosion. The massive tree that has fallen into the river, probably a casualty of the great floods of 1863, forms a striking motif in the centre foreground of the picture. Its now-branchless trunk and soil-encrusted roots are reflected in the smooth surface of the quietly flowing river. On the bank above, three figures — two men and a girl — gather wood for a fire, and behind them, the bush recedes into shadowy thickets.

Buvelot, with his interest in seasonal effects and specific times of the day, inspired the painters of the Heidelberg School who in the 1880s followed in his steps. The effect of a fresh winter morning is beautifully captured in *Winter Morning near Heidelberg,* as is the low morning sunlight as it bathes the distant hills and lances through the trees and bushes on the bank.

Winter Morning near Heidelberg and *Summer Afternoon, Templestowe,* both purchased in 1869 by the Trustees of the Melbourne Public Library, were amongst the first Australian works to enter the collection of what was to become the National Gallery of Victoria.

TL

Louis Buvelot 1814–1888

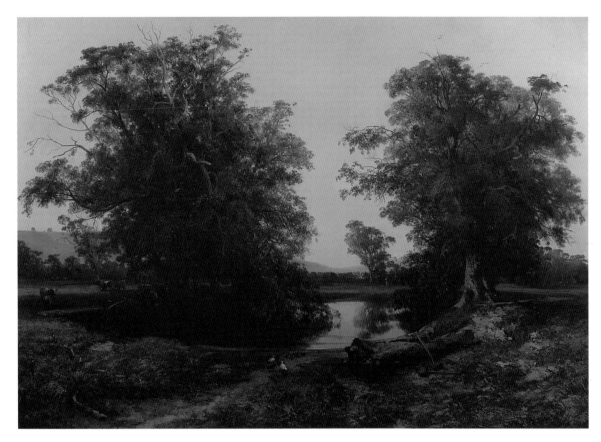

83. *Waterpool near Coleraine (Sunset)* 1869
oil on canvas 107.4 x 153.0 cm (42-1/2 x 60-1/2 in) National Gallery of Victoria, Melbourne

Louis Buvelot's *Waterpool near Coleraine (Sunset)* was one of the first Australian paintings acquired for the Museum of Art at the Melbourne Public Library — soon to become the National Gallery of Victoria, Melbourne — and immediately became one of the best-loved pictures in the collection. (During 1869–70 other early purchases were Buvelot's *Winter Morning near Heidelberg* [cat.82] and *Summer Afternoon Templestowe*). In 1875, when the Trustees of the Library published a selection of photographic reproductions, Marcus Clarke, Secretary to the Trustees, provided the accompanying texts, and in his famous entry on *Waterpool near Coleraine (Sunset)*, wrote:

It is a hot summer evening, and the sun sinking in an unclouded splendour of pure light more dazzling than the crimson glories of a heavier sky, glows already on the rim of the rising pasture land. His beams thus flung over the landscape fill the air with golden splendour, and bathe every tree and herb in soft and vaporous warmth. The scene is a little valley, shut in by the upreaching stretches of the downs. A waterpool in the foreground reflects the deeper tints of the upper sky, and from either bank rise into intermingling bewilderment of branches, the reft and splintered trunks of two ancient gum trees. A little herd of cattle rest lazily on the verge of the clearing, and some horses are approaching from the distant timber belt. On the margin of the pool a few ducks, the property of the new lord

of the soil, preen their plumage; the axe of the settler rests against a hollow log; and the well trodden path to the water would seem to lead to a home at a little distance. But all the accessories of the scene are subordinated to the prevailing sense of quiet. All is hot, silent, still, and dreamy. The mopokes have not yet begun their wild chattering cries. The air is heavy with the intense hush of the last instant of a dying Australian summer's day, and the old gum trees stand alone with motionless branches and folded leaves beside the solitary pool.[1]

Buvelot's first two years in Melbourne were spent establishing his short-lived photographic studio and setting himself up as a painter. In 1867, however, he found time to follow Eugène von Guérard's example and make a trip to Victoria's Western District. The scenery was good but, more importantly, many wealthy potential patrons had properties there. Near Coleraine, 325 kilometres from Melbourne, he found his most poetic subject. 'Mr Buvelot spent 6 weeks at Coleraine', Madame Buvelot later recalled, 'and studied the pool in all its aspects from every side, so great was his love for the spot.'[2] *Waterpool near Coleraine (Sunset)* is also remarkable in his *oeuvre* for its symmetrical composition and the oak-like eucalypts. It shows the lasting influence on Buvelot of seventeenth-century Dutch landscape painting.

TL

Isaac Whitehead 1819–1881

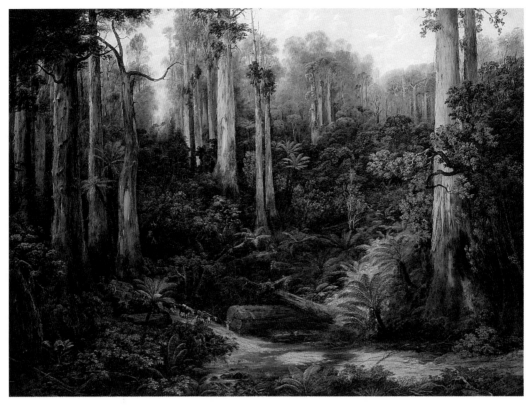

84. *A Sassafras Gully, Gippsland* c.1870
oil on canvas 99.0 x 132.1 cm (39 x 52 in) Rex Nan Kivell Collection, National Library of Australia and National Gallery of Australia, Canberra

Apart from his work as a picture framer, Isaac Whitehead's special subject was the depiction of the forest scenery of Victoria. His two areas of activity are not far apart in that his paintings possess an overall and patterned quality and have little compositional drama — not unlike his picture frames elaborately decorated with floral motifs. (Whitehead's work as a framer can be seen in this exhibition: Eugene von Guérard's *North-east View from the Northern Top of Mount Kosciusko* 1863 [cat.65] has an original Whitehead frame.)

Whitehead's paintings depict the most decorative type of Victorian landscape — the big trees, tree fern gullies and abundant streams of the forests of western Gippsland. Covering a large area of Victoria, Gippsland stretches from east of the Dandenong Ranges to the border of New South Wales and encompasses a range of geographies, from mountain ranges to flat seaboard plains. In Whitehead's time much of Gippsland was heavily forested, particularly in the more mountainous regions. The colossal size of the trees which grew in Gippsland was remarkable and the mountain ash trees were among the largest trees in the world, rivalling in height the redwoods of the western coasts of the United States. While these mountain forests had originally proven a barrier to eastward expansion from Melbourne, by Whitehead's time their rich source of timber was being systematically exploited.

There are interesting similarities between Whitehead's painting and the work of Eugene von Guérard. In many ways Whitehead's subject followed the lead established by von Guérard in his celebrated *Ferntree Gully in the Dandenong Ranges* of 1857 (cat.64). In other ways Whitehead's painting resembles Louis Buvelot's painting of Fernshaw (cat.85) which includes a timber splitter on a well-established track through the trees. However, Whitehead's painting gives an impression of scale, both of the forests and the industry which they supported. He has taken a higher viewpoint than either of the other painters, a viewpoint calculated to emphasise the monumental size of the trees; furthermore he has included a bullock cart laden with a huge load of split timber which draws attention to the magnitude of the forest industry in Gippsland.

Whitehead's work is in fact closer to the work of the photographer Nicholas Caire than to von Guérard or Buvelot. Caire specialised in Australian scenery and his Gippsland views proved very popular. In 1887 Caire made a number of studies of a Gippsland farm which had been literally carved out of a forest of immense trees. Caire warned that Gippsland's big trees would become things of the past, such was the rate of their harvesting in the late nineteenth century: 'our grand and great grandchildren will only hear of the great plants whose seeds were sown in the ground probably about the commencement of the Christian era, or they may perhaps see a photograph of one handed down by those interested in them, but the great giants themselves, the parents of our forests, will have passed away...'[1]

AS

Louis Buvelot 1814–1888

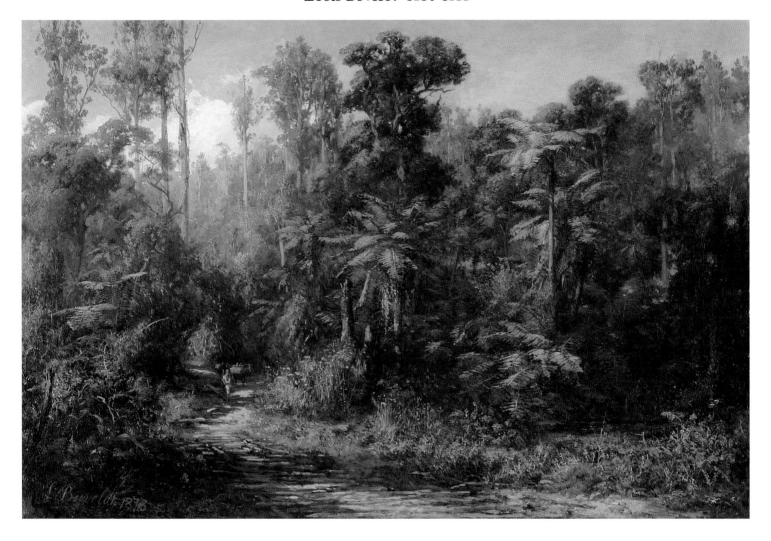

85. *Near Fernshaw* 1873
oil on canvas 69.0 x 122.2 cm (27-1/8 x 48-1/8 in) National Gallery of Australia, Canberra

In 1873 Louis Buvelot made a sketching trip to Fernshaw, an area of dense fern and eucalypt growth on the Watts River, about 65 kilometres north-east of Melbourne. Later that year he completed *Near Fernshaw* which shows splitters and their pack horses carrying felled timber along a stretch of dirt road amid an idyllic bush setting of ferns and towering trees. The Australian term 'splitter' described the men who cut and split timber in the bush for use most commonly as posts, rails, palings and shingles.

Like Fern Tree Gully in Victoria's Dandenong Ranges, Fernshaw became a popular destination for tourists: it was picturesque, secluded yet accessible by road and, at only eight hours by coach, relatively close to Melbourne. According to the *The Illustrated Australian News*, a visit to Fernshaw was also of benefit to the health providing 'a very paradise for invalids, and afford[ing] a shelter and escape from the heat and dust of summer'.[1] Several wood engravings of the area had appeared in local newspapers prior to Buvelot's visit in 1873, but his work is one of the earliest and most admired in a succession of paintings

and photograph of the area produced in following years. Buvelot completed at least three more canvases of scenes around Fernshaw, as well as watercolours and drawings of the area. Several engravings after his sketches also appeared in newspapers and other publications.

Compared with the dramatic, sweeping views by Eugene von Guérard or Nicholas Chevalier that were popular at around the same time, Buvelot's painting captures a more intimate, impressionistic aspect of the Australian landscape. Concentrating on a small patch of bush, he has used loose brush strokes to depict a vivid blue sky and a quality of light which later became associated with the work of artists such as Arthur Streeton and Tom Roberts of the Heidelberg School.

Buvelot exhibited *Near Fernshaw* at the Victorian Academy of Arts in 1873 and received much praise, with critics describing him as 'the only artist who has caught the spirit of Australian scenery'.[2]

MK

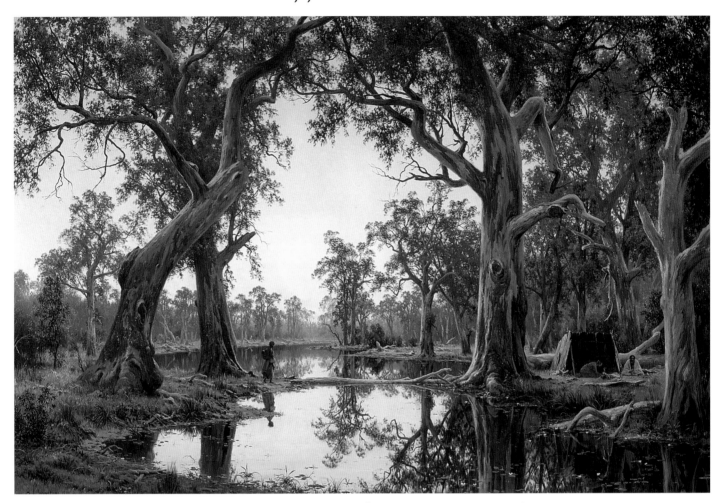

86. *Evening Shadows, Backwater of the Murray, South Australia* 1880
oil on canvas 120.6 x 180.1 cm (47-1/2 x 71 in) Art Gallery of South Australia, Adelaide

When the Adelaide businessman, Mr H.Y. Sparks donated *Evening Shadows* to the Art Gallery of South Australia[1] in 1881, it became the first painting of an Australian subject acquired by the institution, and a very appropriate start to the collection, as it represents what can be considered the quintessential view of the South Australian bush. The Murray River, now the principal water source for the state's capital, Adelaide, and for irrigation, is characterised by the presence of enormous river red gums which stand like beacons in what is largely a flat, arid and sparsely covered landscape.

The scene depicts a quiet backwater of the Murray with the majestic gum trees providing a serene but curiously oppressive atmosphere. Johnstone had a particular preference for evening scenes. His strong background in photography is reflected in the almost unnatural stillness of his paintings and a high degree of precision. He preferred to smooth out his surfaces, using careful tonal gradations to achieve the desired atmospheric effects rather than relying as Buvelot had done on surface texture. Johnstone has captured the washed-out haze of an Australian bush sunset particularly well with the brightness of the light dulling the colour rather than enhancing it.

This particular image also has significance because of the manner in which Johnstone has depicted the Aborigines. Before European settlers arrived, banks along the entire course of the Murray were punctuated by Aboriginal campsites, the river providing plentiful water and food. As in other areas of Australia, traditional Aboriginal life along the Murray was rapidly eroded by pastoralists and by government. In South Australia a policy of relocating Aboriginal people into settlements and providing them with a Christian education was seen as a way of integrating them into white society. Therefore *Evening Shadows* represents a scene which was once common but, by 1880, had almost disappeared.

Johnstone painted *Evening Shadows* in London. He had left Australia four years earlier and continued to paint Australian landscapes on commission, many following a similar theme. After leaving Australia, Johnstone initially moved to California. When he settled in London his Australian works sold well to both expatriate Australians and Americans.

CG

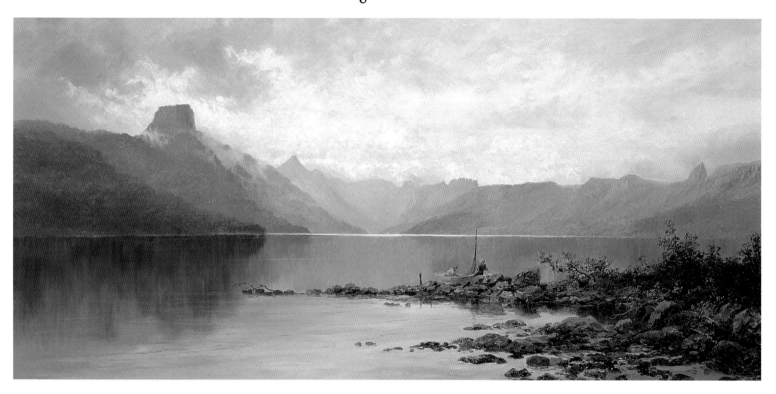

87. *Lake St Clair, the Source of the River Derwent, Tasmania* 1887

oil on canvas 53.7 x 113.0 cm (21-1/8 x 44-1/2 in) Tasmanian Museum and Art Gallery, Hobart Presented by the Tasmanian Government 1889

In 1888, the year after this work was painted, W.C. Piguenit presented it to the Tasmanian Government which subsequently handed it over to the Tasmanian Museum. Six monochrome paintings of Tasmanian wilderness scenery by Piguenit were also presented to the Government by the artist, with the intention that the works should form the nucleus of a future Art Gallery of Tasmania.[1]

It seems fitting that *Lake St Clair, the Source of the River Derwent, Tasmania* — a work of such grandeur, so characteristic of Tasmania — should have been the focus of national art aspirations. The subject is one of the spectacular natural wonders of Tasmania and today forms part of the Cradle Mountain–Lake St Clair National Park within Tasmania's World Heritage area. The view is towards the northern end of the lake; Mount Olympus dominates the range to the left of the composition, while the range on the right is punctuated by the distinctive tooth shape of Mount Ida. The title alludes to Tasmania's most important river, the Derwent, at the mouth of which sits the city of Hobart.

Piguenit first visited Lake St Clair in 1873 as one of a party accompanying James R. Scott to the area which was then largely unexplored. A boat was brought to within a mile of the lake and carried to the lake's edge. The party then rowed up the lake and continued to explore the wilderness valleys of the Murchison and Eldon Rivers to the north-west. Piguenit visited the lake again in 1887 as a member of the exploring party of Charles Sprent which penetrated into the Western Highlands of Tasmania. On this occasion Piguenit did not have the use of a boat. He later explained that while the tourist visitor to the lake finds it an impressive sight, 'it is only by the aid of a boat that he can see its grandest feature, notably the views of Mount Olympus and Mount Ida'. Mount Olympus, Piguenit wrote, towers up before the tourist 'in sombre grandeur, with the slopes at its base covered right down to the water's edge with a most luxuriant growth of myrtle (beech), fern, and other trees ...' Mount Ida stands an 'isolated bare peak with the talus at its base covered with a dense forest of Eucalypti'.[2]

Even after he left Tasmania to live in Sydney in 1880, Piguenit continued to base numerous paintings on his 1873 sketches. The modest topographical watercolour, upon which Piguenit based this painting, is almost devoid of atmosphere (National Gallery of Australia, Canberra).

AS

David Davies 1864–1939

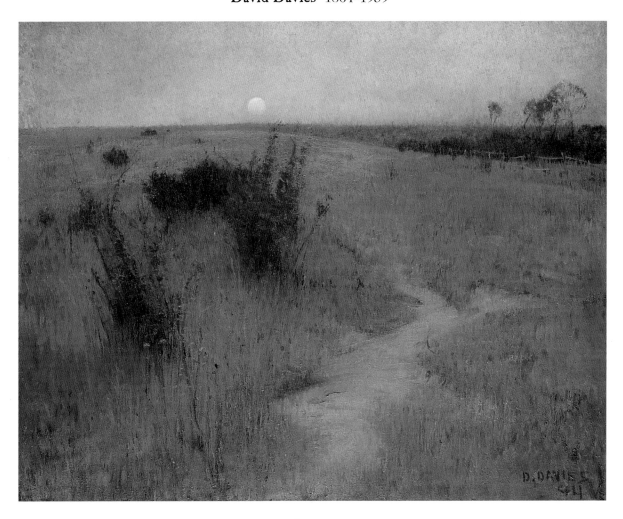

88. *Moonrise* 1894
oil on canvas 119.8 x 150.4 cm (47-1/8 x 59-1/4 in) National Gallery of Victoria, Melbourne

David Davies told William Moore, the author of the first comprehensive study of Australian art, that he painted *Moonrise* 'close to his studio at Templestowe. Being on the spot, he was able to study the effect each evening, the moon rising over the hill in front of him. He managed to make several studies which helped him in carrying out the composition.'[1] The 'bare domed hills'[2] of Heidelberg and Templestowe had been painted in the late 1880s by members of the Heidelberg School, most notably Arthur Streeton (whose *Early Summer — Gorse in Bloom* 1888 [Art Gallery of South Australia, Adelaide] featured a similar patch of degraded pasture). At Heidelberg, however, Streeton and his friends mostly celebrated sunshine and recorded the specifics of the landscape. Davies, on the other hand, deliberately suppressed the details in his nocturne. Streeton's dry grasses are barely identifiable in *Moonrise*, and the rose hips on the struggling briars in the foreground only reveal themselves upon close inspection.

Commentators often remark on the simplicity of *Moonrise*, but subtlety better describes it. The meeting of the rise of the hill with the line of the horizon is beautifully calculated; the rising moon is exquisitely placed; and the earthen track and elongated triangle of remnant bushland, enclosed by a post and rail fence, delicately balance the gorse and briars on the left. The colour is often characterised as monochrome, but in reality is an exquisite melange of tints and tones, ranging from the delicate pink blush in the sky, to the network of greys, pale greens and countless other colours which make up the grasses in the foreground.

Moonrise is the masterpiece of the series of Templestowe nocturnes Davies painted between 1893 and 1897, following his return from three years study in Europe. It shows his exposure to the techniques of French impressionism, to Whistlerian aestheticism and to the notion of the Symbolist landscape. It captures the more contemplative mood of the 1890s, as opposed to the optimism and 'robust vivacity'[3] of the 1880s. On display at the National Gallery of Victoria from 1895, *Moonrise* helped to spread the vogue for nocturnes and grey weather pictures in late nineteenth-century and Edwardian Melbourne.

TL

W.C. Piguenit 1836–1914

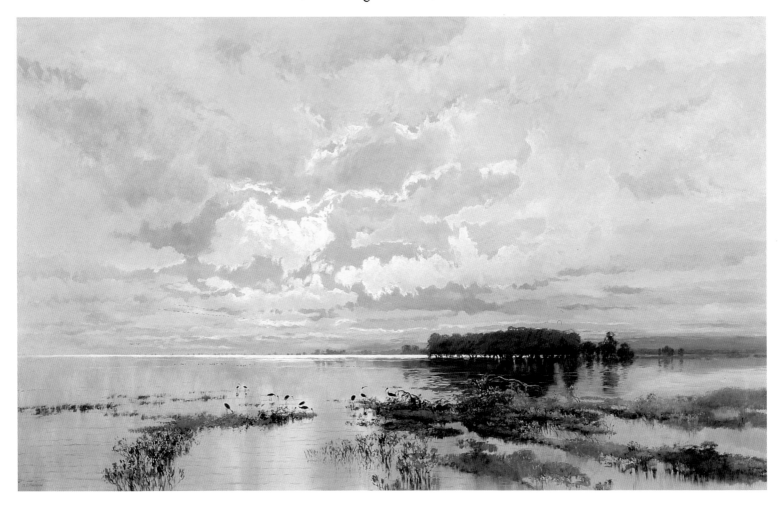

89. *The Flood in the Darling 1890* 1895
oil on canvas 122.5 x 199.3 cm (48-1/4 x 78-1/2 in) Art Gallery of New South Wales, Sydney

From the moment of its first appearance in the Art Society of New South Wales exhibition of 1895, this painting has been considered to be W.C. Piguenit's masterpiece. It was immediately purchased by the Art Gallery of New South Wales and three years later was included in the first full scale overseas survey of Australian art, held at the Grafton Gallery in London in 1898. Sydney newspapers were enthusiastic from the outset. The *Daily Telegraph* assessed the painting as representing 'the artist at his very best' — and the critic gave a full description of the work for readers of the paper:

> In the foreground and middle distance you have an expanse of water, on the horizon the outline of a range of low hills. A solitary clump of mangroves lift their their heads with any degree of assertiveness above the flood. A few birds hover over some tufts of grass. They are the only signs of life abroad. The scene is one of silent desolation. Overhead, however, there are bustle and confusion worse confounded. Indeed,

as a study of rain clouds this picture is, perhaps, the best example we have had from any local artist. Without being theatrical, it is full of dramatic interest, and it certainly bespeaks for the painter the commendation of all who admire what is broad and sympathetic in conception and strong and free in execution.[1]

The subject of Piguenit's painting is the flood of 1890 which inundated the Darling, the major river of western New South Wales. The flood gripped the public imagination and, after reading the newspaper reports, Piguenit marvelled that 'the Darling which averages, in ordinary seasons, from 100 to 200 yards in width, is now in some points 30 to 40 miles — the country being so entirely covered with water as to resemble a sea'.[2] It was certainly a subject worth painting, and Piguenit's visit to the area resulted in a number of sketches and paintings, two of which were shown at the Art Society of New South Wales exhibition.

AS

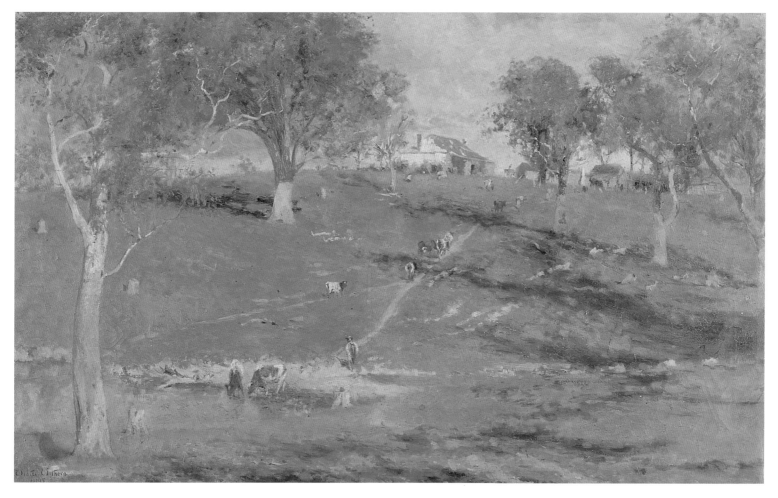

90. *Tranquil Winter* 1895
oil on canvas 76.0 x 122.7 cm (30 x 48-1/4 in) National Gallery of Victoria, Melbourne

Walter Withers was one of the few major painters of the Heidelberg circle who remained in Melbourne after the artistic exodus brought on by the Depression of the early 1890s. Like Frederick McCubbin, he was a family man and did not have the flexibility to pack up and move to Sydney or go overseas. For much of the decade he lived in Heidelberg and painted in its vicinity. *Tranquil Winter* shows one of the tenant farmhouses on the old Banyule Estate.

Tranquil Winter does not belong to the proud tradition of Eugene von Guérard's homestead portraits. It shows instead a property in decline, the farmhouse neglected and the garden run down and open to the depredations of stock. For Withers, though, the farmhouse provides the central focus of his picture. The vertical accents of the tree trunks lead the eye up to it, and it provides the crowning element above the intersecting cattle tracks and spreading shadows.

Tranquil Winter was bought by the National Gallery of Victoria in 1895, the year it was painted. It soon became Withers's best-loved work, both with the public and with his fellow artists. McCubbin, for one, sang its praises:

It was that season of broken sunlight, soft cumulous clouds, and south-west winds that seemed most to appeal to him. He loved the green, fresh landscape ... the dreamy soft atmosphere of winter ... The more you regard this picture, its tone and colour, the more you will feel the truthfulness and poetry of its interpretation. That sunlight has lost its fierce power of burning hillside and plain, and the absence of the hot wind, drying and withering all things green and fresh, is seen in the delightful tenderness and freshness of the landscape. This sunlight is gracious and friendly ... The picture possesses that 'happy' element. One feels that in it, nothing has been arranged. Everything is natural and in its place, as though the Artist has come upon some quiet commonplace spot, and, magician like, revealed to you and me its tender beauty.[1]

TL

Arthur Streeton 1867–1943

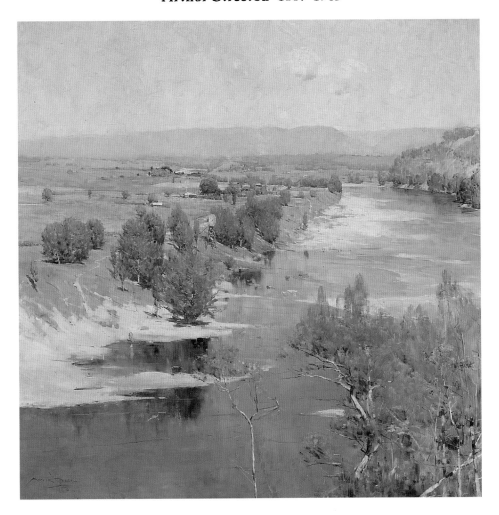

91. *The Purple Noon's Transparent Might* 1896
oil on canvas 123.0 x 123.0 cm (48-1/2 x 48-1/2 in) National Gallery of Victoria, Melbourne

In 1893 Arthur Streeton wrote to his friend Tom Roberts of his desire 'to go straight inland (away from all polite society) ... [to] create some things entirely new, and try and translate some of the great hidden poetry that I know is here, but have not seen or felt it'.[1] A few years later he visited the valley of the Hawkesbury River at Richmond, some 60 kilometres from Sydney. That valley had long been a haunt of artists, but never more so than in the late 1880s when parties came from Sydney to paint its picturesque old towns, farms and orchards. Streeton would have known some of the works, including *The Farm, Richmond* (National Gallery of Victoria, Melbourne), which his friend Charles Conder had painted there in 1888. No-one before Streeton, however, had realised the artistic potential of the panoramic view of the valley from the escarpment of the high river bank, known as The Terrace, looking towards the Blue Mountains. Here, from a ledge above the sheoaks and eucalypts, Streeton painted *The Purple Noon's Transparent Might* in two days and during a shade temperature of 108°F. Later he recalled that he had worked on the canvas in 'a kind of artistic intoxication with thoughts of Shelley [the source of his title] in my mind'.[2] 'My work may perish', he wrote, 'but I must work so as to go on, on ... a man wants all the bother of

drawing & drying and blending & so on, all just in his hand ... & then put forth his mind and out with all he has till he's exhausted, then rest and sleep and on again and on.'[3]

The Purple Noon's Transparent Might was immediately recognised as a masterpiece, and retains that status today. Of the many tributes it has elicited over the years, none is more remarkable than that written by fellow artist Lionel Lindsay:

No-one can paint distance like him ... Who but Streeton, gazing up the Hawkesbury River from the terrace across from those far-stretched plains, could have imagined what he saw? To divine the possibilities of a picture, its shapes and lighting, its character and composition in that wide field, required the intuition of genius. It was virgin landscape, untouched by any brush. He possessed no formula, no precedent to rest upon — only his vision; but that, developed by continuous painting in the open, was ready to resolve its difficulties. When he had finished it, I doubt whether Streeton was aware of the importance of his accomplishment ...[4]

TL

John William Casilear 1811–1893

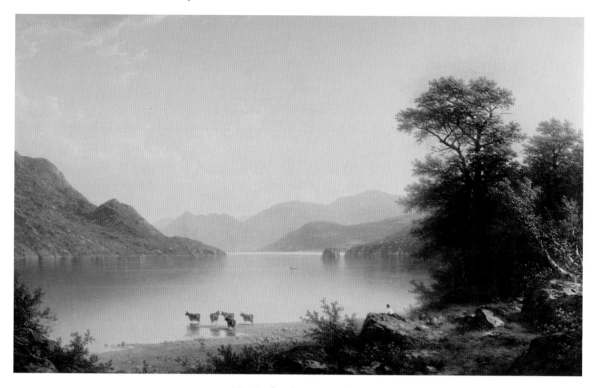

92. *Lake George* 1860

oil on canvas 66.7 x 108.0 cm (26-1/4 x 42-1/2 in) Wadsworth Atheneum, Hartford, Connecticut Bequest of Clara Hinton Gould

Mr. Casilear is a great lover of pastoral scenes, and some of his most notable pictures of this character have been drawn from the neighbourhood of Lake George, and the Genesee Valley in Western New York. His work is marked by a peculiar silvery tone and a delicacy of expression which is in pleasant accord with Nature in repose, and of his own poetically-inclined feelings.[1]

Those remarks made fifteen years after John Casilear painted *Lake George* could well describe it. An unusual aspect of the Atheneum's painting is its large size. In 1876 a commentator wrote: 'Mr. Casilear is no admirer of large canvases, and it is a rare event for him to execute a picture more than twenty-four by thirty-six inches in size.'[2] The scale of the composition suggests that the artist painted it with a public exhibition in mind, but the number of Lake George paintings Casilear executed, in addition to the frequent occurrence of works titled simply *Landscape* in exhibition records, make it difficult to trace the exhibition history of *Lake George* with any certainty.[3]

Henry Tuckerman wrote in 1867 about a lake subject by Casilear very similar to the Atheneum's painting:

One of his most congenial and successful American subjects … The glassy surface of the lake, its smoothness disturbed only by ripples caused by leaping trout, spreads beyond and across to the opposite hills. A small boat, propelled by one person, leaves a slender wake behind it. A few light clouds hover above the hill-tops, and summer's peace seems to pervade the scene.[4]

This peace was characteristic both of American landscape paintings that predate the Civil War and of those that sought to heal the wounds of that bloody struggle. Painted only a year before the war began, *Lake George* offers an idealistic view of the site in marked contrast to that of Sanford Gifford's *A passing Storm* of 1866 (cat.76).

The contrast between N.P. Willis's 1840 description of Lake George in his *American Scenery* and Casilear's 1860 depiction suggests just how idealised is Casilear's portrayal. Willis writes:

Before it became a part of the fashionable tour, this lake was a solitude, appropriated more particularly by the deer and the eagle. Both have nearly disappeared. The echo of the steam-boat, that has now taken the place of the noiseless canoe, — and the peppering of fancy sportsmen, that have followed the far-between but more effectual shots of the borderer's rifle, — have drawn from its shores these and other circumstances of romance. The only poetry of scene which can take the place of that of nature, is historical and legendary; and ages must lapse, and generations pass away, and many changes come over the land, before that time. We are in the interregnum, now, least favourable for poetry.[5]

Casilear's *Lake George* is thus a nostalgic view, but it is not the pure wilderness of Thomas Cole's painting. Including a boy dreaming on the shore, cows watering on the edge of the lake, and a small boat in the middleground, Casilear presents a pastoral or rural view of an area that had been taken over by the tourist trade.[6] The boy and the people in the boat suggest communion with nature, one in which Casilear asks the viewer to participate.

AE

Sanford Robinson Gifford 1823–1880

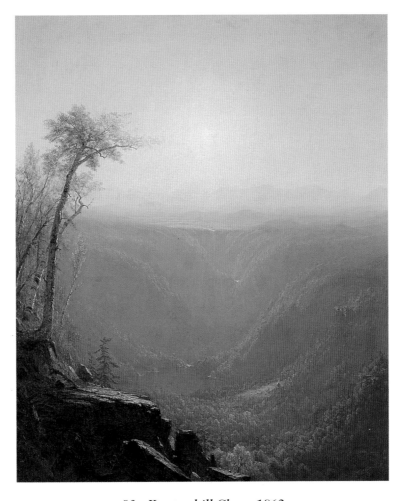

93. *Kauterskill Clove* 1862
oil on canvas 121.9 x 101.3 cm (48 x 39-7/8 in)
The Metropolitan Museum of Art, New York Bequest of Maria DeWitt Jesup, from the collection of her husband, Morris K. Jesup, 1914

In 1867 Henry Tuckerman called a comparable painting of the Clove by Sanford Gifford a 'remarkable instance of Gifford's skill and feeling', and wrote: 'the general effect is grand, true, and singularly attractive to the imagination; the artist has caught the very tint and tone of the hour, and bathed this sublime gorge therewith, so that, like a suggestive and emphatic expression in a poem, the key-note of a boundless scene is struck — the associations of a vast mountain range pensively glorified by the dying day, are awakened by this splendid revelation of one characteristic feature thereof'.[1]

Gifford called his landscapes 'air-painting', and it is the air or atmosphere that is the subject of *Kauterskill Clove*.[2] Rather than focusing on a central mountain or waterfall as had most artists in earlier depictions of the Catskills, Gifford chose to feature atmosphere. The result is a shift from the sublime to the meditative, a turn from what was considered a masculine aesthetic to one that might be called feminine. Also implicit is a move away from the vantage point of one who conquers and colonises to that of one who is absorbed by the surrounding landscape. In this particular version of the composition, a hunter and his dog climb the rocks at the left. Rather than standing at the top of the ledge, surveying the landscape before him, the hunter is almost part of the terrain, as he makes his way upward.[3]

In volume four, chapter three, of *Modern Painters*, John Ruskin treats 'Turnerian light', and it is undoubtedly the influence of Ruskin's writings on J.M.W. Turner, as well as Turner's paintings themselves, that is visible in Gifford's *Kauterskill Clove*.[4] While in London in 1855, Gifford spent a good deal of time studying Turner's paintings in public and private collections, including Ruskin's own collection, and he asked Ruskin questions about Turner's technique.[5] He also studied the work of other artists while in London, and was particularly impressed with Claude Lorrain's 'tone and rich glow'.[6]

Gifford made a number of drawings and paintings of the Clove, many of them dating to the years 1860–63. At least nine drawings and oil sketches of Kauterskill Clove chart the artist's moving from fundamentally topographical depictions to the idealised composition of 1862 — a celebration of sunlight and atmosphere.[7]

AE

Martin Johnson Heade 1819–1904

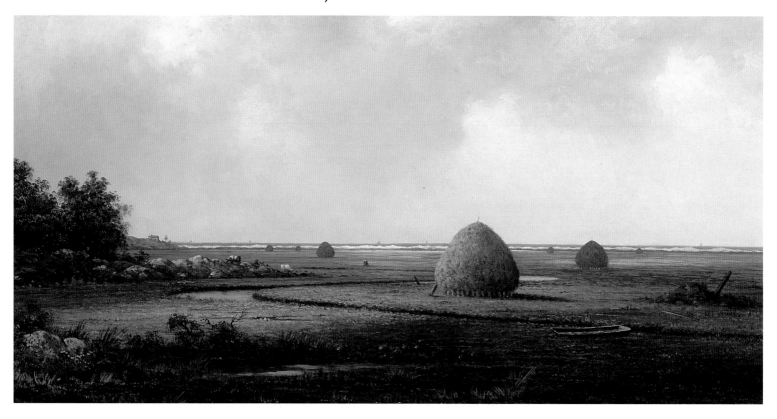

94. *View of Marshfield* 1865–70
oil on canvas 39.0 x 76.8 cm (15-3/8 x 30-1/4 in) The Corcoran Gallery of Art, Washington, DC

Beginning in the late 1850s, Martin Heade painted scenes of haystacks and, in the early 1860s, salt marsh haying. These themes he would continue to paint throughout the 1860s, and then, perhaps with less frequency, until the end of his career. Writing in 1867, Henry Tuckerman commented that Heade 'especially succeeds in representing marsh-lands, with hay-ricks, and the peculiar atmospheric effects thereof'.[1]

In his salt marsh paintings, Heade emphasises the natural horizontality of his subject by using a compositional format almost twice as long as it is high.[2] It was this format that spurred criticism from at least one contemporary: James Jackson Jarves wrote in 1864 of 'wearisome horizontal lines and perspective, with a profuse supply of hay-ricks to vary the monotony of the flatness, but flooded with rich sun-glow and sense of summer warmth'.[3]

Heade's striking pictures of the flat marshlands and their changeable atmosphere are characterised by a diffuse light and a stillness — the contemplative sublime — that, in part, gave rise to twentieth-century identification of his work (and that of Fitz Hugh Lane, among others) as 'luminist'.[4]

In 1862 Heade first visited the salt marshes in Massachusetts, where *View of Marshfield* is set. This area, which stretches for miles along the coast, was from the early colonial period a source of thatch and fodder. By the time Heade was painting them, the marshes had been divided among individual owners, and winding ditches, like the one visible in *View of Marshfield*, marked the boundaries in addition to providing drainage. Gundelows, or barge-like boats such as the one to the right of the large haystack, were used to transport light hay loads during the harvest, which took place from June to October. Heavier loads, sometimes weighing several tons, were stacked on top of vertical posts to keep them dry until removal.[5]

AE

John F. Kensett 1816–1872

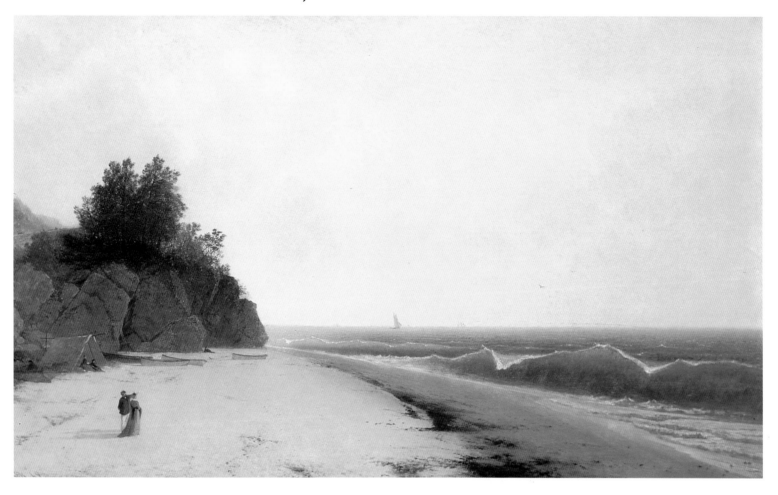

95. *Coast Scene with Figures (Beverly Shore)* 1869
oil on canvas 91.4 x 153.4 cm (36 x 60-3/8 in) Wadsworth Atheneum, Hartford, Connecticut The Ella Gallup Sumner and Mary Catlin Sumner Collection Fund

Set in Beverly, on the North Shore of Massachusetts, Kensett's unusually large depiction of the coast there is an image of contemplation. While other resort towns such as Newport were lively social scenes, Beverly maintained a sense of repose and was described in a popular tourist guide to the area as 'above all places on the coast a quiet summer resort' with 'unsurpassed attractions to those who love rural scenery'.[1]

Kensett has been grouped with a few painters who worked in what has been called the luminist mode. While certain characteristics of *Coast Scene with Figures* do not match the typical compositional strategies of so-called luminist painters, the calm mood and silence of the painting is in keeping with both Beverly itself and the luminist mode.[2]

After Kensett's death, his paintings were described by George W. Curtis as reflecting the artist's personality:

The charm of [Kensett's] character so suffused his life and his works, that each illustrated the other; and through the deep serene repose, the soft silvery tranquility of his pictures, the beholder, unsuspecting, looked into a heart of depthless peace and love …[3]

Daniel Willis James (1832–1907), a New York merchant and philanthropist, bought *Coast Scene with Figures* directly from the artist in 1869. He paid $2,380, one of the highest sums Kensett received for a painting.[4]

AE

Joseph Rusling Meeker 1827–1889

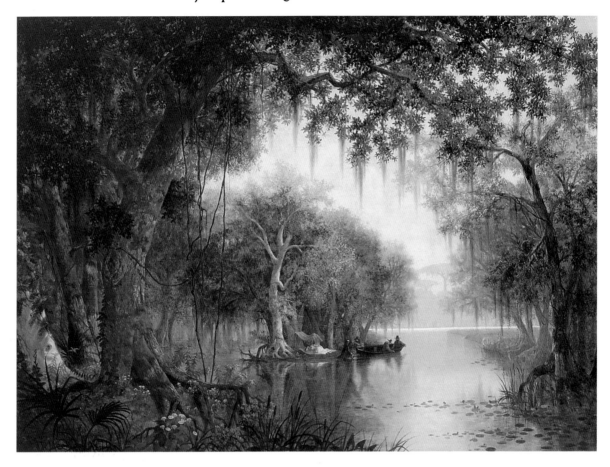

96. *The Land of Evangeline* 1874
oil on canvas 83.8 x 115.6 cm (33 x 45-1/2 in) The Saint Louis Art Museum, Missouri Gift of Mrs W.P. Edgerton by exchange

The subject of Joseph Meeker's painting is from the narrative poem 'Evangeline, A Tale of Acadie', (1847) of Henry Wadsworth Longfellow (1807–1882). The themes of the poem are loneliness and loss. Nathaniel Hawthorne suggested the subject to Longfellow; it takes place during the French and Indian War (1755). The protagonist, Evangeline Bellefontaine, is about to marry Gabriel Lajeunesse, son of Basil, the blacksmith of Grand Pre, an Acadian village. Acadia, a former French colony that included Nova Scotia, Prince Edward Island, and the mainland coast from the Gulf of St Lawrence into Maine, was a region in Eastern Canada. The area was captured by the British in 1710 and, in 1755, those French settlers who refused to shift their allegiance to the British Crown were deported. Gabriel and Basil go to Louisiana, where a number of Acadians had settled. Evangeline follows to look for them and, though she finds Basil, she spends years in a fruitless search for Gabriel.[1]

The scene of Meeker's *The Land of Evangeline* is the mythic and melancholy Louisiana Bayou country. Moss hangs from centuries-old cypress trees over swampwaters populated with water moccasins and alligators. Area sawmills cut cypress for lumber, hunters caught and sold alligators for meat and for their hides, and fishermen caught catfish and crayfish.[2]

Meeker aimed for an 'area of repose' in his paintings — a peaceful point in an exotic landscape.[3] In *The Land of Evangeline,* this point is located where the water meets the bright horizon. Meeker evokes the poem's themes of loneliness and loss through quiet and stillness.[4] The bayou landscape is the setting for the narrative element from Longfellow's poem: Evangeline rests from her search for Gabriel under a canopy of cypresses by the water. According to Estill Curtis Pennington, Evangeline is 'inspired by the vision of hope she gleans from nature'. Longfellow's poem reads in part:

Such was the vision Evangeline saw as she slumbered beneath it./Filled was her heart with love, and the dawn of an opening heaven/Lighted her soul in sleep with the glory of regions celestial.[5]

David Miller, who has written on the subject of the swamp in nineteenth-century American culture, suggests that the swamp corresponds to the mournful quality that nineteenth-century Americans saw in the relation between the individual and the universe. Victorian Americans were both attracted to and repelled by death and often romanticised it.[6] The ability of the landscape to express mood seems to be part of what Meeker is after.

AE

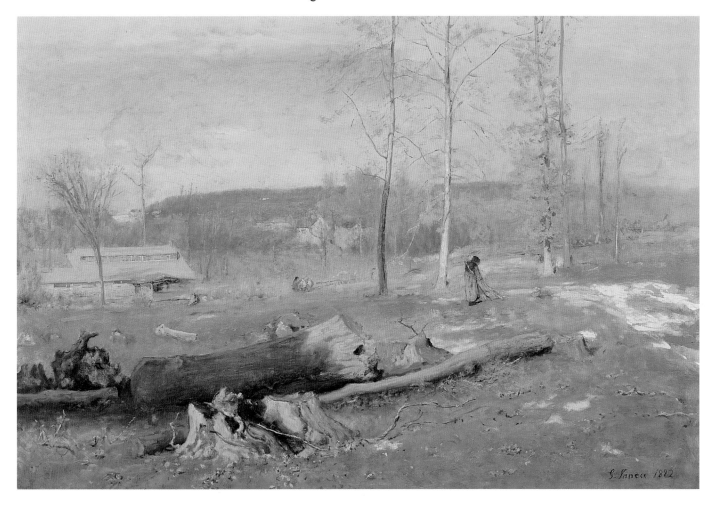

97. *Winter Morning, Montclair* 1882
oil on canvas 76.8 x 114.9 cm (30-1/4 x 45-1/4 in) Montclair Art Museum, New Jersey Gift of Mrs Arthur D. Whiteside

In 1878, George Inness moved to Montclair, New Jersey, where he painted *Winter Morning*, as well as a number of other paintings that are in marked contrast to his earlier work influenced by the Hudson River School. Inness's new attitude toward painting might be summed up in his remark:

The purpose of the painter is simply to reproduce in other minds the impression which a scene has made upon him … a work of art does not appeal to the intellect. It does not appeal to the moral sense. Its aim is not to instruct, not to edify but to awaken an emotion.[1]

Inness played an important role in the rise of tonalism as the primary mode of landscape painting in the 1880s and 1890s. The tonalists studied nature but glossed over detail with subjective interpretation. They recommended a synthetic rather than analytic approach to landscape painting: Inness said a painting must reflect 'both the subjective sentiment — the poetry of nature — and the objective fact'.[2]

Winter Morning is an image of frost after a winter thaw, a moment in the transition from winter to spring. The theme of seasonal transition attracted the tonalists as they sought to move beyond the visual details of a particular landscape to capture its essence.[3] Nicolai Cikovsky has compared the standing trees in *Winter Morning*'s middleground with the foreground trunks. He writes about 'the contrast between nature upright with life and immovably recumbent in death. The simultaneous presence of nature's life and death is the essence and concise expression of the seasonal moment that the painting depicts'.[4]

Nostalgia characterises much of the tonalists' art, and *Winter Morning* is no exception. While Montclair itself was a well-established town in Essex County outside of New York City, Inness ignored the urban landscape and painted the surrounding farms, fields, forests, and orchards.[5] *Winter Morning* shows a woman gathering sticks in the right middleground and a man driving oxen in the centre background, rural labor that harks back to a pre-industrial America. Indeed, as Wanda Corn has written, in subject matter if not in mode or style of painting, the tonalists, George Inness among them, 'stubbornly prolonged for one last generation the nineteenth century's romantic search for the beautiful and the sublime in nature'.[6]

AE

Dwight W. Tryon 1849–1925

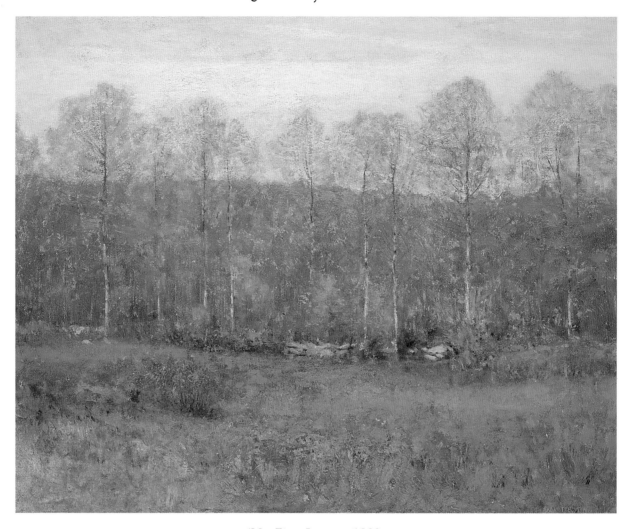

98. *First Leaves* 1889
oil on panel 81.2 x 101.6 cm (32 x 40 in) Smith College Museum of Art, Northampton, Massachusetts

First Leaves was the first of Dwight Tryon's paintings in what became his distinctive style, which Linda Merrill has called 'an affectionate presentation of a simple, local setting'. Tryon wrote that the painting was inspired by a 'walk among the trees in early May' in South Dartmouth, Massachusetts, where he spent seven months of the year on his farm.[1]

Sadakichi Hartmann wrote of Tryon's work:

He set himself the task of fathoming the psychological qualities of colour, the sentiment and poetry they are capable of suggesting, in short, their musical charm. He persistently strove for the subtlest nuances and most fugitive moments of nature. His magic brush leads us to silent meadow-land and straw-coloured fields, where human life seems extinct and only long rows of trees lift their barren branches into dawn … With works of art it should be very much as with human beings, they should possess a soul, an individuality, a certain something which can not be materially grasped, but which produces in the sympathetic spectator feelings, similar to those the artist felt in his creative moments. Tryon's pictures have this to a rare degree.[2]

Tryon owed these qualities in large part to his study in France in the late 1870s. There, he absorbed the influence of the Barbizon painters, noted for capturing the poetry or spirit of landscape — often a reflection of the painter's own mood. The appeal of the Barbizon style to the Americans can be attributed in part to their reaction to the Gilded Age. Americans were becoming increasingly aware of the negative aspects of commercialism, inspiring many artists, such as Tryon and Thomas Wilmer Dewing, to promote a nostalgic and romantic notion of nature as a refuge from the industrial city.[3] The abstraction of *First Leaves*, seen in the line of vertical birch trees silhouetted against the horizon, reflects a reaction against the hard-edged realism of the artist's Hudson River School predecessors as well as the influence of Japanese art, which Tryon had studied since the late 1870s.[4]

The Society of American Artists awarded Tryon the Webb prize in 1889 for *First Leaves*.[5]

AE

Dennis Miller Bunker 1861–1890

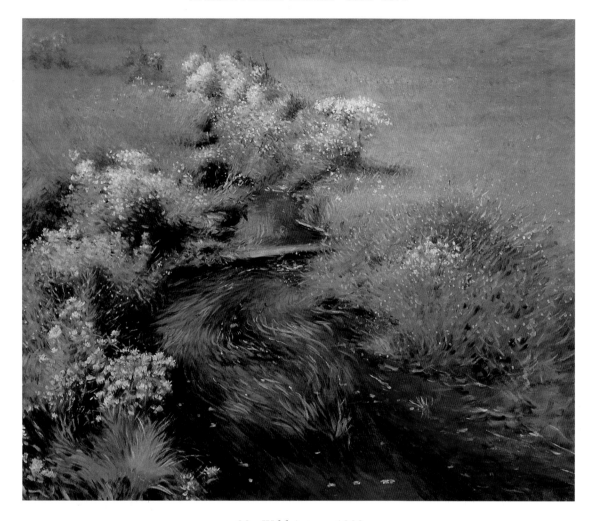

99. *Wild Asters* 1889
oil on canvas 63.5 x 76.2 cm (25 x 30 in) Private collection

Wild Asters is one of the so-called Medfield series, which represents the culmination of Dennis Bunker's work in impressionism. This group of paintings documents the effects of the changing seasons on the Medfield meadow. *Wild Asters*, an early example of American impressionism, is most likely the final picture, depicting a late summer/early fall view of the aster-banked stream running through a meadow. The painting is arguably the most abstract of the series, flattened through Bunker's emphasis on the picture plane and elimination of the horizon. Edmund Tarbell said Bunker's technique was to apply pigment in 'fish-hooks'.[1] These paintings reflect the influence of his time with John Singer Sargent in Calcot, England, the summer before.[2]

Set in Medfield, Massachusetts, *Wild Asters* and the related works were painted during the summers of 1889 and 1890, when Bunker stayed at a boarding house owned by Alice Sewall on the main street of the small town. Bunker described the meadow as 'a funny charming little place, about as big as a pocket-handkerchief with a tiny river, tiny willows and a tiny brook'.[3] The abstraction of the composition qualifies the specificity of the actual site. One scholar has compared the Medfield landscapes to Bunker's portraits, writing: 'His landscapes serve the same idealizing function as his representations of contemplative, well-cared for women'.[4]

When *Wild Asters* was exhibited in the 1890 exhibition held at the Society of American Artists, one writer, critical of the intensity of Bunker's palette, remarked that the artist had 'led a stream from dye-shop through the flowery banks of a milliner's window'.[5] Bunker exhibited *Wild Asters* at the annual exhibition at the Art Institute of Chicago in 1890, and it was shown at the memorial exhibition for Bunker held at the St Botolph Club in Boston in 1891.[6]

Sarah Choate Sears (Mrs J. Montgomery Sears 1858–1935), a Boston collector of French and American impressionist paintings and a social rival to Isabella Stewart Gardner, bought *Wild Asters* from the memorial exhibition. Sears studied painting with Bunker at the Cowles Art School in Boston and was considered to be one of his most talented women students.[7]

AE

John Twachtman 1853–1902

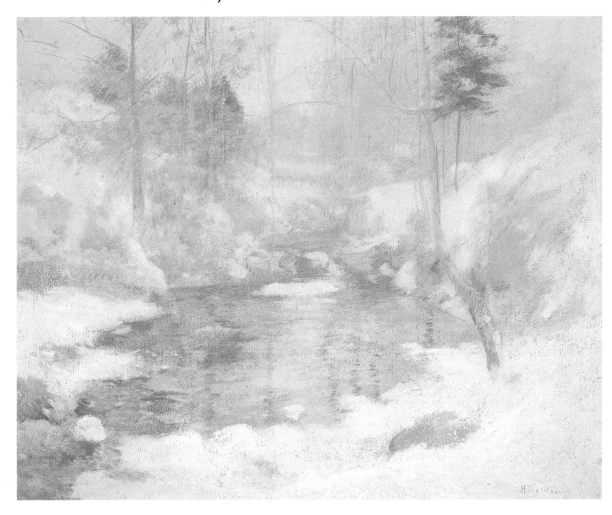

100. *Winter Harmony* c.1890–1900
oil on canvas 65.4 x 81.1 cm (25-3/4 x 32 in) National Gallery of Art, Washington, DC Gift of the Avalon Foundation

John Twatchman's *Winter Harmony* is one of a series depicting the artist's property on Round Hill Road in Greenwich, Connecticut. The view is of Hemlock Pool in Horseneck Brook, which flows through his land. When Twachtman first saw the brook on the property, he reportedly declared, 'This is it'![1]

The structure of the paintings that feature Horseneck Brook, including *Winter Harmony*, centres on a V-shaped niche that draws the viewer into the composition of dematerialised nature, offering a psychological haven. Kathleen Pyne has written that the Connecticut landscape served as an antidote to the urban bustle of New York City, where Twachtman taught and where he met with some professional disappointment. His Greenwich home served as an emotional refuge, and his technique — layers of muted tones bleached in the sun to further blur form — enhances the absorbing and meditative quality of his depictions of it. At the same time, Twachtman's working in the city kept him from finding life dull in a small town in New England.[2]

A number of writers commented on the meditative qualities of Twachtman's winter landscapes of Horseneck Brook. John Cournos, writing in 1914, remarked on the similarity to Japanese Zen paintings and to paintings by James McNeill Whistler. He notes that Twachtman's brushwork conjures 'a kind of artistic Nirvana, wherein the spirit becomes free of matter', thus lending 'serenity to the soul'.[3]

The solace offered by *Winter Harmony* and Twachtman's other paintings was embraced by a *fin-de-siècle* American public eager for a positive response to Darwinism. These pictures suggested a spiritual life beyond physical death and an aesthetic refinement — a higher plane or position in evolution — in opposition to the middle class environment in which they were created.[4] This environment was one of tremendous unrest. Tensions between social classes and among ethnic groups grew as a result of an increase in immigration to the United States from southern and eastern Europe. An economic depression added to the growing feeling that a way of life once taken for granted was now threatened. In part artists, such as Twachtman in *Winter Harmony*, expressed nostalgia for a pre-industrial America.[5]

AE

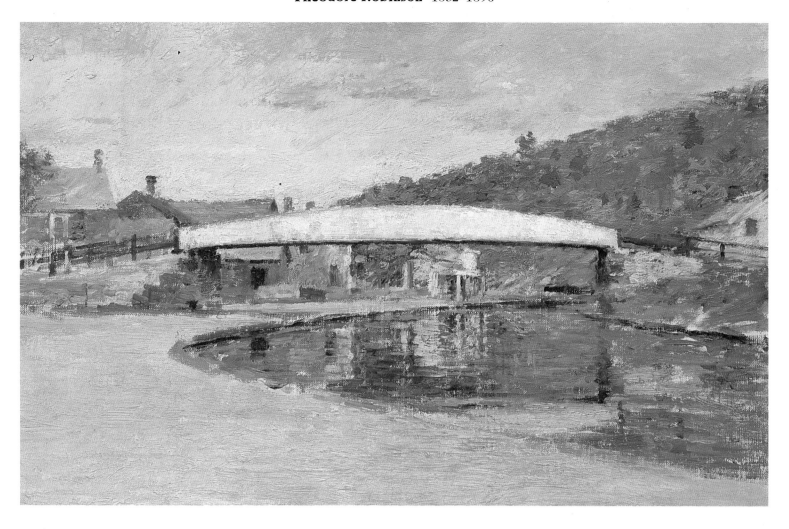

101. *White Bridge on the Canal (White Bridge near Napanoch)* 1893
oil on canvas 36.8 x 55.9 cm (14-1/2 x 22 in) Private collection, courtesy Spanierman Gallery, New York City

Theodore Robinson painted a number of views of the Delaware and Hudson Canal in 1893. That summer and fall, he taught a painting class out of doors in Napanoch, New York. Designed to make the transportation of coal from Pennsylvania to New York City less arduous, the Delaware and Hudson Canal was built between 1825 and 1829 — 108 miles long, it connected the Delaware and Hudson rivers. By the 1860s it brought in more than one million toll dollars a year. By 1893 when *White Bridge on the Canal* was painted, it had lost much of its business to the railroad, which was a quicker and cheaper way to move goods and which was not as often affected by winter weather. By 1904 the canal was no longer in use.[1]

Robinson has edited out much of the decay of the Delaware and Hudson Canal and the despair of those who worked along it.[2] Instead, he offers an abstract view, focusing on the patterns created by the bright white bridge and the winding water.[3] The result is a nostalgic image that ignores the harsh reality of the demise of a commercial enterprise.[4]

AE

John Twachtman 1853–1902

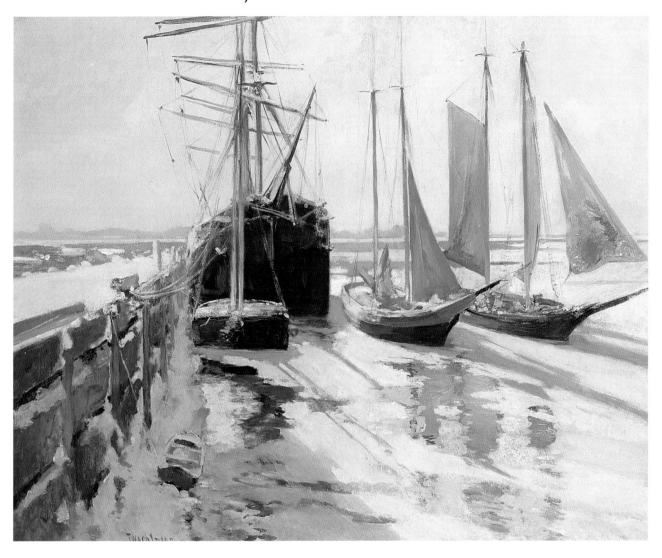

102. *Connecticut Shore, Winter* c.1893
oil on canvas 61.0 x 76.2 cm (24-1/8 x 30 in) Hartford Steam Boiler Inspection and Insurance Company

Cos Cob, Connecticut — the probable setting of John Twachtman's *Connecticut Shore* — was a bustling harbour, where market boats, fishing schooners, and oyster sloops arrived and departed regularly. Only 38 minutes by railroad from New York City, Cos Cob was also the site of an important artists' colony; American impressionists assembled there in the early 1890s.[1]

Although Cos Cob was the home of a vital fishing industry, by 1893 or 1894 its commercial strength was waning. The railroad replaced the waterways for transportation of goods, and Cos Cob was becoming a mecca for affluent New Yorkers who spent summers there. The proximity of the village to the city and its relatively unspoiled charm in conjunction with a variety of recreational pursuits (including boating) made Cos Cob a very attractive summer destination for urban dwellers. As a result, land values rose and local fishers and farmers were forced to leave. Twachtman's *Connecticut Shore*, then, like Theodore Robinson's *White Bridge on the Canal* (cat.101), offers a nostalgic image of a once thriving commercial harbour.[2]

AE

Notes

Cat.82 Louis Buvelot *Winter Morning near Heidelberg*

1. Alexander Sutherland, *Victoria and its Metropolis*, Melbourne, 1888, vol.1, p.274.
2. *Age*, Melbourne, 26 December 1863, p.6.

Cat.83 Louis Buvelot *Waterpool near Coleraine (Sunset)*

1. Marcus Clarke ed., *Photographs of Pictures in the National Gallery of Victoria, Melbourne*, Melbourne, 1875, quoted in Bernard Smith ed., *Documents on Art and Taste in Australia: The Colonial Period, 1770–1914*, Melbourne: Oxford University Press, 1975, p.13.
2. Julie Buvelot to George Lance, 25 January 1897, Warrnambool Art Gallery, Warrnambool.

Cat.84 Isaac Whitehead *A Sassafras Gully, Gippsland*

1. N.J. Caire 'Notes on the Giant Trees of Victoria', *The Victorian Naturalist*, vol.21, no.9. 1905. p.125

Cat.85 Louis Buvelot *Near Fernshaw*

1. *The Illustrated Australian News*, supplement, Melbourne, 16 April 1872, p.18.
2. *Argus*, Melbourne, 24 March 1873, p.6.

Cat.87 W.C. Piguenit *Lake St Clair, the Source of the River Derwent, Tasmania*

1. See Christa Johannes and Anthony Brown, *W.C. Piguenit 1836–1914 Retrospective*, Hobart: Tasmanian Museum and Art Gallery, 1992, p.27.
2. W.C. Piguenit lecture to the 4th meeting of the Australasian Association for the Advancement of Science, January 1892, reprinted in Bernard Smith ed., *Documents on Art and Taste in Australia 1770–1914*, Melbourne: Oxford University Press, 1975, pp.171–179.

Cat.88 David Davies *Moonrise*

1. William Moore, *The Story of Australian Art*, Sydney: Angus and Robertson, 1934, vol.1, p.97.
2. *Age*, Melbourne, 19 May 1894.
3. William Blamire Young, catalogue foreword of the David Davies exhibition at the Fine Art Society Gallery, Melbourne, 1926.

Cat.89 W.C. Piguenit *The Flood in the Darling 1890*

1. *Daily Telegraph*, Sydney, 28 September 1895, p.10.
2. W.C. Piguenit to his cousin Fanny, 26 April 1890, quoted in Christa Johannes and Anthony Brown, *W.C. Piguenit 1836–1914 Retrospective*, exhibition catalogue, Hobart: Tasmanian Museum and Art Gallery, 1992, p.30.

Cat.90 Walter Withers *Tranquil Winter*

1. Frederick McCubbin, 'Some Remarks on Australian Art', in James MacDonald ed., *The Art of Frederick McCubbin*, Melbourne: Lothian, 1916, p.87.

Cat.91 Arthur Streeton *The Purple Noon's Transparent Might*

1. Arthur Streeton to Tom Roberts, letter postmarked 16 November 1893, in Ann Galbally and Anne Gray eds, *Letters from Smike: The Letters of Arthur Streeton, 1890–1943*, Melbourne: Oxford University Press, 1989, p.61.
2. Handwritten notes, quoted in ibid., p.29.
3. Arthur Streeton to Tom Roberts, Tom Roberts correspondence, Mitchell Library, State Library of New South Wales, Sydney, MS A 2480, vol.1, quoted in Jane Clark and Bridget Whitelaw, *Golden Summers: Heidelberg and Beyond*, exhibition catalogue, Melbourne: National Gallery of Victoria, 1985. p.146.
4. Lionel Lindsay, 'Streeton's Australian Work', in Sydney Ure Smith, Bertram Stevens and C.Lloyd Jones eds, *The Art of Arthur Streeton*, Sydney: Art in Australia, 1919, pp.14, 15.

Cat.92 John William Casilear *Lake George*

1. 'American Paintings — John Casilear', *Art Journal* 2, 1876, pp.16–17. See also Amy Ellis, entry for John Casilear, *Lake George*, in Elizabeth Mankin Kornhauser, with contributions by Elizabeth R. McClintock and Amy Ellis, *American Paintings before 1945 in the Wadsworth Atheneum*, vol.1, New Haven and London: Yale University Press, in association with the Wadsworth Atheneum, 1996, pp. 174–176.
2. *Art Journal*, 1876, pp.16–17.
3. See, for example, James L. Yarnall and William H. Gerdts comp. et al., *The National Museum of American Art's Index to American Art Exhibition Catalogues from the Beginning through the 1876 Centennial Year*, Boston: G.K. Hall and Co., 1986, pp. 603–608.
4. Henry T. Tuckerman, *Book of the Artists. American Artist Life*, New York: Putnam, 1867, pp.521–522, quoted in Barbara Ball Buff, entry for John Casilear, *Lake George*, in John K. Howat et al., *American Paradise: The World of the Hudson River School*, exhibition catalogue, New York: The Metropolitan Museum of Art, 1987, p.143.
5. N.P. Willis, Esq., *American Scenery* (1840), reprint, Barre, Massachusetts: Imprint Society, 1971, p.101.
6. See Leo Marx, *The Machine in the Garden: Technology and the Pastoral Ideal in America*, London, Oxford, and New York: Oxford University Press, 1964.

Cat.93 Sandford Robinson Gifford *Kauterskill Clove*

1. Henry T. Tuckerman, *Book of the Artists. American Artist Life*, New York: G.P. Putnam and Son, 1867, pp.526–527.
2. Angela Miller, *The Empire of the Eye: Landscape Representation and American Cultural Politics, 1825–1875*, Ithaca and London: Cornell University Press, 1993, p.282. George Sheldon writes that Gifford refers to his landscape paintings as 'air-painting'. See G.W. Sheldon, *American Painters*, New York: D. Appleton and Company, 1881, p.17. For a full discussion of the painting, see Kevin J. Avery, entry for *Kauterskill Clove*, in John K. Howat, ed., *American Paradise: The World of the Hudson River School*, exhibition catalogue, New York: The Metropolitan Museum of Art, 1987, pp.222–225.
3. See Miller, *The Empire of the Eye* (1993), pp.279–286, for a discussion of Gifford's *Kauterskill Clove* in these terms. Cleaning and the paint's increased transparency over time have enhanced the illusion of the figure's blending in with the landscape. See Natalie Spassky et al., *American Paintings in The Metropolitan Museum of Art*, New York: The Metropolitan Museum of Art, in association with Princeton University Press, 1985, vol.2, p.172.
4. See Miller, *The Empire of the Eye* (1993), p.285, and Ila Weiss, *Poetic Landscape: The Art and Experience of Sanford R. Gifford*, Newark, Delaware: University of Delaware Press, 1987, p.70.
5. Weiss, *Poetic Landscape* (1987), p.70.
6. Sanford R. Gifford, 'European Letters', vol.1, pp.12, 19, Archives of American Art, Smithsonian Institution, Washington, DC, as quoted in ibid., p.70.
7. Avery, in Howat et al., *American Paradise* (1987), p.222. See also the catalogue entry for *Kauterskill Clove* in Spassky et al., *American Paintings in The Metropolitan Museum of Art* (1985), pp.170–173. See also Kenneth Myers, *The Catskills: Painters, Writers, and Tourists in the Mountains 1820–1895*, exhibition catalogue, Yonkers, New York: The Hudson River Museum of Westchester, 1987, p.135.

Cat.94 Martin Johnson Heade *View of Marshfield*

1. Henry T. Tuckerman, *Book of the Artists. American Artist Life,* New York: Putnam, 1867, p.542. The standard reference on Heade is Theodore E. Stebbins, Jr, *The Life and Works of Martin J. Heade*, New Haven and London: Yale University Press, 1975.
2. This observation is made with regard to a group of paintings of Rhode Island, but applies to the Corcoran work as well. See Robert G. Workman et al., *The Eden of America: Rhode Island Landscapes, 1820–1920*, exhibition catalogue, Providence, Rhode Island: Museum of Art, Rhode Island School of Design, 1986, cat.13.
3. James Jackson Jarves, *The Art-Idea*, ed. Benjamin Rowland Jr, (1864), reprint, Cambridge, Massachusetts: Harvard University Press, Belknap, 1960, p.193.
4. For information on 'luminism', see John Wilmerding et al., *American Light: The Luminist Movement, 1850–1875*, exhibition catalogue, Washington, DC: National Gallery of Art, 1980. On the sublime, see Barbara Novak, *Nature and Culture: American Landscape Painting, 1825–1875*, New York: Oxford University Press, 1980, especially pp.18–44.
5. This information is drawn from Teresa A. Carbone's catalogue entry for Heade's *Summer Showers* c.1865–1870, in the collection of the Brooklyn Museum of Art. See Carbone et al., *Masterpieces of American Painting from The Brooklyn Museum*, exhibition catalogue, New York: The Jordan-Volpe Gallery, 1996, pp.70–71.

Cat.95 John F. Kensett *Coast Scene with Figures*

1 Benjamin D. Hill and Winfield S. Nevins, *The North Shore of Massachusetts Bay, An Illustrated Guide*, 8th edn, Salem, Massachusetts, 1885, p.31, as quoted in Kathleen Motes Bennewitz, 'John F. Kensett at Beverly, Massachusetts', *American Art Journal*, vol.21, no 4, 1989, pp.47–48.
2 For a definition of luminism, see Barbara Novak, 'On Defining Luminism', in John Wilmerding et al., *American Light: The Luminist Movement, 1850–1875*, exhibition catalogue, Washington, DC: National Gallery of Art, 1980, pp.23–29.
3 George Curtis, quoted in Robert Sommerville, *Collection of Over Five Hundred Paintings and Studies by the Late John F. Kensett*, New York: Association Hall, New York, 1873, p.1, as cited in Bennewitz, 'John F. Kensett', in *American Art Journal* (1989), pp.61–62. George W. Curtis (1824–1892) was the author of *Lotus Eating: A Summer Book* (New York, 1852), in which he describes the natural beauty of Beverly. See Elizabeth Mankin Kornhauser, entry for John F. Kensett, *Coast Scene with Figures (Beverly Shore)* 1869, in Kornhauser, with contributions by Elizabeth R. McClintock and Amy Ellis, *American Paintings before 1945 in the Wadsworth Atheneum*, New Haven and London: Yale University Press, in association with the Wadsworth Atheneum, 1996, vol.2, p. 522.
4 For biographical information on James, see Dumas Malone ed., *Dictionary of American Biography*, New York: Charles Scribner's Sons, 1932, vol.9, pp. 573-574. See also Kornhauser, in Kornhauser et al., *American Paintings before 1945 in the Wadsworth Atheneum* (1996), p.524.

Cat.96 Joseph R. Meeker *The Land of Evangeline*

1 See Thomas H. Johnson, in consultation with Harvey Wish, *The Oxford Companion to American History*, New York: Oxford University Press, 1966, p.6; Ian Ousby ed., *The Cambridge Guide to Literature in English*, Cambridge and New York: Cambridge University Press, 1988, p.330; and James D. Hart, *The Oxford Companion to American Literature*, New York: Oxford University Press, 1983, pp.233–234.
2 William Bryant Logan and Vance Muse, *The Smithsonian Guide to Historic America: The Deep South*, New York: Stewart, Tabori and Chang, 1989, pp.53–54.
3 Meeker, quoted in Estill Curtis Pennington, *A Southern Collection*, exhibition catalogue, Augusta, Georgia: Morris Museum of Art, 1992, p.68.
4 Estill Curtis Pennington, *Look Away: Reality and Sentiment in Southern Art*, Spartanburg, South Carolina: Peachtree Press, 1989, pp.124–129.
5 Ibid.
6 David C. Miller, *Dark Eden: The Swamp in Nineteenth-Century American Culture*, Cambridge, England, and New York: Cambridge University Press, 1989, p.32.

Cat.97 George Inness *Winter Morning, Montclair*

1 George Inness, as quoted in Kathryn E. Gamble, introduction to *George Inness of Montclair, An Exhibition of Paintings Chiefly From the Artist's Montclair Period: 1878–1894*, exhibition catalogue, Montclair, New Jersey: The Montclair Art Museum, 1964, p.17.
2 George Inness, quoted in Nicolai Cikovsky Jr, *George Inness*, American Art and Artists Series, New York, Praeger Publishers, 1971, p.55, and in Wanda M. Corn, *The Color of Mood: American Tonalism 1880–1910*, exhibition catalogue, San Francisco: M.H. De Young Memorial Museum and the California Palace of the Legion of Honor, 1972, p 5. On tonalism, see ibid., pp.1–3, and on Inness's role in the development of it, ibid., pp.4–7.
3 See ibid., p.1; and Gamble, *George Inness of Montclair* (1964), p.18.
4 Cikovsky, *George Inness* (1971), p.156.
5 Alfred Werner, *Inness Landscapes*, New York: Watson-Guptill Publications, 1973, p.64. *Winter Morning* was exhibited at the National Academy as 'A Winter Morning Environs of Montclair'. See LeRoy Ireland, *The Works of George Inness: An Illustrated Catalogue Raisonné*, Austin and London: University of Texas Press, 1965, p 255.
6 Corn, *The Color of Mood* (1972), p.1.

Cat.98 Dwight W. Tryon *First Leaves*

1 Linda Merrill, *An Ideal Country: Paintings by Dwight William Tryon in the Freer Gallery of Art*, Washington, DC: Freer Gallery of Art, Smithsonian Institution, 1990, pp.49–50. On Tryon in South Dartmouth, see Henry C. White, *The Life and Art of Dwight William Tryon*, Boston and New York: Houghton Mifflin Company, 1930, pp.58–73.
2 Sadakichi Hartmann, *A History of American Art*, vol.1, (rev. edn 1901), reprint, New York: Tudor Publishing Company, Publishers, 1934, pp.129–130.
3 See Wanda M. Corn, *The Color of Mood: American Tonalism 1880–1910*, exhibition catalogue, San Francisco: M.H. De Young Memorial Museum and the California Palace of the Legion of Honor, 1972.
4 Bruce Weber and William H. Gerdts, *In Nature's Ways: American Landscape Painting of the Late Nineteenth Century*, exhibition catalogue, Palm Beach, Florida: The Norton Gallery and School of Art, 1987, p.18.
5 Merrill, *An Ideal Country* (1990), pp.50–51.

Cat. 99 Dennis Miller Bunker *Wild Asters*

1 This analysis and information is from Erica Hirshler's fine monograph *Dennis Miller Bunker: American Impressionist*, exhibition catalogue, Boston: Museum of Fine Arts, 1994, pp.66–67.
2 H. Barbara Weinberg, Doreen Bolger and David Park Curry et al., *American Impressionism and Realism: The Painting of Modern Life, 1885–1915*, exhibition catalogue, New York: The Metropolitan Museum of Art, 1994, pp.77–79.
3 As quoted in William H. Gerdts, *Masterworks of American Impressionism*, New York: Harry N. Abrams, distributors for Thyssen Bornemisza Foundation/Eidolon, 1991, p.34.
4 Weinberg et al., *American Impressionism and Realism* (1994), p.79.
5 As quoted in Gerdts, *Masterworks of American Impressionism* (1991), p.34. See also Hirshler, *Dennis Miller Bunker* (1994), p.176. The original quotation is from 'The Fine Arts: The Society of American Artists (First Notice)', *Critic* 13, 3 May 1890, p.225.
6 Gerdts, *Masterworks of American Impressionism* (1991), p.34.
7 Hirshler, *Dennis Miller Bunker* (1994), p.52. See also Carol Troyen, *The Boston Tradition: American Paintings from the Museum of Fine Arts, Boston*, exhibition catalogue, Boston: The Museum of Fine Arts and New York: American Federation of Arts, 1980, pp.37–38.

Cat.100 John Twachtman *Winter Harmony*

1 Twachtman's son Alden, as quoted in Deborah Chotner, entry for John Henry Twachtman, *Winter Harmony*, in Franklin Kelly et al., *American Paintings of the Nineteenth Century*, part 2, New York and Oxford: Oxford University Press, distributor for National Gallery of Art, Washington, forthcoming.
2 See Kathleen Pyne, *Art and the Higher Life: Painting and Evolutionary Thought in Late Nineteenth-Century America*, Austin: University of Texas Press, 1996, pp.278–281. Pyne also suggests that Twachtman's winter landscapes are a response to Darwinism. See ibid., p.281.
3 John Cournos, 'John Twachtman', *Forum* 52, August 1914, pp.245–248, as quoted in Kathleen A. Pyne, 'John Twachtman and the Therapeutic Landscape', in Deborah N. Chotner, Lisa N. Peters and Kathleen A. Pyne, *John Twachtman: Connecticut Landscapes*, exhibition catalogue, New York: Harry N. Abrams, in association with the National Gallery of Art, Washington, 1989, pp.56–57.
4 See Pyne, *Art and the Higher Life* (1996), pp.280–281.
5 Kathleen Pyne, 'Resisting Modernism: American Painting in the Culture of Conflict', in Thomas W. Gaehtgens and Heinz Ickstadt eds, *American Icons: Transatlantic Perspectives on Eighteenth- and Nineteenth-Century American Art*, Chicago: University of Chicago Press, in association with the Getty Center for the History of Art and the Humanities, 1992, p.292.

Cat.101 Theodore Robinson *White Bridge on the Canal*

1 H. Barbara Weinberg, Doreen Bolger and David Park Curry et al., *American Impressionism and Realism: The Painting of Modern Life, 1885–1915*, exhibition catalogue, New York: Harry N. Abrams, Inc., in association with The Metropolitan Museum of Art, 1994, pp.67,69.
2 Ibid., p.69.
3 Sona Johnston, entry for Theodore Robinson, *White Bridge on the Canal*, 1893, in Spanierman Gallery, *The Spencer Collection of American Art*, exhibition catalogue, New York: Spanierman Gallery, 1990, cat.22.

Cat.102 John Twachtman *Connecticut Shore, Winter*

1 See Susan G. Larkin, 'The Cos Cob School', in *Connecticut and American Impressionism*, exhibition catalogue, Storrs: The William Benton Museum of Art, The University of Connecticut; Greenwich, Connecticut: Hurlbutt Gallery, Greenwich Library, Greenwich; and Old Lyme, Connecticut: Lyme Historical Society, 1908, pp.82–83.
2 H. Barbara Weinberg, Doreen Bolger and David Park Curry et al., *American Impressionism and Realism: The Painting of Modern Life, 1885–1915*, exhibition catalogue, New York: The Metropolitan Museum of Art, 1994, p.71.

Arthur Streeton *The Railway Station, Redfern* 1893 (detail) (cat.113)

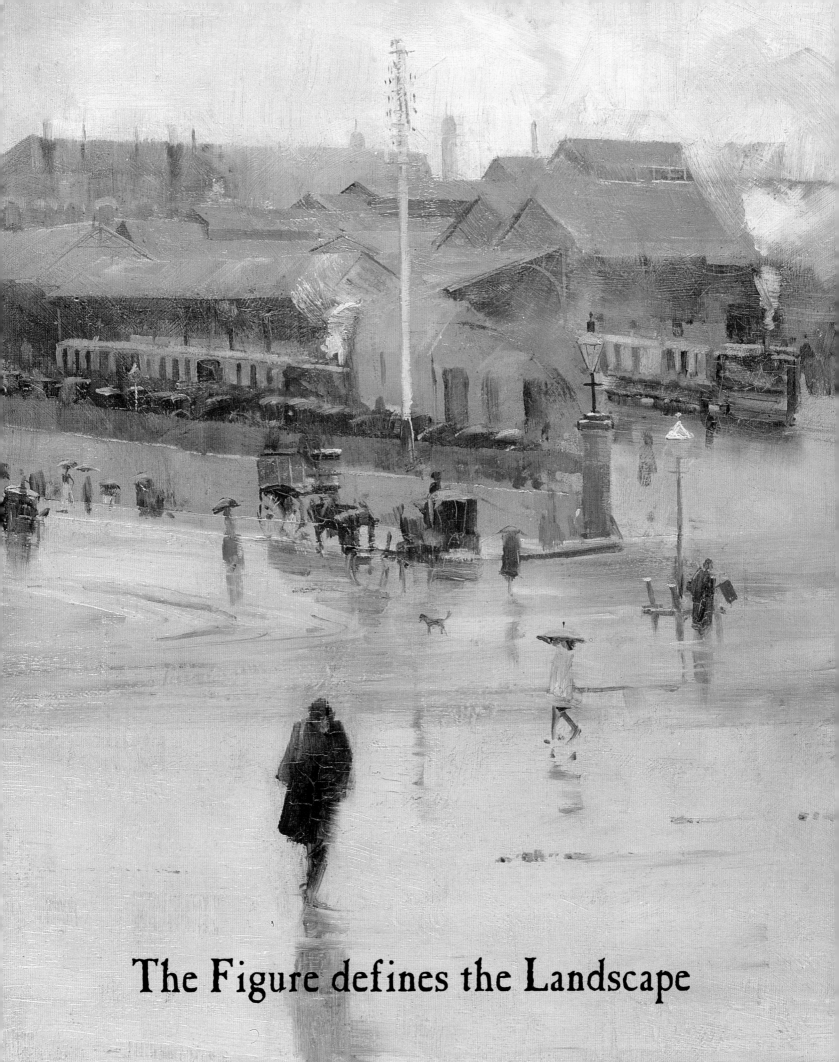

The Figure defines the Landscape

William Ford 1820–1886

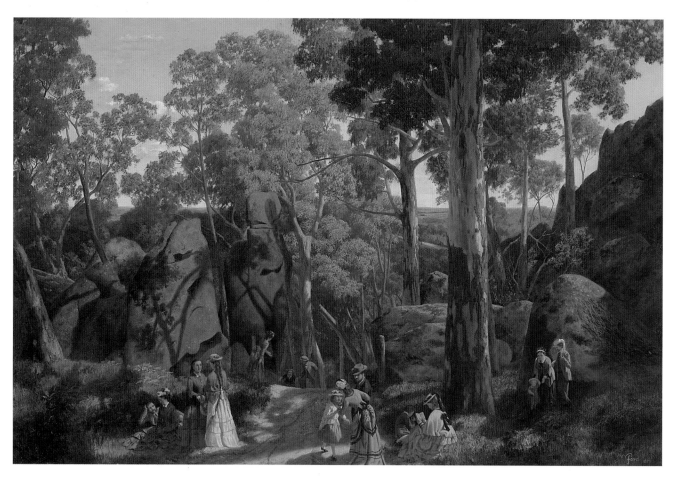

103. *At the Hanging Rock* 1875
oil on canvas 79.2 x 117.5 cm (31-1/8 x 46-1/4 in) National Gallery of Victoria, Melbourne

The extraordinary volcanic outcrop, or mamelon, now known as Hanging Rock, was a sacred site of the Wurundjeri Aborigines. Its first sighting by a European occurred in 1836 when the explorer, Major Thomas Mitchell, passed it on his epic journey to 'Australia Felix'. In the 1850s it was an object of scientific curiosity, but in the following decades it became a popular tourist destination, thronged by excursionists from the surrounding districts, and from Melbourne when the railway was put through to nearby Woodend in the early 1860s. By the mid-1870s its popularity over the Christmas/New Year holidays was such that buggies and light carts 'dotted the hill-sides, and horses were tethered to every convenient tree'.[1] Thousands of people clambered over the slopes and the grass was trodden to bare earth in all directions.

Hanging Rock provided many subjects for early photographers and painters, but of all the surviving views, the best-known is William Ford's *At the Hanging Rock*, painted in 1875.[2] Ford chose an unusual viewpoint, some distance up the rock, looking through the eucalypts and massive boulders to the horizon beyond. The spot seems to be that described by the *Australasian Sketcher* at about the same time:

Beyond this the path climbs up a grassy ascent, out of which stand up some strangely-shaped crags, some scooped and hollowed out by the weather into mere shells, others crowned with great toppling boulders, only held in place by vast wedges of rock. And amidst all grow graceful white gum trees, with their clean white stems and green drooping foliage, casting delicate, gently waving shadows on the grey surfaces of the lichen-grown rocks.[3]

Fifteen excursionists in the foreground, all dressed in their Sunday best, engage in various pursuits in the dappled sunlight. The charming but naive drawing of the figures, together with the extreme contrasts of light and shadow and Ford's meticulous technique, heighten the strangeness of this bush scene.

At the Hanging Rock was poorly received when it was first exhibited at the 1875 Intercolonial Exhibition in Melbourne. Reviewers thought it was 'confused in detail, and deficient in atmosphere'[4] and 'somewhat spoiled by the uniformity of his grey tints'.[5] The following year it was sent on to the New South Wales Academy of Art, and then to the Centennial International Exhibition at Philadelphia, where it was awarded a First Class certificate.

TL

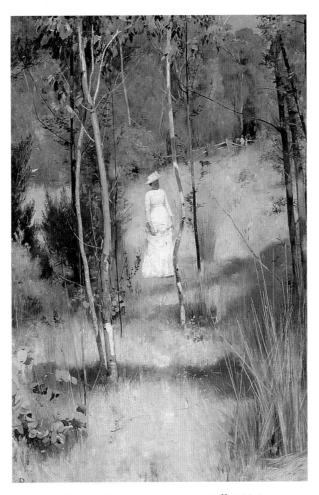

104. *A Summer Morning Tiff* 1886
oil on canvas 78.5 x 50.9 cm (30-7/8 x 20 in) Ballarat Fine Art Gallery Martha K. Pinkerton Bequest Fund 1943

A Summer Morning Tiff was painted at Houston's paddock, which was located about a kilometre from the railway station at Box Hill, on the outskirts of Melbourne.[1] The site, populated with blue gum saplings, was the first of the now famous artists' camps associated with the *plein-air* paintings of the Heidelberg School. After his return from Europe in 1885, Tom Roberts began painting there with fellow artist Fredrick McCubbin and, later, Louis Abrahams. Surrounded by bush, the three painted extensively, directly from nature, camping by the creek and cooking on open fires. Roberts savoured this sense of pioneering life and, many years later, recalled: 'Happy Box Hill … The evening after work — the chops perfect from the fire of gum twigs — the "goodnight" of the jackies as the soft darkness fell — then talks around the fire … we forgot everything but the peace of it.'[2]

On 5 April 1886 Roberts described the composition of this painting in a letter to his future wife Lillie Williamson:

McCubbin's sister stands for us, in the sunlight among some exquisite young white gum saplings. She, a little downcast — up the hill a youth in some state about to let his horse through the slip panel — title not yet decided — 'a tiff' has been done before — suppose 'another tiff'.[3]

'A tiff', to which Roberts refers, is a painting by the English artist Frank Cox, which was exhibited in 1878 and later produced as an engraving. Set in the English countryside, it tells a similar narrative of a quarrel between a young couple.

A Summer Morning Tiff is the first of two companion paintings set in the Australian bush. Although we do not know the precise details of the 'tiff' that has taken place, the painting was shown in 1886 accompanied by a poem which read in part:

A thoughtless blunder. She is fair and haughty and answers back, So they part asunder … [4]

The companion piece, *Reconciliation* 1887 (Castlemaine Art Gallery and Historical Museum)*,* shows the pair together again arm in arm: 'When all bitter thoughts will vanish, At a touch and with a kiss.'

The paintings were exhibited within a year of each other, *A Summer Morning Tiff* in 1886 and *Reconciliation* in 1887 — which the *Argus* described as 'a pretty love story prettily told'.[5]

MK

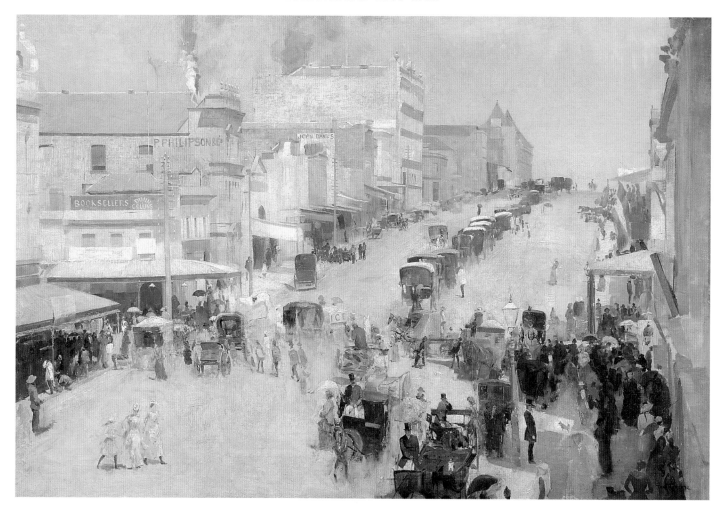

105. *Allegro con brio; Bourke Street West* c.1886
oil on canvas 51.2 x 76.7 cm (20-1/8 x 30-1/8 in) National Library of Australia and National Gallery of Australia, Canberra

The musical term *Allegro con brio* indicates a style of playing that is lively, fast and spirited. Tom Roberts, who possessed musical sensibilities, used the term to describe one of the main thoroughfares through the centre of the city of Melbourne.

During the 1880s and 1890s Melbourne was often referred to in terms of its wealth and cosmopolitan nature: epithets such as Marvellous Melbourne, The Queen City of the South, and The Empire City of Australia, all celebrate a thriving metropolis. In this painting, through its atmospheric effect and evocation of city life, and in its title, Roberts, too, celebrates the pace and the diversity of activity and industry of the city.

From the lower right corner, the subject begins at Melbourne's General Post Office, looking west towards Spencer Street. Roberts painted from a high perspective, possibly the verandah of Buckley and Nunn's, a drapery store next to the Post Office,[1] or a building closer to the corner, perhaps the Post Office itself.[2] The impression is of a hot, dusty day, with a cloudless hazy sky and women sheltering beneath parasols. The buildings and shops which line the street have been rendered accurately and several are clearly identifiable: these include Dunn and Collins

booksellers, P. Philipson and Co. jewellers and opticians, Streetle Stratford and Co. horse and cattle traders, about half way down the street, and the Menzies Hotel on the corner of William Street.[3] The hansom cabs which line the street were prevalent in Melbourne before trams began travelling through the city. *Allegro con brio* was completed before the advent of the cable tramway along Bourke Street which opened on 26 August 1887.[4]

Roberts is well known for his bush narratives; while this painting is his major image of the city. Although completed in 1886, it was not exhibited until 1890, the year that he added the three female figures crossing the street in the lower left of the canvas.[5] *Allegro con brio* received good reviews; a commentary of 1890 in *Table Talk* noting that 'the colouring is very brilliant, the grouping clever and the general effect spirited'.[6] Despite this, the painting remained unsold until 1903 when Roberts left Australia for London, at which time it was acquired by Frederick McCubbin. *Allegro con brio; Bourke Street West* was sold to the Parliamentary Library Committee in 1920.[7]

MK

Tom Roberts 1856–1931

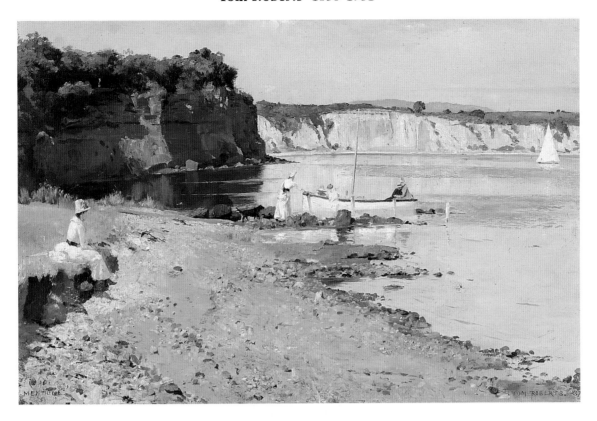

106. *Slumbering Sea, Mentone* 1887
oil on canvas 51.3 x 76.5 cm (20-1/4 x 30-1/8 in) National Gallery of Victoria, Melbourne

In the summer of 1886–87 Tom Roberts, Frederick McCubbin and Louis Abrahams rented a cottage near Mentone, a seaside township on Port Phillip Bay, 22 kilometres from Melbourne. Arthur Streeton, who joined the group there, later recalled that summer:

> In spite of the heat, the vile hammocks we slept in, the pest of flies and the puce-coloured walls, we had a great time here ... On Sundays we took a billy and chops and tomatoes, down to a beautiful little bay which was full of fossils, where we camped for the day. We returned home during the evening through groves of exquisite tea-trees, the sea serene, the cliffs at Sandringham flushed with the afterglow.[1]

Slumbering Sea, Mentone and *The Sunny South* (also National Gallery of Victoria) show Roberts working in a quite different mode from the landscapes painted at Box Hill the previous summer, and from his shipboard painting, *Coming South* (National Gallery of Victoria, Melbourne), and the cityscape, *Allegro con brio, Bourke Street West* (cat. 105), both of 1885–86. What characterises the two seascapes is the freshness of his palette and the sharpness of his vision sustained from foreground to background. Colour and technique enabled him to achieve, with unprecedented success, his goal of capturing the brilliance of Australian sunshine. The newly-reinstated original title of *Slumbering Sea, Mentone* (until recently the painting was known simply as 'Mentone') draws attention to the artist's endeavour to represent specific climatic conditions —

a hot, windless midsummer day, where the mirror-like surface of the sea is ruffled only in patches by stray breezes. The sun is almost directly overhead, casting minimal shadows.

Although *Slumbering Sea, Mentone* was painted *en plein air*, clearly it was finished in the studio. Its realism is underpinned by a sophisticated composition of interlocking and overlaid triangles in the foreground and middleground, and by the well-considered central motif — a woman and boy and an eager dog meeting a boat as it draws in to the shore. The seated figure on the left is a classic device for closing a composition on the side and directing attention into the centre of the picture.

This painting demonstrates Roberts's skill as a colourist. His palette is rich in earth colours, ranging from umbers and chocolate browns through ochres to chalky whites. These colours are relieved by the delicate blues of the sky and sea, and by the vivid whites of the women's and boy's clothing, the boat and mooring posts, and the distant sail. Roberts draws the eye across the picture by his sparing use of black, for the sashes of the women's dresses, the dog and the rim of the boat. Tiny accents of red, for the boy's cap and on the woman's bonnet, show another of the lessons he had learnt from the old masters.

Slumbering Sea, Mentone was exhibited at the Australian Artists' Association exhibition in Melbourne in March 1887. The *Argus* described it as 'a broadly-painted coast scene, full of light and warmth and local colour'.[2]

TL

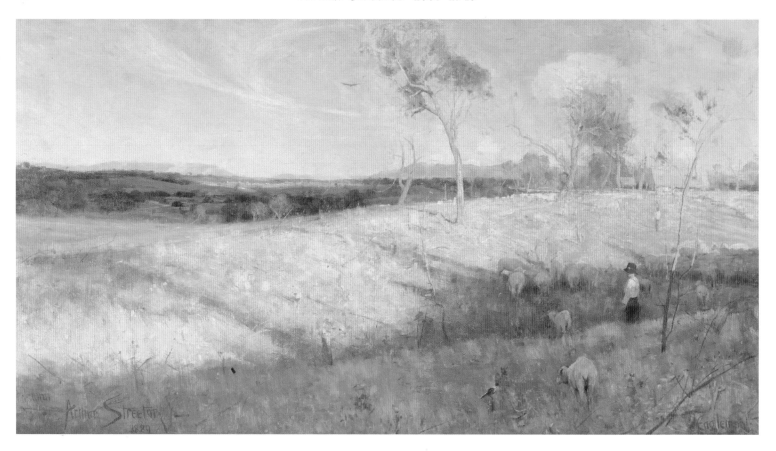

107. *Golden Summer, Eaglemont* 1889
oil on canvas 81.3 x 152.6 cm (32 x 60 in) National Gallery of Australia, Canberra

In 1891 this painting became the first work by an Australian-born artist to be hung in the Royal Academy. It was exhibited as *Golden Summer, Australia*, a title which embodies something of Arthur Streeton's aspiration for many of his paintings of the 1890s — they stand for a generally familiar, rather than localised, Australian landscape. However, the painting is inscribed 'Eaglemont', referring to the rural estate near Melbourne where it was conceived in the summer of 1888–89. In the right-hand side of the composition is the homestead, Mount Eagle, a large empty building in which Streeton and his fellow artists camped to paint the surrounding landscape.[1] The word 'Pastoral', also inscribed on the work, refers to the artist's intention to paint a specific genre of landscape subject with broader associations than a title such as 'Golden Summer' alone might evoke.

Streeton appears to have painted at Eaglemont from Christmas 1888 and it was probably in that year he painted a small oil sketch now known as *Impression for Golden Summer* which formed the idea for the larger painting.[2] This rapid oil sketch which was included in the celebrated 9 by 5 Impression Exhibition mounted in Melbourne in August 1889 — an exhibition comprised of small panel paintings, the great bulk of which were by Streeton, Tom Roberts and Charles Conder.

Golden Summer, Eaglemont rapidly became one of Streeton's most admired paintings, and in many ways it came to be seen as an icon of his vision of the Australian landscape. As early as the year in which it was painted and first exhibited (in the May 1889 exhibition of the Victorian Artists' Society) the work was recognised as a major statement of Australian impressionism. The magazine *Table Talk* commented that the painting showed that Streeton 'paints summer effects as if he loved the country, and had set himself to idealise even the most commonplace scenery.'[3] The status of *Golden Summer* grew throughout the twentieth century, and Streeton was clearly proud of the critic Lionel Lindsay's judgement in 1924 that the painting was 'the first great Australian landscape, untrammelled by picture-making formula, to come from the hand of the native born'.[4] 1924 was the year in which Streeton sold *Golden Summer* (which he had bought back from the widow of the painting's original English purchaser) for a record price of 1,000 guineas. Streeton added passages of paint to the work — however, these have now been removed. The record price paid for the work when it entered the National Gallery's collection added further to its status as a national icon of the 'blue and gold' vision of the Australian landscape.

AS

Frederick McCubbin 1855–1917

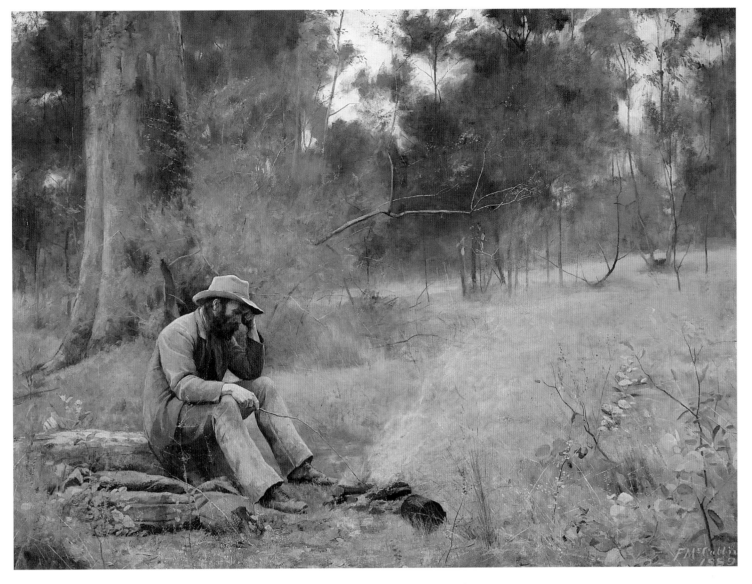

108. *Down on his Luck* 1889
oil on canvas 114.5 x 152.8 cm (45 x 60-1/8 in) Art Gallery of Western Australia, Perth

Down on his Luck is one of a group of figure compositions in Australian bush settings painted by Frederick McCubbin in the period 1886 to 1904. The series began with *Lost* 1886 (National Gallery of Victoria, Melbourne), a painting of a child lost in the bush, and reached its culmination in the monumental triptych *The Pioneer* (National Gallery of Victoria, Melbourne) which comprises a three-phase narrative of Victorian growth from settlement to urbanisation. Their subjects are apparently uncomplicated narratives.

Down on his Luck is easily described: a despondent prospector idly pokes a stick into a small campfire, his pose and expression (his 'body-language') and the title of the painting tell us that he has met with hard times. He has no companion, and nothing material except the clothes he is wearing and the meagre stock of his swag. Whatever dreams this man might have had apparently have come to nothing, his life seems as empty and irrelevant

as the billy-can lying next to the fire. Unlike many of McCubbin's subject paintings, the conjunction of the figure (studio-posed, for which his fellow artist Louis Abrahams was the sitter) and the bush setting (painted at Box Hill near Melbourne) is harmonious and convincing.[1]

For all the despondency of its subject, *Down on his Luck* was recognised by its audience to represent something more broadly symbolic, indeed romantic. Leigh Astbury has written:

> as the figure of the individual gold-prospector passed from view it acquired by the late 1880s a symbolic status in art and literature. The gold-prospector came to symbolise the freedom and independence of a past age, a time when egalitarian ideals and individual initiative were not in conflict and could be equally rewarded by a democratic society.[2]

AS

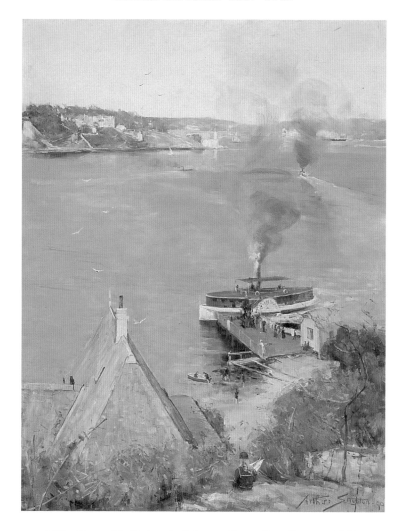

109. *From McMahon's Point — Fare One Penny* 1890
oil on canvas 91.1 x 70.5 cm (35-7/8 x 27-3/4 in) National Gallery of Australia, Canberra

This view of Sydney Harbour was painted during Arthur Streeton's first extended stay in Sydney in 1890. It depicts the wharf at McMahon's Point, on the north shore, from which the ferry conveyed passengers across the harbour to the city. The promontory on the left-hand side of the painting is Milson's Point, the last pick-up point before the ferry crossed to Sydney's Circular Quay — shown in the distance on the right-hand side of the composition. Commuting by ferry was the only way people could cross the harbour before the opening of the Sydney Harbour Bridge in 1932. Were we to look at the harbour today from Streeton's viewpoint of a century ago, the towering pylons of the bridge on Milson's Point and the curve of the steel span over to the southern shore, would dominate this scene.

From Sydney, Streeton wrote to Tom Roberts in Melbourne in July or August 1890:

Commenced fresh work at McMahon Point and have a most delightful subject there looking towards Milson's Pt with expanse of water, tops of houses and landing stage and St(atio)n, in foreground of picture. Make the acquaintance of a lovely little boy; brought me his boat to paint.

I did it in blue and Gold and the rudder Emerald Green — he was very pleased.[1]

A small study exists for *From McMahon's Point — Fare One Penny*, but Mary Eagle has suggested that Streeton painted not only the smaller study on the spot but the larger version too, a practice consistent with his work at the time, as well as that of Tom Roberts and Frederick McCubbin.[2]

When Streeton exhibited *From McMahon's Point — Fare One Penny*, along with other works, at the 1890 exhibition of the Art Society of New South Wales, the *Sydney Morning Herald* judged his more pleasantly conventional *Spring Pastoral* (National Gallery of Victoria, Melbourne) to be superior, commenting that: 'his large view of the harbour from McMahon's Point is not equal to his other work. His smaller view of the same scene is better. Mr Streeton has proved his conspicuous ability as a painter. He will be well advised if he represses his energy and turns out more works in the style of his first-mentioned picture and none of the McMahon's Point order.'[3]

AS

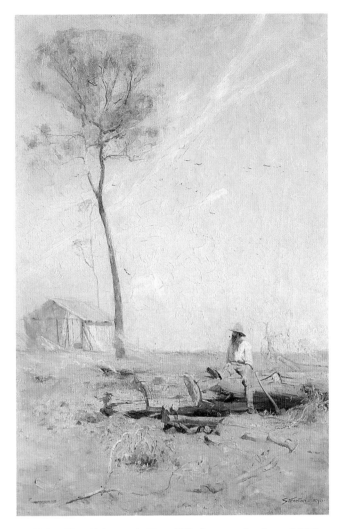

110. *The Selector's Hut: Whelan on the Log* 1890

oil on canvas 76.7 x 51.2 cm (30-1/8 x 20-1/8 in) National Gallery of Australia, Canberra

The named subject of this painting, Whelan, was the farmer at the estate of Eaglemont, where Arthur Streeton had completed his great masterpiece *Golden Summer, Eaglemont* (cat.107) in the previous year. Photographs and drawings of Whelan show him with a long, greying beard, and here his wide-brimmed hat and shirtsleeves suggest a pioneering figure — the figure of the selector, or small farmer, on whose labour (so the myth goes) pastoral Australia was built. As Mary Eagle has written in her essay on this painting:

> Streeton's depiction would be recognised immediately as belonging within a genre of imagery of selectors or 'cockatoo' farmers who, in Australian lore, invaded the large runs of the (aristocratic) settlers to peg out their own farms. They were the equalising heroes of a young, democratic society; they literally cut down to size the pretensions of the big men.[1]

Whelan was not a selector in any true sense. The land he worked was owned by a property speculator, Charles Davies, who subdivided the adjacent estates of Eaglemont and Mount Eagle in the hope of attracting buyers who would build houses.

In the years during which the estates remained pastoral land, Streeton and a number of his fellow artists painted there. Charles Conder painted with Streeton and, alongside Streeton, created a very similar composition, *Under a Southern Sun* (see fig. 40).

Although Eaglemont is the setting for the painting, and its caretaker the subject, the work is more broadly symbolic than descriptive. In fact Streeton gives no hint of topography — what he gives us is simply a horizon. In terms of landscape, the subject is simple; as the prominent Melbourne critic James Smith (no friend of Australian impressionism) wrote, the work 'vaguely conveys the idea of vivid light and great heat, and nothing more'.[2] When Streeton included the work, under the title *Australia,* in his 'Sydney Sunshine' Exhibition in 1896, he clearly meant it to symbolise something broader than its nominal subject. He intended the work to stand for Australian light (which dissolves the elements of landscape and washes out the colour), and Australian sky, and to represent the history of Australia as the transformation of nature into culture.

AS

Tom Roberts 1856–1931

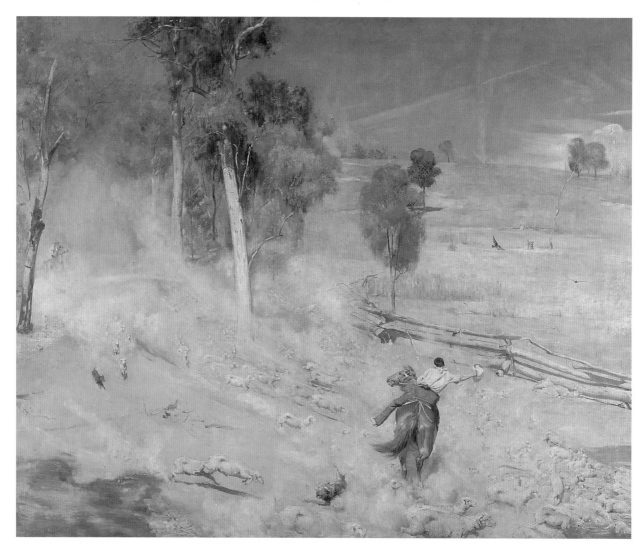

111. *A Break Away!* 1891
oil on canvas 137.0 x 168.0 cm (54 x 66-1/8 in) Art Gallery of South Australia, Adelaide Elder Bequest Fund 1899

A Break Away! tells the story of a chaotic stampede by a drought-affected mustering of sheep and the gallant attempt of a young stockman to slow their desperate rush towards water. It is unlikely that Tom Roberts ever witnessed such a dramatic event, but may have chosen the subject as a heroic recollection of the Australian pioneering spirit on the eve of federation of the colonies — a time when Australians were pondering on their national identity.[1]

Roberts's process in painting *A Break Away!* was quite different from the *plein-air* paintings he completed at artists' camps after his return from England in 1885. He did not paint it spontaneously or directly from nature, but spent much time observing and sketching drovers, horses and sheep in preparation for the painting. While it is likely that he made oil sketches in the open air, he painted most of the final canvas in the Brocklesby woolshed on a property near Corowa, New South Wales, where he stayed for several months during 1891. The painting was then completed in Melbourne.[2] There are similarities between this work and other Heidelberg School works in the quality of light and vivid blueness of the sky which contribute to its strong impact and dramatic effect.

The distinctively Australian quality of *A Break Away!* was immediately recognised when the painting was first exhibited. One contemporary critic described it as 'An Australian incident — tragic, realistic, picturesque'.[3] This was probably a response to the artist's combination of landscape and pastoral imagery with appropriately noble aspirations of bravery and determination to overcome seemingly insurmountable odds. It is often noted that Roberts considered the painting 'the work in which his art has so far most nearly realised his idea'.[4]

A Break Away! remains a strong national symbol today and is one of the most popular paintings in the collection of the Art Gallery of South Australia — a painting that has been almost continuously on display since its purchase in 1899 by the Gallery.[5]

MK

Arthur Streeton 1867–1943

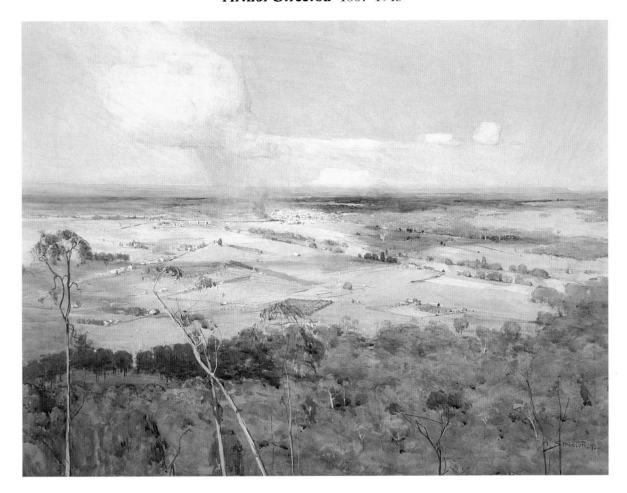

112. *The Valley of the Nepean* 1892
watercolour 55.0 x 73.3 cm (21-5/8 x 28-7/8 in) National Gallery of Australia, Canberra

The competition for a watercolour of characteristic scenery of New South Wales, announced by the Trustees of the Art Gallery of New South Wales early in 1891, was the catalyst which led to Arthur Streeton's move from Melbourne to Sydney in search of subjects.[1]

Towards the end of 1891 Streeton had been painting in the Blue Mountains west of Sydney for some weeks, and for much of that time he had been absorbed in observing the drama of the construction of the railway tunnel at Lapstone, the subject of his large masterpiece *Fire's On!* (fig.38). In December he settled down to work on his competition entry which he clearly believed fitted the celebratory sweep of a competition for a national landscape. He wrote to Tom Roberts from Glenbrook in the Mountains:

> Have chosen a fine subject for the W. Color sitting on the heights of Lucasville where without turning the head, one's eye sweeps a great extensive plain fertile with crops & orange groves, & the pure 'Nepean' water running straight through it, such a grand sight this evening, the sun setting golden behind me & the broad massive shadow of the mountain (on which I sit like a speck) spreading like a great wing of the night over the great blue peaceful vale, all the air is still

the crowing of cocks dogs bark & their melody reaches for miles far up to where i rest cows look like wee bits of colour scraped off your old palette ... Yes, here is a great rich drama going on in front of me. To the right sou-east the plain rises a little, and thousands of strong gum trees stand in a line up to which comes the civilised side of things crops of maize, lucerne & prairie grass, all so soft & Peaceful & Yet gradually edging their way into the stately dominion of the Eucalyptus. Looking from here the gums look like thousands of bronzey grey ants coming over the gentle rises — just like that.[2]

At the bottom of the page Streeton drew a sketch of the composition of *The Valley of the Nepean.*

Streeton was to be disappointed in the outcome of the competition — although he entered two works, this one and *Cutting the Tunnel* (Art Gallery of New South Wales, Sydney), he did not win a prize. The following year — the only other year in which the competition was held — Streeton submitted a not dissimilar composition, *Mittagong* (fig.17), but again he was unsuccessful in winning any of the lucrative prizes (as many as twelve prizes of up to £75 each).

AS

Arthur Streeton 1867–1943

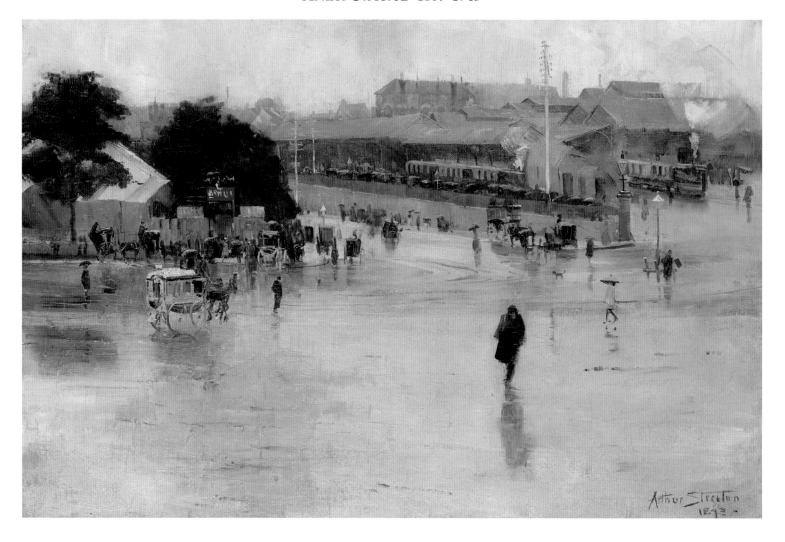

113. *The Railway Station, Redfern* 1893
oil on canvas 40.8 x 61.0 cm (16 x 24 in) Art Gallery of New South Wales, Sydney Gift of Lady Denison 1942

According to the art historian William Moore this painting was executed in a single sitting of three hours.[1] The painting certainly has all the informality of a rapidly executed sketch, although the composition, revolving around the overcoated man in the foreground which gives the work focus, is deliberately constructed.

The Railway Station is somewhat uncharacteristic. Streeton's work of the 1890s almost all celebrates Australia's glaring sunshine. The impression that such paintings represented the focus of Streeton's *oeuvre* was deliberately cultivated by the artist himself; his first significant exhibition was 'Streeton's Sydney Sunshine Exhibition' which he mounted in Melbourne in 1896. There were, however, a number of works of the 1890s in which Streeton experimented with a more Whistlerian colour scheme of muted greys. At this time, too, Streeton was experimenting with a range of unconventional formats — long horizontal or vertical panels, and in this he also demonstrated his debt to Whistlerian ideas. These two approaches combined in Streeton's *Rain over Sydney Harbour* in the collection of the National Gallery of Australia.

The Railway Station is unusual by virtue of its subject. In 1893 Streeton wrote to Tom Roberts that he intended to 'go straight inland (away from all polite society) & stay there 2 or 3 years & create some things entirely new, & try to translate some of the great hidden poetry I know is here'.[2] To an artist with such aspirations, urban subjects were fundamentally unrewarding and almost all of Streeton's city views are views of Sydney Harbour, that is, views in which the sweeping natural beauty of the Harbour is the subject, rather than a cityscape. This is presumably what Streeton meant when he described Sydney as an 'artist's city'. Apart from *The Railway Station*, Streeton painted another rainy-day city view in the 1890s — *Fireman's Funeral, George Street*, 1894 (Art Gallery of New South Wales, Sydney), a painting which echoes faintly the most Whistlerian of all Australian paintings, Charles Conder's *Departure of the Orient — Circular Quay* of 1888 (Art Gallery of New South Wales, Sydney).

AS

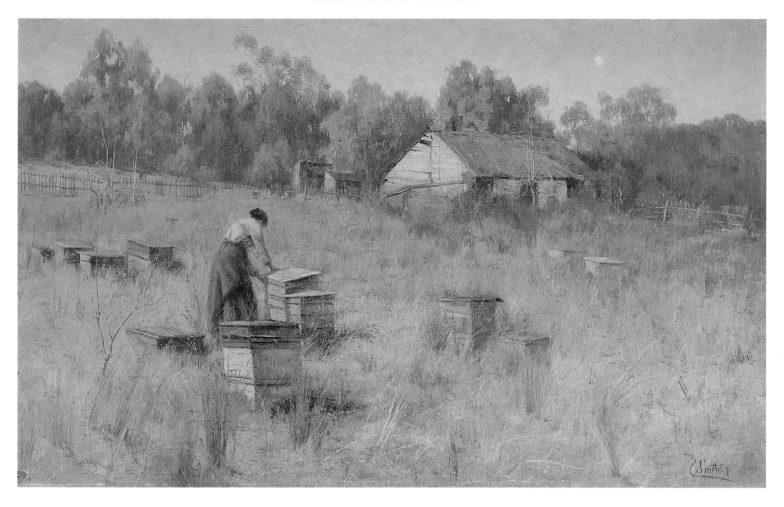

114. *An Old Bee Farm* c.1900
oil on canvas 69.1 x 112.4 cm (27-1/4 x 44-1/4 in) National Gallery of Victoria, Melbourne Felton Bequest 1942

An Old Bee Farm was probably painted at Kew, the Melbourne suburb, where Clara Southern and her 'co-worker', Jane Sutherland, were 'living together as 'bachelor girls' in the country they love to paint'.[1] Although only a few kilometres from the city, Kew in 1900 still offered landscapes of convincing rusticity, particularly on the old farms down on the banks of the Yarra River. Southern appears, however, to have reworked the painting when she moved to Warrandyte, further up the Yarra valley, after her marriage in 1905. *Pentimenti* indicate that the beekeeper has been much altered, perhaps in response to one of the reviews of the picture when it was first exhibited, which likened the figure to a scarecrow. The roof has been changed, too, and the building now approximates to one that appears in Southern's Warrandyte pictures.

Like many of her contemporaries in the 1890s, Southern had a preference for run-down rural subjects — her beekeeper's cottage appears to be an abandoned farmhouse, and the bush seems about to reclaim its territory. Was this a Virgilian response to the land, an attempt to stock the landscape with the shadows of those who have gone before? The centenary of European settlement in Australia was celebrated in 1888, and in 1901 the Australian colonies were to federate in the Commonwealth of Australia. Artists, amongst others, sought a past for the new nation, and their art was often tinged with a *fin de siècle* mood of *tristesse*, of contemplation and introspection. Something of this mood pervades *An Old Bee Farm*, which Southern chose to paint as a nocturne, with the winter moon rising as the sunlight fades and an evening mist descends on the scene.

An Old Bee Farm is interesting technically, apart from its *pentimenti*. The sky is laid on with a wide brush and the landscape built up in a variety of techniques, producing a richly textured foreground and middleground. The artist's final process was to paint in, with a fine brush, the bare fruit trees near the house, and the dry grasses in the foreground.

TL

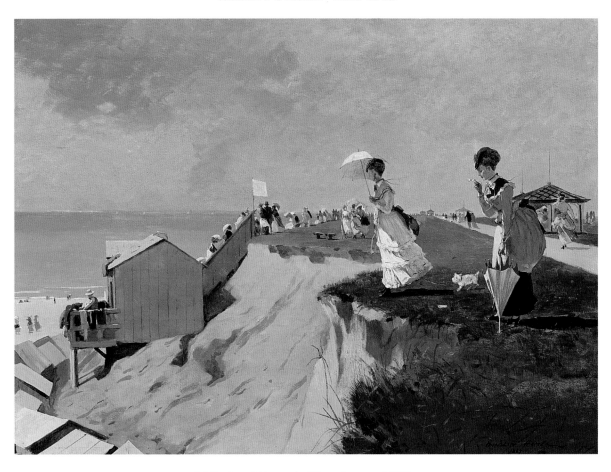

115. *Long Branch, New Jersey* 1869

oil on canvas 40.6 x 55.2 cm (16 x 21-3/4 in) Museum of Fine Arts, Boston, Massachusetts The Hayden Collection

At the time Winslow Homer painted *Long Branch* this New Jersey town was a resort that attracted members of nearly every social class. Located on the Atlantic coastline, Long Branch was established as early as 1788, when it was popular with Philadelphians. By 1847 Long Branch had become a destination for New Yorkers, who arrived by steamboat, coach or wagon. By 1869 the railroad carried large crowds from New York City to the resort on Sundays in the summer. At some point, Ulysses S. Grant, Civil War hero and President of the United States from 1869 to 1877, owned a summer cottage there, purportedly a gift from savvy developers. By the 1880s Long Branch and the surrounding beach towns were dominated by fashionable resorts and were the preserve of the *nouveaux-riches*.[1]

This is the earliest depiction of Long Branch, a resort then considered one of the most democratic in the United States and, consequently, thought of by some as vulgar. In 1868 a writer described the resort population: 'Representatives of all classes are to be met, heavy merchants, railroad magnates, distinguished soldiers, editors, musicians, politicians and divines, and all are on an easy level of temporary equality.'[2] Homer documents the social mix while satirising the vulgarity, portraying two overdressed women perched precariously on the edge of the bluff.[3]

Prior to the Civil War, communion with nature had been restricted primarily to the upper classes and was generally a private event or at least enjoyed only in small groups.[4] Artists usually edited out any evidence of tourist traffic. Homer's painting, on the other hand, displays Long Branch as a place of leisure visited by large numbers of people, and the artist does not seem to have eliminated any of the tourist accommodations from his picture. A contemporary description of the beach reads:

We strolled on toward the south, taking a yellow gravel path that led along the top of the cliff close to its edge. On our left was an immense expanse of ocean, unbroken by islands, or by any land whatever. It came on in long, deliberate swells, and fell languidly but heavily upon the silvered beach … Up on the cliff where we walked was a large number of rough plank pavilions, painted in various colors. These contained seats, facing the sea, that at that hour were filled with a strange multitude.[5]

Some scholars have suggested the influence of French impressionism on Homer's early work in particular — he travelled to Paris in the fall of 1866. While *Long Branch, New Jersey*, is close to the work of the French impressionists in its subject matter and technique, it is more likely that Homer was influenced by French paintings he viewed on exhibition in the United States.[6]

AE

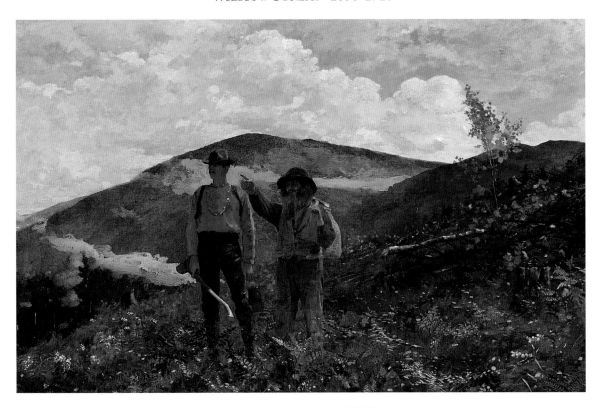

116. *Two Guides* c.1875

oil on canvas 61.6 x 97.2 cm (24-1/4 x 38-1/4 in) Sterling and Francine Clark Art Institute, Williamstown, Massachusetts

Winslow Homer painted Orson Phelps (right) and Monroe Holt in Minerva, in front of Beaver Mountain in Keene Valley in a composite view of the Adirondack Mountains, New York.[1] Phelps, known as 'Old Mountain' by the 1870s, was a legendary figure. Born in Vermont, Phelps arrived in the Adirondacks sometime around 1830. In about 1844 he settled with his new wife in Keene Valley. There he explored the High Peaks of the Adirondacks, mapping the area and blazing trails, one of the earliest to do so.[2]

In 1876, close to the time that Homer painted Phelps, Charles Dudley Warner wrote about the guide in the *Atlantic Monthly*, a national publication:

> I suppose the primitive man is one who owes more to nature than to the forces of civilization … I would expect to find him … enjoying a special communion with nature — admitted to its mysteries, understanding its moods, and able to predict its vagaries. He would be a kind of test to us of what we have lost by our gregarious acquisitions. On the one hand, there would be the sharpness of the senses, the keen instincts which the fox and the beaver still possess, the ability to find one's way in the pathless forest, to follow a trail, to circumvent the wild denizens of the woods; and, on the other hand, there would be the philosophy of life which the primitive man, with little external aid, would evolve from original observation and cogitation. It is our good fortune to know such a man.[3]

In Warner's eyes, and the eyes of many Americans, the guide was the link between themselves — urban-dwellers who had lost touch with nature — and nature itself. In fact, men like Phelps and Holt replaced the Native American as guides to the wilderness. Interestingly, Homer painted Phelps with what was known as an Adirondack pack basket, which Phelps claimed to have invented but which was actually a traditional Native American carrying device. This is just one example of Phelps's ingenuity in crafting his persona as a 'man of the woods' — a type.[4]

The guide's role was to initiate the novice to the wilderness, at the same time that very initiation led to the taming of the North Woods for recreation, for hunting and fishing and hiking.[5] This initiation served to revitalise late nineteenth-century men who worked primarily at desks and used their minds rather than their physical strength. The men whom Phelps guided through the Adirondacks bonded with each other as men and as members of the elite class responsible for the running of the nation, whether in industrial, corporate, or professional occupations. In this way they reinforced their stance against the threat posed by an increasingly heterogeneous population.[6]

The Adirondacks were named by a professor at Williams College, Williamstown, Massachusetts, who surveyed the area in 1837. He mistook the word for the name of a tribe of Native Americans whom he thought had hunted in that region, but in fact Adirondacks is a derisive Iroquois term that translates into 'bark eaters'.[7]

AE

Thomas Eakins 1844–1916

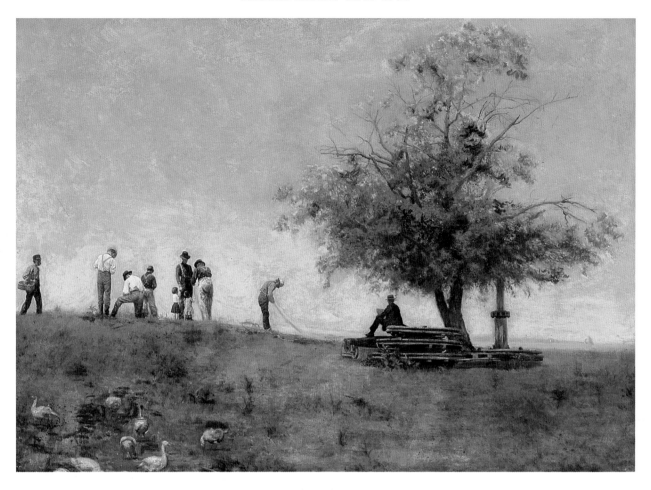

117. *Mending the Nets* 1881
oil on canvas 81.6 x 114.6 cm (32-1/8 x 45-1/8 in) Philadelphia Museum of Art, Philadelphia Gift of Mrs Thomas Eakins and Miss Mary Adeline Williams

Thomas Eakins is thought of as primarily a portraitist, but he also painted a number of landscapes, as in the series of paintings of shad fishing and shad fisherman near Gloucester, New Jersey, across the Delaware River from Philadelphia. *Mending the Nets* is one of eight paintings of the Gloucester shad fisheries.[1]

Certainly Eakins had known Gloucester and the fisheries since childhood. Gloucester was a popular retreat for Philadelphians who took the ferry across the Delaware to relax on the beaches and to bet at the racetrack and gambling halls.[2] They could also watch the fishermen, as Eakins did. In the nineteenth century, the Delaware River was unpolluted and shad were caught in the spring and early summer. Since shad fishing took place near the shore, it could be observed by those on the banks of the river.[3]

Eakins's artistic interest in the Gloucester subject seems to have begun with his purchase of a camera in 1880 or 1881. For the first two years, he photographed New Jersey's Atlantic coast and Gloucester, New Jersey. Thirty-one of these photographs are, in effect, studies for *Mending the Nets*.[4] As Kathleen Foster has observed, the importance Eakins laid on truth to nature — which necessitated long and arduous sittings for his models —

hampered his ability to sketch out of doors and, consequently, his skill in rendering group activity in the landscape. Photography solved this problem for Eakins: the camera could capture the fishermen without disturbing their work with demands for posing.[5]

The photographs demonstrate that along with shad fishermen, Eakins included portraits of family members in *Mending the Nets*. The seated man reading at the right, under the tree, is his father, Benjamin Eakins; the two small children are probably Eakins's sister Frances's (Fanny's) sons, Ben and Willie.[6] Eakins's fidelity to the photographs allowed for what Theodor Siegl identified in the Gloucester paintings as the 'photographic aesthetic' and 'camera vision'. This aesthetic and vision is seen in the blurred figures of the geese, which were moving when Eakins photographed them. As Foster has pointed out, this also creates a visual hierarchy in the painting, with the most important figures, the fishermen, painted with contrasting clarity. Eakins did not rely solely on photography for his composition for *Mending the Nets*, but combined it with a series of *plein-air* sketches, editing each as he saw fit.[7]

AE

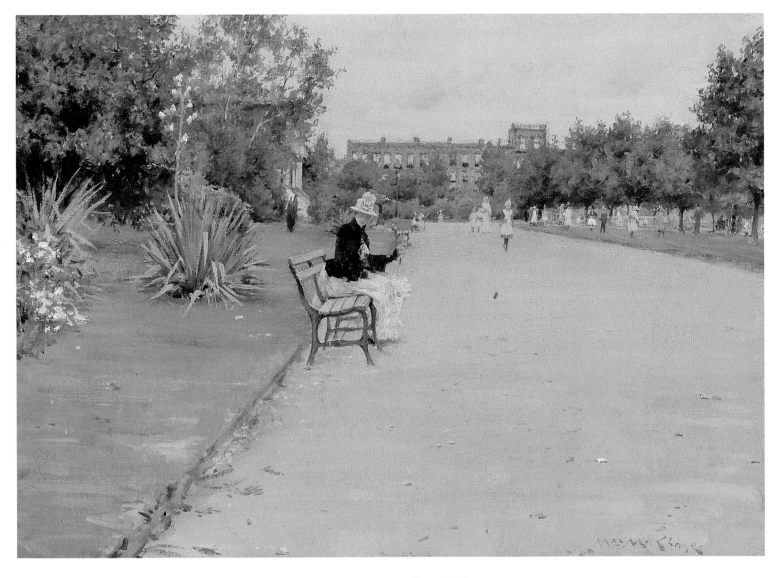

118. *A City Park* c.1887
oil on canvas 34.6 x 49.8 cm (13-5/8 x 19-5/8 in) The Art Institute of Chicago, Illinois Bequest of Dr John J. Ireland

In the late 1880s, William Merritt Chase abandoned his Munich-derived realism in favour of *plein-air* painting. This change was partly due to his meeting the artist Alfred Stevens, who advised him to do as much. Chase's urban park pictures reflect this shift in subject and style.[1]

The urban parks Chase painted — Brooklyn's Tompkins Park and Prospect Park and Manhattan's Central Park — represent two different approaches to bringing nature into the American city.[2] All three parks were designed by Frederick Law Olmsted and Calvert Vaux and were completed in the 1870s. For their design of Central Park and Prospect Park, Olmsted and Vaux combined elements of French landscape design, English landscape tradition, and American rural or park cemeteries. They thus merged the picturesque with the formal to arrive at an antidote to the strain of modern, urban life.[3] Tompkins Park, on the other hand, was smaller and designed more like a city square than a large public park—its terrain is flat instead of hilly, its plantings regular instead of asymmetric, and its paths straight instead of winding.[4]

Barbara Gallati has suggested that the Chicago painting, titled simply *A City Park*, may be Tompkins Park and not Prospect Park as previously supposed.[5] Tompkins Park, according to its designers, was meant to 'form a cheerful, bright, and refreshing object to be observed from the adjoining streets and houses ... [and allow for] agreeable exercise, rest, and social intercourse in the open air'.[6] In the foreground a solitary woman seems startled as if the viewer has come upon her unexpectedly, while in the right background, a group plays tennis.[7] The small size of the park in comparison with Central and Prospect Parks prohibited Olmsted and Vaux's usual focus on naturalism and led them to a more formal design concept.[8]

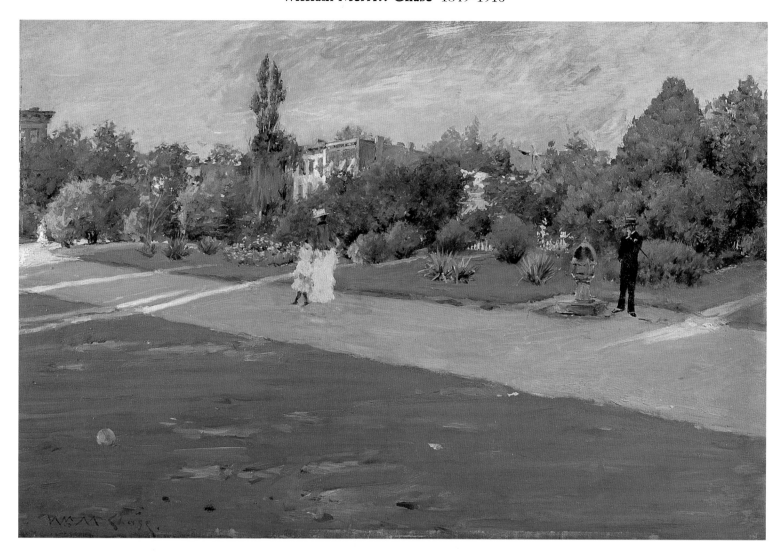

119. *Prospect Park, Brooklyn* c.1887
oil on cradled panel 40.9 x 61.2 cm (16-1/8 x 24-1/8 in) The Parrish Art Museum, Southampton, New York Littlejohn Collection

In contrast are Central and Prospect parks, both created with the urban-dweller's need for quiet contemplation in mind.[9] While Olmsted and Vaux, drawing on the English picturesque landscape tradition of William Gilpin and Uvedale Price, emphasised the experience of a controlled and composed nature, they thought of the park as a place where the classes would mix, and where the lower classes would learn from the upper's proper behaviour. Here nature was to offset the harmful influences of the surrounding urban environment.[10] Much as in Thomas Cole's time, when wilderness and the experience of the landscape acted as a moral influence on the public, the landscape of the city park did so for those who had no other access to nature.

Despite Olmsted and Vaux's vision of a democratic park, it was not until the end of the century that the spaces of Central and Prospect Parks were enjoyed by members of the working classes. Both parks were situated near the residential areas of the middle class and the well-to-do; those who used the parks were for the most part mothers, nurses, and children. Ironically, it was not until the 1890s, when Chase turned from the city to Shinnecock for subject matter, that these urban parks became integrated and truly democratic.[11]

AE

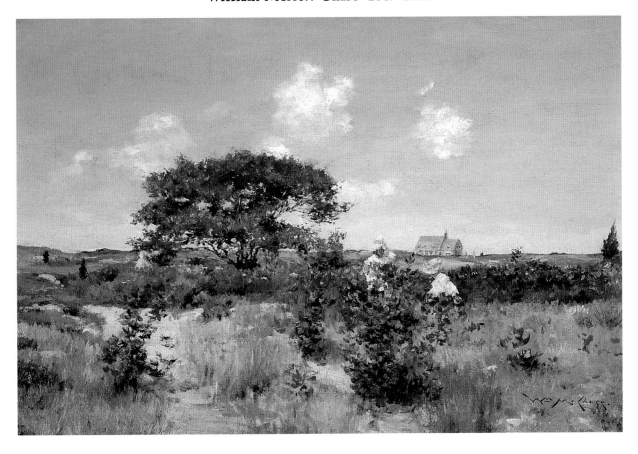

120. *Untitled (Shinnecock Landscape) c.1892*
oil on canvas 40.6 x 61.0 cm (16 x 24 in) The Parrish Art Museum, Southampton, New York

Shinnecock was the American version of Barbizon and Giverny. In 1891 William Merritt Chase opened his Shinnecock Summer School of Art for Men and Women in Shinnecock Hills, Long Island, where he taught *plein-air* painting to both professional artists and amateurs. Chase's own home and studio was three miles from the Art Village.[1]

The landscape of Shinnecock Hills, Chase's home and studio, and members of his family became his primary subject, replacing the city park.[2] The Parrish Museum's *Untitled (Shinnecock Landscape)* features the characteristic terrain with the artist's children playing in the foreground and middleground and his house and studio in the background. The Shingle style house was designed by Stanford White in 1888; the Chases moved there in 1892.[3] Unlike more democratic resorts, such as Long Branch, New Jersey, Shinnecock was the preserve of affluent vacationers who patronised Chase and his students in their artistic endeavours. In 1892, a newspaper noted:

Those who do not care for the gaudy masquerade of the populous beaches can find on the Island quaint and quiet spots, possessed of surpassing natural beauty, and imbued with as restful a charm as the original Sleepy Hollow. For the tired dweller in cities, Long Island holds in waiting every variety of beauty, scenery to harmonize with every mood

and every heart throb of the natural man … a region that is a dreamland of delight … is Shinnecock.[4]

Shinnecock's history was of particular interest to Chase, who was something of a status-seeker and was attracted to the colonial and European resonance of the area. It was the oldest English settlement in New York State; Massachusetts Puritans had purchased the land from the Shinnecock Indians in 1640. A windmill and the beaches were reminiscent of Holland, where Chase had summered and painted in 1883 and 1885.

Although by 1892 the Shinnecock tribe was on the verge of extinction, Chase was on friendly terms with the Indians, obtaining access for his students to the reservation, where they painted and used some tribes' members as models.[5]

Chase once remarked that The School of the [French] Impressionists has been an enormous influence upon almost every painter of this time', but qualified this by adding: 'Most of this work I consider as more scientific than artistic.' It is Chase's resistance to the scientific theories of French impressionism that makes his work — as well as most of the work of the other American Impressionists — distinct from the art of their European predecessors.[6]

AE

Childe Hassam 1859–1935

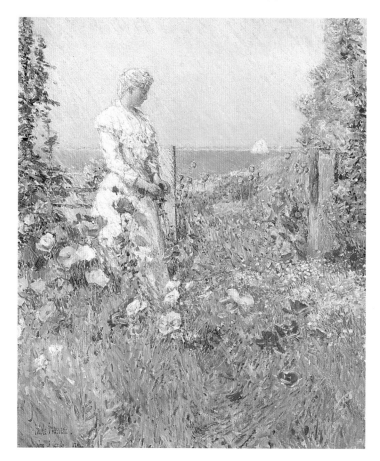

121. *In the Garden (Celia Thaxter in her Garden)* 1892
oil on canvas 56.5 x 45.7 cm (22-1/4 x 18 in) National Museum of American Art, Smithsonian Institution, Washington, DC Gift of John Gellatly

In March 1894, two years after Childe Hassam painted *In the Garden*, Celia Thaxter published *An Island Garden*, illustrated by Hassam. Hassam's painting, reproduced by colour lithography, appears as the frontispiece to the book.[1] Thaxter's preface reads:

> At the Isles of Shoals, among the ledges of the largest island, Appledore, lies the small garden which in the following pages I have endeavored to describe … Year after year the island garden has grown in beauty and charm, so that in response to the many entreaties of strangers as well as friends who have said to me, summer after summer, 'Tell us how you do it! Write a book about it and tell us how it is done, that we may go also and do likewise', I have written this book at last.[2]

Celia Laighton Thaxter, author of poetry and prose, was born in Portsmouth, New Hampshire. Her father was appointed keeper of the lighthouse at the Isles of Shoals, just outside Portsmouth Harbour, and, with his wife and children, moved to the keeper's cottage on White Island in 1839. The islands were for the most part unpopulated at this time, but in 1848 Mr. Laighton opened a summer hotel on Appledore Island, where *In the Garden* was painted. Visitors to the hotel were numerous and included writers Henry David Thoreau and Nathaniel Hawthorne, as well as painters William Morris Hunt and Hassam. In 1851 Celia married her tutor, Levi Lincoln Thaxter. She moved away from the islands for a number of years, returning to Appledore after her father's death in 1866 to take care of her mother. Every year she spent six months in a cottage near her mother's home and there created her garden.[3]

Thaxter's cottage and garden became a genteel retreat for writers and artists seeking asylum from the nineteenth-century city. In his painting of Thaxter's garden, Hassam places its creator in a state of reverie or personal retreat in the midst of her flowers.[4] The silver crescent she habitually wore is depicted by Hassam, perhaps an allusion to Diana, goddess of the moon, forests, animals, and women in childbirth (and thus [pro]creation). Diana was also worshipped as an Earth goddess.[5]

As David Park Curry has observed, Thaxter's island garden contained old-fashioned flowers. A nostalgia for colonial plantings — as well as for architecture and decorative arts — was spurred in the United States by the Centennial, held in Philadelphia in 1876. The informal cottage garden, a response to the industrial revolution, was popular in Great Britain — it is possible that Thaxter was familiar with English gardening theory or prototypes.[6]

AE

Winslow Homer 1836–1910

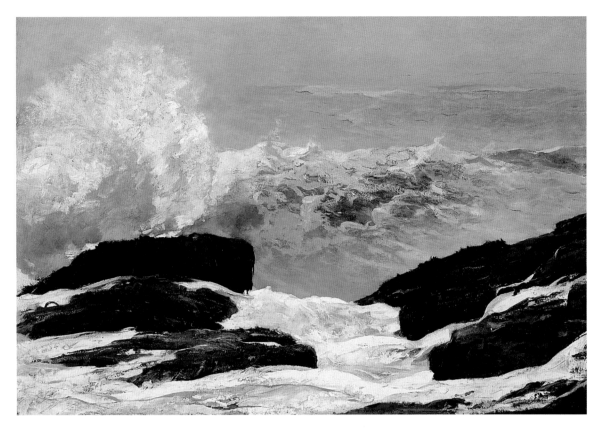

122. *Maine Coast* 1896
oil on canvas 76.2 x 101.6 cm (30 x 40 in) The Metropolitan Museum of Art, New York Gift of George A. Hearn, in memory of Arthur Hoppock Hearn, 1911

Winslow Homer moved to Prout's Neck, a peninsula south of Portland, Maine, in 1884. Maine's rocky coast and the Atlantic Ocean became the focus of his painting in the last two decades of his life. In the Prout's Neck paintings, as they are called, the human figure dominates much of the space, but Homer's real subject is the sea and its effect on the people who live and work around it.[1]

Maine Coast, in which Homer eliminates the human figure, exemplifies the furthest end of this spectrum. From paintings that include only a slice of ocean and yet imply a causal relation between sea and human life Homer moves to pure seascapes, such as *Maine Coast* or *Northeaster* (Metropolitan Museum of Art, New York). In the 1895 *Northeaster*, Homer included two men in sou-westers; in 1900, he painted the figures out, making the picture more abstract and, perhaps, more symbolic. Eliminating the figures from these compositions emphasises the relation between human and nature — the human 'presence' now being that of the viewer. At the time, Homer wrote to Thomas B. Clarke, the first owner of *Northeaster*, about the alteration: 'You have seen it before but I have made it much finer'.[2] Clarke owned *Maine Coast* from 1897 to 1899.[3]

A New York City businessman, Clarke was a 'brain-worker', a nineteenth-century term for those (male) workers — manufacturers, merchants, railway officials, brokers, lawyers, physicists, and clergymen — whose occupations were divorced from any physical connection with the land. These men were particularly susceptible to neurasthenia, a condition characterised by a lack of energy and attributed to the stress of their work. For Clarke and others of this group, an encounter with the wilderness was a cure. One contemporary writer remarked that Homer's paintings blew 'city smoke out of the lungs', and another: 'It is like a breath of health and life to come among these pictures.'[4] Homer took the New England landscape and made it 'masculine' — a shift from the picturesque and nostalgic depictions by such artists as Eastman Johnson.[5]

The viewer's encounter with the painted surface of the canvas simulates humans' actual encounter with the sea and epitomises the artist's integration of the figure into the landscape. Samuel Isham described Homer's seascapes in 1905:

> great swells roll in out of the fog, and slowly heap themselves up against the granite coast without foam, without effort, until with the ebb the thousands of tons of clear green water grind crashing down through the crevices of the rocks, we feel the awful, elemental force ... the verbs *roll*, *heap*, *grind*, and *feel* evoke not only the action of the sea but also something of the act of painting which is preserved on these canvases.[6]

They also evoke the experience of standing on the coast of Prout's Neck and watching the water and, by extension, the relation between human and nature.[7]

AE

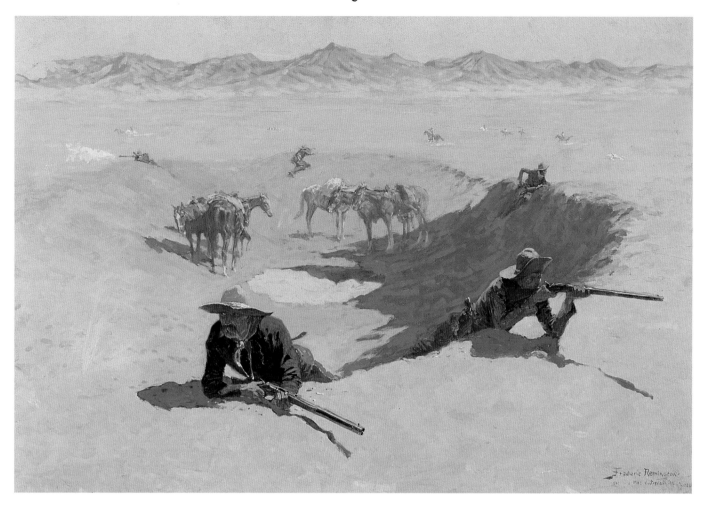

123. *Fight for the Water Hole* c.1903

oil on canvas 69.2 x 102.0 cm (27-1/4 x 40-1/8 in) Museum of Fine Arts Houston, Texas The Hogg Brothers Collection, gift of Miss Ima Hogg

Fight for the Water Hole is one of Frederic Remington's paintings on the theme of 'the last stand'. In it, five cowboys, armed with rifles, defend a nearly dry water hole in the south-western desert from approaching Indians. The cowboys are faced with the possibility of death by two causes: one, dehydration; and two, Indians.[1] As Alexander Nemerov has recently pointed out, in this painting the threat of the Native Americans can be understood on another level. Not only are they a physical threat to the cowboy — or white Anglo-Saxon — but they are also a social threat. In Remington's own mind, Native Americans, or 'inguns' as he called them, were a foreign group; he ignored the fact that they had been inhabitants of the continent long before European settlers. Remington also found the increased influx of non-Anglo-Saxon immigrants to the United States dangerous.[2]

In 1901, with the assassination of President William McKinley, Vice President Theodore Roosevelt took over. Roosevelt was a progressive and supported a number of reforms including consumer protection, labour mediation, and conservation. The other side of progressivism — a complex and heterogeneous movement — however, was its emphasis on social and moral control that resulted in prohibition, censorship, and immigration restriction.[3] It was Roosevelt's emphasis on physical strength and the perceived attributes of masculinity, along with the prevailing Anglo-Saxon bias of the day, that spoke to Remington, who forged a friendship with the president.

Remington's use of realism in *Fight for the Water Hole* misled viewers to see the painting as an objective depiction of what happened in the West rather than as a myth. He accurately and illusionistically depicts elements such as the rifle held by the foremost cowboy and the scattered shells on the sand, and these objects seem to attest to the authenticity of the scene. But they also suggest its historical position in time. The cowboys represent the Anglo–Saxon defence of not only the land for settlement, but also their position in history as the virile and brave in a world becoming increasingly feminised. Though emblematic of a 'primitive' way of life, the cowboys, too, were doomed to extinction.[4]

AE

Notes

Cat.103 William Ford *At the Hanging Rock*
1 'The Hanging Rock, near Woodend', *Australasian Sketcher*,17 February 1877, p.182.
2 The fame of Ford's picture spread when its previous title, 'Picnic at Hanging Rock', was used by Joan Lindsay as the title of her popular novel (Melbourne, 1967), and for the film (1976) that was based on it.
3 *Australasian Sketcher*,17 February 1877, p.182.
4 *Argus*, Melbourne, Supplement, 3 September 1875, p.6.
5 *The Illustrated Australian News*, Melbourne, 6 October 1875, p.158.

Cat.104 Tom Roberts *A Summer Morning Tiff*
1 Helen Topliss, *The Artists' Camps: 'Plein Air' Painting in Australia*, Alphington, Melbourne: Hedley, 1992, p.65.
2 William Moore, *The Story of Australian Art*, Sydney: Angus and Robertson, 1934, vol.1, p.70.
3 Topliss, *The Artists' Camps* (1992), p.69.
4 For the complete poem see Mary Eagle, 'A Painter Making Himself', in Ron Radford ed., *Tom Roberts*, exhibition catalogue, Adelaide: Art Gallery of South Australia, 1996, p.50.
4 Helen Topliss, *Tom Roberts: A Catalogue Raisonné*, Melbourne: Oxford University Press, 1985, vol.1, p.94.

Cat.105 Tom Roberts *Allegro con brio; Bourke Street West*
1 Based on an inscription that appears under a photograph of the painting in one of the artist's scrapbooks. Buckley and Nunn's was located at 25–29 Bourke Street East. From Humphrey McQueen, *Tom Roberts*, Sydney: Macmillan, p.216; and Helen Topliss, *Tom Roberts: A Catalogue Raisonné*, Melbourne: Oxford University Press, 1985, vol.1, p.93.
2 Mary Eagle identifies the writing in Roberts's scrapbook as that of the artist's first biographer, R.H. Croll, and states that 'A high viewpoint close to the GPO is consistent with the angle from which the street is shown'. Mary Eagle, *The Oil Paintings of Tom Roberts in the National Gallery of Australia*, Canberra: National Gallery of Australia, 1997, p.29.
3 Jane Clark and Bridget Whitelaw, *Golden Summers; Heidelberg and Beyond*, Melbourne: International Cultural Corporation of Australia, 1985, p.82.
4 Ibid., and Eagle, *The Oil Paintings of Tom Roberts* (1997), p.30.
5 Topliss, *Tom Roberts* (1985), vol.1, p.93.
6 *Table Talk*, Melbourne, 28 November 1890, in Clark and Whitelaw, *Golden Summers* (1985), p.82.
7 Topliss, *Tom Roberts* (1985), vol.1, p.93.

Cat.106 Tom Roberts *Slumbering Sea, Mentone*
1 William Moore *The Story of Australian Art*, Sydney: Angus and Robertson, 1934, vol.1, p.71.
2 *Argus*, Melbourne, 5 March 1887, p.14.

Cat.107 Arthur Streeton *Golden Summer, Eaglemont*
1 See Mary Eagle *The Oil Paintings of Arthur Streeton in the National Gallery of Australia*, Canberra: National Gallery of Australia, 1994, p.29.
2 *Impression for Golden Summer* is in the collection of Benalla Art Gallery, Victoria.
3 *Table Talk*, Melbourne, 10 May 1889, p.6, quoted in Geoffrey Smith, *Arthur Streeton 1867–1943*, exhibition catalogue, Melbourne: National Gallery of Victoria, 1995, p.29.
4 Streeton refers to Lindsay's review in a letter of 27 March 1924: Ann Galbally and Anne Gray eds, *Letters from Smike; The Letters of Arthur Streeton 1890–1943*, Melbourne: Oxford University Press, 1989, p.178.

Cat.108 Frederick McCubbin *Down on His Luck*
1 Bridget Whitelaw, *The Art of Frederick McCubbin*, exhibition catalogue, Melbourne: National Gallery of Victoria, 1991, p.48.
2 Leigh Astbury, 'Independence:"Thoroughly Australian in Spirit"', in Daniel Thomas ed., *Creating Australia: 200 Years of Art 1788–1988*, Sydney: International Cultural Corporation of Australia, 1988, p.188.

Cat.109 Arthur Streeton *From McMahon's Point – Fare One Penny*
1 Streeton to Roberts, July or August 1890, Tom Roberts papers, State Library of New South Wales, Sydney, quoted in Mary Eagle, *The Oil Paintings of Arthur Streeton in the National Gallery of Australia*, Canberra: National Gallery of Australia, 1994, p.66.
2 Ibid., p.69.
3 *Sydney Morning Herald*, 6 September 1890, p.5.

Cat.110 Arthur Streeton *The Selector's Hut: Whelan on the Log*
1 Mary Eagle *The Oil Paintings of Arthur Streeton in the National Gallery of Australia*, Canberra: National Gallery of Australia, 1994, p.57.
2 James Smith, *Argus*, Melbourne, 29 March 1890, p.11, quoted in ibid.

Cat.111 Tom Roberts *A Break Away!*
1 Jane Clark and Bridget Whitelaw, *Golden Summers; Heidelberg and Beyond*, Melbourne: International Cultural Corporation of Australia, 1985, p.136.
2 Jane Hylton, 'A break away!, 1891', in Ron Radford ed., *Tom Roberts*, exhibition catalogue, Adelaide: Art Gallery of South Australia, 1996, p.108.
3 Clark and Whitelaw, *Golden Summers* (1985), p.136.
4 Helen Topliss, *Tom Roberts: A Catalogue Raisonné*, Melbourne: Oxford University Press, 1985, p.119.
5 Hylton, in Radford *Tom Roberts* (1996), p.108.

Cat.112 Arthur Streeton *The Valley of the Nepean*
1 For details of the competition see author's introductory essay, this catalogue pp.53–69. For Streeton's decision to move to Sydney see Mary Eagle *The Oil Paintings of Arthur Streeton in the National Gallery of Australia*, Canberra: National Gallery of Australia, 1994, p.60.
2 Streeton to Tom Roberts, December 1891, in Ann Galbally and Anne Gray eds, *Letters from Smike; The Letters of Arthur Streeton 1890–1943*, Melbourne: Oxford University Press, 1989, pp.38–39.

Cat.113 Arthur Streeton *The Railway Station, Redfern*
1 William Moore, *The Story of Australian Art*, Sydney: Angus and Robertson, 1934, vol. 2, p.27.
2 Arthur Streeton to Tom Roberts, 16 November 1893, in Ann Galbally and Anne Gray eds, *Letters from Smike: The Letters of Arthur Streeton 1890–1943*, Melbourne: Oxford University Press, 1989, p.61.

Cat.114 Clara Southern *An Old Bee Farm*
1 *Table Talk*, Melbourne, 8 November 1900.

Cat. 115 Winslow Homer *Long Branch, New Jersey*
1 On Long Branch as a summer resort, see Floyd and Marion Rinhart, *Summertime: Photographs of Americans at Play 1850–1900*, New York: Clarkson N. Potter Inc., Publishers, 1978, pp. 58–63.
2 'The Watering Places, Long Branch', *New York Evening Post*, 28 July 1868, as quoted in Nicolai Cikovsky Jr and Franklin Kelly et al., *Winslow Homer*, exhibition catalogue, New Haven and London: Yale University Press, in association with the National Gallery of Art, Washington, DC, 1995, p.80.
3 Nicolai Cikovsky Jr, 'Winslow Homer's National Style', in Thomas Gaehtgens and Heinz Ickstadt, *American Icons: Transatlantic Perspectives on Eighteenth- and Nineteenth-Century American Art*, Santa Monica, California: The Getty Center for the History of Art and the Humanities, 1992, pp.250–253.
4 Ibid., p.253.
5 'American Summer Resorts. VII. Long Branch', *Appleton's Journal*, 12, 3 October 1874, p.431, as quoted in Cikovsky and Kelly et al., *Winslow Homer* (1995), p.79.
6 See Henry Adams, 'Winslow Homer's "Impresisionism" and Its Relation to His Trip to France, in Nicolai Cikovsky Jr, *Winslow Homer: A Symposium, Studies in the History of Art*, 26, Symposium Papers 11, Hanover and London: University Press of New England, in association with the National Gallery of Art, Washington, DC, 1990, pp.61–89.

Cat.116 Winslow Homer *Two Guides*
1 David Tatham, *Winslow Homer in the Adirondacks*, Syracuse, New York: Syracuse University Press, 1996, pp.68–69.
2 David Tatham, '*The Two Guides*: Winslow Homer at Keene Valley, Adirondacks', *American Art Journal*, vol.20, no.2, 1988, p.28. See also David Tatham, *Winslow Homer* (1996), p.71.
3 Warner, 'A Character Study', in *In the Wilderness*, p.49, as quoted in Tatham, *Winslow Homer* (1996), p 69. For more on Phelps and Holt, see ibid.
4 See Tatham, *Winslow Homer* (1996), pp. 68, 72.
5 Ibid., p.75.
6 See Sarah Burns, 'Revitalizing the "Painted-Out" North: Winslow Homer, Manly Health, and New England Regionalism in Turn-of-the Century America', *American Art*, vol.9, no.2, Summer 1995, p.30. Although Burns is primarily writing about Homer's paintings from the 1880s and the 1890s, she does cite *The Two Guides* as an early manifestation of what she sees as a prevailing theme in Homer's later work. See ibid., p.21.
7 Michael S. Durham, *The Smithsonian Guide to Historic America: The Mid-Atlantic States*, New York: Stewart, Tabori and Chang, 1989, p.241. The Williams College professor was Ebenezer Emmons, author of *Geology of New-York* (1842).

Cat.117 Thomas Eakins *Mending the Nets*

1 Elizabeth Johns, *Thomas Eakins: The Heroism of Modern Life*, Princeton, New Jersey: Princeton University Press, 1983, p.xix. Kathleen A. Foster has pointed out that 30 per cent of Eakins's artistic output was landscape. See Foster, 'Realism or Impressionism? The Landscapes of Thomas Eakins', in Doreen Bolger and Nicolai Cikovsky Jr, *American Art around 1900: Lectures in Memory of Daniel Fraad*, Studies in the History of Art, 37, Symposium Papers 21, Hanover and London: University Press of New England, in association with the National Gallery of Art, Washington, 1990, pp 69, 77.

2 Kathleen A. Foster, *Thomas Eakins Rediscovered,* New Haven: Yale University Press, 1997, ms. p.254. I am grateful to Dr Foster who shared with me her manuscript for chapter 16, 'Gloucester Landscapes: "Camera Vision" and Impressionism', from her forthcoming book.

3 Lloyd Goodrich, *Thomas Eakins*, exhibition catalogue, Cambridge, Massachusetts, and London: Harvard University Press, in association with the National Gallery of Art, Washington, 1982, vol.1, p.206.

4 Foster, in Bolger and Cikovsky, *American Art around 1900* (1990), pp.77–78.

5 See Foster, *Thomas Eakins Rediscovered* (1997), ms. p.255.

6 See ibid., ch.16, ms. p.262.

7 Theodor Siegl, cited in ibid., ms. p.263. See ibid., ms. p.264 as well. See entry for *Mending the Net*, cat.40, in Theodor Siegl, *The Thomas Eakins Collection*, Philadelphia: Philadelphia Museum of Art, 1978, p.93. Foster goes into much greater detail in sorting out Eakins's working method with regard to this painting and others in the Gloucester series than can be incorporated in this entry. See Foster, *Thomas Eakins Rediscovered* (1997), ch.16.

Cats 118, 119 William Merritt Chase *A City Park; Prospect Park, Brooklyn*

1 H. Barbara Weinberg, Doreen Bolger and David Park Curry, *American Impressionism and Realism: The Painting of Modern Life, 1885–1915*, exhibition catalogue, New York: Harry N. Abrams, Inc., in association with The Metropolitan Museum of Art, 1994, p.139.

2 Barbara Dayer Gallati, *William Merritt Chase*, Washington, D.C.: National Museum of American Art, Smithsonian Institution, in association with Harry N. Abrams, Inc., Publishers, 1995, p.71.

3 Weinberg et al., *American Impressionism and Realism* (1994), pp.139–140.

4 Gallati, *William Merritt Chase* (1995), p 73.

5 Ibid., p.71.

6 David Schuyler and Jane Turner Censer eds, *The Papers of Frederic Law Olmsted*, vol.6, *The Years of Olmsted, Vaux, and Company, 1865–1874*, Baltimore, Maryland, and London, 1992, p.395, quoted in Kimberly Rhodes, entry for William Merritt Chase, *A City Park*, to be published in a forthcoming catalogue of American art in the collection of the Art Institute of Chicago.

7 Weinberg et al., *American Impressionism and Realism* (1994), pp.147–148.

8 Elizabeth Barlow, *Frederic Law Olmsted's New York*, exhibition catalogue, New York, Washington, and London: Praeger Publishers, in association with the Whitney Museum of American Art, 1972, p.47.

9 Weinberg et al., *American Impressionism and Realism* (1994), p.148.

10 Kathleen Pyne, *Art and the Higher Life: Painting and Evolutionary Thought in Late Nineteenth-Century America*, Austin: University of Texas Press, 1996, pp.262–263. See also Weinberg et al., *American Impression and Realism* (1994), p.145.

11 Ibid., p.147.

Cat.120 William Merritt Chase *Untitled (Shinnecock Landscape)*

1 Barbara Weinberg, Doreen Bolger and David Park Curry, *American Impressionism and Realism: The Painting of Modern Life, 1885–1915*, exhibition catalogue, New York: Harry N. Abrams, Inc., in association with The Metropolitan Museum of Art, 1994, p.107.

2 Barbara Dayer Gallati, *William Merritt Chase*, Washington, D.C.: National Museum of American Art, Smithsonian Institution, in association with Harry N. Abrams, Inc., Publishers, 1995, p.77. On Chase's Shinnecock paintings, see D. Scott Atkinson and Nicolai Cikovsky Jr, *William Merritt Chase: Summers at Shinnecock 1891–1902*, exhibition catalogue, Washington, DC: National Gallery of Art, 1987.

3 Gallati, *William Merritt Chase* (1995), p.77, and Weinberg et al., *American Impressionism and Realism* (1994), p.107.

4 Ibid., p.108. The quote is from 'Complete Guide to the Day Summer Resorts About New York', *New York Sunday Press*, supement, 12 June 1892, p.19, quoted in Fiorino, 'At the Seaside', pp. 9–10, and, from Fiorino, in Weinberg et al., *American Impressionism and Realism* (1994), p.108.

5 Ibid.

6 Chase, as quoted in Gallati, *William Merritt Chase* (1995), pp.83–84.

Cat.121 Childe Hassam *In the Garden (Celia Thaxter in her Garden)*

1 Publisher's Note to 1988 reprint of Celia Thaxter, *An Island Garden*, Boston: Houghton Mifflin Company, 1894, p.v.

2 Thaxter, *An Island Garden* (1894), p.vi.

3 For biographical information on Celia Thaxter, see Dumas Malone ed., *Dictionary of American Biography*, New York: Charles Scribner's Sons, 1936, vol.18, pp.397–398.

4 H. Barbara Weinberg, Doreen Bolger and David Park Curry, *American Impressionism and Realism*, exhibition catalogue, New York: Harry N. Abrams, Inc., in association with The Metropolitan Museum of Art, New York, 1994, p.92.

5 See, for example, William H. Harris and Judith S. Levey eds, *The New Columbia Encyclopedia*, New York and London: Columbia University Press, 1975, p.758.

6 David Park Curry, *Childe Hassam: An Island Garden Revisited*, exhibition catalogue, New York and London: W.W. Norton and Company, in association with the Denver Art Museum, 1990, p.70.

Cat.122 Winslow Homer *Maine Coast*

1 David Tatham, 'Winslow Homer and the Sea', in Philip C. Beam et al., *Winslow Homer in the 1890s: Prout's Neck Observed*, exhibition catalogue, New York: Hudson Hills Press, in association with the Memorial Art Gallery of the University of Rochester, 1990, pp.66, 78–81.

2 See entry for *Northeaster* in Natalie Spassky et al., *American Paintings in The Metropolitan Museum of Art*, Princeton, New Jersey: Princeton University Press, in association with The Metropolitan Museum of Art, 1985, vol.2, p.471. See also Nicolai Cikovsky Jr and Franklin Kelly et al., *Winslow Homer*, exhibition catalogue, New Haven and London: Yale University Press in association with the National Gallery of Art, Washington, 1995, entry 193–195, p.333.

3 See entry for *Maine Coast* in Spassky et al., *American Paintings* (1985), pp.479–482.

4 Sarah Burns, 'Revitalizing the "Painted-Out" North: Winslow Homer, Manly Health, and New England Regionalism in Turn-of-the-Century America', *American Art*, vol.9, no.2, Summer 1995, p.26.

5 Ibid., pp.22–23, 28.

6 Tatham in Beam et al., *Winslow Homer in the 1890s* (1990), p.67. Tatham quotes from Samuel Isham, *History of American Paintings*, New York: Macmillan, 1905, p.355.

7 Burns, in *American Art* (1995), p.25.

Cat.123 Frederic Remington *Fight for the Water Hole*

1 James K. Ballinger, *Frederic Remington*, exhibition catalogue, New York: Harry N. Abrams, Inc., in association with the National Museum of American Art, 1989, pp.110–111, and Ballinger, *Frederic Remington's Southwest*, exhibition catalogue, Phoenix, Arizona: Phoenix Art Museum, 1992, p.78.

2 Remington, quoted in Alexander Nemerov, '"Doing the Old America": The Image of the American West, 1880-1920', in William H. Truettner, ed., *The West as America: Reinterpreting Images of the Frontier, 1820–1920*, exhibition catalogue, Washington and London: Smithsonian Institution Press, for the National Museum of American Art, 1991, p.298.

3 See, for example, Paul S. Boyer et al., *The Enduring Vision: A History of the American People*, 2nd edn, Lexington, Masachusetts, and Toronto: D.C. Heath and Company, 1993, pp.726–727, 733–734, 739–742, 746–754.

6 See Nemerov, 'Frederic Remington & Turn-of-the-Century America', in Treuttner ed., *The West as America* (1991), pp.290–294.

Artists in Australia – Biographies

Ludwig Becker
Offenbach, Germany, 1808 – Bulloo, Queensland, 1861
(Australia from 1851)

Ludwig Becker was one of a number of German artists who travelled to Australia in the nineteenth century. He received his first artistic training while still at school, from teachers of the Darmstadt Gallery. During this time he met Johann Kaup, who became an eminent zoologist and a lifelong friend of Becker. In 1829 Becker was employed by a publishing firm in Frankfurt am Main where he worked as a painter and acquired lithographic skills. He also formally studied lithography at the Städelsches Institut under Peter Vogel.

In 1834 Becker was granted a residence permit in Frankfurt as a portrait painter. From 1840 to 1844 he held the position of court painter to the Archduke of Hesse-Darmstadt: his application for the post indicated that he had obtained an extensive knowledge of natural sciences. During the revolution of 1848 Becker left Germany (perhaps to avoid investigation for possible political activities). His whereabouts are uncertain until 1850 when, travelling in England and Scotland, he decided to emigrate to Australia.

Becker arrived in Launceston in 1851. His strong interests in arts and science and his social connections gave him entry to the highest circles and he was a popular guest at government functions. He travelled in Van Diemen's Land (later officially known as Tasmania), earning a living painting miniatures, before moving in 1852 to the mainland and the goldfields of Bendigo. Becker spent two years gold digging. During this time he continued to draw and publish on astronomy and meteorology. His sketches of the Bendigo goldfields were exhibited at the Melbourne Mechanics Institute in 1854. Becker became a leading member of the German community; he was elected to the council of the Victorian Society of Fine Arts in 1856, and to the council of the Philosophical Institute of Victoria in 1859.

In 1859 Becker joined the Victorian Exploring Expedition led by Robert O'Hara Burke — whose aim was to travel a south to north route across the continent of Australia. As the expedition's artist–naturalist, Becker completed five full reports which included detailed sketches of outback landscapes (cats 14–19), and flora and fauna as well as notes regarding the customs of local Aborigines. It was an arduous journey and Becker became ill, suffering from dysentery, scurvy and exhaustion. On 1 April 1861 Becker took his last scientific readings before collapsing. He died on 29 April 1861.

Further reading: Tipping, Majorie ed., *Ludwig Becker: Artist and Naturalist with the Burke & Wills Expedition*, Melbourne: Melbourne University Press, 1979.

William Blandowski
Gleiwitz, Silesia, 1822 – c.1876
(Australia 1849–59)

The son of a lieutenant-colonel in the Prussian army, William Blandowski trained at the Tarnowitz Mining School and the University of Berlin. He arrived in Australia in 1849 — as a draughtsman and mineralogist his intention was to make geological and botanical surveys of the unique Australian environment. His ship docked in Adelaide and he quickly organised travel into the north, east and south-east regions of South Australia where he sketched and mapped the terrain. From Mt Gambier, Blandowski travelled overland to the goldfields of Victoria. He apparently made a substantial amount of money both as a miner and as the designer of a water pump which was widely used for clearing mine shafts.

Blandowski was a founding member of the Geological Society of Victoria in 1852, and of the Philosophical Society of Victoria in 1854. He was appointed government zoologist in 1854 and, as such, he organised three important expeditions, the most significant being a journey to the junction of the Murray and Darling rivers in 1856 where he collected over 17,000 natural history specimens and identified 19 previously unrecorded species of fish. He was accompanied on this expedition by Gerard Krefft, a German naturalist who produced some 500 drawings. Twenty-nine engravings from Blandowski's drawings of scenes in Victoria and South Australia were included in a portfolio titled 'Australia Terra Cognita' (1855–59) (cats 12, 13).

Taking many of his Australian sketches with him, Blandowski left Melbourne in 1859 for Java, then journeyed to Hamburg. He returned to Gleiwitz and established himself as a photographer. There in 1862 he published papers relating to his scientific findings in Australia as well as a 52-page booklet containing 142 prints of Australian subjects — these were photographs of paintings based on his sketches which had been worked up by Gustav Mutzel who later established a reputation as a natural history painter. Little is known of Blandowski's final years; he died in Gleiwitz c.1876.

Knut Bull
Bergen, Norway, 1811 – Sydney, New South Wales, 1889
(Australia from 1846)

Although some of Knut Bull's early landscapes and portraits can be found in Norwegian collections, there are no records available of his early years there; it has been suggested that he had his first formal art training in Copenhagen. It is known that Bull studied in Dresden, Germany, under the Norwegian J.C. Dahl in 1833–34 and again in 1838.

In 1845 Knut Bull travelled to London and within five weeks was arrested for 'feloniously making part of a foreign note for 100 dollars'. The reason for his foray into forgery is not known but may have stemmed from frustration at his lack of financial success as a painter. He was sentenced to 14 years transportation and sent to Norfolk Island where he arrived in 1846. He was transferred to the Saltwater River probation station in Van Diemen's Land in 1847. Throughout this period Bull sketched and painted. In May 1849 he received a certificate of general good conduct which enabled him, with official consent, to accept payment for private work. He taught at Mrs Rogers's Seminary and then absconded to Melbourne where he was quickly recaptured and returned to Hobart. He received a ticket of leave in 1852 and in that year married a free woman, Mary Anne Bryan — they subsequently had a family of four children. In 1853 Bull was granted a conditional pardon.

Bull spent the next four years teaching and painting. During this period he painted *View of Hobart Town* (cat.44) and *Hobart Town and Mount Nelson* which were shown at the 1855 International Exhibition in Paris — the first time Australian art was officially shown in Europe. Lithographs of his Hobart landscapes, produced locally by E. Walker, were sent to England to be used as promotional material to encourage potential emigrants. In 1856 Bull moved to Sydney where he advertised as an artist; in 1868 he was contracted to paint a large transparency to celebrate the visit of the Duke of Edinburgh in January that year.

Bull died in Sydney in 1889 of typhoid fever.

Louis Buvelot

Morges, Switzerland, 1814 – Melbourne, Victoria, 1888
(Australia from 1865)

After spending his childhood in Morges, Louis Buvelot moved to Lausanne in 1830 to study art under Marc-Louis Arlaud. In 1834 he went to Paris to study with Camille Flers. The next year he travelled to Brazil where his uncle owned a coffee plantation. In 1842 Buvelot joined Auguste Moreau, the French history painter, in producing *Rio de Janeiro Pitoresco*, a series of lithographs of the city and surroundings.

Buvelot first exhibited with the Rio Academy of Fine Arts in 1840, and he continued to exhibit landscapes until his departure from Brazil 1852 — he received a gold medal from the Academy after the exhibition in 1842.

With his family, Buvelot returned to Switzerland in 1852 — he had married in 1843. He was unsuccessful in his attempts to establish himself as a photographer or a painter there, and he moved to Calcutta in 1854 with Ferdinand Krumholtz, an Austrian artist he had met in Rio de Janeiro. Again unable to make a living as a photographer, he returned to Switzerland in 1855 and took a post as drawing master at an experimental industrial school at La Chaux-de-Fonds, Neuchâtel. In 1864 Buvelot left his family and travelled to England. From there he sailed to Victoria accompanied by Caroline-Julie Beguin, a fellow teacher from La Chaux-de-Fonds.

Shortly after his arrival in Melbourne in 1865 Buvelot bought a photographer's studio, and he also resumed painting. His landscapes were included in many Victorian and international exhibitions from 1866 to 1882 and his work was well received. In 1869 Buvelot taught landscape drawing at the Artisans' School of Design in Melbourne, and in 1870 he applied for the position of head of the newly established National Gallery School, but Eugène von Guérard received the appointment.

Buvelot's reputation as one of Victoria's leading landscapists was confirmed in 1869–70 when three of his paintings, including *Waterpool near Coleraine (Sunset)* (cat.83), were purchased by the National Gallery of Victoria. In his later years Buvelot taught privately. In 1888 he died in Melbourne. Buvelot was acknowledged by a younger generation of artists, particularly Tom Roberts, as the pioneer of Australian landscape painting.

Further reading: Jocelyn Gray, 'A New Vision: Louis Buvelot's Press in the 1870s', in Galbally, Ann and Plant, Margaret, *Studies in Australian Art,* Melbourne: University of Melbourne, 1978

J.H Carse

c.1820, Edinburgh, Scotland – Sydney, New South Wales, 1900
(Australia from c.mid-1860s)

J.H. Carse trained at the Royal Scottish Academy — his father, the painter Alexander Carse, had been a founding member of the Academy. From 1860 to 1862 Carse was in London where he exhibited landscapes. The date of his arrival in Melbourne is not known but it was probably the mid-1860s. He also visited and painted in New Zealand before 1869 — as seven of his landscapes, including scenes of New Zealand and some of Victoria, were exhibited and available for sale in Melbourne that year. He is credited with providing drawings for Edwin Carton Booth's *Australia Illustrated*, of scenes as far afield as King George Sound, Western Australia, and Townsville in Queensland — indicating that Carse travelled extensively.

Carse was a founder member of the Victorian Academy of the Arts in 1870. In the following year he moved to Sydney and in 1872 he became a member of the New South Wales Academy of Art. He was awarded a certificate of merit at the Academy's second exhibition for his landscape, *Weatherboard Falls* 1873 (cat.69). In 1875 two oils of Australian subjects won first class certificates at the Intercolonial Exhibition in Melbourne and were sent to the 1876 Philadelphia Centennial Exhibition. Although Carse continued to receive awards, his work found less favour with the critics. In 1880 he was a founder member of the Art Society of New South Wales, established by a group of artists who had become disatisfied with the New South Wales Academy of Art. He exhibited regularly with the Society until 1885.

Carse continued to paint landscapes but the quality of his work deteriorated as he struggled with alcoholism. He died in Sydney in 1900.

Nicholas Chevalier
St Petersburg, Russia, 1828 – London, England, 1902
(Australia 1854–68)

Nicholas Chevalier lived in Russia until 1845 when the family returned to his father's native Switzerland. Chevalier showed early artistic talent; he studied art in Lausanne under J.S. Guignard, and then architecture in Munich. He moved to London in 1851 where he began painting watercolours and studied lithography under Louis Grüner. He exhibited in the 1852 Royal Academy Exhibition, and in 1853 travelled to Italy to continue his art studies.

At the end of 1854 Chevalier arrived in Melbourne to join his brother and attend to family business interests. He quickly gained work as an artist and cartoonist with *Melbourne Punch* and then as illustrator for *The Illustrated Australian News*. He exhibited some watercolours in Melbourne in 1856, and in the following year he exhibited oil paintings with the Victorian Society of Fine Arts.

Chevalier travelled throughout Victoria and continued to paint landscapes in watercolours and oils. He visited New Zealand three times between 1865 and 1869 and was paid by provincial councils to produce works which could be used in Europe to encourage emigrants. In 1866 he produced for sale a portfolio of 12 chromolithographs; and in that year he exhibited at the Intercolonial Exhibition in Melbourne. In 1867 he was engaged to produce the decorations for the visit to Melbourne of Prince Alfred, the Duke of Edinburgh. Subsequently Chevalier was asked to join the royal party on their visit to Tasmania. He produced pen-and-ink drawings of the journey and an invitation followed to accompany the entourage on the return voyage to England. Chevalier left Australia in 1868 and he recorded Prince Alfred's official engagements as they travelled throughout the Pacific, then to Japan, China, India and Ceylon. He arrived in London in 1870 and his sketches were exhibited there in 1872.

Chevalier enjoyed royal patronage over the next decade and produced watercolours for Queen Victoria recording court events. His works continued to be exhibited in Australia; and in 1882 he was appointed London adviser to the Art Gallery of New South Wales. Chevalier died in 1902.

Further reading: Day, Melvin, *Nicholas Chevalier, Artist: His Life and Work with Special Reference to his Career in New Zealand and Australia,* Wellington: Milwood, 1981

David Davies
Ballarat, Victoria, 1864 – Looe, Cornwall, England, 1939
(France/England 1890–93, 1897–1939)

The son of a Welsh miner living in Ballarat, David Davies attended art and design classes at the Ballarat School of Mines and Industries and in 1887 travelled to Melbourne to take classes at the National Gallery School under George Folingsby. With his fellow students at the School, including Frederick McCubbin,

Charles Conder and Tom Roberts, he frequently went on painting excursions to Eaglemont on the outskirts of Melbourne near Heidelberg.

In 1890 Davies went to Paris to study under Jean-Paul Laurens at the Académie Julian. Davies later moved to England and painted at the artists' colony of St Ives in Cornwall. In 1893 he returned to Australia and settled at Templestowe, Victoria. There, from 1893 to 1897, Davies painted his famous series of moonrise subjects, and in 1896 the National Gallery of Victoria purchased *Moonrise* 1894 (cat.88) — the largest and most widely admired of the series.

In 1897 Davies returned to England with his family. A painting of his was accepted for exhibition by the New English Arts Club in 1898; he also exhibited with the Ridley Art Club and the Royal Academy. From 1905 to 1907 he spent periods painting at a studio in London, returning as often as possible to his family who had moved from Cornwall to Wales. In 1908 the family moved to the French coastal town of Dieppe, where Davies painted and gave lessons, principally in watercolour painting. A successful exhibition of Davies's work, mostly French landscapes, was held in Melbourne in 1926.

Apart from returning to England during World War I, the Davies family remained in Dieppe until 1932 when they moved back to Cornwall. In that year a large exhibition of Davies's work was held in Plymouth.

Although his health was deteriorating Davies continued painting. In 1936 his *Evening, Looe* was shown at the Royal Institute of Painters in Water-Colours — the last of his paintings to be shown in a major exhibition during his lifetime. He died in Looe, Cornwall, in 1939.

Further reading: Sparks, Cameron, *David Davies, 1864–1939,* exhibition catalogue, Ballarat: Ballarat Fine Art Gallery, 1984

Augustus Earle
London, England, 1793 – 1838
(Australia/New Zealand 1825–28)

Augustus Earle was the son of the American painter James Earl and nephew of the American portraitist Ralph Earl; both had fled to England because of loyalist sympathies. Augustus showed his artistic talent at a very early age and first exhibited at the Royal Academy when he was just thirteen. By 1815 he had exhibited seven paintings at the Academy, mostly historical subjects.

In 1815 Augustus Earle sailed to Malta and spent the next two years travelling and painting in the Mediterranean region. Following his return to England in 1817, one of his scenes of Valetta was engraved and published. In 1818 he left for North America, and that year he exhibited two paintings at the Pennsylvania Academy of Fine Arts. In 1820 Earle travelled to South America; in Rio de Janeiro he started a series of watercolours to record his extensive travels.

Augustus Earle left South America for India in 1824, but was marooned for eight months on Tristan da Cunha, a small island settlement in the Atlantic, until rescued by the *Admiral Cockburn* bound for Hobart. Earle disembarked there in 1825. He was enthusiastic about the local landscape and produced a number of watercolour views of Hobart Town which were later developed into a large panorama by the London entrepreneur Robert Burford.

After four months in Hobart, Earle sailed for Sydney where he became the colony's foremost artist and received commissions for portrait paintings. He opened a small gallery of his own work and advertised lessons in drawing and painting. He started to experiment in lithography and produced four views of Sydney which were published in 1826 as part of a proposed series of 'Views in Australia'. Earle's journeys into the regions around Sydney resulted in a collection of sketches of the local Aboriginal people and regional landscapes (the majority of which are in the Rex Nan Kivell Collection, National Library of Australia, Canberra).

Earle travelled to New Zealand in 1827 and remained there for six months making pictorial records of the environment and the indigenous people. He was in Sydney briefly in 1828 then departed for the Pacific and South-East Asia before returning to England in 1829. Earle's lithographs of *Views in New South Wales and Van Diemen's Land* were published in 1830, and his lithographs of views of South America and New Zealand were published in 1832.

In 1832 Earle joined the *Beagle* as the artist accompanying Charles Darwin's expedition to Tierra del Fuego and Rio de Janeiro, but he fell ill in Rio and was unable to continue the voyage (Conrad Martens took his place). Earle returned to London in 1833, and though his health remained poor and his ability to travel was restricted he continued to paint. He exhibited at the Royal Academy in 1837 and again in 1838 — the latter painting was his *A Bivouac of Travellers in Australia in a Cabbage Tree Forest, Daybreak* (cat.8), based on a watercolour made in the Illawarra region of New South Wales. In 1838 Earle provided watercolours of the Bay of Islands for another panorama painted by Robert Burford and he published a series of 10 coloured lithographs as *Sketches Illustrative of the Native Inhabitants of New Zealand and Islands*. This was his last major work. Earle's health deteriorated rapidly and he died in London late in 1838.

Further reading: Hackforth-Jones, Jocelyn, *Augustus Earle, Travel Artist: Paintings and Drawings in the Rex Nan Kivell Collection*, Canberra: National Library of Australia

William Ford
England, 1820 – Melbourne, Victoria, 1886
(Australia from 1871)

It is likely that William Ford received his art training in London, as he was certainly a skilled and respected painter when he arrived in Australia. To help establish his reputation prior to his arrival he had sent paintings ahead, and these were exhibited with the Victorian Academy of Arts in 1870.

With his wife and young son, Ford emigrated to Australia, arriving in Melbourne in September 1871. The family settled at the beachside suburb of St Kilda, Melbourne, and Ford quickly became part of the local arts community. He painted a Madonna and Child for All Saints Church in St Kilda.

Ford exhibited with the Victorian Academy of Arts from 1872 until 1883; he was a council member of the Academy from 1873 and vice-president from 1879 to 1883. It is known that Ford taught painting — Rupert Bunny received his first painting lessons from him. Ford's wife also had artistic talents, exhibiting with the Academy in 1879 and 1880.

Ford exhibited many flower paintings before venturing into landscapes; his landscape paintings are quietly pastoral in mood. In 1875 he painted *At the Hanging Rock* (cat.103), his best-known work — it inspired the book by Joan Lindsay and subsequently the film made from it, *Picnic at Hanging Rock*.

By 1883 Ford's failing eyesight prevented him from continuing his artistic endeavours and he eventually became blind. He died in December 1884.

John Glover
Houghton-on-the-Hill, England, 1767 – Deddington, Tasmania, 1849 (Australia from 1831)

John Glover spent his childhood on the family farm near Leicester. At the age of nineteen he obtained a teaching position as writing master at the Free School, Appleby, in Westmoreland (now Cumbria). At the same time he pursued his artistic interests and successfully taught himself drawing and painting skills from the texts available to him. Glover married early and supplemented his income as a teacher by giving drawing lessons.

In 1794 Glover moved his family to Lichfield in Staffordshire, where he worked as a teacher. He first exhibited at the Royal Academy in 1795 and earned praise for his landscape watercolours. The family moved to London in 1805 and Glover became involved with the Society of Painters in Water-Colours. He continued to exhibit on occasion with the Royal Academy but his oil paintings failed to impress the committee (and he was unsuccessful when he eventually sought election as an Associate of the Royal Academy in 1818).

In 1814 Glover travelled to Paris where he studied the works of Claude Lorrain and Nicolas Poussin. He was awarded a gold medal by Louis XVIII for his oil painting *The Bay of Naples* which was exhibited at the Paris Salon of 1814. In 1817 Glover resigned his membership of the Society of Painters in Water-Colours and, that year, he travelled to Italy where he spent some months with one of his pupils, Henry Curzon Allport (1788–1854).

By the 1820s Glover had a well-established reputation and had achieved financial if not critical success. Three of his four sons emigrated to Van Diemen's Land in 1829, and in 1830 Glover sold most of his assets and, with his wife and eldest son, embarked on the *Thomas Lawrie*; he was sixty-four when he arrived in Launceston in 1831.

The family lived in Hobart Town for one year before taking up their grant of land near Deddington, 50 kilometres (31 miles) from Launceston. Glover named the property 'Patterdale' after a favourite area of the Lake District of England.

Inspired by the scenery of Tasmania, Glover's output was prolific, and in 1835 he sent 68 paintings to London for exhibition.

John Glover died at Patterdale in 1849, aged eighty-two.

Further reading: McPhee, John, *The Art of John Glover*, Melbourne: Macmillan, 1980

H.J. Johnstone
Birmingham, England, 1835 — London, England, 1907
(Australia 1853–76)

H.J. Johnstone first studied art at the Birmingham School of Design before joining his father's photographic business. At eighteen he left for Australia and the goldfields where he spent three years prospecting. In 1856 Johnstone returned to photography: his Melbourne firm (listed as Johnston and Company) exhibited photographic views at the 1862 London International Exhibition and received an honourable mention; in 1866 the firm (then known as Johnstone, O'Shannessey and Company) was awarded a medal for portraits and hand-coloured photographs shown at the Intercolonial Exhibition in Melbourne.

Determined to fulfil his ambition to become a painter, Johnstone attended life classes given by the sculptor, Charles Summers, and he took lessons with Louis Buvelot. He exhibited at the Victorian Academy of Arts in 1872 and received encouraging reviews for his landscapes. Johnstone remained involved with the photographic studio until 1874 when he turned to painting full time. In 1875 he travelled to South Australia and painted many landscapes; his popularity was such that 13 of his landscapes, then in private collections, were sent by the South Australian Government to the Paris Universal Exhibition of 1878.

Johnstone left Australia in 1876, travelling to California where he remained for three years. To fulfil commissions he continued to paint Australian landscapes based on sketches made during his travels; and he sent works back to Australia for exhibition. In 1880 his *Evening Shadows, Backwater of the Murray, South Australia* (cat. 86) was exhibited at the International Exhibition in Melbourne.

In 1879 Johnstone moved to England and then to Paris in the following year. He studied at the Académie Julian and spent time at Barbizon before returning to London. He continued to produce oils of Australian scenes on commission for Australian clients. In 1886 he was elected a member of the Royal Society of British Artists, and he exhibited regularly at the Royal Academy from 1887 to 1890. He returned to France in order to reduce his living expenses, but by 1895 was back in England where he continued to paint popular works.

In 1901 Johnstone moved with his family to Wadhurst, Sussex, while retaining a London studio. He became ill at his studio in 1907 and died shortly afterwards.

Joseph Lycett
Staffordshire, England, c.1775 – Bath, England, 1828
(Australia 1814–22)

Joseph Lycett was a professional portrait and miniature painter. He was convicted of forgery in 1811 and sentenced to be transported to Australia for 14 years. He arrived in Sydney in 1814 aboard the *General Hewitt*. In 1815 he was again convicted of forgery and sent to the settlement of secondary punishment at Newcastle in New South Wales. Captain James Wallis, who was appointed commander of the settlement in 1816, made good use of Lycett's drawing and painting skills. Lycett drew the plans for the settlement's church and painted an altarpiece as well as producing views of the scenery around Newcastle including local Aborigines.

By 1820 Lycett was again living in Sydney. He was commissioned by Governor Macquarie to produce drawings of the colony and he made many sketches of Sydney and surrounding areas including the first significant sheep property in Australia — John and Elizabeth Macarthur's Elizabeth Farm. Lycett also painted watercolours of botanical specimens.

After receiving an absolute pardon in 1821, Lycett returned to England in 1822. He produced twelve sets, each of two aquatint scenes of New South Wales and Van Diemen's Land. In 1824–25 the complete set of twenty-four hand-coloured prints was bound and sold as *Views in Australia or New South Wales, & Van Diemen's Land delineated* (cat.5).

In 1827 Lycett was arrested in Bath on suspicion of forgery, and the following year he committed suicide.

Further reading: Turner, John, *Joseph Lycett: Governor Macquarie's Convict Artist*, Newcastle: Hunter History Publications, 1997

Conrad Martens
London, England, 1801 – Sydney, New South Wales, 1878
(Australia from 1835)

Conrad Martens, the son of Austrian parents who settled in London, received his artistic training from Copley Fielding, the popular teacher and watercolourist.

In 1832 Martens accepted a position as artist aboard the *Hyacinth* bound for a three-year voyage to India. In Rio de Janeiro he learned that an artist was required to join the *Beagle* (to replace Augustus Earle who had become ill) and Martens joined the ship in Montevideo. In 1834 he left the *Beagle* in Valparaiso and sailed on the *Peruvian* for Tahiti then New Zealand and Australia. He arrived in Sydney in 1835.

In Sydney, Martens established himself as an art teacher, giving lessons from a studio in Pitt Street. He took commissions for paintings based on sketches made during his travels to the Blue Mountains and the Illawarra region. He married in 1837 and subsequently three children were born; the first-born, Rebecca Martens (1838–1909), was to become a recognised artist.

Conrad Martens painted many views around Sydney Harbour and achieved a degree of financial success painting landscapes in oils and watercolours on commission. In some difficulty as a result of the depression of the 1840s, Martens produced a lithograph of Sydney seen from the North Shore, and hand-coloured prints of the scene were sold for one guinea. During 1850 he prepared 20 lithographs for publication in a series entitled *Sketches in the Environs of Sydney* (1850–51).

Martens undertook a five-month sketching tour to Brisbane and the Darling Downs in 1851. The economic recovery saw a marked improvement in his fortunes as he was again able to generate a good income both as teacher and artist. Despite his continued success, by 1862 he was finding the financial uncertainties of self-employment increasingly difficult and he took a position as deputy parliamentary librarian. He continued to paint and exhibit and made further journeys into the regions surrounding Sydney. In 1870 Martens was appointed a judge for the Intercolonial Exhibition in Sydney, and in 1872 he was commissioned to paint a watercolour of the Apsley Falls for the National Gallery of Victoria. A similar watercolour was commissioned for the newly established National Gallery of New South Wales and was exhibited in 1875.

Conrad Martens died in Sydney in 1878.

Further reading: Ellis, Elizabeth, *Conrad Martens: Life and Art*, Sydney: State Library of New South Wales Press, 1994

Frederick McCubbin
Melbourne, Victoria, 1855–1917

Frederick McCubbin enrolled at fourteen at the Artisan's School of Design and attended weekly classes taken by Thomas Clark. Later he followed Clark to Victoria's National Gallery School of Design. In 1875 McCubbin completed an apprenticeship in coach- painting, but because of the sudden death of his father he had to put his artistic pursuits on hold for one year as he was needed to work in the family's bakery. By 1877 he was attending classes again at the National Gallery School, this time under Eugene von Guérard, with Tom Roberts as a fellow pupil.

McCubbin remained at the School for many years. The appointment of G.S. Folingsby as head of the National Gallery School in 1882 brought new approaches to teaching which appealed to McCubbin. In 1883 he was awarded first prize in the inaugural students' exhibition.

Following Tom Roberts's return to Australia from Europe in 1885, McCubbin and Roberts made painting excursions to the coastal and pastoral outskirts of Melbourne — painting *en plein air* in Mentone, Heidelberg and Box Hill. While on one of these summer camps in 1886 McCubbin painted his well-known work *Lost* (National Gallery of Victoria, Melbourne), and at Box Hill in 1889 he completed *Down on His Luck* (cat.108).

In 1886 McCubbin was appointed drawing master at the National Gallery School (a position he retained until his death in 1917). He joined with friends including Tom Roberts,

Arthur Streeton and Charles Conder in 1886 to split from the Victorian Academy of Arts because they opposed the control of the Academy by amateurs. After two years their rival Australian Artists' Association reunited with the Victorian Academy of Arts to form the Victorian Artists' Society. McCubbin regularly exhibited with the Society until 1912.

In 1889 McCubbin married Anne Moriarty, a fellow artist, and they lived at a number of Melbourne locations, including five years at the beachside suburb of Brighton. Some years were spent at Mount Macedon, a fashionable retreat north of Melbourne, before the McCubbins finally settled nearer the city in South Yarra.

McCubbin was acting director of the National Gallery in 1891–92 following the death of Folingsby who was succeeded by Bernard Hall, and he acted in that position again in 1903 and 1905. He travelled to Europe and England for a short period in 1907, his only overseas experience. He continued painting and teaching until ill-health forced him to take extended leave from the Gallery in 1916. McCubbin died from heart failure the following year. His wife, four sons and two daughters survived him.

Further reading: Whitelaw, Bridget, *The Art of Frederick McCubbin,* Melbourne: National Gallery of Victoria, 1991

W.C. Piguenit
Hobart, Tasmania, 1836 – Sydney, New South Wales, 1914.

W.C. Piguenit received his early drawing lessons from Frank Dunnett, a Scottish painter — at the time Piguenit was a student at Cambridge House Academy in Hobart, where he was commended for his superior skills in drawing and mapping.

In 1850 Piguenit was appointed as a draughtsman with the Survey Office in Hobart, and while in this position he assisted in the preparation of many maps of Tasmania which were produced as lithographs. In 1867 he produced six lithographed landscapes which were published in *The Salmon Ponds and Vicinity, New Norfolk, Tasmania*. Piguenit also started to experiment with daguerreotypes and he entered a group of photographs in the 1870 Intercolonial Exhibition in Sydney. In that year his watercolour landscape of Mount Wellington was shown in the Melbourne Intercolonial exhibition and received promising reviews.

In 1871 Piguenit was appointed as official artist with an expedition led by James Scott to Arthur Plains and Port Davey, in the wilderness areas of south-western Tasmania. Works produced during this trip were later used as illustrations for the *Picturesque Atlas of Australasia* (1886–88) and R.M. Johnston's *Systematic Account of the Geology of Tasmania* (1888). Piguenit resigned from the Survey Office in 1873 to pursue a full-time career as a landscape painter. Later that year he again joined Scott for an expedition to Lake St Clair and Lake Petrarch, and produced many sketches and photographs.

Piguenit first moved to Sydney in 1875 and that year won a silver medal for *Mount Olympus, Lake St Clair, Tasmania* —

this work became the first by an Australian artist to be purchased by subscription for the proposed National Art Gallery of New South Wales. He was a guest artist at the artists' and photographers' camp held in 1875 in the Grose Valley in the Blue Mountains of New South Wales sponsored by the New South Wales Academy of Art and the Philadelphia Centennial Exhibition Commission. In 1876 he received a certificate of merit for an oil landscape of the Grose Valley. In 1887 Piguenit returned to Tasmania to accompany another expedition but had to return early, suffering from exhaustion.

Piguenit continued to live in Sydney, painting both New South Wales and Tasmanian subjects, and he exhibited regularly in Sydney, Melbourne, Launceston and Hobart, consistently winning awards. His work was exhibited at the Chicago World's Fair in 1893. In 1898 and 1900 he travelled to England, and in 1902 he was commissioned to paint Mount Kosciuszko by the Art Gallery of New South Wales.

Piguenit won the Wynne Prize in 1901. (The Wynne is the longest running art prize in Australia: Richard Wynne bequeathed £1,000, from which the income would be awarded annually for a prize for landscape or sculpture.)

W.C. Piguenit died in 1914 from complications following appendicitis.

Further reading: Johannes, Christa and Brown, Anthony, *W.C. Piguenit 1836–1914 Retrospective*, exhibition catalogue, Hobart: Tasmanian Museum and Art Gallery, 1992

John Skinner Prout
Plymouth, England, 1805 – London, England, 1876
(Australia 1840–48)

Although John Skinner Prout was the nephew of Samuel Prout (1783–1852), a popular watercolourist, little is known of his own artistic training. He was listed as a drawing instructor when the family moved to Penzance in 1827. He married in 1828 and moved to Bristol in 1831 where his family remained until 1838.

The artistic style of the Bristol School favoured the expression of light and mood in landscapes, and groups would regularly meet to sketch outdoors. Prout exhibited at the Bristol Society of Artists' inaugural exhibition in 1832, and in 1834 his first volume of lithographs, *Picturesque Antiquities of Bristol,* was published in London by C. Hullmandel. Many of the sketches for the book were made in the company of his friend, the Bristol landscape artist, William Müller (1812–1845).

In 1838 Prout moved with his family to London and he was elected a member of the New Society of Painters in Water-Colours the same year. After two years of struggling to live in London, Prout decided to follow some of his relatives who had travelled to Australia.

Arriving in Sydney in 1840 Prout launched a series of public lectures aimed at increasing the profile of art in the colony. He sketched prolifically and in 1842 published a set of lithographs, *Sydney Illustrated*, with John Rae. Prout was briefly employed as drawing master at Sydney College and as a scene painter at the Olympic Theatre. During 1842–43 he made a series of tours into the regions surrounding Sydney including a visit to Wollongong where he drew portraits of the local Aborigines.

In 1844 Prout moved his family to Van Diemen's Land, and that year produced a set of lithographs titled *Tasmania Illustrated*; and he started work on further volumes including a six-part series, *Views of Melbourne and Geelong*, which was published in 1847. His public lecture series was well received in Hobart and he encouraged the organisation of the Hobart Town Art Exhibition which was held in 1845.

Prout and his family returned to London in 1848. He continued to publish works based on his Australian sketches including *An Illustrated Handbook of the Voyage to Australia* and *A Magical Trip to the Gold Regions*. From 1849 until 1876 Prout exhibited with the New Society of Painters in Water-Colours. He travelled regularly in England and Europe and continued to write articles and produce illustrations based on his Australian experiences.

Further reading: Brown, Tony and Kolenberg, Henrik, *Skinner Prout in Australia 1840–48*, exhibition catalogue, Hobart: Tasmanian Museum and Art Gallery, 1986

Tom Roberts
Dorchester, Dorset, England, 1856 – Kallista, Victoria, 1931
(Australia from 1869)

After the death of his father, Tom Roberts emigrated to Australia in 1869 with his mother and siblings. They arrived in Melbourne and settled in the working class suburb of Collingwood. Tom found employment as a photographer's assistant and soon showed a talent for design. In 1871 he enrolled in the East Collingwood Artisans' School of Design. He was awarded a landscape prize in 1874 and then joined the National Gallery School and studied under Thomas Clark. By 1881 Roberts had saved enough funds to pay for his passage to England that year. He became the first Australian to study at the Royal Academy of Arts, and survived financially by providing drawings for illustrated newspapers such as *The Graphic*.

In 1883 Roberts travelled to Spain with a group of fellow artists. There he met Laureano Barrau and Ramón Casas, and was impressed with their drawing directly from nature. Roberts returned to Melbourne in 1885, inspired by the new approach to *plein-air* painting. In the summer of 1886–87 Roberts, Frederick McCubbin and Louis Abrahams camped at Box Hill on the outskirts of Melbourne and, the following summer, at the seaside settlements of Mentone and Beaumaris. They were joined by Arthur Streeton. During a brief visit to Sydney in 1888, Roberts met Charles Conder and persuaded him to join the group in Melbourne.

In 1886, Roberts led a several artists in a break away from the amateur-run Victorian Academy of Arts to form the Australian Artists' Association. Two years later they amalgamated to form the Victorian Artists' Society.

Tom Roberts exhibited in the Centennial International Exhibition held in Melbourne in 1888 and in 1889 he showed works in the *9 by 5 Impression Exhibition*, most pieces having been painted on cigar box lids (9 inches by 5 inches). In 1890, Roberts made visits to Brocklesby Station in the Riverina area of New South Wales and to Inverell. Some of his most significant works were the result of these travels and include *Shearing the Rams* (National Gallery of Victoria, Melbourne) and *A Break Away!* (cat.111). In 1891 Roberts moved to Sydney and established an artists' camp at Sirius Cove with Streeton and A.H. Fullwood. From 1892 he maintained a Sydney studio which initially he shared with Streeton.

Roberts was elected first president of the New South Wales Society of Artists in 1895. In 1896 he married Lillie Williamson, a former art student, and they moved to Balmain in Sydney in 1897. Roberts was involved in many literary and artistic groups, and became a popular portrait painter.

The economic depression of the late 1890s saw Roberts struggle financially. When he received the commission to paint the official view of the opening of Australia's first Federal Parliament in 1901, which was accompanied by a substantial remuneration, he took the opportunity to return to London. The work was finished there in 1903. Roberts received little recognition while in England and again he had difficulty earning a satisfactory income. He exhibited at the New English Art Club and at the Royal Academy between 1910–19.

At the outbreak of World War I Roberts enlisted and in 1915 was posted as an orderly. He was demobilised with the rank of sergeant and remained in London as a painter before finally moving back to Victoria in 1923. Roberts and his wife settled at Kallista in the Dandenong Ranges near Melbourne. In his later years, Roberts painted few works; he died at Kallista in 1931.

Further reading: McQueen, Humphrey, *Tom Roberts*, Sydney: Macmillan, 1996
Radford, Ron ed., *Tom Roberts*, exhibition catalogue, Adelaide: Art Gallery of South Australia, 1996

Clara Southern
Kyneton, Victoria, 1860 – Melbourne, Victoria, 1940.

Clara Southern was encouraged by her parents in her artistic interests. In 1883 she moved from Kyneton to Melbourne to study at the National Gallery School under G.S. Folingsby and Frederick McCubbin. She also enrolled at Madame Mouchette's Melbourne studio and took lessons from Walter Withers.

In 1886 Southern became a member of the literary and artistic salon, the Buonarotti Society. While primarily a sketching club, many members were also accomplished musicians and writers. Southern gave painting lessons from a studio in Collins Street, Melbourne, which she shared with the composer, Jane Sutherland, from 1888 until 1900. In the late 1880s she frequently joined artists at the *plein-air* painting camps around Melbourne. In 1905 Southern married and moved to Warrandyte near Heidelberg on the outskirts of Melbourne. She encouraged others to move to the area, and several significant artists

painted there: among them, Penleigh Boyd and Louis McCubbin, son of Frederick McCubbin.

Southern exhibited regularly with the Victorian Artists' Society from 1889 to 1917 and served on the Society's council during 1901–06. In 1907 she was awarded first prize for a landscape painting shown at the Australian Exhibition of Women's Work. She became the first female member of the Australian Art Association founded in 1912 for the benefit of professional artists, and was a member of the Melbourne Society of Women Painters and Sculptors, the Twenty Melbourne Painters and the Lyceum Club.

An Old Bee Farm c.1900 (cat.114) was shown at a solo exhibition held in 1914. Her last solo exhibition was held in 1929.

Southern died in a Melbourne convalescent home in 1940.

Further reading: Peers, Juliet and Hammond, Victoria eds, *Completing the Picture: Women Artists and the Heidelberg Era*, Hawthorn East: Artmoves, 1992

Arthur Streeton
Duneed, Victoria, 1867 – Olinda, Victoria, 1943.

Arthur Streeton enjoyed drawing from an early age. He finished formal schooling at age thirteen and was employed as a clerk with an importing firm. In 1882 he enrolled at Victoria's National Gallery School of Design where he studied under Oswald Campbell; he continued at the School until 1888 — the last two years with Frederick McCubbin as teacher. From 1884 to 1887 Streeton exhibited with the Victorian Academy of Arts. In 1888 he joined the newly formed Victorian Artists' Society and exhibited with them until 1890 when he moved to Sydney.

In 1886 Streeton met Tom Roberts who invited him to join an informal painting group with Frederick McCubbin and Louis Abrahams. They spent the next two years travelling regularly to Eaglemont, near Heidelberg on the outskirts of Melbourne, where they painted out of doors. At this time Streeton was an apprentice lithographer and supplemented his income by giving painting lessons. He left his apprenticeship in 1888 to paint full time, earning income from the sale of his works. In 1889 he exhibited with other Heidelberg artists at the *9 by 5 Impression Exhibition* of works mostly painted on cigar box lids.

After his move to Sydney in 1890, he painted numerous harbour subjects including *From McMahon's Point — Fare One Penny* (cat.109). He returned to Melbourne on two occasions before setting up a studio with Tom Roberts in Pitt Street, Sydney in 1892. In 1895 he was a founding member of the New South Wales Society of Artists and served on the committee for two years. Streeton was a popular artist and his works sold well. He held a solo exhibition in Melbourne in 1896, and *The Purple Noon's Transparent Might* (cat.91) was purchased by the National Gallery of Victoria. On the proceeds of his recent successes, in 1897 Streeton sailed to Italy via Cairo, before travelling overland to England in a quest for European recognition. He returned briefly to Australia in 1906, then went back to England in 1907 where he married Esther Leonora (Nora) Clench, a violinist.

Arthur Streeton's years in England were only moderately successful but his popularity continued in Australia and he sent many paintings back for exhibition. After the outbreak of World War I he enlisted in the Royal Army Medical Corps in 1915. He was appointed official war artist by the Australian government in 1918; and in 1919 he exhibited a series of war paintings in London.

In 1920 the Streetons travelled to back to Melbourne and, for the next two years, Streeton painted prolifically and exhibited frequently. They left for Canada in 1922 and travelled in North America before arriving in London. In 1923 Streeton returned to Australia, his family joined him in 1924. They settled at Olinda in the Dandenong Ranges near Melbourne, on a property called Longacres. Streeton continued to paint prolifically and in 1928 was awarded the Wynne prize for landscape.

In 1937 Arthur Streeton was knighted. After his wife Nora became an invalid in 1936, Streeton devoted most of his time nursing her until her death in 1938. He painted only sporadically during this period though his works continued to be exhibited and sold well. Streeton became ill in 1942; he died at Longacres in 1943.

Further reading: Eagle, Mary, *The Oil Paintings of Arthur Streeton in the National Gallery of Australia*, Canberra: National Gallery of Australia, 1994.
Smith, Geoffrey, *Arthur Streeton 1867–1943*, exhibition catalogue, Melbourne: National Gallery of Victoria, 1995

Eugene von Guérard
Vienna, Austria, 1811 – London, England, 1901
(in Australia 1852–81)

Eugene von Guérard was the son of a court painter to Francis I of Austria. His early interest in art was encouraged by his father who took him to Italy in 1826 where he spent some time in Rome studying under Giovanni Battista Bassi. In 1838 he began formal training at the Düsseldorf Academy under J.W.Schirmer. Von Guérard was an inveterate traveller and his whereabouts over the following years are uncertain, though it is likely he travelled extensively through Europe. In 1852, attracted by the gold rush, he sailed for Melbourne aboard the *Windermere*.

Von Guérard spent about two years prospecting for gold near Ballarat before giving up and moving to Melbourne in 1854. He resumed painting and quickly became a leading figure in Melbourne art circles. He exhibited in one of Victoria's first art exhibitions in Melbourne in 1854. He received many commissions from wealthy landowners throughout Australia and travelled extensively to fulfil their requests for landscapes and views of their newly built homesteads.

In 1858 von Guérard received a gold medal at the Victorian Industrial Exhibition. In following years, his work appeared at many international exhibitions including those in Paris (1867, 1878), Vienna (1873) and the Philadelphia Centennial Exhibition (1876). In 1866 his *Spring in the Valley of the Mitta Mitta* entered the National Gallery of Victoria's collection.

During 1866–68 von Guérard produced an album of tinted lithographs entitled *Eugene von Guérard's Australian Landscapes* (cat.68) based on his views of many parts of south-eastern Australia. He travelled to New Zealand in 1876 and two landscape works of New Zealand were awarded a special prize at the Sydney International Exhibition in 1879.

In 1870 von Guérard was appointed master of painting at the National Gallery School in Melbourne and Curator of the National Gallery of Victoria. At the school, his early pupils included Frederick McCubbin and Tom Roberts. The same year he was awarded the Cross of the Order of Franz Josef by the Austrian Emperor and sold his oil painting, *Mount Kosciusko seen from the Victorian Border (Mount Hope Ranges) 1866*, to the National Gallery of Victoria. Von Guérard remained teaching at the National Gallery School until 1882 when he returned to Europe.

After settling in Düsseldorf, von Guérard continued to send paintings to Australia for exhibition. His only child married and moved to England in 1885, and in 1891 von Guérard and his wife followed to live with their daughter. Von Guérard continued sketching even though a stroke in 1898 left him with partial paralysis of his right arm. He died at home in 1901.

Further reading: Bruce, Candice and Comstock, Edward, *Eugene von Guérard; a German Romantic in the Antipodes*, Martinborough: Alistair Taylor, 1982

William Westall
Hertford, England, 1781 – London, England, 1850
(in Australian waters 1801–03)

William Westall received his first drawing instruction from his half-brother Richard (1765–1836) who was a member of the Royal Academy. In 1799 he was accepted at the Royal Academy School as a probationer; and in 1801 was appointed landscape artist accompanying Matthew Flinders's expedition to Australia aboard the *Investigator*. Westall produced many sketches as the ship sailed along the north, south and east coasts of Australia. He was the first to record scenes of the South Australian coast, Kangaroo Island and the Northern Territory. He sketched local fauna and flora as well as producing studies of Aborigines. In 1803 the *Investigator* was found to be unseaworthy, and the *Porpoise*, which was then in Port Jackson (Sydney), was directed to carry Flinders and his crew to England. When the *Porpoise* ran aground on Wreck Reef many of Westall's sketches were damaged. Nevertheless the sketches were returned to England as part of the expedition's official record and at Sir Joseph Banks's suggestion, they were given to Richard Westall for restoration.

William Westall travelled to China and India before returning to London in 1805. He later went to Madeira and Jamaica and exhibited watercolour scenes of those places at a Brook Street gallery and at the Associated Artists' Exhibition in London in 1808. In 1811, at the request of the Admiralty, Flinders, Westall and Banks chose nine of the artist's sketches

to be executed as oil paintings. These paintings were used as subjects for engravings which became illustrations in Flinders's book *A Voyage to Terra Australis* (1814). Westall was also commissioned by publishers to produce watercolours to be reproduced as aquatints for book illustrations. As an illustrator he contributed to more than 45 publications including *A Picturesque Tour of the River Thames* (1828).

Westall was a member of the Old Water-Colour Society and was elected as an associate of the Royal Academy in 1812 (but he failed to become an Academician despite exhibiting more than 70 works at the Academy between 1801 and 1849). He married in 1820 and spent the remainder of his life in London. Westall continued to produce paintings based on the sketches made during his travels and was working on a painting of the wreck of the *Porpoise* when he died in 1850.

Further reading: Perry, T.M. and Simpson, Donald H. ed., *Drawings by William Westall,* London: Royal Commonwealth Society, 1962
Westall, Robert, 'Memoir of William Westall, A.R.A.', *The Art-Journal*. vol.12, 1850, pp.104–105

Isaac Whitehead
Dublin, Ireland, c.1819 – Melbourne, Victoria, 1881
(Autralia from 1853)

Isaac Whitehead was the son of Joseph Whitehead, a carver and gilder. While little is known of his early art instruction, a surviving sketchbook shows his competence in landscape drawing at a young age. Whitehead married in 1848, the year that he was first listed as a picture framer in Dublin.

He emigrated to Australia in 1853, and by 1860 had established himself as a framer in Collingwood, a suburb of Melbourne. He later moved his business into the city. Whitehead exhibited regularly in major art exhibitions including the Intercolonial preparatory exhibitions in Melbourne — at the 1875 exhibition he was awarded a medal, and his firm also received an award for a display of decorative mirrors and frames. Whitehead was awarded a silver medal at the 1878 Paris Universal Exhibition.

His picture framing business was very successful and allowed Whitehead to pursue his painting interests. He took sketching trips into the regions around Melbourne including Gippsland and the rainforest area of Fernshaw — a popular place with artists, including Louis Buvelot. Whitehead was a member of the Victorian Academy of the Arts and exhibited at the Academy's annual exhibitions — the 1873 exhibition was held in his shop in Collins Street.

Whitehead died in 1881. His works continued to be shown with the Victorian Academy of Arts, and at the 1884 Victorians' Jubilee Exhibition, the 1886 London Colonial and Indian Exhibition, and the 1888 Melbourne Centennial International Exhibition.

Walter Withers
Warwickshire, England, 1854 – Eltham, Victoria, 1914
(Australia from 1883)

The grandson of artist Edwin Withers, Walter Withers attended art classes at the Royal Academy and South Kensington schools in London — notwithstanding his father's disapproval. Perhaps to put an end to his son's artistic endeavours, his father assisted Walter Withers to emigrate to Australia and establish himself on the land. Withers arrived in Melbourne on 1 January 1883 and worked in country areas as a jackeroo for eighteen months before returning to Melbourne.

Withers enrolled in night classes at Victoria's National Gallery School under G.F. Folingsby. Through the mid-1880s he worked as a draughtsman for lithographic printing firms, and he produced black and white portraits for periodicals. Withers became friends with Frederick McCubbin and Tom Roberts, the latter encouraging Withers to travel overseas. In 1887 he returned to England where, later that year, he married. He spent the next six months living in Paris where he studied at the Académie Julian under Aldolphe Bouguereau and Joseph Robert-Fleury.

In 1888 Withers received a commission to produce pen and ink drawings to illustrate *The Chronicles of Early Melbourne* by Edmund Finn. He returned to Melbourne that year and settled in Kew where he renewed his friendships with McCubbin and Roberts. In 1889, while his wife was visiting England, Withers joined the Eaglemont artists' camp with Roberts, Arthur Streeton and Charles Conder, and he exhibited in the *9 by 5 Impression Exhibition* of paintings mostly on cigar box lids. In 1890 Withers and his wife moved to Heidelberg on the outskirts of Melbourne, where they rented part of a large mansion called Charterisville. He established a studio and sub-let small cottages on the property to fellow artists.

Withers started teaching in 1891, and in 1893 he was teaching day classes *en plein air* and evening classes at Melbourne's School of Mines. In 1895 he painted *Tranquil Winter* (cat.90), which was exhibited in London in 1898. In 1897 he was awarded the inaugural Wynne prize for landscape painting. He won the Wynne prize again in 1900.

In 1902 Withers completed a commission from a pastoralist, Edmund Smith, to produce six large *art nouveau* panels as a mural for his house Purrumbete (coincidently, one of the properties painted by Eugene von Guérard in the 1850s). The payment enabled Withers to purchase a property at Eltham. From Eltham he travelled to Melbourne where he spent the weekdays working and returned to the family at weekends.

In 1904–05 Withers was president of the Victorian Artists' Society. In 1912 he joined with a group of other professional artists to form the Australian Art Association. He was a judge of students' work at the National Gallery School, and a trustee of the Public Library, Museum and National Gallery of Victoria. He died in 1914 following a stroke.

Further reading: Mackenzie, Andrew, *Walter Withers, 1854–1913,* Sydney: Mallard, 1989

Artists in America – Biographies

Albert Bierstadt
Solingen, Prussia, 1830 – New York City, 1902

Born near Düsseldorf, Albert Bierstadt emigrated with his parents when he was still a baby. He grew up in New Bedford, Massachusetts. At twenty-three, he returned to Düsseldorf to study art for four years and then went on to Rome. His mature painting style reflects his Düsseldorf training.

In 1857 Bierstadt returned to the United States. He joined General F.W. Lander's expedition surveying an overland wagon route west. While there, the artist made many sketches of the Colorado and Wyoming scenery which he used in his large landscape compositions. Back in New York City that fall, he moved into a studio in the Tenth Street Studio Building and began painting the landscapes for which he became famous. His *Rocky Mountains, Lander's Peak* 1863 (The Metropolitan Museum of Art, New York), exhibited at the Metropolitan Sanitary Fair in New York City in 1864, established Bierstadt as a major rival of Frederic E. Church. In 1863 he accompanied the author Fitz Hugh Ludlow to California's Yosemite Valley.

Bierstadt saw tremendous financial success in the 1860s, and his art commanded the highest prices of any works of art by an American artist of the time. He exhibited in the United States and abroad, where he was praised by critics for his application of John Ruskin's emphasis on detail and J.M.W. Turner's gift for the sublime. His primary market was the new industrial upper middle class, who valued the size and virtuosity of Bierstadt's paintings as well as their celebration of America's seemingly limitless resources.

Bierstadt went to Europe in 1867, 1878 and 1883. He was elected a member of the Legion of Honour in France in 1867; in Austria he received the Order of Stanislaus in 1869. He was awarded medals, too, in Prussia, Bavaria and Belgium.

From 1863, the artist maintained Malkastan, a large mansion and studio in Irvington-on-Hudson; it burned down in 1882.

Thomas Birch
Warwickshire, England, 1779 – Philadelphia, Pennsylvania, 1851

Considered the earliest American marine-painting specialist, Thomas Birch was born in central England, in an area noted for its agricultural resources. At fifteen he moved to the United States with his father, William Russell Birch (1755–1834). Best known as a miniaturist, William Birch was also a landscape painter in the pastoral tradition and a line-engraver, as well as the owner of a collection of Old Master paintings, including seventeenth-century Dutch landscapes. The two settled in Philadelphia, where Thomas went to work for his father, producing topographical views of that city for William to engrave. This series of engravings stands as an important document of the post-colonial state capital.

Around the turn of the century, Thomas began to paint portraits. By about 1806 he was painting landscapes and seascapes, including harbour and river views of Philadelphia and New York City, as well as estate views. His landscapes are, for the most part, views of the Philadelphia area. Birch's landscape style owes much to the English rustic tradition, but, because of his early emigration, it is a tradition he absorbed primarily through his father's work and art collection.

From 1812 to 1817, Birch was Keeper of the Pennsylvania Academy of the Fine Arts, and he exhibited there from 1811 until his death. It was at the Academy that the young Thomas Cole first saw and admired the work of Thomas Birch.

Birch died in Philadelphia at the age of seventy-one, never having strayed far from his first port of call in America.

Dennis Miller Bunker
New York City, 1861 – Boston, Massachusetts, 1890

Dennis Miller Bunker was the son of the secretary–treasurer of the Union Ferry Company. They lived in Garden City, New York, and spent summers in Nantucket. There Bunker met artists Charles A. Platt, Joseph T. Evans and Kenneth R. Cranford, with whom he formed lasting friendships.

Bunker first studied art at the Art Students League and the National Academy of Design, both in New York City, enrolling in 1876; in 1880 Bunker showed two landscapes at the National Academy. He also exhibited at the American Watercolor Society and at the Brooklyn Art Association. He showed work at all three venues over the next couple of years.

Bunker left for Paris sometime around the fall of 1882, enrolling at the Ecole des Beaux-Arts, where, in early 1883, he began studying with Jean-Leon Gérome. Over the next year and a half, Bunker travelled to Lacroix-St Ouen on the Oise River, to Rouen and the Normandy coast, and to Larmor in Brittany, where he painted, returning to Paris from time to time to study.

Near the end of 1884, Bunker returned to New York. He exhibited at the American Art Association. In October of 1885, he moved to Boston, where he began teaching art. There he joined the Tavern Club and St Botolph Club, where he exhibited paintings.

In 1886 Bunker met Isabella Stewart Gardner, who became an important patron for him, and a good friend. Bunker met John Singer Sargent in 1887, with whom he spent the following summer in Calcot, England. Bunker's friendship with Sargent influenced his eventual turn to impressionism in his landscape painting. In London, Bunker visited the art collections and spent time in the National Gallery.

Bunker spent the summer of 1889 in a boarding house in Medfield, Massachusetts. There he painted portraits and a number of landscapes of the area. It was a particularly productive time.

In October 1889 Bunker returned to New York City, where he lived and worked on Washington Square in the same building as Platt, Abbott Thayer and Thomas Dewing.

In 1890 Bunker first exhibited his impressionist works, alongside one by Sargent, at the St Botolph Club, receiving positive press. He also exhibited at the Society of American Artists. That year he contracted influenza and died. Charles Platt and others organised a memorial exhibition at the St Botolph Club.

John William Casilear
Staten Island, New York, 1811 – Saratoga Springs, New York, 1893

Trained as an engraver in New York City, John Casilear made his 'first real attempt at a landscape painting' at age twenty, and noted that '[Asher B.] Durand, when he saw it, examined it carefully, and then turning to me, said: "Why you're a painter!"' (Unidentified clipping, artist file, The Metropolitan Museum of Art, New York.) The National Academy of Design in New York City elected him associate in 1833 and academician in 1851. By 1857 Casilear had made enough money to retire from engraving and focus on painting. He lived and worked at Waverly House, 697 Broadway, New York, from 1854 until 1859, when he was one of the first artists to move into the Tenth Street Studio building. Every summer Casilear and artist friends took sketching trips together, travelling to the Catskill Mountains, the Adirondack Mountains, and the Genesee Valley in New York State, and the White Mountains in New Hampshire.

Casilear travelled to Europe twice. He made his first trip in 1840 with Asher Durand, John F. Kensett and Thomas P. Rossiter, spending three years in England and continental Europe, primarily in France. While abroad, Durand introduced Casilear to the work of Claude Lorrain. Casilear took a number of sketching trips with Kensett, who replaced Durand as an important influence on the artist after their return from Europe. Casilear took a second trip to Europe in 1858, spending most of his time sketching in Switzerland; he used these sketches in his paintings of Swiss scenery until well into the 1880s.

Casilear died of a stroke at age eighty-three.

George Catlin
Wilkes-Barre, Pennsylvania, 1796 – Jersey City, New Jersey, 1872

George Catlin was born in the Wyoming Valley, Pennsylvania, to a lawyer whose family was from Litchfield, Connecticut. He went there to study law and was admitted to the bar in Litchfield, but soon abandoned this course. After studying at West Point Academy, he moved to Philadelphia to pursue a career in art. During this time he specialised in portrait miniatures which he exhibited at the Pennsylvania Academy of the Fine Arts. In 1824 Catlin maintained a studio in Hartford, Connecticut. He was in New York City the following year and was elected to the National Academy of Design.

Catlin's earliest-known portrait of an Indian is of Red Jacket, a Seneca chief, dating to 1826. In St Louis in 1830, Catlin met General William Clark (of the Lewis and Clark Expedition), then superintendent of Indian Affairs for the western tribes. Together they visited Native American tribes living near the Mississippi River. Catlin took his first trip in 1832, travelling up the Missouri River on the American Fur Company's steamboat *Yellowstone* to the trading post at Fort Union, North Dakota. His portraits of the Mandan Indians from this trip are some of his best-known. He continued to travel around the West and south-west, documenting the lives and lands of Native Americans. In 1841 he published his travel narrative, *Letters and Notes on the Manners, Customs and Condition of the North American Indians*, illustrated after paintings in his Indian Gallery.

Catlin's Indian Gallery was a collection of almost 600 paintings and a group of Indian artefacts. It opened in New York City in 1837. Its popularity was such that Catlin took it on the road to Washington, DC, Philadelphia and Boston. He tried to sell the Gallery to Congress, but they declined.

In 1839 Catlin sailed to London with his Gallery, hoping to sell it there. He exhibited the collection and hired Englishmen to act the parts of Native Americans, demonstrating traditional customs. Later he employed Iowa or Ojibwa Indians. He took the show to Paris in 1845.

Catlin's Gallery did not meet with the expected popular and commercial success. In 1852, in debt from bad business speculations, Catlin was forced to give the collection to Joseph Harrison of Philadelphia as security for a loan. He was never able to redeem it, and Harrison's wife gave it to the National Museum of American Art, Washington, DC.

The artist then began work on a detailed study of Indian tobacco pipes. Other publications include *Life among the Indians* (1867) and *Last Rambles amongst the Indians of the Rocky Mountains and the Andes* (1867) — this last is based on his travels to South America. He died five years later.

William Merritt Chase
Williamsburg (now Nineveh), Indiana, 1849 – New York City, 1916

William Merritt Chase first studied art in 1867 with Barton S. Hays, a portrait painter in Indianapolis, Indiana. In 1869 he went to New York City with Hays's encouragement and a letter of introduction to Joseph O. Eaton, who suggested he study at the National Academy of Design.

Chase remained in New York studying until 1871, when he joined his family in St Louis, Missouri. In 1872, with the money he earned painting portraits and still lifes there, Chase went to study at the Royal Academy in Munich, which had replaced Düsseldorf as the art centre of Germany. Chase was particularly influenced by the work of the realist Wilhelm Leibl, and his characteristic bravura brush work and broad handling of paint date from his Munich years. In 1877 he travelled to Venice with the American painters Frank Duveneck and John Twachtman.

The following year, Chase exhibited at the inaugural show at the Society of American Artists and began teaching at the Art Students League, New York City. He joined the Tile Club and took a studio at the Tenth Street Studio Building. He returned to Munich for a short time, and, in 1881, he travelled to Antwerp and Madrid, where he studied the work of Velazquez. In Paris, he met John Singer Sargent, among other artists, and exhibited at the Paris Salon. When he returned to the United States, he began working *en plein air*. In 1886 he exhibited at the Boston Art Club where his work met with critical acclaim.

Chase journeyed to Europe several times over the next couple of years, visiting Antwerp and Madrid again, as well as Paris and London. In the United States, he was active in many arts organisations, including the Society of American Artists, the Society of Painters in Pastel, and the Ten American Painters. In 1891 he established the Shinnecock Summer Art School on Long Island, New York, and in 1896, he opened the Chase School, later renamed the New York School of Art (parent institution of Parsons School of Design), in New York City.

Chase taught until late in his life. In 1913 he led students throughout Europe, to Holland, England and Spain, as well as Florence, Bruges and Venice. His role as a teacher was an important one in the history of American art, but with the advent of modernism, his influence declined. He died in 1916 from a lingering disease.

Frederic Edwin Church
Hartford, Connecticut, 1826 – New York City, 1900

Frederic Church was the only surviving son of Joseph Edward Church, a successful businessman, jeweller and silversmith, and Eliza Jane Church. A prominent citizen of Hartford, Joseph served on several boards and, as a neighbour of Daniel Wadsworth, was one of the original subscribers of the Wadsworth Atheneum.

Although Joseph preferred that his son pursue a career in business, Frederic began studying art in 1842, first with Alexander Hamilton Emmons and then with Benjamin Hutchins Coe. In 1844 Wadsworth arranged for Church to study with the leading figure in landscape painting at the time, his friend Thomas Cole. The younger artist studied with Cole in his Catskill studio from 1844 to 1848.

Church completed his first major historical landscapes in 1846 and 1847 and set up a studio in the Art-Union Building in New York City. He was elected to the National Academy of Design in 1848, its youngest associate. When Cole died in 1848, Church succeeded him as the leader of what became known as the Hudson River School of landscape. By the early 1850s, he had absorbed the influence of the works of English artists John Martin and J.M.W. Turner and the writings of the English critic John Ruskin.

In 1853, having read the work of the German naturalist, Alexander von Humboldt, Church became the first American artist to paint on location in South America. He continued to paint North American landscapes but returned to South America in 1857, travelling to Ecuador with the landscape painter, Louis Rémy Mignot.

In the oil paintings that resulted from these expeditions, Church attempted to produce works that were both scientifically accurate and spiritually uplifting. Church also travelled to Labrador (1859), Jamaica (1865), and to Europe and the Near East (1867–68). Again, the important works that resulted from these trips were composites of botanical and geological and meteorological studies made on location. Some of these paintings are *Niagara Falls* (cat.73), *Heart of the Andes* 1859 (The Metropolitan Museum of Art, New York), *Icebergs* 1861 (Dallas Museum of Fine Arts), *Vale of St Thomas, Jamaica* 1867 (Wadsworth Atheneum, Hartford), and *The Parthenon* 1871 (The Metropolitan Museum of Art, New York).

By 1870 Church was preoccupied with the creation of Olana, his mansion designed by Calvert Vaux and situated on a mountaintop on the Hudson River in the Catskill Mountains, New York. Inspired by Church's travels in the Near East, Olana is a fusion of Persian and Moorish architectural styles.

Near the end of the nineteenth century, Church suffered from the effects of degenerative rheumatoid arthritis and spent winters in Mexico, where he continued to sketch, despite the decline in interest in his work and in that of the Hudson River School.

Thomas Cole
Bolton-le-Moor, Lancashire, England, 1801 – Catskill, New York, 1848

Thomas Cole was the son of a textile manufacturer in Lancashire, England. In 1818 financial difficulties caused the Cole family to relocate to the United States.

In 1823 Cole was living in Philadelphia, Pennsylvania, when he moved to Pittsburgh, Pennsylvania, to work with his father, then manufacturing floor cloths. Soon he returned to Philadelphia, where, at the Pennsylvania Academy of the Fine Arts, he drew from casts and probably saw landscapes by Thomas Doughty and Thomas Birch, both of whom had been influenced by European landscape painting.

In the meantime, the Coles had moved to New York City. Thomas followed in 1825, and sold three paintings to George Bruen, who financed his first trip up the Hudson River. The sale of three pictures resulting from this journey brought Cole to the forefront of American art. He continued to take sketching trips up the Hudson to the Catskill Mountains and began to travel to the White Mountains, New Hampshire. He also sketched in the Adirondacks, New York, as well as the Berkshires, Massachusetts, and in Maine and Connecticut. Paintings he composed in his studio were based on these sketches.

Cole's early career centred on the North American wilderness landscape, and it is on this that he built his reputation. He adopted William Oram's methods of composition and drew heavily on English aesthetic theory. He was also familiar with the Scottish philosopher Archibald Alison's theory of associationism.

Cole made two trips to Europe, from 1829 to 1832, and from 1841 to 1842, spending time in London, Paris, and various parts of Italy.

The art and landscape he viewed in Europe affected Cole's own work. On his first trip, he met J.M.W. Turner and John Constable and exhibited paintings at the Royal Academy in London. In 1832 he sailed for Paris, staying only a week before leaving for Italy, travelling to Florence, Volterra, and Rome. He also went to Naples, as well as a number of other places, before returning to New York. On his second visit to Europe, he again went to England, France, and Italy, including Sicily; he also toured Switzerland before returning to New York in 1842.

Cole completed two major series of paintings and began a third before his death in 1848. The first, *The Course of Empire* 1836, a commission from Luman Reed, a New York merchant, charts the rise and fall of civilisation. In the early 1840s he painted his second series, *The Voyage of Life*, a commission from prominent New York banker Samuel Ward. He had no patron for his final, uncompleted series, *The Cross and the World*.

Samuel Colman
Portland, Maine, 1832 – New York City, 1920

Samuel Colman grew up in New York City, where his father, a successful bookseller and publisher in Maine, had moved his family and started a publishing house. Nathaniel Parker Willis (*The Home Book of the Picturesque*, 1852) and Henry Wadsworth Longfellow were just two of the authors whose works Samuel Sr published in illustrated editions. The artist's uncle was William Colman, in whose shop John Trumbull, William Dunlap and Asher B. Durand discovered the work of Thomas Cole.

It is not known where or with whom Colman received his training in art. Some sources suggest that he studied for a short time with Durand around 1850, but this is unconfirmed. As early as 1851 Colman exhibited at the National Academy of Design, where later he was elected associate and academician.

In the 1850s Colman sketched and painted the scenery of the Hudson River, Lake George, and the White Mountains. By 1856 he had established a summer studio in North Conway, New Hampshire, which he shared with five other artists, including Sanford R. Gifford.

Colman took the first of many trips abroad in 1860, when he travelled to France, Italy and Switzerland, as well as to Spain, where he was one of the first American artists to sketch. During the 1860s, he also painted in the Genesee region of western New York State.

In 1866 Colman helped found the American Society of Watercolour Painters and was elected its first president, an office he held until 1871. Also in 1866, he was one of a number of artists — including Durand, Frederic E. Church, and Albert Bierstadt — to contribute to an album of sketches in honour of the noted poet and editor, William Cullen Bryant.

In 1870, the year following the completion of the Union Pacific Railroad, Colman probably travelled west to Wyoming and California. He took at least three additional trips west in 1886, 1888, and from 1898 to 1905, also visiting Canada and Mexico.

Colman left the United States in 1871 for a four-year tour of Europe and Africa. After his return to America, in 1875, he joined with George Inness, Thomas Moran and others to form the Society of American Artists. In 1878, an avid collector of etchings and by this time a maker of etchings himself, Colman joined the New York Etching Club. He also worked as an interior decorator for Tiffany and Company until 1890. He built his own home in 1883 in Newport, Rhode Island, and decorated others there in this period. He began collecting Asian art, and gradually came to possess a wide array of things Japanese.

During the last portion of his life, Colman devoted himself to writing theoretical treatises.

Jasper Francis Cropsey
Rossville, Staten Island, New York, 1823 – Hastings-on-Hudson, New York, 1900

Jasper Cropsey was born to farmers of Dutch and Huguenot ancestry. As a boy, he worked on his father's farm and, in his spare time, developed an interest in architecture. In 1837 he won a diploma at the Mechanics Institute of the City of New York for his model of a country house.

Cropsey pursued his interest as an apprentice in an architectural firm in New York City, where, by the end of his term, he was painting backgrounds for the finished architectural drawings. At the same time, he studied watercolour painting with an Englishman named Edward Maury. He also began taking life drawing classes at the National Academy of Design, and in 1841 he began to make oil paintings after his watercolours.

In 1843 Cropsey's first painting — an imaginary Italian landscape — was exhibited at the National Academy, and the following year he exhibited a view of Greenwood Lake, New Jersey, winning election as an associate of the Academy. (In 1851, he was elected academician.) In 1845 Cropsey addressed the American Art-Union, praising and encouraging the study of nature in an essay called 'Natural Art', the themes of which he took up in his 1855 essay 'Up Among the Clouds'.

Cropsey made two trips to Europe, travelling to England, France and Italy from 1847 to 1849, and establishing a studio at Kensington Gate, London, in 1856. He remained abroad until 1863. While in London, Cropsey studied a variety of work, including paintings by John Constable, J.M.W. Turner, and the Pre-Raphaelites, and became friends with John Ruskin. He also illustrated the poems of Edgar Allan Poe and Thomas More and painted American landscapes which were published by Gambert and Company.

Between European trips, Cropsey made a number of sketching trips to the White Mountains, New Hampshire; Newport, Rhode Island; Greenwood Lake, New Jersey; and the Ramapo Valley; and, in 1855, to Michigan and Canada.

In 1865 and 1866 Cropsey helped found the American Society of Watercolour Painters. Having obtained financial security from the sale of *The Valley of Wyoming* 1865 (The Metropolitan Museum of Art, New York) and *Starrucca Viaduct* 1865 (this version destroyed 1871), he bought land in Warwick,

New York, in 1866. There he designed and built a Gothic revival mansion and studio he called Aladdin. Cropsey continued to accept architectural commissions and to teach art to supplement his income from paintings sales, but by 1884 he was in financial straits and was forced to sell Aladdin. In 1885 he moved to Hastings-on-Hudson, New York, to a house he named Ever Rest and duplicated the studio he had built at Aladdin. He remained there until his death.

Robert S. Duncanson
Seneca County, New York, 1821 – Detroit, Michigan, 1872

Robert Scott Duncanson was born to a free black woman and a white Canadian of Scottish descent. His childhood was probably spent in eastern Canada, where the Duncansons would have found a more racially tolerant environment than in the United States. By 1842, however, Duncanson was living near Cincinnati, Ohio, where he spent much of his professional life. There he met his most important early patron, Nicholas Longworth.

In the 1840s and 1850s Duncanson was a daguerreotypist, and in the 1850s he worked with James P. Ball, an African–American gallery owner who exhibited primarily daguerreotypes. The artist also executed oil paintings after daguerreotypes for display in Ball's gallery.

Despite a longstanding involvement with the movement to abolish slavery in the United States, Duncanson's reliance (although not exclusive) on white patronage caused dissatisfaction in the African–American community and among his own family members, who felt he had betrayed his African–American heritage. Even so, throughout the 1840s and 1850s, Duncanson painted a number of portraits, many of abolitionists, in Detroit and Cincinnati, and in 1853 he was commissioned by the editor of the *Detroit Tribune* to paint a scene from Harriet Beecher Stowe's novel *Uncle Tom's Cabin*, published in 1852.

In 1853 Duncanson visited Europe for the first time, travelling to England, France and Italy, where he saw the work of J.M.W. Turner and Claude Lorrain, among others. When he returned to the United States the following year, he began painting landscapes influenced by Turner and Claude and in the style of Thomas Cole, who had exhibited in Cincinnati as early as 1847.

Duncanson spent 1863 to 1865 in Montreal, Canada (probably to avoid the American Civil War), where in 1863 commercial photographer William Notman held Duncanson's first recorded Montreal exhibition. For an admission fee, the public viewed works by the artist such as *Land of the Lotos Eaters* 1861 (HRH the King of Sweden) and *City and Harbour of Quebec* 1863 (unlocated). These two paintings represent the two poles of Duncanson's subject matter during this period: fantastic landscapes inspired by literary works and realistic scenes of the Canadian landscape. *Land of the Lotos Eaters* was probably inspired by a poem by Alfred, Lord Tennyson, 'The Lotos-Eaters' (1832).

The artist returned to Europe in 1865, staying primarily in England and Scotland; he visited Scotland again in 1870 and 1871.

He painted a number of Scottish landscapes after these trips. Duncanson also continued to paint scenes from the poetry and prose of such British authors as Tennyson, Thomas More, and Sir Walter Scott.

He died at age fifty at the Michigan State Retreat, after three months of treatment for mental illness.

Asher B. Durand
Jefferson Village [Maplewood], New Jersey, 1796 – Maplewood, New Jersey, 1886

Asher B. Durand was trained as an engraver, beginning his apprenticeship in 1812, and establishing himself as one of the premier engravers in the United States by 1823 with a commission for John Trumbull's *Declaration of Independence*.

In 1825 Durand helped organise the New-York Drawing Association (later the National Academy of Design) and, in 1829, the Sketch Club (later the Century Club). Soon after, in the early 1830s, Durand began painting portraits and genre scenes and a few landscapes. In 1835, with the encouragement of Luman Reed — an important patron of Durand and other American artists — Durand gave up engraving and turned his full attention to oil painting. By 1838, after a trip in 1837 with Thomas Cole and Cole's wife, Maria Bartow, Durand was specialising in landscapes; and by 1845, the year he was elected president of the National Academy of Design, he was sending landscapes almost exclusively to the exhibitions.

In 1840 another patron and Luman Reed's business partner, Jonathan Sturges, made it possible for Durand to travel to Europe. He went with John Casilear, John Kensett and Thomas Rossiter, spending seven weeks in London before travelling to Paris, the Low Countries, the Rhine Valley, Switzerland, and Italy. While abroad, Durand studied landscapes by Claude Lorrain and John Constable, as well as the work of Dutch painters such as Albert Cuyp. Durand returned to the United States in 1841 to paint a number of large landscapes that reflected some of the influence of the European painters he had studied, along with that of Cole. After Cole's death in 1848, Durand was considered the leading landscape painter in America.

Durand published nine 'Letters on Landscape Painting' in 1855 in the *Crayon*, which was co-edited by his son, John. These essays advised the reader to paint directly from nature, and to record it realistically. In 1869, at age seventy-six or seventy-seven, Durand left New York and returned to Maplewood, New Jersey, to retire.

Thomas Eakins
Philadelphia, 1844 – 1916

The son of a calligrapher and writing master, Thomas Eakins began his formal art training at the Pennsylvania Academy of the Fine Arts in Philadelphia in 1862. At Jefferson Medical College, he attended anatomy lectures and observed surgical demonstrations which later played a role in his art.

In 1866 Eakins went to Paris, where he studied at the Ecole des Beaux-Arts under Jean-Leon Gérome, whose emphasis on drawing affected Eakins's own work as an artist. His European travel included Switzerland with artists William Crowell and William Sartain, and Italy, Germany, and Belgium. He studied with the portraitist Leon Bonnat, whose technique contrasted with that of Gérome, and clay modeling for a short time with the sculptor Augustin Alexandre Dumont. Eakins went to Spain in 1869, where he viewed the works of Velazquez, Ribera and Goya.

Eakins returned to Philadelphia shortly before the Franco-Prussian War and set up a studio in his family home. There he painted portraits of friends and relatives and scenes of outdoor sporting activities. In 1871 he exhibited at the Union League of Philadelphia for the first time. He continued his anatomical studies at Jefferson and, from 1874 to 1876, he taught life classes at the Philadelphia Sketch Club.

In 1875 Eakins painted *The Gross Clinic*, a portrait of Dr Samuel Gross in the operating theatre that drew on two paintings of anatomy lessons by Rembrandt. Arguably Eakins's most important painting from this period, *The Gross Clinic* was severely criticised for its realism and was ghettoised in the United States Hospital Building at the Centennial Exhibition in 1876.

Eakins continued to teach throughout the 1870s, at the academy and at the newly founded Art-Students' Union, and assisted a doctor with anatomy lectures. Around 1880 he first experimented with photography and, in 1884 and 1885, he worked with Eadweard Muybridge on motion studies. At this time, he became more interested in landscape painting and sketching *en plein air*.

Eakins became director of the school at the Pennsylvania Academy in 1882 and taught there until 1886. He was forced to resign for using nude models in co-ed classes. He remained active in art education, however, teaching at the Art Students' League in Philadelphia and in Manhattan, and at Cooper Union and the National Academy of Design, both in New York, among other institutions.

In the mid-1880s Eakins painted primarily portraits, among these a well-known portrait of Walt Whitman and many compelling character studies. In the 1890s he also sculpted, receiving public commissions in Brooklyn, New York and Trenton, New Jersey.

Eakins was elected to the National Academy of Design in 1902. In 1904, he won a gold medal for *The Gross Clinic* at the Universal Exposition, St Louis, Missouri.

Ralph Earl
Leicester, Massachusetts, 1751 – Bolton, Connecticut, 1801

While best known as a prolific portrait painter during the Revolution and early Federal periods in New England and New York, Ralph Earl was also one of the first native-born artists to paint the American landscape. During his stay in England from 1778 to 1785, Earl painted portraits in Norwich, Windsor and London, exhibiting a number of his works at the Royal Academy.

Earl became a member of the entourage of American artists in the London studio of Benjamin West. His portraits often included scenic landscape backgrounds, an indication of his growing interest and proficiency in landscape painting. Upon his return to the United States, Earl painted portraits of New England subjects in a manner appropriate for citizens of a new nation. He filled the backgrounds with locally-made furnishings, newly built houses, and views of his subjects' cultivated lands. At a period when landscape began to take on a new artistic and intellectual significance in the young nation, Earl succeeded in cultivating a taste for landscape among his patrons by including regional landscape vignettes in his portraits. He was one of the few American artists in the 1790s to receive commissions for landscape paintings, frequently painting houses and thriving towns, including *Landscape View of Old Bennington*.

In 1799, while residing in Northampton, Massachusetts, Earl became the first native-born artist to travel to Niagara Falls, where he took sketches of the 'stupendous cataract'. Returning to Northampton after this arduous journey, he produced a panorama of the falls that measured approximately 15 by 30 feet (about 4.5 x 9.0 metres). The panorama was first placed on public view in Northampton and subsequently in New Haven, Connecticut; eventually, in 1800, it travelled on to London. In 1800, a year before his death, Earl returned to his native town of Leicester, Massachusetts, where he painted a final panoramic landscape of the region in which he was raised, titled *Looking East from Denny Hill*. The artist's idyllic view, with its seemingly limitless fertile farmlands and prosperous town centres, conveys a sense of well-being and the promise of America.

Earl's son Ralph Eleazer Whiteside Earl (1785 or 1788–1838) received artistic instruction from his father and pursued a successful career as a painter of portraits, historical subjects and landscapes. Ralph Earl's brother James Earl (1761–1796) became a successful portrait painter in England and the United States, and his son, Augustus Earle (1793–1838), also pursued an artistic career, travelling to many regions of the world. In addition to his career in England, Augustus is the only artist represented in this exhibition to have painted portraits and landscapes in Australia and in the United States.

Alvan Fisher
Needham, Massachusetts, 1792 – Dedham, Massachusetts, 1863

Alvan Fisher was one of the first American artists to specialise in landscape painting. The British landscape painters of the picturesque inspired Fisher, who sought the ideal, poetic aspect of natural scenery in his early depictions of the American landscape. His work served as a modest prelude to the heroic compositions of the Hudson River School, led by Thomas Cole.

Fisher decided to become an artist at the age of eighteen, when he was placed under the guidance of ornamental painter John Penniman (1782?–1841). He related the following details of his early career to William Dunlap:

'In 1814 I commenced *being* an artist, by painting portraits at a cheap rate. This I pursued until 1815. I then began painting a species of pictures which had not been practiced much, if any, in this country, viz.: barnyard scenes and scenes belonging to rural life, winter pieces, portraits of animals, etc. This species of painting being novel in this part of the country, I found it a more lucrative, pleasant and distinguishing branch of the art than portrait painting...' (William Dunlap, *History of the Rise and Progress of the Arts of Design in the United States*, 1834, vol.3, pp.32–33.)

In the 1820s Fisher travelled through Connecticut, Vermont, western Massachusetts, and upstate New York, recording his observations of American wilderness scenery in his notebook (collection: Museum of Fine Arts, Boston). He produced paintings of such popular tourist attractions as Niagara Falls and the Connecticut River Valley, presenting a pastoral vision of the young country.

Fisher went to Europe in 1825, travelling in England, France, Switzerland and Italy. He arrived in London in May. As were many American artists of his time, he was attracted to the city by its art scene. There he visited a number of exhibitions of Old Master paintings but also spent time studying the work of contemporary English artists at the British Institution, the Society of British Artists, the Water-Colour Society, and the Royal Academy. Sir Edwin Landseer's accuracy and John Martin's romantic imagination had an impact on Fisher's work. In Paris he studied the Old Masters and copied works by them at the Louvre; he was particularly impressed by the art of Claude Lorrain.

Fisher returned to the United States in 1826 and settled in Boston, where he lived until moving to Dedham in 1840. He continued to paint at least until 1852, when he offered a group of paintings for sale at the Art-Union Rooms in Boston. He died in 1863.

Sanford Robinson Gifford
Greenfield, New York, 1823 – New York City, 1880

Sanford Robinson Gifford grew up in Hudson, New York, overlooking the Hudson River and the Catskill Mountains. He attended Brown University in Providence, Rhode Island, for two years before moving to New York City in 1845 to study drawing with John Rubens Smith. (Smith claims to have taught William Guy Wall also.)

By 1847 Gifford was exhibiting landscape paintings at the American Art-Union and the National Academy of Design where he was elected an academician in 1854. Up to 1855, when he went to Europe, he sketched often in the Catskill and the Adirondack Mountains in New York; the Berkshire Mountains in Massachusetts; and the White Mountains in New Hampshire. On his first trip to Europe, Gifford travelled to England and France, among other countries. There he saw the work of J.M.W. Turner and John Constable and met John Ruskin and Jean-François Millet.

Beginning in 1861, Gifford was a soldier for the Union in the volunteer Seventh Regiment in the Civil War; he made many sketches of war life during that time.

He returned to Europe in 1868 to 1869, going on to visit Jerusalem, Syria, Lebanon and Egypt. The following year, with John F. Kensett and Worthington Whittredge, he went to the Colorado Rocky Mountains. He joined a government survey expedition to Wyoming. He continued to sketch in the eastern states, but also travelled along the western coast from Alaska to California. He died in 1880 of malaria and pneumonia.

Childe Hassam
Dorchester, Massachusetts, 1859 – East Hampton, New York, 1935

Frederick Childe Hassam was the son of a well-to-do hardware merchant and antique collector, descended from Puritan ancestors; his mother was the daughter of an English-born colonial official in Massachusetts. Hassam's fascination with New England has been attributed to his Puritan ancestry.

Hassam began his career as an illustrator, working for a Boston wood engraver during the day and taking sketching classes at the Boston Art Club at night. In 1883 he went to Europe and painted in England, Holland, Spain, and Italy. He married Kathleen Maud Doane in Boston the following year, and in 1885 they moved to a studio apartment in Paris. There Hassam studied at the Académie Julian with Gustave Boulanger and Jules Lefebvre and he exhibited at the 1887 Salon. In 1889 he exhibited at the Paris Exposition, winning a bronze medal, and at the 1892 Munich International Art Exposition he won a silver medal. He spent a short time in London before returning to the United States in 1889.

In Manhattan, Hassam joined the Players' Club, where he met J. Alden Weir, John Twachtman, Robert Reid and Willard Metcalf; this group became the core of the Ten American Painters, founded in 1898 — the Ten, as they were called, was a group that seceded from the Society of American Artists which they found too academic and rigid. Hassam painted New York street scenes and interiors. His flag painting series is set in the city, during (and on the theme of) World War I. New England became another theme in his work: he often painted Old Lyme and Cos Cob, both in Connecticut, where important American impressionist colonies were located, as well as in the Isles of Shoals, off the Maine–New Hampshire coast; and in Gloucester, Newport, and Provinceton, Massachusetts.

In 1897 he travelled again to Europe, going to London; Paris and Pont Aven; and Naples, Rome and Florence, where he painted and studied the work of the Old Masters. In 1910 he took his fourth and last trip to Europe, working in Paris and Grez, and visiting Spain. His first trip to the West Coast of the United States was in 1908: he went to San Francisco, California, and Portland, Oregon.

Hassam was in San Francisco again in 1914, when he visited the Panama-Pacific International Exposition where he had work on view. His final trip west was to Los Angeles, California, in 1927.

Throughout his career, Hassam exhibited his oils, watercolours, and etchings all over the United States. He died in 1935 in East Hampton, Long Island, where he had established his permanent summer home and studio since 1920.

Martin Johnson Heade
Lumberville, Bucks County, Pennsylvania, 1819 – St Augustine, Florida, 1904

Martin Johnson Heade began his career as a portrait painter, but few of his portraits have been located. In the 1830s he trained with the painter Edward Hicks in Newtown, Pennsylvania. He may also have studied with Hicks's cousin, Thomas, whose portrait of Heade at fourteen is now in the Bucks County Historical Society.

Heade visited Europe in 1840, going to England and France, and spending two years in Rome. The trip had little impact on his painting, however. While abroad, he exhibited at the Pennsylvania Academy of the Fine Arts in Philadelphia and, in 1843, at the National Academy of Design in New York City. When Heade returned to the United States, he travelled to Manhattan; Brooklyn, New York; Philadelphia; Trenton, New Jersey; and Boston, Massachusetts; and toured the Midwest, continuing to paint portraits and a few landscapes. He also spent time in Providence, Rhode Island.

In the 1850s Heade turned his attention from portraiture and genre to landscape and seascape. The north-eastern marshes became his special subject — the earliest of these dating from 1862. Heade was introduced to the marshes by the Rev. James C. Fletcher, a naturalist who lived in Newburyport, Massachusetts, and who had a keen interest in Brazil, perhaps prompting Heade to go there. The artist visited Brazil in 1863 and began a series of pictures of hummingbirds, which he planned to publish as a book in London. He never completed this project. He travelled to Nicaragua in 1866, and to Colombia, Panama and Jamaica in 1870. He visited British Columbia in 1872 and California in 1875. His paintings of hummingbirds and orchids from this period are considered his greatest.

In the 1880s Heade began painting still lifes. He married and moved to St Augustine, Florida, where he painted Florida flowers such as magnolias and Cherokee roses. He was a frequent contributor to the magazine *Forest and Stream*, writing letters and articles on such topics as birds and game preserves. He gained his first important patron in Florida, an oil and railroad magnate, Henry Morrison Flagler. In his final years Heade began to paint Florida marsh and swamp scenes in addition to the subjects for which he had gained a reputation. By the time of his death, however, he and his work had become obscure.

Edward Hicks
Bucks County, Pennsylvania, 1780 – Newtown, Pennsylvania, 1849

Edward Hicks is most famous for his many versions of the *Peaceable Kingdom*. He was born into a family of well-to-do loyalists who were financially ruined by the American Revolution. With the death of his mother in the early 1780s, he was taken in by the Twinings, a Quaker family. Apprenticed to a coach maker at thirteen, he learned to be a coach painter, which was his only formal training in art.

Hicks married Sarah Worstall of Newtown, Pennsylvania, in 1803, and he joined the Quaker faith. By 1812 he had become a minister, a profession with no remuneration but one that required a good deal of travel. Paintings were considered luxuries by the Quakers, and Hicks's profession was frowned on by the Friends. To comply with Quaker regulation, Hicks turned to farming, but was so unsuccessful that, by 1815, he began painting tavern signs to support his growing family. Around this time he also began to do easel paintings.

In 1827 the American Quaker community split into two factions, the Quaker Orthodox and the Hicksites, led by Hicks's cousin Elias. Edward supported his cousin, and the importance of the split is reflected in the iconography of his *Kingdoms with Quakers Bearing Banners* from this period.

Hicks continued to serve as a minister and to work as an ornamental and coach painter until well into the 1840s. In 1843 he began writing an autobiography which was published posthumously in 1851 as *Memoirs of the Life and Religious Labors of Edward Hicks, Late of Newtown, Bucks County, Pennsylvania*.

Hicks had a number of pupils, including Martin Johnson Heade.

Winslow Homer
Boston, Massachusetts, 1836 – Prout's Neck, Maine, 1910

Winslow Homer learned to draw as an apprentice at a Boston lithography shop, designing sheet-music covers and doing other commercial work. He began his career as a freelance illustrator in 1857 and published his first illustration in *Ballou's Pictorial*.

In 1859 Homer moved to New York City, where *Harper's Weekly* offered him a position as a full-time illustrator. He refused the job, preferring freelance work. He began studying drawing from life at the National Academy of Design and exhibited his first work there in 1860.

During the Civil War, Homer served as an artist–correspondent for *Harper's*. He began to paint in oils, and the war provided material for important paintings. After the war, he was elected to the Century Association and the National Academy of Design. He exhibited his first major painting at the Exposition Universelle in Paris in 1867. He went to Paris for the event, his only trip to continental Europe.

Back in New York in the fall of 1867, Homer executed paintings mainly of rural subjects. In 1873 he began using watercolours and joined the American Watercolor Society three years later. His time in the Adirondacks in New York State in the 1870s produced a number of important watercolours and oils on Adirondacks subjects. He returned to the North Woods Club there almost annually from 1889 until his death.

In 1881 he moved to Cullercoats, a fishing village near Tynemouth, England, where he made studies of the landscape and the fisherfolk who lived there for works he completed after his return in 1882. In 1884 Homer moved to Prout's Neck, in Scarboro, Maine, where he lived for the remainder of his life. There he painted several great paintings of the Maine coast. During the winters, he travelled to Cuba, Nassau, Bermuda and Florida, which inspired some of his most successful watercolours.

Homer died in Prout's Neck in 1910.

George Inness
Newburgh, New York, 1825 – Bridge-of-Allan, Scotland, 1894

At about age sixteen, George Inness began working as a map engraver at the firm Sherman and Smith in Manhattan. He was primarily self-taught as an artist, but he did study briefly with John Jesse Barker and with Régis François Gignoux, who had studied with Delaroche. By 1844, he was exhibiting regularly at the National Academy of Design in New York, where he was elected associate in 1853 and academician in 1868. He helped found the Society of American Artists in 1877; this group revolted against the conservative practices of the Academy.

Inness made several trips to Europe, the first in 1847, when he visited London and Rome with the financial assistance of Ogden Haggerty, a dry-goods auctioneer. In Rome he studied paintings by Salvator Rosa, Claude Lorrain and Nicolas Poussin. From 1851 to 1852, he returned to Europe, staying in Paris where he studied works by the Barbizon school. This group of painters would have a lasting effect on Inness's art. He returned to Europe again in 1870 and stayed four years, spending most of his time in Rome and Paris.

In the 1870s, Thomas B. Clarke of New York City, an art collector and later a dealer, became Inness's agent and patron. Clarke's support gained Inness clients and financial security for the remainder of his life. Inness moved to Montclair, New Jersey, in 1878, spending summers in Nantucket, Niagara Falls and Durham, Connecticut, among other places, and winters in Georgia and Florida. In 1891 Inness travelled to California, where he visited Yosemite.

John F. Kensett
Cheshire, Connecticut, 1816 – New York City, 1872

The son of an English engraver, John Kensett began his career in the same field. He continued in this line of work for several years, and it undoubtedly contributed to the delicacy of his brush stroke later.

Kensett first exhibited a landscape painting in 1838 at the National Academy of Design in New York City. In 1839 he sailed for Europe with fellow landscapists Asher B. Durand, John Casilear and Thomas P. Rossiter. Kensett went to England — visiting family and museums in London and Hampton Court — and to Paris. There he copied paintings on display in the Louvre, many by Claude Lorrain. While in France he painted the countryside at Fontainebleau and elsewhere near Paris — Kensett also met Thomas Cole in the city. From 1843 until 1845 he was in England, then in Paris again, and then he took a walking tour up the Rhine through Switzerland and into Italy. He spent the winter sketching in Rome and then travelled throughout Italy, sketching and visiting art galleries. He went back to England, stopping in Switzerland and Paris on the way. During this time, he supported himself through engraving work, but wished to turn his attention exclusively to painting, especially landscape. In 1845 he exhibited in London at the British Institution and the Royal Academy.

Kensett returned to the United States in 1847 and, in the following year, established a studio in the New York University Building, Washington Square, in New York City. He sold several landscapes to the American Art-Union and was elected to the National Academy of Design, where he exhibited regularly for the rest of his life. In the summers he sketched — in both pencil and oil — in the Catskill Mountains and the Adirondack Mountains, both in New York State; the White Mountains, New Hampshire; and the Green Mountains, Vermont. He travelled along the New England coast, often sketching in Newport, Rhode Island. Over the years Kensett took several trips to the Mississippi River (1854 and 1868) and to the western United States, to Missouri and Montana (1857), and the Rocky Mountains (1870).

In 1859 President James Buchanan named Kensett art commissioner, one of three to advise the decoration of the Capitol. During the Civil War, he served as chairman of the art committee of the Metropolitan Sanitary Fair, which raised money for the United States Sanitary Commission. Kensett lent his considerable talents to the Artist's Fund Society, of which he was a founder and president, and the Metropolitan Museum of Art, New York, which he also helped found.

In the summer of Kensett's last year, he painted a series of pictures known as 'Last Summer's Work'. These reflected his lifelong interest in atmosphere and light, an interest that has often placed him within the ranks of the so-called luminist painters as well as in the Hudson River School.

Fitz Hugh Lane
Gloucester, Massachusetts, 1804 – 1865

Lane's name was changed from Nathaniel Rogers to Fitz Hugh not long after his birth. His father, Jonathan Dennison Lane, was a sailmaker. At the age of two, Lane suffered from what was probably infantile polio; his legs were partially paralysed, a lifelong condition requiring crutches.

In 1816 Lane began to learn drawing and sketching. His earliest known work dates from this period: a watercolour after E.D. Knight's *Burning of the Packet Ship 'Boston'*. In the early 1830s, Lane worked part-time as a shoemaker and was briefly employed by Clegg and Dodge, a Gloucester-based lithographic firm. He soon went to Boston for an apprenticeship with William S. Pendleton, a Boston lithographer, with whom he worked on trade card signs, advertisements and sheet music cover illustrations. Lane's first dated lithograph is from 1835, and his first major landscape print is from 1836.

The artist first began to paint in oils in 1840. Most of his early oils are ship portraits and views of the shoreline in the Cape Ann region. By 1841 he was listed in the *Boston Almanac* as a marine painter. His paintings from the mid-forties, views of Gloucester and Boston harbours, reflect the influence of the English-born marine painter Robert Salmon. Lane continued to publish lithographs of the Massachusetts coast and, from 1845 to 1847, ran his own lithographic firm in partnership with J.W.A. Scott.

In 1848, having met with success as an artist, Lane established a studio in Gloucester, where he painted extensively. That summer he took his first trip to Maine, and exhibited paintings at the American Art-Union in New York City. By 1850 he had purchased property on the Gloucester Harbor and had designed and constructed a seven-gabled granite house for himself. In the summer of that year he spent a good deal of time sailing and sketching in Maine with a friend. He visited Castine and Mount Desert Island and painted his first important views of Somes Sound.

Throughout the 1850s Lane visited Maine many times and travelled to New York and possibly Puerto Rico and Havana. He exhibited at the American Art-Union and the New England Art Union and received favourable reviews. He also took on his first art students.

At the start of the Civil War, Lane painted *Ships and an Approaching Storm Off Owl's Head* (private collection), among other works. He continued to travel to Maine in the 1860s and sketched around Cape Ann. In August of 1865 he fell and possibly had a heart attack or stroke. He died six days later.

Joseph Lee
Oxfordshire, England, 1827 – San Francisco, California, 1880

Joseph Lee began his American career as a sign and ornamental painter. He is first listed in San Francisco directories in 1858. Nothing is known about his life and work prior to this time.

Lee is first listed as 'artist' in the city directory in 1872, and his most active period was in the 1870s. During this time he became well known as a landscape and marine painter and executed detailed estate views and ship portraits in the San Francisco and Alameda County region.

Lee exhibited at the Mechanics Institute and the San Francisco Art Association, from whom he may have rented studio space in 1878 to 1879. He died in 1880 of 'gangrene of the lungs'.

Joseph R. Meeker
Newark, New Jersey, 1827 – St Louis, Missouri, 1889

Joseph Meeker grew up in Auburn, New York, and studied at the National Academy of Design in New York City in 1845 to 1846 with Charles Loring Elliott as well as with Asher B. Durand. In 1852 Meeker moved to Louisville, Kentucky, before moving to St Louis in 1859, where he spent the remainder of his life.

During the Civil War, Meeker was a paymaster in the United States Navy. While in the Navy he travelled to the Deep South, where he made sketches of the Mississippi River swamplands that later served as studies for paintings. He continued to travel to the Mississippi Delta region from 1865 to 1875.

After the war Meeker exhibited at the National Academy of Design and at the Boston Art Club. He helped establish arts organisations in St Louis. Meeker wrote articles on art for magazines, including one on J.M.W. Turner for the *Western* in 1877.

Thomas Moran
Bolton, Lancashire, England, 1837 – Santa Barbara, California, 1926

The Moran family emigrated to the United States in 1844. Thomas was apprenticed to a wood-engraver for two years in Philadelphia. He continued to work in print-making throughout his career. His first paintings were in watercolours; he began painting in oils not long after and exhibited at the Pennsylvania Academy of the Fine Arts in 1856.

In 1861 Moran returned to England, where he visited the National Gallery in London and was impressed by the work of J.M.W. Turner. He copied Turner's pictures and adopted the English artist's grand style and daring palette. On his second trip to Europe, in 1866, he travelled throughout France and Italy, copying paintings by the Old Masters, and gathering material for his Venetian series.

In 1882 Moran went to England with his family and met John Ruskin in London. (Later Ruskin would praise one of Moran's engravings as one of the best to come out of America.)

Moran joined F.V. Hayden on a government-sponsored geological expedition in 1871. His large panoramic picture *The Grand Canyon of the Yellowstone* 1872 (National Museum of American Art, Smithsonian Institution, Washington, DC) resulted from this trip. Two years later he went west again, to the Grand Canyon of the Colorado, and painted *The Chasm of the Colorado* 1873–74 (National Museum of American Art, Smithsonian Institution). The United States Congress bought both of these paintings to hang in the Capitol in Washington, DC. They were considered pictorial records of an unfamiliar region. He made a series of watercolours of the Yellowstone region for Louis Prang and Company, Boston lithographers. Moran has been honoured by the naming of Mount Moran of the Teon Range, in Yellowstone in Wyoming, and Moran Point, in the Grand Canyon in Arizona.

Moran married one of his students, Mary Nimmo, in 1862. A painter and etcher in her own right, she was the daughter of Archibald Nimmo, of Strathaven, Scotland. They lived in Philadelphia until 1872, when they moved to Newark, New Jersey, and later to New York City. Moran was elected a member of the National Academy of Design in New York in 1884. He spent his summers in East Hampton, Long Island, New York, where he built a studio.

Moran continued to travel, visiting Mexico and Cuba in 1883, Italy in 1886, and the Pacific Coast. He moved to Santa Barbara, California, in 1916, where he spent his remaining years.

Henry Cheever Pratt
Orford, New Hampshire, 1803 – Wakefield, Massachusetts, 1880

Henry Cheever Pratt painted portraits, miniatures, panoramas, and landscapes, but he is perhaps best known as a landscapist. His introduction to art was through Samuel F.B. Morse, a portraitist working in the New Hampshire area at the time. In 1818 Pratt was apprenticed to Morse and, in search of commissions, travelled up and down the east coast as far as Charleston, South Carolina.

By 1825 Pratt had established his own studio in Boston, painting primarily portraits. By 1827, however, his emphasis seems to have switched to landscape: he exhibited mostly landscapes at the Boston Athenæum that year. The following year, he exhibited at the National Academy of Design in New York City. (He continued to exhibit at both venues for many years.) It was not long after that he met Thomas Cole, with whom he travelled to the White Mountains, New Hampshire, on a sketching tour in 1828. Cole's art had a significant impact on Pratt's early work and many of his landscapes from this period conspicuously demonstrate his influence. Pratt travelled again with Cole in 1845, this time to Maine.

In 1851 Pratt joined John Russell Bartlett on his government-sponsored expedition to survey the Mexican boundary.

Pratt remained on the expedition until 1853 to record the topography of the boundary region. He produced a sizeable number of paintings of the region that he later exhibited in Boston. Pratt maintained his Boston studio, accepting portrait commissions. He exhibited for the last time at the Boston Athenæum in 1860, and moved with his wife and four sons to Wakefield from Charlestown, Massachusetts.

Frederic Remington
Canton, New York, 1861 – Ridgefield, Conecticut, 1909

Frederic Remington was the only child of Clara Sackrider and Seth Pierre Remington. His father was a prominent Republican journalist and newspaper publisher and distinguished himself as a Federal cavalry officer in the Civil War.

An illustrator, painter and a sculptor, Remington was educated at a military academy in Worcester, Massachusetts, and at Yale University, where he studied art with John Henry Niemeyer and John Ferguson Weir at the School of Fine Arts.

After his father's death in 1880, Remington left Yale and moved to Albany, New York. The following year he travelled west for the first time, working as a cowboy, scout, and sheep and mule rancher. He sold a sketch from this trip to *Harper's Weekly*. On commission for *Harper's*, in 1892 Remington travelled to North Africa and Europe, including Russia, with journalist Poultney Bigelow. In 1898, during the Spanish–American War, he was a war correspondent in Cuba for *Harper's* and the *New York Journal*.

Remington bought a sheep ranch in Kansas in 1883, but moved back to New York City two years later to pursue a career in illustration. His images of cowboys, Native Americans and soldiers appeared in numerous American magazines and books by well-known authors such as Theodore Roosevelt, Francis Parkman and Henry Wadsworth Longfellow. He also wrote and illustrated his own articles and books. Remington wrote his novel, *John Ermine of the Yellowstone*, in response to Owen Wister's *The Virginian*, which explored the conflict between eastern and western American cultures.

As early as 1887, Remington began exhibiting oils and watercolours; he received a silver medal at the Exposition Universelle in Paris in 1889. He was elected an associate of the National Academy of Design in New York City in 1891. Later, he focused on landscape in his painting. He adopted a brighter palette, varied his brush stroke, and heightened the atmospheric effects in his paintings in response to American impressionism and competition from another western realist painter, Charles Schreyvogel.

Remington made his first sculpture, *The Bronco Buster* in 1895 and went on to produce many more. *The Wounded Bunkie* was exhibited at the Royal Academy in London in 1897.

In 1909 he moved to Ridgefield, Connecticut, and exhibited his landscapes at Knoedler Gallery in New York City. That same year he died of peritonitis following an emergency appendectomy performed at his home.

William Trost Richards
Philadelphia, 1833 – Newport, Rhode Island, 1905

William Trost Richards dropped out of school and began designing ornamental metalwork for gas lighting when his father died in 1846. In the evenings he studied with Paul Weber, a German landscape and portrait painter in Philadelphia. In 1852 Richards exhibited at the Pennsylvania Academy of the Fine Arts and, in 1853, he was elected academician.

Richards made seven trips to Europe. In the winter of 1855 and 1856 he travelled to Paris, Zurich and Italy, and, in the spring, to Düsseldorf. He returned to the United States in 1856, little affected by the European masters.

Soon after his return to the United States, Richards married and settled in Germantown, Pennsylvania. Sometime in 1858 he began a study of Pre-Raphaelitism, at first probably independently of the group of painters in New York City who, since 1855, had been reading John Ruskin's writings and articles in the *Crayon* about the English Pre-Raphaelite movement. By 1863 the group had organised as the Association for the Advancement of Truth in Art and was preaching an art that documented nature and that strove for the accuracy of photography and the topographical report. Although the association met formally only two or three times, the movement was sustained by circulation of the *New Path*, which was published monthly from May 1863 to December 1865.

His interests shifted in the 1870s to marine subjects, particularly coastal scenes. His seascapes were at first made with the same attention to detail as his wooded landscapes and botanical studies (which he continued to paint), but soon Richards broadened his brush stroke. Around this time, too, he began working in watercolour, exhibiting frequently with the American Water Color Society, and joining that group in 1874.

From 1878 to 1880 Richards was in England, where he exhibited at the Royal Academy in London, among other places, and toured the English and Irish west coasts and the Channel Islands, sketching and photographing as he went. The artist returned to the United States in October 1880, and the next year he began the design and construction of Graycliff, a house in Newport, Rhode Island, with a view of the ocean. The Richards family spent summers in the house until 1899, when the United States government bought the land for military fortifications. They moved to another house that Richards owned in Newport and lived there year-round until his death in 1905.

Richards was honoured for his work during his lifetime. He was elected academician at the National Academy in 1871 and won a bronze medal at the Paris Exposition in 1889 for *After a Storm* (unlocated).

Joachim Ferdinand Richardt
Brede, Denmark, 1819 – Oakland, California, 1895

Joachim Richardt was born near Copenhagen, brother of the artist Carl Johan Reichardt. (He Anglicised his name sometime around 1856, changing it to Richardt.) While in Europe, he painted rural scenes and the palaces, gardens, and fortresses of Denmark, and worked in Sweden and Norway.

Richardt came to the United States in 1855 'to study the sublimity and grandeur of that wonderful work of Nature' [Niagara], and he became well known for his paintings of that site. He worked in New York City between 1856 and 1859; he exhibited a painting called *Scenery on the Harlem River* at the National Academy of Design in New York in 1858. He had a major exhibition at the Academy in 1859 of his paintings of American and Danish scenery.

Richardt kept a studio in New York City and travelled throughout the eastern United States and Canada. He painted a number of popular American tourist attractions besides Niagara, including Trenton Falls, Minnehaha Falls, Lake Erie, Mammoth Cave in Kentucky, the Natural Bridge in Virginia, and the Mississippi and Hudson River valleys.

In 1863 he went to London and established a studio on Berners Street. There he displayed paintings and sketches of American, Canadian and Scandinavian landscapes. Ten years later, he moved to San Francisco, California, working there and in nearby Oakland. Richardt died of unknown causes in Oakland in October of 1895.

Theodore Robinson
Irasburg, Vermont, 1852 – New York City, 1896

Theodore Robinson was raised in Townshend, Vermont, and Evansville, Wisconsin, where his family moved when his father retired from the ministry. With the encouragement of his mother, Robinson went to Chicago to study art in 1869 or 1870. At first he made portraits, including crayon likenesses after photographs.

Robinson was advised by a doctor to go to Colorado for his asthma. Feeling better after his time in Denver, he moved to New York City in 1874 to study at the National Academy of Design. With other students he met at the Academy, he helped organise the Art Students' League in New York.

In 1877 Robinson travelled to Paris, where he worked with Carolus-Duran and later Jean-Leon Gérome. In France he made friends with John Singer Sargent, Robert Louis Stevenson, James Carroll Beckwith, J. Alden Weir and other Americans who would distinguish themselves as artists or writers. On his return to the United States in 1881, he was elected a member of the Society of American Artists and received prizes for his art. John LaFarge hired him as his assistant and Robinson helped him with the murals for the Vanderbilt house in New York City. After that, he worked at a firm in Boston for three years, saving money so that he could pursue his work as a painter.

Robinson returned to Paris in 1884, when he had the opportunity to see the work of the French impressionists and visit Giverney, where Claude Monet lived and worked. The impressionists had a significant effect on Robinson's work, and he divided his time between France and the United States from this point until 1892.

After his contact with the French artists, Robinson painted directly from nature and concentrated on subjects in the everyday environment. With John Twachtman, J. Alden Weir and Childe Hassam, he became a major proponent of impressionism in the United States.

Robinson died of asthma in 1896.

John Mix Stanley
Canandaigua, New York, 1814 – Detroit, Michigan, 1872

John Mix Stanley is best known for his portrayals of Native-American life. Orphaned at fourteen, he spent his teenage years as an apprentice to a wagon maker in Naples and Buffalo, New York. He moved to Detroit in 1834, where he painted portraits and landscapes. By 1838 he was living in the Chicago area. The following year, Stanley spent time in Fort Snelling, Minnesota, where he began painting Indians. In Oklahoma in 1842, he continued to paint Indian portraits.

In Santa Fe, New Mexico, in 1846, he joined Colonel Stephen Watts Kearney's military expedition to San Diego, California, and illustrated Kearney's official report on it. For two years, Stanley lived in Honolulu, Hawaii, where he painted the portraits of King Kamehameha III and the queen and other native inhabitants.

By 1849 Stanley had enough material to tour an 'Indian Gallery' (modelled on George Catlin's) in the eastern United States. Some 150 pictures that made up his gallery were exhibited in Troy and Albany, New York; in New Haven and Hartford, Connecticut; and in Washington, DC, in the early 1850s. In 1853 he was appointed official artist for a government-sponsored expedition to investigate a new route for the Pacific Railroad.

Stanley spent from 1854 to 1863 in Washington, DC, where he deposited his Indian Gallery paintings with the Smithsonian Institution. (Most of these were destroyed in a fire in 1865.) He then went on to Buffalo where he began one of his most important works, *The Trial of Red Jacket*. Stanley retired in Detroit in 1864; and he died there eight years later of heart disease.

John Trumbull
Lebanon, Connecticut, 1756 – New York City, 1843

John Trumbull's career was distinguished by his lifelong political and artistic patriotism which resulted in his celebrated depictions of the Revolutionary War. These paintings have become icons of American art. The son of a governor of Connecticut, Trumbull was a member of a well-to-do and politically prominent Connecticut family.

At the insistence of his father, Trumbull attended Harvard College. After graduating in 1773, he pursued an artistic career in Boston, painting portraits and scenes from ancient history. During the Revolution, Trumbull served as second aide-de-camp to General George Washington and later as a colonel, under General Horatio Gates. He resigned from the army in 1777 and returned to his artistic career.

In 1780 Trumbull travelled to London where he studied with Benjamin West in his studio. Failing to conceal his anti-British sentiments, Trumbull was arrested as a spy and eventually deported. He returned to London in 1784 and pursued his ambition of creating a heroic record of the key events in the American War of Independence, paintings that could be engraved for profit. Trumbull travelled in England and France, and back to the United States in 1789, taking likenesses in miniature of the principal participants in the war to be incorporated into his historic scenes.

While most famous for his American history paintings and portraits of prominent Americans, Trumbull was one of the earliest native-born artists to depict the American landscape. He painted local scenery, including wilderness scenes in Connecticut in the 1790s, and in the first decade of the nineteenth century he travelled to Niagara Falls, producing several panoramic landscapes of the Falls from 1807 to 1808. Trumbull later helped to launch the career of the young landscape painter Thomas Cole, after discovering his works in the window of a New York City frame shop in 1825.

As a leading artistic figure in the United States in the early decades of the nineteenth century, Trumbull served as the director of the New York Academy of the Fine Arts (later American Academy of the Fine Arts) beginning in 1805. In 1817 he received a commission from the Congress to decorate the rotunda of the United States Capitol with four of his Revolutionary war scenes. In 1831 Trumbull sold most of his remaining works to Yale College for an art gallery affiliated with the college — the first of its kind in the country. In his final years, he published his *Autobiography*, the first by an American artist.

Dwight W. Tryon
Hartford, Connecticut, 1849 – South Dartmouth, Massachusetts, 1925

Dwight Tryon's mother was a custodian at the Wadsworth Atheneum in Hartford, where he undoubtedly became familiar with the art collection. As of 1864, Tryon worked as a bookkeeper and a clerk in a Hartford bookstore. He spent his spare time studying art in the public library and in the books at his employer's store. He also taught himself to draw. Meeting with some success in ornamental calligraphy, he soon turned to painting.

Tryon established a full-time studio in Hartford in 1873 and began teaching and exhibiting there; he also showed works at the National Academy of Design in New York City. One of his students was Henry C. White, who in 1930 published a biography of Tryon.

From 1873 to 1876, Tryon sketched in the White Mountains, New Hampshire; at Mount Desert, Maine; and at Block Island, Rhode Island.

Tryon went to Paris with his wife, Alice H. Belden, also of Hartford, in 1876. There he studied with Jacquesson de la Chevreuse, one of Ingres's pupils, at the Ecole des Beaux-Arts, and met Barbizon painters Henri Joseph Harpignies and Charles François Daubigny, with whom he worked for a short time. He was especially drawn to the work of Corot and Rousseau. Tryon spent the summers on Guernsey with Abbot H. Thayer, in Normandy, Brittany, Venice and Dordrecht, from 1877 to 1881, when he returned to New York City. There he took a studio near Thomas Dewing's in the Rembrandt Building on West 57th Street and began teaching drawing and painting.

In 1883 he began spending the summer in South Dartmouth, Massachusetts, where he painted the countryside. In 1885 he took a job as Professor of Art at Smith College, Northampton, Massachusetts. The college started buying works of art for a museum and purchased paintings by Dewing, Thayer, Albert Pinkham Ryder, George Inness, Ralph Blakelock, Childe Hassam, James McNeill Whistler and Tryon. Most of Tryon's paintings from this period are oil on wood panel.

In 1889 Tryon met Charles Lang Freer who became one of his most important patrons; he commissioned paintings as well as decorative murals for his home in Detroit, Michigan. Around this time the artist began working in pastel. In 1891 he was elected to the National Academy of Design in New York City.

Tryon visited Ogunquit, Maine, in 1907 to sketch, paint and fish, and continued to spend time there in subsequent years. He painted fewer pictures in his last years and they were smaller in size than before. In 1923 he resigned as head of the Art Department at Smith College, and the following year, due to illness, was forced to stop painting.

John Henry Twachtman
Cincinnati, Ohio, 1853 – Gloucester, Massachusetts, 1902

John Twachtman was born to Frederick Christian and Sophia Droege Twachtman, both originally from Hannover, Germany. He began studying art at the Ohio Mechanics Institute in 1868 and, starting in 1871, at the McMicken School of Design (now the Art Academy of Design), both in Cincinnati.

In 1874 Twachtman met Frank Duveneck, who had just taken a teaching position at McMicken. Duveneck, who had trained in Munich, was to become a close friend and early influence on the artist. The following year, Twachtman enrolled in the Royal Academy of Fine Arts in Munich, and in 1877 he travelled with William Merritt Chase and Duveneck to Venice. Twachtman's art from this period reflects the vigorous brushwork and the subdued palette of browns and blacks favoured by the Munich school.

Twachtman returned to Cincinnati in 1878. In 1879 he was elected to the Society of American Artists, and he joined the staff of the Cincinnati Women's Art Association. He went to Florence in 1880, where he began teaching at Duveneck's art school. Twachtman was in Europe again in 1881, painting in Holland with J. Alden Weir and John Weir, and in Paris in 1883 he studied at the Académie Julian. Twachtman's art shifted to a lighter palette, characterised by silvery grays and greens, an attention to atmospheric perspective, and simple compositions resulting from his study in France.

In 1888 Twachtman settled in Greenwich, Connecticut, where he painted a series of pictures featuring his property. His paintings from these years are nuanced and subtle and reflect not only his contact with French art, but his friendships with American impressionists such as Theodore Robinson. The following year he began teaching at the Art Student's League in New York City. He exhibited with Claude Monet, J. Alden Weir and Paul Besnard in New York City in 1893. In 1894 he started teaching at the Cooper Union in New York. Three years later he helped form The Ten American Painters (also known as The Ten).

In 1900 Twachtman began painting harbour scenes and the coastal town of Gloucester, Massachusetts, where he died only two years later.

Daniel Wadsworth
Middletown, Connecticut, 1771 – Hartford, Connecticut, 1848

Daniel Wadsworth was a descendent of the Wadsworth family that had left England and settled in America in about 1632. Heir to this Puritan legacy, Daniel descended from the original settlers of Hartford. During the American Revolution, his father Jeremiah profited greatly from his position as commissary-general for the Continental Army. With his war-time profits, Jeremiah became Hartford's leading financier and manufacturer. At the time of his death in 1804, Daniel inherited a substantial estate which allowed him to lead a genteel life, pursuing his avocations as an amateur artist and architect, picturesque traveller, art patron, and philanthropist.

As a member of the first generation of citizens of the new republic, he saw his country's recent history and its vast wilderness landscape as conjoined, symbolic of the nation's potential greatness. In the early decades of the nineteenth century, Wadsworth's active involvement as both amateur artist and collector in the picturesque description of the country's wilderness helped bring the aesthetic qualities and historic associations of the north-eastern landscape to the nation's attention. One of the earliest and most important patrons of living American artists, he maintained lifelong associations with such leading painters as John Trumbull, Thomas Sully, Thomas Cole, Alvan Fisher and young Frederic Church, who were themselves engaged in creating an artistic heritage for the United States.

In the final decade of his life, Wadsworth turned his attention to opening a permanent art gallery and Atheneum for the public in Hartford. The neo-Gothic building opened in 1844

and was filled with recent landscapes of the American north-east along with history paintings and portraits of prominent Americans by the country's leading artists. Thomas Cole, who was well represented with landscapes in the Atheneum, applauded Wadsworth's vision for the museum, writing a few months before its opening: 'I assure you that I shall feel proud of having a picture of mine in your gallery & hope the example you are about to set, in forming a permanent Gallery, will be followed in other places & be a means of producing a more elevated taste & a warmer love for beautiful Art than at present exists in the Country.'

William Guy Wall
Dublin, Ireland, 1792 – probably Dublin, in or after 1862

According to William Dunlap, Wall was already trained as an artist when he emigrated from Ireland to New York City in 1818. John Rubens Smith, however, claimed to have taught watercolour technique to Wall. Soon after his arrival, Wall began exhibiting in New York at the American Academy of Fine Arts. His earliest views were of Hudson River scenery, published as the *Hudson River Portfolio* and the result of his 1820 trip up the river.

By 1825, when Cole was 'discovered' by John Trumbull, Wall was an established artist. He was a founding member of the National Academy of Design and exhibited there often. His *Cauterskill Falls* met with very favorable reviews when exhibited at the Academy in 1827. He also exhibited at the Pennsylvania Academy of the Fine Arts and the Apollo Association.

Wall remained in New York for several years before moving to Newport, Rhode Island, by 1831. By 1835 he had moved to New Haven, Connecticut; he was in Brooklyn, New York, in 1836. He continued to paint, but returned to Dublin not long after, presumably due to a lack of continuing public and critical recognition. In Dublin he joined forces with Master Hubard, painting the backgrounds for Hubard's very popular and highly profitable silhouettes. He exhibited three American landscapes at the Royal Hibernian Academy in 1840 and one there in 1842. In 1843 he exhibited American views at the Society of Irish Artists, where he was a member and had served as president. He also exhibited at the Royal Irish Art Union (similar to the American Art-Union) from 1843 to 1846.

Between 1857 and 1862, Wall lived in Newburgh, New York, before returning again to Dublin. While in New York, he began painting the scenery around Idlewild, the Hudson-River estate of Nathaniel P. Willis, poet and author of *American Scenery*. As far as is known, Wall died in Dublin.

Contributors

Introduction:
Patrick McCaughey
Director, Yale Center for British Art, New Haven

Essays:
Elizabeth B. Johns
Silfen Term Professor
Department of the History of Art
University of Pennsylvania, Philadelphia

Elizabeth Mankin Kornhauser
Chief Curator and Krieble Curator of American Painting and Sculpture
Wadsworth Atheneum, Hartford, Connecticut

Andrew Sayers
Assistant Director Collections
National Gallery of Australia, Canberra

Catalogue entries:
Roger Butler (RB)
Curator of Australian Prints, Posters and Illustrated Books
National Gallery of Australia, Canberra

Lyn Conybeare (LC)
Exhibition Project Officer
National Gallery of Australia, Canberra

Amy Ellis (AE)
Assistant Curator
American Painting and Sculpture
Wadsworth Atheneum, Hartford, Connecticut

Charlotte Galloway (CG)
Curatorial Assistant
National Gallery of Australia, Canberra

Magdalene Keaney (MK)
Curatorial Assistant
National Gallery of Australia, Canberra

Elizabeth Mankin Kornhauser (EMK)

Terence Lane (TL)
Senior Curator, Australian Art to 1900
National Gallery of Victoria, Melbourne

Andrew Sayers (AS)

Index of Works in the Exhibition

Note: Each artist's works are listed in chronological order. Square brackets after titles indicate works shown in the United States only, or in Australia only.

Becker, Ludwig
Blow-hole, Tasman's Peninsula,
 Van Diemen's Land (cat.11) p.102
Camp on the Edge of the Earthy or
 Mud Plains 40 Miles from Duroadoo
 (cat.19) [Hartford and Washington]
 p.106
Crossing the Terrick-Terrick Plains,
 August 29 1860 (cat.14)
 [Canberra and Melbourne] p.104
Junction: The Bamamoro Creek with
 the Darling, 7 Miles from Minindie,
 up the Darling (cat.16)
 [Canberra and Melbourne] p.105
Mallee Sand-cliffs at the Darling, about
 10 Miles from Cuthro towards Tolano
 (cat.15) [Hartford and Washington]
 p.105
Meteor seen by me on October 11 at
 10h 35m pm at the River Darling,
 25 Miles N. of Macpherson's Station,
 in Lat: 33, S (cat.17)
 [Hartford and Washington] p.106
Mutwanji Ranges from the Track
 to Nanthwinngee Creek (cat.18)
 [Canberra and Melbourne] p.106

Bierstadt, Albert
Mount Corcoran (cat.81) p.173
View of Donner Lake, California
 (cat.78) p.170

Birch, Thomas
Fairmount Waterworks (cat.50) p.138

Blandowski, William
Compressed strata west of section 512
 near Morphet Valley, 16 miles
 S from Adelaide (cat.13) p.103
Pattowatto. Granite boulders
 (Perrys Haystack) looking NW,
 47 miles N by W of Melbourne
 (cat.12) p.103

Bull, Knut
Entrance to the River Derwent
 from the Springs, Mount Wellington
 (cat.45) p.132
View of Hobart Town (cat.44) p.131

Bunker, Dennis Miller
Wild Asters (cat.99) p.195

Buvelot, Louis
Near Fernshaw (cat.85) p.181
Waterpool near Coleraine (Sunset)
 (cat.83) p.179
Winter Morning near Heidelberg
 (cat.82) p.178

Carse, J.H.
Weatherboard Falls (cat.69) p.161

Casilear, John William
Lake George (cat.92) p.188

Catlin, George
Buffaloes in the Salt Meadows,
 Upper Missouri (cat.31) p.115
The Pipestone Quarry (cat.55) p.143

Chase, William Merritt
A City Park (cat.118)
 [Hartford and Washington] p.217
Prospect Park, Brooklyn (cat.119)
 [Canberra and Melbourne] p.218
Untitled (Shinnecock Landscape)
 (cat.120) p.219

Chevalier, Nicholas
Mount Arapiles and the Mitre Rock
 (cat.66) p.158

Church, Frederic Edwin
Coast Scene, Mount Desert (cat.75) p.167
Hooker and Company journeying
 through the Wilderness from Plymouth
 to Hartford in 1636 (cat.54) p.142
Natural Bridge, Virginia (cat.32) p.116
Niagara Falls (1856) (cat.72) p.164
Niagara Falls (1857) (cat.73) p.165
West Rock, New Haven (cat.57) p.145

Cole, Thomas
The Clove, Catskills (cat.30) p.114
Scene from 'The Last of the Mohicans',
 Cora kneeling at the Feet of Tamenund
 (cat.52) p.140
A View of the Mountain Pass called
 the Notch of the White Mountains
 (Crawford Notch) (cat.53) p.141

Colman, Samuel
Storm King on the Hudson (cat.77) p.169

Cropsey, Jasper F.
Sidney Plains with the Union of the
 Susquehanna and Unadilla Rivers
 (cat.80) p.172

Davies, David
Moonrise (cat.88) p.184

Duncanson, Robert S.
View of Cincinnati, Ohio from
 Covington, Kentucky (cat.60) p.148

Durand, Asher B.
Dover Plains, Dutchess County,
 New York (cat.56) p.144

Eakins, Thomas
Mending the Nets (cat.117) p.216

Earl, Ralph
Houses and Shop of Elijah Boardman
 (Houses Fronting New Milford Green)
 (cat.49) p.137

Earle, Augustus
A Bivouac of Travellers in Australia
 in a Cabbage Tree Forest, Daybreak
 (cat.8) p.99
Wentworth Falls (cat.6) p.97

Fisher, Alvan
Niagara Falls (cat.28) p.112

Ford, William
At the Hanging Rock (cat.103) p.202

Gifford, Sanford Robinson
Kauterskill Clove (cat.93) p.189
A passing Storm in the Adirondacks
 (cat.76) p.168

Glover, John
The Bath of Diana, Van Diemen's Land
 (cat.40) p.127
Ben Lomond Setting Sun. From near the
 Bottom of Mr Boney's Farm (cat.42)
 [Canberra and Melbourne] p.129
Cawood on the Ouse River (cat.37) p.124
A Corrobery of Natives in Mills Plains
 (cat.7) p.98
A Corrobery of Natives in Van Diemen's Land
 (cat.41) [Canberra and Melbourne]
 p.128
Hobart Town, taken from the Garden
 where I lived (cat.35) p.122
The Last Muster of the Aborigines
 at Risdon (cat.38) p.125
My Harvest Home (cat.36) p.123

Hassam, Childe
In the Garden (Celia Thaxter in her Garden)
 (cat.121) p.220

Heade, Martin Johnson
View of Marshfield (cat.94) p.190

Hicks, Edward
Peaceable Kingdom of the Branch
 (cat.51) p.139

Homer, Winslow
Long Branch, New Jersey (cat.115) p.214
Maine Coast (cat.122) p.221
Two Guides (cat.116) p.215

Inness, George
Winter Morning, Montclair (cat.97) p.193

Johnstone, H.J.
Evening Shadows, Backwater of the
 Murray, South Australia (cat.86) p.182

Kensett, John F.
Coast Scene with Figures (Beverly Shore)
 (cat.95) p.191

Lane, Fitz Hugh
Fresh Water Cove from Dolliver's Neck,
 Gloucester (cat.59) p.147

Lee, Joseph
 Residence of Captain Thomas W. Badger,
 Brooklyn [California], from the Northwest
 (cat.61) p.149

Lycett, Joseph
 Corroboree at Newcastle (cat.4) p.95
 Views in Australia or New South Wales,
 & Van Diemen's Land delineated (cat.5)
 p.96

McCubbin, Frederick
 Down on His Luck (cat.108) p.207

Martens, Conrad
 Brush Scene, Brisbane Water (cat.10) p.101
 The Cottage, Rose Bay (cat.48)
 [Hartford and Washington] p.136
 View from Rose Bank (cat.43) p.130
 View from Sandy Bay (cat.39) p.126

Meeker, Joseph R.
 The Land of Evangeline (cat.96) p.192

Moran, Thomas
 Hot Springs of Gardiners River, Yellowstone
 National Park (cat.79) p.171

Piguenit, W.C.
 The Flood in the Darling 1890
 (cat.89) p.185
 Lake St Clair, the Source of the River
 Derwent, Tasmania (cat.87) p.183
 A Mountain Top, Tasmania (cat.70) p.162
 The Upper Nepean, New South Wales
 (cat.71) p.163

Pratt, Henry Cheever
 View from Maricopa Mountain
 near the Rio Gila (cat.33) p.117

Prout, John Skinner
 Maria Island from Little Swanport,
 Van Diemen's Land (cat.9) p.100

Remington, Frederic
 Fight for the Water Hole (cat.123) p.222

Richards, William Trost
 In the Woods (cat.74) p.166

Richardt, Joachim Ferdinand
 Echo River, Mammoth Cave (cat.34)
 p.118
Roberts, Tom
 Allegro con brio; Bourke Street West
 (cat.105) p.204
 A Break Away! (cat.111)
 [Hartford and Washington] p.210
 Slumbering Sea, Mentone (cat.106) p.205
 A Summer Morning Tiff (cat.104) p.203

Robinson, Theodore
 White Bridge on the Canal (White Bridge
 near Napanoch) (cat.101) p.197

Silliman Sr, Benjamin
 Remarks made, on a Short Tour,
 between Hartford and Quebec
 in the Autumn of 1819 (cat.23) p.109

Southern, Clara
 An Old Bee Farm (cat.114) p.213

Stanley, John Mix
 Oregon City on the Willamette River
 (cat.58) p.146

Streeton, Arthur
 From McMahon's Point — Fare One Penny
 (cat.109) p.208
 Golden Summer, Eaglemont (cat.107)
 p.206
 The Purple Noon's Transparent Might
 (cat.91) p.187
 The Railway Station, Redfern (cat.113)
 p.212
 The Selector's Hut: Whelan on the Log
 (cat.110) p.209
 The Valley of the Nepean (cat.112) p.211

Trumbull, John
 View on the West Mountain near Hartford
 (cat.20) p.107

Tryon, Dwight W.
 First Leaves (cat.98) p.194

Twachtman, John
 Connecticut Shore, Winter
 (cat.102) p.198
 Winter Harmony (cat.100) p.196

von Guérard, Eugene
 Bushy Park (cat.47) pp.134–135
 Castle Rock, Cape Schanck (cat.67)
 p.159
 Eugene von Guérard's Australian
 Landscapes (cat.68) p.160
 Ferntree Gully in the Dandenong Ranges
 (cat.64) p.156
 Mount William from Mount Dryden,
 Victoria (cat.63) p.155
 North-east View from the Northern Top
 of Mount Kosciusko (cat.65) p.157
 Stony Rises, Lake Corangamite
 (cat.46) p.133
 Tower Hill (cat.62) p.154

Wadsworth, Daniel
 Monte Video (cat.21) p.108
 Monte Video overlooking the Farmington
 Valley (cat.22) p.108

Wall, William Guy
 Cauterskill Falls on the Catskill
 Mountains taken from under
 the Cavern (cat.29) p.113
 Hadley's Falls (cat.24) p.110
 Rapids above Hadley (cat.26) p.111
 View from Fishkill looking to
 West Point (cat.25) p.111
 View near Hudson (cat.27) p.111

Westall, William
 View of Malay Road from Pobassoo's
 Island, February 1803 (cat.3) p.94
 View of Port Bowen, Queensland,
 August 1802 (cat.1) p.93
 View of Sir Edward Pellew's Group,
 Northern Territory, December 1802
 (cat.2) p.94

Whitehead, Isaac
 A Sassafras Gully, Gippsland (cat.84)
 p.180

Withers, Walter
 Tranquil Winter (cat.90) p.186

Cultural, Social and Historical Events in Australia and the United States of America 1770–1901

AUSTRALIA

DATE	CULTURAL EVENTS	SOCIAL AND OTHER HISTORICAL EVENTS
1770		James Cook charts the eastern coast of Australia
1776		Declaration of Independence
1783		Treaty of Paris ends American Revolution
1786	Charles Wilson opens Peale's Museum in Philadelphia	
1787		Northwest Ordinance passed, governing the settling of the Northwest (which became the midwestern states: Michigan, Ohio, Wisconsin, Indiana, Illinois)
		First American steamboat invented by John Finch
1788		Arthur Phillip, with fleet of convict transport ships arrives in Australia and takes possession of New South Wales
		Population: 1,035
1789		Mutiny aboard HMS *Bounty*. Lt. William Bligh reaches the Great Barrier Reef in an open boat
		Ratification of Constitution
1790		Slater builds first factory in US in Providence, Rhode Island
		First Federal Census: 3,929,214
		Beginning of the Second Great Awakening
1792		US ship *Philadelphia* arrives in Sydney, the first ship to import goods to Australia for trade
1793		First free settlers arrive in New South Wales
		The colony becomes entirely dependent on locally produced grain
1794		Eli Whitney invents cotton gin

DATE	CULTURAL EVENTS	SOCIAL AND OTHER HISTORICAL EVENTS
1796	Robert Sidaway establishes first theatre in Sydney	
1797		George Bass explores the coast south of Australia in a whale boat
1800	Founding of Library of Congress	Second Federal Census: 5,308,483
1801	First book published in Australia	British surveying expedition under Mathew Flinders French scientific expedition under Nicolas Baudin First cargo of coal exported from the colony
1802	American Academy of the Fine Arts founded in New York City	President Jefferson's administration begins
1803		Mathew Flinders sails around Australia Establishment of settlement at Hobart, Van Diemen's Land
1804		Louisiana Purchase from France — includes the land between the Mississippi River and the Rocky Mountains Fauna and flora expedition of the Louisiana Purchase and to find water route to Pacific Ocean from Missouri River under Meriweather Lewis and William Clark Beginning of more systematic efforts to help slaves escape; eventually becomes known as the Underground Railroad 200 Irish convicts start an armed rebellion which is defeated by Governor Philip King
1805	Founding of the Boston Athenaeum, Boston and Pennsylvania Academy of the Fine Arts, Philadelphia	
1807		Livingston's and Fulton's steamboat *The Clermont* begins passenger service up the Hudson River from New York City to Albany, New York

DATE	CULTURAL EVENTS	SOCIAL AND OTHER HISTORICAL EVENTS
1808		'The Rum Rebellion' in which the Governor, William Bligh is arrested and martial law declared
		African slave trade outlawed; illicit trade continues until about 1860
		The great Tecumseh and brother ('The Prophet'), sons of a Shawnee chief, form Indian confederation in Old Northwest Territory; Tecumseh also seeks broader pan-Indian unity to halt peacefully white settlement on tribes' land; finally relinquishes peaceful methods
1810		Lachlan Macquarie appointed Governor of New South Wales. He remains in the post until 1821
		Population of the colony: 10,452
1811		Federal Census: 7,239,881
		John Jacob Astor founds American Fur Company at mouth of Colombia river in Oregon. Fur trading encourages westward settlement.
		Federal Government begins building National (or Cumberland) Road in sections: completed to Illinois in 1852. Though raising controversial issues, this road is significant as a route for westward migration
1812		War of 1812 with England
1813		First crossing of the Blue Mountains by Gregory Blaxland, William Wentworth and Lt. William Lawson
		Future President Harrison kills Tecumseh in battle near Lake Erie, splintering Indian unity and paving the way for increasing white settlement in Northwest Territory
		Future President Andrew Jackson, with help of the Cherokee, defeats Creek Indians in crucial battle at Horseshoe Bend, Mississippi Territory

DATE	CULTURAL EVENTS	SOCIAL AND OTHER HISTORICAL EVENTS
1815		Road completed over the Blue Mountains
1816		Exploration of Mississippi River Valley from Great Lakes to New Mexico Substantial increase in foreign trade War of 1812 veterans settle in west on land Government used to entice their enlistment Richard Allen joins the congregation of free Blacks that he founded in Philadelphia (Bethel Church) with those of several others to form the African Methodist Episcopal Church
1817	William Cullen Bryant, premier American poet publishes *Thanatopes*	American Colonisation Society founded to encourage free Blacks to emigrate to new colony of Liberia, Africa; controversial against Blacks and whites Mississippi becomes a state
1818		Illinois becomes a state Transatlantic sailing packets begin service between New York and Liverpool
1819	Barron Field's *First fruits of Australian Verse* published	
		Economic panic and depression until 1823 Spain cedes Florida and Oregon county to US for $5 million Transcontinental Treaty — Spain wins claims to California, New Mexico, Nevada, Utah, Arizona and parts of Texas, Wyoming and Colorado
1820		Population: 23,939
	Washington Irving's *The Sketch Book of Geoffrey Crayon, Gent* published in England; includes stories *Rip Van Winkle* and *The Legend of Sleepy Hollow*	Federal Census: 9,638,453 Missouri Compromise: Missouri's admission to Union as slave state is balanced by Maine's admission to Union as free state; slavery disallowed in Louisiana Purchase north of 36 30° First American ploughs manufactured at Wethersfield, Connecticut

DATE	CULTURAL EVENTS	SOCIAL AND OTHER HISTORICAL EVENTS
1821		Charles Throsby reaches the Murrumbidgee river near the present site of Canberra
	Sequoyah completes the difficult, twelve year task of creating an alphabet that enables the Cherokee language to be written	Mexico's successful revolt against Spain opens Santa Fe to US traders, who travel in large caravans for protection along the dangerous Santa Fe Trail
		Capt. John Davis and Amos Palmer lead Antarctic expedition
1823	W.C. Wentworth's poem *Australasia* wins second place in Chancellor's prize at Cambridge University	New South Wales Judicature Act creates legislative and judicial system for New South Wales and Van Diemen's Land
	James Fenimore Cooper publishes *The Pioneers*, first of his Leatherstocking stories	Monroe Doctrine: declares American continents off limits for further European colonisation
1824	First non-government newspaper *The Australian* published	Legislative Council proclaimed in New South Wales
		Explorers Hamilton Hume and William Hovell discover the Australian alps and reach Port Phillip which later became Melbourne
		Jedidiah Smith finds Great South Pass over the Continental Divide
		Completion of Erie Canal in New York State from Albany, on the Hudson River, to Buffalo, on Lake Erie; opens water route to Northwest Territory
		Religious revivals led by Charles G. Finney, Peter Cartright, James B. Finley
		New Harmony, Indiana — Robert Owen's socialist Godless experiment; one of many contemporary attempts at Utopia
1825		Separation of New South Wales and Van Diemen's Land proclaimed
1826	Augustus Earle opens his gallery in Sydney	
	National Academy of Design founded in New York City as an outgrowth of the New York Drawing Association created from gatherings of artists at the home of Samuel F.B. Morse	
	James Fenimore Cooper publishes *Last of the Mohicans*	

DATE	CULTURAL EVENTS	SOCIAL AND OTHER HISTORICAL EVENTS
1827	John James Audubon's *Birds of America*	
1828		Martial law declared against Aborigines in Van Diemen's Land
		Capt. Charles Sturt explores the Darling River in New South Wales far west
	Publication of Noah Webster's *An American Dictionary of the English Language*	
1829		Legislative Council established for Van Diemen's Land
		Western Australia declared as a possession of Britain
		Swan River settlement proclaimed (Western Australia)
		Charles Sturt's second expedition explores much of the Murray River
		Smallpox epidemic devestates Aboriginal tribes across eastern Australia
		While still a prisoner in Newgate Jail, Edward Gibbon Wakefield outlines a theory of colonisation which includes financing immigration through land sales
		The beginning of Andrew Jackson's two four-year terms as US President
		Free Black, David Walker publishes his militant, provocative antislavery essay, 'Walker's Appeal …'; applies tenets of Declaration of Independence to rights of Blacks to achieve their freedom
1830	First novel published in Australia — Henry Savery's *Quintus Servington*	Total population of Australia: 55,795
		Federal Census: 12,866,020 (150,000 immigrated since 1820)
		Joseph Smith organises the Mormon Church in New York State; publishes *Book of Mormon*
		Baltimore and Ohio Railroad begins operation
		Indian Removal Act ostensibly provides for voluntary removal of southeastern tribes to government-allocated lands west of the Mississippi River; in reality, it paves the way for tribes' removal from their homeland and way of life

DATE	CULTURAL EVENTS	SOCIAL AND OTHER HISTORICAL EVENTS
1831	Artist and engraver Thomas Bock opens a gallery in Hobart while still an assigned convict, becoming the first professional painter in the colony	Maj. Thomas Mitchell's exploration of northern inland rivers of New South Wales
		Invention of McCormack reaper
		Nat Turner's slave rebellion in Virginia. First issue of white abolitionist William Lloyd Garrison's *Liberator*, supported by white and Black abolitionists
1833	Sydney's Theatre Royal opens, with seating for 1000	
1834	William Dunlap's *History of the Rise and Progress of the Arts and Design in the United States* published	
1835	John Glover's exhibition in London of 68 works painted in Australia	Settlement at Port Phillip Bay established, later to become the city of Melbourne
1836		Darwin's *Beagle* visits Sydney
		Maj. Mitchell names Western Districts of Victoria 'Australia Felix'
		Establishment of a colony in South Australia in accordance with Edward Gibbon Wakefield's theories
	Ralph Waldo Emerson's *Essay on Nature*, embodies ideas of Transcendentalism	American Temperance Union founded
1837	First art exhibition held in Hobart Royal Victoria Theatre opens in Hobart	Australia's first passenger railway completed in Van Diemen's Land — propelled by convicts
	Emerson's commencement address, 'The American Scholar', significant for its declaration of independence from European intellectual and literary hegemony and its assertion of *American* uniqueness *American Scenery*, Nathaniel Willis, ed. published	Economic panic and depression

DATE	CULTURAL EVENTS	SOCIAL AND OTHER HISTORICAL EVENTS
1838		Myall Creek Massacre. 28 Aboriginal men women and children massacred by station hands at Myall Creek, near Inverell, New South Wales; seven of the station hands were convicted of murder and subsequently hanged
1839	De Tocqueville's *Democracy in America* published in English Opening of Greenwood Cemetery in Brooklyn, New York, celebrated as merging nature and art Apollo Gallery opens; later becomes American Art-Union Henry Rowe Schoolcraft's *Algic Researaches*, the first major study of American Indian folklore	US Exploring Expedition around the world led by Charles Wilkes; includes exploration in South America Cherokees, forced off their land, migrate west across Mississippi River; called their route 'Trail of Tears', the same route taken Creeks and Choctaws in 1832 and 1836 *Amistad* Affair: important Supreme Court victory for abolitionist movement; argued by former President John Quincy Adams: Africans who mutinied on Spanish slave ship *Amistad* are declared free and allowed to return to Africa
1840	First volume of John Gould's *Birds of Australia* published	Economic depression throughout Australia Paul de Strzelecki climbs Australia's highest mountain and names it Mt Kosciuszko John Campbell becomes the first settler in what will become Queensland when he drives his cattle north Federal Census: 17,069,453 Beginning of the ten year peak of commercial whaling One third of Pawnees in Nebraska killed by smallpox spread by white settlers and traders
1841		New Zealand proclaimed a colony independent of New South Wales Total population of Australia: 206,759 Pre-emptive Act: legalises settlement prior to survey — facilitates settlement Oregon Fever begins extensive migration to Oregon Territory on the Oregon Trail
1843		Collapse of the Bank of Australia John Ridley invents a machine that reaps, threshes and winnows simultaneously, relieving an acute labour shortage Charles Goodyear develops vulcanising process for rubber

DATE	CULTURAL EVENTS	SOCIAL AND OTHER HISTORICAL EVENTS
1844	Establishment of Royal Society of Van Diemen's Land	Charles Sturt explores inland rivers, but fails to find an inland sea
		Ludwig Leichardt travels from Darling Downs to Northern Territory coast
		Opening of a copper mine at Kapunda, South Australia
	Daniel Wadsworth opens his public art museum, The Wadsworth Atheneum, Hartford, Connectict	Inventor Samuel F.B. Morse sends first message over telegraph
1845	Art exhibition in Hobart's legislative chamber organised by John Skinner Prout	
	Publication of *The Life of Frederick Douglass, An African Slave, Written by Himself*; significant contributor to the abolitionist movement	Term 'Manifest Destiny' coined
		Texas admitted as a state
		War with Mexico begins
1846	Congress establishes the Smithsonian Institute	The Oregon Treaty — settles British and US contention for Oregon territory: US gains territory south of Vancouver
		Church of Jesus Christ of the Latter-day Saints (Mormons) and their new leader, Brigham Young, settle at Great Salt Lake, Utah to avoid persecution
1847	First Australian opera performed in Sydney, *Don John of Austria* by Isaac Nathan	
1848	Exhibition of the Society for the Promotion of the Fine Arts in Australia, Sydney	Disappearance of Ludwig Leichardt in Western Queensland in an attempt to cross the continent from east to west
		Gold discovered at Sutter's Mill, California
		Cunard introduces regularly scheduled steamship passage between Liverpool and New York
		Mexican Cessation to US: Texas, New Mexico, Arizona, Upper California
1849	Düsseldorf Gallery opens in New York City	Gold rush to California

DATE	CULTURAL EVENTS	SOCIAL AND OTHER HISTORICAL EVENTS
1850	The University of Sydney established	The first Victorian trade union, the Stonemason's Society formed
	Harper's Magazine founded Nathaniel Hawthorne's *The Scarlet Letter* published	Compromise of 1850: California admitted as free state Utah, New Mexico Territories to decide slavery status upon admission as states Slavery prohibited in DC, Fugitive Slave Law made more rigorous Federal Census: 23,191,876
1851		Bushfires of Black Thursday rage through Victoria Discovery of payable gold in New South Wales and Victoria starts Australian gold rushes Victoria separates from New South Wales Total population of Australia: 437,665
1852	*New York Times* founded Brooklyn Art Union established Herman Melville's *Moby Dick* published Publication of Harriet Beecher Stowe's *Uncle Tom's Cabin* — an instrumental novel in the abolitionist movement Closing of the American Art-Union	America's Cup syndicate formed American Geographical Society founded New York Exhibition of the Industry of All Nations — Crystal Palace
1853	First art exhibition in Melbourne University of Melbourne established Beginning of the American park movement with creation of first US parks to be intended from the start as public urban parks: Bushnell Park, Hartford, Connecticut and Central Park, New York City	End of convict transportation to Van Diemen's Land Commodore Mathew C. Perry opens trade with Japan
1854	 Henry Thoreau's *Walden* published	Eureka Stockade — goldminers in Ballarat, Victoria, stage an armed rebellion over taxes, difficulties with land tenure and competition from the Chinese. The miners were defeated by police and troops Kansas-Nebraska Act — portions of these territories open to slavery

DATE	CULTURAL EVENTS	SOCIAL AND OTHER HISTORICAL EVENTS
1855	Walt Whitman's *Leaves of Grass* published Henry Wadsworth Longfellow's *The Song of Hiawatha* published Publication of *The Crayon*	New England Emigrant Aid Company — fostered abolitionist settlement in Kansas, resulting in Kansas's being hotbed of controversy
1856		Cricket teams from New South Wales and Victoria meet in competition for the first time at the Melbourne Cricket Ground Van Diemen's Land renamed Tasmania Establishment of the 8-hour day for workers
1857	Tenth Street Studio Building; Brooklyn Sketch Club *Atlantic Monthly* founded	Financial panic Dred Scott Decision — landmark Supreme Court decision dealing blow against abolitionist movement
1858	Art Treasures Exhibition, Hobart	Melbourne Football club formed and rules drawn up for what becomes Australian rules Australia's population (non-aboriginal) reaches 1 million 'Welcome' nugget — gold nugget discovered in Ballarat, Victoria, gross weight 68 956 grams
1859		Queensland proclaimed as separate colony from New South Wales
	Brooklyn Art Association established	Abolitionist John Brown's raid on arsenal at Harper's Ferry, West Virginia Oregon admitted to the Union
1860	Establishment of National Gallery of Victoria	Victorian Exploring Expedition led by Robert O'Hara Burke and William John Wills leaves Melbourne to attempt a south–north crossing of Australia. They reached the estuary of the Flinders River in the Gulf of Carpentaria and on the return journey tragically died of starvation at Cooper's Creek, Queensland
		Pony Express mail delivery from Missouri to California Federal Census: 31,444,321

DATE	CULTURAL EVENTS	SOCIAL AND OTHER HISTORICAL EVENTS
1861		First Melbourne Cup run at the Flemington racecourse in Victoria
		Total population of Australia: 1,151,947
	Incidents in the Life of a Slave Girl by Harriet A. Jacobs, edited by Lydia Maria Child	Telegraph completed between east and west coasts
		Beginning of Abraham Lincoln's administration
		Formation of Confederate States of America (South Carolina, Mississippi, Florida, Alabama, Georgia, Arkansas, Tennessee, North Carolina, Texas)
		Civil War begins when Confederate forces in Charleston open fire on Fort Sumter in South Carolina
		Homestead Act encourages settlement in west; particularly appealing to foreign immigrants
1862	Expedition of Georg von Neumayer accompanied by Eugene von Guérard to Australian Alps	John McDoull Stuart crosses the centre of the continent from south to north
1863	The Association for the Advancement of the Cause of Truth in Art established in New York City by American adherents of John Ruskin's writings	Abraham Lincoln's Gettysburg Address
		Emancipation Proclamation
1864		Northern Queensland opened up to pastoralists
		Pullman Palace Car (railroad) invented
		Metropolitan Sanitary Fair, New York
1865	Cincinnatti, Ohio emerges as major art centre	Gen. Robert E. Lee surrenders to General Ulysses S. Grant
	Sculptress Edmonia Lewis, daughter of a free African American and a Chippewa, finances trip to Europe by selling her busts of abolitionist John Brown and white Col. Robert Shaw Gould, leader of famous African American Civil War 54th Regiment	Civil War ends
		Abraham Lincoln assassinated
		13th Amendment to the Constitution — abolishes slavery
		Louis Agassiz leads Thayer Expedition to Brazil
1866	American Society of Painters of Watercolours established	Founding of National Labour Union
		Founding of Ku Klux Klan
		Texas cattle drives to railroad connections in Kansas, Missouri and Wyoming

DATE	CULTURAL EVENTS	SOCIAL AND OTHER HISTORICAL EVENTS
1867	Henry Tuckerman's *Book on the Artists, American Artist Life* published	Purchase of Alaska from Russia Reconstruction begins in the South American slaughter of buffalo for food and hides decimates buffalo herds which destroys livelihood of many Native American tribes
1868	Tour of the Aboriginal cricket team to England, the first Australian touring team	Last convicts transported to Australia arrive in Fremantle, Western Australia Prince Alfred, Duke of Edinburgh visits Australia and is subject to attempted assassination in Sydney
	Louisa May Alcott's *Little Women* published Bret Harte becomes the first editor of *The Overland Monthly* a journal published in San Francisco	14th Amendment to the Constitution — admits Blacks as citizens of the United States Battles between US Army and Cheyenne, Arapaho and Sioux Indians Massacre of sleeping Cheyenne warriors led by Lt. Col. George Armstrong Custer
1869	Exhibition: Works of Art Ornamental and Decorative Art in Melbourne	'Welcome Stranger' nugget — gold nugget discovered on the Donolly goldfield, was the largest nugget known to exist, weighing 78,381 grams
	Mark Twain's *Innocents Abroad* published	First continental railroad completed Congress establishes Board of Indian Commissioners First professional baseball team established First intercollegiate football game
1870	Foundation of National Gallery School, Victoria Sydney International Exhibition	
	Founding of Metropolitan Museum of Art, New York City Founding of Museum of Fine Arts, Boston	Federal Census: 39,818,449
1872	Francis Ellen Watkins Harper's *Sketches of Southern Life* published Publication of *Picturesque America*, William Cullen Bryant ed.	Yellowstone National Park established — Wyoming, Idaho, Montana

DATE	CULTURAL EVENTS	SOCIAL AND OTHER HISTORICAL EVENTS
1873		Expedition to inland led by William Christie Gosse encountered Uluru (which he named Ayers Rock) Bureau of Labor Statistics formed
1874	Marcus Clarke's *His Natural Life* published	Seaman's unions formed in Sydney and Melbourne
1875	St. Louis (Missouri) School and Museum of Fine Art established Students League of New York established	Civil Rights Act — prohibits discrimination in public accommodations and jury duty
1876	Art Gallery of New South Wales established	Death of Truganini in Hobart — believed to be the last full blooded Aborigine to live in Tasmania
	Alexander Graham Bell invents the telephone Centennial Exhibition in Philadelphia	Lt. Col. Custer and men massacred by Native Americans led by Sioux chiefs Sitting Bull and Crazy Horse at Little Big Horn
1877		Stumpjump plough, designed to rise over ground obstacles was registred by R.B. and C.H. Smith of South Australia
	Foundation of American Museum of Natural History, New York City Founding of Society of American Artists, Society of Decorative Art, New York Etching Club	End of Reconstruction in the South Chief Joseph leads Nez Perce Indians against US army
1878		Bicycles first made in US
1879	Foundation of the Art Gallery of South Australia Sydney International Exhibition	After more than 10 years of experimentation with refrigeration, Thomas Mort consigned a shipment of frozen meat to London. It arrived in good condition
	Founding of Society of American Artists — Hudson River School Carlisle Indian School, Pennsylvania teaches Native Americans white skills	Mary Baker Eddy founds Church of Christ, Scientist

DATE	CULTURAL EVENTS	SOCIAL AND OTHER HISTORICAL EVENTS
1880	First publication of the *Bulletin* — illustrated magazine influential in development of 'black and white' art in Australia Melbourne International Exhibition Formation of Art Society of New South Wales	The Kelly gang destroyed in a police siege of Glenrowan, Victoria. Ned Kelly, leader of the bushranger gang was tried and hanged in Melbourne Founding of the Salvation Army
		Thomas Edison develops incandescent lamp Founding of Salvation Army Federal Census: 50,155,783
1881		Australia's population: 2,250,194
	Architectural League of New York established	Billy the Kid (William H. Bonney), outlaw killed Founding of American Red Cross
1882	Society of Painters in Pastel established	Chinese Exclusion Act prohibits immigration of Chinese primarily in response to numbers of Chinese in California Native American Geronimo captured End of Plains Indian warfare with US
1883	Metropolitan Opera House built in New York City Mark Twain's *Life on the Mississippi* published Exhibition that includes French Impressionist paintings, at Foreign Exhibition Association, Boston	Brooklyn Bridge completed First of Buffalo Bill Cody's travelling Wild West Shows
1884	Mark Twain's *Huckleberry Finn* published	
1886	American Art Association exhibition of French Impressionists, the most important show of French Impressionists in US, organised by Paul Durand-Ruel, New York City	Statue of Liberty dedicated (gift from France) American Federation of Labor founded
1887		Dawes Indian Allotment Act — breaks reservations into parcels for farms; allots to individual heads of families; opposed by Native Americans because it counters their cultural view of land as sacred and communal, and reduces their control over land

DATE	CULTURAL EVENTS	SOCIAL AND OTHER HISTORICAL EVENTS
1888	Melbourne Centennial Exhibition Formation of Victorian Artists' Society Edward Bellamy's novel *Looking backward, 2000 to 1887* published	Centenary of European settlement Land boom in Victoria
1889	9 x 5 Impressionist Exhibition, Melbourne, of works mostly painted on cigar box lids	Sir Henry Parkes, premier of New South Wales, begins calling for a federated Australian Parliament
1890	American Fine Arts Society established	Thomas Edison and William Dickson produce moving pictures Jane Addams founds Hull Settlement House for the poor in Chicago, Illinois Federal Census: 62,947,714 US massacred Sioux, led by Chief Big Foot, at Battle of Wounded Knee, South Dakota Yosemite National Park established — California Sherman Anti-trust Act passed Electric Street cars facilitate residential movement to outskirts of cities
1891	Art Gallery of Western Australia opens	Sheep shearers' strike throughout Queensland, New South Wales and Victoria Economic depression begins Game of basketball invented
1893		Establishment of William Lane's socialist utopia 'New Australia' in Paraguay
	World's Columbian Exposition at Chicago; includes first major exhibition of Japanese art Frederick Jackson Turner's lecture, 'The Significance of the Frontier in American History' — declares the western (romanticised) frontier is gone	Cherokees strip in Oklahoma opened for white settlement Economic depression begins

DATE	CULTURAL EVENTS	SOCIAL AND OTHER HISTORICAL EVENTS
1894	Henry Lawson's *Short Stories in Prose and Verse* published Ethel Turner's *Seven Little Australians* published	South Australia grants the vote to women Pullman railroad strike
1895	National Society of Mural Painters established	
1896	Henry Lawson's *While the Billy Boils* published Poet Paul Lawrence Dunbar, son of former slaves, publishes highly successful *Lyrics of a Lowly Life*	
1897	*Saturday Evening Post* begins publication Brooklyn (NY) Museum founded Ten American Painters formed when a group of artists resigned from the Society of American Artists; includes John Twachtman, Childe Hassam, Thomas Dewey, Willard Metcalf, William Merritt Chase	First American subway — Boston
1898	Exhibition of Australian Art, Grafton Galleries, London First exhibition of American Impressionists (The Ten) in New York City	Spanish American War Hawaiian Islands annexed Spain cedes Philippines, Guam, Puerto Rico to US
1899	Salvation Army makes a feature film on the life of Christ Scott Joplin introduces Ragtime to white Americans	Open door policy with China
1900		American citizenship granted to Hawaiians Federal Census: 75,994,575
1901		On 1 January the Commonwealth of Australia is inaugurated in the first federated Parliament established under Prime Minister Edmund Barton

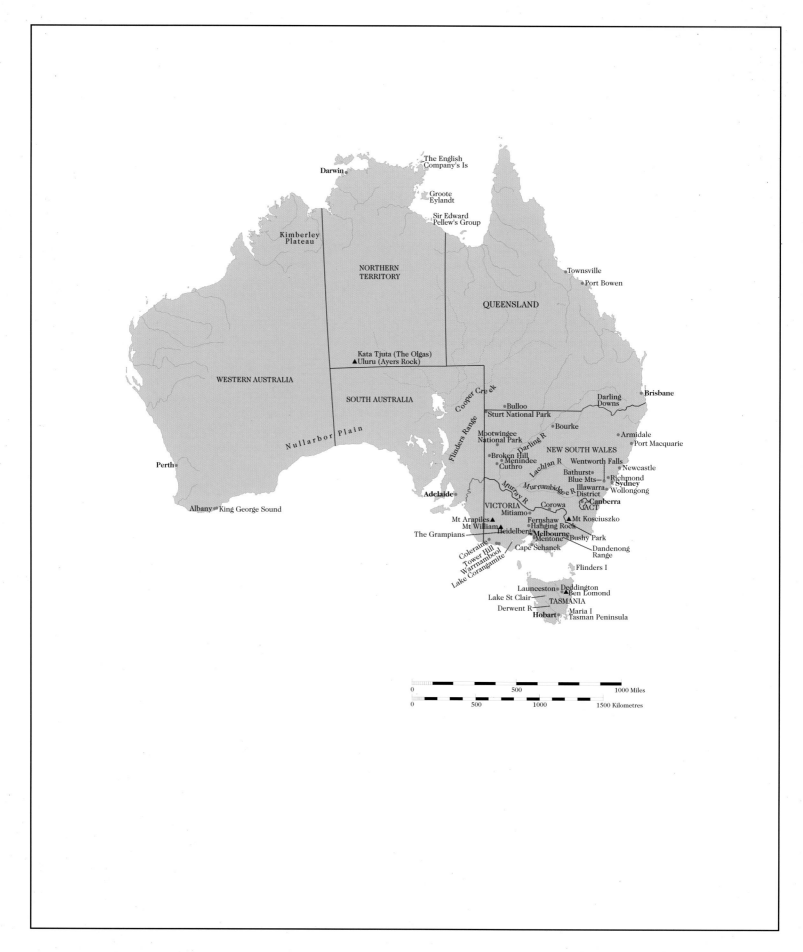

The English
Company's Is

Darwin

Groote
Eylandt

Sir Edward
Pellew's Group

Kimberley
Plateau

NORTHERN
TERRITORY

Townsville
Port Bowen

QUEENSLAND

Kata Tjuta (The Olgas)
▲Uluru (Ayers Rock)

WESTERN AUSTRALIA

SOUTH AUSTRALIA

Cooper Creek

Darling
Downs

Brisbane

Bulloo
Sturt National Park

Flinders Range

Mootwingee
National Park

Bourke

Armidale
Port Macquarie

Nullarbor Plain

Darling R

NEW SOUTH WALES

Broken Hill
Menindee
Cuthro

Lachlan R

Wentworth Falls

Perth

Bathurst
Blue Mts
Richmond
Sydney

Newcastle

Murrumbidgee R
Illawarra
District
Wollongong

Adelaide

Murray R

Canberra
ACT

Corowa

Albany King George Sound

VICTORIA
Mitiamo

Mt Arapiles▲
Mt William▲
The Grampians

Fernshaw
Hanging Rock

▲Mt Kosciuszko

Heidelberg
Melbourne
Mentone Bushy Park
Cape Schanck Dandenong
Range

Coleraine
Tower Hill
Warrnambool
Lake Corangamite

Flinders I

Launceston Deddington
▲Ben Lomond
Lake St Clair TASMANIA
Derwent R
Hobart Maria I
Tasman Peninsula

0 500 1000 Miles

0 500 1000 1500 Kilometres

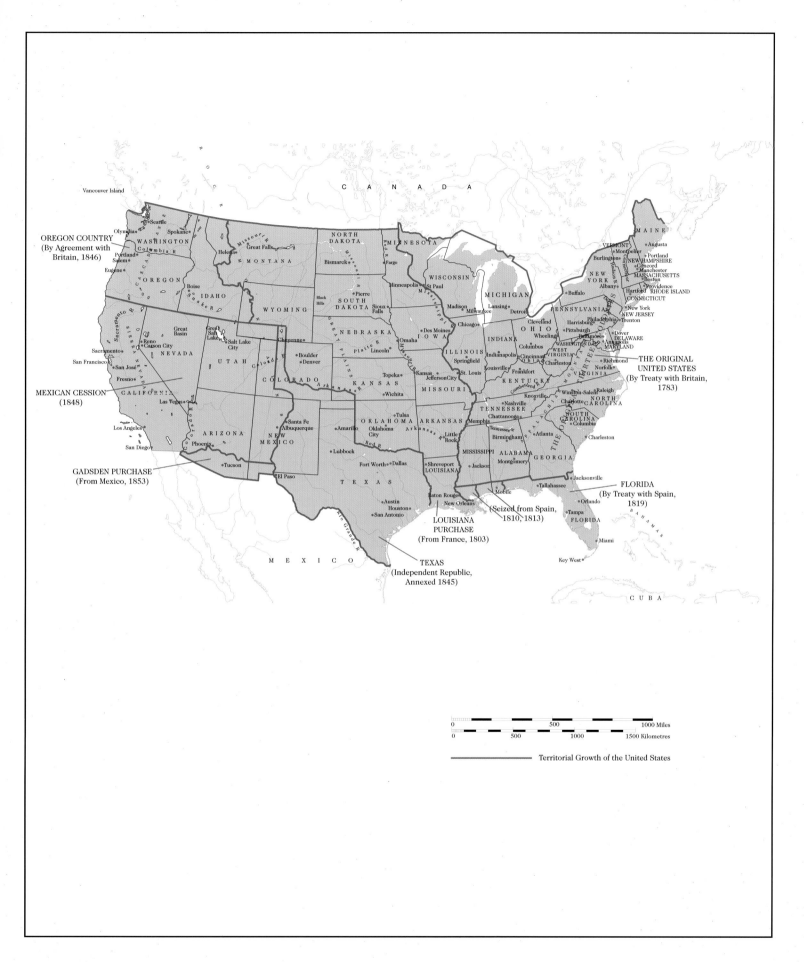

OREGON COUNTRY
(By Agreement with
Britain, 1846)

MEXICAN CESSION
(1848)

GADSDEN PURCHASE
(From Mexico, 1853)

THE ORIGINAL
UNITED STATES
(By Treaty with Britain,
1783)

FLORIDA
(By Treaty with Spain,
1819)

(Seized from Spain,
1810, 1813)

LOUISIANA
PURCHASE
(From France, 1803)

TEXAS
(Independent Republic,
Annexed 1845)

0 500 1000 Miles
0 500 1000 1500 Kilometres

Territorial Growth of the United States